ABOUT THE AUTHOR

Nicholas Foulkes is the author of around twenty books. He is best known for his critically acclaimed trilogy of nineteenth-century histories: *Scandalous Society* (a biography of Count d'Orsay); *Dancing into Battle: A Social History of the Battle of Waterloo*; and *Gentleman and Blackguards: Gambling Mania and the Plot to Steal the Derby of 1844*. He is a columnist for *Country Life*; a contributing editor to the *FT's How To Spend It* magazine, a contributing editor to *Vanity Fair*; and luxury editor of British *GQ*. He is the founding editor of 'Vanity Fair on Art' and he has written on the arts for a wide range of periodicals. In 2009 he was appointed to the board of the Norman Mailer Center. He is a graduate of Hertford College Oxford and lives in London with his wife and two sons.

'Splendidly unstuffy . . . first class' – *The Times*

'Riveting' – *Daily Mail*

'[A] fascinating account' – Bill Prince, *Telegraph Luxury*

'[A] thoroughly researched account of a life tinged with sadness, spent mostly in the studio, compulsively painting' – *Independent*

'[What] Foulkes is really good at, the thing with which this book is happily stuffed, is snappy storytelling . . . [The] years of excess provide the book with its most entertaining stretches' – *Sunday Times*

'Foulkes has drowned himself in the subject and done some impressive research . . . He always has interesting things to say . . . bold and stylish' – *Spectator*

'Foulkes recounts, with skill and a sense of fun . . . [He] is especially good at evoking Fifties and Sixties French culture, with all the cigarette smoke, beautiful people and Paris-Match style it deserves' – *Esquire*

'Whatever your opinion of the work of the prolific French expressionist Bernard Buffet, it's not hard to be seduced by the premise of Nick Foulkes' new biography, *Bernard Buffet: The Invention of the Modern Mega-Artist*' – *Wallpaper**

'A storyteller beyond compare' – *The Rake*

'[Nicholas Foulkes] has a sure eye and ear for the nuances of hierarchy in both Euro-trash's sumps and the art world. His book is diligently researched, elegantly written and well-paced. He does period colour and local colour with discretion and seldom dramatizes incidents' – *Country Life*

'A fascinating portrait of French cultural life in the second half of the 20th century, and of the contemporary art market, told with aplomb by Foulkes' – *S Magazine, Sunday Express*

Bernard Buffet

*The Invention of the Modern
Mega-Artist*

NICHOLAS FOULKES

arrow books

1 3 5 7 9 10 8 6 4 2

Arrow Books
20 Vauxhall Bridge Road
London SW1V 2SA

Arrow Books is part of the Penguin Random House group of companies
whose addresses can be found at global.penguinrandomhouse.com.

Penguin
Random House
UK

First published by Preface Publishing in 2016
First published in paperback by Arrow Books in 2017

www.penguin.co.uk

A CIP catalogue record for this book is available from the British Library.

ISBN 9780099594222

Printed and bound by Clays Ltd, St Ives Plc

Penguin Random House is committed to a sustainable future for our business,
our readers and our planet. This book is made from Forest Stewardship
Council® certified paper.

To my wife Alexandra and our sons Max and Freddie,
who have lived with my Buffet obsession
(and many others besides)

Contents

Introduction

One afternoon around the turn of the century, I had just finished lunch and, having paid my postprandial visit to Davidoff, was strolling through St James's with a cigar when my eye was forcibly seized by a painting in a gallery window. It was a still life, not very big, a water-colour if memory serves. It showed a handgun, some books, a coffee pot, a Ricard-branded ashtray on the edge of which rested a smoking cigarette, and an antique desk lamp with a shade of pleated green fabric tilted to create a cone of light that illuminated the items, causing them to emerge from the black background. It was an effectful picture. Who was smoking the cigarette? Was it the owner of the gun? How did they relate to the pile of books? It was dramatic, and had all the more impact because of the artist's signature. Right in the middle of the composition, in an angular script that would become very familiar to me, were the two words 'Bernard Buffet'.

I fell for it immediately. It could have been the cover of a mid-century detective novel, or a moody film poster. I felt it had something of the 1950s about it, and it surprised me to learn that it had been painted in 1978. Tempted, I called a friend who knows about paintings; he told me that Bernard Buffet was a terrible artist, and that was that – a pity really, as I still think about that painting today. However, in a way, the work has remained with me as part of a personal version of André Malraux's Musée Imaginaire, remaining stubbornly in my mind, reproaching me for not buying it.

I have to thank that picture for making me aware of the work and the life of Bernard Buffet. Over the course of the ensuing years, I would see his works in auction catalogues. The artist himself appeared in photographs of the beau monde during the 1950s and 1960s. I would spot him among the jury of the Cannes Film Festival. I would come

across him loping moodily, smartly suited, cigarette dangling as if attached genetically to his lower lip, amidst giant scenery flats of his own design on stage at the opera house in Monte Carlo. Occasionally I would come across an old copy of *Paris Match* in which he would be photographed in one or other of the many castles and grand houses he would own during his life.

Clearly at one time Bernard Buffet had been a big deal, famous and, if the pictures of him looking like a movie star in slick three-piece suits or neatly turned out in a dinner jacket were anything to go by, unafraid to embrace the material pleasures that this success had afforded him.

I became intrigued.

A few years later, sitting around a dinner table with a couple of figures from the art world, I mentioned Buffet. The reaction was almost violent, an intake of breath and then a torrent of disparaging comments. By this time we were living in the age of the iPhone, and a cursory internet search turned up examples of his work. What struck me as remarkable was that the art professionals held an opinion diametrically opposed to the rest of the dinner party, laymen who found the variety of subjects treated and the accomplished manner in which they were executed immediately attractive.

I was no longer intrigued.

I was fascinated.

Unfortunately, the overwhelming majority of the literature on this enigmatic figure is in French, so it took me some time to find out about him, but what I found was well worth the hours pondering the language of Racine and Corneille. I discovered a painter who had been proclaimed a star at the age of twenty. Along with Bardot, Sagan, Vadim and Yves Saint Laurent, he had been one of the glittering constellation of talented youth who had found fame while still in their teens, and who had shaped French culture and the perception of France during the fifties and sixties.

The Frenchness he represented was the image of France with which I had grown up: glamorous women in haute couture; blue, silver and black cylindrical canisters of YSL Rive Gauche; Café de Flore, Brasserie Lipp, and of course Ricard ashtrays in which one stubbed out one's Gauloises or Gitanes. Back in the 1970s, France may have long since ceased to be an international power of any consequence, but when it came to food, fashion and sophistication, it was still the world leader.

I am of the generation who took family holidays in the Dordogne and in Paris, the city in which Buffet grew up and which he painted throughout his life. When I took my honeymoon, it was to the chateaux of the Loire, painted in 1971 by Bernard Buffet, that we travelled. And when we conceived our first child, it was on the Côte d'Azur, of which the painter was one of the chief ornaments during the fifties and sixties, and which of course he had painted many a time.

The more I looked into Buffet's life, the more compelling I found it. Sometimes he was a ubiquitous socialite, seemingly omnipresent wherever there was a film festival or a fashion show to attend, at other times a recluse to rival Howard Hughes. Sometimes he was homosexual, at other times heterosexual. Sometimes he consumed drink and drugs insatiably; at other times he was completely ascetic. Sometimes he painted scenes of such horror and cruelty that they are hard to look at; at other times he produced landscapes of remarkable, soothing serenity. At first he was lionised by the critics, and later laughed at by them. To some he was the artist in the Rolls-Royce, and yet he had come to fame painting pictures of post-war austerity.

But the drama of his life aside, what fascinated me was the trajectory taken by his reputation. How could a man who was hailed a genius at the age of twenty, the saviour of French painting and the designated successor to Picasso, have become a national embarrassment by the time he was in his thirties? Why, whenever I mentioned his name around educated French people, was the reaction so visceral, so hostile?

While in the middle years of the twentieth century, the same man had been a phenomenon who enjoyed spectacular commercial and, at least at first, critical success.

The deeper I delved into his story, the more obsessed I became. The man was a painting machine: working unaided over the course of a career that lasted from the 1940s until the end of the century, he painted no one knows quite how many pictures, the conservative estimate being 8,000–10,000 oils and plenty of watercolours and drawings. He could polish off a vast canvas of 200 square feet in a week and finish a couple of dozen drawings in a day, all characterised by the same confident, infallible lines. There were no preparatory sketches; instead, with an almost unearthly precision, he worked directly on to the canvas.

I was fortunate enough to get to know Buffet's art dealer, Maurice Garnier, a year before his death at the beginning of 2014. Garnier was a remarkable man who had worked with the painter since the late 1940s and who from the 1970s had devoted himself solely to his work.

Their relationship was unique, and when I first crossed the threshold of Garnier's eponymous Paris gallery in the spring of 2013, it was like stepping back into the sleek, understated mid-century modernism of France under General de Gaulle. At that time the country was experiencing a period of unprecedented prosperity and when every February le Tout-Paris would gather here amidst the clink of glasses and the susurrus of animated conversation for Buffet's annual exhibition.

It is often said that Maurice Garnier entered the art of Bernard Buffet much as he might have entered a religion, and at his gallery on the Avenue Matignon it was as if everything were being held in readiness for the return of the artist's reputation. But for Garnier, Buffet might already be forgotten, yet like the obsequies of some arcane faith, the ritual February exhibition continued for years after the painter's death.

Garnier was a memorable character, courteous, correct and incredibly strong-willed. Moreover, even though he was in his mid nineties, he was able to muster a soupçon of Gallic lady-killing charm. When I met him, he was still walking to the gallery every morning, although he feared that with his rapidly failing eyesight, this pleasure would soon be denied him. We discussed this over lunch in the Chinese restaurant once favoured by Buffet, where Garnier always ordered the same thing, so that even if he could not see it, he knew what he was eating. On that occasion I was accompanied by a colleague from *Vanity Fair*; having explained his failing eyesight, Garnier turned to my friend and said, 'But I can see well enough to tell that you are a very beautiful woman.'

I liked going to see him because he was such good company. We would talk about how he remembered seeing Édith Piaf perform before the war, and how he had met Buffet for the first time playing table tennis. On one occasion I remember him placing a plastic bag over his head to show me how Buffet had died. Another time, when we were discussing Buffet's sexual orientation, he digressed into the sexual tastes of leading men of that day, and told me how a newspaper

editor of his acquaintance had only been able to have sex with prostitutes.

Talking to this remarkable survivor was like returning to the Paris of the 1940s and 1950s, when figures such as Picasso and Cocteau, Camus and Sartre were not characters to be studied by historians, but living men with the strengths and failings that characterise all human beings.

There were times when he could be a little inflexible. I remember the occasion when his charming wife Ida appeared at the gallery with a sheaf of faxes from Bernard's wife. Naturally I was jubilant to have struck such a rich seam of primary material; however, instead of taking them off her there and then, I suggested that copies were made in case any of them got lost. This was thought to be a good idea, and in a week or so, an envelope arrived, but instead of the armful of fax paper, there were just two or three sheets. I asked where the others were and was told that they were of no interest to me. It was useless to argue.

Indeed, one of the pleasures of researching this book has been the opportunity to encounter some of the powerful characters who shaped France in those vibrant years. Pierre Bergé, Jacqueline de Ribes and Juliette Gréco are among those who through their reminiscences took me back to a time very different from our own. A time when a young, good-looking millionaire artist with a castle, a yacht and a Rolls-Royce was something new. And in an attempt to understand the painter better, travelled around France and to Japan to visit some of the places he knew in his lifetime, among them the houses he knew as a child and an old man.

I do not feel qualified to say whether Buffet was a great painter, but I believe that he was an important one. The case could be made that he is the link between Picasso and Warhol, as is the belief of one of the great collectors of our age, Bernard Arnault, who by the way got very excited when I showed him some photographs that I had taken of Buffet's truly monumental paintings, which are anything up to seven metres in length.

Through his paintings, Buffet speaks eloquently across the years and from beyond the grave about what it was like to live in the middle of the last century. Standing in front of his masterpieces and getting to know them, becoming aware of the way in which those now dead hands, once so swift, supple and dextrous, applied the paint to the canvas, until the stylistic devices and individual brushstrokes take on

the familiarity of old friends, has made him and his oeuvre more alive to me than the work of many of the most renowned artists living today. Upon leaving Buffet's exhibition of Paris landscapes and seeing the city anew through the painter's eyes, his friend Jean Cocteau confided to his diary that 'the test that a painter is a painter is when everything starts to resemble his painting'.[1] It is certainly a test that he passed with me, as I now have difficulty looking at anything – whether a flower or a snow-covered road; whether an oil lamp or an ashtray; whether the Place des Vosges or the sombrely gaudy spectacle of the corrida – without my mind's eye imagining how Bernard Buffet would have seen it.

Recently I was discussing the painter with one of the higher-profile twenty-first-century collectors of Buffet's work. After I had limned out the briefest of biographies, he asked me just how many lives this man had led, and wondered how I was going to fit them all into one book. It was a pertinent question. Faced with a life so crowded with incident, I could only answer that it was my own limitations as a writer rather than a paucity of material that would impose restrictions. Moreover, given that Buffet's oeuvre provided the artistic backdrop and iconography of his times, it is impossible to contemplate the artist without placing him in the context of his era. Thus one of the pleasures of writing this book has been the chance to become better acquainted with the remarkable years that took Europe from the rubble and ruin of total war to the bright and brash world in which we live today, through the pages of countless newspapers, artistic journals, exhibition catalogues and, of course, back numbers of *Paris Match*. And while the two discrete periods seem separated by an almost unbridgeable gulf of history, it has astonished me to learn just how much of what we experience today can be traced back to Buffet's day: the mechanics of modern celebrity; the cult of the contemporary artist; the frenzied speculation in works of art; the art boom; the melting of the barriers between high and popular culture; and the emergence of art as a de facto branch of the entertainment and luxury goods industry.

Even though this is a relatively long book, I feel that I have managed to produce only an impressionistic sketch of Bernard Buffet rather than a fully realised portrait. Happily there are already many excellent studies of the painter and various aspects of his work, published during his lifetime and posthumously. Moreover, as I am not an art professional

and lack any formal art historical training, my judgements should be viewed for what they are: subjective observations. Nevertheless, since the defining leitmotif of the arts in our current century has been the explosion in the cultural and financial value attached to contemporary art, Bernard Buffet's story seems extremely topical.

Of course nowadays, rich celebrity artists are almost as common-place as poor, starving ones. Today the most successful artists are among the wealthiest people on earth, their work sells for millions and their faces and stories are as familiar to us as those of film stars and musicians: Tracey and her unmade bed, Damien and his pickled shark, Anish Kapoor's wax, Richard Prince's nurses and cowboys, Jeff Koons's supersize kitsch . . . Once upon a time, Bernard Buffet was just as famous, and the Icarus-like rise and abrupt catastrophic crash of his reputation make for a cautionary tale that today's art market, with its celebrity artists and soaring prices, might do well to heed.

Chapter 1

Death in Provence

It is said that asphyxiation brings on a state of hallucinatory intoxication – in which case, the seventy-one-year-old man who lay sprawled on the floor of his Provençal villa died happy.

Monday 4 October 1999 had begun as a day much like any other at the Domaine de la Baume, a substantial eighteenth-century manor house a few minutes from Tourtour, a tourist-brochure-perfect example of a hilltop village in the Var: all ancient stone and red-tiled roofs; houses crammed together in charming propinquity around a delightful tree-shaded square filled in summer with café tables and the babble of tourists sampling the *douceur de vivre* of *la vie Provençale*.

Behind the thick ochre walls of the old house, life was stirring. The view from its broad terrace overlooking the large estate gave the impression that morning, as it did every day, that the inhabitants of this paradisiacal property had Provence more or less to themselves. But the magic of the house and its picturesque setting had long since ceased to cast its spell over the man who awoke that morning. Waking up and getting out of bed was a painful, agonising business.

Each day the Parkinson's disease that laid siege to his nervous system robbed him of more of his independence. Breakfast with his wife of forty years, a once beautiful woman now inclining to stoutness, was a sullen affair. After that, he heaved his heavy body up the stairs to his first-floor artist's studio. He had always felt better about life when alone with his work, surrounded by the tools of his craft and the comfortable, familiar chaos of paint-spattered furniture, canvases pinned to the wall, tabletops piled with mountains of crumpled paper and crowded with countless creased and squeezed tubes, the floor covered with balled-up rags upon which brushes had been hastily wiped. But since he had broken his wrist during the summer, even the slight reprieve offered by holding a brush in his shaking hands

and moving it across the taut surface of a canvas was denied him. Throughout the morning his wife dropped in to consult him on a trivial matter or ask him some inconsequential question or other; both of them knew these were just pretexts for her to check on him.

At about midday, however, his mood lightened. The old couple took a short stroll with their dogs, listening to the chuckling fountain and enjoying the views out over the formal gardens to the pool and the dovecote just visible through the trees. The walk to the dramatic waterfall, where water poured out of the mountain and tumbled in a torrent down a cliff to fill the cold, clear pools below, was out of the question. Yet as they wandered slowly arm in arm, watching the dogs play and breathing in the autumnal air, the man seemed to take a little pleasure in life. He even plucked a rose from the bush in front of the house and laid it at the feet of the small statue of the Virgin Mary on the terrace. This light exercise seemed to have given him an appetite, and he ate lunch with relish, after which he stretched out on the sofa in the large drawing room for a short nap.

Waking shortly after three o'clock, he called his wife, who found him smiling and relaxed. He said that he was going to go into the studio for a short while, after which they would watch television together. He also said that if it was not too much bother, he would like an omelette *aux fines herbes* for dinner. His wife bustled happily off to the kitchen to check if they had any eggs and to enjoy a coffee and a cigarette.

And then, having rested, planned the remainder of his day and chosen what he was going to eat for dinner, he went upstairs, calmly placed a plastic bag over his head, taped it tight around his neck and patiently waited the few minutes it took for death to arrive.

At four o'clock, having not heard him come down, the woman mounted the stairs and opened the studio door.

At first she thought he had fallen. But the sight of the plastic bag and the tape soon robbed her of this comforting fiction. Using the scissors with which he trimmed his beard, she cut away the bag, taking care not to injure him, to reveal a face that she later described as 'peaceful and smiling'.[1] In a twist of macabre irony, the black polythene through which she sliced was printed with two words in her late husband's distinctive angular handwriting, once described by *The Times* of London as arachnoid, and which his friend Jean Cocteau with typical figurative flamboyance had been moved to call a praying mantis

script. The two words were those of his name, Bernard Buffet, repeated over and over again as if in mute funerary lamentation.

Perhaps instinctively, or maybe in real hope that he might be revived, his wife called for help and the employees on the estate came running. But she knew it was too late. Soon the machinery of death began to grind: firemen, a doctor and the police arrived quickly. And then came the press, because her husband was still a famous man in France, even though his reputation as an artist seemed irretrievable, dismissed as he had been by the art establishment as a painter of gaudy commercial junk: landscapes, polychromatic vases of flowers, and clowns – particularly clowns – reproductions of which had hung in a thousand doctors' and dentists' waiting rooms from Brittany to the Alpes-Maritimes.

Shunned by major cultural institutions, Bernard Buffet was not so much a footnote in art history as an embarrassing memory, a cultural one-night stand that the art world seemed determined to forget. The orthodox view of intellectuals in this most cerebral of nations was that his work barely warranted exhibition on the easels of street-corner tourist-trap painters, far less the consideration of being hung on the walls of a serious museum. Typical of the coverage of his death was a ten-page survey of his life in the following Saturday's *Figaro* magazine. It delicately avoided any critical appraisal of the quality of his body of work, preferring to focus on its quantity. His prodigious output of over 8,000 canvases allowed *Le Figaro* to describe him as the 'Stakhanovite of painting'.[2] Instead of talking about his work, the magazine took refuge in the past, printing page after page of black-and-white pictures of the man at his glamorous best, slim and elegant, with cigarette perpetually poised between index and middle finger; his wife with similar, seemingly genetically attached tobacco product, transformed by the mediating benevolence of archive photography from the matronly septuagenarian with the sun-spotted features who had sliced open the plastic bag with which her husband had suffocated himself, into the gamine beauty who had bewitched Saint-Germain-des-Prés during the fabulous fifties like a second Juliette Gréco.

With the exception of a rather prurient little fact box that dwelt on the erection-enhancing properties of asphyxiation, likening it to the then recently launched Viagra, and a Q&A transcribed from a television interview, it was as if Buffet had died a generation earlier.

Elsewhere in the world, he warranted short, almost perfunctory obituaries that talked of early promise betrayed by a long and productive life. 'For years, the art press had ignored his shows and the Pompidou Centre never bought a single work,'[3] observed the *Guardian*. 'As he found himself overwhelmed with commissions, his work became more stylised and decorative, losing its original impact,'[4] wrote the *New York Times*. 'Critically scorned but commercially popular'[5] was the verdict of the *Los Angeles Times*.

Had Buffet died forty years earlier, however, he would have gone to his grave lauded as the last truly great painter produced by France, an artist whose commercial success and critical acclaim looked to some to put him on a collision course with Picasso.

Chapter 2

The Boy from Les Batignolles

The life that had ended so melodramatically on a large country estate began in the rather more pedestrian surroundings of a maternity hospital in Paris's 9th arrondissement on 10 July 1928. Bernard Buffet joined a family of three: his father managed a mirror factory and glass-cutting business; his mother looked after his older brother Claude in the family's small apartment on the second floor of a building on the Rue Mariotte.

In later years when asked about his childhood, Buffet would dismiss it almost grudgingly as neither interesting nor amusing.[1] The year before he died, he participated in a biographical film and dispatched the entirety of his early family life with a couple of dozen words. 'My parents were separated, there were money problems. You couldn't say I was privileged. I wasn't in an artistic environment, far from it,' wheezed the plump, florid-faced, snowy-haired man sitting in his country gentleman's drawing room surrounded by valuable antiques, exotic curios and the works of his own hand. 'My mother died alone, when I was young. And my father didn't bother much about me, so I was left to my own devices, and I could do whatever I pleased.'[2]

It is as if he would have us believe that he created himself much as he created his paintings, starting with a blank canvas: a semi-feral child of the city, a creature of his own invention, abandoned by his parents and living on his wits like Hugo's Gavroche. It is of course not as simple as his bald statements would suggest; in fact the opposite is almost true.

By the time he was born, at the end of the 1920s, there was the unmistakable sense that the Buffets had rather come down in the world. His grandfathers, both from families with ties to the quiet northern French town of Le Quesnoy on the border with Belgium, were career soldiers who had served and died during the Great War. His maternal grandfather, Felix Colombe, seems to have been an

unusually peaceful man for a professional soldier. A regimental librarian, he is variously described as well read, a gifted draughtsman,[3] calm, cultivated, a voracious reader and a pianist.[4] A man of fragile health, he was already fifty-five years old at the outbreak of war, when he was attached to the staff of Philippe Pétain (on which one of the junior officers was a certain Lieutenant de Gaulle). His death, like his life, was not a particularly martial one: he caught a cold while buying sheepskins in December 1914, and his weak lungs did the rest.

By contrast, Henry Buffet, a lieutenant colonel, was killed in action in October 1915, during the assault on Souin in Champagne. He thought there was nothing finer for a man than a career in the military, and had pushed his son into enrolling at the famous military academy of Saint-Cyr. By extremely good luck, Charles Buffet failed his entrance exams; most of those who passed that year would not live to see the end of the decade.

During his preparation for the military academy, Charles had travelled to the Kaiser's Germany to acquaint himself with the language and customs of the country that France confidently predicted it would invade. These studies served him well when, in August 1914, his home town was swiftly occupied by the Germans; he spent the rest of the war serving as an official translator to the *mairie* of Cambrai. It was only after the armistice that he got round to performing his military service, in a cavalry regiment. In August 1919, his army duty complete, he went straight to Paris to seek out his childhood sweetheart Blanche Colombe, with whom he had grown up in Le Quesnoy. In November of the same year, the young couple were married at the Church of Saint-Michel-des-Batignolles.

Their married life began in circumstances that were far from luxurious. Their first cramped flat was in the eaves of the building on the Rue Mariotte, and Charles, son of Lieutenant Colonel Buffet, Légion d'Honneur and five citations, found work managing a bicycle factory. Eventually, thanks to his aunt, he was offered the managerial position at the glass and mirror works belonging to Georges Guenne, and with the birth of their first son, the Buffets moved to a slightly more spacious second-floor apartment: just big enough for a family of three, but not for the family of four that they became in the summer of 1928.

It was his employer who helped Charles out with a small second-floor flat of seventy square metres[5] at the back of a light-starved inner

courtyard in the Batignolles district of Paris. Essentially still a nine-teenth-century apartment, the property needed a bathroom and electricity before the family could move in.

Rising canyon-like into the grey Parisian sky, the various facades – a little art deco here, faintly neoclassical there, but essentially anonymous everywhere – that make up the inner courtyard of 29 Rue des Batignolles have a cramped pretension to grandeur that aims at impressive but settles for a bourgeois austerity, and it was here that Bernard Buffet grew up. With accommodation hard to find in post-war Paris, this set of rooms did not exactly represent the world of Bugattis, cocktails and Ruhlmann furniture of the French capital during Les Années Folles. Nevertheless, as the *New Yorker* observed in a 1950s article about Bernard: 'The Buffet apartment, on the populous Rue des Batignolles, may have seemed poor compared to what M and Mme Buffet had been brought up to, but it certainly had no connection with hardship or poverty as known in that working-class quarter.'[6]

Les Batignolles had been a village until the Second Empire, when Napoleon III's grandiose remodelling of the city under Baron Haussmann absorbed it into the capital. By the end of Napoleon III's rule, the area had become a less notorious alternative to Montmartre for artists seeking somewhere out of the centre of Paris to work and live; Fantin-Latour's famous 1870 painting *A Studio at Les Batignolles* shows Manet at work at his easel surrounded by a group of students and admirers, including a young Renoir and a firebrand journalist called Émile Zola.

Almost 150 years after Fantin-Latour depicted this scene of artistic endeavour, Les Batignolles retains something of a village feel. Although not far from the tourist centre, it is not an area popular with visitors and remains resolutely French in character. At the end of the Rue des Batignolles, no more than five minutes' walk from number 29, is a delightful little crescent of shops and restaurants facing the charming church of Sainte Marie des Batignolles, behind which is a miniature park, the tree-lined Square des Batignolles, edged with cafés. The Square des Batignolles even has that *sine qua non* of French village life: a ground for playing pétanque and boules.

However, it was not here that little Bernard was taken to play. Instead, his mother took the two boys across town to the considerably more upmarket Parc Monceau, crossing en route the main railway lines as they converged towards their terminus, the Gare Saint-Lazare.

Occasionally Claude and Bernard, who was growing into a sickly and withdrawn child, would stop and look at the trains. It could have been that Blanche was keeping up appearances and hoping that at the Parc Monceau her children would be mixing with a better class of playmate, or it could have been that she wished to get as far away as possible from a domestic life that was far from idyllic.

Just as the Square des Batignolles conforms to the cliché of French life, so Charles Buffet conformed to the national stereotype of marital morality; as well as the family establishment in Rue des Batignolles, he kept a mistress, Marguerite Samson, an independently minded woman who had studied and become a pharmacist. Blanche's jealousy can only have been heightened by the fact that like her, Marguerite was a childhood friend of her husband, and had been known to her family as well. Protective of her children and resentful of her husband, Blanche was not happy. For much of the time, their second-floor apartment with its drab courtyard must have seemed no better than a prison, seventy square metres of misery in which the moping depression of the devoutly religious abandoned wife and mother alternated with the underlying tension between man and wife when the philandering husband returned, which he did with a rigid, metronomic regularity, splitting his time away from work scrupulously between his two households, prompting one of Buffet's biographers to say of Charles that as the 'son of a soldier he had inherited a military sense of organisation'.[7]

Combined with his frailty and shy disposition, this poisonous domestic atmosphere had made young Bernard into 'a timid, untalkative, and unsocial child, chiefly recalled for saying nothing but no. He always referred to other children as "les gens", or "people", as if he felt no youthful identification with them at all.'[8] And his sullen, uncommunicative and withdrawn demeanour accompanied him to the Jesuit school he had begun to attend, where he distinguished himself by showing an interest in and aptitude for nothing – except drawing. 'When I began to draw I was about seven or eight. I would see things in books, schoolbooks or in shop windows, and I would copy what I'd seen in the books. I think that if you really want to do something, you do it, even if nobody gives you a basic grounding,'[9] he would later recall.

Unable to keep her husband by her, Blanche poured her affection into her sons. Binding herself ever closer to her taciturn younger boy,

she nurtured his talent and interest; after church and Sunday lunch, she would often take her children to the Louvre, and the picture in front of which they spent most time was Antoine-Jean Gros's *Les Pestiférés de Jaffa*.

Commissioned by Napoleon himself, the painting depicts the young emperor-to-be visiting soldiers suffering from the bubonic plague, which tore through his army after the capture of the city of Jaffa by French forces in 1799. The blatantly propagandist melodramatic canvas shows Bonaparte touching plague victims, a powerfully symbolic act freighted with associations of royal laying-on of hands from the days of Shakespeare, when the 'royal touch' was supposed to cure scrofula, to Diana, Princess of Wales comforting the sick. The drama of the moment, the exotic splendour of the setting and the misery portrayed were compounded by the overpowering scale of the work. At over seven metres long and five metres high, the canvas was more than half the size of the Buffets' entire family home. The image burned itself into the impressionable child's mind. Later Buffet would come to revere Gros as the 'true master of Géricault and Delacroix', skilled at composition and 'without doubt the master of history painting'.[10] It was the vast compositions at which Gros excelled that he would attempt to emulate later in life, and that would prove to have such a polarising effect on his reputation.

It is tempting to imagine what was racing through the mind of the determined but frail little boy as he stood in front of that picture on so many Sunday afternoons during the 1930s. Around him Picasso, Léger, Braque and Matisse were reinventing art. History painting, once the height of artistic ambition, had been on the slide since the days of the Impressionists, its practitioners derided as *pompiers* (after the classical helmets resembling French firemen's headgear that littered their work). Yet while the world outside the Louvre echoed with the isms of twentieth century art – cubism, futurism, Fauvism, surrealism, expressionism – that little boy decided that one day he would paint as artists had done at the beginning of the nineteenth century.

Life for the young Buffet was not an unremitting round of school, church and museums, punctuated by visits to socially acceptable inner-city green spaces; Easter and Christmas were spent at his grandmother's house in Le Quesnoy, and although he lived in Paris, the emotional connection he felt to the area from which his parents came remained powerful throughout his life. Even when he was celebrated

and living in splendour, the sight of his childhood haunts affected him profoundly. His wife, Annabel, would recall that, many years later, in 1959, en route to a major exhibition in the Belgian resort of Knokke-le-Zoute, he suggested in the elaborately casual manner that he 'used to disguise deeply felt emotion'[11] that he wanted to stop at Le Quesnoy to show her his grandmother's house and the nearby farm of his great-uncle where he had spent some of his childhood holidays. The memory of his reaction to the sight of the family farm remained with her till the end of her life.

> The expression on your face when we arrived at your great-uncle's farm remains unforgettable. You were upset. In the voice of a betrayed child you told me how you had dreamed of owning the farm. Your mother ought to have inherited it. You seemed inconsolable at not having been a farmer there and nowhere else. For a few seconds I knew you as a child; so vulnerable, so sensitive . . . heartbroken by the hypocrisy of adults, their lies, sown with an anguish that had never left you in peace since.[12]

But there were moments of happiness too, and it is from this period that his lifelong love of rural France dates. As well as visits to grand-parents, there were also seaside holidays; aged seven, he began an enduring love affair with the sea, and had his first holiday adventures with a bucket and spade on the beaches of Saint-Cast, a small port near Saint-Malo, 'where, to his happiness, they returned in following years'.[13]

For two and a half months each year, Bernard lived a different life to the one overlooking the grey courtyard of 29 Rue des Batignolles. Photographs of the time show the two brothers in matching berets living a Gallic Arthur Ransome existence while their mother sits watching them from the shade of a beach tent characteristic of the area. Pegged into the sand at each corner, with one side transformed into a canopy supported by two poles, these little canvas shelters have a medieval jauntiness to them and are still very much in evidence on the beaches of Brittany today. It is a measure of how much this period of his childhood meant to Buffet that over the course of his long career he painted and drew hundreds of these tents as he tried repeatedly to recapture on canvas and paper, in pencil, in ink and in oils, a childhood idyll that had disappeared too early.

Bernard and his brother were on the sands of Saint-Cast in 1939 when war broke out. They were living on the first floor of a house belonging to a fisherman by the name of LeClerc. Fearing German bombardment of Paris, their mother decided that it was safer for her sons to enrol at the lycée at Dinan, a few kilometres inland. And so for the first year of the war, the young Buffet actually saw his life improve. It was almost as if his holiday had been extended by a year; freed from the oppressively devout education dispensed by the Jesuits on the Rue de Madrid in Paris, the secular instruction of the lycée must have seemed a relief.

It was also at this time that he began to develop an interest in food. Living under the same roof as a fisherman, he enjoyed superb seafood, and as well as bodily nourishment, this Breton way of life was a 'source of invaluable enrichment for the future painter. Lobster pots, large fillets of fish in shades of blue and brown, baskets full of glistening flat and long fish filled his memory with sufficiently numerous images for a lifetime of painting.'[14] All manner of marine life would come to feature strongly in his work. Just a couple of years after that prolonged sojourn in Brittany, he would produce his first oil paintings, among them still lifes of an accomplished precocity that would take as their subjects those opalescent fish piled atop each other, lobster and crabs filling his canvas with their subtle variations of brickish red. In those early paintings there is an almost Lucullan, gourmandising extravagance: a characteristic diametrically opposite to the style that would make his name and his fortune. These works would come from a place that was darker both literally and figuratively than the bright, joyful, sand-duned shores of pre-war Brittany.

Chapter 3

The Spectral City

Shortly before sunrise on 10 May 1940, a train steamed into the station at Euskirchen, a small German town close to the border with Belgium. Euskirchen was a blameless sort of place, typical of many in that part of the world. Picturesque, and possessed of a past reaching back to the beginning of the thirteenth century, this trim little settlement had been able to keep itself out of the history books, except perhaps for a brief quarter-minute of fame in 1902 when one of its sons, Emil Fischer, won the Nobel Prize for Chemistry. However, it was to become famous down the ages that spring morning, as the train from Berlin carried a very special passenger: German chancellor Adolf Hitler.

About an hour after his train pulled into the little station, dawn broke over the Belgian border, bringing with it the unstoppable force of 136 crack German divisions. As tanks and infantry poured across the border along a 150-mile front, 2,500 Nazi aircraft screamed through the skies, showering death and destruction on the airfields and cities of Belgium, Luxembourg, Holland and France.

The Drôle de Guerre, as the French called the Phoney War, had suddenly ceased to be *drôle*. The months of waiting since the declaration of war in September 1939 had ended and the German Blitzkrieg that had so decisively destroyed Poland had been turned westwards.

France's agony was brief. Just thirty-five days later, at 9.45 on the morning of 14 June, a flag bearing the Nazi swastika unfurled over the Arc de Triomphe.

On 11 June, the French capital had been declared an open city, and when Parisians learned that the government had already abandoned the capital and headed for Bordeaux, panic set in. Railway stations were besieged, and columns of refugees on foot, in carts and in slow-moving cars clogged the roads to the Loire valley, where General Weygand, the French commander-in-chief, had set up his temporary headquarters in the Château du Muguet.

As the German army marched down the Champs-Élysées, just a quarter of Paris's population of 2.8 million remained in the city. Marshal Pétain (with whom Buffet's maternal grandfather had served at the outbreak of the First World War) formed a government to run the rump state of Vichy France, and on 17 June he broadcast to the nation telling his compatriots that they must lay down their arms. A month and seven days was all it had taken to conquer France. And once word spread that the invaders were on the whole impeccably behaved, and actually paid for the goods and services that they enjoyed, life and people returned to the capital, though the semblance of normality was superficial.

The Paris that twelve-year-old Bernard Buffet came back to in September 1940 was an eerie place. The familiar landmarks and hotels were draped in the theatrical red and black of the flags of the occupier. But what really struck those returning to the French capital more than anything was that the city was quiet and, at night under curfew, empty. To Buffet's fertile young mind, it was an aesthetic revelation.

'Even the most deeply despairing of hearts swelled at the unimaginable splendor of the city,' recalled essayist and writer Gilles Perrault, who, like Buffet, was a young child at the time of the occupation of Paris.

> One of the first things the Occupier did was to dismantle the walls of sandbags protecting the major monuments from bomb damage. Private cars, buses, and taxis, all proscribed, were to remain in their garages for four years. Cleared of the mundane flow of traffic, the great avenues took on new and unexpected perspectives. Stone reigned supreme. Released from the thrall of traffic, the eye could rediscover the facades of buildings. The ear suddenly heard old-fashioned urban sounds like the hammering of a cobbler, the clattering of a press, which the internal combustion engine had all but banished from our century. People heard nightingales sing. The air was as pure as country air. Parks and gardens were fragrant with forgotten perfumes. Having thrown off their sooty widows' weeds, trees came into bud earlier in the spring and kept their russet foliage later in the autumn.[1]

It was even more breathtaking at night. The curfew, fixed at 11 p.m. on 27 July, was put back to midnight in November, 'to reward the peaceable and understanding attitude of the people of Paris'. The blue-painted street lamps gave out such a pale light

that anyone out walking at night had to carry a flashlight, which also had to be covered with a blue filter. The streets, narrower in the deep shadows, seemed more like the lanes of some medieval town. No light filtered out from houses, and the police on the beat, like the night watch of old, whistled furiously at the rare forgetful folk who had failed to put their blackout up in time. The Ville Lumière cloaked herself in darkness, but the full moon exposed her in all her majesty. Unreal, transformed by a lighting man of genius, Paris was like a deserted yet miraculously preserved city of the ancients. In this dream-like state she offered the double gift of physical beauty and the absence of man. In the intoxicating silence, footsteps rang out in the streets with proprietorial self-confidence. Never had such pleasure been taken in Paris herself since the city had been open to the enemy.[2]

This was the city that presented itself to the young Buffet, returning from the luminous land of plenty that was Brittany. Nevertheless life, however changed, went on as best it could, and that meant that Buffet continued his education. Now attending the prestigious Lycée Carnot, he proved to be an utterly abysmal pupil. His innate shyness and taciturnity, exacerbated by an overprotective mother, had turned the frail, timid and solitary child into a frail, timid and solitary adolescent whose fear of crowds prevented him from taking the Métro.

The one vague hint of academic achievement came in 1942, at the age of fourteen, when he won the school prize for natural history, 'principally because of the drawings of insects with which he illustrated his class papers'.[3] It would appear that Jean Roy, who taught science at the Lycée Carnot, was the only teacher to inspire him. Later Buffet would recall with fondness how every Thursday Roy took him to the natural history museum. This prize was the sole flowering of academic achievement in an otherwise barren educational career. And in the summer of 1943, as he celebrated his fifteenth birthday, the lycée had had enough and invited him not to return for the start of the new academic year that autumn. 'Madame,' wrote the headmaster to Blanche Buffet:

To our great regret, we cannot permit your son Bernard to repeat his recent school year. We have taken into consideration the state of his health, which caused his numerous absences. But an examination of his marks, and the fact that he has systematically had to take his classes

twice, proves that young Bernard is gifted in no subject whatever . . .
except perhaps in drawing.[4]

It was an academic career unblemished by success. One of his
earliest champions in the art world would later describe Buffet's mind
as completely unencumbered by conventional learning of the sort
needed to satisfy – as he put it with a memorable conflation of ancient
and Christian mythology – 'the Cerberuses who guard the paradise
of the baccalaureate'.[5] But, he argued, the absence of scholastic
baggage to lug around made Buffet far more original than those who
excelled within the rigid confines of the French education system.
Moreover, it would be wrong to infer that he was neither curious nor
intelligent; he was just unconventional, as was his approach to
erudition.

While Buffet may not have been able to satisfy the examiners, he
had nevertheless assembled an eclectic body of knowledge through
voracious reading at home. In 1940, one of his parents' friends had
been obliged to flee Paris and had left his magnificent library with
the Buffets, who had hidden the books in the attic of 29 Rue des
Batignolles. It was the space under the eaves of this austere apartment
building, rather than Gustave Eiffel's famous glass-roofed hall at the
Lycée Carnot, that was his real school.

'It is true that people think me ignorant,' Buffet once admitted, but
added, 'You know that at twelve I had read all the authors who could
best shape the mind.' He then rattled off an extraordinary list of
writers, among them the devoutly Catholic poet Paul Claudel; Marcel
Jouhandeau, a tortured writer in whom mystical Catholicism battled
with homosexuality; and Oscar Wilde's friend, the Nobel prize-winning
child molester André Gide. As well as reading what was considered
fairly racy literature, the young Buffet tore out the endpapers of many
of the books and drew upon them, as 'it was such pretty paper'.[6]

This unconventional autodidactic course of instruction resulted in
the acquisition of what the author of one monograph described with
commendable restraint as a 'very particular culture'.[7] Typical of this
idiosyncratic body of knowledge was: the costume of gentlewomen
in south-west Flanders during the fifteenth century; the rigging of
sailing ships; the amount of wax needed to bind the pigment in
encaustic paint; the horsepower of a De Dion-Bouton of 1904; and
the colour used by Baron Gros for the harness of the horse on which

he painted Napoleon's brother-in-law Murat (and if people told Buffet that the harness was leather, he would delight in correcting them, informing them it was made of gold).

It was this head full of mental bric-a-brac that Buffet brought to evening classes in drawing taught in the Place des Vosges. An academic failure living in a dysfunctional household in a city under an increasingly oppressive army of occupation, he had started attending these drawing classes run by the city of Paris while he was still at the lycée. Now, however, he was able to surrender himself fully to drawing and painting. And once he had given himself to the muse, his life became much easier, as his devotion to art became a sort of physical possession. Painting was much more than a passion; it became a compulsion or addiction. He was seized by a need to draw, to fill the empty space of a sheet of paper or blank canvas. It was as if he became an instrument of an invisible power, and in those evening classes, under the guidance of his teacher, Monsieur Darbefeuille, the future course of his life emerged.

As he worked by the subdued blue light dictated by the authorities, Buffet was accompanied by the strains of violins coming from a neighbouring room, where evening classes in music were held. As one critic later observed, 'there while he was drawing and painting he was able to forget his own miseries made worse by the occupation'.[8] A retreat into the mind offered a refuge; as Gilles Perrault said, 'There was no escape from the sadness except in the imagination; our misery could only be anaesthetised by distractions.'[9] But sooner or later they had to return to the grind of real life, and the fifteen-year-old Bernard would have to hurry through bleak, largely empty streets after his drawing class had finished, to make it home before the curfew.

On the first night of the Nazi occupation of Paris, having settled in at the Hôtel de Crillon, Major General von Studnitz had ordered a curfew at 9 p.m. Over the ensuing 1,552 nights of the occupation, the timing of the curfew varied, depending on the behaviour of the population. During a visit to the city on 23 July 1940, Joseph Goebbels had been of the opinion that it was a drab and joyless place, and that it was vital to revive its image as the capital of gaiety and pleasure. Accordingly, four days later, the curfew was extended to 11 p.m., and in November it was relaxed further and pushed back another hour until midnight, 'to reward the peaceable and understanding attitude of the people of Paris'.[10] That was the carrot. The stick was administered

in September 1941, when, following attacks on German personnel, cafés, restaurants and theatres in the city were ordered to close at 8 p.m. so that the streets could be cleared by 9. There were daytime curfews too, as in September 1941, when, following an appeal by Moscow radio, partisans stepped up their attacks on the occupiers, and the Nazis ordered that the streets be empty by 3 p.m.

The miseries of life in Nazi Paris were many: Hitler's secretary recalled how, in his final days in the bunker in Berlin, the Führer consoled himself with the story that during the occupation, Parisian women had had to use lipstick made from grease retrieved from the walls of sewers. By 1940, everything was in short supply. Buffet once said that he did not see butter on his table between the ages of twelve and eighteen, and this was just one of the more trivial of the countless deprivations as the war dragged on. Rationing of bread and sugar had started on 2 August 1940 and had soon extended to cover almost every foodstuff. The winter of 1940–1 was one of the most brutal of the century: coal soon ran short, and many old and vulnerable Parisians simply froze to death. By 1942, the daily calorific value of official rations stood at just 1,200. TB was rife. The mortality rate in Paris was almost 50 per cent higher than it had been in the mid 1930s. A 1944 survey of fourteen-year-olds in the more deprived districts found boys to be three inches shorter than they should have been, while girls were four inches under height. Just scraping together the means to exist was a full-time job.

> Well before dawn – three o'clock by the sun – furtive shadows gathered
> in front of food shops to watch for the raising of the iron curtain. At
> a price, concierges rented their porches or an empty cellar to house-
> wives who were determined to be the first: wrapped in blankets, they
> awaited the end of the curfew before hurrying to the shop next door.
> Shivering in the chill of the autumn morning, women stood bleakly,
> hoping for the return of the shopkeeper from Les Halles.[11]

It was in this grinding environment of perpetual gnawing hunger, shortages of the most basic commodities, febrile paranoia, and the casual cruelty of life in time of war that the young painter began to emerge from the chrysalis of the sickly, silent, solitary mother's boy. For the first time in his life, he flourished. The aimless drift through life, the directionless acquisition of random knowledge, the distracted

air – all this suddenly snapped into sharp focus as the teenage Buffet's remarkable natural talent for drawing and painting was nourished by the knowledge of technique. Throughout his life he would acknow-ledge his debt to Darbefeuille, who, he said, 'had taught him the essentials'.[12] But more than teaching him how to handle his materials, Darbefeuille can also be said to have influenced Buffet in a much more profound way, as it was under his tuition that the young man's mind was indelibly imprinted, branded even, with the unshakeable convic-tion that accurate drawing was crucial to becoming an artist. Typical of Buffet's early utterances was the rhetorical 'Does a painter know how to draw a hand or a foot? He doesn't? Then he'd better learn. There are too many young painters who have thought themselves competent to toss all discipline overboard.'[13] Half a century later, towards the end of his life, when the famished inner-city adolescent had changed into a corpulent country gentleman, he was still saying exactly the same thing: 'Drawing is the starting point. You can't get away from that. If you can't draw you have nothing, there's simply nothing. If you look at painting over the centuries, you've always got draughtsmanship.'[14]

So rapid was his progress, so sure was his hand, so convinced of his talent was his teacher that during the winter of 1943–4, the deci-sion was taken to apply to the École Nationale Superieure des Beaux-Arts. Barely six months earlier, Buffet had been a school dropout, with 'perhaps' some talent in drawing; now he was a teenage prodigy on the threshold of entering what was still at the time the world's most celebrated and exigent art school.

The École des Beaux-Arts is a monument to the importance that the French nation attaches to the fine arts. A huge building occupying five acres in Saint-Germain-des-Prés, it manages to take the ineffable, elusive gift of artistic genius and combine it with the imposing dignity of grand architecture to transform it into an instrument of national prestige. Walking through the gates on the Rue Bonaparte, flanked by a pair of pillars, topped on one side with a monumental bust of Puget and Poussin on the other, facing the sober grandeur of the neoclassical facade of the Palais des Études, the young Buffet would have been left in no doubt as to how art was at the centre of the national identity; a symbol of French cultural superiority. It is unsur-prising that he said that 'going into the Beaux-Arts was for many pupils like entering a convent'.[15]

And in common with many convents, the weight of anachronistic tradition rested heavily on the place. Everywhere students looked, they were confronted with the ritualised approach to the arts, not least in the monumental twenty-seven-metre mural that covered the amphitheatrical 'Hémicycle d'Honneur'. Executed in the best nineteenth-century historical style, it depicted the great artists of the past, from Phidias onwards, in learned discussion with each other. It was almost as if France had appropriated the cultural glories of antiquity for itself: it was in the Hémicycle d'Honneur that the prizes were awarded, the highest being the Prix de Rome, which awarded outstanding students a scholarship to study at the French Academy in Rome, where they were accommodated at the Villa Medici and soaked themselves in the art of the ancient world. And for those who did not get the chance to travel to see the wonders of the ancient world for themselves at first hand, the Beaux-Arts had a ready stock of classical sculpture, including full-scale plaster replicas of the pillars of the Parthenon, to enable its students to perfect their imitative representation of the arts of millennia past.

At the turn of the century, the Beaux Arts style had exercised an almost complete hegemony over the arts and architecture; everything from municipal buildings to the palatial homes of the plutocrats of America's Gilded Age was executed in a style that borrowed freely from all manner of historical eras. Although it had been wiped from fashion by the hard-edged modernism that would later become known as art deco, it still ruled at the Rue Bonaparte, and if Buffet wanted to study at the École des Beaux-Arts, he would need to submit a selection of drawings after the antique. Darbefeuille had taught him many things, but he had never subjected his star pupil to the arid discipline of drawing plaster casts of ancient pieces of sculpture. He need not have worried. 'To meet the needs of the occasion, in the course of a day Buffet produced the dozen or so drawings of hoplites' helmets, Roman cuirasses, thighs of Hermes, and busts of Venus necessary to get past the front door.'[16]

In 1944, Buffet passed between Poussin and Puget as an art student. Even by the straitened standards of the time he cut a forlorn figure, in his grimy grey roll-neck sweater and crumpled trousers, his chestnut hair cut en brosse, matted and unwashed. Occasionally his pale features, arranged in a long face that looked like an inverted isosceles triangle, would crease into a melancholic smile revealing crooked teeth, but

his face was full of sadness. Even his hands looked tragic, resembling, said one of his fellow students, 'those of a crucified man painted by Grünewald'.[17] He was just fifteen years old, and special dispensation was needed to admit such a young student.

At the Beaux-Arts, Buffet blossomed. On occasion he might even have begun to enjoy life. 'Being among nothing but art students, he felt competent for the first time in his school life, and made friends, and even admirers.'[18] At this time in his artistic development it is possible to see him looking for a style; he is notably influenced by Vlaminck and Utrillo in his representations of Paris street scenes. With portraiture that exaggerates and disperses facial features, he flirts with cubism. His still lifes have the classic composition of the Dutch masters of the seventeenth century and show the influence of Cézanne and Van Gogh. But there are also signs of early Buffet. There, in his start-lingly lifelike representations of fish, it is possible to discern the winner of the Carnot natural sciences prize, while in the street scenes, the one or two splashes of colour to indicate a human being soon disappear, to be replaced by the eerie emptiness that will come to characterise his later cityscapes.

However, while Buffet was depopulating the streets he was painting, the avenues and boulevards of Paris were anything but empty. The Normandy landings had taken place in the summer of 1944, and by the middle of August, the Allies had broken out of their beachhead and the uprising in Paris began. In the fierce summer heat, fighting in short-sleeved shirts and sandals, the Resistance surprised the German occupiers with a coordinated attack that initially seized a number of public buildings, while amidst the street-fighting could be heard echoes of Paris's turbulent nineteenth century, with cries of 'To the barricades!' It has been argued that the uprising was unnecessary and illogical. With Patton's forces on the road to Paris, slicing their way through the Wehrmacht, the result was in no doubt, and von Choltitz, the German commander in Paris, had no wish to enter history as the man who blew up the most beautiful capital city in the world. Instead there was a feeling that it was not about achieving a military goal, but about retrieving some scintilla of self-respect from the four years and one month of collaboration with, or sullen acceptance of, the Nazi regime.

On the eve of deliverance came insane heroisms, of the kind reserved for desperate causes. A Paris already warmed by the rising sun of

freedom battled like the Warsaw ghetto. Little kids rushed at Tiger tanks brandishing petrol bombs, men armed with shotguns stopped trucks full of SS, women were shot down trying to retrieve a fallen soldier's automatic pistol. But it was not really about impressing the world with a hastily colored tableau, an *image d'Épinal*, nor about wounding the enemy with what would amount to a pinprick compared to the dreadful wounds they were by then receiving. It was to do with the rest of us. It was a matter between us and our long humiliation. A battle lasting a few days would never wash the city clean of its corruption, but at least the fighters could hold their heads up high, all the more so because they would have fought for the principle of it.[19]

Throughout the occupation there had of course been heroic acts of resistance and savage acts of retribution, and now the roles were reversed as Parisians abandoned themselves to cruel acts. Women who had indulged in what was known as horizontal collaboration were publicly humiliated; their heads shaved, they were stripped and jeered. Buffet, no less sensitive than before, was deeply affected by what he saw as the seemingly infinite human capacity for cruelty. The memory of one particular incident retained the power to drain his features of colour for the rest of his life. One afternoon after the liberation, he was on the Place Clichy, where he saw 'two men holding a young German soldier little older than him, whom a woman had just found hiding in her building; this woman brandishing a knitting needle burst his eyeballs'. Buffet vomited on the spot.[20]

But the end of the war brought happier times. The defeat of the Germans may not have lifted the burden of material hardship immediately, but restrictions on travel were eased, and in order to recapture some of the flavour of those long, fondly remembered pre-war summers, during the holidays of 1945 Bernard and his mother decided to return to Saint-Cast. It was just to be the two of them. His father remained in Paris to look after his mistress and his glass factory, while his brother was on military service in Germany.

Exposed to the sea air and the Breton cuisine, the seventeen-year-old's appearance improved and the immediate traces of malnutrition disappeared. However, at the beginning of August, Blanche fell ill and was admitted to hospital. A brain tumour was discovered. It was deemed necessary to operate. By September, her case was declared hopeless. The doctor forbade her to be moved to Paris, and yet it

appears that Bernard, after spending the remainder of his holidays at his grandmother's house, returned to the city to resume his studies. Perhaps she played down the seriousness of her illness; perhaps Buffet himself felt the need to return to his painting, already in thrall as he was to the addiction that would shape his existence. Whatever the reason, by the end of October she was dead.

The funeral took place in the cathedral of Sainte-Brieuc. The congregation was small: Buffet, his father, his uncle, a cousin, and the family with whom he and his mother had lodged during their holiday. She was buried in the Cimitière de l'Ouest; however, Bernard never went to visit her tomb there.[21] This was not out of a lack of care, but rather from a surfeit of it. It seems that he simply could not bring himself to face the physical evidence that his beloved mother was no longer alive, so first his father and later his brother paid for the maintenance of the grave, until the beginning of this century, when, with no one left to pay for it, it was made available to another occupant.[22]

For a self-absorbed and overly sensitive young man, the loss of his mother, to whom he had been so close, and who had doted on him, mingled with feelings of guilt over how he might have behaved better towards her, would be something he would never overcome. The poignancy of that relationship, so unhealthily intense and protective, and then so abruptly and cruelly removed, would remain with him for the remainder of his life.

While he might have brusquely tried to downplay his childhood with carefully studied offhand casualness, his wife and a handful of true close friends knew that this bravado masked much deeper feeling. His 1994 canvas that borrows from Manet's famous painting shows Buffet and his mother in front of railings behind which the railway lines enter the Gare Saint-Lazare, a familiar stop on their journey from the rough-and-ready Batignolles to the refined Parc Monceau. It is the perfect visual definition of the cliché that a picture is worth a thousand words.

Chapter 4

Existentialism à la Mode

In the aftermath of his mother's death, Buffet quickly lost what little interest he had had in his appearance. His shoes were spotted and streaked with paint. His Canadienne, a fleece-collared military surplus garment favoured by Left Bank intellectuals and immortalised in Cartier-Bresson's portrait of a spectacled pipe-smoking Jean-Paul Sartre, was so caked in paint, grime and grease that it was described as having the appearance of a cuirasse and looked like it would stand up on its own.[1]

For Buffet, the personal tragedy of his mother's death was reinforced by the gratuitous cruelty of war, the bombardment of images from the death camps, and the sight of the emaciated figures who arrived at the Hôtel Lutetia in Paris from concentration camps to be reclaimed by families barely able to recognise them. Without the stabilising influence of his elder brother, who was still in Germany, his mood spiralled downwards. For his generation, the war was the defining event of their lives; although he was too young to have been a combatant, the long years of adolescence during which the future man was shaped had left their mark.

Wartime Paris was not something exceptional for Buffet; it was what he regarded as normal. The blackout, the absence of cars, the newspapers reduced to one single grubby sheet trumpeting the glorious victories of the Nazis: all this was his world. The city of gaiety, light, glamorous women, well-dressed men, cars and restaurants that was suddenly reasserting itself was utterly alien to him. Even a decade after the liberation, he still found it hard to adjust to the plenty around him. 'I was eleven when the war broke out. The misery of the occupation, the cold, the swedes, all of that became for me normal life,' he said in 1954. 'After the Liberation, when what the grown-ups called real life began again, I believed that this was an accident. Today, I am astonished to find that one can go into a shop and ask for what one wants.'[2]

A gulf opened between the teenage Buffet and those on the other side of the generational divide who had known Paris before the war. Parisians who had been born earlier found it hard to understand a generation whose terms of reference were so different from their own. For them, Paris was the City of Light, the most beautiful capital in the world, the city of romance that seduced its visitors with its charm and its appetite for the better things that life had to offer. Occupation had been a tragic interruption of an established existence and they were at a loss as to how to relate to young adults for whom the exact opposite was true. The sensitive Buffet could not look around him without seeing the city in which he had grown up; every vista, every landmark, every facade reminded him of that dreadful time.

Born in 1888, Gerard Bauer came to know Bernard Buffet well, and wrote a critical monograph about the painter's canvases depicting Paris. He was a Parisian man of letters, respected newspaper columnist, and director of the newspaper *La Presse*, which had been set up in the euphoria and confusion of the liberation. After the war, his ageing brow would be garlanded with further laurels: membership of the Académie Goncourt, presidency of the Société des Gens de Lettres, and the Grand Prix Littéraire de la Ville de Paris. He said of Buffet:

> His Paris . . . is not mine. Forty years separate us; I knew the inhuman period in which he grew up, feeling the need to reproduce what he saw, but it is impossible for me to forget all that preceded that time of misery and oppression. My Paris, even in its indifference, was a more tender place – a city which invited the passer-by and forced him to fall in love with her.
>
> What was Paris like in 1943? A capital occupied by the enemy – a city of restrictions, furtive exchanges, secret hopes; a city in which a child growing into adolescence might well wish at times to eliminate the human element in order to be left alone with a city he loved. Not by dogged will-power, but by an obscure repression, a desire to get rid of all that moved, all that lived in those blacked-out nights. I have not questioned Bernard Buffet, although I have known him for a long time, and this hypothesis is in no way an 'author's explanation'. It may not even be correct. But one must try and find a reason for this bareness which despite everything appears like a moral negation, a voluntary withdrawal, or a destruction which only spares the stones. The city is naked. Naked like a stage set before the play has started, naked like a

house of crime after the tragedy is over. Not a bud, not a leaf tremble in the sunlight: thin black branches like charcoal streaks penetrate the regular railings rising up from the deserted banks of the Quai Bourbon and the solitary approaches of the Canal St Martin.[3]

It is an acute analysis, with perhaps one slight clarification: Buffet loved to *paint* Paris. Although he would keep a pied-à-terre in the city, long periods in Paris put him on edge for much of his life, it was a feeling that strengthened with age. 'I still like the look of Paris but I'd hate to live there. I don't like cities any more . . . I like architecture,'[4] he said half a century on from the liberation.

To these external factors must be added his own fragile mental state, his highly sensitive nature, his apparent inability to care for himself and his increasingly obsessive absorption in his work. Unchecked by the comfort of family life, his animosity towards his father had strengthened since the death of his mother. His time with the Jesuits as a child had left him with a deeply personal interpretation of the Catholic faith that would remain with him, and his attempt to make sense of life through religious belief would soon be seen in his work. It was a volatile emotional cocktail.

However, while Buffet may have been extreme and almost unremitting in his bleak, nihilistic view of the world, seeing life as a friendless Sisyphean struggle, he was not alone. He spoke to a generation who had grown up with the horrors of war and whose young lives had been shaped by misery. 'We had the feeling that we had undergone an amputation under anaesthetic,' said one writer of Buffet's age many years later, 'but we did not know which limb had been removed.'[5]

On the evening of 29 October 1945, the night before Buffet's mother died, an unassuming, earnest-looking bespectacled man in his late thirties left his fourth-floor apartment at 42 Rue Bonaparte, a little further up the street from the École des Beaux-Arts, and took the Métro across town, getting out at the Marbeuf station, which the following year would be renamed in honour of the wartime president of the USA, Franklin D. Roosevelt. He was on his way to a public meeting, but when he turned the street corner, he saw that the venue was already full to capacity and that the mood among the crowd of latecomers outside was turning ugly. The talk had been advertised in *Combat*, *Le Figaro*, *Libération* and *Le Monde*, as well as promoted with

leaflets. Whoever was responsible for the publicity had done a good job. The sensible thing would have been to turn round and go back to the Left Bank, perhaps stopping in at the Café de Flore, where he was such a regular that the proprietor, Paul Bubal, would eventually install a separate telephone line for him.

But, however tempting the pleasant fug of his favourite café might have seemed on that chilly autumn evening, the man decided that he would persevere; after all, he was the speaker that the hundreds inside the hall and the hundreds more outside had come to see, to listen to, to applaud and to heckle. His name was Jean-Paul Sartre, and he was just about to become very famous.

The title of the lecture he was giving that evening was 'Existentialism & Humanism'. It took fifteen minutes of jostling for him to work his way to the front of the crowd, and it was an hour after the advertised time that his talk began. Had anyone listening to the opening lines of the speech known the young painter who studied just a few metres down the road from Sartre's apartment, they would have been struck by parallels that were almost eerie in their similarities.

Adjusting his spectacles, Sartre began:

My purpose here is to offer a defence of existentialism against several reproaches that have been laid against it.

First, it has been reproached as an invitation to people to dwell in quietism of despair. For if every way to a solution is barred, one would have to regard any action in this world as entirely ineffective, and one would arrive finally at a contemplative philosophy. Moreover, since contemplation is a luxury, this would be only another bourgeois philosophy. This is, especially, the reproach made by the Communists.

From another quarter we are reproached for having underlined all that is ignominious in the human situation, for depicting what is mean, sordid or base to the neglect of certain things that possess charm and beauty and belong to the brighter side of human nature: for example according to the Catholic critic Mlle Mercier, we forget how an infant smiles. Both from this side and from the other we are also reproached for leaving out of account the solidarity of mankind and considering man in isolation.

Despair, helplessness, depicting what is mean, sordid or base to the neglect of charm, beauty and the brighter side of life, isolation: in

essence it came down to one thing. 'The essential charge laid against us is, of course, that of over-emphasis upon the evil side of human life,' Sartre continued, adding with a touch of incongruous levity, 'I have lately been told of a lady who, whenever she lets slip a vulgar expression in a moment of nervousness, excuses herself by exclaiming, "I believe I am becoming an existentialist."'[6]

Whatever the subtleties of the philosophy that Sartre was outlining – and this speech contained enough Descartes, Leibniz, Kant, Diderot and Voltaire to keep several cafés full of earnest bespectacled intellectuals debating for months, if not years – the name 'existentialism' had, in the public imagination, already attached itself to the mood of anxiety and unhappiness that prevailed in the post-war world. No longer a philosophy, existentialism had become a lifestyle choice, as across Paris, and soon Europe and the world, it would become chic to be miserable.

When it came to misery, Bernard Buffet was already an expert. With his mother dead and his animosity towards his absent philandering father as powerful as ever, he was in need of affection to fill the emotional void, and he found it in the surrogate family of his fellow students.

In particular, there was one young man and fellow art student to whom he would become deeply attached. That autumn Buffet completed a portrait of Robert Mantienne at work: bent forward with a pipe in his mouth, his left fist clasping a trio of brushes, his right directing a fourth with delicacy at the canvas in front of him. The combination of strength and an artistic tenderness results in an accomplished and affectionate painting. It is not characteristic of anything he did before or after; as well as the care taken with the subject, there is something cheerful, almost joyous in the colourful striped background. It is as if Buffet is stealing covert and longing glances at his classmate as he works. Whether it is a sort of love letter in oil paint or not, it is a mature and accomplished piece of work; one person who saw it observed that 'it could have been by a painter of any age; just as easily an old independent painter as student. In any case, someone who already knew some tricks.'[7]

Robert Mantienne was Buffet's opposite. Four years his senior, and a confident man of action, he had interrupted his studies to participate actively in the Resistance. He had been imprisoned for six months by the Germans in 1943, and was wounded in one eye while undertaking

intelligence work in the closing months of the war. Mantienne was handsome in a masculine, boy scout sort of way, with close-cropped dark hair, and the beard and pipe he favoured made Buffet's pale awkwardness seem even more gangling and adolescent. He took pity on his withdrawn, unkempt classmate and the two men formed a close, intense friendship. 'Mantienne was the charming boy who Bernard saw more of than of the rest of us outside school,'[8] recalled a fellow student.

The war was over. The museums reopened. The commercial galleries hung works by Picasso, Matisse, Braque, Léger and other contemporary masters. Men like Marc Chagall returned from exile in America. There was an explosion of colour, all the more astonishing when viewed in contrast to the preceding years of gloom. Bernard and Mantienne walked together through this polychromatic landscape of sudden artistic plenty and discovered the work of the 'modern' French painters such as Courbet and Cézanne, as well as rediscovering such old favourites from his childhood as Gros, Delacroix, Géricault and David. The two men would also go and paint together, leaving the centre of Paris to work in Massy, on the outskirts of the city, where Mantienne's sister put her house at the disposal of her brother and his young friend. Here Buffet would paint all day and often into the night. Even at this early stage of Buffet's life as an artist, Mantienne would marvel at the stamina, industry and productivity his friend demonstrated.

By now Buffet had come to the notice of two painters, today largely forgotten, but at the time of considerable influence, who sat on various judging panels at the École des Beaux-Arts: Léon-Alphonse Quizet and Jean Aujame. Quizet, born in 1885, still crops up in auction catalogues today; his career seems to have essentially been predicated on painting the same sort of Parisian street scenes as his friend and almost exact contemporary Maurice Utrillo, only not as well. Aujame, meanwhile, appears to have experimented with a broad variety of stylistic fads, sometimes directly representational landscapes, sometimes whimsical Chagall-alikes, sometimes abstract, sometimes cubist, none of them with much in the way of lasting success. Both men, however, recognised Buffet's talent, and Aujame in particular set about encouraging the sad, strange young artist. In 1946, he urged the young painter to submit a work to Le Salon des Moins de Trente Ans, the major competitive exhibition for painters under thirty years of age,[9] in which a self-portrait of Buffet was selected to hang.

In the painting, Buffet depicts himself using a palette of pale browns, dirty whites and greys. With his triangular head, short hair, exaggeratedly large ears and buttoned tieless collar, he presents a maladroit air of inner and outer awkwardness. It was the beginning of the Buffet style, uncomfortable and unhappy, representing an alternative vision of the world to that of the grand old men of contemporary art, men who had made their reputations before the last war, or even the one before that, with the bright colours of Fauvism, cubism and post-Impressionism, who had returned to the windows and walls of the post-war Paris gallery scene with their bright and what must have seemed to Buffet indecently cheerful canvases. A slightly sinister painting, the self-portrait was enough to get Buffet noticed, not least by his father, who felt that it was his paternal duty to see whether his strange younger son possessed sufficient talent to make a career of painting. Through a mutual friend, he was introduced to Maximilien Gauthier, one of France's leading critics.

An established figure in late middle age, Gauthier would later describe the visit of the glass factory manager with a sort of incredulity, telling Bernard, 'He asked me to tell him truthfully whether I thought you had any talent, and he even insinuated that if you embarked on a career which according to him was precarious, we – my friends and I – had a certain responsibility.'[10] It says much for Gauthier's tolerant, conscientious professionalism that following the visit of this complete stranger, he returned to the salon, examined Buffet's canvas again and made a reassuring report back to the worried parent.

By the time Buffet's painting was hanging in the Salon des Moins de Trente Ans in 1946, he had already advanced very rapidly beyond that spare self-portrait. His paintings of village streets had acquired a rectilinear quality and lost the few human beings that had populated his juvenilia. He was also starting to live from his art, albeit not yet selling the work that he would become famous for. He began to paint miniatures in little frames surrounded by fake pearls. They depicted sentimental boudoir subjects, escapist fluff that had nothing to do with what he felt: bouquets of flowers were, he said, the easiest; another popular subject was a woman in the manner of Watteau with a harlequin strumming on a guitar, though these were more complicated. However, it is not the subject matter that intrigues so much as the manner in which they were produced: 'I lined fifty of them up

on the table. I prepared my colours in advance. Then a little brush-
stroke one after another in series. Fifteen hundred francs for fifty
miniatures . . . it wasn't bad.'[11]

It was at this time that he produced his first truly significant painting.
It was undertaken in 1946 while in Massy with Mantienne, and was,
wrote his friend Bauer, 'an important canvas from every point of view,
through its size, its negation of life, and its youthful competence'.[12]
It measured 1.72 x 2.55 metres, and was a religious painting, a pietà,
a Crucifixion scene, the saviour of mankind taken down from a
T-shaped cross, his emaciated frame emphasised by a loose loincloth.
But what is really striking is the way that Buffet integrates the great
Christian tragedy into his own time. Christ is the only recognisably
religious feature of the whole painting; the rest of the canvas is popu-
lated with the ordinary people of wartime Paris. Just as in medieval
religious paintings, the supporting cast is often clad in the manner of
the painter's time. They are archetypes of the Parisian street: the
woman in a headscarf, a housekeeper or concierge of an apartment
building, carrying a little cage-like wire basket for transporting bottles
(it is empty, of course); the father and son seen from the back, the
parent in a drab belted greatcoat, the son in short trousers, one hand
behind his back, the other held listlessly by his father; the Virgin Mary
depicted as a housewife of the Batignolles; and sitting exhausted on
the lower rungs of a stepladder an overalled workman, at his bare
feet the large pliers with which he has removed the nails that until a
few minutes before fixed the Son of God to the cross. It captures the
emotional numbness of the Paris citizenry in the war, too weary and
worn out to do anything other than stand and gawp at the tragedy
of another human life slipping away. That same year Buffet also
completed a large Crucifixion, not quite as monumental or as idiosyn-
cratic as the pietà translated to the streets of 1940s Paris, but a work
of sensitivity and almost baroque intensity.

In the autumn of 1946, Buffet's brother returned from military service,
restoring a flicker of familial warmth to the cold, dark apartment
on the Rue des Batignolles. At the beginning of 1947, Claude's fiancée
Simone moved in. Intense, brooding and slightly sinister, her brother-
in-law-to-be occupied his own tiny universe bounded by the walls of
his room, where with the shutters closed he painted ceaselessly,
neither knowing nor particularly caring whether he was working

from daybreak until nightfall, from dusk to dawn, or around the clock.

Still under the shadow of collaboration, Paris was a city of existentialists, hardship and shortages, limping along against a backdrop of political uncertainty; and yet the Parisian art world continued to be organised along lines that in some respects had not changed much since the nineteenth century, when the only outlet for new art had been the official exhibition of the Académie des Beaux-Arts, which took place in the late spring and early summer. Known simply as the Salon, it took its name from the Salon Carré at the Louvre, one of the early locations of the exhibition. For generations the Salon was the most important art event in the world. From 1820, painters from all countries could submit work, and the power of the exhibition cemented the position of Paris as the cultural capital of the Western world.

However, it was not known for its flexibility or its receptiveness to new ideas. In a situation analogous with that other great French export, gastronomy, rather like the restaurants that aspire to inclusion in the Michelin guide there were certain standards to be met and conventions to be obeyed, and as the nineteenth century progressed, the rigidly applied standards of classical academic painting (those hoplite spears, busts of Venus and 'firemen's' helmets) became increasingly suffocating. As well as treating an accepted range of subjects – portraiture, landscape still lifes, historical and of course classical scenes – the importance of 'finish', a forensic, photographic attention to detail, was paramount. At its worst, the Salon offered the nouveaux riches of the Deuxième Empire a place to buy safe, conventional art, with any titillation from female nudity justified as long it fell within the parameters of illustration of a classical legend or a subject from antiquity. Inclusion or otherwise in the exhibition could make a reputation or break a career, and for the artist without independent means it was a gateway to collectors and income. The private view, or vernissage ('varnishing day'), was a significant date on the social calendar, and until the beginning of the 1880s, the event attracted the patronage of the state.

It was an ossified system that rewarded traditionalists and penalised innovators. Among the artists who had work rejected by the Salon are many now recognised as hugely important, such as Manet and Corot. Decisions as to which paintings would be hung and which rejected fell to a jury of august painters. The juries were notoriously

hard to please, and in 1863, such was the outcry at the volume of
rejected work that Napoleon III had to step in and authorise a 'Salon
des Refusés', where work that had been rejected could be shown.
Among the paintings exhibited there was Manet's *Déjeuner sur l'Herbe*.

This safety valve was repeated periodically in subsequent years, and
in time was joined by other salons that together loosened the stran-
glehold of the official exhibition. Among them was the Salon des
Indépendants, which had been inaugurated in 1884 and at which Buffet
had *Homme Accoudé* accepted in the early months of 1947. He was still
only eighteen years old. Painted in the year it was exhibited, the canvas
depicts a scene of the sort that would propel him to fame. It is a big
painting, 114cm by 195cm, but what it shows is emptiness: a scrawny
man, his elbow on a plain kitchen table, the top of which holds an
oil lamp, a bottle and a clothes iron; behind him on the wall, an empty
picture frame hangs askew.

It was here, at the Salon, with this canvas and some prompting
from Aujame, that his work came to the attention of an ambitious
young art critic, Pierre Descargues. In 1940s Paris, the art world was
small, almost a closed shop. Newspaper and magazine art critics
wielded immense power. Descargues was just three year older than
Buffet and, like him, precocious. He wasted no time in making a name
for himself. His articles had first been published while he was still a
student. Writing in *Arts* on 21 March 1947, he made special mention
of the work of Bernard Buffet: 'Hanging in the corridor leading to
room 8 one notices two canvases by a young painter of whom before
too long, I presume one will hear much said.' He went on to praise
the two works, a landscape and a still life, ending with the prophetic
words, 'One should await the arrival of his next pictures with interest.'[13]

The wait would not be long. On 26 September, the readers of *Arts*
became further acquainted with the work of this withdrawn young
man, as another critic commented favourably on works shown at the
Salon d'Automne, praising 'a magnificent canvas in which the harmo-
nious use of greys and browns achieved an exalted sense of misery'.[14]
For a painter as young as Buffet to have work accepted by the jury
of the Salon d'Automne was to receive a benediction from the art
world. Founded in 1903 to exhibit experimental artists, the first Salon
d'Automne had shown works by Gauguin, Cézanne and Matisse. It
was in a review of the salon of 1905 that one critic had used the term
fauves (wild beasts) to describe the work of a cadre of young

Montmartre artists. The same critic covering the salon of 1910 wrote disparagingly of paintings that appeared to be made of nothing but little cubes.

Having thus given birth to Fauvism and cubism, two of the twentieth century's major artistic movements, the Salon d'Automne continued to be seen as a barometer of the coming creative climate. Sure enough, other critics started to take an interest in the young Buffet, but the ambitious Descargues was ahead of the pack. He had tracked his quarry to the Rue des Batignolles. 'After the war the Batignolles district was cold. Without coal, all of Paris was cold, but perhaps the Rue des Batignolles was even more cold. Was it because the sun never penetrated there?' he would ponder fifty years later, as an old man and a pillar of the art establishment in France.

On that first visit, he went through the main door from the street, crossed the courtyard, climbed the stairs to the second floor and entered the artist's room.

He kept his shutters closed. I remember an iron bedstead on which the sheets were impregnated with linseed oil and white lead paint. The floor was covered in newspaper, with drawings stacked one on top another. Postcards were pinned to the door, there was a wicker basket, he was using a stool as a palette, there were pieces of cardboard completely covered with drawings and flattened canvases some of which were tacked to his largest wall. One of them showed a young man, his elbows on a table, with a bottle, a petrol lamp, a clothes iron. It was him, less desperate than the portrait of the year before, with a certain elegance of gesture. This young man resembled him more than a brother, and he painted him again surrounded by bottle racks, little gas stoves, knives and forks. It was as if one were plunged into one of Georges Simenons' detective stories, which he was reading avidly at the time; was he surrounding himself with objects used to commit a crime? No, it was simply the accumulation of objects which poverty had rendered precious.[15]

Descargues sensed he was on to something, something that had the potential to be big. Bernard Buffet was just nineteen; he painted with the anger, the anguish and the directness of which only the certainty of youth is capable. He made the established contemporary art scene suddenly seem very old indeed. In 1947, the Impressionists

were still considered modern painters; Claude Monet had died a little more than twenty years earlier, in 1926, Paul Signac even more recently in 1935. Contemporary art was dominated by the seventy-eight-year-old Matisse and the sixty-six-year-old Picasso. The other artists of note – Rouault, Vlaminck, van Dongen, Dufy, Derain, Léger, Braque and Utrillo – were of a similar vintage. Descargues believed that he had seen the future of painting, and it was the pale, withdrawn young man with the intense viridian eyes, the hollow cheeks, the filthy clothes and the hair standing on end. The critic described him as looking like a walking corpse.

If existentialism was chic and misery à la mode, then Buffet, living in self-imposed imprisonment in a shuttered room at the back of a lightless courtyard in a street where the sun never shone, in a district that was the coldest of a perpetually cold Paris, was to be its poster boy. Having singled out his work at public exhibitions and sought him out in Les Batignolles, Descargues clearly saw in Buffet a star about to rise, and for the next decade it was a star to which he would harness himself. They became close friends. If Buffet was going to be the Christ of contemporary painting, Descargues would be his John the Baptist. The portrait that Buffet painted of the twenty-two-year-old critic that year shows a neatly dressed and coiffed individual, his fox-like features and furrowed brow outward manifestations of the racing thoughts inside his skull.

Descargues' faith in Buffet was unshakeable, and he believed that a show of the artist's work would make his genius plain for all to see. Les Impressions d'Art, a small bookshop on the Rue des Écoles in the Latin Quarter, lent its jute-covered walls to a display of the young painter's work, and Descargues organised the show with the help of another critic, twenty-eight-year-old Guy Weelen, and Michel Brient, who had recently founded the monthly magazine *Arts et Lettres*.

Seeing himself as discoverer-in-chief of this teenage talent, Descargues penned the preface to the catalogue with all the emotion and dramatic nihilism of youth, 'a youth for whom painting is not a habit of mornings or evenings, but a passion, a passion that puts life at stake every moment'. Bernard Buffet, the reader was told, was the sort of painter who painted as if tomorrow he would die, and as proof of his existential torment, Descargues quoted a line from a letter Buffet had sent him: 'I force myself not to think any more so that I can live.'[16]

Catalogue written, invitations sent, and pictures hung, all that remained was to wait for the besieging mob of art lovers to come and see the work of this tortured prodigy. The exhibition opened on 1 December 1947.

It was a disaster. It was snowing heavily. There was a transport strike. Buffet spent all day encased in his Canadienne, staring increasingly miserably out of the shop window, but he did not see a single art lover. Nevertheless, he was able to derive some morose satisfaction from the fact that he was having an exhibition devoted to his work at an age when other painters were just enrolling in art school. 'The area and the snow mattered little,' recorded Descargues. 'What mattered was that he could see a couple of dozen of his paintings hanging side by side.'[17]

On subsequent days the exhibition did attract visitors and critics prepared to trudge through the elements to the student district. Aged nineteen, Buffet had his first solo show, and this only added to his growing reputation for precocity. It may not have been the triumphant start he might have hoped for, but in a way that was somehow appropriate. Were one to write a film script about a despairing young painter of bleak works depicting the kitchen-sink end of life, it would have been too predictable to set the opening night of his first solo exhibition in the middle of a snowstorm and transport strike that stopped anyone from attending.

Nevertheless, that was what happened, and it only added to the Buffet legend.

Chapter 5

A Tale of Two Collectors

Times passes slowly for the young, and at the beginning of 1948 it must have seemed to Buffet that it was proceeding at a glacial pace. For a teenager who painted with a fury, intensity and above all speed that astonished those who saw him at work, it must have appeared that the rest of the world was moving in slow motion. At that time, the mechanics by which an artist became known had changed little in a century: submit work to salons and competitions and wait and see. But for Buffet, things were about to change. In March, he showed at the Salon des Indépendants and received positive notices. The next month he sent a canvas along to the famous Galerie Drouant-David for consideration for the Prix de la Jeune Peinture.

This prize in itself was not especially important; however, the composition of the jury was of immense significance. As well as Maximilien Gauthier, who had been charged with looking after the young painter by his father, there were two other names that would become immensely important for Buffet: an industrialist from northern France called Roger Dutilleul and a Paris dentist called Maurice Girardin. Although both men were more bourgeois than beau monde, they were extremely significant collectors. Girardin in particular was a legend.

Maurice Girardin was the sort of collector now extinct, a true connoisseur with an almost clairvoyant gift for spotting talent. It is not that there are no longer collectors with informed taste; however, the nature of collecting has changed. In the second decade of the twenty-first century, the collecting of contemporary art is much more of a business activity: the sums of money involved in building a meaningful collection range from considerable to immense. For the socially ambitious and the newly rich, it is a tool for social advancement; and for brands wishing to access a high- and free-spending demographic, it is a fabulous marketing tool. Although it is a gener-

alisation with some exceptions, in Girardin's day the majority of collectors bought through galleries, with auction houses acting as wholesalers to the trade, largely eschewing the field of contemporary art. Obviously the quantity of and ease of access to knowledge today is immeasurably different. The rise of information technology and the growing number of biennales and art fairs strung out across the globe has reinforced a sense of awareness about the art world, fuelling the rise of the celebrity artist. These days there is a glut of museums, private, corporate and public, that have made art ever more readily accessible, and at least part of this proliferation of cultural institutions can be traced back to the sort of collectors who were becoming interested in the work of the strange, withdrawn young Parisian painter of post-war misery.

In 1948, Girardin was sixty-four. In just three years his life would be claimed by cancer, but he would leave a remarkable legacy: 'His art collection, willed to the Paris Petit-Palais Museum, was valued at two billion francs and was found to include seventeen Dufys, four Braques, one Chagall, five Derains, three Dunoyer de Segonzacs, one Juan Gris, two Légers, four Matisses, five Modiglianis, four Pascins, five Picassos, four Soutines, four Vlamincks, eight Utrillos, a hundred and nine Gromaires, fifty-two Rouaults . . .'[1] The value of such a collection today would be well into nine figures.

In his later years, Girardin would come across as gruff and impatient; someone who met him for the first time described him as giving the impression of being 'a hunter from the Ardennes, rough, cold, closed and authoritative'.[2] But this tough exterior concealed a great sensitivity that enabled him to discover and buy magnificent paintings time and time again. His approach was rigorously intellectual and a touch dry. A dinner guest at his painting-stuffed home on the Rue de la Ville-l'Évêque at the end of the 1940s recalled an atmosphere '*très amateur d'art*',[3] where conversation was invariably about art or artists.

His paintings were crammed on to the walls of his home. 'In the modest Paris apartment where the Doctor lived and practised, his best pictures, including Utrillos of the early White Period, covered the walls of his waiting room. There were seventeen Dufys on his dining room walls, and what he could not find space to hang invaded the maid's room – or so he said – and filled his and his wife's clothes cupboards.'[4] He was once likened to Cousin Pons, the eponymous and ostensibly unremarkable protagonist of Balzac's 1847 novel, who

spends a lifetime assembling a priceless collection of artworks. Like Pons, Girardin had a truffle hunter's nose for great art, and was once said to have unearthed a Modigliani in the flea market at Clignancourt. As well as a keen eye, he had a sharp sense of humour. 'When acquaintances, hoping for lucrative tips, asked him what to buy, he always growled, "Royal Dutch Shell".'[5]

In his 1919 portrait painted by Modigliani, Roger Dutilleul, with his white wing collar and his neatly parted and brushed sandy hair, comes across as a fastidious, faintly dandified character. Born into the provincial *haute bourgeoisie*, Dutilleul was a *rentier*, a man who lived from investments. It would appear that the closest he got to holding down any sort of remunerated occupation was sitting on the board of a cement company in the Pas de Calais that specialised in the manufacture of fake Portland stone, but even that was, says one account of his life, 'an honorary role rather than a real job'.[6]

However, beneath the neat exterior of this cement company director lurked the soul of an artist, 'a great poet, a marvellous and sensitive man' whose passion for art, unlike the arid academic Girardin's, 'remained human'.[7] When it came to collecting art, he had a natural gift; as legendary art dealer Daniel-Henry Kahnweiler observed, 'Dutilleul was a connoisseur guided by instinct.'[8]

Although affluent, he was not rich, at least not rich enough to collect the post-Impressionists he so loved. Instead he turned to works by more affordable artists, among them a rising young Spaniard called Pablo Picasso, purchasing *Tête de Femme* for 130 francs in 1908, the same year he paid 100 francs for a Braque. He is described as being the most important collector of modern and contemporary art in France in the first half of the twentieth century, his collecting career in part shaped by the means at his disposal. He bought paintings by artists until he could no longer afford them, and then moved on to newer talent. He bought Picasso concentratedly from 1908 until 1914 (with a few purchases here and there afterwards); his Braque binge lasted a little longer, from 1908 until 1921, by which time he had already started to assemble works by Modigliani, Utrillo and Léger. Klee, Lanskoy and Miró were among the names that he was buying during the 1940s.

Towards the end of his life, he was frail and could only walk with the aid of a pair of walking sticks, even when pottering about his high-ceilinged apartment on the Rue de Monceau. Moreover, two

world wars and galloping inflation had severely eroded his income, curtailing the spending power of the fastidiously dressed belle époque dandy that he had been when he had begun to buy paintings.

In a letter written during August 1947 responding to a request for the loan of some of his paintings to a gallery, he launched into a jeremiad railing against the system that had reduced him to relative penury. He accused the gallery director of not having 'noticed that social conditions had changed', and complained that he was 'more in need than the avergage Frenchman' because he had neither pension nor social security. 'I would like to have my dividends readjusted, I would like to earn what a gas worker earns.' He felt that the uncertain political situation in France, with its powerful communist party, had left him a 'threadbare outcast'.[9]

Well, not quite threadbare: with his formal suits and his spats he looked like a survivor from the age of Proust's *gratin* rather than the gas worker he wished to be. By the time he was invited to join the jury for the Prix de la Jeune Peinture in 1948, he was entering the second half of his seventies and looked like an old Georges Clemenceau.

But, aged, snowy-haired and occasionally curmudgeonly though he may have been, his tastes in painting were as far ahead of the avant-garde as ever. By now his collection was immense: after his death, it would be further enriched by his nephew, Jean Masurel, and in 1979 it was donated to the city of Lille. It was for this collection that the Lille Métropole Musée d'Art Moderne, d'Art Contemporain et d'Art Brut (LAM) was built.

Dutilleul lived with his paintings as if they were friends or pets. When the walls were crammed from the skirting to the picture rail, he hung paintings on doors. Small studies were stuck around door frames higgledy-piggledy. Paintings and drawings, some framed, many not, were propped up against each other, stacked on chairs, leant against walls, piled on every surface. He had to be careful when brushing his teeth, as his washbasin was surrounded by pictures that in twenty-first-century terms would be worth millions, including a pair of Légers. His passion for art was intense and authentic, and had only strengthened and deepened over time. A reclusive figure, he seldom gave interviews, but in that same year of 1948, he told the magazine *Art Présent*: 'By living for so many years with this collection, never being separated from it, enriching it little by little, I came to feel how much paintings can, especially in difficult times or when

faced with loneliness, be an uplifting presence, a means of escape, particularly during a period when even purchasing a book became a luxury.'[10]

Even though he no longer had any wall space left, he was still buying and hungry for new work by new artists, which was why he was sitting on the jury of a relatively minor and obscure art prize.

The judging session was stormy. The majority disliked Buffet's painting, depicting a young man with a triangular head sitting at a table in front of an empty bowl, bottle and wine glass. Many found what they termed the poverty of the subject so offputting that they barely considered it. The young man had the awkward air characteristic of Buffet's self-portraits of the time, causing one of the panel to comment, 'He looks stupid to me, that fellow. One of those men you always see in public places waiting for somebody who will never come.'

'You are mistaken,' said the gruff Girardin. 'The person he's waiting for is me.'[11] He was utterly furious when the result was announced and the winner was not Buffet. 'It was a fine commotion,' recalled Emmanuel David, in whose Galerie Drouant-David the jury convened. 'Happily it took place behind closed doors! People did not quite come to blows, but almost, and strong words were exchanged.'[12] Just as time passes slowly for the young, it accelerates with age, and Girardin, with the experience of his years and perhaps already in the knowledge that he was seriously ill, did not want to have to wait to have Buffet's genius recognised. 'I am resigning from the jury!'[13] he shouted.

David did not know what to do. Girardin's outburst made him realise that a mistake had been made, and he tugged at the enraged dentist's sleeve, saying that he was sorry and that he had been in error. Whether he genuinely experienced some sort of Damascene conversion or whether he sensed commercial disaster from offending one of the most influential collectors in Paris is uncertain. However, the grovelling worked. Mollified, Dr Girardin smiled and told him not to worry, and that he would be back in the morning to discuss this interesting new painter further.

Buffet may not have won the prize on offer; only four of the jury voted for his work, an impressive minority including Girardin, Dutilleul and Gauthier. However, that evening he received something infinitely more important: a *pneumatique* from Gauthier announcing that Girardin would make the pilgrimage out to Les Batignolles the

following day. And once Girardin had made his histrionic exit from
David's gallery on the Rue du Faubourg Saint-Honoré, and the prize
had been awarded to an anodyne painting depicting a port on the
Mediterranean littoral, it is said that Emmanuel David sat in front of
the depressing picture of the emaciated youth sitting at a barren dining
table with the air of waiting for someone who would never arrive,
and studied it closely. For a long time he peered into that canvas
covered with every variation of grey from anthracite to the pale
powdery hue of cigarette ash; the only deviation from this strict
pigmentary regime was offered by the dirty pale mustard of the jacket
that seemed to hang several sizes too large from shoulders so fragile
and angular that they might have been made of wire. David had voted
for the harbour scene, but Girardin's passionate reaction had awakened
both his curiosity and his acute commercial sense. Just what, wondered
the respected art dealer, did the dentist collector see in that unappealing
painting that he and the majority of the jury had missed?

When he arrived at the sun-starved Rue des Batignolles the following
day, Girardin found the young Buffet furiously at work in his creative
squalor. There is no substitute for wisdom and experience, and he
knew, as surely as Descargues had done when he saw the painter in
his environment, that he had made a discovery. Having made the
journey out to Les Batignolles, he was not going home empty-handed.
He paid 100,000 francs (equivalent to $85)[14] for four paintings, including
the one over which he had left Emmanuel David poring the day before,
and what has come to be regarded as one of Buffet's early master-
pieces, *Net-mending*, a canvas that referenced his days in Brittany. A
large work two metres high and just over three metres in length, it
shows a fisherman's wife engaged in the homely humdrum task of
repairing her husband's nets. It is fascinating in that it shows how
Buffet's style had developed in the space of a little over eighteen
months. Gone were the hints of Utrillo and Vlaminck that had shad-
owed his canvases of 1946, and the emphasis on naturalistic reproduc-
tion of the subject; in its place was the unmistakable angularity that
would become his signature (literally and stylistically). The woman's
hair is held back from her pinched and furrowed features by a clip at
either temple that creates little points, giving her the air of some
demonic version of Arachne working at the web-like mesh of netting
hung like a curtain across the room in which she toils. This was no
romanticised, folkloric vision of contented domesticity; the economy,

almost meanness, with which the scene is depicted and the resistance to the temptation to fill the canvas with nautical accessories enhances the air of despair. This, Buffet was saying, was what life amounted to.

Girardin took an immediate and almost proprietorial interest in the young painter, making it a personal mission to talk him up wherever he went, seeing himself, with some justification, as Buffet's discoverer, of whom there would be a number. In fact Buffet would be the last artist that he would take under his wing. It could of course be the highly transformative nature of Buffet's style, but his 1948 portrait of Dr and Mrs Girardin does not show a man in the peak of physical shape. Gaunt and grey, Girardin gazes balefully off to the left of the canvas, giving the impression that he can see death in the distance and awaits its arrival. A sick man, he could not direct the same energy to promoting the career of the painter he called Le Gamin as he would have done in the twenties, when he had opened a gallery and put artists under contract. Happily, though, he would live – just – to see his protégé achieve recognition.

One of the last times he was seen out in Paris was shortly before his death, when, walking with the help of his doctor, he struggled into the gallery that was representing Buffet. He slumped into the first armchair he could find, lacking the strength to cover even the thirty metres to the director's office. 'I would like to see the most recent works of Bernard,'[15] he whispered.

Hurriedly the gallery director fetched the rolled-up canvases that had arrived the day before and spread them out on the floor around Girardin's chair. 'Suddenly his eyes lit up. A smile appeared on his emaciated face. Colour returned to his cheeks and, miraculously, without help, he stood up and walked, looking at the pictures one after the other with renewed strength.'[16] However, the recovery was short-lived, and with a few minutes he had slumped back into the chair. A taxi came to pick him up, and with difficulty he rose to his feet, thanked the gallerist and said goodbye. He died two days later.

Dutilleul, although less voluble, was similarly taken with the work of Buffet; he found the palette of greys and taupes almost serene. In the summer of 1948, he wrote to a friend about how he, Gauthier and Girardin had campaigned for the young painter, without success. 'He was incontestably the most original; the discretion of his colour surely harmed him in the eyes of those who only judge by Fauvism(!) and Abstraction. If, as I am assured, he is just twenty years old, one

can predict much from the sober, distinguished style of his drawing.'
He did, however, concede that the 'grey aspect of his canvases is a
little monotonous, but not without finesse in its nuances'.[17]

Although Dutilleul was to outlive Girardin by five years, Buffet was
the last artist to enter his stable too. The collections of both men
were so significant that Girardin's, which included thirteen Buffets
and was left to the city of Paris, formed the nucleus of the permanent
collection of the Musée d'Art Moderne de la Ville de Paris, while
Dutilleul's, also rich in the work of the artist of Les Batignolles, would
become the basis of the LAM, the contemporary and modern gallery
in Lille.

The effect on Buffet of entering these two collections is hard to
overestimate. Dutilleul and Girardin provided almost instant critical
validation. At the time, the world of art collectors was a less frenzied,
less moneyed and less crowded place than it would become. Buffet
was fortunate to have encountered two of the great figures of a time
that was already passing into history, when real amateurs (in the sense
of art lovers) and connoisseurs of comfortable but far from limitless
means could assemble hugely important collections. Collecting art
was still a quasi-intellectual pastime, and men such as Girardin and
Dutilleul were respected for their taste, their eye and their intelligence
rather than for what was in their bank accounts. Had they lived long
enough, they would have recoiled in revulsion at what would become
of the art world, horrified to see how in the second half of the century,
the fruits of human creativity, which they had loved and treasured for
their intrinsic qualities, would come to be regarded as little more than
commodities to be traded on a vast, global and unregulated bourse.

Chapter 6

Buffet goes to Hollywood

The gallery in which the dying dentist saw his last new Buffets belonged to Emmanuel David and his partner Armand Drouant. It occupied large premises just off the Rue du Faubourg Saint-Honoré. The fashionable shopping street was not the most obvious location in which to find such work. However, the Galerie Drouant-David was not an entirely conventional Right Bank art gallery. For a start, it was huge, arranged over two levels. The lower floor was a large open space with white-tiled walls and a large glass dome– its appearance led to it being called 'la piscine'[1] by some. In this space David and Drouant created an environment that was unlike the formal galleries of old with their velvet curtains, brass rails and hushed interiors. They actively sought and encouraged new painters, and the exhibitions held at the gallery changed every couple of weeks, so there was always a lively sense of freshness and excitement.

Recalling the Galerie Drouant-David in its heyday, one veteran of the post-war Paris art scene described it as 'an extraordinary gallery; every fortnight there was a different exhibition of anything and everything: figurative painters, abstract painters, anything. From October 1st to June 30th there was an exhibition every two weeks: good, not so good, better, no good at all . . .'[2]

The atmosphere was as open as the space itself. In the evenings it became a de facto club, and various young artists, dealers and others connected with the art world would gather to socialise and to play table tennis on the ping-pong table that was erected between seven and eight o'clock every evening,[3] after the gallery had closed for conventional business.

David's way of selling art would have been familiar to many dealers of the twenty-first century, in that it was about creating a 'buzz' around the space rather than presiding over a silent and sepulchral environment. For instance, when he was approached by a fashionable milliner

and asked if he would mind lending the venue for a catwalk show of hats, he seized upon the idea immediately. 'We accepted thinking that this would be good publicity for the gallery: plenty of invitations, elegant people, future clients perhaps! Basically, the idea amused me very much and I was very happy to be seated in the front row of this chic crowd.'[4]

David also had an eye for the ladies. One young model in particular stood out for him, a sixteen-year-old ballerina. He was struck by 'the grace of her gestures, the perfect harmony of her proportions, the faultless curve of her long legs, and her delightful little face'. She was closely chaperoned by her mother, who did not take her eyes off her daughter all night. 'If I were a film-maker, Madame, I would offer your daughter a ten-year contract,' he said gallantly. The woman smiled at him half seriously, half mockingly. 'Yes, *mais voilà*, my daughter will never do cinema.'[5] Six months later, he picked up a newspaper and saw a picture of that screen-averse young ballerina he had found so captivating: the article announced that she was about to embark on a film career and that her name was Brigitte Bardot.

Bardot was not the only BB to make an early career debut at *la piscine* and be offered a contract. David himself had been prejudiced against Buffet, initially failing to discern the gifts that Dutilleul and Girardin had perceived. He had of course seen Buffet's work at the Salon d'Automne, prompting him to say:

> There is a boy with power, sober colours and surely something to say, but he exasperates me with his choice of subject. That woman is ugly, the stove is shocking, the interior sordid . . . Oh the young! Do they ignore that there is a blue sky, flowers, pretty girls, and places where you can live well? And that giant, disproportionate signature, what else could it signify other than the demented pride of the young generation![6]

However, the opinions of two of France's greatest collectors quickly changed David's mind and, as was now becoming something of a habit among the avant-garde of the Parisian art scene, he made the pilgrimage out to the arrondissement where the sun never seemed to shine and found, as had Girardin and Descargues, a thin, unwashed young man with a forced smile, his clothes and the small room in which he worked and slept caked in paint. David recalls that the place was covered with canvases pinned directly to the wall; he describes

them as having been 'energetically punished' rather than painted, and found himself drawn to them by their 'hard-hitting'[7] graphic qualities. He left that day with an enormous roll of paintings under each arm, having bought all available works in small and medium formats, which he judged to be easier to sell than the large-scale works that the painter showed him – he was to regret not buying these as well. And the month after he failed to win the prize for young painters, Buffet was put under contract by the very men who had voted against him in the competition.

David's decision was rapidly vindicated. Years later he would recount with pride how Derain, one of the great icons of the Fauve period, who had painted with Matisse, attended an early Buffet show at his gallery. Derain was a polarising figure in that during the war he had visited Germany as part of a cultural delegation and had been accused of collaboration. By the time Buffet was becoming known, Derain was living quietly in retirement in Saint-Germain-en-Laye, seldom visiting Paris. One day, however, David noticed the distinguished painter walking slowly around the gallery, going from one painting to the next and studying each one intently. His features did not betray his opinion.

Flattered by the unexpected visit and curious to know what the great man thought of a youth about whom much was already being said, David approached him.

'Dare I ask you what you think of Bernard Buffet?'

Half a century earlier, as a slim, elegant dandy with bright waistcoats and bold ties, Derain had captivated Picasso's mistress Fernande. Now, on the threshold of his seventies, he was corpulent, moving slowly and deliberately. The man who had painted with Matisse at the beginning of the century, who had participated in the famous Armory show of 1913 and had devised sets for Diaghilev turned his huge face with its large Roman nose towards Emmanuel David.

'This boy has done at twenty what I would like to be able to do at my age.'[8]

As well as talent and hard work, timing and luck are crucial to success, and had David hesitated and delayed his decision to represent Buffet by even a few weeks, he would not have had any of the young artist's work to hand when he received his surprise visitor.

February 1948 had seen the franc devalued against the dollar, and as Antony Beevor and Artemis Cooper put it in their excellent history

of Paris after the liberation, 'France once again became affordable for writers and anyone else with artistic pretensions.'[9] Buffet was signed by Drouant-David just as the luxury liners bearing a wave of dollar-rich American visitors docked in Le Havre in the spring of 1948. These were the years of the Marshall Plan, when American funds were rebuilding a shattered Europe. The last great tide of Americans in Paris during the 1920s had receded after the Wall Street Crash; but the Great Depression and the Second World War had only made Paris more desirable for those nostalgic to relive their wild youth, and for a generation who had learned to view Paris as the source of art, fashion, sex and sophistication but had been denied the chance of visiting it.

Among those arriving in the city that year was Hollywood director Jean Negulesco. As old as the century, Negulesco had led an event-packed life. He had been born in Romania and had begun his working life as an artist, experiencing the Paris of Les Années Folles as a penniless painter. He had lived the bohemian life to the full during those frenetic pleasure-seeking years, meeting among others Cocteau, Modigliani and Brancusi. In the 1930s he had gone to America, and had worked his way up through the nascent film industry to become a director and screenwriter. By 1948, the year in which he received an Academy Award nomination, he was well established. Although his most famous work, films such as *How to Marry a Millionaire* and *Three Coins in a Fountain*, was still ahead of him, he was already – in the industry parlance of a later generation – a player.

> One day in Hollywood I woke to the realisation that I was making movies, I was part of the industry, and a stream of cash was flowing in. Then I remembered a promise I had made myself thirty years earlier when I was young and hungry in Paris – that if I ever had the opportunity to collect paintings I would buy only young painters.

He had just married a young actress, a forces pin-up called Dusty Anderson, and was in England shooting a film. It was his wife's first overseas trip, so he decided to take her to the city of romance. In today's world, shrunk by information technology and airline travel, it is hard to imagine the excitement of visiting a foreign country. Different languages were spoken, different food was eaten, different customs prevailed; the homogenisation of the world through

international brands and restaurant chains had not begun. The Hollywood of the post-war years was still a small town dominated by a single industry, where stars were tied to the studios by contracts and were not the powerful, rich and well-travelled individuals they were to become. For most of them, a weekend in Palm Springs was the apotheosis of *mondaine* sophistication.

This was a time when the tourist clichés of 'Gay Paree' were still fresh and attractive, and to stroll hand-in-hand with your lover along the banks of the Seine was really to live life. After dinner at La Tour d'Argent, Mr and Mrs Negulesco embarked on a nocturnal odyssey that might have come from one of the Hollywood storyboards the director had sketched in his early days in film-making. 'We walked in cobblestoned alleys, climbing long and twisted stairways up in Montmartre, met and talked with workers and street girls. We admired visions of bridges and black trees, spellbinding sights in the moonlight.' Their evening ended at dawn, naturally, in Les Halles. 'In this rich combination of colors, amid the fast and furious clamor of French calls and the uproar of friendly arguments, our stomachs welcomed the classic hot onion soup, topped with toasted French bread and saturated in stringy Parmesan cheese.'[10] It seems almost churlish to point out that Parmesan is an Italian cheese.

'After that night in Paris, at eleven the next day, we were ready for new galleries and young painters.' Souvenirs are, after all, an important part of any holiday. Also in Paris was Negulesco's Hollywood contemporary Sidney Sheldon, who asked if he could come along. An Academy Award-winning screenwriter who had yet to find fame as a best-selling author, Sheldon was nevertheless doing well enough to collect art; on this trip he treated himself to a small Renoir.

The Galerie Drouant-David was situated at 52 Rue du Faubourg St-Honoré in a courtyard away from the busy street. The director of the gallery – Emmanuel David ('Mano' for his friends) – was everything that is special about a Frenchman: happy, anxious, demonstrative. He was unable and unwilling to utter a word of any language but French, a middle-aged admirer of beauty and with an appreciative eye for curves.

We looked around at the paintings hanging on the walls – big names, already famous, masters.

'Do you have any young exciting painters?' I asked him finally.

'Yes, many.' He thought for a moment, looked at me and Sidney [Sheldon], and smiled at Dusty. From behind a curtain he brought out an unframed painting and placed it against the wall.

'Bernard Buffet.' That's all he said.

It was a big canvas of an emaciated, angular woman, with enormous black eyes and deep lines crossing her face framed by stringy hair. A blouse stretched over her thin elongated skeleton as she sat at a square table that held a half-empty bottle. Scratches of hard pencil crisscrossed her face and the background. A nervous hard push of the brush palette knife had made a hole in her neck: *The Absinthe Drinker.* It was my first meeting with Bernard Buffet's work. I didn't like it, yet I couldn't take my eyes from it. I criticised it. I fought against it. An enormous signature covered a whole corner of the canvas. It was pretentious and ostentatious. And again, it belonged to the total of the painting. Without it the work was not complete.

It is interesting to note that as an informed connoisseur, Negulesco's initial reaction was almost identical to that of David when faced with the painter's work at the Salon d'Automne. He bought works by other painters and was about to go shopping at nearby Hermès, but could not free his mind from the image of the Buffet painting.

'Do you have any more of him?' he asked.

'Upstairs in the attic. Would you like to see them?'

Negulesco glanced at *The Absinthe Drinker*, shuddered slightly and said, 'No, thank you. Maybe another time.'

I wrote the check for the paintings I purchased, and then Dusty, her intuition always alert, said: 'Why don't you look at them anyway. We have time.'

I did.

Upstairs, behind a big dark red door with an ordinary lock, Mano stored thousands of new paintings. We sat on a comfortable sofa. With love and care, Mano started to prop against furniture, boxes, easels, and the wall the latest work of Bernard Buffet: sad landscapes outside Paris, still lifes of a hard and hungry home, a black table with an empty plate and a lonely fork set against the corner of a desolate white wall, angular and triangular gaunt faces lined with black contours, gray tones with chalky splashes, unframed, all witnesses of misery and hopeless despair.

Mano did not receive any comment or encouragement from me. I was bewildered. It was a nightmare, a combination of El Greco distortions against the funeral of a René Clair film.

Dusty felt she should say something. She timidly tried her French. '*Très bon*,' she whispered.

'Good' was probably the worst polite comment. These paintings were not there to be admired. They shocked and slapped and spat on your face.

'That is all I have.' Mano came and sat close to me.

'How many?'

'How many what?'

'How many are there?'

Mano counted the canvases slowly. 'Twenty-one.'

'How much?'

He took out of his pocket a typed list of prices. 'Which one?'

'All twenty-one.'

He got up, then sat down, looked at his list, then longer at me.

'All twenty-one?'

'Yes, and all you can get together in the next few days before I return to London.'

'I will add the prices.'

'You don't have to, Mr David. There are twenty-one paintings. I'll give you two hundred and ten thousand francs. Two hundred and ten thousand francs and not one cent more.'

David was in a quandary. These twenty-one paintings were worth together three times[11] what Negulesco was offering, and in selling at this price he was concerned that he would be devaluing the market price of the painter. However, he found Negulesco likeable, *sympa*. He shared many of David's tastes and clearly knew about paintings.

Mano David had to make a decision. With his French business spirit he added together the prices of the canvases. It probably amounted to much more than I offered him. But he was a good businessman. He accepted. Later he confided to me that he knew he could use me as a public-relations man for Bernard Buffet in Hollywood. He was right.[12]

Negulesco's 'bungalow office on the 20th Century Fox lot', 'a marvel of comfort and luxury', served as a de facto Hollywood gallery for

the artist, its walls 'plastered'[13] with his canvases. At one point the director would claim to own more than 150 Bernard Buffet paintings. He gave them as presents to the actors and producers with whom he worked, and even managed to work the paintings into the films he directed: *Daddy Long Legs*, starring Fred Astaire and Leslie Caron, and *Three Coins in a Fountain* both featured Buffets as part of the set dressing, and in *How to Marry a Millionaire*, starring Lauren Bacall, Marilyn Monroe and Betty Grable, the painting that one of the girls tries to sell to make ends meet is a Buffet. *How to Marry a Millionaire* was the second film to be released by 20th Century Fox in CinemaScope, which was hyped as an 'Entire New World of Entertainment Never Before Possible',[14] and Buffet was the preferred artist of this technologically advanced breakthrough in cinema.

It was not always easy in the land of sunshine and perpetual optimism that was California to proselytise the work of a depressive young man who worked in a shuttered room on a sunless street in an obscure arrondissement, as Negulesco recalled.

A few Beverly Hills collectors liked him. But fewer of my friends shared my enthusiasm.

How could I live with this kind of painting? was the usual rebuff. Eat in front of it? Kiss or make love in front of it?

'Since when should Bernard Buffet's paintings accommodate your natural joys?' I remarked. One of my friends rejected a painting flatly: 'A Bernard Buffet in *my* collection?'

David continued to send him all kinds of paintings. And Negulesco persevered.

I began to sell the Buffets. I used a pattern: I charged the price I paid (mostly under one hundred dollars) plus 20 percent for framing, transport, and insurance. If they didn't like it within three months, they could return it and the whole amount would be refunded. Many of my sales were returned.

One point was certain: *like them or not*, Beverly Hills, Hollywood, and as a matter of fact, California became Bernard Buffet conscious.[15]

For some of the elite of Hollywood in the 1950s, a Buffet on the wall became as much of a *sine qua non* of civilised living as a pool in

the garden and a large convertible in the driveway. For those who visited Paris, a visit to Buffet or his dealer was as much a vital part of the itinerary as a trip up the Eiffel Tower or a stroll down the Champs-Élysées. Typical Tinseltown Buffet fans of this period were Lauren Bacall and Humphrey Bogart, who bought a Buffet on their first visit to Paris together; it would remain on the wall in Bacall's apartment in the Dakota building in New York until her death in 2014, a reminder of the trip of a lifetime she had taken a lifetime before.[16] Indeed, Bogart appears to have been particularly attached to the oeuvre of Bernard Buffet. In terms that recall the dying Girardin's visit to David's gallery to see the latest works of Le Gamin, Negulesco remembers calling on Bogart at the end of 1956, when the actor was in his final months.

> He was watching television. I brought him two of the latest lithos by Bernard Buffet, signed and dedicated to him. When he was sentimental – which he was – he usually covered up with a wisecrack and indifference. This time he was moved. He made us hold them above the fireplace that he might appreciate them better. I still see him now – Bogie in a dark red robe, his neck grown thin, his crooked face studying the lithos and telling us in his gravelly voice where he planned to hang them in the house.[17]

Other noted Buffet owners in the film-making community at the time included Charles Boyer, Alfred Hitchcock, Kirk Douglas and John Huston.

'When I met him at the Drouant-David Gallery in Paris in the summer of 1949,' recalled Irving Stone in the preface to an exhibition of Buffet's paintings at the Los Angeles County Museum, 'he was just celebrating his twenty-first birthday, yet he had a school of imitators, and his canvases were being bought by curators from such distant museums as Copenhagen and Buenos Aires.'

Given that Stone's 1934 best-seller *Lust for Life* had been a biographical novel about Van Gogh, it was perhaps to be expected that he would compare the despairing young painter of post-war Paris with the tortured Dutchman.

The first article written about Vincent Van Gogh was called *Les Isolies*. Without straining the comparison, Bernard Buffet is also an isolated

one: he imitates no one, borrows from no one, flatters no one, seems to derive from no school or pattern. He is as isolated from the world about him as are the lonely still-lifes he paints; and why not, since the figures, male and female alike, are always himself?[18]

But while isolation and loneliness may not have made for an easy life for the painter, it was good for business, and as a result David had to accustom himself to a new sort of client. 'The result was immediate,' he would later recall of Negulesco's enthusiastic endorsement of the painter. 'A new type of American tourists, more or less all sacred monsters of the film studios of California, beat a path to the gallery asking "Do you have Biouffet?"'[19]

Later Negulesco would try to analyse his impulse buy in David's gallery.

Why, that day, did I make this impulsive and expensive decision? Because Buffet's paintings shrieked that he painted with hard talent that never fell into facility.

I wanted to meet the painter. Mano arranged a lunch in his Paris apartment. 'Bernard, this is Jean Negulesco.'

There stood in front of me one of Buffet's characters. He looked as if he had stepped down from one of his paintings. He was tall, lean, with a thin nervous face, a long aquiline nose, gaunt cheeks, stooped shoulders. Trying to smile but not knowing how, what he gave us was a forced grimace. He was wearing an American pilot's coat with an imitation-fur collar, splattered with paints. He never took it off. He smoked incessantly.

At the table I sat next to him during an excellent French lunch – nothing like home cooking in France. Bernard gulped it down hungrily and was preoccupied most of the time. I watched his hands, the hands that produced such marvels. He had long, nervous fingers, bony, with nails badly in need of cutting. It seemed as if black paint had been pushed under the nails deliberately with the palette knife. I tried to talk to him about the weather, Paris, sex. We didn't get very far.

'Bernard, why is all your work so tragic? Why so much unhappiness?'

He lit a new cigarette from his old one, inhaled deeply, let his lungs be free again, then, polite but definite: '*La grande peinture n'a jamais faire rire* – Great painting has never produced laughter.'

And having made the sort of statement that would doubtless have him cast as an existential in a Hollywood film, he lapsed once more into brooding silence, encased in his paint-stiffened Canadienne, wreathed in the smoke from the cigarettes he smoked incessantly, lighting each new one from the dying end of the one before.

Negulesco assessed him shrewdly. 'He was wise, but still pompous, an angry young Frenchman.'[20]

Upon meeting Buffet for the first time, many people would come away describing a sort of arrogance. In part this was a defensive reaction emanating from his acute shyness, but there was also a sense of a solidly rooted, almost unshakeable belief in his own talent. A few years later, he would describe how one day at the Beaux-Arts, when he was seventeen years old, one of his teachers had told him that 'in ten years you will be the best painter of your generation'.[21] It would seem that he had taken this kindly observation very much to heart, but at the same time he does not appear to have been motivated by the material signs of success. Later in life he was perhaps being disingenuous when he said, as he often did, that he was indifferent to his huge financial success, that he did not concern himself one way or the other with his market and that he did not care what the critics said about him. However, at the end of the 1940s he was still very much an angry young man who worked with a selfish ferocity, painting for himself and himself alone. One commentator observed that Buffet painted in much the same way that a drug user took morphine, to ease the pain of life experienced by a too sensitive soul.

David would describe the fortuitous meeting with Negulesco as the first trampoline that he placed under the feet of the young artist, and as an instant introduction to the higher echelons of Hollywood in what many would come to see as its golden era, it was invaluable. However, Buffet was a French artist, more than that, a Parisian artist, and Paris in 1948 was still seen as the capital of the art world. What happened in the salons and galleries of the City of Light and on the arts pages of its newspapers and magazines was what counted. Just two weeks after Negulesco's decisive visit to the Galerie Drouant-David, the young Buffet would find another springboard beneath his scuffed and paint-stained shoes, and this time it would catapult him and his reputation to the very forefront of the contemporary art world in France.

Chapter 7

The Prix de la Critique

As Drouant and David had discovered, the painting competition was a very useful business tool: it promoted the gallery; it assisted in the discovery of young talent; and in the selection of the jury, it brought the leading figures of the art world across the threshold. As such, they were far from being the only gallerists in Paris to have been attracted to the idea.

Taking its name from the street on which it was located, the Galerie Saint-Placide opened in 1947 on the Left Bank and determined that the best way to promote itself was to offer a painting prize. The stroke of genius that defined the Prix de la Critique was the composition of the jury, which would be formed by eleven of the leading art critics of the day, among them Gauthier and Descargues. Today, with a panoply of media channels and a highly developed art market, it is hard to imagine how much power in Paris's post-war art scene was concentrated in the writings of a dozen or so critics. As a PR stunt it was brilliant: eleven journalists would be writing about the prize in their columns, and there was certainly plenty of build-up to the event.

The original list of eighteen painters under consideration for the prize had been announced as far back as February, but by June, with the competing works on show at Saint-Placide, it had become a two-horse, or rather a two-Bernard, race, between forty-year-old Bernard Lorjou, and the boy from Les Batignolles, who was half his age. As befitted the capital city of the art world, where emotions were supposed to run high where creativity was concerned, the judging session was described euphemistically as animated. But on this occasion, a compromise was reached, and the prize of 50,000 francs was to be split between the two men.

Although they shared the prize and a first name, the two painters could not have looked more different in the photograph that announced

their twin triumph. Bespectacled and grinning, his hair brilliantined against his skull and his ample frame filling his smart double-breasted suit, Lorjou looked like a prosperous businessman, a collector of art rather than a maker of it. By contrast Buffet appears hunched and nervous; he glances furtively at the camera, his lips forming a straight bloodless gash between sunken cheeks, his jacket sitting awkwardly on his shoulders, his shirt open-necked and crumpled, his hair tousled, the ever-present cigarette dangling like a sixth digit between the index and middle fingers of his left hand.

The contrast between the two men's work was just as marked. Lorjou's canvas was colourful, almost joyous; even his detractors recognised the sheer ebullience and extravagance of his work. 'He paints with a trowel,' observed one commentator about the heavily impastoed work. 'Lorjou's presumption is equaled only by the vulgarity of his talent,'[1] complained another.

In diametric opposition to Lorjou's cheerful or, depending on your view, vulgar canvas, Buffet's scene was characteristically spare and cheerless. It was an interior in the classic Buffet manner, stripped of any comfort or ornament; the rickety dining chair and the feeble fringed pendant lamp that dangles from the ceiling are the only attempts at bourgeois domesticity. There are more lavishly appointed prison cells. The almost painful lack of anything else to look at forces the viewer to study the two emaciated men, one of whom stands in the background, nude except for a beret and pair of shorts that he has unbuttoned and lowered to his thighs to reveal his genitals. In the foreground, fixing the viewer with a gaze both gentle and bleak, is a totally naked man, with Buffet's inverted isosceles face and hair cut *en brosse*, sitting on the dining chair, his legs splayed. It is as if L. S. Lowry had painted a male nude in the manner of Sharon Stone in *Basic Instinct*. If the two men are about to engage in or have just completed some form of sexual interaction, no sign of accompanying emotion is to be found on their features.

In contrast to Lorjou's lavish application of material, the paint on Buffet's canvas is as thin and pale as the painter and his subjects. The rear of the painting is as telling as the front; even at a distance of almost three quarters of a century, it is possible to see just how the artist worked. There is an immediacy about the makeshift manner of the surface on which he painted, as in a fever of creativity he stitched together sheets, tablecloths, curtains – anything he could

find – to give himself a surface to work on. When he attacked the canvas too viciously, the mind's eye can see him stooping impatiently to pick up a piece of paint-smeared newspaper from the floor of his bedroom studio and plastering it on to the damaged portion of canvas.

Provocative, disturbing and harsh, this painting caused a sensation. Yet sensation need not be an enemy to commercial success; far from it, as the show of that name at London's Royal Academy at the end of the twentieth century showed. An entire artistic school can be founded on works that challenge accepted notions of propriety, generating notoriety, provoking outrage and, of course, attracting huge publicity. Two thin, naked boys about to engage in some loveless physical coupling in a room with all the amenities of the sort of Gestapo interrogation room that until just four years earlier had been a fact of Parisian life did not make for comfortable viewing. It would have been hard to hang in a domestic setting, but then as Buffet commented, 'Art is not light-hearted. If you want to amuse yourself, go to the circus, not the Louvre.'[2]

If such a gnomic observation can be dignified with the description 'explanation', it was more or less all the backstory that his public was to be vouchsafed. His utterances, whether in public or private, were rare. Buffet was taciturn to the point of muteness. It is said that he was indifferent to fame, and at that time, it was most likely true. Occasionally he gave the impression of being amused by his growing celebrity, as if 'pleased by a joke that had come off well'.[3] There is the story that, as he became better known, he would take malicious pleasure in pretending that he was not at home, pulling the curtain back to watch a dejected art lover trudging away across the gloomy courtyard.

At this time in his life, success certainly did not make him any more comfortable with himself. The awkwardness of the transition from adolescence to adulthood was compounded by his natural reticence. If he found himself at a social gathering, he tended to remain silent, a silence upon which those around him wrote their own impression of a young man wise beyond his years and myopically obsessed with his art; whereas the mundane truth was probably that he did not have all that much to say and was too shy to say it anyway. As one fellow student who knew him well at that time commented, perhaps unfairly, 'with great intelligence he hid a lack of culture with silences that

others found mysterious'.[4] Instead he locked himself away and worked. Painting was a soothing activity and production of work was a compulsive act. When not painting, he would slump in a paint-stained leather armchair in the drawing room of the family apartment, drinking rum and gazing sombrely at one of his large canvases depicting a woman at work on a sewing machine, while his brother and sister-in-law sat in quiet admiration at his side.

This pain of interacting with what others called everyday life was written in every nervous gesture, enigmatic silence and shy darting look. Even sharing the prize with Lorjou rather than winning it outright worked in his favour. Buffet had always looked frail, pale and vulnerable, but next to the plump Lorjou he appeared to be a different species of human being altogether. As the *New York Times* commented shrewdly, the fact that he was half Lorjou's age 'means that Buffet will ineluctably be referred to as the enfant terrible of Paris art even when, like Jean Cocteau, he is well past 50'.[5]

The Buffet myth was shaping itself fast, and the Prix de la Critique presented him as a ferocious talent of almost autistic demeanour, treating risqué subject matter in bleak canvases in a way that somehow helped France to process its recent confusing and shameful history. The years after the war saw trials of high-profile collaborators, and the embarrassing revelation that leading figures from all areas of public life had ingratiated themselves with the Nazis, among them prominent painters in the Fauvist movement.

By contrast it could be argued that Buffet's art represented French life as subtly heroic; the act of carrying on under the harsh circumstances was recognised as having a sort of stoic dignity. The world as Buffet saw it from his bedroom in Les Batignolles was that of oppressed ordinary people rebuilding their lives amidst the shortages and shattered remains of post-bellum life.

Seldom is there an overt reference to the Resistance as such, but his 1949 canvas *La Barricade* could be said to be an exception: it shows two dead or unconscious nudes surrounded by piled cobblestones and furniture. However, if it aimed to achieve the effect of, say, Meissonier's or Manet's watercolours of scenes at the barricades in Paris in 1848 and 1871 respectively, then it was insufficiently unambiguous: one critic mischievously dubbed it 'Horror in the Coalbin'.[6]

What Buffet appeared to be offering was a newly revitalised approach to figurative art. History has a habit of imparting definitive

clarity to debates between rival ideologies, but during the late 1940s it was by no means clear that abstraction would triumph over figurative art during the second half of the century. In the year that Buffet won the Prix de la Critique, abstraction might have seemed to some to be in retreat. Peggy Guggenheim's gallery in New York, which had done so much to promote abstract, kinetic and cubist art, had closed the year before, and the eccentric American heiress was in the process of moving to Venice. Admittedly, 1948 saw her exhibit her collection at the disused Greek pavilion during the first post-war Biennale, but at the time there was little interest in the work she showed, and she had yet to establish herself at the Palazzo Venier dei Leoni. Meanwhile, the *New York Times* reported that Parisian art dealers who had invested in abstract art were complaining 'that the new vogue for realism is ruining their business'.[7] With the communist party enjoying much popular support in post-war France, realism, particularly socialist realist painting, was in favour.

Certainly the scandal and excitement was not hurting business at the Galerie Saint-Placide, which had taken advantage of the tied result of the Prix de la Critique to present a joint show of works by Buffet and Lorjou. And it was here that Buffet's frantic pace of production told in his favour: he was able to send around thirty paintings to this opportunistic exhibition (it was said he could have sent a hundred), far outnumbering the half-dozen works supplied by Lorjou.

Meanwhile Descargues continued to promote the young painter's career, making use of the most up-to-date medium: television. At the end of the year, Buffet appeared on France's sole television network in *Quatre Peintres d'Aujourd'hui*, looking exactly like an artist should: thin, tortured and enveloped in his signature garment, the filthy Canadienne, alongside a painting depicting a man naked from the waist down standing beside a lavatory. It was once again perfect timing for the young painter: in one of those felicitous accidents history sometimes obligingly delivers, this new talent emerged at a time when television was leaving the laboratory and entering the drawing room, where it would become the dominant medium of the second half of the century. Buffet was on track to become the first celebrity painter of the television age.

Shocking though his work may have seemed, it was executed with sufficient technical ability to make it acceptable. A century of conditioning from Courbet via the Impressionists and Fauves had taught

the art-buying public that from time to time a degree of infamy was an accurate harbinger and predictor of new talent; past examples had demonstrated that art that at the beginning might have been 'difficult' often matured into an enduring body of work. And it was this long-term staying power that a new type of collector was on the lookout for. In this respect, even the economic hardship and uncertainty of the times in which Buffet lived and which he depicted on his canvases was a godsend.

It is understating the matter to say that France's Fourth Republic was a model of political instability. Time after time the office of prime minister was barely occupied before it became vacant again; in 1948 alone, the year of Buffet's Prix de la Critique triumph, the job changed hands four times. This political uncertainty was mirrored by an economic situation in which the shortages of the war and the devaluation of the franc led to a distrust of conventional investments. Those who had money were finding that they were better able to insulate themselves from the alarming fluctuations in the money markets; the hyper-inflation that had destroyed Weimar Germany was still very much within the compass of living memory, and the 1950s were febrile times over which loomed the spectre of a third world war. And during the war that had recently ended, many fortunes large and small had been made by black marketeers, who were now looking for a way to shelter and, if possible, clean their dirty money. Increasingly it was to art that investors turned.

The French capital had experienced a mini art boom during the early months of the occupation, when rich Parisians panicked that there was nowhere to put their money and started buying paintings. It was a time when, in the words of one who lived through that period, frustrated and alarmed industrialists, unable to run their factories, 'bought paintings like leather or livestock'.[8] The commoditisation of art had begun. In 1941, Picasso was said to have commented caustically to the owner of a very average Utrillo of a shabby house in Montmartre, 'For the price paid for that canvas you could buy the house on it.'[9] As one commentator put it, 'The period of the Occupation transformed the evolution of the market into revolution',[10] and with the return of peace and prosperity, 'the taste for painting had reached the public. Visitor numbers at exhibitions soared. The perfection of means of reproduction enlarged the market, and

Malraux could make a career publishing his books on the Musée Imaginaire.'[11]

Now, with the swirl of interest around Buffet, moneyed collectors had begun to take note. Their interest was stoked by the suave salesman par excellence, Emmanuel David, who would doubtless have made much of Negulesco's bulk-buying of the painter's work. At first, recalled David, 'the passionate collectors, like Dr Girardin, could be counted on the fingers of one hand. Yet, day by day the number of those who appreciated his work never stopped growing.'[12]

After that first visit to Buffet in Les Batignolles, when David came away with all the small and medium-sized works he could carry, believing these to be the most saleable, he ignored the larger-format works, which were quickly snapped up by financier André Fried. Fried was typical of a new breed of collectors that was beginning to emerge, collectors who would find Buffet particularly attractive. Like Girardin, he believed in the young artist and had an insatiable appetite for his work; the difference was that as a banker rather than a dentist he had the means to indulge his taste and very quickly assembled a collection of some sixty paintings.

The combination of pioneering experimental taste and a huge fortune is rare. More often those who make money acquire works of art for their status-conferring properties, and they need to be reassured by the example of their peers. Fried was no crackpot dentist nor a flamboyant, free-spending film-maker from Hollywood, but a solid and successful man of business. His considerable investment would have reassured the entrepreneurs and speculators who entered the market in the next few years, for whom it was natural to consider the potential for financial reward that was locked into these depictions of grimy, careworn, downtrodden misery. Buffet had been noticed and promoted by energetic critics, collected by two leading connoisseurs, championed by two young galleries, his fame further bolstered by a television appearance; the endorsement by Fried was another important component in his inexorable rise.

'Other private collectors, among them industrial millionaires, were also buying his paintings of anguish in quantity,' recorded the *New Yorker* in a lengthy profile of the artist in the following decade, 'because they thought him an interesting and probably important new artist whose pictures would greatly rise in value. This was one of the discreet

opening movements of what eventually became the big speculative contemporary art boom in Paris.'[13] Although the market towards the end of the forties was far from white hot, the coals heating the artist's prices had started to glow.

One by one circumstances were aligning themselves in favour of the young painter from Les Batignolles.

Chapter 8

Marriage and Divorce Parisian Style

The year of his apotheosis was far from over. Buffet's sexual orientation was variable. It has been suggested that he had already enjoyed a gay relationship with the son of the owner of the Galerie Saint-Placide: a supposition circumstantially substantiated by the subject of his prize-winning work. However, after the blazing success of the summer of 1948, it began to become clear that, for the moment at least, he was favouring women: he seemed to believe that it was a truth universally acknowledged that a single painter in possession of a rising reputation must be in want of a wife.

It is easy to apply a facile, Oedipal motivation to Buffet's decision to marry in the autumn of 1948, but just because it is obvious, easy and trite does not mean that it is wrong. Buffet detested his father as certainly as he worshipped his mother, and in Agnès Nanquette, a fellow art student from the Beaux-Arts, he found a physical facsimile of his female parent. Like his mother she even came from northern France. The two had become close while studying together, and she says that during 1947 Buffet would escape from the claustrophobic atmosphere of his family home and come to her lodgings, where his conversation would echo with the refrain 'Agnès when are we getting married?'[1] To which she would invariably reply that theirs would be a second marriage. Such was the chaste catechism between the two young people as they exchanged letters when they were apart and discussed literature and made occasional visits to theatre when they were together.

After the summer of 1948, Buffet returned from a holiday with Jean Rumeau of the Galerie Saint-Placide and resumed his wooing of Agnès without the polish of a seasoned seducer but with a doomed and gloomy persistence that was all his own.

Agnès meanwhile had spent the summer on the Côte d'Azur with a couple of male friends and on her return had found work in a smart

art gallery on the Avenue Matignon, the sort of place at which, in time, Buffet's works would be exhibited. She cared about her appearance, still had a little bit of a suntan from her holiday and must have looked rather fetching. She returned, as she would later recall, 'in love, in love with a memory'[2] – not a memory of Bernard Buffet, though, but someone else entirely: an actor called Ecoffard,[3] with whom she had enjoyed an intense week-long relationship but who had not been in touch with her for six months. Worldly and well-dressed, he favoured smart Prince of Wales suits rather than the drab army-surplus khaki shirts and crumpled trousers that Buffet continued to wear. However, upon seeing her elegantly dressed lover again, Agnès weighed the 'eight days of happiness' against 'six months of loneliness'[4] and became less certain of her love. At that moment of uncertainty Buffet is said to have walked into the gallery, morose as usual, and, having stared with glum intensity at a Boucher on one of the walls, whispered to her the familiar words: 'Agnès, when are we going to get married?'

He was completely unprepared for her answer: 'In three weeks if you would like.'[5]

Imagining that Buffet would lavish attention on her and care for her in a way that her smartly suited lover would not, Agnès accepted his proposal rationally rather than emotionally. His persistence had finally overcome her indifference. The initial reaction was disbelief, and then the young couple went out to a nearby café and sank three Pernods in quick succession to overcome their nerves. For a while Bernard was optimistic, even dangerously close to jolly, as, his tongue loosened by the alcohol and the excitement, he talked of the plans he had for their life together. For her part she was gratified by the response of the director of the gallery where she worked, who was impressed that she was marrying 'un homme célèbre'.[6]

The reaction from another gallery director was more or less identical. 'You are both very young, forty years combined. You are very lucky, young lady, to be marrying someone extraordinary'[7] was the smooth response of Buffet's dealer Emmanuel David, when one Monday evening Bernard took his fiancée round to the gallery on the Rue du Faubourg Saint-Honoré. Having received the ambivalent benediction of the courtly David, the couple declined to join in the ping-pong game that was going on in the background and hurried off to their usual supper of oysters, chicken and Rhine wine – once he had

the means, Buffet was a gourmand until the day he died – an unvarying menu that they enjoyed at the same time each day at the neon-lit Brasserie Dupont-Montparnasse.[8] Already the young Buffet was beginning to make sufficient money to enjoy luxuries beyond the means of the majority of people – let alone young artists – in post-war Paris. Agnès joked that the maître d' must have thought they were two successful black marketeers, given the amount of time, and money, they spent eating oysters.

The brightly lit, buzzing brasserie made the oppressive gloom of the Buffet family apartment all the more overpowering. When one Sunday Bernard took Agnès home to meet his family, she found the experience disorientating. It was not that Buffet's brother and sister-in-law were unkind or impolite; it was rather the nimbus of tension and moroseness that hung in the air like a thick fog. Agnès was a flirtatious young woman who liked pretty dresses and was by her own admission 'a little bourgeois girl used to a family home furnished with taste'. The disordered bohemia of Les Batignolles unsettled her profoundly. 'In vain I looked for an object of beauty or a harmonious piece of furniture.'[9] Instead they ate a gloomy meal in a kitchen dominated by a large black stove, after which they showed her the door of their father's room, much as if it were a monster's lair, creating an image of a terrifying potential father-in-law that did little to quiet her mounting anxiety. It was as if she were visiting a cadet brand of the Addams family, with all of the bizarreness but none of the humour.

This tense horror film of a visit then moved to the drawing room, where they took their postprandial coffee: a sofa covered in mattress ticking, a couple of rustic chairs, and at the centre of it all a sepulchral piece of furniture known simply as 'le fauteuil de Bernard', in which no one else was permitted to sit. In much the same way that the large, sooty stove loomed over the kitchen; so this big brown leather armchair with its gilt metal nails and its paint-stained back imposed itself on the room.

Once Bernard had seated himself in his throne-like seat, a supplicant Simone approached him meekly with a small electric heater, by which the great painter warmed himself. In this cramped little second-floor kingdom, 'Bernard reigned'.[10] He leant back and said little. Occasionally he would lift his head to look at his little niece in her pram and reward his court with a flicker of a smile. His bibliophile brother (after all, his grandfather had been a regimental librarian)

stretched out on the couch and immersed himself in a book. Above this reclining reader hung the huge Buffet canvas of a woman at a sewing machine, a work that 'expressed the sadness, the hours of struggle, the desperate silences of Bernard'.[11] Misery seeped out of the painting into the room.

This then was a typical Sunday *chez les Buffet*.

Agnès was relieved when the following Saturday Bernard gave her some money to go to the theatre with a friend. As well as her taciturn and slightly sinister in-laws, another thing was bothering her: when he took her home in the evenings and left her at the door of her digs, his good-night kisses were tame, timid, almost chaste. 'These are the kisses of an engaged couple,' Agnès reassured herself. 'We will make up for lost time later.'[12] Bernard did, however, demonstrate his affection in other ways, and painted his bride-to-be, though it was hardly an idealised portrait by a love-struck fiancé; Agnès found that it looked more like her father. When it came to their wedding plans, he was apathetic: 'You look after everything. I have a horror of formalities.'[13] As engagements go, it was hardly a paradigm of youthful romance. This was to be no white wedding with confetti, but rather a perfunctory affair, set to take place on 23 November 1948.

The only concession, made at the insistence of the bride's mother, who agreed not to attend because Bernard wanted to keep things simple, was that there be a church ceremony as well as the civil one. Bernard, indifferent, acquiesced. According to Agnès, he was not at all religious at the time, although given that the Crucifixion was already a recurring theme in his painting, what she probably meant was that he was not a regular churchgoer, which was true throughout his life. She booked the smallest chapel of the Church of Saint-Sulpice for an 800-franc ceremony 'without flowers, without organ, without tralala'.[14]

And so shortly before ten o'clock on an icy November morning, Agnès and an aunt stood in the courtyard of the town hall of the 6th arrondissement waiting for her husband-to-be. It was a wedding party that recalled the crowd clustered around one of his twentieth-century Crucifixion paintings: a forlorn young woman, her elderly aunt and the two witnesses, Bernard's brother Claude and an old friend from the Beaux-Arts, Daniel Billon, who looked like Bernard's identical twin, right down to the paint-stained collar of his Canadienne. There were one or two other guests – but no bridegroom.

At last, at ten past ten, Bernard loped moodily under the archway, hands in pockets. He gave his fiancée a perfunctory kiss and was clearly in a bad mood; he had been up late painting and evidently did not appreciate being roused so early. He had, however, made a slight effort with his appearance in the form of striped trousers and new shoes.

The official ceremony complete, Mr and Mrs Buffet headed to the church, where there were a handful more guests, including a distinguished-looking man *'d'un certain âge'*[15] – Agnès's new father-in-law. His appearance immediately reassured the bride, and likewise she thought she saw a look of relief cross his features. Once married in the eyes of both God and state, the couple left the church, Agnès cheerfully thumbing her nose at a photographer, much to the amusement of Billon, while a cadaverous-looking Buffet puffed on a cigarette.

Shortly after the wedding breakfast, Buffet left his wife at the Rue des Batignolles and went off with a couple of friends for the afternoon. He returned at 6 p.m. Shoving a few things into a backpack and sticking some rolls of canvas under his arm, he announced that he was ready to begin his married life and that they would go to his wife's former lodgings to pick up her belongings.

The young couple were to set up house in a handsome villa about twenty minutes from central Paris, in a western suburb called Garches. Standing among mature trees in its own railing-girt park, Les Clochettes had been uninhabited since the war and was the property of André Fried, who had snapped up the large-format works that David had left. For the price of a canvas per month – which given the speed at which Buffet worked even then would not have taken him more than a day – he let the newly-weds move in.

When they arrived, witnesses still in tow, the atmosphere was that of a hammily suspenseful horror film. Thick fog enveloped the trees; the gate creaked; neighbours' dogs howled, and thus alerted, the caretaker arrived to open up the house.

The iron-bound door opened on to a hall with a black-and-white floor and a big table surmounted with a large bouquet.

'Flowers! What the hell are they doing here?' asked Bernard. The little card from Fried wishing them well answered his question. 'Let's drink,' he instructed. The housekeeper rushed off and came back with some mustard jars into which cold red wine was poured. Then the caretaker and the housekeeper left them alone and the four young

people ate a supper of tinned sardines as condensation streamed down the inside of the windows and the institutional green walls of the large kitchen. They ate in their coats to keep warm, and drank to keep out the cold, Bernard uncorking several bottles of red wine and one of rum. At ten o'clock the two witnesses felt it was time to leave the young married couple alone; clearly Bernard did not agree. Turning up the collar of his Canadienne, he disappeared with his friends into the inky gloom of the park, and if Agnès thought that her husband was walking them to the gate and that he would return shortly, she was disappointed.

Bernard seemed keen to postpone the physical fulfilment of his wedding night for as long as possible, and stayed out of the house for some time, perhaps further fortifying himself for the coming ordeal at a local café, as when he finally found his way into the nuptial bed at four o'clock the following morning, he was a little drunk. 'I felt him against me with the desire of a lover and the rights of a husband. We fulfilled our conjugal duty. We still had much to learn.'[16] The following morning they ate breakfast together in silence. 'We were two deceived children who dared not admit it to each other.'[17]

Daylight did little to improve the situation. Buffet wandered in the park, hands in pockets, shoulders hunched. His wife settled into their new home, even if the only sort of bride who would have felt comfortable here would have been Miss Havisham. Neglect was everywhere, from the termite-eaten billiard table to the weeds that pushed through the surface of the tennis court. At night they ate supper under the kitchen's single light bulb, which dangled from the ceiling with the familiar meagreness of Buffet's world. For pudding they ate mandarin oranges, and as a mark of his affection he spat the pips at her.

He only began to relax when he set up his studio in a large first-floor room and, lost in the world of his creation, began to paint. At this time he was working on sharp-lined, grey-toned minimalist still-life paintings of shrivelled fruit and household objects: pieces of etiolated cutlery drawn so thinly they resembled bent knitting needles or obscure surgical instruments, gas stoves, clothes irons, oil lamps, coffee mills, salt jars, and all the other drab, banal items that provided the daily scenery for the lives of the majority of Parisians.

In portraying them as 'art', however, Buffet was forcing the viewer to evaluate them differently. As well as being the art of austerity, it was also the art of the ordinary, daring to dignify the everyday object.

It would work just as well at a time of plenty; it was much the same trick Warhol would use a few years later, taking a bottle of Coke or a tin of soup from the supermarket shelf and placing it in the spotlight.

The impact of the paintings was phenomenal. 'At that time when one began to see Buffet's canvases at the Galerie Saint-Placide and at the Galerie Drouant-David, we were gripped by this naked, cold vocabulary,' recalled Pierre Cabanne, then a twenty-seven-year-old art critic and later the author of books about Picasso, Matisse and Duchamp among others, 'but we were also astonished by one who could paint a simple casserole in the middle of an almost empty canvas of 90[cm] or a banal plucked chicken. We compared this stripping down to the first Picassos, the pregnant women and the harlequins adorned with melancholy pinks or washed-out blues.'[18]

However, while Buffet's depictions of domestic utensils were causing the art world to take notice, his method of painting was not exactly conducive to domestic harmony.

He would come to bed close to dawn reeking of rum, his breath smelling of anchovies, which he loved and his wife hated. Tired by his hours with brush and canvas, he did not bother to remove the rabbit-skin gilet with which he kept warm, nor the hobnailed boots on his feet. Engrossed in his work and sustained by an heroic intake of cigarettes, he forgot to wash, and never used a toothbrush. Only his work mattered, and fuelling himself with rum and orthedrine, a type of amphetamine – both of which he consumed in large and ever-increasing quantities – he painted at a furious rate and with a sustained intensity. He cared about nothing else and would wipe his brushes on curtains and blankets if no rags were to hand.

Painting took him over entirely, leaving nothing for his new wife; when not sleeping, he would slump monosyllabic in a high-backed armchair, a bottle of rum close to hand. It was not that he was indifferent to her; he encouraged her to paint and to exhibit her work, and in one group show he insisted that one of her paintings should be on display alongside his – a portrait she had painted of him that they both liked. But beyond art, nothing else much interested him, and he just did not know, or want to know, how to communicate with her.

From time to time they would receive guests, the same crowd that had made the pilgrimage to the Rue des Batignolles: the supportive critics Guy Weelen and Pierre Descargues, and Mantienne, their

contemporary at the Beaux-Arts. Family members too came out to see them: the sinister Claude, and even Agnès's father, who arrived from the Ardennes and stayed just about long enough to give his daughter his opinion of his son-in-law. 'Not very talkative this bloke.'[19]

After some months they decided, without acrimony or flying crockery, to live apart but to remain married; thus Agnès remained at Garches and Bernard returned to Les Batignolles, and they would meet under the clock at the Gare Saint-Lazare. He would take her to dinner with collectors such as Girardin, Dutilleul and Fried, or with Emmanuel David. She would invite him out to the villa. The arrangement appears to have suited them both, and they were still close enough by 29 April 1949 for her to tell him that she wanted a child.

However, he would play games. He would ask Agnès to host an event and then not attend himself, as in the case of one dinner for the Davids and David's protégé, a young art dealer called Maurice Garnier, son of a wealthy engineer and collector who in 1946 had opened the Galerie Visconti on the Left Bank. Or he might turn up late, as happened when Dr Girardin made the trip out to Garches. On the latter occasion the frosty atmosphere melted into conviviality when Bernard arrived at the end of dinner with a canvas under his arm, which he unrolled with a flourish to reveal a nude of an unhealthily pale woman stretched out on a waiting room couch. It was exactly the sort of joyless composition that the dentist adored, and putting down fifteen 1,000-franc notes there and then, he went home triumphant. If Buffet's energetic output meant that his work was anything but scarce, he was adept at creating an atmosphere of rarity by rationing his person and thus maintaining a precious aura of mystery and enigma.

However, by the summer of 1949, his peculiar marriage was showing signs of strain. Emmanuel David had invited the couple to the Midi and Bernard wanted Agnès to go with him, but she refused. She also refused to have dinner with him on 23 July, perhaps because she was tired of the strains of the relationship and perhaps because she had just visited a fortune-teller, who predicted that she would separate from her husband and return to her dashing, smartly suited lover.

Buffet was furious. He wrote a violently angry letter saying that he loved her deeply, and then accused her of being foolish, of having her head turned by the society in which they were mixing, of being

concerned only with money, et cetera. She also received another letter, rather more welcome, from her former lover, the actor Ecoffard, a prince in a Prince of Wales suit, which contained everything she had been waiting to hear for the past two years. She embarked on a passionate physical relationship of the sort she never could have enjoyed with her husband, a fact that she kept from him, even though their marriage had now broken down. Nevertheless, Buffet clearly guessed what had caused this final rupture; they met for a Pernod at the bistro near the station in Garches to discuss their divorce in an atmosphere of friendliness, but as he got up to go he said: 'Be careful, Agnès, you are going to ruin your life because you are dominated by your sensuality.'[20]

At first, their divorce was as distantly affectionate as had been their commuter marriage. After the judge had heard their case, they kissed in the corridor outside the courtroom and left the Palais de Justice arm in arm. That night he took her to dinner at a Chinese restaurant. It seemed to many to be the definition of the modern relationship, with the couple appearing together around the dining tables of collectors and critics. Agnès continued to spend time with Emmanuel David's wife Gany. When Agnès had her first solo show, it was at Maurice Garnier's little Left Bank Galerie Visconti, and the night before it opened, Buffet took her to dinner with Pierre Descargues and did his best to assuage her nerves.

With her experienced lover meeting her physical needs and her ex-husband taking care of her career, Agnès was far from unhappy, but the same cannot be said for Buffet. His marriage had been a confused emotional maelstrom; he had idealised Agnès and simultaneously taken her for granted, seeing in her a substitute mother rather than a wife. On the opening night of her show, he appeared sad and worried. He treated her and her friends to drink after drink in the bar across the road from the gallery, and seemed unwilling or unable to let them go, his natural melancholy further adumbrated by Agnès's rejection. It was as if he could not bear to move on. He would visit his ex-wife in the house where they had, in their fumbling, youthful way, tried to live as man and wife, and where the detritus of his existence, from his painting materials to his copper ashtray, seemed to await his return.

In the spring of 1950, however, his visits became less frequent. One morning Agnès was in the bath when there was a persistent ringing at the gate. It was André Fried and her ex-husband, both with an

official look about them. They had come to tell her to vacate the house in eight days.

But it was not her abrupt eviction that surprised Agnès the most; rather it was Bernard's astonishing transformation. Gone was the melancholy former husband desperate for affection. In his place was a man in complete command of his emotions. 'If you would like I authorise you to keep my name,'[21] he offered icily. But his confidence and callousness were not as surprising as his appearance. Washed and groomed, he looked sleek, almost elegant. In the place of the usual army-surplus khaki was a sky-blue pullover. It was that piece of knitwear that signalled to his ex-wife the scale of the change.

As Fried set out the terms of her eviction, Agnès studied Buffet's appearance closely. 'He has washed and dressed up for someone,'[22] she thought to herself.

And that someone was definitely not her.

Chapter 9

Love on The Left Bank

Back at the beginning of the year, Agnès Nanquette had probably been too preoccupied with the nerves and excitement of her first solo show as an artist to bother too much about the other shops along the Rue de Seine. However, in the bookshop across the street, a young, charming and quick-witted sales assistant in his late teens was taking careful note of the comings and goings at Maurice Garnier's Galerie Visconti at number 35. Buffet later painted the gallery, its neat red facade introducing an unwonted pop of colour into the taupe and grey streetscape. It is of course a scene without people, but upon close examination it is possible to see a tiny representation of a Buffet still life in each window.

The Galerie Visconti, which had opened in the summer of 1946, was typical of Left Bank art spaces of the time, which filled their walls with the work of young painters. However, Visconti's proprietor was anything but typical. Maurice Garnier was a keen ping-pong player, and it was as an after-hours table tennis regular at the Galerie Drouant-David that he had first seen and got to know Buffet. A year later, in 1949, Buffet painted his portrait.

It is a painting of a man's mind as much as his body; the sitter's head rests in the crook of the thumb and index finger in a pose of pensive contemplation. But while head and body are composed, the young art dealer's eyes appear quick and intelligent. Somehow Buffet manages to impart a liveliness to them, and they seem to dart hither and thither, seeing everything, missing nothing. And what those perceptive eyes saw in Buffet was a great talent to which he would consecrate the rest of his life.

Looking back on his career shortly before his death, Garnier said, 'I consecrated my life to the oeuvre of Bernard Buffet, consecrated it willingly and with joy because I knew he was a genius, even in 1948.'[1]

Over the course of the ensuing six and a half decades, it would be with a convert's zeal that Garnier would proselytise the work and protect the reputation of his friend. It was to be a remarkable bond, quite unlike any other between art dealer and artist. It would survive even the death of the painter, and end only with Garnier's long life in January 2014.

It is extraordinary to think that the relationship, which endured into the age of the internet, began on those far-off noisy 1940s evenings of table tennis, when the babble of conversation and laughter echoed off the tiled walls and the air was hazy with the pungent smoke of Gauloises Bleues, Gitanes and, for those who could afford them, the lighter aroma of the Virginia tobacco of American cigarettes.

Today they would be called networking opportunities, but pleasant though these social events were, they did not generate revenue, and as well as being an innovative gallerist, Emmanuel David was a shrewd businessman. He saw that Garnier, the son of a rich family, could be a useful ally in business. Running a large gallery with a sizeable inventory and a rapidly changing carousel of exhibitions was an expensive business, and there were very few young '*poulains*', as the gallerists called the young talent they had signed up, who could match Le Gamin on production, price and PR value.

'I got to know Bernard there, and then Emmanuel David wanted me to participate in his contract,' recalled Garnier towards the end of his life. 'It was he who signed the contract with Bernard Buffet and very quickly he and Bernard realised that Emmanuel David's business partner Armand Drouant disliked Buffet's painting.'[2] The root of Drouant's distaste for the work of the rising young artist, who had clearly become the star not just of the gallery but of the Paris contemporary art scene, lay in his own aspirations as an artist.

'He was an amateur painter and from the point of view of an amateur painter, what Buffet painted did not respect the rules,' explains Garnier. 'The tables he painted were vertical, the lines of perspective were not respected. He did not respect anything. This wouldn't work for him [Drouant], he didn't like it.'[3] It can easily be imagined how, as the young painter's renown increased, so did Drouant's envy at the speed and apparent ease of the success of a boy barely out of adolescence. It was at this impasse that the idea occurred to David to approach Garnier with the proposal to share the contract.

The result was to prove propitious and demanding for Buffet, who, starting in the 1950s, would settle into a lifelong pattern of annual exhibitions, each year tackling a new theme. Under the terms of the agreement struck in the autumn of 1948 between Garnier and David – 'it was a verbal agreement, it was a time when people kept their word'[4] – the large canvases would be shown at the Galerie Drouant-David, while the smaller paintings, drawings and works on paper were sold at the Galerie Visconti.

Garnier believed that for Buffet, the most compelling attraction of the Galerie Drouant-David was its size. As a little boy the artist had marvelled at the vast historical canvases in the Louvre, and in the large white-tiled walls of David's gallery, he saw just the place to hang such works. 'Buffet had plenty of offers from other galleries,'[5] recalls Garnier, including one from the prestigious gallery of Pierre Loeb, a friend of Picasso, who had been among the first to show Miró's work. 'He was a famous gallerist at that time but it was a gallery without much space. Pierre Loeb made him an offer, which he did not accept. In my opinion it was not Pierre Loèb, but rather Pierre Loeb's gallery that did not suit him.'[6]

Annual deadlines and the need to produce both large and small formats in sufficient quantities to fill two galleries, one of them very big, would have been punishing for any other artist, but the speed at which Buffet worked ensured that he could meet the schedule.

As his marriage disintegrated, Buffet retreated further and further into his painting, and the lustre of his reputation was such that these works found ready exhibition space. In 1949, there were no fewer than four solo Buffet shows: one at the Galerie Drouant-David, one at the Galerie du Seminaire des Arts in Brussels, one at the Hall des Beaux-Arts, Clermont-Ferrand, and one in Marseilles, at the Galerie Garibaldi. In 1950, the ripples of his reputation had reached further afield and there were six shows of his work: Paris, Geneva, Basel, Brussels, Copenhagen and his first solo show in New York.[7]

In addition to filling the walls of these galleries, he still found time for other work; for instance in 1949 he entered a competition held by Hallmark for representations of the Nativity. Perhaps understandably, the prize was awarded to someone else, as Buffet's Nativity would have made for a disturbing Christmas card: in tones ranging from black to pale grey, with a daring splash of taupe, the infant saviour of mankind looks like a stillborn child on a mortuary slab as his

parents gaze on, the father in a beret (headgear that clearly appealed to Buffet), his long, stick-like fingers interlaced in a miniature pyre of anxiety. All things considered, Agnès may have been fortunate not to have borne Bernard's child. But what might have been unpalatable for a greetings card manufacturer was meat and drink to hard-core Buffet collectors, and the Nativity became one of Roger Dutilleul's most prized paintings, hanging in his study.[8]

This truly Stakhanovite level of production can be explained only as a desire to process everything he saw through the paint-laden ends of his brushes. There would never be a lack of inspiration for Buffet; he just had to open his eyes and begin painting. 'I don't believe in inspiration,' he once said. 'I just keep working.'[9] His work had the alchemical power to transform an ordinary object – be it a thin, cheaply made fork, an empty bottle or a table lamp – and force the viewer to reassess, to recalibrate their appreciation of something that had become invisible through overfamiliarity. Doubtless part of the popularity of Buffet's work at that time came from its power to relate to the everyday experience of millions of people in a way they could easily understand. Buffet always avoided assigning a reason or meaning to his work, but even though he may have studiously avoided claiming that he was saying something through his art, it clearly spoke to a growing public.

For him the act of painting, of drawing the brush across the canvas, was not so much intellectual as physical: a craving to be sated, an appetite to be fed, an immanent need so visceral that to attempt to deny it was painful, an addiction so strong that he suffered withdrawal symptoms. Nor did it get any easier with age. 'I paint every day,' he said a year or two before he died. 'If I don't paint, if I don't work, I'm bad-tempered, irritable, I don't feel right.'[10]

Throughout his career, the parallel with drug addiction would appear from time to time. 'Buffet paints the way you shoot morphine,'[11] wrote one critic, while another observed:

Buffet threw himself into painting just as one falls into drugs. It was his only chance to forget his condition and he abandoned himself to it as one abandons oneself to a vice. This explains the quantity of pictures that he had painted. For free, one could even say, if nobody had bought them. When he did not have enough money to buy new canvas he took a knife and scraped the paint off those he had finished

and started again. He was drunk on painting and I remain of the opinion that those who use narcotics do so for the same reasons.[12]

This shrewd analysis, with its arresting image of a man so possessed that he takes a knife to his own work in order only to remake it, just as an alcoholic will drink whatever comes to hand, whether Mouton Rothschild or methylated spirits, came from the man who would know Buffet the best during the 1950s: Pierre Bergé.

Although not especially tall, and these days somewhat wizened, Pierre Bergé is a towering figure in French life. The telltale tiny slash of red in his lapel that betokens the Légion d'Honneur is shorthand for a life in which he has been the adviser to governments; the confidant of at least one French president; the founder of museums; the chairman of opera houses; and, of course, the co-creator of Maison Yves Saint Laurent. Today he is a character around whom myths and legends swirl, but in 1950 he was just another talented, ambitious and vigorous young man who had come from the provinces to make his name and his fortune in Paris. Had he lived a century earlier, he would have been found in the pages of the novels of Honoré de Balzac.

The son of a teacher and a tax official, Bergé was born on the island of Oleron, about halfway down the Atlantic coast of France. His precocity was remarkable: at nine years of age he had read *David Copperfield*, and by the time he entered his teens, he had expanded his reading to include, among other light literature, *War and Peace*. At the age of fifteen, he took himself off to a conference: 'Baudelaire, an existentialist before his time'; unimpressed, he shared his disappointment candidly with the organiser. He wanted to be a writer, and he was in a hurry. From school he wrote to André Gide, but received no reply; then to Jean Giono, the laureate of Provence whose novels were later filmed by Marcel Pagnol. The result was a correspondence that would endure until Giono's death.

Bergé arrived in Paris in October 1948, shortly before his eighteenth birthday. Walking down the Champs-Élysées on his first day in the city, he was hit by a falling poet, the defenestrated Jacques Prévert, who, having enjoyed a good lunch, had inadvertently plunged from a radio studio in which he was preparing a broadcast. By November, young Bergé was already mixing with Left Bank existentialist royalty; five days after his eighteenth birthday, he spent a night in a police cell along with Albert Camus for trying to disrupt a UN meeting. They

were released early the following morning and went for coffee at the Brasserie du Coq. By December, he had launched a radical newspaper, *La Patrie Mondiale*; there were only ever two issues, but the contents were top-notch: an interview with his old cellmate Camus,[13] along with contributions from Maurice Rostand, who dedicated a poem to Bergé, and André Breton.[14]

Bergé's day job was as a 'courtier' for Richard Anacréon, a book-seller at number 22 Rue de Seine. He would spend his morning looking for books that he would – so he hoped – be able to sell at a profit that afternoon. Although in the centre of Paris, there was nevertheless a little bit of a Left Bank bohemian village community feel to things on the Rue de Seine. Garnier remembers Anacréon, who lived at the back of his shop, wandering into the Galerie Visconti in his dressing gown, and it was in this easy manner that Anacréon's agreeable and efficient apprentice was introduced to Buffet.

A few months before his death, Garnier would recall the fateful introduction, and while his sight may have been failing, his mind's eye could see perfectly well. He remembered the evening in April 1950 with a clarity that belied the passage of almost six and a half decades. 'I introduced Pierre Bergé to Bernard Buffet,'[15] he said, describing how, his marriage over, Buffet gave the impression of being little more than a walking corpse in a dirty Canadienne.

Although the timing is the same, Bergé's recollection is a little different. 'One day Richard Anacréon said to me, "This evening I have promised to leave my bookshop open for a broadcast arranged by the television channel on Bernard Buffet because they need electricity." There was a little café, but they did not have enough power.'[16] At a time when television was still a miraculous innovation, the arrival of a film crew on the Rue de Seine to celebrate a local artist must have caused quite some excitement. 'I already knew him,' says Bergé, 'because he had won first prize with another painter, Bernard Lorjou. His reputation was already well established, something along the lines of "He's the new painter, a young painter, look out for him as he could get even better . . ." I liked his work because I was there in Paris. You have to understand that this was after the war and Bernard Buffet captured the exact atmosphere of that period with his painting.'[17]

The film shows the young painter, in the existentialist uniform of the time, leaving his apartment in the Rue des Batignolles and appearing in various locations around Paris, including Chez Constant,

a bar on the Rue de Seine, a place like so many others with marble tabletops and Cinzano ashtrays, where he chatted with the barman and ate a hard-boiled egg.

In that limpid black-and-white footage, Buffet looks pale and drawn, in line with his status as the leading artistic interpreter of post-war privation. His looks suit the moody monochrome medium of grey-scale; he somehow manages to appear both sombre and glamorous. 'He was so handsome,' recalls Bergé with a fond smile. 'He was a rebel; not a bourgeois; au contraire, he was wild.'[18]

'I met Bernard Buffet in 1950. I was young, nineteen years old, and he was born in '28, that means he was almost twenty-two. And we met one night in a bistro, a café, next to that bookshop and next to his gallery at that time.'[19] It was Chez Constant, and Buffet was, of course, drinking hard. Yet Bergé managed to see beyond the dirt, the poor personal hygiene, the withdrawn manner and the tumbler of cognac.

He was attracted to the vulnerability of the unwashed, etiolated painter. 'He was a strange boy with a body that was also a little strange and he was timid, shy, very shy,'[20] remembers Bergé over sixty years after their first meeting. 'He was a very timid person but like all timid people he was very determined.'[21] It was a combination that appealed. 'He was timid, I like timid people. He was talented, I like talented people.'[22] Maybe, as an ambitious collector of famous and useful acquaintances, Bergé felt that Buffet's was another name with which he could enlarge his circle of friends.

Whatever drew Bergé to approach the solitary young painter, he and Buffet fell in love, each smitten with the other. 'I had a *coup de foudre*, as we say in French, for Bernard Buffet in 1950,'[23] states Bergé with all the simplicity of unadorned fact. 'We had a very strong relationship, very, very strong . . . a strength that I have never known with other people. For eight years we were inseparable, we never lunched or dined apart. You have to understand that it is incredible even for me, it is incredible today. Because I could not and never did do that afterwards. But *voilà*, it was like that.'[24]

The two young men, one powerfully built and confident, the other pale, nervous and fragile, got talking, and gradually Buffet opened up just enough to put down his glass and his cigarette and teach Bergé the rudiments of a dice game called 421. The pair arranged to meet again, and Buffet took him to see a boxing match in the Rue du Faubourg Saint-Denis. By now the feeling between them was strong,

almost electric, and the following Sunday, after a visit to the Foire du Trône, an Easter funfair and freak show with roots in the Middle Ages, they found a seedy hotel on the Rue des Canettes, where, says Bergé, they were shown to their room and handed a frayed towel by a dignified and silent woman who had once been Proust's housekeeper.

'After the hotel,' says Bergé with delicacy, 'we had dinner in the neighbourhood and then walked on the banks of the Seine. It was not easy for us to part!'[25] It must have seemed perfect: they were young, passionately in love and revelling in their post-coital intimacy on a balmy spring evening in Paris.

When Buffet appeared at the gate of Fried's mansion in Garches to evict his former wife, the blue sweater and the unaccustomed care in his appearance were due to Bergé. Moreover, to judge by the paintings he made of the bar at Liberty's, a popular cabaret, nightclub and gay bar, and his later series of transvestites, he was also starting to enjoy some of the nightlife on offer in Pigalle, a part of Paris best known today for its sex shops. Certainly Liberty's liked him: Tonton de Montmartre, as the owner Gaston Baheux was known, was a Buffet collector.

It was almost as if Buffet felt betrayed not just by his wife but by her entire gender; with Bergé he received that precious commodity he so craved: the love of another human being. 'I had fallen in love,' says Bergé, 'and for me love is more important than anything else.'[26]

Buffet clearly wanted to put the Parisian chapters of his life into the past, and the early summer of 1950 would mark the beginning of a significant new era in his personal and professional life. He was happy, and he wanted to protect this unfamiliar feeling by moving somewhere that had no associations with his anxious childhood, his miserable adolescence or his unhappy marriage. The war, poignant memories of his dead mother, the scenes of his recent painful married life . . . Paris carried too much emotional baggage, and in the parlance of the addict that he was, he decided to do a geographical. It was to establish a nomadic pattern that would remain with him for the rest of his life, seeing him live everywhere from the cold, austere north of France to sunny, sybaritic Saint-Tropez, sometimes in a castle, at other times an apartment, and moving on every few years.

Descargues also suggests that his growing celebrity was becoming an irritant. It was no longer just a matter of sitting through excruciating lunches and dinners with boastful collectors and their wives,

parrying profound questions about his paintings and the work of others with a polite 'yes, perhaps' or 'I don't know',[27] or the famous silence that so many interpreted as a sphinx-like air of mysterious omniscience. The Buffet industry was beginning to gear up, and enterprising dealers had decided to market their *poulains* as members of a Buffet school. Yet the painter himself hated to be part of a group, and took a perverse delight in avoiding explaining his work, much less allying himself with any movement. A brief association in the late 1940s with a group called L'Homme Témoin, founded by his co-laureate Bernard Lorjou, had taught him that he did not enjoy being aggregated with others, and early commercial success had shown him that he did not need such alliances to help his career.

'I don't know exactly why he wanted to leave Paris, he probably wanted to be calm and peaceful and live in the countryside,' says Bergé. 'He was young and he wanted to live in the South of France in Provence.'[28] And in the giddy excitement of complete infatuation, Bergé decided that he too would like nothing better than to be alone in the middle of nowhere with his handsome, wild, timid rebel of a lover, somewhere he could have him to himself. The previous year Buffet had gone on holiday to the neighbourhood of Orange in Provence with Emmanuel David. It had been one of the triggers for the collapse of his marriage, but nevertheless the place appeared to hold fond memories for him. The lovestruck couple decided to leave Paris as soon as they could.

Chapter 10

Honeymoon in the House of Death

L'Usclade was perhaps not everyone's idea of the perfect holiday villa. Séguret, the nearest village, was picturesque enough: a jumble of red-roofed houses clinging to a hill topped by a ruined chateau. But L'Usclade was a lonely spot, not made any more welcoming by the fact that the final twenty minutes of the journey had to be completed on foot, fighting through an abandoned olive grove.

A stranger to electricity and running water, this house with its fortress-thick walls had been uninhabited for almost fifty years. The locals in the neighbourhood (in the loosest sense of the word) tended to avoid the place, and not merely for its inaccessibility. Arriving at nightfall, Pierre Bergé shouldered a knapsack and led the way with an electric torch, followed by Buffet and Descargues, who had decided that he too needed a break from Paris.

Having wrestled with rusty locks and stiff doors, the three young men arrived in a vast hall with a huge fireplace, which they soon filled with burning logs. In amongst the shadows thrown by the leaping flames they saw a house seemingly abandoned at a moment's notice: piles of plates, armoires with creaking doors filled with linen. It was as if the family who lived there had left it expecting to return but never had. The calendar on the wall told its own eerie story. It was the sort from which a sheet of paper is torn each day, and was frozen in time on 20 August 1903, the day upon which the occupants of the house had been mysteriously slaughtered. Ever since this 'bloody night',[1] the house had, understandably, enjoyed a reputation akin to that of a haunted house in a horror film, with locals keeping well away, especially at night.

A house of death with large, echoing rooms, miles from anywhere, with no road and neither running water nor power: it was perfect. 'The house was dirty, but everything in it exalted man to nobility,'[2] gushed Pierre Descargues, gilding this inauspicious beginning with

retrospective romance as he looked back on the youthful adventure some years later. Maybe this was how he had dreamt of starting his summer break, but for Buffet it was not a proper holiday until he had begun working, and before too long he had found a nearby railway station from which he could send aluminium tubes containing his rolled-up canvases back to Paris.

The isolation worked on him like a tonic. 'Who would have recognised this boy, simply but elegantly dressed, with shaved face, white hands and sparkling teeth, as the filthy young painter,' marvelled Descargues, who believed that the solitude was different this time; not obsessive as it had been in his claustrophobic bedroom in Les Batignolles, but a choice made to allow him to work. Perhaps for the first time in his life 'Buffet knew security and independence. It was enough for him to paint to live. Painting and living were not unconnected activities but complementary.'[3] As for so many artists before him, Provence was a revelation: the light, the heat, the space and the solitude. He claimed not to need inspiration, but Provence offered it to him anyway, and he accepted greedily.

There was a period during the late 1950s and 1960s when most interviewers would ask Buffet a question the thrust of which was more or less 'Don't you find figurative painting restrictive, and the results repetitive compared to the liberty of expression offered by abstraction?' France remains a country that values an intellectual dimension to life, and half a century ago this tendency to intellectualise was a stereotypically Gallic characteristic. The French get excited by ideas, and even more excited when opposing ideas collide, and at that time the figurative vs abstract question was still a live cultural issue to be debated on television, in newspapers and of course in Left Bank cafés.

It is easy to imagine the earnest interviewer, scribbling in shorthand or sweating under the studio lights with the cameras rolling, inviting the celebrated French painter to defend pictorial realism in the face of the abstract expressionism that was beginning to emerge from America. Buffet, who was never really comfortable giving interviews anyway, must have become tired of being asked the same thing over and over again. Sometimes when he was feeling mischievous or impatient he would give one-word answers to lengthy questions, but in essence his answer would be simple and irrefutable. 'An insect, painted by 20 painters, results in 20 different interpretations, 20 different

pictures'[4] was the answer he gave in 1964. On another occasion it was sixty artists painting the same landscape from the same position resulting in sixty different but recognisable representations. Accordingly Buffet's Provence was different from anyone else's.

Appearing on a slightly strange television show called *De l'Art et du Cochon*, a twenty-first-century attempt to appreciate art through the medium of gastronomy – only in France – Bergé would describe Buffet's excitement at being in Provence, and expand with a rhetorical flourish on the thrill for any artist of seeing and experiencing the landscape that had inspired Cézanne. It is unlikely, however, that Buffet was thinking about Cézanne when he discovered Provence. He was once asked if the landscape around Aix inspired him, especially the Mont Sainte-Victoire and the pine trees that had meant so much to Cézanne. His response was rather surly, not to say provocative: 'I paint landscapes sometimes. But I believe Cézanne to be a minor painter.'[5]

Certainly Buffet's Provence owes nothing to the Impressionists' love affair with the effects of light and colour and the prismatic palette presented by the play of sunlight on the rugged Provençal landscape; the fields of lavender melting into the purple-hued mountains at sunset. For Buffet, Provence was a grid to be transferred to paper, a grid that lent itself admirably to his talents as a draughtsman. Nature might abhor a straight line, but Buffet loved them; in a 1949 painting of a studio, the intersection of the lines of a pair of empty easels with the glazing bars of a wall of windows creates an almost Mondrian-like pattern on the canvas. With a visual filter or a sort of X-ray vision, Buffet's eyes dissected the world with lines, much in the way that Picasso and Braque had experimented with the fragmentation of the natural world in cubism at the beginning of the century.

Everywhere he looked in Provence Buffet saw lines: cypresses, village houses, tiled roofs, furrowed fields, telegraph poles, overhead cables, ruler-straight roads and even the profiles of mountains revealed themselves in all their harsh angularity. Not for him the delicate play of light and shade; he saw in the landscape a sort of bleak, vacant grandeur. For Buffet, Provence at the beginning of the 1950s had one immense advantage over Paris: there was virtually no one in it. He did not have to leave the people out of his paintings, because they were not there. And yet although they are indisputably Buffet's, his drawings of Provence made in the summer of 1950 are also identifi-

ably Provençal; for instance, the houses hugging the base of the hill are immediately recognisable as Séguret.

It was at this time that he painted the controversial *Vacances en Vaucluse*, which can be seen as a reworking of the theme that had made his name: male nudity in a typically Buffet setting. But whereas the prize-winning canvas of 1948 had seemed despairing – and almost seventy years after it was painted remains fresh with the energy of adolescent anger – the later work seems more contemplative, more peaceful. The typical room of Buffet's Paris had been replaced by the typical landscape of Buffet's Provence, but the men are relaxed, the greys of Paris transformed into a warm umber that has the effect of making the completely naked men look as if they have been tanning themselves on a nudist beach all summer long. As if to emphasise his absence of tan lines, the figure on the left sits with his knees up, legs apart and genitals visible.

When the painting went on show in Paris at the end of the year during the Salon des Tuileries, its impact was likened by one of Buffet's biographers to the scandal caused by Manet's *Déjeuner sur l'Herbe*,[6] drawing crowds, sparking demonstrations and generally causing such disruption that the police had to remove the naked men from the window and hang them at the back of the gallery.

Pierre Bergé, however, does not recall any particular scandal at the time. 'No, that's wrong,' he says of the suggestion that it caused outrage and rioting. 'It must not be exaggerated. We were not militant homosexuals but we never lived in the closet, we were always out of the closet. It was completely known and completely admitted, that is the way it was; at least that is the way that I think of homosexuality; it is not something remarkable, it is totally natural.'[7] And what could be more natural than capturing a happy moment on holiday, the difference being that while most people might have taken a snapshot, Buffet painted a canvas that was over two metres long and nearly one and a half metres high and then put it on public display.

At some stage during their summer holiday Bergé and Buffet decided that they would not be returning to Paris. They wanted to prolong their Provençal idyll and Bergé had the idea of getting in touch with the penfriend of his schooldays, the author Jean Giono. A well and widely read autodidact, the 'Provençal Dalai Lama'[8] lived the quiet and simple country life that he wrote about in his novels.

Giono had not had a good war: his experiences of the horrors of the 1914–18 conflict had made him a committed pacifist, and at the outbreak of the Second World War his views had landed him in prison. In *l'épuration* that followed the liberation, as France sought hysterically to clean away the stubborn and enduring taint of collaboration, he had once again been arrested, this time as a Nazi collaborator, and was held for five and a half months before being released without charge.

However, in the summer of 1950, aged fifty-five, he was poised for a remarkable comeback that would eclipse his already considerable pre-war reputation. He was working on his historical novel *Le Hussard sur le Toit*, which would be published the following year. It would become a huge success, and remain an enduring twentieth-century classic, eventually being made into a film starring a young Juliette Binoche in 1995.

Giono lived in Manosque, where he had been born in 1895 and where he would locate much of his writing. 'Orange wasn't exactly close to Manosque, but it wasn't very far,' remembers Bergé of that long-gone summer. 'One day I decided to call Giono. I said to him, "I am with a friend of mine, a painter called Bernard Buffet" and he said to me, "I know him, I have seen his picture in the papers."' And so early in the afternoon of 16 June, the two young men got off their bus in Manosque and walked up to Le Parais, the house at the top of the town with its arresting views over the rooftops, where the author lived with his wife and daughters.

Giono invited his young guests for lunch. 'At about four or six p.m., I no longer remember exactly when, we had to catch our bus back to Orange.' However, the charming, quick-witted Bergé and the silent, sensitive Buffet had clearly captivated the older man. '"Don't go, we have some guest rooms where you can stay and I would like to propose something to you." We stayed talking for hours and he put his proposal to us. "I would like to write a book about Bernard's life, his career and him."'[9] At some stage during this long discussion, the subject of Giono's own biography that Gallimard wished to publish came up, and he asked Bergé if he would like to write it. Bergé was dumbfounded; it was a remarkable opportunity for the young man. As it happens, he never quite got round to writing the biography, but rather belatedly in 2003 he published a slender volume of pen portraits of the famous people he had known, in which Giono merited an affectionate essay of ten pages.

Giono then made another remarkable offer: they could live in *le bastidon*, a little cottage in the grounds of Le Parais: it was not an offer to be refused. A few years before the Great War, Giono's father had bought some land, which he worked as an allotment, raising rabbits as well as a few olive and fruit trees. He had sunk a well and built a one-roomed structure with a fireplace and a sink. When Giono had bought his house in 1930, near to his father's land, he enlarged *le bastidon* and used it as a guest cottage.

The two young men moved in, and would stay there until the end of the following year. It was a sort of extension of their honeymoon. Photographs of the time show them smiling in shirtsleeves with the avuncular Giono, overlooking what was still a picturesque Provençal town; and when the weather became colder, muffled in scarves, blousons, thick baggy trousers and double-soled shoes, sitting on a stone wall, their feet swinging, the comfortingly solid little cottage *le bastidon* in the background.

They were accepted by the household as members of the extended family. Giono was a simple man, the son of a shoemaker and auto-didact who seldom left the town of his birth, dying there in 1970. It was a life without pretension, a world away from the big-shot Parisian collectors like André Fried and the *mondaine* Americans such as Jean Negulesco. Le Parais had no bathroom, so every Sunday a zinc tub would be placed in front of the kitchen fire and Giono would wallow in hot water, emerging for dinner smelling of lavender. Buffet painted day and night, and at the same time Giono worked on *Le Hussard*. Bergé would later recall how every day the author would read the latest pages of his manuscript aloud as the young men sat spellbound. It must have been a thrilling time for Bergé: a few months earlier he had been buying and selling old books; now he was living with not just one but two geniuses, with a ringside seat for the creation of a literary masterpiece.

Life in Manosque settled into a parochial routine: lunch at the local bistro; occasional excursions to buy antiques (which would become a lifelong habit for Buffet); maybe an ice cream or a coffee in the café during the afternoon, and dinner chez Giono. Such excitement as there was arrived in the rare form of a visitor from out of town, such as for example a doctor from Orange who was also the consul for the Netherlands and whose wife made incredible pastis. The bar at Liberty's it was not. Buffet thrived. A regular supply of aluminium

tubes carrying blank canvases would arrive from Paris, be emptied, refilled with completed works and sent back to the capital.

This period, first at Séguret and then at Manosque, saw Buffet develop from an angry youthful phenomenon into an accomplished artist. As Descargues put it, 'Painting became for him an art, more enduring and more exigent than the rage which had led his beginnings'; he 'installed himself in art, and discovered his style'.[10] During 1951, he would produce three immense paintings each five metres long and almost three metres high that would take full advantage of the dimensions of the Galerie Drouant-David when they were exhibited there in February 1952. Called *La Passion*, they revisit the theme of the Crucifixion, and are noteworthy in both scale and subject. It would be an understatement to call them stark.

Descargues was firmly of the opinion that these three religious works of a medieval intensity established Buffet and commanded the attention of the art world. They certainly startled and surprised those who thought they knew what to expect from him, such as this critic writing for London arts magazine *The Studio*:

> During the past three or four years I have been criticising Buffet for obstinately refusing to execute anything but his uninspiring, empty, colourless, geometric canvases, morbid in subject and devoid of form. But now Buffet has suddenly proved himself to be a remarkable, talented young artist. His two exhibitions at present being held at the Galeries Drouant-David and Visconti are a revelation. At last Buffet seems to have decided to come out of his shell.[11]

There is the sense of Buffet's talent hatching under the warmth and affection of Bergé's companionship, in contrast to the unsettled days of his marriage spent shuttling between Garches, Les Batignolles and the various galleries and dinner tables of Parisian collectors.

However, *The Studio*'s correspondent was not quite ready to relinquish all his reservations about Buffet's work, though he did sweeten his criticism with words of encouragement.

> The three outsize paintings of *La Passion*, on exhibition chez Drouant-David, leave one in a strange, unsatisfied mood. They appear to have been executed in frenzied haste. I can imagine Buffet, when presented with these paints and great stretches of canvas, being suddenly inspired

with this theme of The Passion and applying himself to it with excitement and intent. But the finished product can hardly be called satisfactory: it is evident that these three rapidly sketched compositions may well serve as a stepping stone to something much more significant in the near future.

The Flagellation was *The Studio*'s least favourite among the triptych exhibited on the Rue du Faubourg Saint-Honoré. 'There is little one can say about *La Flagellation* other than stating there is a directness of expression due to the rigid composition; the harsh, heavy outline of his emaciated figures; the dry, monochromatic colour scheme, and the atmosphere of torture and suffering.' Clearly this was too close to Buffet's usual territory, although ironically, given the critic's opinion of the painting, a reproduction of *La Flagellation* dominated the article, of which the review of the Buffets was only part, and which dealt with other news from Paris including the donation of Gachet's Impressionist collection to the nation.

What makes the *Studio* article so fascinating is that it shows the power of Buffet's double-barrelled exhibition approach, a Right (Bank) and Left (Bank), so to speak. The magazine found much to recommend at Garnier's gallery on the Rue de Seine.

The exhibition of Buffet's pencil and pen-and-ink drawings at the Galerie Visconti, over on the left bank, in the Rue de Seine, is more revealing than that chez Drouant-David. These twenty-odd drawings were all executed in 1951 specially for this exhibition. Till now he has shown only a few meagre, formless sketches of little significance. But these works are so completely different in character, and so superior in quality and technique, that one wonders if Buffet has not been deliberately hiding his light under a bushel.

These drawings, at the Galerie Visconti, have marked content and form. They are solidly constructed and judiciously balanced. Here Buffet employs his pronounced line to give added effect to plastic qualities, particularly when he is drawing dead rabbits and chickens.[12]

It was clear that Buffet knew what he was doing.

Comfortable in his self-imposed exile, he never slackened; far from it. After he spent the day painting, he would pass the night performing the physically demanding work of engraving: dragging a burin over copper to produce the plate from which a print could be taken.

He was working on a series of 125 engravings to accompany *Les Chants de Maldoror*, a poetic work divided into six long cantos that appeared at the end of the 1860s. It was written by the Comte de Lautréamont, pseudonym of Isidore-Lucien Ducasse, a poet who died in his mid twenties during the Siege of Paris. Maldoror was an antihero of unspeakable and unremitting evil, and the work tapped right into the decadent symbolist zeitgeist. Ducasse had started writing *Les Chants* in 1868, the year after Baudelaire died, when the decadent movement was gaining momentum, the same year a posthumous edition of the notorious *Fleurs du Mal* was brought out by Théophile Gautier. The poem captured the spirit of its times and survived beyond them, with many of the leading artists of the surrealist movement, most famously Salvador Dalí, citing it as a major influence. The founder of the surrealist movement, André Breton, described it as 'the expression of a revelation so complete it seems to exceed human potential'.[13]

Buffet's engravings were a loose interpretation of the text, the artist allowing the surreal Gothicism of the work to suggest images to him. The project had been the idea of Dr Girardin, and was produced in a very limited edition by the prestigious engraving firm of Daragnès. As a collectors' item it was quickly sold to eager bibliophiles. Such was the reception given to this work that further similar commissions followed: among them *Cyrano de Bergerac*, Dante's *Inferno* and the incredibly striking edition of *La Voix Humaine* by Jean Cocteau, in which Buffet does not merely illustrate the work, but writes the entire text in his own inimitable angular hand.

Aimed at an intellectual, aesthetically advanced elite, these rare volumes rapidly disappeared into private collections, but the experience of *Les Chants de Maldoror* opened up a way for Buffet to address a much broader audience. His extraordinarily graphic style of draughtsmanship lent itself particularly well to engraving, and much of his immense popularity with the general public came from the proliferation of his engravings, an affordable and yet authentic example of his work. Moreover, as his career advanced and his signature became in effect a brand logo, its presence in pencil at the bottom of an engraving took on an almost talismanic importance. As is the case with so many luxury branded goods, so it was with Buffet, that the logo itself even when divorced from the objects it adorned became precious and valued in its own right.

Of course in 1950s Provence the world of branded goods lay in the future, though not that far in the future. Another famous and creative Frenchman a few years Buffet's senior would accumulate a fortune by allowing his signature to appear on everything from umbrellas to kitchen utensils: his name was Pierre Cardin. Moreover, Buffet would live – just – to see the day when another famous signature found its way on to the coachwork of a family car: the Citroën Xsara Picasso.

But for the time being, he was content to live simply and anonymously, testing himself, perfecting his technique, and finding himself both as an artist and a man. Over the next five years he was to enter one of the most productive and successful periods of his career, creating a body of work that would propel him to the very top of his field and see his renown spread around the world. It would also be the period during which he would sow the seeds of his own *Fleurs du Mal*, causing damage from which his career would never recover.

Chapter 11

Isolation in Provence

Buffet and Bergé would spend eighteen months living as part of Giono's family. When the time came to leave, they did not go far, although when they moved into the remote farmhouse situated on a wind-scoured plateau a little over ten miles outside Manosque, it must have seemed as if they had travelled to the ends of the earth.

There is a painting that Buffet made at about the time they moved in that captures the place more fully and accurately than any photograph would have managed. The sky at the top and the ground at the bottom of the canvas could almost be interchangeable; as they near the middle of the canvas the colours fade so that the farmhouse, in the same sort of grey taupe that characterises the earth and the sky, stands silhouetted against the penumbral glimmer on the horizon. Two trees, skeletal and inclining somewhat to the right after a lifetime of mistrals and gales, only emphasise the emptiness.

A couple of years later he painted a watercolour of the view from his studio – but for the stunted leafless trees he might have been depicting some post-apocalyptic landscape or the surface of a planet incapable of supporting life of any sort.

Nanse was bleak but the couple loved it, as Pierre Bergé recalls. 'You have to understand that it was fantastic at that time. It was just the two of us with no one else. It was five kilometres to the next house and after winter came we would be snowed in.'[1] In order to keep out the cold, Buffet had a pot-bellied stove in the middle of his studio, formerly a lofty barn; a large area of five by fifteen metres[2] where he could prepare his monumental canvases in the sort of space in which they would be exhibited. Buffet was no Barbizon painter. Not for him the setting-up of an easel out of doors like a Monet or Renoir. The studio was where he felt safe. Light was obviously important: as well as the three large windows that presented the bleak mountainous view, he had two panes of glass inserted into the roof

to ensure adequate illumination for daytime painting. And as he often painted at night, he rigged up floodlights. He did not bother with an easel; instead he nailed canvases directly on to the wall and sometimes worked on them with such intensity that he scratched the stone beneath. Photographs of Buffet at work in this studio show a tension, a defiance; he is like a boxer momentarily distracted from pummelling his opponent.

Once ensconced, Buffet painted and painted and painted. 'Life revolved around Bernard's work,'[3] recalls Bergé, and the painter's total absorption in his art was accentuated by their physical isolation. Provincial though Manosque had been, Bergé had had the reassuring feeling of being involved in the literary current of the times, listening to Giono, his childhood hero (and bear in mind that Bergé was barely out of his teens), giving him a preview of a masterpiece in the making. There had been other distractions in Manosque too, but here Bergé would find himself alone for hours on end as Buffet spent entire days standing in front of vast canvases, wrapped up against the cold in pullovers, scarf and tattered blouson. If nothing else it was physically tiring work.

Even though it may be imagined that Buffet, relaxed, comfortable in himself and secure in the captive affection of his lover, behaved in a more demonstratively loving manner than he had with his wife (one hopes for Bergé's sake that he at least removed his boots before getting into bed), if it had not dawned on Bergé before, their new situation made it starkly clear that their relationship was in fact not that of a couple, but of a love triangle with painting as the third participant.

If Bergé wanted to be with Buffet then he had no choice but to follow his lover where his art took him. He says that when Bernard announced that they should go to the Vaucluse, he pointed out various impediments, among them his own need to earn a living, and the absence of money. 'But it is hard to resist the imperative of timid people,'[4] he says cryptically. He was in love.

That said, it must have been hard for the ambitious and industrious youngster as he weighed up the career benefits of staying in Paris to pursue his own professional course and to cultivate the many useful relationships he had already formed, against the decision to link his destiny to that of a highly talented, and highly strung, artist.

What the relationship with Buffet offered was something more than a career in letters. Bergé may have thought that he wanted to become a writer, but it is more likely that he wanted to be successful and prominent. He could, of course, write, but as his later life would amply demonstrate, his talents were simply too broad to be confined within a single profession. Had he truly wanted to be an author, he would have completed the biography of Giono and with it launched a distinguished career, but he did not, and nor did he write the definitive book about Buffet.

In 1958, a small book of Buffet's portraits was published in which paintings of collectors such as André Fried, Charles Im Obersteg and Arpad Plesch are reproduced alongside the inner circle of supporters and friends, including of course Bergé. The text that accompanies the picture is revealing. 'Dynamic and never out of breath, the poet Pierre Bergé has devoted himself to the cult of Buffet as others devoted themselves to Valéry and spent their lives elucidating the enigmas of creativity.'[5] Poet? A few lines later we are told that 'Bergé has written the book about Buffet that we have all been waiting for.'[6] If the book referred to is the one that was published in Geneva in 1958, then the adjective 'slight' might reasonably be applied. There are barely twenty pages of widely spaced text, fascinating at least because of the author's closeness to the subject, but as a long-awaited and exhaustive biographical and critical study, the reader might have had good reason to feel a little short-changed.

It is hard to evaluate exactly what Bergé's contribution to Buffet's success was while they were together, just as it is hard to quantify how much he contributed to the damage inflicted on the artist's reputation after they parted. Certainly at the time he was seen by some as a sort of *éminence grise*. 'He kept discreetly quiet about his influence, which was however enormous,'[7] wrote one commentator.

Bergé may of course be being deliberately disingenuous, but today he downplays any suggestion that he directed Buffet's career. 'I was not his art dealer, I was his lover. We were a couple. We lived together for eight years, Bernard and me, and I never took control of his career, it was not like that. I put some order into his affairs. I started to establish a relationship with his dealers, I organised his career a little. But I was not in charge.'[8]

Today the Galerie Maurice Garnier denies that Bergé did any of these things,[9] but he was certainly an energetic promoter of his

boyfriend in terms of articles, exhibition catalogues and so forth. Moreover, recently published correspondence between Bergé and Giono indicates that he had opinions on the direction Buffet's career should take, on one occasion writing to Giono to decline a commission to illustrate one of his books.

A word in haste: we have received a letter from Roger Allard asking to illustrate *Colline*. Bernard (who Allard calls André Buffet!) cannot really accept. The other illustrators are too bad, too notoriously known as bad. I pray that you forgive and understand. Once more Gallimards have screwed up! Why didn't you impose your own illustrators? It could be a *marvellous* book, but Hans Erni, Trémois, André Minaux, Elie Lascaux etc., it really is too much, and Bernard would be the locomotive pulling these rickety carriages. Believe me, Jean, and you know that I speak from the heart and I do as I say, believe me, if you can regain control of this edition, do it. Your work is too important to be illustrated by mediocrities. *And there are painters capable of translating you perfectly.* Don't let your work be botched like this. Finally, you said yesterday, our friendship is above that! Above illustrations. But Bernard would have been pleased to work for you.[10]

Nevertheless, irrespective of how much or how little influence the young poet/bookseller/journalist/author had, this appears to have been a time of great stability in Buffet's life.

Thrown into each other's company without the diluting effects of Parisian life, the two lovers developed an intense bond and a sense of a common purpose that was almost idealistic. Bear in mind that ideals and ideas were important in those days; people believed in things: God, communism, science and of course art. 'When I met Buffet, I thought I had met Rimbaud,'[11] Bergé would later say, and during those short days and long nights of late 1951 and early 1952, with nothing but Buffet, his art and a few animals for company, it is easy to see how the young man thought he had discovered 'a new language in painting'. After all, he had spent the previous year watching and listening as Giono created a masterpiece, so it must have seemed only natural to him that Buffet, already with a reputation around him, was creating 'something that would change everything'.[12]

While Buffet worked for hours on end at his canvases and the winds whipped the snows across the Provençal steppe, Bergé kept himself

busy. 'I read, I listened to music and I wrote many things.'[13] Typical of the things he wrote in those early years with Buffet was an article in a magazine that had recently been started in Paris by a group of young writers in their twenties. They were part of the invasion of Francophile Americans flooding into Paris on a tide of dollars and vague fantasies of a bohemian existence that involved roll-neck sweaters, berets, artists in Montmartre and existentialists in the smoky basement nightclubs of Saint-Germain-des-Prés. The second ever number of the *Paris Review* proudly announced on its cover that it had secured an interview with François Mauriac and eight drawings by Bernard Buffet, which were accompanied by a short text written by Bergé. It was suitably, almost hyperbolically, evangelical.

> Before Bernard Buffet one might possibly have considered drawing an insufficient art form, wanting paint to give it true value. The greatest painter of a generation had also to be its greatest draftsman. Bernard Buffet uses pen or pencil as a brush. He doesn't draw in the usual sense of the word: he paints with skillful gradations which range from lightest gray to darkest black. At twenty-four he has already acquired a thorough knowledge of his craft.
>
> In the past he filled canvas and paper with the pain of passion; today he may be included among the greatest French landscape artists with his drawings of the Poitevin marshes and of the Charentes. We like to find that breaking with present trends Bernard Buffet has gazed upon streams and rivers dotted with pointed boats, bordered with poplars, and has expressed them with unusual emotion. We like those village streets framed by telegraph wires, becoming part of masterful compositions – deserted streets, abandoned ports – such is Buffet's universe. Carrying on with old tradition, he works in the villages he loves and lives in them.
>
> We are familiar with his shabby rooms, iron beds, lampshade frames; henceforth Bernard Buffet is not just a recorder of kitchen utensils but also of French landscapes.[14]

Bergé later said, 'I got interested in painting the way I got interested in fashion, because I met someone who made paintings, and then I met someone who made fashion.'[15] By his own admission he may not have been the ultimate art expert – 'I never believed you had to know a lot to do something' – but viewed as a positioning document for a

product, the article was perfect: a new talent delivering on the promise of early fame, demonstrating his versatility, an artist who represented a break with tradition but who was clearly also within the tradition of French landscape painters. Bergé makes a virtue out of what might be considered limitations, heading off criticism about the restricted and sombre palette and with it the implicit suggestion that here is an artist who cannot handle colour. Instead he invites the reader to appreciate this as evidence of immense subtlety and technical flair. The word is 'spin', and in all Bergé's writing on Buffet one sees the same techniques at work: the extravagant art history parallels – he once described him as 'a man for large surfaces, capable, most surely, of decorating the Sistine Chapel';[16] the abstruse metaphor – a particularly wonderful Bergé-ism was the 'placenta of imagination'; and the cloaking of Buffet's shortcomings with a mantle of nobility – the shy silences and uncomfortable longueurs that Agnès found so irritating become 'ramparts of silence and discretion',[17] a barrier from behind which he disdained to dignify any criticism with a response.

The exhibition that revealed Buffet as a landscape artist took place in Paris in February 1953, and, following the pattern that had been established by *La Passion*, was tightly themed. The larger works were shown once again at Drouant-David, while the smaller formats, drawings of suburban streetscapes, were shown at the gallery with the red facade on the Rue de Seine.

But extravagant though Bergé was in praise of his lover's work, his enthusiasm was wan in comparison to the response of a much more substantial cultural commentator. Louis Aragon, in his late fifties, was the grand old man of left-wing letters. His credentials were impressive: early surrealist, Dadaist, friend of Picasso, poet, decorated war hero, member of the Resistance, committed communist (France in those days had a large communist party, many of whom had been active in the Resistance during the war), and patriot.

Rave does not begin to describe the review that Aragon gave Buffet's landscape show in *Les Lettres Françaises*; the article was so long that it had to run in two instalments. A few weeks after the exhibition opened, Aragon would become internationally famous for having persuaded his friend Picasso to produce a portrait of Stalin for publication in the magazine to mark the death of the Russian leader. What might reasonably have been thought to be a coup turned to a fiasco when loyal

communists condemned Aragon for having permitted anyone, even Picasso, to dare to depict the features of the sainted and revered Stalin, still at that time the genial pipe-smoking Uncle Joe rather than the paranoid bloodthirsty mass murderer known to history today. The notoriety of the Picasso-Stalin debacle, which linked the greatest living artist with the laureate of Gallic communism, would have lent extra weight to the opinions that Aragon shared with his readers over two successive issues.

For Aragon, Buffet's show was nothing less than a complete renewal and revival of the tradition of the French landscape: 'One can say that he takes his place in the great lineage of French landscape painters from Daubigny to Utrillo, via Corot, Courbet, Boudin and Claude Monet'[18] was the way he kicked off an article that was part panegyric, part art history lesson that name-checked most of the great artists of the preceding four centuries: Canaletto, Guardi, Piranesi, Hobbema, Rembrandt just for starters. According to Aragon, Buffet was not just an extraordinarily accomplished young painter, but a painter of whom the nation could and should be proud. As he saw it, the French had a particular fondness for landscape painting, owing in large part to their love of their country and their pride in the painters who depicted it. But over the last fifty years or so, with one or two exceptions, landscape painting had run out of steam – not of course that he would use such a pedestrian metaphor – and fallen into desuetude.

> For my part I think that this decline of landscapes is an expression of the degradation of national feeling in the petite bourgeoisie of France, from whom the majority of our painters come. It is why in 1953 I salute, as a symptom of a renaissance in this area, the exhibitions of Bernard Buffet, which seem to me to confirm dreams motivated by the highest concern for our nation that I know to be in the hearts of certain painters.[19]

All this from a man of immense intellectual stature, as well as unimpeachable patriotism, who just happened to have Picasso on speed dial. You could almost hear the great poet humming the 'Marseillaise' as he penned these lines. Similarly audible was the sigh of cultural relief and the puffing of the national *poitrine* as France's cultural elite could point to a new flowering of the country's creative genius. At that time, French writers and philosophers, 'from Sartre

and Camus downwards, held a prestige across the world unmatched since the days of Voltaire and Rousseau',[20] and Buffet was increasingly seen as the French painter capable of supplying pictures of an importance that matched their words and thoughts.

It would be interesting to know what Picasso thought of this renewal of the French nation through the landscape painting of a boy whose parents had not even been married when he himself had been busy transforming modern art and changing the very way in which men painted pictures.

Chapter 12

The Orestes and Pylades of the
Atomic Age

While the landscape shows might have moved the venerable Aragon to raptures of patriotic praise, they came as a disappointment to one of Buffet's long-term supporters. As Descargues saw them, those 'village streets framed by telegraph wires'[1] invited comparison with Utrillo and Vlaminck, but not in a particularly good way. It was, as he put it, 'solid ground',[2] safe rather than shocking. As a demonstration of technique it was all very well, but the way that Descargues saw it the landscapes were a bit bathetic when compared to the powerful impact of Buffet's monumental religious works of the preceding year. Clearly they did not carry enough of the shock value that Descargues was looking for. He found them too easy, saying of the majority of dark, oppressive and slightly sinister northern suburban landscapes, 'All of this came straight out of one of the stacks of postcards that Buffet bought from second-hand booksellers along the Seine, in flea markets, or from specialist shops.'[3]

The following year's show also failed to excite Descargues. If he had been hoping for a return to the raw and bleak nudes of the late 1940s, with their subjects using the lavatory, getting into the bath or just staring bleakly at the viewer as in the prize-winning painting of 1948, he was in for a disappointment. The cell-like interiors of austerity Paris had been replaced by interiors of a restrained opulence: floral wallpaper (of a design that would continue to reappear throughout the Buffet oeuvre), succulent pot plants, rich red armchairs and couches with bullion fringes, screens, rugs and all the paraphernalia of an old-fashioned bourgeois home furnished according to ideas that had been out of date before Buffet was born. The scenery put Descargues in mind of a 'luxurious *maison close* aimed at an ageing clientele or a clientele frightened by the stripped-down functionality of modern furniture'.[4]

However, were it a brothel it would not have been a particularly successful one, as the nudes are pitilessly portrayed. He singles out the women for especially contemptuous treatment. Gravity has taken its full toll on their bodies, and their faces are those of men; perhaps the saddest is a particularly flabby woman looking vainly into a hand-held mirror. Of course Buffet declined to explain his work, once declaring flatly, 'A painter does not have to have ideas';[5] when asked about the role of the painter in society he said, 'He doesn't have to worry about society. His contribution is his work.'[6] Presumably the critics' contribution was to assign meaning to his paintings, and for these paintings with their ugly subjects and a decor that owed more to the France of Napoleon III than to the Fourth Republic the decadence of civilisation was a handy meaning to slap on to them. But was Buffet himself becoming decadent?

Just as the work was changing, so was the man. He may have felt that he was the same angry adolescent, but he didn't look it. Instead, presumably under Bergé's guidance, he had smartened himself up. Although the couple were never apart, except of course when Buffet was painting, they did spend time away from Nanse. Every February they would go to Paris for his exhibitions and stay for about a month, seeing friends and visiting the Louvre.

Like a butterfly emerging from a chrysalis, the thin, unwashed chain-smoker with poor dental hygiene and filthy clothes was being replaced by a more elegant man. While he still painted in the old clothes, what he wore outside the studio assumed a new chic: on one occasion he would be photographed in a velvet jacket with piped edges, a vividly checked waistcoat and grey trousers; another time he might be seen in a 'green tweed houndstooth checked jacket and flannel trousers'[7] from Dorian Guy, a fashionable Paris tailor of the time.

For those who had not witnessed the metamorphosis taking place in Provence, the change was abrupt. In the summer of 1954 he was interviewed in Le Figaro Littéraire. 'I had already seen photographs of Buffet,' wrote the reporter, who was familiar with the Canadienne, the mournful look, the perpetually lit cigarette, and had been expecting someone the colour of coal with a tuberculoid cough. Instead, in walked in a man who looked like a film star 'Sky blue eyes' – Buffet's wife would always describe them as green, so perhaps they changed with age – 'a lock of hair that tumbled over the fore-head. And along with the jaunty manner, an extreme elegance: a

jacket in a fabric as thick as two fingers, a grey silk tie, shoes in the
"archbishop" style fashionable today. And above all one of those blue
and grey striped dandy's waistcoats that has brought colour back to
our wardrobes.'[8]

One thing, however, had not changed: Buffet's chronic reticence
and evasiveness. Reading the article, one can sense the irritation of
the writer as Buffet parries his questions with the vocabulary of vague-
ness. But now his shyness came across as something else; as Descargues
shrewdly observed, 'You saw a side to his personality that was like a
young nobleman. His timidity revealed itself as a distance.'[9]

With stability had come creativity, with creativity came productivity,
and with productivity came money. Buffet was starting to become
rich. 'It was not the sums of money that painters get today, not at all,
not by a long way. But it was money,' says Bergé. The change in the
painter's fortunes was swift and seemed disproportionately pronounced,
'because at that time I believe the difference between the rich and the
poor was bigger. Perhaps because for the majority of people life was
hard during the 1950s.'[10]

It was as if while he had been locked away in his studio in Provence
his life had changed around him, almost without him noticing. In
the same sort of cinematic shorthand that indicates the passage of
time by the swift succession of seasons across the screen, so a film-
maker would have been able to chart Buffet's rapidly ameliorating
fortunes by showing the string of vehicles used by the painter and his
lover. When they had first arrived in Séguret they had got around on
bicycles. Then they discovered the landscapes around Mont Ventoux
on a motorcycle. When the local baker finally upgraded to a better
car for making deliveries, they bought his wheezy old 5CV, a mass-
produced old banger from the 1920s. That was followed by a 2CV,
next a 203, and then all of a sudden we see a fabulous photograph of
Bernard and Pierre getting into a white convertible Jaguar, like a couple
of playboys off for a night at La Tour d'Argent or to see a game of
polo at La Bagatelle. Buffet loved cars and in the early 1980s painted
a series of them (driverless naturally), but he never learned to drive.

He was no longer painting in a small bedroom in a gloomy apart-
ment, unsure of whether his work would ever be exhibited. His
canvases hung in some of the greatest art collections in Europe. The
French state had even acquired some of his paintings: 'Beating all
records, his work entered the Musée d'Art Moderne when he was

twenty years old with a descent from the cross and a still life.'[11] Canvases that had sold for 5,000 francs at the beginning of his career were changing hands for a hundred times as much half a dozen years later, and by 1956 some of his works fetched up to two million.[12] In London in 1956 a 'moderate-sized Buffet fetched £5,000';[13] at that time the average UK house price was around £2,000 (the Nationwide cites prices rising from £1,975 at the start of the year to £2,003,[14] while the Office of National Statistics gives a slightly higher overall figure of £2,280),[15] and a typical annual salary for the head of the household was around £750.

By the mid 1950s, Buffet was no longer the treasured *trouvaille* of a tight circle of passionate collectors. Girardin had succumbed to cancer and Dutilleul too would be dead by 1956. With the prices of his canvases soaring, Buffet's work had become a status-conferring object. Florence Gould, the Francophile American heiress, had commissioned a large stained-glass window from Buffet for the chapel of Juan-les-Pins. But when the clergymen rejected it, she installed it at her Côte d'Azur villa El Patio, where it was the centrepiece of what was known as the Gothic Room. Another collector who had bought one of his large religious works, *The Resurrection*, had had a room in his *hôtel particulier* in Paris redecorated and refurnished in the medieval style to better show off the vast canvas; a totally different approach from Girardin, who crammed his paintings on the walls wherever possible, or Dutilleul, who stacked them against each other on the floor.

The annual double-barrelled exhibition during February – a timing chosen, said Maurice Garnier, for the absence of anything else to clash with – had become a ritual for le Tout-Paris, that shiny group of fashion leaders who were the mid-century equivalent of Proust's *gratin*. Buffet and Bergé were young, good-looking and charming. 'Together they made a stunning sight, this Orestes and Pylades of the atomic age,' trilled one delighted observer, who omitted to say which of the two he saw in the role of the son of Agamemnon.

Time and time again it is the youth of the pair that is talismanically invoked. Buffet was taken up by the fashionable crowd; 'he saw more and more of the people whose names appeared in the reports of opening nights and particularly old people, famous old people who were thrilled to find in him someone who gave them the impression of not being completely unknown by the young'.[16] Distinguished scholar and Picasso intimate Sir John Richardson, who lived in France

during the 1950s, well recalls the soufflé of interest that began to rise around the young painter. 'Bernard Buffet was regarded as a kind of mannerist, a fashionable mannerist, whose work pleased rich bourgeois people who wanted to look perhaps more sophisticated and modern than they were.'[17] According to Descargues, these encounters were the source of much amusement at the end of a night out, when Bergé and Buffet would dissect the evening. Buffet's sense of humour and his ability to make fun of the people around him was remarked on by Maurice Garnier's wife, who in later years would accompany the painter on his trips.

It was the beginning of a period that French economist Jean Fourastié called Les Trente Glorieuses, a pun on Les Trois Glorieuses, the three 'glorious' days of revolution in the summer of 1830 when the French king Charles X was deposed in favour of Louis Philippe, an event crystallised in Delacroix's canvas of Marianne. Society was changing. There was still the old world of the salons of Marie-Laure de Noailles, and the costume balls of Étienne de Beaumont, Charlie de Beistegui and the Marquis de Cuevas, but this was a hangover from Les Années Folles of the 1920s, when Picasso and Chanel had collaborated on costumes and *mise-en-scène* for fancy dress parties given by people whose names would have been familiar to Proust. But now, in the atomic age, with transatlantic jet flights and the first hit records of Elvis Presley just months in the future, all that began to look rather dated.

Having an opinion on Buffet was vital if you wanted to hold your own at a bourgeois dinner table, and owning a portrait of yourself by the artist was to identify firmly with the modern age. The mid 1950s saw him paint middle-aged actress Jacqueline Delubac, whose husband's collection, mainly Impressionists, was given a much-needed update with the addition of this portrait. High priest of the New Look, Christian Dior, was also painted by Buffet: a splendid picture (albeit with a variation on the *maison close* wallpaper of the nudes of 1954) that hangs in the boutique on the Avenue Montaigne. Elderly salon hostess Marie-Louise Bousquet also got the Buffet treatment, as did sexagenarian author and journalist Gerard Bauer. The portraits he painted were different from those of just three or four years earlier, the faces of the sitters sometimes enlarged and perhaps relieved of a few of the glyphs that time had etched on them; still striking, but perhaps more flattering than before.

One of the most indecent in his haste to add his ageing, rouged and lipsticked features to the Buffet gallery was Jean Cocteau. Now in his late sixties, he was so smitten with the Orestes (or was it the Pylades?) of the atomic age that in 1955 he dedicated a poem to him. According to Sir John Richardson:

> Anybody who was taken up by *Paris Match* and was in and chic, Cocteau would naturally have promoted. I don't think it was a question of fancying Buffet. Maybe I'm wrong about that, I wouldn't know about that. Cocteau was a star fucker – well, not a star fucker, a star devourer, and anybody who was in the news, Cocteau would support and befriend. There was a very good side to Cocteau in that respect. He did promote younger artists and poets whenever possible. With the general public, the *Paris Match* public, it was taken sort of seriously, but by nobody else.[18]

But while Picasso and his circle may not have taken the cult of Buffet seriously, there were quite a few others who made the pilgrimage to Nanse, just as Girardin, Fried, David and Descargues had once traipsed out to Les Batignolles. *Life* magazine travelled to the remote Provençal farmhouse. Hollywood actor and art collector Edward G. Robinson made the trip, as did Simone de Beauvoir. Even a government minister, André Marie, who ran the department of education, arrived complete with motorcycle outriders to see what all the fuss was about.[19]

Nanse may have become romanticised in memory as a simple shepherd's croft, but by the time the magazine *Connaissance des Arts* came to visit in 1955, it had been transformed into a country house of great taste and a sort of austere comfort that the magazine called 'a Louis XIII or Henri II rustic style'. Pale walls, simple dark wooden furniture, elegant lamps, a long-case clock, artfully casual arrangements of dried flowers and of course walls hung with Buffet's own paintings. The couple clearly had taste, and equally clearly the money to indulge it.

'I like the style of Louis XIII, because of a sort of rigour that is at the same time pleasing,' commented Buffet, adding helpfully, 'There are no flourishes, no marquetry.' Here he was debating the merits or otherwise of marquetry, while just five years earlier his most prized piece of furniture had been a paint-stained leather armchair, where

he would sit warmed by the pusillanimous glow of an electric heater. Now it was all Louis XIII and Henri II, seasoned with the occasional eighteenth-century religious sculpture, a collection of pistols and a pair of little seventeenth-century cannons. With the exception of his own paintings and two ceramic works by Picasso, the twentieth century did not intrude into this paradise of perfect taste.

But charming as it was, with its grey-painted shutters and tinkling courtyard fountain, by the time the house and its contents were shared with the readers of *Connaissance des Arts*, Buffet no longer lived there. The butterfly had flown from his chrysalis, or if you prefer, the artist had left his Provençal placenta. For no other reason, he said, than a desire for a change, he and Bergé had decided to move to a manor house within twenty minutes of Paris. It was time for Bernard Buffet to take his place among the beau monde.

Chapter 13

Picasso Means Nothing to Me, Matisse is Only a Décorateur

The *Figaro Littéraire* put it rather well when it said of the madeover Buffet, 'He is doing his apprenticeship as a public figure.' By 1955 his apprenticeship as both a public figure and an artist was complete. The last paintings to come out of the floodlit barn of a studio in Provence were the series that would cement his reputation as the leading French painter of his day

The term '*exposition choc*' – shock exhibition – had been applied to Buffet's strategy of annual thematic exhibition in two galleries simultaneously. But never was the phrase more merited than in 1955, when an extraordinarily disturbing series of giant canvases called *Horreur de la Guerre* was put on show at the Galerie Drouant-David. The three canvases, each over two and a half metres high and very nearly seven metres in length, comprised an unrelenting twentieth-century Bayeux Tapestry of terror and degradation: human beings butchering, mutilating and torturing each other; dead babies; severed heads; naked men and women hanging from the branches of black leafless trees; bodies piled pitilessly like refuse, and a female angel of war soaring over a strange penumbral, almost medieval landscape, the orange sky aglow as if with the flames of a burning city over the horizon. With the horrors of the Nazi extermination camps still recent memories and the shadow of nuclear apocalypse looming over the future, it was a vision of despair that chimed perfectly with the pessimism of the time. It is, explains Fabrice Hergott, director of the Musée d'Art Moderne de la Ville de Paris, 'in its subject matter, very close to *Guernica*'.[1] However, this is a *Guernica* for the atomic age.

It was almost a résumé of his career so far: the hideous nudes of what Descargues dubbed the '*maison close*', the landscapes of the Vaucluse, the anger of the early works and the overarching mood of

despair. As unexpected as it was provocative, this was, predictably, the sort of work that appealed to hard-core Buffet supporters, most notably Descargues, who enumerated the many technical difficulties the artist had set for himself and explained how he had cleared them all faultlessly like a champion showjumper. 'Who, he seemed to be saying, today could do better?'[2]

The *Guernica*-esque theme, the ambitious scale, the dazzling reputation – it is to be wondered whether Picasso himself did not begin to feel a little uncomfortable. Certainly comparison with Picasso is a leitmotif of many of the articles, reviews, monographs and books written about Buffet at this point in his career. If painting in 1950s France were a race, then Bernard Buffet seemed to have overtaken the rest of the field and was closing in on the leader. 'They are very close in quality,' says Hergott, adding smartly, 'All the same, Picasso is a very great artist.'

History is a marvellous sieve. It strains the events of every day and decides what should be maintained in memory and what passes through to be forgotten. It has decided that of all the artists of the last century, it is Picasso we should remember as head, shoulders and torso above the rest. But in mid-century France, history was still sieving the reputations of these painters. For a start, Picasso was alive and working, as was the man who had been his rival since their days in Montmartre at the beginning of the century, Henri Matisse. It was Matisse who had dominated the French pavilion of the 1950 Venice Biennale with a major solo show and been awarded the grand prize. Two years earlier, that honour had gone to another contemporary of Picasso and Matisse from the days of Fauvism, Georges Braque, one more big beast still to be found roaming the plains of twentieth-century art. Picasso may have been *primus inter pares*, but by the time Buffet began to be taken seriously, he had occupied the throne for decades, moving in that time from being the outsider who had broken every rule to the personification of modern art.

Justified or not, a backlash, correction, revision – call it what you want – was inevitable. It was not enough for a younger generation to emerge; they had to emerge at the expense of those who had preceded them: 'To Them Picasso Is Old Hat' ran the headline of an article at the start of 1950 about the 'the new look in Paris Art' by the Paris editor of the *New York Times*. 'Here, once again, Paris is Paris and offers the fulfilment of a wish for art: that the second half of this century be free from the heavy hand of the first.'

Readers were left in no doubt as to the tradition in which Buffet and his contemporaries found themselves. 'It is an old story. Since the start of the nineteenth century Paris has been the great center toward which painters of all nations have gravitated or looked. Here in Paris the Impressionists focused the brilliance of their colors and theories and burned the names of Monet, Renoir, Sisley and Pissarro into the great tradition of art.' The newspaper recognised that 'the influence of Picasso and Matisse alone outweighs that of all the other old masters. Yet now, at the opening of 1950, everyone here interested in man's two-dimensional expression of a four-dimensional life is listening to other voices.'[3]

Among those voices was that of the then twenty-one-year-old Buffet. 'Picasso? He means nothing to me, although he is a great painter. Matisse, on the other hand, is only a *decorateur*.' But by comparison with others quoted in this article, Buffet was ambivalent, almost polite. André Minaux, who won the Prix de la Critique in 1949, declared that Matisse's work 'isn't worth a radish. Let's admit it. He and Picasso are getting old and they don't have as much control any more. They think anything they do is a *chef d'oeuvre*, whether it's a paper cut-out or a drawing of their concierge's daughter.' The severest critic was actually one of the old Fauves. 'Pablo Picasso is guilty of having dragged French painting into a most mortal dead-end and indescribable confusion,' ranted Maurice de Vlaminck. 'The only thing Picasso is utterly unable to do is to produce a Picasso which is Picasso.'

Of course these caustic observations come with caveats and health warnings. Although Vlaminck had been a contemporary of Picasso in turn-of-the-century Montmartre, and had shown early promise with his paintings, he had long been left behind. He had been firmly opposed to cubism, which he acknowledged was an 'aesthetic revolution' but one that he felt 'would remain uncontrolled and would allow all sorts of anomalies to qualify as courageous experiments'.[4] It is unsurprising that Buffet preferred Vlaminck to Picasso, given the older painter's robust refusal to travel along the road towards abstraction. His feelings would come to mirror Vlaminck's views on abstract painting as he grew older and his own attitudes hardened. Nevertheless, history had already done its work on Vlaminck, and while popular in the mid twentieth century, he was a second-tier artist who was, moreover, touched by the taint of having collaborated during the occupation, while Picasso of course was a communist (albeit a rich one).

The reaction of the younger painters is also understandable. Youthful impatience with the established order of things and the utter conviction of their opinions are hardly new phenomena. In addition, the *New York Times* article believed that the imminent replacement of the older generation was already foretold by the way that the Impressionists had been supplanted by the Fauves and the Fauves by the cubists.

Then there was the character of the article itself; it is not what it said about art that is so interesting so much as what it indicated about the modern nature of fame. The emphasis is on youth and the creation of a compelling narrative. Most tellingly it takes liberties with Buffet's biography: 'Buffet, the son of an ex-miner, was very poor a year or so ago and still lives with his family in Montmartre. But now he is turning out a painting about every three days to feed the insatiable maw of the gallery exhibiting him. His paintings are selling like Van Gogh prints in a department store.'[5] Buffet may have thought he was a painter, but he was also already being built up as a story, a new kind of celebrity created by the media with as much ease and rapidity as that with which he created his canvases. Clearly the fact that his father was the director of a mirror factory did not make enough of a dramatic contrast, and one could not expect the readers in Manhattan to know Les Batignolles (or for that matter Garches), but everyone knew Montmartre, which had the benefit of being a sort of *appellation contrôlée* for French artists. And of course the sensational and provocative headline told its own story: the Paris art world was being presented as an Oedipal Punch and Judy show to amuse the readers of the *New York Times* on a dreary Sunday in January, alongside advertisements for washing powder ('Tide's Got What Women Want') and cars ('Buick's the Fashion for 1950') as well as articles on the latest styles in hats and interior design tips for small apartments.

Whether Buffet's talent warranted it or not – and certainly his early years demonstrated an enormous range and facility – he would soon find himself on a collision course with the grand panjandrum of art of the first half of the twentieth century. It must not be forgotten that this was a time of enormous societal change: the atomic age, the jet age, the television age, the space age. It was a time when what was newest was, *ipso facto*, best.

Picasso may have been getting old, but he was certainly au fait with the latest developments in art. Maurice Garnier recalls the occasion

when he came to the Galerie Visconti. 'I once saw Picasso in my gallery on the Rue de Seine in 1950. He came in because opposite the door was hanging a picture by Bernard Buffet, *Femme au Poulet*.' The work, from 1947, the same time as *Net-mending*, shows a woman with bows in her hair, which appear as two horn-like protrusions on her head, her mouth wide and face creased in a howl as the chicken held just below its head flaps its wings and moves its legs as its neck is wrung. 'Picasso planted himself in front of the picture, hands on hips, and stayed there for three minutes, then he turned on his heel and left. He did not look at a single other picture, just that picture; the other pictures were not Buffets but by other painters.'[6]

Sir John Richardson, however, scoffs at the notion that Picasso was in competition with Buffet. 'There was absolutely no rivalry whatsoever. Picasso was a giant. Bernard Buffet was a flash in the pan, he had a sort of chic reputation. But it wasn't taken seriously by anybody that I knew. It was flashy stuff, which his boyfriend in those days was clever enough to promote.'[7]

But no matter whether Picasso believed it or not, as the fifties progressed, some of the popular and indeed specialist art press portrayed the older man as somehow under threat from the young prodigy. 'At 27 Bernard Buffet has overtaken everyone except Picasso,'[8] said one article on the Buffet phenomenon.

For the wider public beyond the art world, Buffet was a *vedette* who happened to be a painter. By the mid 1950s, the mechanics of fame were changing, and one no longer needed a body of work of enduring value to qualify for public renown. Warhol was still a commercial illustrator and had yet to make his observation about fifteen minutes of fame; but with his name and his picture in the papers and the increasingly popular colour magazines, Buffet's celebrity status was becoming an accepted fact of French life. As such it was natural that he would be compared in the public imagination with that other celebrity painter, Picasso. In this context, his comparative inexperience actually told in his favour, as he was younger, better-looking and new.

However, the persistence of the Picasso parallel in sections of the art press is less easy to explain away. As has been noted, the younger critics such as Pierre Cabanne saw something of early Picasso in those eerie still lives of the late 1940s, and throughout the 1950s the comparison continued to be made. Typical was an article in *Le Jardin des Arts*, a serious periodical that could not have been further from the vulgarity

of the celebrity-driven press. In its 1956 issue, it carried an article on
Matisse's chapel in Vence by Daniel Rops of the Académie Française
and a lengthy essay on Pisanello by the noted aesthete and collector
Bernard Berenson, as well as pieces on Metz Cathedral, life in Chantilly
in the eighteenth century, and the lithographs of Toulouse-Lautrec.
Clearly *Le Jardin des Arts* was a magazine that took art (not to mention
itself) rather seriously, and as such it commissioned the impeccably
credentialled Jean-Albert Cartier, art critic of *Combat*, the paper
founded during the war, to write about Buffet.

'Buffet is the most discussed artist in contemporary painting since
Picasso'[9] was the way he opened his article. Acknowledging that the
painter divided opinion into those who violently loved his work and
those who detested it with equal cordiality, he went on to say, 'One
of the strengths of Bernard Buffet is that he is able to renew himself
while knowing how to remain faithful to himself. His manner of
working, like for instance that of Picasso, with whom he has more
than one point in common, is in cycles, in stages and often also in
themes.'[10] It is ironic that Cartier identifies a quality in Buffet of
constant renewal and development, whereas among those who dismiss
his work in the twenty-first century, it is the absence of any such
ability and instead a tendency for repetition that is one of the chief
pieces of received wisdom. To compare him to Picasso today would
be to appear as the protagonist in one's own Bateman cartoon, but
in some intellectual circles of the 1950s it was a comparison to be
considered.

It was of course a comparison that Buffet's friends and supporters
were happy to expand upon. 'Today, Bernard Buffet – since after all
Picasso is Spanish – is the most talked about French painter'[11] and
'After Picasso he is the most written about painter'[12] were typical of
the sentences that Bergé would slot into his frequent writings about
his lover. And the comparison would continue to be evoked well into
the 1960s: 'Buffet is one of the few artists today – one of the few and
perhaps the only one after Picasso, the ancestral monster, the magi-
cian, the omnipotent demiurge – who by the exercise of pictorial
expression, has taken permanent rank among the stars,'[13] enthused
the author Maurice Druon in a lavishly illustrated monograph about
the painter published in 1964.

Rather unwisely, Buffet appears to have let himself get a bit carried
away by his own press. To insult one's elders as a precocious young-

ster barely out of one's teens is one thing, but to do so after becoming established begins to smell of cockiness. He must also have been aware that those who had preceded him had done him a great service by releasing painting from the chains of slavish mimesis: without the Impressionists, pointillists, cubists and so forth, it would still be judged solely on its capacity to record and reproduce the effect of life. Nevertheless, he could not resist taking occasional swipes at the *'vieillards'*, as he sneeringly called them. Of Matisse's famous chapel at Vence, now regarded as one of the twentieth-century's great masterpieces, he said, 'It is not something that knocks you off your feet', adding, 'There is nothing religious about it. Matisse paints odalisques very well, his Christ has the air of an odalisque.'[14] On the subject of Picasso he declared witheringly, 'The day will come when people will say the truth about him. He had a moment between 1932 and 1939, but now he just regurgitates everything.'[15]

Picasso was aware of the rising reputation of Buffet, and according to Richardson 'would sort of snort when his name was mentioned'.[16] Buffet's twenty-first-century supporters have made much of the occasion when, upon spotting Buffet in the restaurant where they were eating with their father on the Croisette in Cannes, Claude and Paloma Picasso dashed over to his table to get his autograph, which, predictably, infuriated Pablo. 'Picasso had, as it were, experienced for himself the star cult surrounding Buffet and the attraction his work had above all for the younger generation, for his two children sought to obtain autographs from his young rival, and in his presence at that,' writes German curator and artist Alexander Roob in the catalogue accompanying a show that did much to begin the rehabilitation of Buffet's work in the twenty-first century. 'And no doubt he did not find it hard to identify distorted versions of his own art in countless of his rival's popular themes. After all, he had made his debut with miserabilist depictions of the world of the circus and the Bohemian art scene in Montmartre' (the year after the *Horreur de la Guerre*, Buffet tackled the circus with all the joylessness one might expect).

The opportunities for Picasso to be confronted with Buffet's success were legion; certainly it seems that he was irritated. In a diary entry on 21 December 1957, Jean Cocteau – for whom Buffet had by now illustrated an edition of *La Voix Humaine*, dedicated interestingly enough to Pierre Bergé – recorded how Picasso had spent a dinner demolishing the younger artist's reputation And when Cocteau dared

to write that Picasso was going to be succeeded by Buffet, using the French metaphor *un clou chasse l'autre*, with Buffet as the 'nail' of his generation, the Spaniard's reaction can be imagined.

Yet as far as Richardson recalls, this sort of behaviour was quite characteristic of the relationship that he observed between the painter and the poet.

> Picasso had known Cocteau since 1916, 1917, and Cocteau was totally in love with Picasso for the rest of his life. Picasso was his hero and Picasso treated him like shit most of the time. It was a very funny kind of S&M relationship. Picasso loved having Cocteau around as a kind of court jester whom he would kick around and make a fool of. And to that extent he was very fond of Cocteau, because Cocteau was very necessary to Picasso's court, as it were. And Picasso was always deriding, oh Cocteau's craze for so and so . . . this was always somewhat a joke with Picasso. And that was part of their relationship.

Richardson's opinion is that 'Picasso regarded Buffet as a joke. His name cropped up in conversation occasionally and Picasso was very dismissive. I never saw any sign of it but maybe Picasso did feel, "God, who the hell is this guy who's in the headlines of *Paris Match*?"'[17]

And if Picasso wondered about the guy in the headlines of *Paris Match*, he was not alone. By the second half of the 1950s, the public appetite for information about the lifestyle of Bernard Buffet was seemingly insatiable, and the content of one article in particular would dog him for the rest of his life.

Chapter 14

Artist in a Rolls-Royce

The second half of the 1950s began well for Buffet. The success of his gruesome *exposition choc* was confirmed by the news in February 1955 that a poll in the magazine *Connaissance des Arts* had ranked him number one on a list of the ten best painters of the young generation. This was no random vox pop, but rather a once-in-a-generation health check on the French art scene, with opinion canvassed from around fifty opinion-formers, forty of whom placed him in the top spot.[1] A similar survey conducted in 1925 had put Matisse at the head of a list that included Picasso, Braque, Derain, Segonzac, Utrillo, Rouault, Bonnard and Vlaminck.[2] Now, three decades on, Buffet was almost unanimously declared to be Matisse's heir in terms of significance if not style.

Further recognition of his status as the leading painter of his generation followed when Buffet was selected, upon the initiative of Raymond Cogniat, to represent France at the Venice Biennale. Cogniat, chief inspector of the Beaux-Arts and a respected writer on the arts, was, until the establishment of a ministry of culture under André Malraux in 1959, a sort of de facto arts minister. A friend of Buffet's teacher Aujame, he had been behind the purchase of a Buffet still life for the state as early as 1947, and nine years later he championed the artist again. Thus in the course of their patriotic duties, Buffet, Bergé and David made the trip to Venice, a city that they were all visiting for the first time.

Today the Venice Biennale is a sprawling social event that has contemporary art as its pretext. But in the middle years of the century it was a much more academic and conservative affair. It had restarted after the war in 1948 and was dominated by established French artists. At the time when Buffet arrived to represent his country, it was, according to one historian of the event, characterised by tastes that favoured France often at the expense of visiting nations.

In 1950, for example, the United States pavilion already exhibited Arshile Gorky, Jackson Pollock, and Willem de Kooning, but only a few were aware of it. The Biennale prizes were instead repeatedly awarded, as we have already noticed, to Georges Braque, Henri Matisse, Jean Arp, and Max Ernst (who was not French, but had achieved maturity within the French surrealist movement).[3]

But, interestingly, as well as being aesthetically conservative, the Biennale was beginning to attract a social crowd intent on experiencing the art lifestyle.

In the mid 1950s, a growing number of articles and illustrations bear witness to the growing number of female visitors attending major art exhibitions. Magazines like *Grazia*, *L'Europeo*, *Gente*, *Tempo* which published the Cameraphoto photo-reportages, employed fashion models for photographs that alluded to leisure time and represented the synthesis of 'modern lifestyle and dress style'.[4]

And inevitably it was the elegant women, rather than the often wizened and untidy artists, let alone the art itself, that first attracted the eye.

It was in short the perfect environment for Buffet; rigidly figurative, and possessed of an immense artistic culture, he regularly astonished serious art world professionals with the depth of his knowledge and the sheer amount of abstruse art history trivia he was capable of retrieving from inside his angular head. But as well as what was inside the head and what came out of it on to canvas, there was the head itself. Buffet had a film star's looks, and in his natty checks, archbishop shoes and Dorian Guy trousers, he was the perfect artist for inclusion in what were then known as women's magazines. It is tempting to imagine young women if not swooning then certainly pausing to admire his picture, which appeared so often those days. Shy though he may have been, the camera loved him.

Also present in the French pavilion that year were the sculptor Giacometti and the painter Jacques Villon, pseudonym of Gaston Duchamp, an older brother of Marcel Duchamp. But it is testimony to how far Bernard Buffet has been erased from the canon of serious art that while Giacometti's participation in Venice is much discussed,

Buffet's is largely forgotten, although of course at the time he was the bigger name.

While they were in Venice, Bernard and Pierre enjoyed themselves. Emmanuel David recalls that he arranged to meet them for a drink at Florian in St Mark's Square with the rest of the French delegation. David arrived a little later in the company of Giacometti and saw that the party was already well advanced: 'These ladies and gentlemen had already drunk a lot.' The tables were filled with plenty of glasses and the large group, in a state of fairly advanced refreshment, was becoming quite jolly. As well as Bergé and Buffet, Villon was there along with Raymond Cogniat, veteran artist André Dunoyer de Segonzac, elderly actress Thérèse Dorny, quite a few journalists, and Villon's dealer Louis Carré, who seemed particularly excited to see David.

David and Giacometti had just sat down on the famous banquettes of St Mark's Square and were about to enjoy their first Scotch when Carré turned to David and asked at the top of his voice:

'So, David, are you paying painters with Rolls-Royces these days?'

David was irritated. 'Instead of holding my tongue as I should have done, I answered back smartly, "And what are you paying yours with . . . Métro tickets!"'[5]

In February of that year, *Paris Match* had published an article about Bernard Buffet. Press interest in the artist was high, particularly around the time of his annual exhibition. This was his year of the circus, which as Alexander Roob indicated must have caught Picasso's attention, coming as it did directly after Buffet's atomic age *Guernica*.

However, after *Paris Match* appeared, nobody was talking about Buffet's big top; instead, all the gossip was about his new car: a metallic grey Rolls-Royce Silver Wraith, arguably one of the most beautiful and certainly one of the most 'snob' cars that money could buy during the 1950s. The impact of this news was seismic; luxury cars were far less commonplace than they would become. In those days, a Rolls-Royce was a British stately home on wheels, and here it was at the service of a young artist who had made his name and his fortune painting pictures that evoked a life of hardship. The juxtaposition was simply too much for many to take, and Carré's essentially good-natured joshing of David was probably the milder end of the obloquy being dished out.

Until 1956, as far as most people were concerned, Buffet had still
been Le Gamin, the pale and nervous painter of misery whom they
still half expected to see chain-smoking in a dirty Canadienne. From
now on he was the artist in a Rolls-Royce. 'It was that article in *Paris
Match*, in which you saw him with his Rolls-Royce, his chauffeur and
his chateau,' recalls Maurice Garnier sorrowfully. '*Alors*, in those days
that was catastrophic; what was good for Andy Warhol twenty years
later was very bad for Bernard Buffet.'⁶ The break-in at the Watergate
Hotel in Washington was still a decade and a half in the future, but
had the suffix 'gate' been in use at the time, some headline-hungry
news editor would have called it Rollsgate.

Paris Match showed how, in February 1956 – the atomic age and all
that – the twenty-eight-year-old painter lived the sort of life of luxury
and refinement that had more in common with the lives of belle
époque aesthetes such as Robert de Montesquiou and Boni de
Castellane, or the fabulously wealthy Charlie de Beistegui, whose
Château de Groussay was a synonym for sybaritic good taste and
whose costume ball in Venice in 1951 had made headlines around the
world. The water on the ornamental lake in the park was mirror still;
a pet monkey played in a winter garden; the flaming logs in the baro-
nial fireplace crackled; the soft light glinted on polished silver and
wood; wherever the eye alighted it found something of exquisite
beauty; and the walls were crammed with his paintings. Very few
people around the world, let alone in France, lived like Buffet.

> In less than ten years little Bernard, the miserable adolescent who
> during the winters of the war would take refuge in the Louvre, not
> to look at paintings, but to warm himself over the heating vents, is
> transformed into a rich gentleman farmer. The magic wand that
> effected this transformation is his paintbrush.⁷

Buffet and Bergé were living in a manor house called Manines on
the edge of the Forest of Montmorency, just outside Paris. Here,
behind iron and gilt gates, he pursued the same sort of regime as at
Nanse; it was just that it was much more luxurious. His studio was
a converted double-glazed garage, and he painted in a surgeon's smock.

The world into which he invited *Paris Match* is presented as some
sort of enchanted realm, in which Buffet is both monarch and, from
the looks of it, sole human inhabitant. In the evocative, slightly

bleached colour photographs typical of the period, he is shown posing with palette, brushes and half-completed canvas, alone; strolling in the woods alone; walking down the gravel drive alone; standing in a punt on the lake, with two ducks; sitting in an armchair in a natty checked dressing gown with an antique backgammon board and a large German Shepherd called Biscaye. In the most impressive picture of all, he has changed out of his corduroy jacket and flannels and into a dark suit, and is sitting backwards on a chair, his arms resting on its back. Behind him is a wall of his paintings, one from each year of his career, starting in 1943 with a church painted from an engraving in a school book, up to the most recent, a lobster from 1956 in front of various colourful kitchen utensils, a vision of plenty that is perhaps an ironic commentary on the paintings of austerity that made his fortune, and shows the 'beginning of a new style: a return to violent colours'.

However, it was not the brightly hued lobster that stuck in the mind but the silver-grey coachwork of the 4.5-million-franc Rolls-Royce, its door being held open by a uniformed driver complete with cap. Juxtaposed were some pictures of Buffet playing as a child on the beach, providing the headline 'Success has made the orphan with his sand castle the master with the Rolls'.[8] Buffet's father was still alive, as had been his mother at the time the holiday snaps were taken, but the headline writer had permitted himself some licence with the facts.

On 4 February 1956, Bernard Buffet stopped being the promising future of French painting and became forever the artist in the Rolls-Royce.

Young, good-looking, rich, living a life of exquisite luxury, wafting along the roads of fifties France in the back of the most opulent of vehicles . . . all of a sudden the world was presented with an image of the artist very different from the paint-spattered, dishevelled and impoverished cliché. Contemporary art changed that day in February 1956, although this was probably not what Descargues had in mind when he wrote that 'Buffet represents a new phenomenon in contemporary art.'[9]

He was still being asked about the Rolls-Royce in the 1990s. 'We had two of them – a blue one and a very large one. I can't remember how much they cost! We don't drive.' Forty years later, he claimed it was an aesthetic choice. 'It was the look of them. The beauty of them. I loved those big headlights, the "goddess" on the bonnet, and those doors – they opened the wrong way, dangerously backwards.'[10] In the

same interview he was asked about a painting of a dishwasher and why he had chosen it as a subject. 'Because it is beautiful looking,' he answered. 'As beautiful as a Rolls.' In the time of Jeff Koons and Damien Hirst, he could cheerfully admit to actually having had more than one of these cars and pass it off as an eccentric painterly whim or mildly ironic gesture; but in the 1950s, things were very different.

He and Pierre realised instantly their mistake in letting *Paris Match* into their exquisitely decorated and furnished house. Buffet immediately took to the pages of his friend Aragon's *Lettres Françaises*. On 9 February, an article appeared headlined 'I am reproached for earning too much money!' and signed in the arachnoid script. It was a spirited and very Buffet defence in that it relied almost entirely on precedents from art history to demonstrate that there had been a time when artists had been among the richest and most prominent citizens. Never one to aim low, Buffet drew parallels with the status of Rubens and the standing of artists in the time of the Medicis. He invoked the earning power of Courbet and Meissonier, and pointed out how anyway 'neither misery nor opulence alone created good painting'.[11]

Given the communist inclination of *Les Lettres Françaises*, it was perhaps an unusual court in which to argue his case. If this article achieved anything, it was to isolate Buffet even further. 'After the issue of *Paris Match*, Bernard made the blunder of defending himself in *Les Lettres Françaises*,'[12] wrote Cocteau in his diary, when the backlash showed no sign of dying down. After a dinner with Bergé and Buffet on Monday 19 March, he describes Buffet as sad and visibly affected by the 'wave of bad feeling that the article in *Match* had unleashed against him'. A veritable hate campaign had been stirred up and had taken on a particularly sinister dimension. 'Someone had sent an envelope of shit anonymously and threatened David with a letter bomb. One can imagine that the millions Bernard earns revolt mediocre painters, who do not dare to take themselves for Braque or Picasso, but who explode with fury when these millions fall into a young pocket.'[13]

While many of the artists and intellectuals who saw his article in *Les Lettres* condemned him, millions around the planet now knew him as the artist who could afford a Rolls-Royce. Buffet would find that the modern world had no hiding places for the celebrities it created. Fifty years earlier, what happened in Montmartre (or in this case Montmorency) stayed in Montmartre. Now the news flashed around the globe. He made both *Time*, under the ironic headline 'An Artist

Must Eat', and *Newsweek*, which opted for the more prosaic 'Artist in a Rolls-Royce'. And if to the readers of *Paris Match* he was 'the young man who printed banknotes with his paintbrush', then to readers of the West German news magazine *Der Spiegel* that summer he was 'the Man with the Golden Arm'.

The headline, borrowed from the film of the same name about a heroin addict musician, ran on the cover of the magazine with a self-portrait of the artist; the first time that a mere painter had made the front page of a publication more used to showing statesmen, economists and world leaders. Compared to the benign tone of the *Paris Match* article, which had let the photographs do the talking, *Der Spiegel* took a more questioning tone, suggesting that behind the hype, there was just emptiness. Notwithstanding the occasional tart observation, such as the description of a 'pale face slightly bloated by good living',[14] and the 'long nicotine-yellowed fingers',[15] there is no overt hostility towards the painter. Nevertheless, because of the almost prurient lingering over the details of the luxurious way of life – the Provençal housekeeper, the Venetian gardener, the butler, the liveried chauffeur of a Rolls-Royce, the price of which was quoted helpfully in francs and Deutschmarks – juxtaposed with the unalteringly nihilistic tone of his work ('an unbroken monologue of misery'), it would be an unperceptive reader who did not infer the sense that Buffet was in some way hypocritically and cynically producing immense quantities of work that bore little relevance to the life that he led . . . beyond of course paying for it.

Discussions of his work now had to address his astonishing success and his remarkable output. The *Spectator* in London is typical.

> *Time* magazine reported his profits in one week as £40,000. A secretary of my acquaintance was asked by her employer to telephone the Drouant-David Gallery about buying a Buffet; she was told that his next eighty-three paintings were spoken for, but that the eighty-fourth place on a waiting list was available. This was not disheartening, since Buffet turns out 150 oils a year and has painted more pictures at twenty-eight than had Renoir when he died at seventy-nine. Those are the statistics; as to their meaning, you can choose among French critics, to whom Buffet is either 'this young millionaire, whose lack of culture is equalled only by his cynicism', or else 'the Goya of our times', who speaks for '*cette generation sacrifiée*'.[16]

In truth, Buffet had been rich for some time. Already in the 1950s he had bought what was described as a yacht but which Bergé describes as a small boat. It was just that living twenty minutes from Paris and making the journey to his openings in his own Rolls-Royce, his success was rather more obvious than it had been up in the Provençal steppe. He had had to answer concerns over production almost from the start of his career. 'Some people think I work too fast,' he admitted in early 1950, 'but I think all artists should paint a lot. Sure I'm glad I'm selling. It means I have a chance to work in tranquillity.'[17] And in a review of his first London show at the Lefevre Gallery in 1951, the reviewer from *The Times* brought a generally favourable notice to an end with a note of warning: 'It seems possible that M Buffet is running something of a risk in producing very large numbers of pictures, as he must have done to supply the many exhibitions that have recently been held of his work.'[18]

Depending on whether one was pro- or anti-Buffet, it was a virtuous or vicious circle: the more he painted, the better and quicker he got at it. 'He had an incredible aptitude: in those days he could do twenty or thirty drawings in a day,' says Pierre Bergé, of the time around which Buffet painted *Horreur de la Guerre*. 'It was astonishing; he finished a six-metre canvas in a couple of days, no more than a week. He worked extremely quickly' – and accurately. 'If you look at the nudes of Bernard Buffet, you can like them or dislike them, but there is not a single mistake! And he never had a model, it is extraordinary, never, never had a model, he did it like that and there were no mistakes, not one.'[19] As he neared the end of his twenties, Buffet was a painting machine. To see him sketch directly on to canvas without a second of hesitation, and then paint, was a marvel.

And it happened that this facility with a brush made him the perfect artist for the market in the latter half of the 1950s. His 1956 exhibition of circus performers might not have appealed to all the critics – 'This year's, the circus, was not a fortunate choice for a painter without a grain of mirth or tenderness, or even, apparently, much interest in human gestures,'[20] said the *Spectator* – but it was to win him huge public popularity. These lurid, colourful characters, their pathos all too visible behind the make-up, were to prove a huge commercial success. Some of his early circus figures capture the sad desperation of the itinerant life on the lowest rung of show-business; there is in particular a magical harlequin that he painted in 1956 (against the

familiar *maison close* wallpaper) that lingers in the mind as a haunting presence. Clowns fascinated him much as they had obsessed Picasso during his pink period half a century before.

It is often said that when Buffet painted a face, whether human or animal, he was painting a self-portrait; while not entirely true, there is no doubt that he used his own features as the basis for some of his clown paintings. There is a wonderful piece of film that shows Buffet making himself up as a clown, dextrously applying the face paint as he peered into the mirror through tendrils of smoke from the ever-present cigarette. 'The clown can indulge himself with all sorts of disguises and caricatures,' he says as he daubs his features with grease-paint, adding tellingly, 'It's freedom.'[21] The irony was that the clown would lead him down a creative cul-de-sac too lucrative to reverse out of. Rather than being liberated, Buffet became a prisoner of the clowns, continuing to paint them until the end of his life. By then he would admit to Maurice Garnier that '*malheureusement*' it was for his clowns that he would be remembered.[22]

Soon the clowns appeared in their dozens, then their hundreds, and were reproduced as prints and posters in their thousands and tens of thousands. They quickly became a cliché and remain to this day his most popular work. When they appeared in the 1950s, however, they did so unfreighted by the weary overfamiliarity that four decades of funny-faced depressives would bring.

It is easy to see why Buffet's clowns enjoyed such immediate and enduring popularity. Without the disturbing overtones of the *Horreur de la Guerre* or the need to redecorate your house in the medieval style to accommodate his religious paintings, they were just right for the booming investment market in art that took off like a rocket in the second half of the 1950s. Had a collector got into the Buffet market as early as Girardin did, he could have been looking at an appreciation in the order of 10,000 per cent, and even those paintings bought in 1950 were now worth around ten times what the buyer had originally paid. 'Why wait for the Sahara oil? Buy oil paintings'[23] was the cheerful maxim of those days. During the final years of the 1950s, money poured into the art market; in order to assist new investors, one adviser demystified things greatly by reducing this field of human creativity to a matter of stocks and bonds. 'The stocks in art represent the works of young painters that should rise rapidly in value in two to five years.' By contrast, 'The bonds in the art market are represented by the famous artists

whose works cost more than you can immediately sell them for but nevertheless constitute a very sure value to hold, because they are backed by the world's museums and great private collectors.'[24]

Art fever was everywhere. In the cinema, the film of the year was *Lust for Life*, based on the novel written by Irving Stone, who had also penned the preface to the 1955 Los Angeles museum show of Buffet's work. In the screen adaptation, Hollywood Buffet collector Kirk Douglas portrayed the troubled Vincent Van Gogh and Anthony Quinn played Paul Gaugin, both being nominated for Academy Awards and the latter winning the Oscar for best supporting actor. Meanwhile on an elite global level, the exciting new crowd of the international super-rich that was becoming known as the jet set had discovered the trophy value of art.

During 1957 and 1958, as Philip Hook, a director of Sotheby's and author of *The Ultimate Trophy: How the Impressionist Painting Conquered the World*, explains, 'The market had become truly international. Wherever you offered a great Manet or Renoir or Cézanne, it would be competed for by the same moneyed jet-setting group.'[25] The great auction houses became the arenas in which Greek shipowners competed with European industrialists, American plutocrats and museum directors to own the world's most coveted paintings.

Over the course of 1957 and 1958, records for Impressionist paintings, or 'modern art' as it then was, just kept on tumbling. In May 1957, Gauguin's *Still Life with Apples* sold at auction in Paris, tripling its pre-sale estimate and going for very nearly $300,000; due, said the *New Yorker*, to 'a sudden desire to acquire the canvas which ignited simultaneously in the bosom of Mr Goulandris and Mr Stavros Niarchos, causing an explosion of human nature that blew the roof off the international art market'.[26]

And if the roof had been blown off in Paris, then the door was blown down in London at the Weinberg sale. Wilhelm Weinberg had been a banker in Amsterdam and had shipped much of his art to America before the Nazis overran the Low Countries. His collection of Impressionists and modern masters was of such quality that a number of his Van Goghs were used as props during the filming of *Lust for Life*.

Next, the action moved to New York's Parke-Bernet saleroom, where the art market's windows were all blown out by the bidding. By now, art auctions were regarded as breaking news, and *Life*, which had visited Buffet in Nanse a couple of years earlier, was there to

record the triumph and dejection as bidders won or lost. 'As mouths drooped and faces fell, art prices soared to an all-time high at a New York auction two weeks ago. The occasion was the sale of 65 pictures collected by the late Georges Lurcy, a wealthy Frenchman who became a Manhattan investment banker.' The collection realised $1,708,500, 'the highest amount brought by any auction of paintings in history'.[27] It was not a record that would stand for long.

The art market's walls were blown down by the Jericho-like trumpeting of the world's rich fighting it out for trophy canvases at the Goldschmidt sale in London the following year, a black-tie event that saw the art market change dramatically in a little over twenty minutes. 'Seven paintings make £781,000 in 21 mins'[28] was the headline in the London *Times* the following morning; a total that sounded even more impressive when converted into dollars by the *New York Times*: '7 Paintings Sold for $2,186,800'.[29]

Of course not every art investor – sorry, lover – could afford to spend that kind of money, but as the economy picked up after the war, French industrialists and entrepreneurs chose not to leave their fortunes in the unpredictable French franc, preferring instead to convert them into canvases. The art dealer joined the doctor, lawyer and stockbroker on the council of advisers upon whose professional opinion the prosperous bourgeois businessman relied. As many of the men buying Buffets were manufacturers themselves, they did not necessarily regard his high output as a problem; often the reverse: it gave them confidence that they could rely upon him to produce. The metronomic regularity of his work gave structure to his market, and rather like a new season's gowns being paraded twice a year in the salons of the couturiers, or the latest models of Citroën and Renault being unveiled at the Paris Motor Show, every February that year's new collection of Buffets made its debut.

Buying art was approached with all the emotion and impetuousness of a pension plan. Once a promising painter or two had been selected, the industrialist would make regular purchases, building up a collection of anything up to a couple of hundred artworks over a five-year period. Buffet adopted a production-line approach. Bergé describes how he used to see him cranking out flower paintings ten at a time, applying the base colour to each canvas, then returning to the first to apply the next colour, and so on. It was evidence of an overwhelming need to paint, but also, suggests Bergé, 'perhaps the need to earn money'.[30]

Chapter 15

Paris Goes to Texas

In his *Lettres Françaises* answer to those who criticised him for earning too much, Buffet ended on a stirring, almost patriotic note.

> There was a time when the painter was not regarded as a curious animal, who needed to be dirty and live on crumbs of bread, but instead he was a true participant in the affairs of the nation. He contributed to a country's prestige, he was its ambassador abroad. He was valued because it was known then that kingdoms came and went, but paintings remained.[1]

However, when he wrote about being an ambassador of national culture abroad, he was probably thinking of the princes of the Renaissance and their court artists, and not about being stuck at Orly airport waiting for a delayed flight, along with a planeload of champagne salesmen, cloth merchants, and assorted representatives of mustard makers, fragrance factories and even braces manufacturers.

In the autumn of 1957, Buffet and Bergé joined a delegation of representatives of the French *art de vivre* who were travelling to Dallas at the invitation of Neiman Marcus. Founded in Dallas in 1907, the famous department store was marking its fiftieth anniversary, and to celebrate, Stanley Marcus had decided to bring a touch of what was doubtless spoken of as 'Gay Paree' to the Lone Star State. As well as Buffet, Bergé and the assorted mustard and braces salesmen, there were the 'twelve most beautiful models in Paris';[2] Canon Kir, the *bon vivant* war hero clergyman, Mayor of Dijon and eponym of the famous cocktail of cassis and Bourgogne Aligoté; art historian Gérald Van der Kemp, who was making the trip to solicit donations for his ongoing work of restoring Versailles; and Louise de Vilmorin, seed-fortune heiress, sometime poet, part-time novelist and full-time femme fatale, who seems to have slept with anyone of consequence in Paris in the

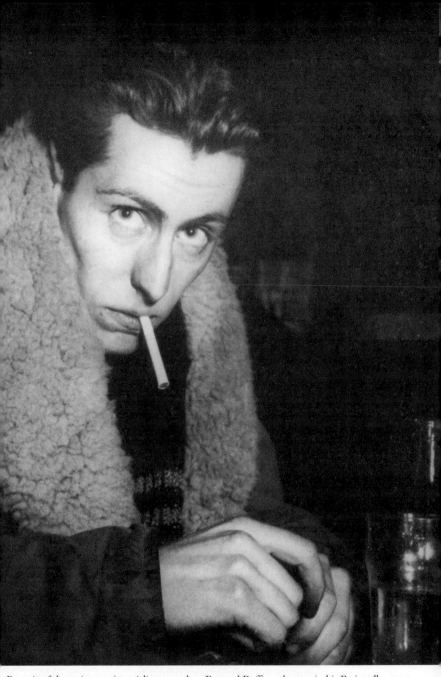

Portrait of the artist as existentialist poster boy. Bernard Buffet as he was in his Batignolles years in the early 1950s: filth-encrusted Canadienne, gaunt good looks and ever-present cigarette.

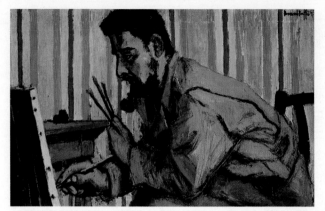

(*Above*) *Le Peintre Robert Mantienne*, 1945, oil on canvas, 63x100 cm. Buffet's closest student friend Robert Mantienne, painted by Buffet while he was a teenager in 1945, was a sensation. Buffet's juvenilia was already attracting the attention of the critics at this time, one of whom said of his work: 'it could have been by a painter of any age; just as easily an old independent painter as student'.(*Right*) Buffet with fellow painter Bernard Lorjou. At the age of just twenty Buffet won the prestigious Prix de la Critique ex aequo with Lorjou.

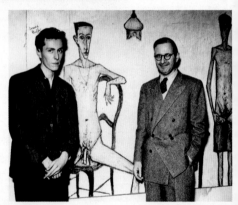

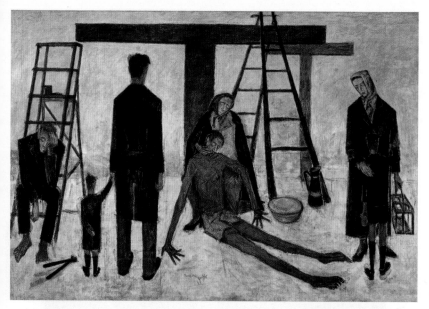

Déposition de Croix, 1946, oil on canvas, 172x255 cm. A strong but idiosyncratic Christian faith was to remain with Buffet throughout his life and would be reflected in his art, whether in the work he painted for the chapels or in the early works such as this, which mixed the familiar iconography of the Christian tragedy, with the typical shabby, hungry, careworn inhabitants of post-war Paris.

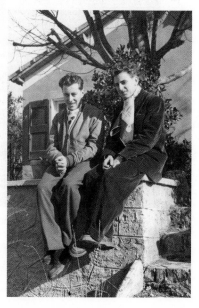

(*Right*) 'Les Petits' was the affectionate name by which their host Jean Giono knew Buffet and Pierre Bergé. The two young men enjoyed the celebrated author's hospitality, in 1951 moving into 'le bastidon', his guest cottage near the author's home in the Provençal town of Manosque.

(*Facing page*) Buffet in his studio in a converted barn at the remote farmhouse he shared with Pierre Bergé in Provence in 1952. 'It was five kilometres to the next house and after winter came we would be snowed in,' recalled Bergé. Warmed by the pot-bellied stove, Buffet spent long hours in his studio: during the day he painted by the light from windows put into the roof; at night by powerful spotlights.

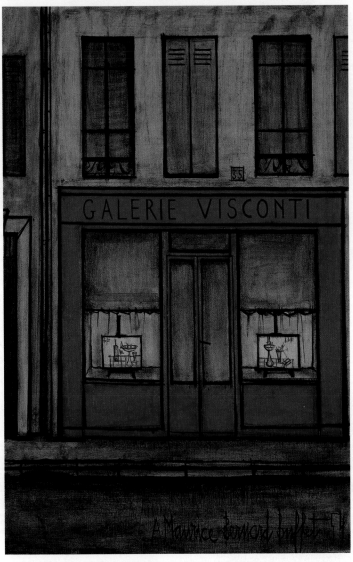

Galerie Visconti, 1954, oil on canvas, 81x54 cm. The Galerie Visconti on the
Left Bank was where Maurice Garnier exhibited Buffet's aquarelles, drawings
and smaller works (look closely at the windows). The monumental canvases
were displayed on the Right Bank at Drouant-David. During the 1950s the term
'*exposition choc*' – shock exhibition – was applied to Buffet's strategy of annual
thematic exhibition in two galleries simultaneously.

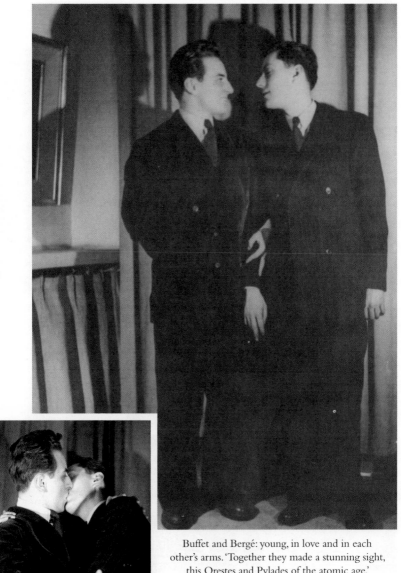

Buffet and Bergé: young, in love and in each other's arms. 'Together they made a stunning sight, this Orestes and Pylades of the atomic age,' trilled one delighted observer.

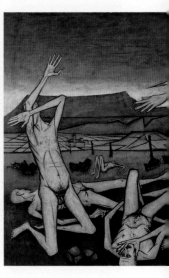

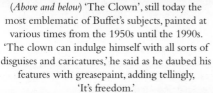

(*Above and below*) 'The Clown', still today the most emblematic of Buffet's subjects, painted at various times from the 1950s until the 1990s. 'The clown can indulge himself with all sorts of disguises and caricatures,' he said as he daubed his features with greasepaint, adding tellingly, 'It's freedom.'

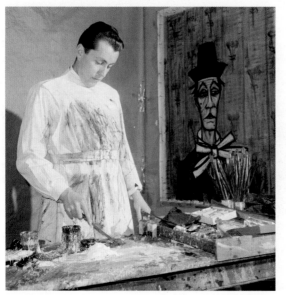

(*Facing page*) Portrait of the artist as a young squire. Buffet's metamorphosis from dirty Canadienne-clad adolescent to elegant young plutocrat is complete, but the combination of success, youth and money was too much for some. The Rolls-Royce would prove fatal for his reputation.

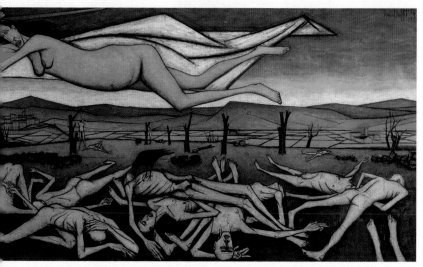

Horreur de la Guerre – L'Ange de la Guerre, 1954, oil on canvas, 265x685 cm.
A Bayeux Tapestry of timeless terror, and an extraordinary work that unsettles as deeply as it impresses. Buffet's triptych of huge canvases recording man's cruelty and violence is seen by some as an atomic-age *Guernica* that captures the horrors of the Second World War and the nimbus of doom that hovered over Cold War Europe.

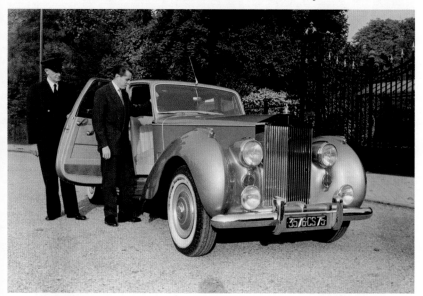

Buffet and the Beau Monde.
One of France's 'Fabulous Five' and a leader of *Les Moins de Trente Ans*,
the late Fifties saw Buffet in the news and out on the town.

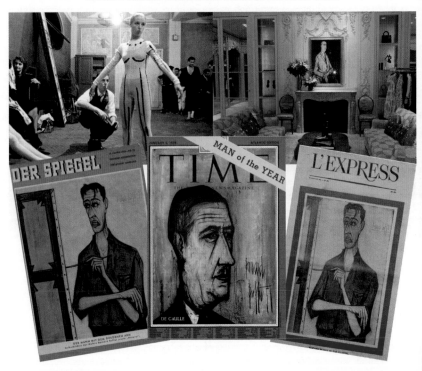

years before and after the war. She would in her later years live with André Malraux and delight in calling herself Marilyn Malraux. She had been invited on the trip because she had designed a line of jewellery for Neiman Marcus.

The commercial odyssey kicked off with an absolutely ghastly cocktail party at Orly. 'I cannot describe the vulgarity and the scrimmage of the cocktail-champagne that Air France (I suppose) gave on the first floor of Orly in honour of the 68 passengers in the special plane that would take us to Texas,'³ wrote Vilmorin in aristocratic horror to a friend, adding that together with the journalists and photographers who swelled the numbers at the party, they formed a 'disgusting group'.⁴ Nor did Vilmorin's mood improve when after a delay of two hours, she found herself in tourist class, though happily the gallant salesman from Parfums Patou gave up his couchette for her – the trip took place just before passenger jets entered service across the Atlantic, and the journey on piston-engined aircraft was noisy, long and uncomfortable.

Things looked up on the New York–Dallas leg of the trip, when Vilmorin bonded with Van der Kemp, Bergé and Buffet, all of them cracking jokes and giggling like children at the back of the bus on a school trip. When they arrived in Dallas, they were greeted by an immense crowd, along with a brass band playing the 'Marseillaise' (and a Burgundian hymn for the benefit of Felix Kir). A motorcade of thirty of the recently launched Renault Dauphines, complete with police escort, then swept the visitors through a city draped with French flags.

Evincing the American mania for convenience tourism of the 'it's Friday, it must be France' type, this extravaganza united all the highlights of an idealised travel guide version of Paris under the roof of Stanley Marcus's department store, where the French capital was deconstructed as a series of shopping and dining opportunities. It had been enthusiastically trailed in the Dallas press, who had announced that 'the exterior of the store will be decorated like a French street, and the first floor interior will feature a scene of the Place de la Concorde'.

'French Celebrities and Products will be in Dallas,' trumpeted one local paper. 'The Neiman-Marcus store will take on a French look with a replica of Christian Dior's Paris boutique on the fourth floor and a Hermès boutique on the second floor. The Zodiac Room will suggest the decor of Maxim's, and Monsieur Carrere will be present

the first week,' ran the report. 'André Paplon, chef of the French liner Liberté, will preside the second week. Rober Gourdin, chief somme-lier of "21" in New York, will serve more than 30 French wines at the events during the fortnight.'

There would be cookery demonstrations and a 'special wine tasting party and dinner for the Confrérie des Chevaliers du Tastevin', while one of the highlights of the fortnight would be 'a "twinning" ceremony for Dallas and Dijon, France',[5] as opposed, one presumes, to the Dijon of any other nation.

In addition to being a Francophile, Stanley Marcus was a man of culture, and an early collector of Buffet's work when it was still rela-tively unknown. In order to impart the necessary cultural veneer to his tourist-trap vision of Paris, who better to recruit than his favourite French artist? Described as one of 'the biggest artistic fish', Buffet was interviewed as successfully as a shy non-English-speaking Frenchman could be in 1950s Dallas. Cheerfully admitting to having 'sold at least 1,000 canvases in the 10 to 12 years he has been painting profession-ally', he gave no indication of either slowing down or changing style. 'Why should I,' he asked, 'when I have a product they want to buy?'[6] Presumably the irony that Neiman Marcus was celebrating a France of bounteous abundance and sensory pleasures, while Buffet had made his name and his fortune depicting deprivation and misery, was over-looked.

Buffet had come a long way from the scanty meals served in the miserable kitchen of the Rue des Batignolles. Typical of the lavish events laid on for the visiting delegation was a banquet at the Adolphus, a beaux arts hotel that had recently been upgraded so that it now boasted 1,200 bedrooms. Green satin tablecloth on top of white satin. A thousand negro servants. Pyramids of lobsters, langoustines, shrimps, and all sorts of meat and fruit. Magnificent flowers. Luxury without taste and not to my taste,'[7] sneered the worldly Vilmorin. Indeed Vilmorin's *de haut en bas* condescension, her mordant words biting the hand that in this instance was quite literally feeding her, neatly encapsulates the attitude of educated French people of the period towards America: a sense of superiority all the more keenly felt because of the knowledge that post-war France now relied upon the transatlantic nation.

For Buffet and Bergé, the trip to Texas was extraordinary not least because of the institutionalised racism and extreme conservatism they encountered there, which was in marked contrast to the life as a gay

couple they had been leading in France. 'At that time there was an enormous difference,' recalls Bergé when comparing permissive Paris with strait-laced Dallas. For him and Buffet, 'It was the discovery of America. It has to be understood that this was still the time of segregation and Prohibition. You could buy alcohol in the shops and take your bottle into a restaurant but you could not order it in the restaurant.' This must have been an inconvenience, as Buffet was already drinking regularly. 'He did not drink as much as he did afterwards. But he did drink with me.'[8] It is the segregation, though, that stays in Bergé's mind six decades on.

Buffet and Bergé returned home via New York. 'It was like a monster, ugly,'[9] said Buffet of a city that he would paint twice in his life. 'I know that after me, he made paintings of New York,' says Bergé. 'They were not very good.'[10] But pictorial quality aside, Bergé would have another, more personal reason for not entertaining a particularly fond memory of these paintings.

Before they had joined the mustard and braces makers as ambassadors of French prestige on their triumphal tour of Dallas, Bergé and Buffet had dined with their friend Christian Dior, whose portrait Buffet had painted in 1955 and which the couturier hung in his converted mill in Versailles. When they returned from America in October, almost the first news that greeted them off the plane was that Dior was dead. It was a great loss for France, and in addition to the natural shock and grief that accompanies such news, the death of the dressmaker was to have life-changing consequences for both Buffet and Bergé. The two were among the mourners at the funeral, which was almost a state affair, with some 2,500 people in attendance and the Duchess of Windsor as guest of honour. But even before the funerary obsequies, the future of the couture house had become a matter of national concern.

Like Buffet, Dior had been one of those ambassadors of national prestige that France had been fortunate enough to find during the difficult post-war years. *Le Monde* summed up his contribution to French life when it described him as indissolubly 'identified with good taste, the art of living and refined culture that epitomises Paris to the outside world. One can thus claim that a significant part of France's prestige is due to this man.'[11] Like a Buffet on the wall, a gown by Dior (or a wife in a gown by Dior) was a potent symbol of both status and sophistication.

Moreover, both were aspirational brands into which those on relatively modest incomes could buy. Just as those who could not afford a canvas or an original drawing by Buffet could purchase a lithograph, by the time he died Dior's name had been licensed across a range of products, and it was the licensees who moved quickly to persuade Dior's backer, Marcel Boussac, not to close down the company. On 15 November 1957, a press conference was held at which a statement was read out. 'The studio will be run by Madame Zehnacker, the couture workshops by Madame Marguerite Carré,' said the spokesman. 'Mitza Bricard will continue to exercise her good taste over the collections. All the sketches will be the responsibility of Yves Mathieu-Saint-Laurent.'[12] Overnight, the world was made aware of the existence of a shy, bespectacled twenty-one-year-old design studio assistant who would from now on be taking control of the designs at the most famous fashion house in the world. Yves Saint Laurent (according to his biographer Alice Rawsthorn, the Mathieu and the hyphens were too problematic for the foreign press) completed a constellation of youth that the *New York Times* called 'France's Fabulous Young Five'.

Chapter 16

Apotheosis

> They are two girls and three men who, barely past their teens, speak for their restless contemporaries with outrageous success.
>
> For the past four or five years, Frenchmen have been watching, with a mixture of fascination, envy, amusement and irritation, the fabulously swift appearance of a handful of new stars in the seventh heaven of celebrity. They share a number of features – a private life that is barely distinguishable from public myth, a magnetic attraction for publicity and above all, their youth, for these men and women have achieved popular and financial success, although they are still barely more than teenagers.

So enthused the *New York Times*, with a little licence, when reporting from the capital of youthful creativity that Paris was fast becoming.

As well as Buffet, who at twenty-nine was rather an old teenager, and Saint Laurent, the fabulous five included 'Françoise Sagan, 22, whose *Bonjour Tristesse*, written when she was 17, sold 810,000 copies in France and more than a million in the United States, and has been translated into twenty languages. Her two subsequent novels so far have sold a total of a million copies in France.' Then there was the young woman who had made her debut at the Galerie Drouant-David, Brigitte Bardot, aged twenty-three, 'whose picture *And God Created Woman*, directed by her former husband Roger Vadim (himself 29), stands fourth in American box-office ratings.' The paper added approvingly, 'She is now rumored to be worth 125,000,000 francs per film and to have a yearly income of $1,400,000.'[1]

According to the *New York Times*, as the fifties drew to a close, 'the teenage millionaires had held up the mirror: Sagan had given it speech; Buffet, eyes; Bardot, a body; Vadim, action, and St Laurent was about to dress it. What gave these spokesmen their air of authenticity was their age; they were like characters out of their own works.'[2] It seemed

that Buffet had just emerged from another chrysalis, effortlessly making the transition from promising young artist to world-famous celebrity: the man who put art on the same level as fashion and filmed entertainment.

As the *Times* saw it, 'Few persons had thought of relating these various success stories as so many symptoms of the same phenomenon.' Not entirely true: the *moins de trente ans* (under thirties), as they were collectively known, were already an established cultural phenomenon in France, which as a nation oscillated between seeing the talented *jeunesse* as evidence of the French capacity for national renewal and being scandalised by the misanthropic misery of Buffet's canvases, the precocious amorality of Sagan's novellas, and the unabashedly sensuous, sexually predatory screen persona of Bardot.

As well as being under thirty, these youngsters were prolific. By 1958, Bardot had already appeared in twenty films and got through one husband. Sagan had brought out three novels by 1957, and although her rhythm was interrupted aged twenty-one when a horrific crash in her Aston Martin put her in a coma and left her with a morphine addiction, she managed to write a play while convalescing[3] and her fourth work of fiction, *Aimez-vous Brahms?*, appeared in 1959. Meanwhile, nobody was really quite sure how many thousands of works of art Buffet had turned out; one accepted estimate was that he worked at the rate of 150 oil paintings a year,[4] to say nothing of the aquarelles, engravings and other works on paper. Already in 1957 he admitted to having painted 2,000 pictures,[5] and his quick, dextrous hands could produce dozens of highly accomplished drawings a day. 'This young millionaire, whose lack of culture is equaled only by his cynicism,' spat one critic, 'has painted more pictures at the age of 28 than August [*sic*] Renoir produced in his entire lifetime'[6] (and limited production was not exactly an accusation that could be laid at Renoir's door).

Now, in 1958, some of the most high-profile of the *moins de trente ans* would gain international recognition when they pooled their talents to create a ballet named *Le Rendez-vous Manqué*, or *The Broken Date*.

Sagan supplied the storyline: a young man has an affair with a woman, who announces that she is to return to her husband in New York; one last rendezvous is promised, but when she is late, he takes poison to kill himself. This slender, far from original storyline was set to music composed by another French youngster, Michel Magne, who

was then twenty-seven years old and would go on to score *Barbarella*. Vadim staged the production and Buffet designed the sets. It was not the first time that Buffet had designed a ballet: in 1955 he had worked with Georges Simenon, who would become a close friend, composer Georges Auric and Roland Petit on a ballet called *La Chambre*, but this was something of a different order and became one of the most talked-about productions in years.

When British critic Peter Williams had first heard about it the year before, he had predicted that 'possibly Picasso would design some of the scenery while Jean Cocteau was to design and produce the rest'.[7] Another mooted collaborator was singer Juliette Gréco, for whom Sagan had written song lyrics. However, by the time it came to the stage, Gréco was no longer a part of it, while Picasso and Cocteau had been replaced by Buffet.

The dance critic of the London *Times* called it a 'not particularly modern ballet – it might have been composed in the twenties',[8] and at some stage the group who put on the show might have thought they were creating a piece that would have the same sort of impact as *Le Train Bleu*, a ballet about the eponymous train that connected Calais to the Côte d'Azur, premiered in June 1924 at the Théâtre des Champs-Élysées. At that time, express trains were the jet aircraft of their day and people wrote popular novels about them. Sunbathing had just been invented, as had the concept of sportswear, and this ballet was the quintessence of modernity, with music by Darius Milhaud, story by Jean Cocteau, and costumes made by a rising young dressmaker called Coco Chanel. There was even a contribution from Picasso in the form of a curtain design.

Pre-performance gossip about *Le Rendez-vous Manqué* promised something even more up to date. Buffet's designs were graphic and avant-garde; treating the sets like giant canvases, he was still working on them half an hour before the curtain rose, and was photographed by Edward Quinn, the Nadar of the Côte d'Azur, inspecting his work looking sleekly chic in a three-piece suit, a cigarette dangling moodily from his lip. Moreover, there were scenes of simulated sex, said to be so realistic that they needed to be toned down so that Prince Rainier and Princess Grace could attend the premiere in Monte Carlo. All in all, when the ballet opened on 3 January in the small Mediterranean principality, in front of such noted balletomanes as Aristotle Onassis, hopes were understandably high that this meeting of talent would

achieve something of equal if not greater cultural moment than *Le Train Bleu*.

If Picasso had been worried, he need not have been. The kindest that could be said about *Le Rendez-vous Manqué* was said by the *New York Times*, when it observed that 'it barely escaped being a flop'.[9] The French press was less sympathetic. '*Sagan a manqué son rendezvous*,' announced one paper with malicious glee.

However, in the new world of youthful celebrity, mediocrity was no barrier to success, and when the ballet transferred to the French capital, le Tout-Paris turned out to see if it was really as bad as they had heard. Gossip columnists and the sort of photographers who had yet to be called paparazzi outnumbered the serious critics, and when reports of the evening appeared, 'more papers . . . carried pictures of Mlle Brigitte Bardot', who was among the first night crowd, 'escorted by M Jean Marais than of the ballet itself'.[10]

It was perhaps because of its social significance that 'reviews of this ballet in Paris have been even more vicious on the whole than they were three weeks ago'. It was left to *Le Figaro* to point out that

> One can pardon Mlle Sagan and M Buffet at a pinch; what is quite unforgivable is their enormous commercial success. And indeed, it cannot be denied that both they and the metteur-en-scéne, Roger Vadim, have the Midas Touch (it was M Vadim who, it will be recalled, discovered in Mlle Bardot what bids fair to be a prolific Golden Goose even by transatlantic standards). The whole operation was perhaps too neatly timed to coincide with M Buffet's retrospective exhibition (at the age of 29!) at the Galerie Charpentier for the critics to take kindly to it.[11]

Today, the impressive early-nineteenth-century *hôtel particulier* at 76 Rue du Faubourg Saint-Honoré, across the road from the Élysée Palace, is the French headquarters of Sotheby's auction house. But for much of the twentieth century it bore the name of Jean Charpentier, a noted collector who allowed public access to his art collection. In 1924, he had mounted a landmark exhibition devoted to the work of Géricault, and thereafter the venue hosted major exhibitions and was the location of prestigious Parisian auctions.

Its unique character, part *espace culturelle*, part commercial venue, accorded it a singular position in the cultural life of Paris. 'It was at

the level of a public museum today,' explains Pierre Bergé. 'La Galerie Charpentier was very important. At that time there were no museums, there was the Louvre and that was all.' Not quite all, but it is not much of an exaggeration. 'La Galerie Charpentier was a huge consecration,'[12] recalls Bergé of the sensation caused by Buffet's retrospective at the age of twenty-nine. It was not a selling exhibition; the works were lent by collectors and by the artist himself, and visitors paid to see them. It was, in effect, a major museum show.

In the twenty-first century, with a superabundance of museums and a cultural appetite forever hungry for the newest, latest, youngest phenomenon, it is perhaps difficult to appreciate the significance of such an exhibition. In the mid twentieth century, a major retrospective for one so young was an astonishing compliment. It was, said the *New Yorker*, 'something rare in Paris for an artist who is not yet dead. Modigliani had been dead for thirty-eight years before he was given his retrospective (which, by chance, immediately followed Buffet's at the Charpentier); van Gogh had been in his grave twenty years before he had his.'[13]

'The Charpentier show was the most phenomenal exhibition of a young French painter's canvases that Paris had ever seen, either before or after the war.'[14] Although the exhibition was called *100 Pictures of Bernard Buffet*, it comprised rather more than that: 110 oils, and 20 drawings and aquarelles,[15] a body of work that told his life story, taking the visitor on a journey from the 1944 canvas of the Rue Mariotte, where his family had lived at the time of his birth, to a painting of the skyscrapers of Dallas executed after his trip to Texas.

The Galerie Charpentier was now owned by Raymond Nacenta, and there is the suggestion that in mounting an exhibition of Buffet, he was aiming at success through sensation. When asked why he was organising a Buffet exhibition, his answer was simple: 'Because he is the most famous of the young painters, the most talked about and that he is only thirty years old'[16] (well, 29½). Famous, controversial and young, Buffet had the ingredients that made good box office, and if Nacenta had been hoping for a blockbuster, then his hopes were, if anything, exceeded.

The most remarkable thing about the exhibition, however, was neither the youth of the painter nor the nihilistic despondency of an oeuvre that Mauriac described with metaphorical flourish as 'a dead sea that spreads out over a dead world – spiritually dead',[17] but the

scenes of public hysteria that attended its opening. In a few years' time, a quartet of mop-haired popular musicians from the British city of Liverpool would lend the name Beatlemania to this level of collective public excitement, but in January 1958 it was Buffetmania that gripped the citizens of Paris. Much in the way of attendees at a major sporting event, a queue formed well before the doors opened, and those at the front of the lengthening line started 'banging impatiently on the glass doors of the gallery'.[18]

'Half an hour before the four-o'clock afternoon opening of the Charpentier retrospective last Friday, the sidewalk catercorner to the President's Élysée Palace was jammed and the Rue du Faubourg St Honoré traffic was disrupted, and by six a record crowd of seven thousand visitors had pushed their way in and out of the doors.'[19] One newspaper put the number of visitors on that opening day at over 8,000 and reported a 200-metre queue to get in, as well as a monster traffic jam that stretched from the Élysée Palace to the Rue de la Paix[20] (bear in mind that this was Paris in the 1950s, when car ownership was far from universal).

It was international news. 'Five thousand people queue for an hour to get into a Paris show by a young French artist, Bernard Buffet,' carolled the clipped, cut-glass tones of the British Pathé newsreel reporter, who took the opportunity to comment on the rapid appreciation in the price of Buffet's paintings. 'Ten years ago his austere but striking pictures were selling at ten shillings each, but today thirty-year-old Buffet, seen here beside one of his self-portraits, can earn a thousand pounds for a small painting.'[21]

'Atmosphere of a major boxing match at the Bernard Buffet vernissage' ran the headline of an article in which the journalist wrote that beyond 'visits by the Queen of England and the Liberation of Paris, I have rarely seen so many people in one place in our capital than in the Buffet exhibition'.[22] 'Neither Brigitte Bardot, nor Françoise Sagan nor la Callas could have hoped for more.'[23]

Photographs of the exhibition show a vast room packed tight with people, most of them completely unable to see a single painting, so dense were the crowds in front of each work. The entire city was electrified. One reporter guaranteed to his readers that he had overheard a trucker at the wheel of a lorry loaded with five tonnes of coal say to a man on a delivery tricycle, 'I cannot stop now to see the Buffets, but I am going to pass by later on.'[24] As Buffet fever

swept through the city, it seemed that everyone in France had an opinion.

> As at the troubling old Picasso exhibitions, the visitors manifested two sorts of curiosity. That displayed, through open mouth or goggle eyes, by those who had never seen any Buffet paintings before, and that of those – more worldly and partisan – who were apparently eager to discover, beyond cavil this time, with a hundred pictures for evidence, whether they accepted or refused, admired or detested, were angered or moved, as the Charpentier catalogue's preface candidly suggested, by the essence of his talent, and why.[25]

By now, the comparisons with Picasso were so embedded in the public consciousness that the journal *Arts* used inverted commas to highlight the words 'the most talked about artist in France after Picasso'.[26] Inevitably this show offered further opportunity to measure the young Frenchman against the elderly Spaniard. 'It must be remembered that Picasso was barely 25 years old when he overturned canons that had been established since the Renaissance and turned painting all around the world upside down.'[27] Writing his celebrated 'Bloc-Notes' in *L'Express*, though, François Mauriac warned that 'one must not believe the devil', referring to Picasso, while Buffet was 'a young man of today. His universe is ours.' The Nobel laureate also took the opportunity to stoke the ongoing figurative versus abstract debate. 'This wise young man has not brought any bomb. He glues the world of Picasso back together. The world, our world, reassembles itself in this painting; with its pylons that are gallows and the crucified person who was tortured and who will not come back to life.'[28]

Of course Buffet's detractors could and did accuse the young artist of cynical hypocrisy in pursuit of monetary gain, and lambasted him for painting too much, living too well and owning a Rolls-Royce and a pet monkey. But his supporters too were, albeit unintentionally, creating a hostage to fortune. All the noise around Buffet placed him in what the *New Yorker* critic percipiently identified as 'the dangerous position of being almost an official phenomenon'.[29]

It was not so much that Buffet was the official artist of the regime (governments in those days had a habit of changing too quickly for an officially sanctioned art to emerge). But the young painter and his work had become a live issue of the day, along with the war in Algeria,

the mounting risk to the nation's youth posed by imported comic books, the relevance of the Catholic Church to modern life, the atomic threat and other items of public concern that occupied France's rickety Fourth Republic as it creaked towards its collapse later in the year. Officialdom was required to have an opinion, even if that opinion was as platitudinous and anodyne as that of Edmond Sidet, director of the museums of France, who felt it was 'reassuring that in the century of the atom, in the period of the gestation of the Common Market and at the time of an important debate in the National Assembly, Paris, its public and its press, give an exhibition of paintings the conse-cration of a major news event'.[30] In his much longer statement, M Sidet proved himself to be quite an expert when it came to saying a great deal without expressing any point of view more controversial than that Buffet was an artist under thirty years of age who was so produc-tive and varied that he attracted attention and had become a talking point.

Since the artist himself hated discussing the 'meaning' of his work, increasingly lofty and opinionated characters took it upon themselves to explain the disturbing dramas that Buffet committed to canvas. One of the more intriguing of these was a Catholic author, media mogul and journalist called Georges Hourdin. Born in the final year of the nineteenth century, Hourdin would live to celebrate his hundredth birthday in 1999. In 1945, he had relaunched *La Vie Catholique* as a colour magazine that aimed to engage the general reader who was also a believer. *Paris Match* it was not. However, in the post-war periodical boom, it flourished as a sort of *Life* magazine for the prac-tising Catholic, and by the mid 1950s its circulation stood at 600,000.[31] For many Frenchmen, *La Vie Catholique* represented a traditional bulwark against the left-wing and communist press.

At the same time, Hourdin maintained a furious literary output, publishing commentaries on the issues of the day. *Mauriac – Christian Novelist*, *The Catholic Press*, *St Thomas More*, *In Favour of Bourgeois Values*, *Christians Against the Consumer Society*, *Catholics and Socialists* were the titles of a handful of his publications. As well as industrious, he was versatile: in 1978 he penned *The Communist Temptation*, then, just two years later, brought out *Response to the New Right*. Like so many social commentators in the late 1950s, he was obsessed with the cult of youth loosely called the *nouvelle vague*, resulting in his book *Does the Nouvelle Vague Believe in God?* In 1958 he wrote two books on the year's

chief preoccupations: *The Case of Françoise Sagan* and *Everybody Is Talking About – The Heaven and Hell of Bernard Buffet.*

Heaven and Hell was written after his visit to the Charpentier exhibition. 'Money' is the bald title of the first chapter, and Hourdin doesn't waste any time coming to the point.

> The thing that strikes me most in this whole story is the indecent character of the success achieved. The success of Bernard Buffet, in which we have assisted, is not just disproportionate to its object. It has a speculative character. It puts us face to face with the leprosy that is gnawing at and gravely polluting modern painting. Speculation in his work isolates the artist, distorts the creative process, transforms the amateur into an avid speculator, and finally destroys the independence of the critic. That is the first lesson given to us by the all too brilliant Bernard Buffet exhibition, put on by dealers and writers transformed into supporters.[32]

As nationalistic as he was moralistic, Hourdin was in no doubt as to who was to blame for this corruption of French art. Alluding to the global success of Impressionism and the devaluation of the franc, he said: 'The intervention of the foreign public in our market will contribute to the distortion of everything, and I know of young painters regularly sent by their galleries to spend months in the United States to cover canvases with colour because their stay over there costs less than the payment of customs duties. Thus the painter is turned into manufacturer.'[33]

There is a Cassandra-like tone to Hourdin's predictions; predictions that have in time proved uncannily accurate. In the mid twentieth century, the commercialisation – or perhaps monetisation is more accurate – of contemporary art was not the accepted axiom that it has become in the twenty-first century. Back in the late 1950s, it was still enough of a new phenomenon for a crusading moralist such as Hourdin to get his teeth into, and he locked his jaws around the idea like a frenzied terrier. He talks of the client who 'bought Buffet's canvases over the telephone without having seen them or even taken possession of them. He paid by cheque, left them at the gallery with which he was transacting, never saw them and resold them by telephone after they had reached a far higher price.'[34] The result of which, if one takes Hourdin's view, was too much money, too soon, too

young for a man who instead of an authentic relationship with the world had a Rolls-Royce and a castle. 'Money will place itself between the artist and his public, through a screen of dealers and editors. It will distance the painter from those who could really love his work. He risks cutting himself off from his true sources of inspiration,' he says, adding with doom-laden misgiving, 'if he has not already done so.'[35]

As Hourdin saw it, Buffetmania was just another symptom of the *'vedette'* or celebrity syndrome that was beginning to establish itself in all fields of life, and not just painting. 'The crowds of the 20th century want vedettes. They go and look for them where they take their pleasure. They idealise them, magnify them and transform them, but in return they are very exacting of them.'[36] He talks of a champion cyclist and expands on the charm of 'le sex-appeal and round buttocks of Brigitte Bardot',[37] explaining that the day the cyclist no longer pedals as fast as he used to and the day that cinemagoers no longer 'go to see the body of Brigitte Bardot',[38] their pecuniary value will plummet. The mechanics of fame are even more pernicious for painting, says Hourdin, as the picture has been turned from its primary purpose as an instrument of pleasure into a financial one.

His chapter on 'Sexual Inversion' – 'after unhappiness the problem with which he is indissolubly associated'[39] – would probably see him prosecuted in this century for inciting hatred, albeit dressed up in such wonderful terms as 'Promethean concupiscence'.[40] This chapter reveals more about Hourdin's views about homosexuality than Buffet's, but it does air the accusation of misogyny that keeps reappearing vis-à-vis Buffet's depiction of women as ugly, almost male albeit for a couple of anatomical details. But overall the book is hard to dismiss as the maniacal ravings of a religious zealot. While some of his views now seem antiquated – at one point he says that Buffet's landscapes and flower paintings 'lead our thoughts to God, the creator of everything'[41] – at other times he argues persuasively, writes well, acknowledges Buffet's technical strengths (especially as an engraver), and proves himself to be a sensitive critic of the work.

If for intellectuals Buffet was an issue to be debated, and for official figures a topical controversy upon which one had to be briefed and around which one had to navigate, then for society hostesses, ageing *salonistes* and social lion-hunters of 1950s Paris he was a glittering new trophy, a prize example of that desirable species, *les moins de trente ans*.

As the crowds left the crepuscular chill of that January afternoon in Paris and surged through the doors of the Galerie Charpentier, like waves of bargain hunters on the opening day of the sales, Buffet was hiding on the first floor in the director's office, 'protected like a boxer before the fight from photographers, autograph hunters, amateurs of art or sport and female admirers'.[42]

As he made his way down to the gallery, blinking at the blinding explosions of photographers' flashbulbs that illuminated his descent, the enigmatic half-grin behind which he had hidden for most of his life was firmly in place. Part of him must have been terrified. But he would not have been human had he not also experienced a frisson of pleasure, a premonition that he was walking into a glorious future; that this was what it was going to be like from now on.

With lover at his side, the gallery director Raymond Nacenta and his associate the Marquis de Masclary in front, and two security guards clearing a path for him, he walked among his public. He was trailed by his inner coven, a group of influential women in late middle age, which by now included his old Dallas chum Louise de Vilmorin, who had developed a decided taste for his flower and fish paintings; French *Vogue* editor Edmonde Charles-Roux; the pearl-bedecked Marie-Louise Bousquet, editor of the French edition of *Harper's Bazaar*; and Héléne Lazareff, co-founder of *Elle* and wife of *France Soir* editor Pierre Lazareff. His progress across the room was described by one observer as being like that of an icebreaker cleaving through Arctic floes.

Buffet was besieged. Although well used to crowds, it was only with the utmost difficulty that actor and singer Maurice Chevalier managed to work his way to the front of the crush to see the painter. Everybody wanted a bit of Buffet magic that night. He was besieged by autograph-hunters eager for him to sign any scrap of paper; he even obligingly signed a proffered Métro ticket.[43] For every successful supplicant who made it into the painter's presence, dozens were beaten back by the crowds; among them towering literary figures including André Maurois, Roland Dorgelés, Pierre Daninos, Julien Green and Maurice Druon. When he could stand it no more, Buffet would slip out of a back door for air under the protection of the two burly bodyguards, before returning to the scene of his apotheosis to receive more adulation.

But long-term champions of his work looked on in concern. 'Now, Buffet is the anti-Picasso par excellence,' wrote Descargues, who still

believed in the artist and his work. 'He has emerged as the painter who has reacted most violently against the pictural trend of his times.'[44] But he noted that the Charpentier show had subtly changed things. Taken together with the sets for Sagan's ballet, and the announcement that a film would be made showing him at work, Descargues detected the beginnings of Buffet fatigue. He mused that as the artist's popularity with the wider public grew, so his standing with the art world declined. Moreover, Descargues' disdain for, or perhaps frustration with, Buffet the socialite had started to become quite palpable. 'There was no advertising campaign that was not undertaken without him, no cinematic jury at Cannes on which it was not proposed that he serve and no haute couture show where his presence was not desired.'[45]

And later on that opening night at the Galerie Charpentier, Buffet's social star would rise even higher in the Paris firmament. After the hordes had left, a gala candlelit dinner was held in front of the paintings, attended by among others Edmond Sidet, who in this age of the atom and the gestation of the Common Market had been so reassured by the excitement around the exhibition; the president of the Assemblée Nationale, who had been able to drag himself away from that momentous debate; the Canadian ambassador; the Princess of Liechtenstein; and sundry dukes, duchesses and other representatives of *le haut ton*. They did wait for Françoise Sagan, but when by ten she had not arrived (perhaps her sports car had got caught up in the traffic chaos and she had decided to spend the evening at home with a bottle of whisky or a syringe of morphine), the assembled dignitaries sat down to eat, drink and lionise the guest of honour.

It was a splendid sight, the candlelight imparting a warm glow to the varnished canvases and glinting as it caught the silver. As the elegant crowd ate and drank, the room was filled with the decorous sounds of the good life: the chuckle of wine being poured, the susurrus of polite conversation, the occasional laughter at a well-timed bon mot. It would be fascinating to know if at any time during that evening, behind the shy half-smile and the non-committal conversation of *'oui'*, *'non'* and *'peut-être'*, Buffet was aware of the Faustian bargain he had just struck, or perhaps more accurately, that had been struck on his behalf.

It was often said by his supporters that Buffet would have painted with the same ferocity and fecundity even if his paintings had not sold for millions of francs – even if they had not sold at all. We can

be sure that when Buffet himself said this, he believed it to be the case, and it may even have been true that he would have been happy to paint in penurious obscurity, an unbalanced, unrecognised genius like Van Gogh before him. However, whether sincere or not, it was disingenuous or at best utterly irrelevant. He had tasted success and, like the exquisite dinners prepared by his personal chef after a day in the studio, he found it agreed with him. He may not have actively chosen to become rich and famous, but riches and fame had been heaped upon him, and it had become very difficult to disentangle the work from the phenomenon.

In later years Maurice Garnier would argue that Buffet's work could and should be appreciated without reference to the life of the man, and maybe a man of Garnier's remarkable intellectual strength was able to set aside the chaff of trivial trappings from the wheat of the work. However, Garnier was unique, and in practice, as early as the year of his circus show and the Rolls-Royce revelation, discussion and appraisal of Buffet's oeuvre without tacit or explicit reference to his immense commercial success and mass-media popularity had become increasingly difficult. Now, after Charpentier, it would become impossible.

While he might have been able to slip out of the back door of the Galerie Charpentier for a breath of fresh air or a crafty Gitane during his retrospective, from now on his life would have no back door through which he could escape. 'Buffet had now come to represent *une valeur française* in the eyes of the world and in the eyes of the Fourth Republic, sensitive to any emanations of French glory.'[46] The year 1958 would be a momentous one for France as well as for Bernard Buffet – and it was still only January.

Chapter 17

Number 6 Avenue Matignon

Just because he was painting the sets for a major ballet, appearing in a film about his life and having a hugely successful retrospective of his work, it did not follow that Buffet would neglect his annual commitment to his dealers, his collectors, and now his public. February in Paris would not be February in Paris without a Buffet show, and accordingly the second month of 1958 saw a spectacular exhibition around the theme of Joan of Arc.

To see these paintings in the second decade of the current century, impeccably preserved in storage in a purpose-built facility on Paris's *périphérique*, is to see them much as they must have looked to those who first viewed them almost sixty years before, and to experience the same surprise. To those who complained that Buffet could not do colour, this was his answer: tangerine, gold, primrose, carmine and green of a shade between lettuce, lime and Lamborghini. The pigments pop and fizz with a sherbet sharpness. They are extraordinary works.

A winged skeleton vouchsafing shepherdess Joan a blazing vision of a gilded suit of armour with flames that explode in the place of a head is the overture for an eventful narrative of bishops, courtiers, royalty, bowmen, mounted knights, vaulted halls, dank dungeons and of course the burning at the stake, as Buffet presents the pageantry and brutality of medieval France in the age of chivalry. They are immense pictures; the Siege of Orléans unfolds over a canvas five metres long.

Here we see Buffet making good on Descargues' promise of the coming of the anti-Picasso. He is doing nothing less than attempting to revive, single-handedly, the neglected genre of history painting. A century earlier, large-format history painting had been – second perhaps to the painting of frescoes – one of the most highly regarded expressions of artistic genius. All the gravitas that had once attended large-scale religious works had appended itself to heroic depictions

of stirring events; these were the semi-propagandist paintings that had held the young Buffet rapt Sunday after Sunday as he was taken by his mother to the Louvre. However, the permanence of history that these paintings proclaimed was in fact a mirage, evaporating in a generation as the Impressionists and their successors rejected the self-consciously noble subjects and forensic levels of 'finish' in favour of loosely painted vigorous snapshots of pretty women, carousing bohemians, sun-dappled gardens and so on; capturing on canvas the evanescent sensual pleasures of daily existence that distract the living from contemplation of lofty ideals (and their own mortality).

The Impressionists also ushered in an era of smaller canvases that were more commercial. It was not that there had not been small works of art before, but to walk along the top floor of the Musée d'Orsay through the enfilade of rooms that houses the breathtaking riches of the Impressionist movement is to see works that are on the whole as domestic in scale as they are in the subject matter they treat. Thanks to their dimensions and their gaiety they became (once the initial resistance facing any new cultural movement had been overcome) readily saleable works, sized to fit the drawing rooms of Haussmann's Paris.

By contrast, looking at Buffet's paintings of the Maid of Orleans it is impossible not to be struck by the irony of the accusation that he was solely a commercial painter. Unlike the themes of the preceding two years – the phenomenally successful circus paintings of 1956 and the following year's eerily empty depictions of Parisian landmarks familiar from innumerable postcards, which had nonetheless moved Cocteau to observe that leaving the exhibition at nightfall, 'I saw the town with Bernard's eyes'[1] – these monster paintings, each covering dozens of square feet of canvas, can hardly be considered, even by the most elastic stretch of the imagination, market-driven works.

In scale and painterly ambition they compared to and arguably eclipsed his three paintings about the horrors of war. While Buffet's 'Guernica' triptych had been confident, his seven Brobdingnagian canvases of Jeanne d'Arc were the assured work of an established painter who could afford not to care what the critics thought and the collectors bought.

Horreur de la Guerre had a medieval intensity about it, but by depicting the human subjects in the nude, he rendered their suffering and cruelty intemporal, universal. The tragic piles of corpses recalled

the Nazi death camps, and yet the nudity made them eternally relevant; in the second half of the 1950s, concern about France's war against Algerian separatists and reports of mounting torture and atrocities would have enabled these paintings to be viewed as a commentary on the inhumanity of a mid-century colonial war. Fast-forward six decades to the orange jumpsuits, black flags and masked executioners of the Islamic State, and the images of sword-severed heads and decapitations suddenly seem uncannily clairvoyant. In all likelihood this particular refinement in cruelty was inspired by a photograph that Buffet had seen in Lurs, a few kilometres up the Durance valley from Manosque, in sunny Provence. It was a snapshot that had been taken at the time of the liberation and showed a group of typical Provençal country folk posing cheerfully for the camera with the severed head of a man at their feet. Unsurprisingly, 'this image haunted Buffet's nightmares for a long time'.[2]

However, by dressing his subjects in period clothes, Buffet was being didactic, almost prescriptive in what he wanted the viewer to think; by placing these pictures unequivocally five centuries in the past, he reduces quite drastically the scope for imaginative interpretation on the part of the viewer. Demonstrating the autodidact's unslakeable thirst for knowledge, he considered historical verisimilitude of cardinal importance when tackling a subject so familiar and so central to the French sense of identity. He researched the pictures exhaustively and sought advice on the tiniest detail, from experts including Lucien Henry, a noted antiquarian known to his intimates as Lulu. Speaking of the preparatory work that he undertook, Buffet said that he 'made numerous sketches at Chantilly', the chateau close to Paris famous for its library of medieval documents, 'and spent many hours in front of its illuminations. Lulu told me that the archbishop of Reims wore his ring on his middle finger, and that for the rhythm of the picture, half the bishops had to hold their croziers in the right hand and the others in their left hand. I leave nothing to chance.'[3]

Instead of conveying a meaning or a message he is narrating a story in flawlessly composed, densely realised panels. It is this sense of a series of lavish storyboards that has led to some critics dismissing the paintings as having too much of the *bande dessinée* or comic book about them; calling it an arid exercise in empty technique. That, however, could be just the point, in that these seven paintings fuse the high and low culture with which Buffet was conversant. His

knowledge of art history is on parade here, as is his love of comic books, of which he was an eager devourer. Along with thrillers, reading comics was one of his preferred methods of relaxation; he had a marked fondness for Mickey Mouse and Tintin.

It is only when viewed in the context of the art of the decade to come that Pierre Descargues' comment 'it is without doubt the most risky exhibition and the most scandalous as well that Buffet has ever yet done'[4] can be fully understood. Currents in art sometimes defy analysis; the independent development in different parts of the world of similar styles and movements is a frequently remarked phenomenon. Buffet painted his Joan of Arc series in 1957, the same year that saw the opening of Leo Castelli's eponymous art gallery on New York's Upper East Side.

Amidst the same sort of appalling weather conditions that had accompanied Buffet's debut show a decade earlier, a new chapter in the history of art was begun. On 3 February 1957, 'as piles of filthy snow still clogged the streets, the visitors to the first Castelli opening endured the lesser ordeal of the tiny and rickety elevator creaking its way to the top floor in the classic white four-story townhouse on the corner of Fifth Avenue at Seventy-seventh', tantalisingly close to the Carlyle Hotel on East 76th and Madison Avenue, where Buffet stayed on his return from Dallas to Paris that autumn. 'The gallerist's project became evident as of the entrance door: a dialogue between Pollock and Delaunay – a confrontation between one of the most magnificent drip paintings of the 1950s and a truncated Eiffel Tower.'[5]

The following year the Leo Castelli Gallery gave a young Jasper Johns his first show; within a decade the gallery was established as one of the holy sites of the Pop Art movement, showing among others Robert Rauschenberg, Andy Warhol and Roy Lichtenstein. One day it would be interesting to see Buffet's Joan of Arc series exhibited alongside Lichtenstein's famous fighter jet painting *Whaam!* or his *Drowning Girl*, both painted in 1963, five years after Buffet's seven monumental canvases went on show in Paris.

Like the history paintings of the past, or indeed a site-specific installation of the current century, the Joan of Arc canvases were not intended to be sold, but to fit an interior. The difference was that in February 1958, the works were not to hang on the familiar tiled walls of the large, echoing '*piscine*', the Galerie Drouant-David on the Rue

du Faubourg Saint-Honoré. Instead they were destined for the sober hush of the beige-curtained walls of number 6 Avenue Matignon. Moreover, it was not just a change of location; the name on the invitation had changed too, as for the second year running, guests were summoned to a *vernissage* at the newly opened Galerie David et Garnier. Today this venue remains exactly as it was during the painter's lifetime: the pleated curtain, the sleek ascetic modernist furnishings by Jacques Adnet, the dignified but courteous atmosphere.

The last decade had made David and Drouant rich, but if anything it seems the latter's aversion to Buffet's work had strengthened; most likely he envied the younger man's almost instantaneous success. The antipathy was equally cordial on Buffet's side. He had never liked Drouant. Now it occurred to him, or his lover, that the relationship between gallery and artist had changed. In the late 1950s, as 'the most talked about artist in France after Picasso', the 'man with the golden arm' and 'the young man who printed banknotes with his paintbrush', Buffet was able to sell more paintings than even he was able to produce. He began to ask himself if he needed Drouant and David, or whether they needed him. David later recalled:

> This ascent to the zenith of fame left the painters of the same generation far behind, so much so that one fine day, our prize-winner not out of pride – that was not one of his shortcomings – but because of his certainty that he was an exceptional artist, became rebellious . . . [He] announced to me without warning 'I do not want to stay with the Galerie Drouant-David any more. Either you leave with me or you stay. Choose. Drouant or me.'
>
> What could I do other than follow my spiritual son to whom for years I had devoted almost all my time? This decision was not taken without regrets. Bringing to an end fourteen years of life shared with a colleague – who, faults set aside, had behaved like a friend.
>
> To upset a colleague, to leave artists that I had helped, believe you me these things are not done lightheartedly.[6]

And so, with a heavy heart, he followed the money round the corner to the Avenue Matignon.

While David recalls being given his ultimatum by Buffet one morning in 1955, Maurice Garnier would remember a meeting at Buffet's country house outside Paris in 1956.

Bernard Buffet and Pierre Bergé called a meeting. At the time they were living near Paris in the house they had bought at D'Aumont. They asked that Emmanuel David and I merge our galleries and that David leave the Galerie Drouant-David and that I leave the Galerie Visconti to create a gallery together. They said to Emmanuel David, 'We very much like working with you but we no longer wish to have any financial dealings with you; we would like those to be handled by Maurice Garnier.'

They had confidence in me, because our agreement was very special. With no other painter did I experience the same confidence that Bernard Buffet showed me. He gave us the pictures and then let us do what we wanted. We sold them at the price we wanted, how we wanted, and we agreed that we would give him half the sum we received when we sold a picture. We did not buy from him; we took the pictures on consignment, we sold them and we gave him half the sales price. No other painter would have accepted that, not one.[7]

As far as Buffet saw it, David and Garnier formed a dream team. He could be sure that both dealers believed in him wholeheartedly. In the latter he had found a scrupulously fair, pathologically honest man; if Garnier says that no other painter would have shown the same confidence in him, then it could be argued that no dealer better merited that confidence. This new commercial arrangement would mark the beginning of a remarkable relationship between dealer and artist that is most likely unique in the history of art. Garnier would become not so much Buffet's dealer as chief hierophant of the cult of Buffet, managing every aspect of his business affairs and settling everything from his restaurant bills to his house purchases. Invoices great and small would be sent on to the gallery to be dealt with by Garnier.

Bernard sent us the pictures but he did not keep track of what he sent: he knew neither the number of pictures, nor which ones. After that, I paid his expenses, I did not pay him. When he came to the gallery I would go to the bank to get cash to give him so that he had some spending money. But other than that I paid everything for him. When he was in Saint-Tropez, I even received bills from the grocer, from restaurants on the beach, I received the bills for everything he bought in Saint-Tropez. Even in Paris, when they were going shopping, I would

get a call to say 'Monsieur has bought so much, could you . . .' It was marvellous. He had total confidence.[8]

There was one shortcoming, however, to which Garnier freely admitted. 'I never knew how to sell pictures. A client needs to buy a picture, I do not know how to sell him one.' But while he may not have known how to sell a painting, he knew a man who did. 'Emmanuel David . . . he was a salesman without equal,' he recalls with a fond smile. 'He was absolutely marvellous. Jovial, a *bon vivant*, and an excellent salesman. Ah, he could sell. He knew how to sell pictures.' And if there was one thing that recommended David even more highly to Garnier than his phenomenal salesmanship, it was that 'he did a great deal for Bernard Buffet'.[9]

A collaboration with France's leading literary *enfant terrible*; a stage design that was touring the world; a major retrospective that was the talk of everyone from lorry drivers to members of the Assemblée Nationale; a series of unsaleable Pop Art historical canvases that signalled to his staunchest supporters a return to form at a gallery with a new business structure devised entirely to his specifications; plus a hectic round of social engagements. It had been a busy start to the year and it was time to head to the country to relax. However, it was not to Manines, outside Paris, to which he and Bergé would retire, but to the south and the new, even grander home that Buffet had acquired.

Manines doubtless brought back unhappy memories of the embarrassing coverage in *Paris Match* that had photographed Buffet in most rooms and many parts of the grounds; added to this there were poignant reminders of the rooms in which Pepito, the now deceased pet monkey, had been wont to scamper. All in all it had not been a happy home, and after a few windswept months on the Breton coast in what the magazines called a villa but which looked more like a solidly built, well-proportioned cottage, the couple moved to Provence, to a 'chateau almost in ruins when he bought it, and which sixty workmen rebuilt in six months'.[10]

Chapter 18

An Artist's Home is his Castle

If the popular press and colour magazines had exaggerated the opulence of *la vie Buffet* hitherto, when he acquired the Louis XIII Château l'Arc, they no longer needed to. In its famous article about his Rolls-Royce, *Paris Match* had only been able to mention Buffet's sandcastles. Now the magazine would become a frequent visitor to his real castle. Located on a 200-acre estate (some contemporary reports put it at as much as 800 hectares) in wine country between Aix and Marseilles, with Cézanne's Montagne Sainte-Victoire as a backdrop, the property dated back to the eleventh century, first as the site of a Benedictine monastery and from the fourteenth century as a chateau. Today, in common with other houses Buffet would later inhabit, the Château l'Arc is an hotel.

Although not as grand as the chateaux of the Loire, Buffet's new home was most definitely a castle. With a stout tower at each corner and metre-thick walls, it was of the kind to be found in legends, historical novels, fairy tales and films such as his friend Jean Cocteau's *La Belle et la Bête*. It was the sort of castle a child would draw, or for that matter build on the beach. It is easy to imagine the two young men coming across this romantic half-ruin: their bright eyes, their excited smiles, the optimism for their shared future behind those time-weathered stones, and the sheer exhilaration of knowing that, although neither of them was yet thirty, they could realise a childhood dream.

Buffet's life had offered him many exciting contrasts to his straitened upbringing, and it had become a journalistic ritual, when discussing him, to compare the luxurious lifestyle he enjoyed as an adult with the miserable circumstances of his childhood. He lived at an interesting time for the arts and for the status of artists in society. As well as being an artist, he was also a representative of *les moins de trente ans*, the most extreme example of the economic empowerment of a

commercial demographic that had not existed before. At the same time, the Western world was enjoying a sustained commercial boom that would last a generation. Oil was cheap, employment was high, and for the first time the young were emerging as an economic force.

At the time, the tools for manufacturing modern celebrities were only just becoming available: television, high-circulation colour magazines, the increasing popularity of cinema and the birth of something rather alarming called pop music. Even if he was approaching his thirtieth birthday when he recorded 'Rock Around the Clock' in 1954 – and to modern eyes, in his bow tie and vigorously checked shawl-collared dinner jacket, he looks like a middle-aged entertainer at a holiday camp – Bill Haley was a phenomenon. Although not the first rock-and-roll record, it was the first to enter mainstream consciousness, and it was accompanied by tales of riots, the ripping-out of seats in cinemas where the tune was heard, and other examples of delinquency. If only Georges Hourdin had been able to get to work on Haley . . .

There were film stars. There were beginning to be rock stars. But would there be art stars?

It was a question that occupied some of the best minds in France. According to Buffet's staunch friend and loyal supporter Maurice Druon of the Académie Française:

> Each period has its own standards in the matter of success. At certain times in the history of the world the fame of the philosophers or the tragic poet provided the measure of renown, and no actor, however applauded, would have dreamed of attracting the universal attention Euripides and Plato enjoyed. Today the yardstick of celebrity is that of the film-star.
>
> One should be neither surprised nor shocked. Human beings need to admire themselves vicariously in some supreme image; and we have no, or scarcely any, princes to incarnate our institutions; the religions, at least in the West, are becalmed, the generals no longer dare to glory in the blood they have spilt; the poets speak so low and for such a small audience that they might almost have disappeared from the planet; and the scientist's hour has not yet struck. In these circumstances, it is natural that pre-eminence in success should fall to the men and women whose function it is to lend their persons to the fugitive representation of myths. Dreams fill the gap.

All celebrity today is therefore gauged by that of film-actors, regulated by the same processes, bound by the same servitudes; a man who exercises an activity other than that of film-actor is not considered famous today unless he himself becomes a star, unless his picture from time to time claims the front page of the newspapers from those of the film-stars, unless his journeys are escorted by cameras and microphones, a legend is created about his personality, and popular curiosity aroused by his work, unless in fact his life resembles a film story.

And since money exercises a magic appeal to the contemporary imagination, it is necessary also that the income he derives from his work should equal the emoluments of the cinema.[1]

Apropos of Buffet, it could most certainly be argued that he was living the dream. There is the slightly unreal sense that he was starring in his own biopic; and his presence on the jury of the 1958 Cannes Film Festival further blurred the lines as to exactly what sort of stardom he embodied. Could an artist be a star? And should an artist live the materialist dream with such flamboyance and quite so much obvious enjoyment?

Certainly by the next century the answer to both questions was indubitably 'yes'. The idea of a rich artist is as axiomatic in the early twenty-first century as the stereotype of the starving Montmartre bohemian was in the early twentieth.

The odd thing, as many who know Koons . . . will say, is that money doesn't interest him. He has three very personal luxuries: his home in New York City, the farm, and his collection of older art, which includes Magrittes, Courbets, and Manets. The farm, now expanded from 40 acres to approximately 800, is almost a Koonsian artwork. The buildings are painted in heritage red, yellow, and white in the full-on tradition of the area. In the main house, historic wallpapers, the patterns shifting from room to room, give the feeling of a kaleidoscope. But this farm is very much a private retreat for the family.[2]

So wrote *Vanity Fair* in the summer of 2014 about Jeff Koons, breezily dismissing a portfolio of real estate and museum-quality art (notice the plurals) worth perhaps hundreds of millions. (In this piece Koons says that he is keeping fit so that he can work into old age like Picasso.) It should be remembered that the very same line about

money not interesting him was spoken by Buffet supporters. It is of course easier not to care about money when you have a great deal of it.

A few weeks later in 2014 it was noted on the other side of the Atlantic that Damien Hirst, another one of those fifty-something *enfants terribles* of the art world, had spent an estimated £34 million on a fourteen-bedroom Regency house in London designed by John Nash. Hirst's ever-expanding property portfolio has become almost as much of a cherished aspect of his reputation as the pickled shark. According to the *Daily Mail*:

> Hirst, who has a £215 million fortune, already has an extensive property portfolio but the latest acquisition confirms his position as the world's most financially successful artist. His main residence is a 300-year-old farmhouse in Combe Martin, North Devon, set in 24 acres, but he has also owned a house in Thailand and a beach home in Mexico. Until now, one of his most spectacular purchases had been Toddington Manor, a magnificent 19th century Grade I listed 300-room country pile in Gloucestershire.[3]

It was also announced during 2014 that Hirst was becoming a property developer, becoming involved in a project to build 750 houses near Ilfracombe. These details are recounted almost as unremarkable facts; the exaggerated spending habits of another tycoon, who just happens to have amassed his money by making art rather than, say, manipulating the stock market, harnessing the power of the internet, or extracting natural resources from beneath the soil of one or other of the former satrap states of the USSR.

Things were rather different in Buffet's time. For his detractors, the manner in which he flaunted his money substantiated their accusations of hypocrisy. Academic Kenneth Cornell wrote in 1957 that

> The Buffet enigma has become more complicated with the years. His change of residence to southern France, his purchase of a farm near Manosque, and, even worse, the acquisition of a luxurious car, have established a mythic evolution from half-starved painter to man of property. Photographers have established visual proof that the new Buffet looks neither haunted nor underfed. But critics appear somewhat perplexed that this young man, whose income is reported to be about

$20,000 a year, should not reveal affluence and success in his works. One does not encounter overt accusations of insincerity, but astonishment and hostility are the order of the day.[4]

And as time passed and Buffet's lifestyle appeared to become ever more sumptuous, his supporters found themselves increasingly defensive on the subject. Maurice Druon fell back on the not entirely successful argument that Buffet had adopted himself in his open letter to those who critised him in 1956.

Faced with these signs of wealth, the journalists appear to be so overcome that they can see nothing more; their surprise is due to ignorance. Buffet's car cost the price of one of his large canvases, no more. Throughout history, famous painters have been magnificently paid. What Van Dyck earned in a year, and even lesser masters such as Pourbus or Maratta, what Philippe de Champaigne earned, translated into modern currency, might also make the crowd gasp. In fact, what is astonishing and unusual, and therefore insolent in the view of many, is the way Buffet has of spending what he earns so overtly in a period when wealth seems to be embarrassed and ashamed, and conceals its outward signs. But why should the artist share his shame when he is his own capital?[5]

With Château l'Arc, Buffet can hardly be accused of shame, embarrassment or concealment of the outward signs of wealth. He was to remain a nomad all his life, and he would later explain this restlessness as the result of a reluctance to travel abroad. 'We move house often, because we travel little. Moving house is our way of travelling.'[6] As soon as he could afford to, he lived luxuriously, but it could be argued that the contrast with his beginnings was never quite so marked as at the Château l'Arc, heightened as it was by Buffet's youth. According to Maurice Garnier, the Château l'Arc was bought in 1956 for 280,000 francs. Only a decade earlier, aged eighteen, he had been a student living and painting in a small cramped bedroom and had just exhibited his first painting, a self-portrait, at Le Salon des Moins de Trente Ans. Now he was buying his first proper castle. 'The chateau in Provence has become part of the Buffet legend, like the millionaire's car.'[7]

Of course the real expenditure began once the tumbledown chateau had passed from its aristocratic to its artistic owner. Perhaps

remembering his portrait of the emaciated youth in the spartan lavatory, Buffet set about installing proper plumbing and central heating, but in such a way as not to disturb a decorative style perhaps best described as monastic deluxe. Cocteau was one of the first guests, and used typically floral language to describe it, calling it a 'castle of sadness on which 70 [the figure varies depending on who is telling the story] toiled to make it habitable and suitable to receive us. We are the first guests. Picasso is the tramp in splendour' – in 1958 the Malaga-born painter would buy the Château de Vauvenargues, on the other side of the Mont Sainte-Victoire – 'Buffet is the millionaire amidst poverty. The more that Bernard organises and perfects, paints, adds linen cupboards and bathrooms, the more the spaces "resemble" him, becoming emaciated and shoeless, taking on the air of a tormented soul that he has, this air of the scaffold or the gallows, the victim and executioner looking alike.'[8]

Cocteau hardly summons up the image of luxurious weekends in the country. His account of being served dinner in a vast, echoing refectory smacks more of Gothic melodrama than a sunny summer break in Provence. Nevertheless, in his poetic and anthropomorphically metaphorical way, he comes close to expressing a deep truth about Bernard Buffet. No matter how rich he would become, and how many castles he could buy or how many luxury cars he could afford, a part of him would forever remain the shy, pale child of Blanche Buffet and wartime Paris. Years after the end of the war, Buffet would still be astonished by the simple fact of being able to enter a shop and purchase whatever he wanted. Yes, the mean twisted spoons and forks of the Rue des Batignolles had been replaced by excellent silver that had once been laid at the table of a baronial house, but Buffet's eyes remained capable of stripping them of their magnificence and seeing them as painful X-rays of themselves.

It may be placing too much emphasis on his acquisitiveness, but it seems that no matter how luxurious and comfortable Buffet's life would become, it would always be haunted by the hovering spectre that it could all be taken away. This is perhaps the most satisfactory answer to those who questioned how he could paint misery when he lived amidst so much bounty. The experiences of youth had made far too deep an impact for them ever to be erased. Writing of him at the beginning of the following century, shortly after his death, Pierre Descargues observed, 'There remained in him throughout his life,

despite the worldly distractions that amused him, something of the angry boy he had been.'⁹

Certainly his friend Maurice Druon picked up a defensive side to Buffet's taste in interior design, and was also sensitive to the similarity between house and owner that Cocteau described.

His tumultuous leisure is spent in huge, high rooms, hung with damask, in which he accumulates Renaissance cabinets, Gothic cupboards, wooden saints, stone popes, stuffed animals, modern vases, and all kinds of strange objects, provided they are of giant size. If he collects eggs, they are ostrich eggs. It might be Ali Baba's cave, but for a single robber who amasses the unusual from all over the world, the curious, the abnormal, the astonishing, the rare and the exceptional, everything that by its uniqueness or excessiveness refuses to conform to the common measure. The decor in which Buffet lives resembles Buffet. On the walls of the reception rooms and bedrooms there is not a picture that is not by him. Other people's pictures would probably 'disturb' him. His work is all about him, like a rampart.¹⁰

The chateau gave Buffet the chance to hang some of his major work. Perhaps unsurprisingly, given its subject matter, not to mention its huge size, the angel of war painting had failed to find a buyer and hung sombrely in the salon of the chateau, occupying one entire wall. Equally arresting, but for a different reason, was the large nude of Pierre Bergé that greeted visitors as they entered the chateau. This was clearly a portrait that meant much to Buffet; there is a photograph of him baring his teeth in a broad grin (rare enough), his outstretched hand demurely covering Bergé's genitals. The idealised, almost Arno Breker-type depiction of the young, good-looking, muscular, trim-waisted, smooth-skinned Bergé could not be in greater contrast to the flabby women with their masculine features and pendulous with-ered breasts.

The chateau also provided Buffet with an almost factory-like space in which to work, albeit a factory unlike Warhol's in that he consti-tuted the entire workforce as much as its director. His industrial methods of production had become even more impressive. 'If Buffet is preparing thirty pictures for an exhibition, thirty landscapes of Venice for instance, he will sometimes work during one session of eight to twelve hours, on all thirty in succession, adding that reflection

of dark water he discovered for the first, or that line separating the architecture from the sky, to each in turn.'[11] Illuminated by a row of small windows tucked under the eaves, the rooms of the top floor were used as studios, with one visitor noting that in some rooms 'he dries his large unframed paintings on the floor, where they lie like canvas carpeting'.[12] However, his primary studio was a vast room at the back of the chateau that gloried in disorder. Photographs of this space sometimes show a tiled floor entirely invisible, ankle deep in what look like alluvial deposits of paint-stiffened rags, balled-up paper, discarded canvas, bits of cardboard, plates, cups, bottles, and piles of cigarette ends spilling from ashtrays. Emerging from this sea of detritus are paint-smeared chairs, ladders, tables, and even a distressed belle époque sofa daubed with the warning in uneven capital letters 'Attention Peinture'.

It was a warning that guests did well to take seriously. The primary purpose of the house was as a machine for painting. 'House, people, objects must be adapted to his current needs and conform to the rhythm of the work in progress. Everything obeys . . .'[13] said one person who would know him intimately. 'When Buffet has guests at the chateau, everyone eats at the hours established by his working rhythm,' recalled a visitor to Château l'Arc in the late 1950s.

> Lunch is at around 3 p.m. If he goes to his studio afterward, sandwiches or hard-boiled eggs and a bottle of red wine are sent there for him in the early evening, when the guests are having their tea. At ten or eleven o'clock, he bathes and dresses for what is left of his peculiarly allocated twenty-four hours, usually wearing a bright wool shirt, to make sure he will be warm.[14]

What is truly astonishing is that with everything geared around this way of working, he contemplated a change of style. Pierre recalls how during the month in which Cocteau came as their first guest, 'He tried to paint differently, to tackle colour and change his technique. It was in July 1957. He did around ten such canvases, showed them to me and destroyed them. We never spoke of them again.'[15]

Buffet was in the habit of destroying work that he did not deem any good. There is for instance a film shot towards the end of his life that shows him draw a Napoleonic-era soldier in charcoal, only to erase it with his sleeve in dissatisfaction. However, it may be that he

did not see those ten paintings as an attempt at a new direction at all. Interviewed in the early 1990s, he was asked the question 'You have not deviated a great deal over the years from this style. Have you ever been tempted to try something else?'

The answer he gave was categorical. 'I cannot change. It is like handwriting. It is the way I think. It is the way I paint, and that is that. Being an artist for me is like being a tree. New branches appear, but it is the same tree. But, I think I have changed over time. There are lots of differences. More colour, less colour . . .'[16]

'It's absolutely true,' says Bergé, recalling the summer that saw those ten failed paintings. 'They were very bad, very bad.' However, when asked to describe them, he is unable to. 'It happened a long time ago. What I do know is that they were bad and that he completely destroyed them . . . they were completely figurative . . . they were landscapes.'[17]

In a book of memoirs, *Les Jours S'en Vont Je Demeure*, in which Bergé mentions these ten attempts at a new way of painting, he is noticeably harsh about his quondam lover. Of his early nude self-portraits, he says they 'were a way of confessing his masochism'. However, after

> that universe ceased to be his, he continued to paint it and, tirelessly, to repeat it. He was wrong. He said the great painters, Rembrandt for example, always did the same thing. He confused the subject and the painting. In his youth he had found that which would serve him all his life. Around him painting changed, followed new paths: he took no notice. He reassured the collectors who were out of their depth when faced with abstract art and who were happy to find a world that they understood in his work. The breakdown in communication/ misunderstanding was considerable: he was loved by those he despised who hung his canvases next to bad Vlaminck. Did he realise this? His name was to be found in fashion magazines, in Society gossip columns, less and less in the arts pages. He had become famous. He was recognised in the street, he was photographed just like a film star.[18]

There are a couple of sentences of perfunctory hand-wringing. 'I had been complicit, probably guilty. I believed so much in his genius,'[19] he says. It is hardly much of an admission; more perhaps a plea for mitigation, almost suggesting that he been taken in or duped.

The passage of the years is usually agreed to mellow opinions, but when it comes to Pierre Bergé's opinion of Bernard Buffet, time has had the opposite effect. It would be interesting to know what the young and beautiful Bergé, painted so exquisitely, dare one say so lovingly, in the nude by his talented boyfriend, would have made of the uncompromising pronouncements of his older self.

When he was alive, Maurice Garnier was predictably fierce in Buffet's defence, arguing that if Buffet painted canvases in an industrial manner, he was slaving away so that he could gratify the desires of Bergé, keeping him in the style to which he had happily become accustomed. After their arrival at Château l'Arc, Pierre had started to ride, and the couple kept a white horse.

However, that is not to say that Buffet himself did not enjoy the good life, but his attitude was rather uncomplicated; as he would later say, 'I like my lifestyle. I like to have money – as long as someone else takes care of it – I do the work.'[20] Comparing him to a champion thoroughbred when speaking of the painter's taste for life's luxuries, Emmanuel David had said, 'You must feed your best horse plenty of oats if you want him to run fast.'[21] But it has been suggested that Bergé had begun to work the horse a little too hard, watching over Buffet much as he might keep a racehorse in training. And it was at Château l'Arc, the home that should have been so happy for them both, that tiny fissures started to appear in their relationship. For instance, Cocteau's journals record that Niçois gallerist Jacques Matarasso 'had broken with Buffet because of Pierre Bergé', Matarasso accusing Bergé of turning 'a painter of genius, into a piece of business'.[22]

On the whole, castle life seemed to suit both Bergé and Buffet. However, had they been hoping to recapture the intensity of their years at Nanse, where Buffet painted maniacally and the couple were marooned in their remote farmhouse by the snows of winter, they found that those days had gone. Life was different now. Both Bergé and Buffet were established social figures, and if Bergé was not stopped in the street and photographed like a film star, the rocket-like rise of Buffet to prominence had placed him in the enviable position of gatekeeper. In Maurice Garnier's account of the meeting at which the foundation of the Galerie David et Garnier was discussed, it is significant that Bergé was present; given Buffet's characteristic timidity, it is safe to assume that his lover's presence betokened more than moral

support. And, as the Riviera gallerist's remonstrations with Bergé attest, there were those who thought by the late 1950s that Bergé was treating Buffet as less of a champion throroughbred and more as a cash cow to be ever more frequently milked.

That there continued to be a strong and mutual affection between the two men is undeniable. However, the concentrated, claustrophobic closeness that had characterised their days in Nanse had been diluted by an increasingly hectic social life. Château l'Arc welcomed a steady stream of guests; Buffet's family (he doted on his niece Blanche, of whom he had painted an uncharacteristically tender portrait), as well as old friends such as the Gionos and the froth of café society, would appear, sometimes in ones and twos and at other times, on special occasions, in large numbers. In mid July 1957, to celebrate Bernard's birthday and the publication of his edition of Cocteau's *La Voix Humaine*, a swimming pool was installed and the walls of the chateau were floodlit. Impressive though these celebrations were, however, they would be just an *amuse-bouche*, a rehearsal for the gala that Pierre was planning for his lover's thirtieth birthday in July 1958.

As the summer of 1957 drew to a close, the two young men enjoyed the last rays of the summer sun in their grand Provençal retreat, relaxing by the pool, admiring the nocturnal illuminations of their chateau, and taking the white stallion for a canter round the estate. It could not have occurred to either of them that within a year, their relationship would be at an end.

Chapter 19

A Tale of Two Coups de Foudre

During January 1958, Bernard Buffet was not the only one of *les moins de trente ans* to have a career-defining show.

It had barely been three months since the death of Christian Dior, but the unforgiving schedule of the fashion world makes no allowance for mere personal tragedies and trivial matters of life and death. Accordingly, towards the end of January, as the city's couturiers put their finishing touches to that season's gowns and the mannequins – as the catwalk models were then known – were fitted for their *défilé* in front of press and customers, attention turned from the scene of Bernard Buffet's triumph on the Rue du Faubourg Saint-Honoré to the Avenue Montaigne.

As the couture shows got under way, Paris held its breath. The outcome of the Dior show was of interest well beyond the limited world of those interested in, and the even smaller number able to afford, haute couture; it was a matter of national prestige that attracted attention from around the world.

The show was a triumph, and the French and international press ransacked their thesauruses for superlatives. 'Rarely does a hoped-for miracle come off just on time and in full splendor, but it can happen,' reported the *New York Times* on its front page. 'Today's magnificent collection has made a French national hero of Dior's successor, 22-year-old Yves St Laurent.' It was an emotional scene. 'Tears flowed copiously and joyously while bravos shook the glittering chandeliers. Extravagant compliments swirled as thick and fast as snowflakes.'

It was as if the scenes of a fortnight earlier at the Galerie Charpentier had been re-enacted in the gilt and taupe rooms of Dior, with their dainty Deuxième Empire-style gilded concert chairs with cane seats.

Applause was no polite ripple; it roared [and] stayed crescendo [*sic*] a full two minutes. St Laurent, who had peeked surreptitiously from

behind a curtain throughout the two-hour show, shyly came into the
main room and was immediately mobbed.

Looking more like a schoolboy than any 10-year-old, St Laurent
confessed that he was 'tres heureux and tres emu'. He did not look
'very happy or very touched', but he said it with such innocent,
charming gratitude that one almost forgot he looked more terrified
than anything else.

The most encouraging thing about St Laurent's success without
Dior is that it proves that a production-line, team-work set-up is
possible, and desirable, in even the highly individualistic French haute
couture.[1]

The parallels with Buffet were uncanny: the youth, the shyness, the
taciturnity, the public anointing of the young saviour of a traditional
area of French cultural supremacy. Yves Saint Laurent was the Bernard
Buffet of fashion, and what is more, the two men even looked alike.

In their capacity as both increasingly important actors on the social
stage of Paris and personal friends of its late eponym, Bergé and Buffet
took more than a passing interest in the future of the house of Dior.
On 30 January, along with the usual guest list (Louise de Vilmorin,
Hélène Lazareff and Marie-Louise Bousquet inter alia), they were
among the privileged few who witnessed the birth of the new Dior
and shared in the crying, cheering and clapping in the normally sepul-
chral, subdued salons of the Avenue Montaigne. And when the house
magazine of les moins de trente ans, L'Express, reported on the show, it
reproduced a sketch made by Buffet of what Saint Laurent had called
the 'trapeze line'.

Yves Saint Laurent's succession to the throne of Dior made him
one of the most sought-after social ornaments in Paris. Marie-Louise
Bousquet had both a professional and, as a major customer of Dior,
a personal interest in haute couture and the house's new design star.
As well as being the editor of a fashion magazine, she was fabulously
rich; the hostess of a weekly salon in her handsome town house on
the Place du Palais-Bourbon; and an art collector.

A tireless socialite who collected people as avidly as she did paint-
ings, 'she invited anyone in Paris who attracted her interest, as well
as any intriguing foreigners who happened to be passing through the
city', records Saint Laurent's biographer Alice Rawsthorn. 'A great
friend of Christian Dior's, she was anxious to meet his successor and

asked Raymonde Zehnacker [Dior's secretary and confidant] to bring Yves to dinner a few evenings after the show. Anxious that he should feel at ease she invited two other young men to join them,' Pierre Bergé and Bernard Buffet, 'whom Yves had long admired. He set off for dinner that evening looking forward to meeting the artist; but it was his companion who caught his eye.'[2]

For Bergé it was more than his eye that was caught; his heart was ensnared. Exactly the same characteristics that had attracted him to Buffet drew him to the young fashion designer. Saint Laurent was 'a strange, shy boy' who instead of burying himself in a filthy Canadienne 'wore very tight jackets as if he were trying to keep himself buttoned up against the world'.[3] As far as Bergé was concerned, it was love at first sight. 'I had *un coup de foudre*, as we say in French, for Bernard Buffet in 1950, and I had a second *coup de foudre* for Yves Saint Laurent in 1958. *Voilà*. And I left, yes, I left.'[4]

The break with Buffet did not happen instantly, however. Buffet made a sketch of the bespectacled couturier for publication in the *Journal des Arts*, and in mute testimony to his enduring admiration for the artist, it would remain hanging over Saint Laurent's desk throughout his career.

After the stress of preparing his show, Yves had intended to go home to Algeria to see his family. But perhaps the worsening news from France's North African colony, or maybe a reciprocation of the feelings that Bergé had for him, prompted him to invite himself down to Château l'Arc to recuperate and knit the ravelled sleeve of care. He was chaperoned by Raymonde Zehnacker and stayed a fortnight. Indeed, during the spring and early summer of 1958, the bespectacled couturier became a regular guest at Château l'Arc, even attending the Cannes Film Festival of that year, when Buffet served on the jury.

Admittedly photographs never tell the whole story, but the images of that spring show Buffet apparently happy enough, standing next to a frail and wizened Cocteau, looking a little like one of Bill Haley's Comets, with a narrow bow tie and shawl-collared dinner jacket (albeit in white rather than Haley tartan), and the hint of a quiff. There is even the suggestion that Buffet is enjoying hamming it up for the cameras. There he is drawing with Sophia Loren; the Italian actress still has a sketch they made together, which carries both their signatures. It remains one of her most precious possessions and hangs

above her desk under a small Picasso.[5] There is Buffet on the beach with Jean Marais, having just completed another sketch, this time tracing it in the sand. Standing slightly nervously alongside is the slender figure of Yves Saint Laurent, arms straight by his sides, suit buttoned as if he has just come from a funeral, looking as if he is terrified that the sand might mess up the shine on his shoes, while a confident Buffet steps back and runs a comb through his quiff as he admires his work.

Indeed, while the attraction between Bergé and Saint Laurent might have been instant, they may not have acted upon it, or if they did, they managed to be very discreet, as the events of that spring would suggest that Bergé and Buffet still seemed to be planning a life together as late as May, when the island of Stagadon off the Breton coast came up for sale and they bought it as an early thirtieth birthday present for Buffet. According to one source, it was registered, like Château l'Arc, in Bergé's name. In June, Buffet was photographed by *Paris Match* on the four-hectare island sketching a fish, a carefree image that gives little sign of the impending personal crisis that would dramatically change his life in a matter of weeks.

As expected, Buffet and Bergé were invited to attend Saint Laurent's second Dior show in the summer, and it was on the morning that they were due to fly to Paris that Buffet gave his lover an ultimatum.

I was ready very early in the morning, the aircraft was leaving at midday and around nine o'clock I told him, '*Alors*, come on, Bernard, pack your bags and come along.' He told me, 'I will not be going, my mind is made up. And I am telling you here and now that if you leave, I will not be here when you come back.' *Voilà*, and I left.[6]

Demonstrating the determination that Bergé believes to be a key characteristic of timid people, Buffet was as good as his word. When Bergé returned from Paris to Château l'Arc, Buffet was gone, and though he spent much of that summer looking for him up and down the Côte d'Azur, 'because I couldn't leave without an explanation',[7] Bergé, who had not spent a day apart from Buffet for eight years, could no longer find the man who had been his lover. Their life together was at an end.

Shortly before they split, they did, however, share one last important event.

That summer, le Tout-Paris (and le Tout-Saint-Tropez) had received a card in the familiar angular 'praying mantis' script. It read simply:

Diner d'Anniversaire
10 Juillet 1958
Bernard Buffet[8]

It was to be a sensational evening, with a bullfight staged in a temporary bullring that had been specially built for the evening, dinner, dancing and a firework display. The guest list mixed familiar names from society with representatives of *les moins de trente ans*, including Sagan, ballet impresario Roland Petit, and a good-looking young Englishman called Martin Summers, who had recently arrived in the area.

Summers is now a distinguished art dealer who divides his time between Chelsea and Punta del Este. Coincidentally, his career encompassed a long period as a director of Lefevre, which had shown Buffet's paintings in London in the early 1950s. Today he cuts an elegant, silver-haired, patrician figure, but there remains what might be called a twinkle in the corner of his eyes, and even though very nearly six decades have passed since that summer in Provence, he is recognisable as the handsome youth who stares back out of his scrapbook, meeting your gaze with a level gaze.

I came across Bernard Buffet because I went briefly to the University of Aix-en-Provence, and I stayed with a painter who knew my parents. I was staying with them for six months, and they got an invitation to Bernard Buffet's thirtieth birthday party, so they said would I like to come, so I said, 'Of course.' I was nineteen.

So I went to the party, and it was magnificent. I got there I would say about six thirty, and it was huge. There must have been two or three hundred people. Françoise Sagan was there, the whole of the French crowd were there, but I didn't know who anyone was. It was all a mystery.

There was a bullring and there was a bullfight, there was an orchestra, there was dancing, there was food like I'd never seen before, there was a swimming pool and it was all very stylish. I'd never seen anything like it before in my life, and aged nineteen I thought this was pretty good stuff.

But at about half past eleven my host and hostess said, 'Time to go home now.'

I said, 'Go home? But I have just started eating.'

'No. Time to go now.'

I said, 'Well, I don't want to go, I want to stay, I want to have some fun.'

He said, 'Well, I'm just saying, I would advise you it's time to leave.'

And I said, 'Well, I'll see you in the morning. I'll find my way back.'

So this was now midnight, and the festivities had all been taking place in the garden. Suddenly everybody started to converge on the chateau, just sort of drifting in arm in arm. And obviously the party was going to carry on inside, so as we got inside there were two huge staircases going up either side and up the right-hand staircase went all the ladies. So I immediately joined that staircase, you see, and they said, 'No no no no no, you can't come up here, you have to go up that staircase.' Well, that was men only. And we got to a room at the top, and I suddenly realised I'd got involved in a massive gang bang of about fifty strong. So I got a bottle of whisky and I hid behind the curtains!

Occasionally Summers would peep out from his hiding place. 'I can't say I actually saw Buffet, but I saw a mass of heaving humanity, and I think he was already buried in there somewhere!' he laughs. 'It was all taking place right there in front of me . . . and the girls were having their fun next door. At about three o'clock in the morning I managed to tiptoe out, and somehow got a lift back, and it was a very strange evening.'⁹

But there may have been another reason why Summers could not see Buffet cavorting in the group sex session that he describes. At the very time that the young Englishman was making good his escape from the Château l'Arc, Buffet was walking through the park with a companion from whom he had been inseparable throughout the evening. In mid July, the nights are short and warm, and when the pink fingers of dawn began to pull back the night sky, some of the revellers who were still up and dressed (it appears that not everyone had joined the sex party) threw themselves fully clothed into the pool. Even though it was late (or early), Buffet did not neglect his duties as host, and in order to make his guests feel at ease, he was just about to join them when the boyish figure at his side took his hand and leapt with

him into the water. And as dawn broke on 11 July 1958, it became plain that the figure with whom Bernard was now laughing and joking in the pool was not Bergé, nor any other man, but a woman.

It would appear that Pierre Bergé and Yves Saint Laurent were not the only ones experiencing *un coup de foudre* that year.

Buffet was in love.

Chapter 20

'The most beautiful woman's body I've ever seen in my life'

The person with whom he had decided to take an impromptu early-morning swim was Annabel Schwob de Lure, one of the more remarkable women to emerge from the subterranean nightclubs and pavement cafés of post-war Saint-Germain-des-Prés. If she can be said to have had any profession, it would be that of bohemian. She had what today would probably be called a portfolio career. After studying to be an artist, she had worked as a mannequin, she sang in nightclubs, and that summer she was in Saint-Tropez working on her first novel – all of which she did competently rather than brilliantly. 'Annabel wanted to be Françoise [Sagan] when it came to writing and me for song,' laughs Juliette Gréco, recalling the woman with whom she had been young in the years after the war. 'She was a young woman from a very good family which was of the Jewish aristocracy.'[1]

What was more, she had a sense of humour, once saying of herself that at least people did not say that she sang like Sagan and wrote like Gréco.

But there was one thing at which she excelled: she was stunning to look at. 'She was not a great brain, Annabel, but she was very beautiful,' says Gréco. 'Very strange and very beautiful.'[2]

Well into his nineties, Maurice Garnier would smile at the recollection of Annabel in her prime.

'Oh la la. I believe that hers was the most beautiful woman's body I've ever seen in my life. I saw her naked in Saint-Tropez when she was about forty and she still had this androgynous quality. She had no hips. She didn't have a woman's pelvis, it was straight, she had very beautiful breasts. She was tall. She was elegant. She was extraordinary.'[3]

She was also gay – or at least that was what was generally thought to be the case, with gossip linking her name with Sagan's. 'Annabel was a man!' laughs Juliette Gréco, and when asked whether Sagan

and Annabel were lovers, her answer is as ambivalent as the sexuality of Annabel, Buffet and Sagan. 'Yes and no. A little. A little. It was a casual affair. Sagan really liked Buffet very much and she liked Annabel; she liked Annabel, but she also could not resist making fun of her a little, because she was very naughty, Françoise. She called Annabel "Annabeau".'[4] And this punning reference to Annabel's androgynous appearance is echoed in *Toxique*, Sagan's account of her addiction to morphine following her horrific car accident, illustrated beautifully by Buffet. In it, she talks of being visited as she dried out by Annibal,[5] a convenient masculine alias for her lover, a fact confirmed by Annabel's son Nicolas.[6] It would appear that, 'casual affair' or not, at the time, Annabel occupied an important place in Sagan's affections. At one point in *Toxique* she describes 'Annibal' as 'reassuring' in a 'very real way', and she clearly looks forward to his (her) visits. 'Annibal has brought me a black and white Shetland wool sweater. If I hadn't decided not to talk about anyone in this diary I'd sing a hymn to the glory of Annibal, and to a black Shetland wool sweater on a tanned skin.'[7]

When news broke of the incipient love affair between Buffet and this *égérie* of Saint-Germain-des-Prés, it was assumed that she had been brought to Buffet's party by Sagan, who had, according to one report, introduced the couple on the morning of his birthday. 'The painter and the singer did not leave each other's side all afternoon. During the evening they dined side by side by candlelight.'[8]

However, as Annabel would later recount, the couple had met, quite by chance, in Saint-Tropez earlier that summer. The story was *très vedette* and *très moins de trente ans*. Cupid in this instance was a photographer called Luc Fournol, who had just left *Paris Match* for its rival *Jours de France*, which had been launched in 1954 by aviation tycoon Marcel Dassault and served up a similarly invigorating journalistic cocktail of current affairs, colour photography and celebrity tittle-tattle.

It was 1958 – late May or early June – in the seaside resort of Saint-Tropez. I was living in the Hôtel de la Ponche, writing my first book. Luc had asked me to pose for some shots for a pre-season photo spread. Bernard was passing through, having taken a few hours' break to go and see the sea, which always attracted him. We might have crossed paths without ever meeting – if it hadn't been for Luc. Luc had a very particular attitude to his photographer's job, a schizophrenia

that has never left him: he would obediently take whatever pictures
his editor-in-chief requested, carefully respecting the prevailing taste;
but at the same time, nothing or nobody could stop him from having
fun by taking other photos unrelated to his journalistic chore. He
could never resist the temptations offered by his perpetually roving
eye – his roving artist's eye. That day in 1958, an old lady peered
through her window and looked disapprovingly at our rambunctious
little crowd. So in order to snap a portrait of that stern lady – not to
take a portrait of us – Luc introduced me to Bernard, asking us to sit
side-by-side beneath the window in question. Amused by his request,
we had no idea that we were being introduced to true happiness, that
the three of us would henceforth be linked forever.[9]

The picture is charming. The old crone peeks through her window
like some fairy-tale witch about to proffer a glossy poisoned apple.
But it is the hauntingly beautiful young couple that stays in the mind:
gamine Annabel with her tousled cropped hair in the regulation Saint-
Germain-des-Prés uniform of several-sizes-too-large dark roll-neck
sweater and jeans; her face inclined towards Buffet, boyish in a loose
white shirt, the sleeves rolled up above the elbow, his shy gap-toothed
smile making him look more like a schoolboy on holiday than 'the
most talked about artist in France after Picasso'.[10] They seem relaxed
in each other's company, their faces unlined and carefree in the early
summer sun of a Saint-Tropez that in those days would still have been
recognisable to Paul Signac as the light-bathed fishing village he had
painted half a century earlier.

In short, they looked like what they would soon become: a young
couple deeply in love.

It is never easy to analyse what it is that attracts two human beings
to one another and binds them together. Annabel and Bernard were
certainly ravishing to look at, and of course Buffet's emotional need-
iness, heightened by the increasingly apparent tension in his relation-
ship with Bergé, would have made him particularly receptive to any
affectionate overtures. As before, Buffet appears to have been reluctant
to relinquish one relationship until another was in place: when his
marriage to Agnès Nanquette had come to an end, he had seemed
unable to sever the link entirely, continuing to see her and to mope
around André Fried's house, only evicting her once he was established
in a relationship with Bergé.

For Buffet, it appears not to be so much gender as strength of character that held the power of attraction. Having had a childhood and adolescence in which the dominant factor had been the intense immersive relationship with a mother who died before he could reach adulthood and grow away from her, the subsequent important relationships in his life were with strong characters. Garnier was an exceptional individual and powerful personality. Bergé too was a fearless powerhouse of a man, fizzing with ambition. Even Nanquette had been lively, outgoing and self-assured.

To be sure, Buffet's needs were remarkable; as Bergé recalled, they never ate a meal apart. But to those people who could replenish his ever-depleting reserves of confidence, he responded with total loyalty and trust. It is this quality upon which Garnier would remark long after the painter's death and shortly before his own. 'I had the good fortune that he trusted me and was faithful to me,' he said. 'This is the strength that I have, that we have at the gallery: it is the loyalty and confidence of Bernard Buffet.'[11]

In Annabel, Buffet had found someone of almost adamantine self-belief. According to Garnier's widow Ida, 'It would simply never have occurred to her that Bernard did not love her utterly.'[12] And as Juliette Gréco sees it, the combination of haunting androgynous beauty and strength of character proved irresistible for Buffet. 'I think that at that time he found a model and a strong companion. Stronger than he was.'[13]

However, Annabel's strength was born out of a childhood that was, if anything, even more tragic and damaged than Buffet's. Her family may have been part of what Gréco terms the Jewish aristocracy, but money and social position proved utterly powerless in the face of both personal and historical tragedy.

On 10 May 1928, exactly two months before Bernard Buffet drew his first lungfuls of air in rather humbler surroundings, Annabel Schwob de Lure was born into an affluent and sophisticated household. Her parents bought contemporary art, drove a Bugatti and were friendly with such personalities of the day as Josephine Baker. Her father, Guy-Charles, was tall, handsome and fastidiously dressed. Photographs of her mother taken by Man Ray show a striking sable-haired beauty with an almost sculptural profile.

Annabel was just eight when her mother took her own life. Suicide would stalk her for the rest of her life: both her father and her husband would kill themselves.

Her father remarried, and his new wife, conforming to the stereo-type of the stepmother, detested her husband's daughter. This loathing was reciprocated by Annabel. 'I took refuge in an animal life, refusing instinctively whatever looked like a feeling. Like a beaten dog I was on the defensive' – and like a cornered animal she was prepared to growl and bite to protect herself. 'I invented cruel games that enthralled me. For example: "Who will be the next to die?" In this way I was able to dispose of those who bothered me.'

The only emotion she felt was the perpetual gnawing pain of the absence of her mother, and guilt; torturing herself by imagining what might have been if only she had been a more affectionate daughter. To avoid ever feeling this way again, she allowed impenetrable scar tissue to form over this emotional wound.

> I no longer became attached to anyone; like that, if I were abandoned again it would be all the same to me. Like an athlete in Antiquity who is preparing for the arena, I imposed a rigorous regime of mental exercise to forge for myself an invincible suit of armour that no suffering could penetrate. It was a strength that would help me always, but also a chasm of loneliness, because my emotional capacity atro-phied more and more each day.[14]

By the age of twelve she was smoking; aged fifteen she discovered the magical power of alcohol to chase away sadness, experiencing through drink the sense of release and even the distant prospect of happiness that eluded her in sobriety.

She was a problem child, and when France capitulated to the Nazis, her predicament worsened.

At first, compared to many, the Schwob de Lures did not exactly have to rough it. After a confused and hectic train journey south, during which Annabel slept in the netting of the luggage rack, they arrived in Cannes, where her father rented a house near the Palm Beach Casino. Here relations between stepmother and stepdaughter deteriorated to such an extent that Annabel was sent to boarding school. Then one day she was called from a maths class to go to the headmistress's office.

> My father was there . . . without his wife. I was relieved to see that she had not accompanied him. Why had he come? Had he forgiven

me? At least he had missed me, not much, but enough to come and see me. Hopeful I looked up and gave a hint of a smile.

He was standing. I found him handsome. He had considerable allure, but this haughty elegance had me paralysed. I stood rooted to the spot, I dared not go to him; I wanted to kiss him. I watched him, mute, looking for a sign of affection. He was terribly pale, his face closed. I felt cold, a cold that shook my knees and my lips. A lengthy silence and terrible certainty made me want to be sick. He doesn't love me . . . He doesn't love me . . . He doesn't love me . . .

'How could I, at my grand old age of almost 13, have guessed that this man, to my eyes a symbol of power, of authority, upon whom I depended, was nothing but weak?

It was a meeting that would mark the end of her childhood as brutally and effectively as the death of Buffet's mother would mark the end of his.

His words spun around me like bats. 'Jews' . . . 'life in danger' . . . 'Going to the United States' . . . Jew sounded like thief, an insult.

They were the ones who were leaving. He wanted to save his family, to which I did not belong. The family was him, her, the baby, the Yorkshire terrier . . . dirty beast, fake dog . . . Me, she did not want me . . . She was paying . . .'[15]

Having spent the rest of the war living with a friend's family, Annabel completed her education in precocity aged seventeen, surrendering her virginity on the beach in Cannes to a good-looking man in his early twenties who had picked her up one evening at the Carlton.

When he led me to the beach, I followed without hesitation. We instinctively avoided lies. We spent only one night together. I abandoned myself to a sumptuous experience. This was a carnal feast, a beautiful entrance to the paradise of pleasure. I was awed by love, by the fullness of the sensations, by the calming of the storm. I discovered a new strength in the certainty of having my body as an ally, it became a source of balance, of joy and one more means to fight against an agonising loneliness.

I was not mistaken. My body had not betrayed me. I happily obeyed its desires and even abused its appetite. As with alcohol, they are

excesses that I do not regret. The pleasure gave me the taste for life. In giving myself shamelessly to sensuality I found a solid counterpoint to the negativity towards which I was led by a disordered mind and an empty heart.[16]

Sex, like cigarettes and alcohol, had become an important part of her life, but much as she enjoyed it, she refused to be defined by it. 'Personally I never dreamed of putting my self-respect in my panties nor in anyone else's. Making love seemed to me as natural as drinking, eating and sleeping.'[17]

After the Allied landings in the south and the liberation of Paris, Annabel went to the capital to rejoin her father, who had returned to his apartment on the Avenue Foch, leaving his wife and daughter on the other side of the Atlantic. He bought some old Schiaparelli dresses from a friend and 'disguised me as a woman'.[18] In the evenings, after he had finished working with his parents to rebuild his property business, and she had finished her studies at the Académie Julian, a fashionable art school, they went out on the town. This curious episode of her life, the precocious teenage daughter and the worldly father, predicts with eerie precision the ambience of the novella that would make her future lover Françoise Sagan famous.

Her stepmother's return, however, saw her placed in a convent, where she gained her initial experience of music, joining the choir and singing her first solo a few days before leaving and returning home to resume her art studies.

Most nights she would climb out of her bedroom window and head for Saint-Germain-des-Prés with her fellow students, but early one morning, returning home slightly the worse for wear, she got into an argument with her father and spent what remained of the night packing her bags. By the time her father was studying the financial pages over breakfast, she had gone to live among the artists, musicians and bohemians of the Left Bank.

Saint-Germain-des-Prés came easily to her. Soon she was one of its more remarkable-looking ornaments. 'If I shed the moral influence of my background with ease, the same did not go for the taste for refinement that clung to my skin. It is this, I believe, that helped me find my style.'[19]

She cut her hair very short, applied plenty of heavy ink-dark eyeliner, and alternated between a pair of jeans given to her by an

American pilot in Cannes and a pair of black trousers given to her by Juliette Gréco. The emblematic roll-neck sweaters came from an ecclesiastical outfitters on the Place Saint-Sulpice, who sold them to priests to wear under their soutanes in winter. Striking-looking and physically suited to the taste for the new, Annabel was soon in demand as a fashion model. At the dawn end of one of her *nuits blanches*, Orson Welles, who adored the way of life in Saint-Germain-des-Prés at that time, suggested that she try her hand at cabaret, and got her an engagement at a nightclub called Carroll's, which was where she would meet Françoise Sagan. A month later, she had quit the catwalk for the stage, and embarked on the life of an *haute bohème* that in the early summer of 1958 found her trying to start a career as a novelist.

The term *coup de foudre* is used by Pierre Bergé to describe his immediate attraction to Buffet and then Saint Laurent. Of course, the idea that a self-assured, hard-nosed, hard-drinking, highly sexed, chain-smoking veteran of a decade of *nuits blanches* in Saint-Germain-des-Prés could experience such a thing was preposterous. 'At that time the very mention of *un coup de foudre* would have had me shrugging my shoulders with contempt.'[20]

She recalls how it was a particularly sunny May and how, finally, towards the end of the afternoon, the light had softened enough for the picture to be taken. Her photographer friend Fournol was waiting on the terrace. She closed the exercise book in which she had been writing and went to have her picture taken with Buffet and the old woman. She had no way of knowing that within minutes her life would be turned upside down.

She felt she knew all she needed to know about Buffet.

I knew a few of your paintings; I saw your designs for *Rendez-vous Manqué* written by Françoise Sagan and staged by Roger Vadim; I had noticed you many times with a boy with whom I was told you lived and, probably because of your Rolls-Royce, I had classed you in the category of worldly snobs. All things which until then had left me indifferent.[21]

As the shutter on Luc Fournol's camera started to click, she looked up into Buffet's viridian eyes. It was as if some divine hand had pressed life's pause button. If her memory recorded as an old widow is to be

believed, 'At that precise second I drowned in a green ocean of passion.'[22] The language of love can sound foolish when spoken so others can hear, or written so others can read it; nevertheless, there is something particularly poignant in this well-worn amorous metaphor being used by a septuagenarian Annabel looking back on that sunny May in Saint-Tropez.

There was clearly some attraction on Buffet's side, as he stayed for dinner, after which 'your friend wanted to leave; you wanted to stay and I found you a room at the Hôtel de la Pinède'.[23] The following day there was a picnic on the beach, complete with tepid rosé wine, sand-filled sandwiches and swimming in the still-icy water. And then, 'after 48 hours of euphoria camouflaged as nascent friendship, we said goodbye'.[24]

It was only when left alone in her room with her thoughts and the exercise book containing her embryonic novel that she realised how stupid she had been to be swept away by this unexpected green ocean of passion. 'How idiotic! One does not fall in love with a man who prefers boys.'[25] Anyway, she had a lover waiting for her in Paris. So thinking, she threw herself into a routine of writing, revelry and games of tennis, congratulating herself on having averted what she called 'un mauvais scénario'.[26]

However, she was reckoning without Buffet, who was about to fulfil Bergé's observation concerning the determination of timid people.

A few days later, she received a call from another photographer friend, Michou Simon, who worked for Paris Match. Michou was one of the demi-paparazzi, whose work hovered between the candid and the staged and would shape the visual signature of the colour magazine that by the end of the 1950s was sometimes selling close to two million copies. Like Buffet, Paris Match was booming, and the parallels with his career are uncanny. Taking the name of a pre-war sporting paper called Match, Paris Match was founded in 1949, the year after Buffet had carried off the Prix de la Critique. A couple of months later, the familiar red and white masthead was adopted, soon becoming a visual shorthand for a certain type of brittle modern glamour, as recognisable as Buffet's praying mantis signature.

As Buffet became more of a personnage on the Paris scene, a symbiotic relationship developed between the artist and the magazine, a relationship that would endure until the painter's death. Much

in the way that, say, Johnny Hallyday would become a familiar ingredient in the editorial mix, so a few pages of Buffet could be counted to spice up the magazine; the appearance of a *Paris Match* interview and photo shoot with the artist at around the time of his February exhibition would become a ritual of almost metronomic regularity.

There was a tacit collusion between subject and media that was an important part of Hourdin's celebrity syndrome. It can hardly be called media manipulation, or if it could, then both parties were guilty of it. As it was, close ties between *vedettes* and colour magazines were a matter of mutual self-interest. The journalists of the popular media were not so much impartial recorders of the events that were giving shape to the period as active participants in them. 'Annabel was very worldly,' recalls Juliette Gréco. 'She was very friendly with journalists, with *Match*, with everyone. We were all also very good friends with *Match* photographers, they were friends to us.'[27]

Annabel and Michou had known each other since their teens, and he had a favour to ask. Would she accompany him and his fiancée to see Buffet at the Château l'Arc? He had telephoned the painter to ask if he could do a photo story about him, and Buffet had agreed on the condition that they bring Annabel along with them. She had been intending to go to Paris to see her lover, but she decided to go via Château l'Arc and appeared with a large Irish setter called Antoine that had been given to her by Françoise Sagan.

'I remember having been taken aback by the luxury that was too much on display for my taste.' She did not share Cocteau's lyrical view of a castle of melancholy comfort. 'I found the house beautiful but pompous.'[28]

It was, nevertheless, a 'lovely day because both of you knew how to entertain beautifully'. It is easy to imagine the day of lazy luxury by the pool, unfolding over many bottles of wine and packs of cigarettes, the thrum of crickets lending an air of southern languor to the scene. But beneath the studiedly idyllic setting, she detected a strained atmosphere that came to the surface when she was about to leave to take the plane to Paris.

'With an authority for which there was absolutely no justification you decided to keep Antoine to spare him a round trip in the hold. You were preparing a big party for your thirtieth birthday. I had to come to this party and reclaim my canine hostage at the same time.' Clearly

Bergé noticed that something strange was afoot. 'The atmosphere was tense, and rather than have an argument, I got in the car to go to the airport.'[29]

And this, according to Annabel, is how she came to find herself leaping fully clothed into the millionaire artist's swimming pool early in the morning of 11 July 1958.

Chapter 21

'I want you without your past'

And then, after the photograph, the picnic, the call from Michou, the taking hostage of Antoine, the party and the dawn dip . . . nothing.

If Annabel had loosened her mind-forged 'invincible suit of armour' to allow a scintilla of emotion to pierce her heart, she now prepared once more to fortify her emotions.

'The silence that followed had let me believe in a final separation.' She was not to know that the relationship between Bergé and Buffet was entering its febrile final phase. 'I went sailing with friends; a cruise far out to sea that was supposed to clear my mind.' Upon the return of the boat to harbour, she went back to the villa where she was now staying in Beauvallon, across the bay from Saint-Tropez. That same evening, the phone rang.

It was Buffet.

> As usual you do not ask me my opinion . . . Jean-Pierre Capron, one of your friends from the Beaux-Arts, would be there in an instant. You were waiting for me at the Auberge des Maures. As usual, I did not argue . . . I said 'I am coming.'

For three weeks, Buffet shuttled between Aix and Saint-Tropez. Each evening, as soon as he finished work, he hit the road with Capron at the wheel, the only one privy to his destination. It must have been interesting for Capron to see his friend so infatuated, as ten years earlier he had been one of the witnesses at Buffet's marriage to Agnès Nanquette.[1] But whatever his thoughts may have been, Capron kept them to himself, and somehow these assignations remained undiscovered.

> You courted me as a young man courts a young girl. Lovingly we held hands and whispered words tender and silly; dreamily, we listened to

songs by Aznavour and at dawn we sensibly went our separate ways. You awoke in me teenage love that without you I would have not known. Suddenly, this slow, languorous waltz sped up. I can still hear your voice on the phone: 'Be in Marseilles at four o'clock. This is forever. Come with nothing. I want you without your past.' I did not hesitate for a second. I did not disobey you, except on one point. I took my dog.

Annabel didn't drive – another thing they had in common – and was given a lift by a friend with a 'heart of gold' called Ghislaine.

We told no one and we arrived in the Brasserie du Vieux-Port, as you had told me, on the hour. I remember the smile on your face when you saw Antoine who was on the end of a rope as a leash. You had eschewed your elegant 'famous painter' outfit. Dressed in jeans and a white shirt, you were wonderfully beautiful.[2]

Buffet had planned this clandestine tryst with minute precision. They were to go to a friend's yacht, and a couple of hours later, without having been recognised, they were on board, dog and all, out at sea, watching the sun set over the Mediterranean. 'Our first night . . . an emotion that has marked me forever. Submerged in passion, maddened with desire, filled until exhaustion, I learned love in capital letters.'[3]

Towards the end of her life, Annabel would marvel at the ease with which she changed her life in the summer of '58.

I am surprised at the casualness with which I broke up with everything that had been my life before our meeting. I was thirty years old and you convinced me that I was fifteen. My mother's suicide had devastated my childhood; the horrors of the war could but only strengthen my suspicion; coming out of an adolescence blighted by these unforgettable horrors, I fashioned for myself a life dedicated to immediate pleasures. I had fun at the games of seduction. You saved me from the abyss. You tamed me; day after day, night after night you rebuilt me . . . at your side I discovered that happiness existed.[4]

At the same time as Pierre Bergé was embarking on the next phase of his life as the lover and svengali of Yves Saint Laurent, with whom he would perfect his mastery of the alchemy of starmaking, Buffet

sailed into the setting summer sun with his beautiful, boyish girlfriend. 'Painter Bernard Buffet disappeared six days ago with Anabel [*sic*] the singer' screamed the headline in *France Soir* on 17 August 1958. 'The public rumour: "they have married in secret".'

The sensation of the summer was communicated with a telegraphic urgency. Here at the very zenith of the holiday season, the entire nation *en vacances*, was the news story that everyone had been waiting for to take their minds off the rumours of an impending military coup, which, along with the worsening Algerian crisis, was hastening the Fourth Republic to its end. A beautiful woman (*France Soir* helpfully printed an old picture of Annabel in a bikini so that its readers could reacquaint themselves with her body) who sang songs written by Françoise Sagan, a famous painter whose works sold for between 'one and five million',[5] both seeming to vanish off the face of the earth – or at least off the Côte d'Azur.

The hunt was on.

Reporters were dispatched to the south. Annabel's host confirmed that she had received a telephone call and left the house as if it were on fire. Much in the manner that during the 1970s the British media would record sightings of the errant Earl of Lucan, so rumours of a wedding in Roussillon and then in the Bouches-du-Rhône appeared in print, as editors in Paris bombarded their reporters in the South of France with telephone calls demanding fresh details.

And as rumours spread from one end of the Riviera to the other like forest fires under an August sun, the painter and the singer were far out to sea, swimming off the boat, feeding the dog tuna fish and olives, and, to put none too fine a point on it, fucking their brains out: 'We made love like crazy.'[6]

But they could not stay out on the boat indefinitely. Buffet was never happy for long if separated from his work; he would become irritable and discontented if prevented from painting. Even the beautiful naked body that Annabel presented to him for his enjoyment could only distract him for a few days. Finding themselves confined to port in Genoa by bad weather, they decided to return to France, to start tidying up the wreckage of the lives that they had so precipitously abandoned.

Running short of money and unwilling to return to Château l'Arc, Buffet got hold of David, who was on holiday near Orange, and the art dealer hid them at the Château de Grignan for forty-eight hours

while he put together the cash they needed. Then, like a couple of fugitives, the couple set off to the Camargue.

On Saturday 23 August, *Paris Match* published two pages of pictures that have an air of candour about them. The first shows Annabel reclining on a sunlounger, inevitable cigarette poised delicately between index and middle fingers of her right hand, her faced turned away from the camera to face Buffet, who crouches barefoot by her side and gazes into her eyes; there is a sense of unaffected, extemporaneous affection. In the second picture, grainy, slightly blurred, as if taken at a distance, Buffet's grinning face is glimpsed through some foliage, while Annabel to his right in profile recalls something of his Jeanne d'Arc. 'These photographs are the first of an idyll; they tell of the *coup de foudre* of the painter Bernard Buffet and the singer Anabel [*sic*],' carolled the magazine jubilantly. 'Our photographer saw the birth of their romance.'[7]

But by the end of the summer, Buffet was getting restless. Skulking round the South of France trying to avoid newspapermen, behaving as if he and Annabel were some sort of beau monde Bonnie and Clyde, he had not done any serious painting for weeks.

We were tired of this nomadic existence. Especially Bernard, because this instability prevented him from painting. It was I who had the idea to seek refuge where nobody would think of looking for us, in Saint-Tropez itself . . .

It was a lovely pink house, nestled in vineyards . . . we did not move from it . . . Suzanne Pelet, who had rented us it, did not betray us. She kept resupplying us with alcohol, cigarettes, and newspapers. The housekeeper, a woman from Brittany, went shopping in the market, did the housework and cooked; she was called Françoise and made a potato salad with garlic as I've never eaten since . . . We were crazy, in love, happy . . . Bernard had transformed the garage into a studio, in a corner he put in a chair and a table for me and decided that it was my office. While he painted gigantic landscapes of New York for his February exhibition, I finished my book.[8]

So the days elapsed. The tourists packed up their parasols and deck-chairs and headed back to the cities. With the passing weeks, the days shortened and the nights cooled. And as the weeks turned to months, the storms of winter began to lash the little seaside town, which by

December seemed almost as empty of people as the monumental canvases of New York on which Buffet was working sixteen hours a day in the garage of the Villa Tibur, furiously depicting the concrete canyons and glass towers of Manhattan in ochres, reds, greys and, of course, black. Annabel too tasted the satisfaction of a completed task: her novel was finished. Unsurprisingly, given the media storm around her disappearance with Buffet, it had been accepted by a publisher, who wanted to bring it out at the beginning of the new year.

So all in all, it was a contented Buffet who, on the afternoon of 12 December 1958, stepped outside the pink villa that had been his home for the last three months. He was snappily dressed. 'His Havana coloured suit and chestnut coloured tie matched his straw coloured hair.'[9]

He took a few loping steps and looked through the trees to the neighbouring houses, as if to check that he was not being watched. The road outside the house was empty.

He heard the gentle crunch of gravel as, instead of the Rolls-Royce of legend, a rather humble red-roofed Simca Aronde drew up between beds of rosemary and lavender. It was Suzanne Pelet, the estate agent who had found them the house, and Buffet walked down the steps to join her and an emotional-looking Annabel. If Annabel looked nervous, then she can be forgiven, as that stormy Friday in December was her wedding day.

Almost exactly a decade after a sullen twenty-year-old Buffet, enveloped in his filthy Canadienne, had arrived late at the *mairie* of Paris's 6th arrondissement to be married to Agnès Nanquette, he was giving the institution of marriage and the notion of sex with a woman a second chance.

There were those who simply did not believe that Buffet was what might euphemistically be called the marrying type. As the account in *Jours de France* put it, 'this marriage seemed simply too Parisian to be true'. Although the reporter stopped short of outing Buffet, readers did not have to look too hard between the lines to get the point. 'It was no secret that Buffet was not at ease in the company of women. He was so hostile that he used to hide his first marriage', apparently going as far as denying to one reporter that he had ever been married at all. 'This misogyny was put down to a bad first experience,' says *Jours de France*. 'He only relaxed after a solid man with a wily peasant's face appeared suddenly at his side. That man was Pierre Bergé.'[10]

Nor did the magazine spare the bride, saying that it was widely believed from the outset that this was one of 'those burlesque marriages that reflects the appetite of Le Tout-Paris for the baroque'. According to this reporter, everyone thought 'Annabel likes nothing more than to be in the spotlight. She has found a new means of talking about herself.' It was suggested that 'the friendship'[11] she had with Françoise Sagan was one of the reasons for her fame, allowing the reader to infer that she was a talentless publicity-seeker desperate for attention. For good measure the article even mocked her nose job.

The bride was nervous, terrified even, of leaving the safety of the house that had been their home since the summer. Far from revelling in a new opportunity to publicise herself, the famously self-possessed Annabel, so practised in the ways of the world and the games of seduction, whose husky voice was always to be heard talking the most and loudest at Jimmy's and the other fashionable nightclubs, dreaded 'being thrown as food to Le Tout-Paris, to the press. I was on the edge of panic.' Only when they had made love was she slightly calmer.

> Then we dressed for the ceremony that we had wanted to keep secret and quiet. Snobbery dictates that you consider marriage as a formality without importance. It was not the case for me. I saw it as a mark of mutual trust, a serious commitment, and I was proud of the beautiful name that Bernard was going to give me. Forever in jeans, I was determined to find a skirt, which, in a deserted Saint-Tropez in winter, was no mean feat.

Dressed in their 'Sunday best, a Scotch in hand', about to become strangers to the house where they had lived and worked without ever being apart, they waited for Suzanne to take them to the town hall not in Saint-Tropez, but in nearby Ramatuelle. It was Suzanne who had had the idea to choose Ramatuelle. The mandatory publication of the banns had attracted the press, who were keeping watch in Saint-Tropez without suspecting that they would go elsewhere.

For a while it seemed that Buffet's second wedding ceremony would be even more bathetic than his first attempt at matrimony.

> We had the appointment at half past eight. It was night. The square was deserted. We were five in the office. The Mayor was so flustered

that he couldn't put his sash on; our second witness, his secretary, had a tear in her eye. Emotion paralysed me, *I managed to say the fateful Yes*. Not Bernard, who merely nodded.

The signing of the register was almost perfunctory, and then

After the inevitable flute of champagne with those who had just united us, Suzanne took us to dinner at a restaurant in the village, opened for us. We were only three in the dining room. The idiot had ordered a veal stew. She could have asked me my opinion! I hate stew! Married for half an hour, I watched my husband greedily devour this stringy meat swimming in white sauce. I did not eat any of it and just pushed the little that I was served around my plate so as not to offend the staff.

The feeling that this was a bad omen was, however, dispelled with a slice of apricot tart and a few glasses of wine, after which they returned to Saint-Tropez, where Buffet's driver was waiting with the Rolls-Royce. 'The gleaming limousine increased my concerns. It was tangible proof of the changes that were waiting for me at the threshold of my life as a legitimised concubine.'

They set off for Château l'Arc. During the journey Annabel started to talk about her nervousness at becoming its chatelaine, only to find that her husband of a few hours was sound asleep. 'The stew, the snoring husband, me done up in an uncomfortable skirt, a far too prestigious car . . .' It took all her self-control to keep the black thoughts from completely crowding her mind during the two-hour night drive across country to her 'new and gigantic home. I tried to forget the intimacy of our pink hideout, I had to pull myself together. My dogs, Noblesse and Sibelle, had been sent on ahead. I knew that they were waiting for me; their presence would help me.' And sustained by the thought of being reunited with her pets on her wedding night, Mrs Buffet endured the gloomy drive through the December night.

It must have been after midnight when Bernard awoke just as the Rolls came on to the impressive tree-lined avenue leading up to the splendid chateau, which had been floodlit in anticipation of the happy couple's arrival. The nearer they came to the splendid shimmering sight, the deeper Annabel's spirits sank.

In a great hall hung with crimson brocade a fire burned in a monumental fireplace, throwing flickering shadows across the ceiling. Apart from her two dogs, the only other thing that looked remotely welcoming was the bottle of Scotch that had been left on a silver tray along with an ice bucket. Buffet poured his wife a generous tumbler of whisky. Then he told her to wait and promptly disappeared.

I felt an overwhelming urge to flee and sat, struggling to find a semblance of calm. Disoriented, tired, I wanted to cry. Trained since childhood to stay on my guard, and not to have the indecency to show my feelings, I buried my sobs deep inside. I was *thirty years* old. I had not married under duress.

Steeling herself, she decided that if she could not feel indifferent to the situation, she would at least act it. She arranged herself in a Louis Treize fauteuil, stroked the head of her greyhound and became so absorbed in her imaginary *mise-en-scène* as Mrs Bernard Buffet on the cover of *Vogue* that she did not hear her husband open the door.

He told her to follow him to the first floor, where in the library she found not the orgy that Martin Summers had seen, but instead

an orgy of flowers, and there on the wall, as if it had been there for all eternity, my portrait . . . It had been to prepare this surprise that he had left me. What I had taken for selfishness, the tour of the owner, the satisfaction of looking over his restituted 'property', was in fact a new mark of tenderness. New proof of the attentive love with which he surrounded me.

This time her self-possession deserted her, as she abandoned herself to tears and poetic metaphors. 'Tears of joy washed my soul of doubt, of helplessness, and drowned me in the love of this man, who, day after day, taught me happiness.' Using language that manages to unite the usually opposed spirits of Georgette Heyer and the *Histoire d'O*, she recalls how

In the middle of the night, on which he became the legal owner of all my being, of the deepest part of me, I realised that this was not just an agreement on paper. I had entered into slavery. Needless to say, the veal stew and the monotonous journey were already no more than

a comic interlude. As to my fears about the bourgeois and gentrifying effects of marriage; by dawn they had been well and truly allayed.

Exactly what means Bernard Buffet had used to strip away the bourgeois connotations of wedlock is, alas, left to the imagination. But the following morning Buffet made an extravagant gesture that was both symbolic and concrete.

Our bedroom was separated from the studio by a wall. We were in bed, I was sleepy, he wanted to work and neither one of us wanted to be apart from the other. So, in the early morning, armed with a sledge-hammer, striking it like a madman, Bernard attacked the thick parti-tion. He went fiercely at this hole in the wall until he had opened a gaping passage. No barrier has ever stood between us since.[12]

Meanwhile in Paris, at six o'clock in the morning, the news broke on the radio that Buffet was now married. An hour later, further details emerged, including the salient fact that Annabel had worn a yellow roll-neck sweater. One of those who listened to the news was Jean Cocteau, who had received an 'affectionate' letter from Buffet. Bergé was of course aware of it too, and there is the tantalising suggestion in Cocteau's diaries that the younger man still cared enough for the painter to hope for reconciliation. 'I wrote a letter to Pierre in which I advised him not to play the ridiculous role of a male lover deceived by a woman. I advised him to manage the couple's fortune and to remain on the scene until the divorce. "Don't forget," I said to him, "that Bernard is a born divorcé." Civil marriage. Because of his first divorce,'[13] notes Cocteau tersely.

For all the elaborate subterfuge and the discretion of its ceremony in out-of-season Ramatuelle, Buffet's wedding was highly publicised after the event. The marriage of the greatest living French painter after months of speculation was, after all, bound to attract attention. Annabel says that he married her 'so that I would not be considered just his bit on the side'.[14] But in the context of Buffet's need for love and an almost claustrophobic level of companionship, a speedy marriage after the split with Bergé could be seen as an additional means of binding Annabel to him, in effect contractually locking in his life partner. Bergé and Annabel could hardly have been more different from each other, but their experience of life with Buffet was

identical in one respect. Just as Bergé marvels today that he never spent a day apart from Buffet during their life together, so, after ten years of marriage, Annabel would observe, 'I had never been apart from my husband for more than an hour.'[15]

However unreasonable it may seem – and after all, love and passion are the antithesis of reason – even though he had walked out on Buffet, Bergé may well have felt wounded that Bernard had decided to share his life with a woman, and in his eyes, a trivial woman at that. Certainly the passage of time did nothing to ease the sting of waking up that December morning in 1958 to learn that the lover he had left just a few months earlier was now a married man. Speaking about Annabel fifty-five years after their marriage, Bergé remained withering. 'It is not my fault if he married someone who was not really very interesting.'[16] If that was how he felt in the second decade of the twenty-first century, it can be imagined how he might have reacted when the news was fresh.

However, four hundred miles south of Bergé and Cocteau, in the middle of the French countryside, the newly married Mr and Mrs Buffet could not have cared less what the gay gratin of Paris made of their sudden marriage.

That Saturday morning, as Buffet wielded his hammer with the strength of a lunatic, filling the air with noise and showering his bride and his bed with plaster and dust, Annabel must have finally been relieved of the fear that had crept up on her in the days before the wedding. 'How I was afraid of marriage! Shaky relationships, sordid divorces were too frequent for me to renounce a deep-rooted superstition, according to which the legal recognition of our passion would bring us bad luck.'[17]

But if Annabel had been disabused of such a foolish notion, there were nevertheless ominous signs that, as the 1950s drew to their close, Buffet's decade-long run of luck was about to turn.

Chapter 22

The Fifth Republic

On 27 December, *Jours de France* published its last issue of the year. Its cover carried a statesmanlike portrait of General de Gaulle seated at a desk in a sober striped suit, silver tie and white Charvet shirt; behind him is a tapestry. At the bottom of the page – not that anyone in France in 1958 would have needed telling – the picture is captioned 'Charles de Gaulle, Président de la République'.

The year had been a momentous one for France. The Algerian war that had been the defining issue of the Fourth Republic had not been solely confined to North Africa. Official figures suggest that three quarters of a million Algerians arrived in Paris between 1947 and 1953, but it is likely that the actual number living in the city was much higher. The struggle had spilled on to the streets of Paris as early as 1953, when police had shot and killed a number of Algerian militants, and by 1957 the press had dubbed one area of the city the 'Medina of Paris'[1] and declared it a no-go zone for Europeans.

On 13 May 1958, at about the time that Buffet and Annabel were being photographed in the sun of Saint-Tropez by Luc Fournol, there was a military coup in Algiers. A 'committee of public safety'[2] under General Jacques Massu, backed by Pieds-Noirs (French expats) who felt that they had been abandoned by a weak and vacillating political elite in the mother country, seized power. Massu, a diehard Gaullist, wanted his hero, de Gaulle to lead France. De Gaulle placed himself at the service of the nation, and to help focus the minds of the disintegrating government of René Coty, paratroopers from the French army in Algeria seized Corsica on 24 May. Had President Coty not called upon de Gaulle to come to the aid of France, it is likely that the highly trained and motivated renegades would have attempted to seize power in Paris. A new constitution was drafted, and in October 1958, as Buffet was holed up in the garage of the Villa Tibur painting his New York landscapes, the Fifth – and current – Republic came into being.

Initially it seemed that Buffet would occupy the same central posi-
tion in French public and artistic life under the Fifth Republic as he
had in the Fourth. On her first visit to Château l'Arc, Annabel observed
that Buffet 'had just done the portrait of General de Gaulle for *Time*
magazine'.[3] *Time* had a tradition of naming a man of the year, and it
was no surprise to find that on 5 January 1959, the American weekly
news magazine conferred this honour on General de Gaulle, using
Buffet's likeness of the French leader on the cover. It was not the first
magazine cover that had featured the names of both Buffet and de
Gaulle: the same *Jours de France* that had placed the leader of the
Fifth Republic on its cover had also used the cover line 'Bernard Buffet
metamorphosed by love',[4] appearing in a box above the General's
thinly haired pate (Buffet's portrait was rather more generous when
it came to covering the presidential scalp and smoothing some of his
facial lines).

Of course the timing of the *Time* magazine cover could hardly have
been more propitious given the annual February exhibition at the
Galerie David et Garnier on the Avenue Matignon, where his New
York landscapes went on show. If cynics had seen a hint of carefully
managed publicity in the premiere of the Sagan ballet and the Buffet
retrospective the preceding year, then this year there could have been
no doubt that a PR coup was expected, as Annabel's first novel was
published on the very day that Buffet's annual show opened on the
Avenue Matignon.

The theme of the exhibition was New York. Today, with transat-
lantic travel demystified to the point that it is almost as banal as a
bus journey, it is hard to imagine the excitement of visiting New York
for the first time more than half a century ago as, driving in from
what was then still known as Idlewild airport, the famous city of
glass and concrete towers revealed itself. The contrast with the French
capital could not have been more marked. Buffet had left a Paris that
would have been familiar to Manet, Renoir and Lautrec to arrive a
few hours later in the city of the future. America was rich and
powerful; moreover, to Europeans it was just as exotic and intoxicating
as the world of Gay Paree was to Americans. American cars were
status symbols among the European rich, American jeans were *le
dernier cri* among the youth of Saint-Germain-des-Prés, and avant-
garde American artists were being taken seriously by an increasing
number of Europeans.

As with any Buffet exhibition, there was the usual media interest, and one magazine commissioned his friend Georges Simenon to write a proleptic paean to the painter that would answer the increasingly audible mutterings to be heard around Paris: that Buffet was too much talked about, that he was a product of cunning dealers who were manipulating the market, et cetera.

What counts is what we saw at the Charpentier Gallery when, to the outrage of some, it organised the retrospective of a thirty-year-old painter: crowds coming from morning to evening, queuing up on the pavement as if for a solemn event, the real crowd composed of people of all kinds, workers, students, typists and shopgirls all seeking on the walls the reflection of a world they learned to love and which has become a little of theirs.

Tomorrow, New York will never quite seem the same again as in spite of ourselves, sometimes unbeknownst to us, we shall see it with the eyes of Buffet.

Having eulogised Buffet, Simenon turns to his wife.

The young man of yesterday is married and television has shown him walking away hand in hand with a young woman as tall and lithe as him.

Legend has begun to take hold of her as well. She was known only to a small crowd, what the English call the *furious generation*, as if each generation had not its Musset and its Rimbaud in revolt against a world of which they refute the rules.

Tomorrow, she publishes her first novel and the legend will grow around her.

We will hear much of them. But no doubt we will see them little, and after the media has finished stalking them, they will move on again, stealthy, solitary – in solitude for two, this time – to expand their universe and ours.

Bonne route, Bernard and Annabel![5]

However well-intentioned Simenon's words may have been, they merely fuelled the Buffet backlash, as the observations of the critic and philosopher Pierre Restany made clear.

All the socialite admirers of the artist *en vogue* had their rendezvous at the *vernissage le plus snob* of the season. Before their avalanche of praise, my opinion will probably carry little weight, but I could not resist the temptation to proclaim aloud, from some final internal moral scruple, that only very rarely does the Buffet of today exceed the artisanal level, that is to say the manufacture of the 'Buffet object' emptied of all content and all artistic emotion. These linear and graphic 'magazine layouts', in cold and acid colours, may have had the ambition to represent the deleterious void of a dehumanised metropolis. The artist has greatly exceeded his aim as this is painting without warmth, without soul and without presence that serves only to give value to a commercially well protected signature with high quoted value.[6]

Buffet had been criticised before, but contrary to his protestations, Restany's observations are of interest because of what lay in the future for both him and art. At the time, Restany was in his late twenties but already friendly with Yves Klein, with whom in two years he would create the term 'Nouveau Réalisme' to describe a movement that would come to number among its members such significant figures of late-twentieth-century art as César and Christo. In 1960, Restany would write a manifesto for Nouveau Réalisme, at the centre of which was the championing of 'new perceptual approaches to reality'. Buffet, by inclination a loner, loathed artistic movements, and the idea of 'new perceptual approaches to reality' would have struck him as just more risibly pretentious bullshit. But like it or not, this was the way that art was heading, and if at the beginning of 1950 the *New York Times* had run the headline 'To Them Picasso Is Old Hat', by the beginning of the following decade there were those who believed that Buffet himself was *vieux chapeau*.

No matter how much he painted – and he painted a great deal – no number of canvases was great enough to hide the man who created them. Even those who supported the artist now found it impossible to follow Maurice Garnier's maxim that Buffet's work should be viewed without reference to Buffet the man. They agreed more or less with Restany that a Buffet was first a Buffet and second a painting. 'What if this exhibition were the first show of a stranger?' pondered Jean Bouret in *Les Lettres Françaises* after visiting Buffet's New York show.

Critics would seize on him wholeheartedly to praise him, some in the name of a powerful and assertive realism, others for what to them would be the so clearly abstract depiction of the American city; and a last group for its haunting magic surrealism. Each would be at leisure to find in these paintings his own interpretation of the world, because it is well known that each finds in painting what he wants to find, and first his own image.

But with Buffet this was impossible.

It does not matter whether this is the 20th or the 50th exhibition of Bernard Buffet, the painter is no more judged by it, but by the image that has been shaped over the 15 years, because Buffet has the happiness or misfortune to be one of these 'sacred monsters' of the intellectual media. Too many articles have been written about Buffet which, alas, were not by poets nor even critics, and they forged a legend which is difficult to discard.

Now Buffet the legend was becoming more important than Buffet the artist. 'Today the painter is paying for this accumulation of articles in romance magazines, in women's newspapers, in tabloid magazines; it is Buffet, but is he still a painter for all these people who stalk him and his young wife?'[7]

So that he has 'a clear conscience' – suddenly to both supporters and detractors Buffet has become a matter of conscience – the critic rereads what was written about Picasso when he was Buffet's age and finds 'the same phrases, the same venom, the same predictions, the same curses, which never prevented Picasso from continuing his work'.[8]

However, Buffet was not Picasso. The Spaniard had not had the misfortune to find success in his teens. He had only left the insanitary squalor of the Bateau Lavoir in Montmartre in September 1909, a month before his twenty-eighth birthday. By then his paintings had been selling well and he had become sufficiently financially comfortable to move to an apartment on the Boulevard de Clichy, which he furnished so opulently that one of the removal men lugging his belongings upstairs observed that 'these people must have hit the jackpot'.[9]

Clearly Picasso enjoyed the material fruits of his work just as much as Buffet and Bergé. The difference was that while Picasso celebrated

his twenty-eighth birthday as the occupant of a Paris flat, by the time Buffet was in his late twenties he was a world-famous millionaire with a Rolls-Royce and a castle. Picasso only moved into his Provençal castle when he was in his sixties.

By the age of thirty, Picasso may well have had a lively personal life and suffered attacks from envious rivals and critics who could not see in him the genius that would make him the defining artist of his era; but all this happened in the relative obscurity of a bohemian slum quarter of Paris at a time when the latest advances in information technology were represented by a telephone that looked like a small lamp post and the mute flickering images of early moving pictures. By contrast, at the age of thirty, Buffet had lived in the spotlight for a dozen years in the age of television, colour photography and jet planes. The mechanics of fame and riches had changed greatly in half a century. Moreover, while Picasso tasted success and fame as a mature and experienced man, Buffet had fame thrust upon him as an awkward, undeveloped, unworldly adolescent. By the standards of the world of young pop stars, film stars, fashion stars and sports stars, who were learning to live life at the end of a photographer's lens, he coped much better than many teenagers would have done in his place.

His celebrity status aside, Buffet's chief 'crime' was his popularity. Maigret may have been as much of a cherished national institution in France as, say, James Bond was in England, but having a successful crime fiction writer defend his work would have scarcely impressed the intelligentsia. Of course Buffet never sought to impress the intelligentsia, and as he aged he took an active pleasure in disdaining fashionable intellectual theories about art. As he saw it, painters should stick to painting rather than theorising. He believed that good painting appealed on a more profound and emotional level than the merely intellectual. He had little time for new perceptual approaches to reality, and nor did the majority of people in France at the end of the 1950s. His friend Maurice Druon believed that

Here the phenomenon that is Buffet is of particular importance. Even to the least artistically informed circles, and to those most remote from any chance of being able to buy, the name of Bernard Buffet has penetrated; it is known that this name denotes a painter, and even that it corresponds to a certain genre of painting which one can recognise

and discuss, whether sensibly or not is of no importance. People refer to it as to a known reality.[10]

For the intellectual snob, the difficulty with figurative painting is that it need not be difficult. It is accessible. Even those with little formal education – perish the thought – can appreciate a figurative painting and form an opinion as to whether it is good or bad. Of course it could be argued that at times Buffet's paintings verged on the abstract, in that he used the shapes formed by his subjects as vehicles for colour and texture. From early paintings of the studio in which the fenestration combines with easels to create an almost Mondrian-like grid to the austerely linear depictions of New York denuded of any signs of humanity, Buffet's paintings were never slavishly mimetic. As has been seen, his disregard for such basic rules as perspective when it suited him infuriated traditionalists such as Drouant, while the exaggerations and liberties that he took with his portrait subjects were enough for some to label him a caricaturist, a sort of Daumier for the *Paris Match* set.

Nevertheless, in front of a Buffet there is never any doubt what it is that one is looking at, and in that sense his work had the power, as noted by Simenon in his critique of the New York paintings, and by Cocteau after having visited the 1957 show of Paris landscapes, with streets as empty as during the wartime curfew, to make the viewer see familiar things afresh, appreciating them through the artist's eyes, whether the subject was a humble coffee grinder or the grandeur of the Place Vendôme. By contrast, abstract art can only be appreciated, at least at first, by having someone clever explain why a canvas of colourful shapes and splashes, or one painted solely in black, is superior, or inferior, to, say, a canvas that has been sliced by a scalpel. And at the end of the 1950s it was becoming clear that abstract art was triumphing over the figurative to become the 'official' art of the educated classes, much in the way that conceptual art would dominate the cultural dialogue in the early twenty-first century.

And in the Fifth Republic, abstract art would find that it had a powerful ally. André Malraux was appointed by de Gaulle as the Minister of State for Cultural Affairs. Malraux, a friend of Picasso – although he found it hard to forgive his communist politics – had been a young man in Paris in the early days of abstraction, and had even written a book about cubist poetry, and these youthful experiences

informed his mature tastes. In 1959, while visiting the Cannes Film Festival, where Buffet had also gone to see his friend Simenon, who was on the jury that year, Malraux announced the end of Buffet's sort of painting, saying, 'Great painting is no longer figurative.'[11]

'From that moment the French museum curators did not want to show him,' according to Maurice Garnier.

> The Ministry of Culture which was created by André Malraux in 1959 was the end of Bernard Buffet in the museums. They could no longer show Bernard Buffet. He was excommunicated. Malraux wanted to support French abstract painters and he was right, but it was not necessary to forbid Bernard Buffet in order to achieve that and he did forbid Bernard Buffet.[12]

Buffet would become increasingly bitter about what he perceived as a personal vendetta against him by Malraux. 'Malraux hated me. He thought painting should be abstract. We argued a lot. He didn't like figurative art – except for Balthus, who was his good Jew.'[13] The invocation of the racial policies of the Third Reich may not be in the best taste; nevertheless, it gives a sense of the degree to which Buffet believed he was persecuted. Certainly Malraux's effective relegation of contemporary figurative painting to the status of second-class art was unfortunate for Buffet, and even more so because Malraux remained in his job for ten years and was hugely energetic in his role.

It must not be forgotten that this was the height of the Trente Glorieuses; unlike at the time of the economic crisis half a century later, the state had money to spend on the arts. Although then as now there were always grumblings about budgets and it would be wrong to suggest that the Fifth Republic poured money into the arts, it is worth bearing in mind Pierre Bergé's observation that during the 1950s, the number of museums in Paris was considerably smaller than it would be half a century later, and this growth got under way during the Fifth Republic. Malraux clearly believed that he was on a state-sanctioned mission to improve the nation through the imposition of a progressive and intellectual form of cultural life, a vision of the arts that, unsurprisingly, reflected his own views. His most celebrated initiative was the establishment of *maisons de la culture*. The first of them opened in Le Havre in 1961 and signalled its status as a haven for and beacon of the avant-garde with its daring architecture. Even

in the building's appearance it is possible to see how far and how fast the cultural centre of gravity was moving away from Buffet, who lived in historic houses surrounded by historic bric-a-brac. This is not to say that Malraux was not aware of and sensitive to the art and architecture of the past – it is thanks to him that historic buildings were cleaned of generations of soot and grime – but he was also a man of the modern age.

Malraux had first mentioned the idea of *maisons de la culture* in the 1930s, and now he could realise the ambitious project to place one in every *département* of France to bring the arts to the widest possible number of citizens. As he himself said when addressing the Assemblée Nationale on 17 November 1959:

> There is a democratic inclusive culture and that means something very simple. This means that with these houses of culture, in each French department, we will disseminate what we try to do in Paris, so that by the age of 16 any child, no matter how poor he may be, can have a real contact with his national heritage and the glory of the spirit of humanity. It is not true that it is unfeasible.

Of course the dissemination of culture to the provinces was perfectly feasible: after all, anyone who had visited a dentist or doctor in France during Les Trente Glorieues was already in touch with his national heritage in the form of a Buffet reproduction on the wall, or an article about the artist in *Jours de France*, *Paris Match* or one of the other magazines left lying around the waiting room. But of course from Malraux's viewpoint this was second-class culture for second-class citizens, and not what he as minister of culture had in mind for the population.

As it happens, only half a dozen of these *maisons de la culture* got built over the course of a decade. But while blanket coverage of what might be called the Malraux manifesto was never achieved, it was abundantly clear that there was an officially sanctioned view of the arts, in which contemporary figurative art had very little role and from which by extension Buffet, as the nation's most high-profile contemporary figurative artist, was excluded.

Quite whether this amounts to what Buffet's supporters have come to see as a cultural pogrom promulgated against the artist by a ruthless state apparatus behind which the more imaginative

conspiracy theorists see the vengeful hand of Pierre Bergé is another matter.

However, it stands to reason that Malraux established a cultural climate in which it was easier for some individuals to flourish than others. Malraux may have been a remarkable man, of immense culture, but not every curator and museum director in France, or for that matter any other nation, then or now, can be said to have shared his unique gifts and outstanding qualities. Moreover, with the appointment of a minister of state to deal with cultural affairs, the arts became in effect a fully recognised branch of the civil service; and no apparatus of state can function unless it is staffed by those who share, either out of self-interest or, perhaps even more dangerously, genuine strongly held conviction, the views of their superiors.

As to a direct, ad hominem attack by Malraux, Buffet apologists have tended to make much of two rather trifling incidents that are, so they would have us believe, evidence of an official policy of exclusion motivated by personal malice. The first is a question put by a government official to Malraux: 'Why do you detest Buffet so much?' To which Malraux gave the answer: 'Don't talk to me about that individual.'[14] The second tells of how Malraux ignored, or pretended to ignore, David and Garnier one day when they were having lunch in a fashionable restaurant opposite their gallery, while his mistress Louise de Vilmorin felt no shame in coming over to say hello.[15] An alternative version takes place in the same restaurant, but this time it is Bernard and Annabel receiving the snub from Malraux while his mistress crosses the restaurant to exchange greetings with her old friend from their days in Dallas.[16]

However, in February 1959 Malraux had only been officially in the job for barely a month, his pronouncement of cultural apartheid concerning figurative art was still some months in the future, and for the time being at least, the voices of Buffet's supporters were still louder than those of his detractors.

Chapter 23

Art Brut and Black Pearls

In 1959, Buffet and Annabel went to New York and then Chicago for an opening at the Wally Findlay Gallery. In Chicago, the couple took in the sights. In particular, there was one aspect of the city's attractions that appealed to the newly-weds, creating memories that would last a lifetime. Looking back on this trip over thirty years later, Buffet would recall it with great fondness. 'I adore strip-tease, it is a taste I share with Annabel, and we took some risks to go and see it. When we were in America a long time ago, we visited all the strip clubs in Chicago – there were whole streets of them.'[1]

Perhaps he was too dazzled by those nights of nudity on the shores of Lake Michigan to notice, but looking back, it is possible to see that there was a kind of inevitability to the Buffet fatigue that was beginning to set in by the start of the 1960s. The reception in New York suggested a certain weariness.

> In recent paintings Bernard Buffet has ridden his particular attitude to life so hard that his gaunt and stylish manner understandably needs new subject matter if he is to continue the successful pace of his showmanship. Hence, perhaps, the motive behind his latest oils, entirely devoted to the Manhattan skyline, at the Findlay Gallery. Buffet keeps sentimentalism sternly out of these decoratively effective pictures. His feeling for exaggerated verticals, for skeletal linear compositions, for inhuman personality and for grim, positive color fits piled-up skyscrapers like a glove. These pictures would make excellent ballet decors.[2]

To return for a moment to Brigitte Bardot's buttocks: Hourdin had observed that the day the cinema-going public tired of Bardot's flesh, her value would plummet. While a simplification of the inexorable rules of the *vedette* system, what held true for a cinema sex symbol was equally applicable to the celebrity painter. Neither Buffet nor

Bardot would ever suffer materially. But fashion would move on, and just as surely as Bardot would be replaced as the embodiment of sex appeal by Catherine Deneuve, so, inevitably, Buffet would be toppled.

It is ironic that one of the first blows to rain down on him during the 1960s would come from the homonymous Jean Dubuffet, who in February 1962 was anointed by the *New York Times* as 'France's Leading Post-War Artist'[3] on the occasion of the opening of a major exhibition of his work at the Museum of Modern Art. Dubuffet was older than Buffet and had known Braque and Léger in Paris at the beginning of the century; but between the wars he had vacillated between art and the wine trade (his father had been a wine merchant). However, after the war he made up for lost time and worked using all manner of materials – sand, paint, bits of metal – peddling a new perceptual approach to reality that mixed splashes of colour, crude cave art and the techniques of graffiti. He called it l'Art Brut.

And if the enthusiasm of the *New York Times* is anything to go by, Americans loved this 'Raw Art'. 'The work of Jean Dubuffet, who under no circumstances is to be confused with Bernard Buffet, is the subject of a large and beautiful exhibition that opened Wednesday at the Museum of Modern Art,' reported the paper. The author of the article clearly considered Dubuffet a genius; amidst paragraph after paragraph of panegyric there are a few lines that explain why he was the perfect artist for the times. 'Dubuffet is a difficult man to explain, and although he has done very well in talking about his theories (few artists are any good at this) his art is ultimately inexplicable in the area that makes it more than an exercise demonstrating these theories. This is true of an art that rises above the merely proficient or even the merely brilliant.'[4] What a contrast to the perfunctory paragraph that had accompanied the selling exhibition of Buffet's *New York* barely eighteen months earlier

An art that rose above the merely brilliant. If there had been a checklist of qualities that defined the perfect artist of France's Fifth Republic, then Dubuffet would have ticked every box on Malraux's wish list: he was French; he was Malraux's age; he had hung out with the artists that Malraux had liked in the early years of the century; he was a dab hand at expanding on his catchily named theory of Art Brut; his work was so abstract that one could, as the *New York Times* critic enthusiastically did, project any meaning one liked on to it; and perhaps best of all, such was the intellectual complexity and opacity

of his oeuvre that even after he had finished telling you about his theories, it was still so baffling that you needed a clever art critic to explain why it transcended mere brilliance. An added bonus was that it was also rather colourful and decorative.

Unsurprisingly, Malraux loved it. When he visited the newly built university of West Paris in Nanterre at the end of 1964, he decided that what the place needed as a finishing touch was a major work by Dubuffet, and two monumental murals twenty metres long and four and a half high were commissioned – although as it happens, the commission was never completed.

Of course if Buffet had any theories about his art, he kept them to himself, and in the absence of words, it was his actions that were scrutinised. There were times when he behaved like a rock star. During a tour of America in the 1960s, for instance, Garnier recalled one important lunch in New York given by the French consul at which Buffet was the guest of honour, only for the artist to announce half an hour before that he did not feel like turning up.

Where Buffet had once been a champion racehorse in training, he began to live up, or perhaps down, to the public perception of the jet-set millionaire artist of *Paris Match*. It is hard to imagine a younger Buffet arbitrarily cancelling an important and commercially significant dinner; it is perhaps possible to see the influence of his marriage to Annabel in his changing behaviour.

And if, as Garnier suggested, Buffet bought his famous Rolls-Royce for his boyfriend Pierre Bergé, then he was equally generous to his wife. Increasingly the sort of show being associated with Buffet's name was the fashion show rather than the museum show. It began almost as soon as he was married, as one fashion pundit noted in March 1960.

A show of mixed jewelry is becoming increasingly rare around the top dinner tables in Paris and at theater premieres. Jewel boxes are being sorted over and only one kind of stone is given an outing at a time. Pearls are favorites in this one-of-a-kind treatment.

One of the directors at Dior, Madame Bricard, has long been famous for her all-pearl collection that began 30 years ago with a necklace with which she could skip rope.

Typifying the same trend in the younger set is the growing black pearl collection of former model and nightclub singer Annabel, now

married to painter Bernard Buffet. In the past year Buffet has bought only black pearls for the fingers, throat and ears of his new bride.[5]

According to Maurice Druon, Annabel's predilection for black pearls became 'as much a part of the Buffet legend'[6] as his chateau and his Rolls-Royce, which was probably not what Simenon had intended when he had predicted that the legend would grow around Annabel.

Buffet was besotted, as his 1961 exhibition showed. It comprised a series of portraits of his wife in a variety of outfits; his paintings evoke the idea of Annabel as a little girl. Yes, she was young and pretty, but not that young; one thinks back to the portrait of his niece that Hourdin singled out with the word 'tender'. However, looking at these pictures it is hard not to see Annabel as some kind of dress-up doll, one of those paper cut-outs that come with clothes to be fixed on by means of folding tabs. The titles of the works say it all: *Annabel en Robe du Soir, Annabel en T-shirt, Annabel à la Robe Rouge, Annabel à la Blouse, Annabel à la Tunique Grecque* (twice), *Annabel en Blue-jeans, Annabel au Bikini Rose, Annabel au . . .* you get the picture. They are accomplished, decorative, and as a series of period fashion illustrations they have charm. But depicting his wife as a clothes horse was probably not what he had in mind when he embarked upon this extended love letter in oil and canvas.

Of course the relationship between artist and muse is one of the recurring leitmotifs of art history: in 1959 and 1960, when Buffet painted these works, the most obvious comparison would have been with Picasso's paintings of Sylvette, a series of around forty fascinating depictions of the ponytailed blonde who worked in a nearby ceramics studio. Clearly the old man desired the pretty, awkward girl, but they are more than just an expression of an old satyr's lust; they are also a sort of test. Completed over a period of a few weeks, this concentrated series shows how he could paint exactly the same thing, often from an identical angle or perspective, and achieve a different result every time.

If Buffet's Annabels invited comparison with these paintings, then they suffered by it. It may sound harsh, but on the whole they veer perilously close to the sort of competent caricatures that an 'artist' in beret and striped jersey wandering the streets of twenty-first-century Montmartre might prepare as a tourist souvenir. Buffet cannot bring himself to record anything other than a saccharine image of an

infantilised woman with a 'cute' little button nose (the result of fifty-five minutes of surgery), big dark eyes of the sort that authors of romantic fiction would probably call 'soulful', and a neck of such unfeasible length that one thinks of Avedon's portraits of Gianni Agnelli's wife Marella. Their interest and value therefore lies not in their status as immortal works of art – they are not – but rather in what they reveal about the psychological state of the man who painted them. And they show a man besotted, infatuated, blindly in love with every last detail of his wife's appearance, which he discovers with an almost painfully adolescent idealisation.

During the 1950s, Buffet's women had tended to be cruel, night-marish distortions of femininity, their gender and humanity invisible behind rolls and folds of sagging flesh and distended pendulous breasts; or at best, as in the works such as the *Femmes Buvants*, haggard and miserable animated corpses, their eyes gazing blankly, hopelessly out of time-creased faces. Often they had not been women at all, but garishly dressed transvestites of the sort that hung around Pigalle and patronised Liberty's, for whom femininity was a sort of burlesque fancy dress outfit: camp, colourful and close to the clowns that would become his calling card. The exceptions were few. He (or perhaps Bergé) knew better than to apply this unforgiving eye and sadistic brush to the grandes dames of post-war Paris, who, like the women of Maupassant and Proust's time, had the power to make or mar artistic careers. He was similarly circumspect with the wives of his collectors. And there is the large canvas that was a homage to Courbet's Sapphic masterpiece *Le Sommeil*, although in this instance the sense is that Buffet's restraint is more out of respect for Courbet in partic-ular than women in general.

Gender stereotyping is always hazardous, but looking at the works depicting women that he created during his time with Bergé, it is hard not to perceive an echo of the fabulously bitchy opinion of Elizabeth Taylor that Cecil Beaton confided to his diary after photographing her at a costume ball, a commission he undertook with

disgust and loathing at this monster. Her breasts, hanging and huge, were like those of a peasant woman suckling her young in Peru. They were seen in their full shape, blotched and mauve, plum. Round her neck was a velvet ribbon with the biggest diamond in the world pinned on it. On her fat, coarse hands more of the biggest diamonds and

emeralds, her head a ridiculous mass of diamond necklaces sewn together, a snood of blue and black pompoms and black osprey aigrettes. Sausage curls, Alexandre, the hairdresser, had done his worst. And this was the woman who is the greatest 'draw'.[7]

And then suddenly Buffet gives us his vision of the ideal woman, perfect whether in Balenciaga or blue denim, a living doll.

This is not to say that there are no good paintings of Annabel. Far from it: he is rather better at painting her without clothes at all. There is one of her lying naked with her back to the painter, which hung at Château l'Arc: one leg bent, the other straight, the line of her right arm continued in the angle of her left shoulder. It is a masterpiece of painterly economy; imagine a painting with the energy of a sure and rapid sketch, only a sketch that is two metres long and almost a metre high.

Buffet had discovered the pleasure of heterosexual sex and, a late starter, he made up for lost time. He became friends with France's leading stripper, Rita Renoir, although of course France being France, taking one's clothes off was an art form, and Buffet revered her as 'a genius of strip-tease',[8] painting her portrait. Indeed, the dramatic opening of new sexual horizons is made abundantly clear in the paintings of this period. His 1960 screen of four slightly larger-than-life-sized nudes in stockings and suspenders is conventionally titillating and viewed in sequence recalls something of the opening titles of a 1970s James Bond film or Roald Dahl's *Tales of the Unexpected*. Rather more graphic is a painting he dedicated to Maurice Garnier in the same year: it depicts a naked woman on her back, legs apart, displaying the lips of her vulva to the viewer. Given that he was a lifelong admirer of Courbet, it is possible to see an echo here of the controversial 1866 painting of female genitalia, *L'Origine du Monde*. What these paintings showed was that Buffet had finally found a woman with whom he enjoyed going to bed and who knew what to do when they got there.

Annabel says that Buffet made her feel like a teenager. Likewise his paintings of her, both clothed and unclothed, bear witness to the lovesick, sex-crazed adolescent that Buffet had never time to be, because he was so busy hating his father and loving, then grieving, his mother, with the remainder of his energy absorbed by the task of depicting the misery and futility of human existence. The dozens of portraits of Annabel in different outfits and with different hairstyles

were executed with the sure and craftsman-like hand of a master draughtsman at the height of his powers. But he saw his subject through the idealising and worshipping eyes of a teenage boy in the throes of his first serious love affair.

Of course infatuation has a habit of affecting one's judgement, and early in his marriage he lovingly acceded to her every whim. If she wished to wear only black pearls, then her fingers, ears and that long neck would be covered in them. More remarkable still, given the rigid and at times academic historicity of his tastes in interior design, he allowed her to change the way Château l'Arc looked. What had once been a temple of good taste that blended modern comforts with monastic simplicity so perfectly that it moved Jean Cocteau to excited spasms of oxymoronic lyricism became a common bar of the sort that one might find in any village or working-class neighbourhood in France; not like a bar, or reminiscent of a bar, but actually a bar.

Clearly Annabel was not about to be another Rebecca moving into a grand home and being terrorised by its spirit personified by the evil housekeeper Mrs Danvers. She was going to cheer the place up, have a bit of a giggle and generally deflate some of the pomposity that she had felt when she had first turned up there with Michou.

It had taken the couple a year to assemble and install the fittings of a classic French café-bar-bistro. As Bernard explained, they wanted to do things properly, cutting no corners, lamenting that 'even in the country they have replaced old fittings with plastic'.[9] The handsome bar was of solid oak and had come from Marseilles, as had the mirror behind it. The shelves were ranged with bottles of Cointreau, cognac, whisky, pastis, vermouth and every other conceivable drink, intersticed with the occasional gaudy souvenir bottle of some exotic liqueur of the sort that remains at the back of a drinks cabinet unused and accumulating dust. There was even *bière à la pression*.

Alcohol was beginning to play an increasingly important part in Buffet's life. It will be remembered that as a young man, he had fuelled himself with amphetamines and rum. During his racehorse-in-training years with Bergé, he had drunk in relative moderation, but now, with his wife, whose decade and a half of solid drinking experience and years in the nightclubs of Paris had built up an almost Olympic-level of tolerance, he had fun dreaming up new knockout drinks, such as '*recontre au sommet*', which consisted of one part cognac, one part

whisky, one part Cointreau and two parts champagne, or 'l'hibou', a milder mix of just vodka, whisky and champagne.[10]

The rest of the room was filled with marble-topped iron-legged tables covered with all the appurtenances of a real bistro – bottles of oil and vinegar, carafes, condiments, Duralex tumblers, long-necked curvaceous bottles of Provençal wine and little vases of flowers – laid up as if in the expectation of paying customers. There was even a hat stand for convenience. The walls were plastered haphazardly with the confusion of images that might decorate a local village café or *bar de charactère*: posters, vintage belle époque advertising, postcards, *Playboy* pin-ups and, inevitably, some reproductions of Buffet's works, including his de Gaulle portrait.

When he welcomed *Paris Match* to see his latest masterpiece, the word '*chef-d'oeuvre*' was actually used in connection with this forensic re-creation of the French hospitality industry. Buffet observed that 'it is very nice to be able to go to the café without having to leave home'.[11]

It would have been interesting to see Pierre Bergé's face as he opened that particular issue of *Paris Match*, which along with the pictures of the bar showed the couple tête-à-tête and reproduced a handful of the more than thirty portraits of Annabel as a living doll. Somehow it is hard to imagine Bergé playing the '*machine à sous*' with which this café-bistro was equipped, as Jean Cocteau perches on one of the high bentwood barstools propping up the zinc-topped bar and Buffet plays barman, swapping banter, running a damp cloth over the counter and asking, 'What's your poison, squire?' Or its French equivalent.

It is tempting to see the contrast between the forensic level of kitsch of the in-house café-bistro and the gravitas of the formal rooms with their sombre, almost ecclesiastical air as a powerful metaphor for the change that Buffet was undergoing now that he was married to Annabel.

Certainly there is a cheerful and rather endearing vulgarity, or perhaps it is kinder to say irreverence, about the way that Annabel set her mark upon Château l'Arc. The carefully considered, almost museum level of refinement and period detail was joined by such anachronisms as the walkie-talkie with its long antenna, which, with a range of seven kilometres, enabled Bernard and Annabel to keep in touch when they were at opposite ends not just of the house, but of the estate. Moreover, it must be remembered that unlike Bergé and

Buffet, her upbringing had accustomed her to luxury. Bergé and Buffet had spent the 1950s escaping rather drab backgrounds by learning how to be rich and taking pleasure in accumulating the physical fruits of immense commercial success. Meanwhile Annabel had spent the same time fleeing the world of smart *mondaine* luxury in pursuit of a romantic ideal of *la vie bohème*.

'I had forgotten the luxury of my childhood and I devoted the first weeks to my apprenticeship,' she says of becoming the lady of l'Arc. 'I had been disoriented by all the noise around my new position and I was just starting to get used to it. At the end it was natural enough.'[12]

It may be true, as Gréco and Bergé say, that she was not a woman of the highest intellect or deepest profundity, and she may well have been vain and self-obsessed (after all, if you are worshipped by Bernard Buffet and painted over and over again, it is hard not to let that go to your pretty little head). However, beyond her obvious physical attractiveness there was a spontaneity about her that was extremely endearing. For instance, she loved Christmas with the enthusiasm of a child, and when she was chatelaine of Château l'Arc, she would festoon the place with seasonal decorations and even – *quelle horreur* – extend the decorations outside.

'Each year the collection increases,' she explained of the garlands and baubles that were stored in the attic. 'There are so many trees and I like the Anglo-Saxon custom, which brings the forest into the house. Yet the most beautiful, the largest, is outside, halfway between the chapel and the house. Throughout the year, in the middle of the others, it leads an anonymous existence. Then on the 20th of December, the boys' – the chateau had a large staff including José, who gloried in the title *valet de chambre*, Vicente, Maria, Paco, and Marie-Antoinette the cook – 'climb up its trunk and dress it in regal clothing. The most dextrous of them, Sauveur, puts a giant red illuminated ball at the top, from which cascade tresses of garlands.'[13]

Once again it is hard to imagine that such festive gaudiness as a giant illuminated bauble flashing on and off like a traffic light atop one of the trees outside this Louis XIII chateau would have created the right conditions for the muses to inspire Cocteau to one of his panegyrics. However, it is possible to argue that life with Annabel was more fun that it had been before. The relentless and skilful social manoeuvring of the 1950s during which Buffet had become the darling of the Paris salons and the pet painter of the grandes dames who saw

themselves as the heirs to Proust's *gratin* became less important. As a man married to a highly sexed and highly sexy young woman, Buffet lost some of his interest for the creaking and creased old fag hags of the Faubourg who had been so assiduously cultivated and flatteringly painted during the mid 1950s.

A couple of years after his marriage, he was asked if he painted any portraits other than those of Annabel. 'No,' he said, adding revealingly, 'To paint portraits on commission you have to need to.'[14] The implication is that the portraits he painted before were carried out either for money or for a commodity even more valuable: social and professional advancement. It is certainly true that after the angular early portraits of his immediate circle of friends and collectors, which were executed in his late teens and early twenties, the portraits dating from the Manines and Rolls-Royce period of the mid 1950s demonstrate a caricatural facility that is nonetheless flattering, strongly identifiable as the work of Buffet and exactly the sort of thing that one might hang on the wall of one's *hôtel particulier* for the admiration of one's smart, influential friends.

This is not to say that there were no interesting portraits from this period. Buffet's masterful 1955 portrait of the Académie Goncourt is a fascinating piece of work. It depicts a Mount Rushmore of literary achievement; old, impassive and inscrutable, the men in the painting exude gravitas. A cynical reading of the book of Buffet's art could take this group portrait depicting a group of elderly writers as a sort of literary court of cardinals, another form of flattery designed to ease his path up the Parisian Parnassus. It was not universally liked – Cocteau found it 'a little superficial and caricatural'[15] – but at the very least it proved to be a handy piece of PR: there is newsreel footage that shows Buffet joining his subjects for lunch around a large circular table, sketchbook at the ready. Certainly the worlds of Parisian society, its salons and its writers were well represented amongst the turnout.

Now, Buffet could only see Annabel. He was so engrossed in his marriage; in having sex with his wife, in painting his wife, in scouring Paris jewellers for black pearls with which he could adorn his wife much as she adorned the Christmas trees on 20 December, that he neglected, or did not really allow himself to be concerned by, the effect that this was having on his career.

The image of Buffet that has survived from the 1960s is of a jet-set figure, always at Maxim's or the fashionable Left Bank nightspots

Jimmy's and Castel, but if anything, he had been more conspicuously social when he had been living with Pierre Bergé. At Château l'Arc there had been the big summer parties, and the stream of prominent house guests from the worlds of fashion, arts and letters. In Paris there had been the round of salons, dinners and the obligatory attendance at fashion shows and so on.

Certainly Mr and Mrs Buffet were out and about on the Paris scene, but even though they willingly welcomed the colour magazines into their country home during the weeks before the annual exhibitions, one of the reasons Annabel liked having her own bar – convenience and ready, tempting selection of alcohol apart – was that she enjoyed being able to visit a café 'without meeting anyone else'.[16] Buffet, naturally shy and still in the early ecstasies of love, readily acquiesced to his wife's wish to spend time alone or *en petit comité* with just a few close friends such as Luc Fournol or the ever-loyal Maurice Garnier. As a fledgling novelist, Annabel is almost like a starstruck teenager when she meets her husband's writer friends. There is Jean Giono, who drinks Campari contrary to his doctor's advice. There is a 'marathon of *nuits blanches* with tons of alcohol and conversation that was clever or silly depending on the hour'[17] with Georges Simenon in the early summer of 1960, after the Cannes Film Festival; Simenon was president of the jury that year. Of course the festival gave Buffet the chance to paint another picture of Annabel, this time sashaying down the Croisette in a hat and sundress, shadowed by a Rolls-Royce.

But increasingly their country life appears to have become relatively quiet, partly out of inclination and partly because they were being discreetly dropped by some of their old circle.

Annabel had been surprised, puzzled and saddened to find that not all her friends had been happy for her.

> The carapace of indifference in which I had taken refuge, that was my second skin, was chipped without me noticing. In opening up to happiness I had become vulnerable . . . I was wounded by the hatred that my marriage unleashed in my former accomplices. They reproached me for being happy. A curious concept of friendship. But their nastiness did me a favour. From now on that which was not 'us' would become 'the others'. I wanted us to be loved or hated as a couple.[18]

Nevertheless, this ostracism clearly continued to upset her. 'Our marriage has lost us a few friends, among them Françoise Sagan. I don't understand them. The happiness of others upsets them perhaps,' she told one visitor in the summer of 1961. 'Do we have friends to stay? Yes, from time to time. But they have to be real friends because Château l'Arc is very isolated. In fact we live the whole year without any distractions from outside,' she continued. 'We don't get at all bored,'[19] she said about her life in Provence, adding for good measure, 'We destest the life in Paris.'[20] It is possible to detect a certain defiance, and a touch of perhaps protesting too much, in her observations as to the couple's social self-sufficiency.

Chapter 24

The Coming of the Anti-Picasso

The picture of the young artist in the Rolls-Royce was the defining image of Buffet in the 1950s, a single *clin d'oeil* or snapshot that summed up the Buffet phenomenon and that would dog him throughout his life and after his death. There is, however, another photograph, much less well known but perhaps even more damning and representative of the direction in which Buffet's reputation was heading.

Having painted Paris and New York, it made sense to complete the triumvirate of world cities, and in November 1960 Buffet made the trip to London with the aim of depicting the British capital. He spent just a few days in the city; one highlight of his visit was a lunch at the famous Prospect of Whitby pub in Wapping, where he was much taken by the then still active London docklands. Thanks to what the London *Times* termed his 'capacity for concentrated observation which enabled him to produce an impressive series of London landscapes after a first visit of a few days',[1] he was back in London at the beginning of March with enough paintings for a show at the prestigious Lefevre Gallery. As usual, it is a city without inhabitants that Buffet paints, but in these canvases he demonstrates a variety of techniques, locations and perspectives that was not evident in the architectural documents of Paris and the linear exercise of the New York paintings.

The London works show what is best about Buffet as a painter of cities. These are paintings by a man who understands the importance of history, and how a city like London is neither a unified architectural vision like the Paris of Baron Haussmann, nor the constantly renewing and self-devouring spectacle of sheer-faced angular modernity presented by New York. It is instead an accretion of its past, a palimpsest, and Buffet's pictures understand this. Just as Cocteau said of his Paris paintings and Simenon observed of his New York canvases: one sees the city anew through Buffet's work. The buildings depicted are familiar: the Palace of Westminster, the

Tower of London, St Paul's Cathedral, Tower Bridge, and the cranes of the docklands.

Even though the first Clean Air Act had been passed in 1956, Buffet's city was still the *locus classicus* of the pea souper. In some canvases the famous landmarks appear nicotine-stained, and in one picture of the famous clock tower at the Houses of Parliament, Buffet has managed to reproduce a quite startling effect. It is probably a clumsy way of describing it, but the entire canvas gives the impression of being a photograph taken through fine rain, with the photographer being jostled at precisely the moment that the image is captured: the spires and crenellations of Sir Charles Barry's famous and flamboyant pastiche of the Gothic are elongated with deft flicks of the brush; the effect is the very Buffet one best described by the French word *hérissé*, like a hedgehog, bristling and spiky. His ochre view of barges passing under bridges, the riverbanks lined on each side with a phalanx of cranes, forming a sort of tunnel that leads all the way to Tower Bridge in the distance, manages to evoke Turner and Monet while still being Buffet. Other paintings, meanwhile, have the mathematical quality and sense of precision of a Canaletto.

Speaking to *The Times* at the time of his London opening, he gave an insight into his working methods.

He relies, he said, largely on memory, though he would make sketches of detail or notes of composition on the spot. He smiled when I commented on the number of industrial chimneys he had introduced among the cranes in his 'London Docks'. Memory, he conveyed, had brought out this salient impression. His aim, he added, was to fix the general structure of a scene (either in buildings or landscape character) without attempting to include human interest.[2]

They are paintings of which he could be justifiably proud. However, it is not the pictures that are remarkable, but rather the photo call arranged to promote them. A picture of Annabel and Buffet looking lovingly into each other's eyes or exchanging furtive lovers' smiles among his February crop of canvases had quickly become a media tradition. Already this convention swayed on the brink of schmaltz, and in 1961 it toppled over and sank to an embarrassing nadir when the couple consented to be photographed in raincoats underneath an open umbrella, flanked by his paintings of London. After all, everyone

knows that it always rains in London, just as everyone knows that all Frenchmen walk around in berets with strings of onions around their necks and that all Americans wear Stetsons and cowboy boots.

If he could not take his work seriously, why should anyone else?

The days of performance art, when crass stunts such as this could be passed off as witty ironies, lay a long way in the future. This was just cheap publicity-seeking at its most desperate; had Buffet dressed up as a London policeman, it could hardly have been more embarrassing. What is particularly troubling is that someone had clearly put thought into this and felt that it would be a good idea. Looking at the picture today, it is easy to be harsh. After all, it may be that he and Annabel were already wearing matching trench coats and that when they had turned up at the gallery it had been raining. They may have been just about to put the umbrella into a stand when the photographer had had this particularly luckless inspiration and asked them to hold the moment and stand between the pictures. Maybe Annabel thought it would be a bit of fun. Maybe Buffet was having a light-hearted (or light-headed) moment when he agreed. They may just have been playful and slightly provocative and thought, 'Sod the lot of them.'

Buffet's supporters had defended or excused his love of luxury, his fondness for giving after-show dinners at Maxim's, his Mediterranean cruises and his castle, but it is hard to find an intellectual justification for this. Even supporters from the old days found themselves increasingly pre-emptive in their defence, and some of the critics who had at first considered him a genius began to drift away.

Even Pierre Descargues, the companion of his youth who had invested so much of his time and his own reputation into the Buffet phenomenon, found himself itemising a long list of caveats and issues that needed explanation or accounting for before a full appreciation of Buffet could be reached.

Success, he said, had come in 'a devastating way'. Buffet had been greeted 'as a young genius. Bankers and the women of the world invited him to lunch, bought his paintings, offered him villas in which to work. Buffet started with unanimous encouragement, fans of abstraction making him the exception that proves the rule, the leader of the figurative revival.'

He had moved to the Vaucluse, said Descargues, first 'because he had an urgent need to live calmly, then because he knew that he had

to put an end to the tragic teenager he had been until then'. So sudden had been his appearance and so compelling was his depiction of both troubled youth and dramatic times that 'everyone was wondering if born of war and crisis of adolescence, he and his work would survive for long. The odour of death that one inhales from Buffet's paintings, the extreme frailty one saw in the painter appeared to allow one to believe that the meteor would soon extinguish itself.'

Then Descargues gives voice to the shocking idea that Buffet might be better off dead. He 'could have died, leaving an outstanding body of work that would have still held the attention of art lovers and psychologists. It would have made him a tragic figure of youth, of the war; newspapers would have called him the Rimbaud of painting (and they would not have been completely wrong) and he would have joined the romantic cortège of young geniuses who died too young.'

However, Buffet was alive and well, and when he was not sheltering from an imaginary London shower under an umbrella, he could be found serving drinks from behind the bar of the bistro that he had installed in his castle in the South of France.

'He survived, and it was then that everything became difficult.' Descargues goes on to enumerate what is in effect a charge sheet of counterintuitive artistic decisions taken by Buffet.

> People began to reconsider the work of Buffet from the brilliance of his 'cursed' youth and concluded that really he wasn't going in the right direction. Critics were more scathing, there were more sour looks and pulled faces leaving the gallery where he exhibited every year or the Charpentier Gallery where he showed one hundred paintings in 1958. This led to the prediction of the breaking of a second Buffet scandal. The first made him a star. The second will cut off not his future, because he will paint without respite for as long as God grants him life, but his career.[3]

There is much more to this long and thoughtful essay written in 1961, but its import can be gathered from the subtitle. Just as the *New York Times* would take away Buffet's status as France's leading post-war artist and present it to Dubuffet, so Descargues would replace Buffet's long-held position as 'the most talked about artist in France after Picasso' with something much more ambivalent: 'Is the most discussed painter of our era, the anti-Picasso.'[4] Antichrist, anti-hero, anti-Picasso . . . it

is a troubling prefix, and although Descargues is far too much of a
subtle thinker to deal in binary choices of good and bad, there is
nonetheless the suggestion of diametric opposition to what Picasso
stands for, beyond the abstract versus figurative debate: constant evolu-
tion, critical acclaim, an unshakeable reputation, and acceptance by
the serious art world – in short, success.

It is almost possible to see Descargues wrestling with the 'evidence'
and reconciling it with his admiration for the painter and affection for
a friend, doubtless recalling the long road that he and Buffet had
travelled together since the days of the Rue des Batignolles and the
ill-starred first exhibition on a day of blizzards and strikes.

Descargues never quite lost faith in Buffet, but by the early sixties
he was troubled, his opinion of the artist affected by what religious
people call doubts. Already in the 1950s he had felt that he needed to
excuse Buffet's love of the high life and his presence at fashion shows
and on the jury of the Cannes Film Festival. Half a century later, of
course, a social profile, appearance in gossip columns, friendships with
celebrities and so on would all become important components in the
success of an artist; viewed in purely cynical terms, the artist, as much
as the work, would become a social trophy.

In the early twenty-first century; with the inflated prices being paid
for contemporary art making the sums paid for Buffets during his
lifetime look insignificant, and with the international caravanserai of
Biennales and globally franchised branded art fairs offering the new
rich a ready-made social life; being what Hourdin described as a *vedette*
has become just another part of the profession of artist. Besides, why
shouldn't an artist be entitled to a social life? However, in the earnest
and rather high-minded European contemporary art world of the
1950s and 1960s, with artists coming up with pretentious theories and
creating manifestos, there was an invisible line between the worlds of
serious artist and socialite; and Buffet was beginning to find that while
it was easy to make a one-way trip across this frontier, a return journey
was almost impossible. Plus he did not really see why he should play
the game. He had always been his own man; as far as he was concerned,
his paintings spoke for themselves, and with an arrogance built on
foundations of insecurity, he was damned if he was going to smear
on some bogus intellectual veneer and dress up his work with a label
or theory for the benefit of those critics such as the one at the *New
York Times* who was so enamoured of Art Brut.

As an old man, Descargues looked back on the work of the painter he had met over half a century before and came to the conclusion that Buffet's work had represented an alternative future that had never happened.

Buffet hoped for a role as a witness of society and a potential corrector of its flaws. He believed that the painting could be a magnified expression of the present, as it had been for thousands of years and until the 19th century. Seeing that the national structures of art were in a state of decomposition, leaving the field open for living art, the adventure could begin. But neither officialdom nor the opinion-forming press followed the painter in his effort. The society on which he had counted no longer existed. It had ceased to believe that art was necessary for its development. It had entrusted the plastic arts of its time to museums of modern art and to the design industry. It looked for nothing more from living art than its aesthetic and fashionable qualities. Was it an abandonment, a resignation? Such fundamental developments often come about without our knowledge. But only taking a step back do we see them.[5]

Maybe Buffet himself had been unaware of this mission to restore art to a position of social importance, or maybe he was aware of it at a visceral level. However, as a thoughtful and sensitive man, working hour after hour in his studio, it must surely have occurred to him to wonder why he painted as he did. If he reached any conclusion, he did not share it with his public or the critics. It is perhaps why religious faith remained so important to him, in that, in all humility, he could believe that he had been given a gift by God, which came with an obligation to exercise it.

It was of course far simpler to retreat into the anti-intellectualisation of his work and to make the disingenuous claim of being merely a conscientious craftsman. 'When I am in the studio I am a painter. When I leave, it is finished and I don't talk about it,' he once observed. 'You don't have to be intelligent to paint. You don't ask a painter to be clever, but to make good paintings.'[6]

'He considers himself a manual labourer,' explained Annabel, and 'he judges himself with the severity of a perfectionist'.[7] Even his love of clothes – like General de Gaulle, his shirts came from Charvet on the Place Vendôme and the features of one of the famous *chemisier*

salesmen appeared in his canvases – became a statement of rebellion against what he saw as the pretension of the art world. According to Annabel:

> Contrary to what one might think, the disappearance of false bohemia is not a right-wing provocation; far from it. At the beginning of our marriage, I scolded him for dressing like a notary when we went out. He explained that he found the idea of an artistic form of dress ridiculous and preferred passing as a man of law rather than dressing up . . . Bernard is a manual labourer and gets very dirty when working. He changes each time he leaves his workshop and whenever he returns. I know it irritates him and that these multiple stripteases are an extra effort. However, he is right when he points out that a mechanic does not come to the dining table dirty with oil, nor a baker covered in flour. Simple people have the clothes and the respect for occasions.[8]

Simple is perhaps the last adjective that anyone would append to Bernard Buffet. But as one more relatively trivial example of his desire to swim against the current of the times – bearing in mind that by the early 1960s, the beatniks were already presaging the all-out rejection of formality of the hippies – his desire to look like a lawyer or a mechanic or a baker in his 'Sunday best' is telling. What others might see as a symptom of selling out and joining the bourgeoisie who bought his paintings is in reality a complicated piece of inverted snobbery too subtle for many to grasp; and as the sixties started to swing, this most complicated of simple men became further and further estranged from the *soi-disant* serious art world.

Chapter 25

Creativity on a Production Line

'Contrary to popular legend, I do not work quickly, I work a lot. There is a difference.'[1] While Buffet's timetable varied throughout his life, and by the mid sixties he favoured starting at around four o'clock in the afternoon and finishing at around two o'clock in the morning or later, he never slackened. With practice and experience came facility and ease. Still in his thirties and blessed with a stout constitution, he could keep up this pace for weeks on end, and while he said he did not work quickly and may even have believed as much, the truth was that his output was astonishing. He was once asked why he painted themes each year. His answer was typical offhand Buffet; words to the effect that the works exhibited each February were just a small fraction of what he painted in a year and that – well, one had to exhibit something, so why not themes?

One of the accusations that dogged him throughout his career was that of overproduction; even today the number of works in circulation is not truly known, but is estimated at around 8,000–10,000 oil paintings. As has been seen, Buffet had outstripped the lifetime output of Renoir before he was thirty. Only Picasso and Warhol were as prolific.

Perhaps he painted so much to avoid having to think too hard about why he painted. Certainly he liked to paint and felt uneasy when he did not have a brush in his hand, seeming to want to process the entirety of creation through the pointed end of his paintbrush. Descargues believes that Emmanuel David was culpable for exploiting this.

I never understood how he made Bernard Buffet agree to painting works in series, so that he achieved the rhythm of producing a picture per day. And sometimes more, as needed, to make gifts to wives, sons . . . Creativity cannot survive on a production line. Bernard Buffet resisted as long as he could. What would have happened if, instead of

confiding in David, Buffet had responded to the proposal of another
dealer who handled Juan Miró, the surrealists and later Riopelle, Kallos,
Mathieu and Vieira da Silva? The gallery was in Saint-Germain-des-
Prés. It was the Gallery Pierre. The dealer was named Pierre Loeb. Beyond
the choice of a dealer who encouraged him to produce more and more,
the reasons for the failure of Bernard Buffet are more general.[2]

Descargues is nothing if not consistent: he wrote these words in
2001, and back in 1958 he had written more or less exactly the same
thing, speculating what might have been had Buffet gone to Loeb.
There appears to be a slightly puritanical streak in Descargues that
reacts against the worldliness of Emmanuel David, the slick salesman
with the smooth manners of a man of the world. He clearly believes
that Buffet is degrading himself when, for instance, in a still life he
shows an envelope bearing the address of the Galerie Drouant-David.

Certainly accusations of overproduction and the suggestion that
he was not best served by his merchants occur with frequency. Indeed,
Pierre Bergé is quite vociferous.

> I was complicit, probably culpable. I believed so much in his genius.
> Everything turned out badly. A war between dealers broke out. The
> most crafty carried him off. The truth is that he never had a dealer
> the equal of Kahnweiler, Rosenberg, Pierre Loeb, Vollard. Able to
> understand him – above all to understand the painting – to talk to
> him, to warn him, to guide him. In the face of those struck dumb
> with admiration he started drifting, unable to see that he was going
> to crash, to lose himself. They were content to reassure him, to meet
> his needs, and to play the role of banker, secretary, steward. He knew
> nothing, they hid everything from him. He no longer had any contact
> with life or the art of his time.[3]

Not one to sugarcoat things, Bergé maintained this view right up until
a few weeks before Garnier's death, describing the windows of the
gallery as *'une grande tristesse'*.[4]

Not unexpectedly, Garnier's view of the situation was somewhat
different.

> Pierre Bergé has done many very, very good things. He discreetly helps
> many people in difficulties, but discreetly. He has excellent sides, Pierre

Bergé. I know him well, I know that there are two faces: a generous intelligent face and a nasty face.

With me, he was always charming. I had no problem with him, during the eight years when he lived with Bernard. Pierre Bergé was very lazy. I, too, was lazy, but I was forced to work and I worked and Pierre Bergé, he was lazy but he went to work afterwards. But when I arrived at the Château l'Arc, I found a stack of unopened letters. I was forced to pick up the mail and open it.

Among this stack of mail were unpaid bills; Garnier would later recall how on at least one occasion he received an alarmed call from Buffet to say that bailiffs had threatened to visit Château l'Arc.

'Pierre Bergé has said, even if it was not against me in particular, "these" merchants were his bankers, secretaries and nannies.'[5] Far from disputing that at one stage or another he had been all these things to Buffet, Garnier was proud to admit it, because as he saw it there could be nothing more wonderful for a painter than to be relieved of all quotidian cares and be free to just paint.

For me these are qualities: being banker, secretary and nursemaid. It's great. For him it was a criticism. For him, he imagined that the role of an art dealer was guiding the career of the painter and knowing what he should paint in order to make sure that he is in the trend of the time, and that he follows fashion. This is not it at all. When it comes to a painter like Bernard Buffet it is not a matter of following fashion.[6]

Garnier then revealed how after their split, Buffet gave Bergé the rights to handle the distribution of his work. Bergé recalls one final interview with his former lover, in the autumn of 1958. 'I saw him only once again. We arranged a meeting at Château l'Arc, he wanted to get rid of his two dealers David and Garnier and he asked me to take his career in hand officially. But I wasn't an art dealer and it would not have worked.'[7]

However, according to Garnier, this is not the entire story: the bidding war between dealers that Bergé recalls in his memoirs was instigated by Bergé himself, and Garnier's recollection of the events is that the terms proposed by Bergé were simply too onerous for any other gallery to want to take him on. What is more, for a period of

time after leaving Buffet, Garnier recalls Bergé coming to the Galerie David et Garnier to collect a monthly allowance. This gesture of generosity on the part of Buffet shows that even though the two men were no longer a couple, he still held Bergé in high regard and high affection. It also demonstrates a rather touching level of trust in those close to him.

And when it comes to the accusation that it was his dealers who forced Buffet to paint on a production-line basis, Garnier countered by saying that Bergé too profited from his partner's industrial level of production.

> Starting from the moment when Pierre Bergé appears in his life, we see that there is a year where he started to paint many small flowers paintings. Why? Because Pierre Bergé wanted money . . . It was in 1951 to 1952. It is not 'these' merchants who asked him to paint these small flower paintings; it is Pierre Bergé, who wanted money.[8]

Garnier remained trenchantly dismissive of Bergé's verdict on the artist: 'For the eight years that Pierre Bergé lived with Bernard Buffet, Buffet had talent, but the day that Pierre Bergé no longer lived with him, Bernard Buffet had no more talent.'[9] It is an oversimplification, but it does loosely correspond to the received wisdom about the painter: that his work up until the second half of the 1950s was exceptional and important, while the remaining four decades were almost an embarrassment. According to Bergé:

> It is not because of me, it is not because I left. I do not believe that, I think that things had already turned bad. The Buffet I knew was an extraordinary painter. Moreover, one day, I would very much like to mount an exhibition of Bernard Buffet in the 'early years'. That is to say, 1946, 47, until 1955, 56, 57, something like that. For ten years, I think he was a very, very important painter. A very great painter. I simply think that in ten years he had said all that he had to say and then, when he had no more to say, he repeated, and repeated and repeated. Et voilà.[10]

Garnier contended that Bergé's views were affected by a degree of bitterness.

Firstly it is he who left with Yves Saint Laurent, not Bernard who left him, and it was afterwards that Bernard left with Annabel. And Pierre said in front of Françoise Sagan in September 1958: Bernard affronted me when he left with Annabel. Had Bernard remained at home crying quietly awaiting the return of Pierre, Pierre would have found that all very well, fine. Had Bernard left him for a boy perhaps he could have taken that. But he could not take it that Bernard left him for a woman, a famous woman and on top of that a woman who at the time was very beautiful.[11]

Chapter 26

A Slender Matador in a Large Suit

Leaving aside the question of Bergé's feelings about Buffet's taste in women, it is simply wrong to suggest that all Buffet did was repeat himself. Certain themes, most notably flowers and clowns, were revisited periodically, sometimes in exhibitions but more often as readily saleable pieces. But throughout his career he also tackled new subjects and used new techniques, some successful, some not. Certainly in the first half of the 1960s there is the strong sense that Buffet himself seemed to have realised that he needed to pull off a creative coup that would restore the lustre to his tarnished reputation.

Take for instance the bizarre series of paintings that went on show in February 1960. *Les Oiseaux* (*The Birds*), seven monumental and densely worked canvases, is easily amongst the most disturbing set of paintings of his career, rendered all the more disquieting because of the artist's reluctance to offer any explanation. The largest of the canvases was 5.3 metres long and 2.3 metres high, but the scale only amplified the strangeness of the work. Eroticised female nudes lie in the Provençal countryside that Buffet had first painted almost a decade earlier; completing the composition in each canvas is a large bird straddling the naked woman. The bird, the scale of which is completely out of proportion, sometimes appears to be unaware of the woman and seems to have strayed into the canvas almost by accident.

The effect is startling to say the least. As much as the portraits of Annabel were saccharine platitudes, these new canvases were bold and utterly bewildering. There were calls by *Le Figaro* for the exhibition to be closed, and Paris demonstrated just how scandalised it was by forming queues that snaked 100 metres along the Avenue Matignon for the two months that the exhibition was on to fully acquaint itself with the shocking canvases.

The legend of Leda and the Swan was invoked as a classical precedent, and indeed the theme of this particular example of a sexually

incontinent Zeus turning himself into an animal to have sex with a mortal woman has been frequently interpreted by artists from antiquity to the present day. However, it is the apparent randomness of these works that is so startling. Beyond the British slang reference that describes women as birds, there is nothing to connect human and avian subjects. Given that Buffet loved animals and loved Annabel, it is safe to assume that they are a sort of love letter in thick impasto. Nevertheless, in the juxtaposition of the oversized birds with the overtly sexualised female nudes there is something of a warped, unsettling adult *Sesame Street* about this series of works.

Of course, in true tight-lipped '*oui, non, peut-être*' style, Buffet declined to give any elucidatory gloss, unlike the loquacious Dubuffet, whose garrulousness in explaining his own theories so impressed the *New York Times*. Buffet's silence forces the viewer to react individually to these paintings rather than be conducted to an intellectual conclusion. Much later, towards the end of his life, he said of his work, 'I don't think my oeuvre is academic paintings. I never think about paintings. I only paint them. I am not the type of person who thinks carefully. I am an emotional and natural human being.'[1] And it is an emotional response that he wants to evoke in the viewer.

It is hard to see this series of paintings as drearily repetitive of anything that came before, or indeed predictive of anything that would succeed it – unless of course all one wanted to see was the distinctive 'praying mantis' branded signature. It can be argued that there are familiar Buffet elements here: the Provençal landscape, his love of the animal world, and his post-Bergé depiction of naked women not as grotesques but as compellingly sexually beings. But they are combined in a new way. It is almost as if he is showing not merely his own versatility, once again demonstrating that he can handle colour and use it generously, but the fundamental versatility of figurative painting, using representational imagery to convey an idea so abstract that it is not even anything as cogent as an idea. In the works' disturbing sense of menace and their controlled eroticism, it is inevitable that today, like some beautifully painted Rorschach test, they prompt an association with another surreal and frightening work of the 1960s involving menacing winged creatures and an idealised representation of a certain type of sexually desirable woman. *The Birds* of Alfred Hitchcock, starring the archetypal Hitchcock blonde Tippi Hedren, was released three years after *The Birds* of Bernard Buffet.

When it is considered that Buffet was not painting *The Birds* in isolation, and that more or less contemporaneous works include the forgettable portraits of Annabel, an exhibition of film stars that was shown during the 1960 Cannes Film Festival, and the virtuoso London landscapes, accusations of slavish repetition become hard to sustain. It was almost as if he were setting out to prove his detractors wrong to claim that he was more than an *enfant terrible* past his sell-by date who had sold out to live the bourgeois life of a country gentleman on his estate. And it was on his estate, in conditions of secrecy, that Buffet was, at the same time, working on a series of paintings that must surely be counted among his masterpieces.

Buffet often painted Château l'Arc. He clearly had an affection for the house in which some of his most tumultuous life events had taken place, and the view towards the chateau framed by two inclined umbrella pines became familiar through both his own work and the numerous photographs taken during his time there. But turning one's back on the chateau and looking along the path, the eye alights on a more humble low-built structure, flanked by two wings to create in effect a courtyard without a fourth side. This tidily symmetrical group of buildings served sometimes as studio space. The central building was a chapel, which Buffet restored and for which he painted a quite remarkable suite of works.

The early 1960s sees the spectacular rebirth or reappearance of Buffet the religious artist. If Cocteau and Matisse had their chapels, Buffet was not about to be left out, but this was not the result of a cynical dealer guiding the artist's career and nudging his charge towards the artistic trend of the time; it was a genuine emotional response.

> At the David et Garnier art gallery recently Paris was confronted with a somewhat unorthodox picture of Judas, turning his back on Christ and the other Apostles. And so discovered a new Buffet, a mystical Buffet, in the tradition of Matisse, Le Corbusier and Cocteau. The young artist was trying his hand at religious art, in his own fashion, in black, yellow and red.
>
> People either like this dark, violent painting or they don't, but all are agreed that these fragile faces possess a remarkable mesmerising quality. The exhibition was also significant in underlining the extraordinary success of Annabel's husband.

> At the age of thirty-two he could afford the luxury of exhibiting
> paintings which could have fetched millions, but none were for sale.[2]

So announced the newsreel footage that showed Bernard and Annabel
walking among the paintings that Buffet had been working on at
Château l'Arc and which were exhibited at the Galerie David et Garnier
in 1962.

The works that went on show that year are a sustained aesthetic
high-wire act, with Buffet balancing his own identifiable style and an
interpretation of the Christian faith that while idiosyncratic was of
profound personal importance with the entire canon of Christian
devotional art. The modern-day crucifixions that characterised his
work immediately after the war; his 1951 *exposition choc* of three monu-
mental canvases depicting the Passion of Christ; a book of his drypoint
engravings of the Passion brought out in 1954 by the Paris art publisher
Henri Creuzevault in a limited-edition run of 140 copies . . . all of
them had been but a rehearsal for this.

In saying in an almost offhand way that Buffet was trying his hand
as a religious artist, the jaunty-voiced narrator of this newsreel showed
himself unfamiliar with the early work of the painter; not so Madeleine
Ochsé, writing in *Ecclesia*. Her work *Sacred Art for Our Time* had won
the Académie Française's prestigious Prix Charles Blanc in 1960, and
her assessment of Buffet as *enfant terrible*, religious painter and
Christian make intriguing reading.

She says she detects 'something of the Cathar in Buffet. He goes
fiercely at the human body and all that is carnal with a bitter sadness
that falls like little cold rain on the hurricanes of despair.' This is
an ingenious way of understanding Buffet and his relationship with
religion. The Albigensian heresy, as Catharism was known by the
Catholic Church during the Middle Ages, was founded on a
duotheistic reading of the Bible, in which the 'bad' God of the Old
Testament was balanced by the 'good' God of the New Testament.
This esoteric mutation of Christian faith was spread by ascetic
preachers who taught that the body was impure, having been created
by the hand of the bad God; while the immortal human soul was
the work of the good God. This is of course a monstrous oversim-
plification of a theological question that obsessed medieval Europe
and provoked a savage suppression dignified by the name of
the Albigensian Crusade. Nevertheless, it offers a neat way of

understanding Buffet's religious beliefs, and could also account for what Descargues identified as the 'self-disgust'[3] with which he painted. Here was a man who corporeally surrendered himself to drink, drugs, material excess and sex with both men and women; and yet he was spiritually drawn to the Christian faith, moved by the tragic narrative of the New Testament, revisiting it frequently throughout his career.

Catharism seems to have seeped out of Byzantium, that Petri dish of ecclesiastical and liturgical oddities, before making its way across Europe, and there is something almost Byzantine about these paintings. Very early Christian art did not focus on the Crucifixion but dwelt on more conventionally attractive aspects of the religion: miracles, resurrection and so forth. 'The simple fact is that the early Church needed converts, and from this point of view the Crucifixion is not an encouraging subject,' writes Lord Clark in his typically confident manner, explaining the first millennium or so of Christian art as having the aesthetics of a recruiting poster. 'It was the tenth century, that despised and rejected epoch of European history, that made the Crucifixion into a moving symbol of Christian faith. In a figure like the one for Archbishop Gero of Cologne, it has become very much what it has been ever since – the upstretched arms, the sunken head, the poignant twist of the body.'[4]

In dispensing with any hint of perspective painting, an art that was lost to the medieval world and only rediscovered in the Renaissance, Buffet places his paintings in this tradition of early mystical Christianity. The strangely unexpressive faces nonetheless seem to radiate tenderness and humanity. 'We have not said that our painter was perfectly Christian. He believes in God, and the man of Sorrows fascinates him. An insightful eye detects tenderness and pity in his work,' writes Ochsé, pausing to 'wonder if Bernard Buffet does not use cruelty to defend himself against a sensitivity that tears at him'.[5]

It is the combination of the austerity of the line – the triangulation of faces, robes and even flasks of wine, the skeletal rendering of the unclothed body – with the rich palette of red and gold, the painting of haloes and the sunburst effect of the panels that makes these such striking works. Even his characteristic mordant, angular script is turned to the service of the work; it has something of early graffiti about it: monumental, deliberate and visceral.

The writing of Bernard Buffet is a cry. In drawing the figures of his great Passion of 1961 the painter has felt the need to make the images talk; He has given them a human voice and they address us directly: 'Have pity, Mother, behold your son – Jesus Christ – Judas.' The words are huge and twisted, stuck like rusty nails in the wall that is the background of each picture.[6]

The photographs taken by Luc Fournol documenting the work in progress have an almost voyeuristic quality to them. In marked contrast to the usual posed and sometimes downright kitsch *Paris Match/Jours de France* fare, Buffet seems so comfortable in the company of Fournol that he appears genuinely unaware of the camera. We see him working with an intensity so powerful that it leaps out of the black-and-white print and across the decades with freshness and feeling: a high-definition film shot with all the technology of the twenty-first century could not improve upon the immediacy of these images.

The intensity and absorption with which he worked on these pictures was absolute, as one of his guests at Château l'Arc during that Provençal summer of 1962 would recall.

He invited me one afternoon to see his studio, where he was finishing the panels for the chapel.

It was a big barn, the size of a public garage. The canvases made to fit the chapel walls were all around – on easels, on the floor, on tables, hanging from the ceiling. They were magnificent. Unprepared to be in the middle of this miracle, I was silent and bewildered.

Suddenly Bernard was absent. He had a problem, something he wanted to change on one of the panels. I did not exist. Bernard was alone. He attacked the panel angrily. His movements were sure, definite, the judgment instantaneous and exact. I had time to look around. On a table the length of the studio and the cluttered floor were the proofs of his monumental physical work – no quiet organised labor but a battle of chaos. No colors carefully squeezed on his palette but enormous wrought pots with fresh-dried colors splashed on hard mounds of blue skies, white walls, green leaves, and black lines. A jungle of boxes were filled with new colors and thousands of twisted and discarded tubes – a hodgepodge of empty cigarette packs, hundreds of bottles of oil and turpentine, large plates everywhere covered with

all shades of colors, a jam-packed disorder, this was the working room
of the *one* the gods had chosen.

Surrounded by the religious panels where every line and every color
and every composition listens to his will, I felt that I had trespassed in
his special world. I left quietly. Bernard never noticed my leaving.[7]

The paintings were installed in time for the wedding of two of the
household staff of Château l'Arc, and the restored chapel was conse-
crated with a midnight Mass dedicated to St Bernard in December. It
was one of the rare occasions when the Buffets opened their house
to more than just a close circle of friends, and there was a festive
dinner at the chateau afterwards. When the works went on display
in Paris, their impact was so powerful that when in front of the paint-
ings, the largest of which was six metres long and two metres high,
'visitors to the exhibition on the Avenue Matignon believed themselves
to be in the chapel of Château l'Arc and lowered their voices and
were rooted to the spot in unaccustomed silence'.[8]

These works are now at the Vatican. Talking about them in later
life, Buffet adopted a carapace of indifference. 'I used to live in a house
near Aix, and then I moved. And there was a little chapel that
I converted. I didn't know what to do with the pictures, which were
quite big. And it happened that Pope Paul VI's secretary asked me if
I would give them to the Vatican, and I was delighted to.'[9] For many
years the paintings were on show in the Vatican museum in a room
next to the Sistine Chapel.[10] Sadly, they are no longer on show, nor
do they appear to have aged well; according to the Vatican's Dr Micol
Forti, 'It is not possible to see them since they are stored in our store-
houses, very fragile, and some of them have to be restored.'[11]

Buffet's whirlwind of creativity during the early 1960s continued.
In the year that the paintings from the chapel of Château l'Arc went
on show at the Galerie David et Garnier, the Marseilles Opera
announced that it would be staging a revival of *Carmen* designed by
Bernard Buffet. The excitement in the port city, where Buffet had
found the bar for his in-house bistro, was electric: 'The posters, deco-
rated with a drawing by the painter, had had to be placed behind
wire-netting to discourage anonymous collectors from tearing them
down while the paste was still wet.'[12]

This was no trivial *moins de trente ans* project with too many fash-
ionable collaborators and not enough substance; this was proper

culture, and Buffet took it seriously. There is something almost heroic about Maurice Druon's description of his friend at work; he uses language a little more decorative but essentially the same as that used by the friend who saw him in his studio at work on his religious paintings.

Supporters and friends often talk of Buffet's working methods in terms of a duel or a struggle, one man testing himself in the accomplishment of an immense task, and in the awed description given by Druon one is taken back to a day in the early 1960s when Buffet, Annabel and Druon appeared at the Marseilles opera house to cast a final eye over the stage set. Buffet spotted a fault, and as a perfectionist he set about correcting it, only to find that each brushstroke led him further and further into the heart of this giant work.

> I remember seeing Buffet, the day the sets were set up – or the day, rather, when the sets should have been set up and lighting arranged – entirely repaint, between six in the evening and midnight, the huge curtain intended for the Overture, which had been lowered for the first time from the flies.

> It was first a line he found unsatisfactory, lacking in vigour; he asked for a paintbrush and a pot of black paint. Then it was another line which, owing to the strengthening of the first, now looked thin by contrast. Then it was the outline of the Seville bullring against the canvas sky, then the Spanish ladies, with mantillas held in place by large combs, whom he had placed on the tiers. He asked for more brushes and more buckets of paint. The scene-shifters operated the curtain, raising or lowering it to bring the portion of the design he wanted to work on within reach. He worked with assurance, and at prodigious speed. A slender matador in a lounge suit, isolated by the ardent sun of a projector, he was using his brushes like banderillas, fighting some invisible bull concealed behind this gigantic muleta.

> I understood that day why all painters, particularly those who work standing, dream, one after the other, of doing their 'corrida'.[13]

Like Picasso, Buffet would indeed go on to execute a marvellous corrida series in 1966, with Annabel as the model for the matador and the initials BB picked out in blood on the rumps and flanks of the dying bulls.

Buffet at work was a spellbinding spectacle. In a rare, perhaps unique instance, the intensity, exactitude, sureness, speed and total absorption with which he worked became evident to all those in the auditorium that day. The struggle of artist against canvas, which was usually conducted in the cloistered privacy of the studio at Château l'Arc, was that day a public contest, not unlike the boxing matches that he enjoyed attending with Bergé; the difference being that while modern boxing matches were divided into a maximum number of bouts, each just a few moments long, this was a struggle more akin to the bare-knuckle marathons of the preceding centuries, when combatants fought for as long as it took for one man to leave the ring as victor.

We were three privileged spectators of this fight: Louis Ducreux, the director, Annabel Buffet, the painter's wife, and myself as a friend. Three spectators, and the scene-painters. The latter, at first, seemed surprised and even rather vexed; they were highly qualified and extremely conscientious professionals; they had reproduced the painter's sketch with the greatest precision and integrity. But they soon realised that Buffet was not so much retouching their work as transforming his own. They became attentive deacons, or *peones*, if one may pursue the comparison, respectfully handing the high-priest of a difficult art the accessories he required. And while Buffet was completing his fresco, peopling his ideal arena with an immobile and tragic crowd, I heard one of the scene-painters, a young man, who had gone to the back of the house to judge the effect, murmur: 'Well, of course, it's Monsieur Buffet!'

And this was quite simply a statement of his superiority. The first-class professional, the specialist, talking to himself, gave Buffet the title 'Monsieur', as one does to masters.

There is a sad irony about what Druon writes next. 'This happened in 1962. I imagine that if this Marseilles scene-painter, one day towards the end of our twentieth century or the beginning of the next, tells his grandchildren of this recollection, he will say: "If you had seen Monsieur Buffet, when he was repainting in our presence his curtain for *Carmen* . . ."'[14] As the late afternoon turned from evening into night and Druon watched fascinated as Buffet wrestled the gigantic canvas into shape, he thought that he was a privileged witness to a

defining moment in the history of twentieth-century art; the setting of a seal of some sort on the oeuvre of the painter. What he understood to be the acknowledgement of Buffet's innate virtuosity by an artisanal theatre worker was to his eyes just one more piece of evidence testifying to the irrefutable genius of this painter of destiny.

The rather more prosaic truth was that if, half a century afterwards, this scene-painter from a provincial opera house had been able to recall the event, the grandchild to whom he was relating it would probably have needed to ask 'Monsieur who?', so effectively would Buffet be erased from the cultural life of France.

Chapter 27

The Most French of French Painters

In the first half of the 1960s, those who remained loyal to Buffet were rewarded with an extraordinary range and diversity of works, themes and techniques. Unless one were one of the artist's truly intimate circle, there was really no way of knowing what might meet the eye upon crossing the threshold of 6 Avenue Matignon: the surreal and disturbing *Birds*; the technically impressive depictions of London; the sickly schmaltz of the Annabel portraits; the hush-inducing emotional power of the Cathar Buffet's excursion into the realms of Byzantine and medieval Christian art; or a series of densely worked paintings of Venice, the best and largest of which are possessed of an incredible wallpower.

February 1964 was no exception. For this year he had chosen to engage in another type of artistic struggle, showing, in addition to a series of animal paintings, sculptures of butterflies and insects – except that he did not describe the butterflies and crickets as sculptures but as 'paintings in relief',[1] three-dimensional 'paintings to be placed in the middle of a room rather than hung on its walls'.[2] At one time just such a painting in relief of a skate could be seen in one of his characteristically curio-populated interiors.

Here, with paintings of biological veracity, magnifying such humble creatures as the stag beetle until they filled large canvases, as if preserved in the cabinet of some Brobdingnagian natural history museum, he was reliving the one happy memory of his schooldays at the Lycée Carnot, when his science teacher Jean Roy had recognised his talent, shown an interest in him and taken him to the natural history museum.

As usual, Buffet gave interviews at around this time to promote his work, and what is interesting about this particular year is that one sees him becoming an old man. It is almost as if the painting of these animals and insects that had so captivated him as a child had made

him aware just how much time had passed since he had left school. In one sense it was not a huge chasm of time, barely two decades, but his had been a life rich in incident, and along with the astonishing change in his circumstances, it must have seemed more than a lifetime ago that he had been the pale, wan child. No longer a walking skeleton, he was now becoming stout; his hairline was inching its way higher up his scalp, and incipient jowls and the beginnings of a double chin could be seen. He remained good-looking, but no matter how well he looked after himself (and the evidence would indicate that he did not take particularly good care of himself), painting at the rate he did and creating the monumental canvases that he specialised in was physically demanding.

When interviewed by *L'Express* in February 1964, the enigmatic epicene youngster with his intriguing half-smile and infuriating *oui*, *non*, *peut-être* had been replaced by a middle-aged curmudgeon. The second question that Buffet was asked was whether he was tired of life. 'Not at all,' came the answer. 'I like life and I like a good rest. To me death is nothing else.'[3]

However, he did seem tired of modern life. When asked if he thought he lived during a great age for painting, he was adamant. '*Détestable*. It is a great era for science, not for painting. In painting we are suffering the rebound from an extraordinary 19th century.' As to the question of whether there was any modern painter who interested him: 'Not really. There are only minor masters. They do minor things.' Indeed, he did not seem to have much time for anything of the century in which he lived.

Braque?

'A total lack of imagination.'

Cubism?

'Nothing.'

Snack bars in museums?

'Disgusting.'

'I detest intellectuals.'

'I find modern architecture horrible' (in which case it was just as well that he had not been asked to contribute anything to the University of Nanterre). He even did not care especially for the cleaning of major landmarks; it was acceptable, so he said, for the Louvre because that was beautiful anyway, but when it came to the Opéra, he found the effect 'shocking, it would be better for it to be black, as it would

benefit from the erosion of the years'.[4] It is perhaps worth recalling that the programme of cleaning public buildings is arguably what Malraux is best remembered for, so even if this was not a calculated insult to Malraux – and there is no reason to believe that it was – it can be seen that art was not the only thing on which the two men held very different views.

Buffet had begun to adopt a siege mentality: 'The hatred by which I am surrounded is for me the most marvellous present that I could have been made – I do not have to care about anything or anyone – few people can say as much.'[5] Variations on this point of view – another was 'The hatred with which I am surrounded is a stimulant'[6] – shaped his *Weltanschauung* for the remainder of his life. Certainly the isolation from the currents of art was no great loss to him: in his eyes, Rembrandt was the greatest painter and it had been downhill ever since. 'La Grande Peinture more or less stopped with Courbet.'[7]

It perhaps came as a relief: in some way, the sense of being persecuted would have been familiar from his childhood, when he had felt the cruelties of the world with such anguish and sensitivity. At such moments, close friends saw a mixture of endearing childish bravado and affection. 'I am also deeply attached to his childlike weaknesses of blatantly talking tough instead of whining as he tries to be stoic, and feigning misanthropy, while wanting to love someone,'[8] said one who knew him well. As he neared middle age, Buffet was getting in touch with his inner child, not of course that he would have had any time for psycho-jargon.

The insects and sculptures that he preferred to call paintings in relief were not the only echoes of his childhood to be found in his work at this time. In 1962, he had published a volume of engravings entitled *St Cast, Childhood Memories*; just 125 copies were printed. Buffet's angular, graphic, highly contrasted style suits itself uniquely well to engravings, and the resulting bleakness was frequently in keeping with the spirit of his subjects, but in this instance there is, if not quite cheerfulness, then certainly affection and warmth. It is almost as if Buffet is creating for himself the idealised photograph album of his childhood; the sense of a family album is enhanced by the commentary in his own hand. But whereas the domestic photography of the 1930s was clumsy and unsatisfactory, these images are reproduced with all the sharpness and clarity of memories that may have been a generation old but which had been carefully treasured and lovingly

set down. 'Labour of love' may be a cliché worn to near meaningless by overuse, and yet it is the only possible description for this very personal body of work. The dedication on the frontispiece says it all: 'To my mother'.

And it is this same tenderness that seems to characterise his domestic life with Annabel and a very small circle of friends. There is one particularly touching image taken by Fournol; it shows the couple walking hand-in-hand up a path on a summer's day, a dachshund trotting along by their side. Although black and white and over half a century old, it conveys a sense of place so strongly that it has one almost straining one's ear to hear the crickets filling the air with their aestival thrum, the eternal soundtrack of Mediterranean summers. It manages to be moving, casual and glamorous all at the same time. The two profiles are silhouetted against the landscape, bright with the blinding sun of that distant Provençal day, frozen forever through the magic of the camera lens, the couple unconsciously echoing each other's movement symmetrically, their arms swaying and their feet raised mid step in a perfect mirror of the other. There is a balance and harmony about this photography, the sun at its zenith, the couple and their canine companion in the foreground, the trees creating a proscenium arch beyond which is the stage of the Château l'Arc on which they play out their life together. Moving and beautiful, it speaks eloquently of the affection and security that characterised Buffet's private life, and as the obloquy around him intensified in the coming years, he would need all the personal stability he could find.

Sitting in his Louis XIII castle with his beautiful wife, Buffet might have been tempted to see himself as some chivalric figure venturing forth to Paris each February; a lone figurative Paladin ready for a clash of arms with the forces of abstraction, modernism and pretension. He certainly had a sympathy for the character of the knight errant, and was inspired by Cervantes' *Don Quixote* at various points in his life: most notably during the 1960s, when he made some ink drawings; and again in 1988, when he painted a suite of works for his February show.

In February 1965, he entered the lists again with *Les Écorchés*. Just looking at these flayed human beings, whose eyes stare, lidless, into ours, is a draining and unsettling experience. It is impossible to imagine the state of mind of the painter as he worked away at these paintings, piling on the pigment until it lay thick almost in bas-relief on the

canvas. The austere brushwork, which for his chapel paintings gave that beatific, radiating, sunburst effect, here delineates strings of muscle and tendons. This is as much an emotional as an anatomical baring of the flesh.

All twenty canvases were painted in one furious burst in September 1964. It is amazing to think that at the end of a gruelling session in the studio, Buffet put his brushes down, took a step back to survey his work and then calmly left his studio to rejoin life. Perhaps, if there was time, he might catch a thriller on television, or read one of his friend Simenon's economically written novels, or head into the bistro l'Arc, fix himself one of his powerful house cocktails and idly feed a few coins into the one-armed bandit.

Muscles, tendons, vertebrae, cartilage and bones are offered up to the viewer in all their grisly, bloody magnificence as if part of some mass human sacrifice in which, though deprived of their skin, the sacrificed remain alive. It is easy to apply glib home-made psychological readings of these works, seeing them as some sort of personal Ecce Homo, Buffet laying himself bare, and just because it is easy, it does not necessarily follow that it is untrue. But there is also defiance with the defencelessness. Although more than naked, these figures retain a terrifying power. Could he be challenging his critics to do the same and examine themselves inside their *maisons de la culture* and their newly cleaned ministerial offices, without the shield of their prolix theorising?

Of course, he may just have felt like painting dozens of flayed human beings.

Certainly Pierre Cabanne, who had been impressed with Buffet's audacity in placing the everyday objects of post-war Paris in the middle of empty canvases and calling them art, saw a tour de force. The headline of his article in *Arts* was eloquent and simple: 'Buffet Rediscovered'.

Suppose that the exhibition of 'Heads and Figures' that the Gallery David and Garnier presents had taken place at an avant-garde Left Bank gallery and that the artist had not been Buffet, but one of the young hopes of the Nouvelle Figuration, all the 'intelligentsia' of Paris and so-called 'advanced' critics would shout that it was a miracle! Instead it is likely that the oracles of fashion will pout and shrug their shoulders and talk of the well-known whiff of scandal around the owner of the Château l'Arc.

This Paris does not think, it crowns or condemns. Without appeal. Before even seeing them it condemned these huge nightmarish faces with their hallucinatory gaze, painted with incredible violence.

Cabanne goes on to enlarge upon the terror and anguish of these figures, picked out with strong black lines and set against a sulphurous background.

Of course, some will think that this macabre dance of flagella is the work of one of these young artists ashamed to please, to succeed or to sell and who defend themselves with offended dignity that they have 'arrived' even before they have left. This punch was thrown by a rich, famous thirty-five-year-old, who spends time with neither painters nor critics of his generation, prefers Paul-Louis Weiller [a leading industrialist and socialite] to Michel Troche [a fashionable writer on the arts] and over almost 20 years has developed one of the most discussed and exciting bodies of work of our epoch.

Cabanne is far from being a blind devotee. He talks of Buffet as 'a very uneven painter'. While he had been stunned by Paris, Venice and the Passion, the portraits of Annabel struck him as 'deplorably stereotyped', Joan of Arc was nothing but 'childish imagery', and the 'gratuitous ugliness of the circus performers' left him unmoved. And it is this intelligence that provides one of the best explanations of what for many at that time was the chief problem with Buffet: his astonishing success.

He has learned to live with fashion, success, fortune, he did not set out to make them, and this international star behaves with painting as a surgeon with his patient; we never hear that the price of the operation affected the movements of the scalpel. The sad child of the Château l'Arc puts on his mask and his surgeon's blouse and with his gloved hands seizes the instrument which will extract the innermost secrets of man. This spoiled brat is perhaps our Goya.[9]

At one point in his article, Cabanne declares, 'Young painters, whether you like it or not, this is one of your masters.'[10]

And the young painters of the day were almost unanimous in not liking it.

In 1955, Buffet had been crowned the greatest post-war artist by a poll in *Connaissance des Arts*. In 1965, the periodical *Arts* decided to ask ten of the young generation of artists who had come to prominence in the early 1960s what they thought of Buffet. It was as if they had lined up a firing squad. With one exception, their opinions ranged from indifferent to dismissive via patronising.

CHELIMSKY: Surely gifted at the start, he was unable to assimilate visual data of this century and from then the interest of his painting declined.

DUVILLIER: I never liked his painting; what he proposes is outdated and is absolutely not suited to our time.

SATO: At the beginning it was very good (the period 1949–51). I understand what he wants to do, but he has lost all feeling and, what is more serious, the poetry of his youth. It is a real pity.

JEAN COUY: Painting is not a craft with or without the heavy reinforcement of advertising. One paints with the heart; artists who do otherwise I find indifferent.

PICHETTE: Buffet has brought nothing new to the history of modern painting: he did not go to school. Buffet is an illustrator rather than a painter.

MIHAILOVITCH: It is an adventure that started well but has had no sequel. I do not see how to position the 'case' of Bernard Buffet.

J.-L. BRAU: Buffet represents an aspect of speculation and this is because there are influential dealers close to the jury of critics. I do not believe that there is any development when compared to Gruber.

LAPOUJADE: Nothing.

CANJURA: Bernard Buffet is the most French of French painters. He remains a great painter especially when he is restrained, when he does not overdo colour.

FORRESTER: I never thought about Bernard Buffet, nor have I seen one of his canvases. However, I have heard of him as a painter and I am sure that he paints exactly as he wants; this is the privilege of each man. It is good that it is this way.[11]

It is ironic to note that these young talents, so confident in their opinions, have themselves slid from view. However, by the mid 1960s, the art world of Paris had moved on, and Buffet had not moved with it. He could dazzle, startle and disturb all he wanted on the Avenue

Matignon, with his bravura displays of technique and imagination, but no one in fashionable intellectual circles was bothering to look. Even the location of the gallery, in the heartland of Paris's moneyed elite, told against him. In de Gaulle's France, with Malraux rolling out a cultural programme of national enlightenment that viewed figurative painting as the art of the past, Buffet was an anachronism who was becoming an embarrassment.

However, if he was a pariah in the city that had once lionised him, he was about to learn of a miraculous reputational renaissance that was beginning to gain momentum in a country about as culturally and geographically distant from France as it was possible to be.

Chapter 28

'A light and a new road'

Surugadaira is barely three quarters of an hour by the whisper-quiet high-speed train that shoots out of Tokyo's main railway station; a bullet train that has been fired from a gun with a silencer. And yet in character it could barely be more different.

With its esoteric concept stores, its clothing shops catering to the needs of pets, its electronic gadgetry, its Ritz Carlton hotel high above the city, its youth with their taste for heavy denim and haircuts of a uniform strangeness, and its curiously quiet crowds, many of whom wear surgical masks to avoid infection in a city where even the highways with their multiple lanes of traffic combine an almost surgical level of cleanliness with an unreal quietness, Tokyo assaults the occidental visitor with its strangeness.

In Surugadaira, however, one sees a different Japan: rural, traditional, a place of forests and undulating hills. And in one particularly well-chosen spot, a large bronze sculpture rises out of a shrub that with its yellow and green leaves has been selected to highlight the gilded features and hands that emerge from the traditional robes that would have allowed its subject to pass unnoticed in Edo-period Japan, the two and a half centuries during which Japan isolated itself hermetically from the rest of the world until Commodore Perry opened the country up once more in the late nineteenth century.

The statue's face is stern. The lines around the downturned mouth are continued by the sloping shoulders of his haori, the short kimono-like jacket with broad sleeves that terminate above his wrists. Twice life size and rendered in bronze, he is an impressive figure, managing to radiate a contemplative yet austere energy. There is a sense of wakeful repose about him: his eyelids are closed, his features, etched with the glyphs of a long, eventful life, are still, and yet there is the very real sense that those eyelids could open at any moment to reveal a baleful glare, and that the downturned mouth will open to bark a

command. The sculptor has done his work well, capturing a man whose ancestor was a general in the service of Shingen Takeda, a noted warlord of the sixteenth century.

Only the hair, cropped high above the ears and parted with a geometric insistence upon the stereotypical Japanese characteristic of order, betrays the fact that this is not a monument to some important figure of the shogunate. It commemorates a figure from a more recent episode of Japanese history, and if his hairstyle appears to be that of a banker, then that is because that is what Kiichiro Okano was, by birth and by profession. By inclination, however, he was an amateur and connoisseur of the oeuvre of Buffet, and he would come to assemble the most important collection of the artist's works, outstripping anything that Dutilleul or Girardin could have imagined or afforded, a collection that at the time of his death in 1995 would number some 2,000 works.

Born in 1917, and a member of the generation of Japanese who had fought in the Second World War, Okano had returned to a country that had been shattered by the effects of the conflict, entire cities obliterated, razed by both nuclear and conventional bombing. But already by the time he crossed the threshold of Tokyo's National Museum of Modern Art in 1963, this period was fading into memory. Japan was now a trusted ally of the NATO powers. The country held baseball matches and used hula hoops. Japanese industry had rebuilt itself on an entirely modern basis, producing items that were so far advanced as to be almost science fiction. An increasing number of the transistor radios upon which Western teenagers were listening to American rock-and-roll were made in Japan, and in 1960, Sony went even further and put a portable transistor television into production. It was in this museum, away from the world of portable televisions, bubblegum and baseball, that Okano discovered the work of Bernard Buffet, who was the subject of a retrospective exhibition. It was art that spoke to him, of a world that he knew, a place of shortages and scarcity. The dark outlines reminded him of the fire-blackened ruins of the cities of his homeland.

It was a moment of Damascene importance that would stay with him for the remainder of his life.

I remember standing still in front of his paintings, deeply moved and astonished, admiring the sharp and original shapes and lines, the

gloomy colours and the dominant black, white and gray; the truculence, the keenness, the deep sorrow and the dry emptiness pervading his work. Rusty silence and poetry. There I saw accusation of and provocation against the devastated post-war French society. His paintings instilled a ray of hope in the void and stupor oppressing our generation after the defeat. France, a country which repeatedly had been a battlefield, which suffered the Occupation, and where fellow citizens killed each other. I was awed by the fact that a young genius with such sensibility and ability had been born in the apocalyptic context of World War II. His art undoubtedly was a new dawn, which overcame the melancholy in my mind. Since then, I have been a captive of Buffet. His paintings showed me a light, and a new road, and his paintings only could do that as I had no religion. This is how my ardent admiration for Buffet started.[1]

Japanese artist Genpei Akasegawa well remembers the effect that Buffet's works had on post-war Japan.

I first saw paintings by Buffet when I was in high school, maybe ten years after the War. It was in an art magazine, an article about a three-man show of neo-realists, Lorjou, Minaux and Buffet, the so-called L'Homme-Témoin group. They painted mostly people; Lorjou's figures were heavyset, Minaux's of median build, and Buffet's scrawny everymen. I personally preferred Minaux's still-lifes, but Buffet's images really gnawed at my nerves; the same capacity to linger in the mind that had affected Cocteau and Negulesco proved that it had power even over a culture that had very little in common beyond a post-war hungriness.

His dark, almost monochromatic pictures bristled with fine scratchy lines. He seemed to dirty his canvases rather than finish them, his lines akin to what we now call 'self-inflicted injury' creating an impenetrable tension. The post-War era had yet to be tidied up, everywhere was gloomy. Of course there is always a dark side to the world, but back then, so soon after the War, that darkness was especially palpable.

It was the heyday of French cinema, everyone from René Clement to Marcel Carné to Henri Verneuil, their black-and-white films brimming with dark brilliance. We wrote off colorful American movies as shallow entertainment. Darkly flashing words, existentialism, the absurd, Sartre, Beauvoir, Camus and a bleak Saint-Germain-des-Prés mood were order of the day.

Buffet's paintings steeped in that bleak, blackened post-War mood made their mark. His spindly figures, spindly furnishings, spindly dishes and spindly signature prickled with a sharp presence that tore at the gut of the viewer. Buffet's paintings came into wide acclaim among a like-minded audience, and as a result he became a saleable artist.[2]

As post-war Japan became rich, its citizens, by now conditioned to look to the West for inspiration as to how to spend their money, bought art, Western art, which at that time was synonymous with French art. 'He could have chosen to collect Impressionists, but he didn't,' explains Okano's granddaughter Koko.

He did collect other artists' works, like Utrillo and Vlaminck. So he was aware of and he was interested in other works, and he owned a Renoir as well as a Chagall. But he said that there was a philosophy to Buffet's line that was different to the philosophy of other lines of the time, and that the philosophy of society, and history was reflected in his line. And it wasn't the same for Chagall or Matisse. He said Buffet's line was very particular.[3]

Okano's favourite painting was also one of Buffet's earliest and is called simply *Two Tables*. 'I think it was the forms; it's very abstract in a way, and yet it is also two tables, just two tables.'[4]

There were also wider factors at work that made Buffet particularly attractive to the Japanese market. 'Japanese people are often influenced by what is most popular in the West, and because Buffet was so influential at that time, I think it was natural for him to come to Japan. What was popular in France came, always came, to Japan,' explains Koko Okano, who believes that thanks to Buffet's 'black rigid lines, it was easy for Japanese people to appreciate his work'.[5]

Easy to appreciate but also European, Buffet became a handy shorthand for a lifestyle that was becoming increasingly attractive to young people in Japan.

I know he had a lot of influence on people during the sixties, like Japanese people would like the Beatles, it was the same with Buffet. You know, it was cool to be like them, it was cool to wear black turtle necks like in Saint-Germain-des-Prés. Japanese people knew what was going on in the West, and would go to a jazz club . . . and

often some restaurants or jazz clubs had Buffet's paintings or prints, and it was something cool. It blended into the lifestyle, and young people thought it was cool to go to those jazz clubs or café and be philosophical.[6]

However, to understand the immense popularity that Buffet would come to enjoy in Japan, it is necessary to look further back, beyond the young people in their polo necks listening to the Beatles and thinking deep thoughts, beyond the retrospective in Tokyo, back to the summer of 1951, when Tetsuro Furukaki, then recently appointed as chairman of NHK, the Japanese national broadcaster, was visiting the United States.

'I first experienced Buffet's work at an art museum in America and was deeply moved by the solemn humanism overflowing in his painting. Afterward, I was kept informed of developments involving his artistic works by a French acquaintance living in Paris,' recalled Furukaki. Four years later, his wife Masuko, a musician, was on a trip to Europe at the invitation of La Scala.

After a month of travel abroad, my wife returned to Haneda airport. The single baggage she was clutching onto with extreme care was the 81cm x 100cm oil on canvas by Buffet. It was most probably the very first oil painting by Buffet to enter Japan. As soon as my wife returned home, I set everything aside to unwrap the painting and became captivated. A pistol on a round table, a pure white envelope that appears to be a farewell note, an oval-shaped frame without a portrait, a candle stand, a wine bottle with some wine left, 3 bullets for the pistol. Each still life was positioned in a complex situation, with the tight arrangement and balance of linear and curved lines which united in perfect order within the harmony of perpendicular and straight lines . . . This still life drawn in 1955 went to the extreme in the exclusion of color and was painted almost all in black and white. His style cut away any excess to only the bare minimum, and his tenacious black lines seemed to speak to me through their commonality with oriental art.

In Furukaki, Buffet had acquired an intelligent and powerful ally; within a couple of years Furukaki was named Japanese ambassador to Paris, and was in the French capital just in time for the opening of

Buffet's 1957 exhibition at the Galerie David et Garnier of landscapes of Paris. It was one of those moments of coincidence that was to prove pivotal to Buffet's career.

Joining the many visitors on the opening day, it was the first time I had met Bernard Buffet. At that time, newspaper reporters immediately asked for my opinion. I concisely answered what I had always felt about his art, especially emphasising the point of how the vitality of every one of his lines strongly resonates with the Asian spirit. When asked whether I found his Parisian scenery to be lonely, as they were void of any people, I answered, 'Take a look at this crowd. There's nothing lonely about this city.' The reporters laughed aloud. Indeed, after viewing Buffet's Parisian sceneries at his show, I believe we fell deeper in love with Paris. I feel Buffet had taken a part of the heart of Paris, and revealed it to us. Through these events, my friendship with Buffet began.[7]

Their friendship was an important component of Ambassador Furukaki's lifelong Francophilia. He went to the trouble of learning French and then composing poems in the language.

When I published my third collection of poems, Buffet had generously drawn 40 illustrations for the book over a 3 year period, without remuneration. I was completely taken aback that this world-renowned artist had wholeheartedly taken his own time and effort to create such an extensive collection for my amateur, unsophisticated French poems – a foreign language for me after all. I was deeply moved at this show of remarkable friendship, and all the more overjoyed especially since I had already thought the promise made 3 years ago had understandably been forgotten. Moreover, all 40 illustrations were unique creations done with the Japanese ink cake and ink brush I had given to him some time in the past. I suppose he had wished to create a joint Japanese and French work between us of which he could be proud. Furthermore, he had even beautifully written out a few of my short poems in his unique strokes. He had included a note saying, 'I'm confident these will maybe please you.' Even though the young man in front of me had just reached his thirties, and I had dawdled my time away to nearly twice his age, all I could do was be ecstatic like a child as I realised anew my great admiration.[8]

As it happens, the ambassador was not the only Japanese Buffet enthusiast in Paris at that time.

Today Kiyoshi Tamenaga's name is to be found on galleries in Tokyo, Osaka and even on the Avenue Matignon a few doors along from the Galerie Maurice Garnier. But in the 1950s, he was a young man just beginning his career in the art world. Today his business is run by his son, who recounts his father's role in bringing Buffet to the East. 'My father is four years younger than Bernard, and when they were both in their late twenties or early thirties my father was living in Paris, just after he got married, and he was an art dealer already. So he was visiting all the artists; he was looking for the new painters and exploring the art world.'

Realising that the market for Impressionist painting was already a mature one, he decided to focus on the École de Paris, collecting works by Soutine, Kisling, Chagall, Foujita and Modigliani. 'And my father fell in love with the talent of Bernard. He was already well known in a way, but was not introduced to Japan at all, so he said he wanted to introduce Bernard Buffet to Japan. Then he talked to Garnier and they agreed that my father would have the exclusive contract in Asia.'[9] In being on the spot and early to the market, Tamenaga shaped the tastes of a generation of Japanese collectors of work by painters now regarded as modern masters. It is worth noting that the National Museum of Western Art, housed in a building by Le Corbusier, only opened in Tokyo in 1959, and that a number of the works subsequently bequeathed to it first found their way into Japanese collections thanks to Tamenaga.

Although it was difficult to export French works of art in those days, Tamenaga persevered. In a very short number of years after his first encounter with the work of Bernard Buffet at the Tokyo retro-spective, Kiichiro Okano had emerged as the most dedicated collector of Buffet's work, not just in Japan but worldwide. 'He was my father's client and a friend. Tamenaga was instrumental in Okano's decision to collect the works of Bernard Buffet.'[10]

A few years after his posting to Paris had come to an end and Furukaki had returned to Japan to serve as an adviser to the Foreign Ministry, the former Japanese ambassador was visiting Paris with his wife when he heard about plans to open a museum in Japan dedicated entirely to Bernard Buffet. They had been invited by Pierre Lazareff

(founder of *France Soir*) and his wife for lunch at their villa near Versailles.

There, we also met with Bernard, since the Lazareffs are both among the very small circle of close friends to Buffet. That was when Annabel told us of Mr Kiichiro Okano's plans about creating the Bernard Buffet Museum. The key person himself seemed embarrassed but at the same time, couldn't contain his excitement. Of course, we were thrilled with the news and took each other's hands in joy, congratulating the wonderful endeavor.[11]

'Mr Okano had a passion enough to build the museum in his birth-place, and he was asking my father which artist he should pick to do the museum,' says Tamenaga's son.

And my father chose Bernard Buffet because my father thought Mr Okano was a businessman, but he was quite a lonely figure. He was the owner of a local bank. The big banks are owned by the share-holders and so on, and there were not so many privately owned banks. But Mr Okano's is a smaller bank and he stood out as a bit different from the others. So my father thought his image fitting with the lone-liness and the sharp image that Mr Okano showed my dad, and my dad suggested to Mr Okano 'Why not Bernard Buffet?'[12]

It would appear that Mr Okano could see no reason why not, and it is overlooking this museum that his large and rather austere statue stands today.

Chapter 29

Lunch in Louveciennes, Dinner in Moscow

It is rather typical that the first Furukaki should get to hear of the Buffet museum was not in Japan, where it was being built, but at the Sunday lunch table of pint-sized press baron Pierre Lazareff.

Lazareff's wife, *Elle* founder Hélène, was a Buffet groupie of long standing and had been among the phalanx of *femmes d'un certain âge* that had been part of the protective cordon around Buffet at the Charpentier *vernissage*. Together the fashionista and her bespectacled, billiard-ball-headed husband were one of the most formidable power couples of post-war France.

Pierre Lazareff was one of the greatest, perhaps even *the* greatest, twentieth-century French journalist during the final heyday of print. He began his career in his mid teens, and as well as his journalistic work, he was, among other things, director general of the Moulin Rouge. Returning to France after the war, he worked on a Resistance newspaper that became *France Soir*. When the title was bought by Hachette in 1949, he was named editor-in-chief. By the time Furukaki bumped into Buffet at a lunch given by the Lazareffs, the circulation of *France Soir* was in the region of two million. Lazareff was also a pioneer of current affairs programmes on television. He and his wife could make stars and destroy reputations. Sophie Delassein, one of Sagan's biographers,[1] credits the Lazareffs with having been hugely important for the writer early in her career; and Pierre was godfather to Brigitte Bardot's only son, Nicolas.

Lively and energetic, Lazareff had the newspaperman's voracious appetite for the times in which he lived. Surrounded by half a dozen secretaries, his heavy-framed round glasses pushed up on to his gleaming pate, pipe clamped in his jaw, he sat at the nexus of a web of information. He had a ringside seat on the great events of his time, which he never gave up, not even at weekends, especially not at week-

ends, when the leading figures of French life of the day would gather at his table for Sunday lunches that, more than forty years after his death, continue to have a resonance in France.

From 1956, the Lazareffs weekended at La Grille Royale, a large house with a park of seven hectares in Louveciennes to the west of Paris. Leafy Louveciennes was a favourite with the *haute bourgeoisie*, who cherished its air of sedate respectability. It was where affluent industrialists such as Brigitte's father, Louis Bardot, had their weekend retreats, and it was here that, the decree of exile having been lifted, Henri, Comte de Paris, pretender to the French throne, came to live in a rambling country house that would not have looked out of place in the West Country. Into this respectable suburban idyll blew the Lazareffs, bringing with them almost anyone who was anyone in France.

With its steeply pitched roof, La Grille Royale had something of the feel of Deauville's Hôtel Normandie. And it was here that on Sundays Gallic glamour and power would meet, as for a few hours each weekend Louveciennes became the centre of the Francophone world. It was thrilling, in the way that only a head-on collision between money, power, talent, fame and beauty can be.

When the flamboyant cigar-smoking advertising tycoon Marcel Bleustein-Blanchet, founder of advertising company Publicis, came to lunch, the thrum of helicopter blades would disrupt the Sunday stillness as he landed on the tennis court – an enthusiastic pilot, he said that he liked aviation as much as he enjoyed advertising, and his success in the latter permitted him to indulge in the former. Stately limousines driven by uniformed chauffeurs would sweep through the gates, as would flamboyant sports cars and whichever Rolls-Royce Buffet was being driven in at the time.

In summer, the lunches at Louveciennes were large-scale affairs under marquees in the park. In winter they were more intimate: about twenty guests would gather for aperitifs in a drawing room where their attention was torn between the delightful view over the park and the artistic treasures inside, among them an impressive Giacometti sculpture and walls hung with power pictures including, perhaps, Buffet's portrait of the chatelaine of La Grille Royale.

Her gift was to mix an intoxicating and invigorating social cocktail of gravitas and glitz. She and her husband understood that having been surrounded by serious men in suits all week, being troubled by affairs of state, the last thing politicians wanted was more of the same

for Sunday lunch. Likewise, the *vedettes* identified by Hourdin, at least the more intelligent ones, yearned to be taken seriously, aspiring to something more profound and enduring than the life of the flashbulb and the gossip column. Thus, walking martini in hand among the armchairs and sofas, admiring the contemporary art, one might encounter politicians such as François Mitterand, casting a covert eye over the buttocks of Brigitte Bardot, who along with Marlene Dietrich, Alain Delon, Jeanne Moreau and Simone Signoret represented the practitioners of the seventh art. Further star power came from singers including Juliette Gréco and Yves Montand; while any notion that these were just frivolous gatherings was dispelled by the presence of ambassadors, prominent surgeons and eminent lawyers. Against this vivid social backdrop the Lazareffs would parade whichever international star turn happened to be passing through Paris that week: a brooding Marlon Brando perhaps; or that Talleyrand of the atomic age Henry Kissinger; the ruling couple of what was increasingly known as the jet set, Onassis and La Callas; maybe even Martin Luther King.

Placement at the oval table was carefully mapped, and conversation was orchestrated by Pierre, who ran the lunch much in the manner of a debating society, ensuring that everyone who had a view could express it. Following lunch, the guests would return to the drawing room for coffee, more to drink and then a walk in the park, after which, as the skeletal trees slowly disappeared from view into the winter night, Alain Delon and a few others would settle down to a Sunday-evening poker school.

The Lazareffs had a voracious appetite for the beau monde, and their energy was extraordinary. But the glittering couple came to a sad end. He succumbed to cancer in 1972, and her life ended in 1988, unable even to console herself with memories of those marvellous days when the world came to lunch, so cruelly was her mind ravaged by Alzheimer's.

To make it on to the lunching list at Louveciennes was an achievement, the conquest of a social peak that few in that increasingly prosperous France of the Citroën DS and Sacha Distel could scale. And Buffet's status as a favoured guest was eloquently expressive of how, even if his critical reputation with the intelligentsia in his homeland was sinking, his social stock had risen ever higher.

Of course there were those for whom this incarnation of Buffet as a slick and polished socialite with a glamorous, expensive, black-pearl-

bedizened wife draped on his arm was just further evidence that he had in some way sold out. And whether or not one believes that he had, it is impossible to deny that in the France of the late 1960s, he had become a piece of social shorthand, a trophy guest, moving in a milieu that was at once frivolous and sophisticated.

His status as a member of le Tout-Paris was confirmed in April 1965, when he and Annabel were invited to join a trip organised by Parisian PR man Georges Cravenne. Cravenne, who had been among the *mondaine* crowd at the Mass to celebrate the decoration of the chapel at Château l'Arc, was a publicist of true genius. He is credited with the creation of the César film awards and is described by one who worked for him as the inventor of modern public relations in France. He certainly had an eye for a good publicity stunt.

In 1965, Cravenne was in charge of promoting a record by Gilbert Bécaud. Bécaud was known as Monsieur 100,000 Volts for the super-charged energy of his performances. If he is remembered outside France today, it is as the composer of 'What Now My Love', an English-language version of 'Et Maintenant', which had been a huge hit in France in 1961. In 1965, he released a piece of catchy, sentimental mush about falling in love with a Moscow tour guide. The first two verses give enough of a flavour of a record that manages to embrace such cherished musical clichés as the sound of accordion music to indicate French romance and stirring non-specific Eastern European folk music of the sort to which drunken customers in Russian-themed restaurants attempt to dance after too much vodka.

La Place Rouge était vide
Devant moi marchait Nathalie
Elle avait un joli nom, mon guide
Nathalie
La Place Rouge était blanche
La neige faisait un tapis
Et je suivait par ce froid dimanche
Nathalie

They go for a hot chocolate at the Café Pushkin, which apparently did not exist at the time, attend a party at the university and so forth. It may not be profound, but it was topical. The Cold War was an accepted fact of life for a generation, and relations between the USSR

and the West had become even frostier during the first half of the 1960s with the building of the Berlin Wall in 1961 and the Cuban Missile Crisis of 1962. Moreover, 1965 saw the release of the film version of Pasternak's *Dr Zhivago*, starring Julie Christie and Omar Sharif, a smash hit that heightened interest in the then almost impossibly remote and inaccessible Soviet Union, a place as fascinating as it was threatening.

Cravenne's masterstroke was to arrange a Russian tour for the social leaders – *les locomotives* – of Paris, to be led, of course, by a guide called Nathalie. The climax of the trip was a photograph in Red Square of the sort of people who used to crowd out Maxim's, Regine's and Castel. The mix was a representative cross-section of mid-sixties high society; and topping the list of guests in news reports . . . Monsieur et Madame Buffet.

Also among the seventy-nine celebrities who would leave Paris that Easter for communist Russia were actor Curd Jürgens and his wife Simone, fashion designer Pierre Cardin, hairdresser 'Alexandre de Paris', star lawyer René Floriot and perfume queen Hélène Rochas, dancer Ludmilla Tchérina and nightclub owner Régine, Gunter Sachs, who was to become Brigitte Bardot's third husband the following year, and Porfirio Rubirosa , the five-times-married Dominican playboy, famous for his sexual prowess, who would die a few weeks later crashing his Ferrari in the Bois de Boulogne at 8 a.m. at the end of a long night.[2]

The list of socialites, playboys, beauties and society figures was pretty much encyclopedic: the exquisitely tasteful and extremely gay Baron Alexis de Rédé, the immensely rich and extremely heterosexual Paul Louis Weiller, celebrity Parisian hairdressing duo the Carita sisters, tennis player and lady's man Jean-Noël Grinda, with his wife Florence, Cristiana Brandolini (née Agnelli), fashion designer Guy Laroche, Buffet's friend, collector and sitter Jacqueline Delubac, Marc Bohan of Dior, TV dance star Jacques Chazot, Hélène Rochas's bisexual lover Kim d'Estainville, who became famous as the man who gave Tina Chow AIDS, and helicopter-flying Louveciennes luncher Bleustein-Blanchet.

Among the social leaders making the trip that spring half a century ago was the Comtesse de Ribes. One of Truman Capote's original Swans, the leading hostess of her day and for many years a famous fashion designer, Jacqueline de Ribes is now a distinguished patroness

of the arts who has been honoured with the Légion d'Honneur in France and a retrospective of her life and work at the Met in New York. She remembers the tour with pinprick accuracy, in her crisp, delightfully accented English.

Buffet and Annabel were on that trip. First of all Russia was for all of us a mystery, so the idea that we could go to Russia, to be officially invited, was remarkable. We were all young then and we all accepted. It didn't last very long, I think it lasted three or four days. We were two days in Moscow and two days in Leningrad, and the famous picture of all of us walking in front of the rehearsal of the Red Army for 1 May was in Leningrad.

She did not spend much time with the Buffets. 'We were a large group, enough to divide into little groups, enough that we all didn't go to the one same restaurant.' However, she well remembers the day that she and the couple attempted to disrupt the Red Army's May Day rehearsal.

I had this stupid idea. I said, 'What about walking in front of them? Do you think we can stop them all?' And Annabel immediately picked up the thing and she said, 'Oh yes, let's do it, let's do it,' and finally, it was ridiculous, I mean to see Cristiana Brandolini and myself, Elsa Martinelli, Annabel, Bernard Buffet, walking in front of the Red Flag. It was a crazy picture.

However, the Comtesse mixed in a different milieu to the Buffets, and although her mother had bought some of Bernard's paintings, their shared experience provoking the Red Army did not lead to a deeper friendship. 'I never had them for dinner. I saw Annabel several times' – her face puckers with slight disapproval – 'not very *sympathique*, to be quite frank. With someone like me she wouldn't have been *sympathique*.

'Later I think that we had an official fight, because I think that Frédéric Mitterand made a TV show. I defended the Musée de la Mode' – Paris's museum of fashion opened in 1977 – 'and Frédéric congratulated me, but she was attacking, saying how ridiculous it was to open a Musée de la Mode. We were very *antipathique* to each other there.'[3]

However much she and Annabel may have disagreed about enshrining fashion in a museum, she continues to enjoy the Buffet paintings her mother left her, and the memory of the day she and the Buffets went up against the Red Army.

Whether one was a clever PR pulling off an elaborate stunt to promote a hit record, or a socially ambitious hostess wishing to demonstrate a level of understanding of the arts, les Buffet were perfect. But Bernard's apparent ubiquity in society circles and his taste for the good life adumbrated his artistic standing. For those who wished to criticise him, whether the motive was envy of his success or a dislike of his art, his ascent as a socialite became another handy peg on which to hang their disapproval. In the twenty-first century, artists are permitted, almost required, to be celebrities, but France in the 1960s was still attached to the idea of the artist as an outsider – either a rebel, a hierophant, or a seer sage – rather than a suave socialite.

Buffet would say that he did nothing by halves.

I have a very simple method. It is that of my friend Simenon: if one works, one works; if one has fun, one has fun. But never the two together. In Provence, I work continuously from four o'clock in the afternoon until two o'clock in the morning. Sometimes more. In Paris, I have fun. But I can't work a little, then go out a bit, then go back to work a bit . . . No: it is either all one or all the other. You have to choose.[4]

Even taking the speed at which he claimed not to work into account, the sheer quantity and scale of his output demonstrates that he spent more time working than doing anything else. Painting remained a drug, and even if he had been travelling, it was not uncommon for him to go straight from a long flight into the studio.

Thirty years later, when he was nearing seventy, it was still the same story. 'It's rather like cycle racing, when they have an easy stage it's disastrous, and I climb a lot of hills' was the rather bizarre metaphor he used to explain his regime. 'So people think I get help, but the truth is I work a lot, that's all. And when you love something you can't stand being helped, it's annoying.'[5]

But even though the hours spent pedalling up those creative hills outnumbered those spent in nightclubs, on madcap international jaunts or just mixing with the le Tout-Paris, they were not written

about in newspapers and magazines, whereas of course his nights out on the town and forays into society were closely documented to be devoured by millions, not just in France but around the world, who countered the dreariness of their own existences by experiencing life vicariously through people they knew only from their photographs in the popular press.

Buffet had become what Descargues had feared: an archetype, a gossip column item. It does not take much for an image to install itself sufficiently vividly in the mind to form a handy stereotype: Bianca Jagger may have done many things with her life, but she will *always* be the woman who rode into Studio 54 on a horse, just as Halston spent *all* his time at the same New York nightclub being photographed with Liza Minnelli.

Indeed in New York, at about the same time that Bernard and Annabel were traipsing out to Louveciennes for Sunday lunch and flying to the USSR, another future habitué of the as yet unopened Studio 54, Andy Warhol, was pioneering a new style of art that permitted its practitioner to enjoy the social and material fruits of his success, provided that it was with a sort of sphinx-like detachment and ironic inscrutability.

However, New York and Paris were very different places in the 1960s, and to many among Buffet's generation of Frenchmen, now of an age when they were beginning to arrive at positions of influence in cultural life, he remained the artist in the Rolls-Royce. And that famous praying mantis signature that appeared ever more prominently on the canvases impeded their view of the art on which it was scrawled.

He had been photographed with celebrities for so long that he became interchangeable with them. He was no longer a famous artist, but a celebrity who painted and around whom other brush-wielding celebrities gathered. Photographed alongside Kirk Douglas in front of one of his self-portraits, his name became linked with any actor who wanted to mess about with a paintbrush. 'Yul Brynner's taking painting lessons from famed French artist Bernard Buffet,'[6] announced one gossip column. 'Bullshit,'[7] says the actor's second wife Doris stoutly, although the couples did meet at Balenciaga, where both Doris and Annabel were customers. Cristóbal Balenciaga liked Buffet's work and shared his love of animals, and one of the more bizarre portraits that Buffet painted during his jet-set period was of the fashion designer's pet Yorkshire terrier Plume.

It seems that if there was a fashionista's pet to be painted, or a nightclub to be attended, or indeed decorated, society's favourite artist was there. 'There's a New "In" Spot in Paris,' raved Eugenia Sheppard in her Inside Fashion column.

> It's called Alcazar from a famous night spot on the Riviera and the proprietor is Jean-Marc Rivière, who once ran a nightclub in St Tropez.
>
> Every night Alcazar is full of socialite sables and all the familiar faces from the Paris couture. It's the formula that made Régine's and New Jimmy's famous, but Alcazar is quite different.
>
> As far as thrills go, the discotheque has become a little old hat in Paris. Alcazar is a big, high-ceilinged room that looks as if it might have once been a gymnasium. It is strictly drink, dine, and talk. There is no dance floor but the kick is one of the maddest floor shows ever seen anywhere.
>
> Bernard Buffet has painted the stage curtain, a giant pair of stylised eyes with spiky lashes. The in-people recognised them as belonging to Rivière.

The eyes were vividly, luridly painted on two sheets; much later they were to sell at Christie's in London in 2014 for a six figure sum. The club also had a chorus line 'got up in enough feathers to strip an ostrich farm and a 16-year-old star in a bikini and kid gloves'.[8]

Thus it was that the painter of misery turned his hand to decorating the sort of nightclub where scantily clad dancing girls cavorted in ostrich feathers; it must have seemed like a good idea at the time and it might even have been fun. But success in the art world was becoming increasingly about reputation management, and Buffet was too free with his time and his skill. He did what amused him, and did not see painting a friend's pet dog as anything more than an affectionate gesture.

Maurice Garnier would frequently talk about the generosity of both Annabel and Bernard. What is more, as a man who was fiercely loyal to his friends, Buffet found it hard to say no, especially to someone who had supported him in his Batignolles years. Typical was the request made by Jean Negulesco.

> Fourteen years after I first met Bernard, in 1962, I was in Sicily making my first independent production, *Jessica*, with Angie Dickinson and Maurice Chevalier.

A poster by Bernard Buffet, I thought. What a send-off for the film!

I called him at his new castle, Château de l'Arc [sic], in Aix-en-Provence.

'Yes, why not. Come and spend a week with us,' Annabel answered.

A white Rolls-Royce picked us up in Nice.

The man he found at the Château l'Arc was very different from the sullen youth in the filthy Canadienne. 'He looked at ease, kinder, interested in friends and food. Bernard looked happy, carefully dressed and prosperous. Yet his nails were still saturated with black color.'

Even though at the time he was engaged on the series of religious paintings for his chapel, he gladly broke off from the emotionally intense task to help out an old friend. *Jessica*, a fairly routine romantic story about a woman who becomes a midwife on Sicily following the death of her husband and falls in love with a nobleman who passes himself off as a fisherman, is not exactly art house cinema, but Negulesco was a friend. So, just as Balenciaga wanted a picture of his pooch, Buffet 'made the poster of *Jessica*, now a prized collector's item. As a going-away present, Bernard drew with simple lines a heart pierced by an arrow: "To Jean and Dusty, Bernard and Annabel."'[9]

Maurice Garnier insisted that Buffet did not undertake this sort of work because he needed the money but because he wanted to. Even so, if not actually indiscriminate, he was certainly not precious about where his work went; among his commercial output was advertising for Parker Pens, and a series of six engravings for Siemens. The Siemens pictures are actually rather good. The subject matter of the electronics facilities lend themselves to his linear style and his skills as an engraver; while he was most definitely the artist of capitalism, it is easy to imagine that if the engravings had been executed on the other side of the Iron Curtain, depicting a state-owned enterprise, they would have been celebrated as paradigms of contemporary socialist realism.

But there is another way of looking at this work. Buffet painted the daily life of ordinary people, or, to put it slightly differently, the ordinary objects of daily life around him, which was what he had been doing since his earliest days. 'Early Buffet is not miserabilist, it is existentialist. There is a rapport with Jean-Paul Sartre's existentialism,' was the view of Maurice Garnier. 'What Bernard Buffet was doing in 1947 was both existentialism and arguably already *art populaire*. It showed people's life in France.'[10]

The difference was that in the late 1940s, life had been a monotonous struggle to assemble the means of survival: a world of thin soups made on black stoves, power cuts, candle stubs and elderly hand-operated coffee grinders. Twenty years later, at the height of Les Trente Glorieuses, the material circumstances of many French people had changed dramatically; they lived an entirely different life. It was to this very much changed domestic environment that Buffet returned during the 1960s and 1970s. Ordinary people listened to radios and record players that had been made in the electronics factories of the newly resurgent West Germany of the *Wirtschaftswunder*; they wrote their letters not with cheap pencils but with brand-new fountain pens; they drank, as Buffet did, Vat 69 whisky, Gordon's Gin and Cointreau; some of them chain-smoked, while others shared his taste for that ultimate emblem of capitalist indulgence, the Havana cigar. These were the objects that had replaced the desiccated scraps and miserable etiolated utensils of the hungry 1940s, and whereas on those early canvases the paint had been scraped on in a mean, sparing way that suited the subject matter, the still lives of the 1960s were generously impastoed.

The paintings still had a dark edge, often literally. A lone table lamp, these days a handsome object with a pretty shade rather than the perfunctory petrol lamp with its memories of austerity, sheds a cone of light, allowing the colourful bottles, cigar boxes, packs of cigarettes, cups and glasses to emerge from the Stygian gloom of heavily applied black paint. Buffet was a friend and reader of Simenon, and in some of these works, the slightly sinister suggestion of a crime scene is heightened by the addition of a revolver or an automatic pistol, a familiar motif from earlier paintings and one that would return along with daggers and skulls in the much more loosely painted series of still lives from 1977 that feature roulette wheels, playing cards, yet more bottles of spirits and yellow Ricard ashtrays, in which cigarettes emit tendrils of smoke.

This was bourgeois existentialism with a touch of Maigret and the macabre. Not everyone liked it. 'I was very saddened to see his paintings of objects such as ashtrays,' recalls Juliette Gréco, who had thitherto been forcibly struck by the power of early Buffet, in particular a *boeuf écorché* that she had seen at her friend Pierre Bergé's apartment. 'It amazed me . . . coffee cups . . . I found it bizarre. It was crass and commercial: it lessened [him] a little for me. People are happy to have

it of course, but I find it too bad. It is like a Picasso "ashtray", it's a little bizarre,' says Gréco, who would 'have preferred [him] to remain in the museum. I think that the commercialisation of his work was not a good thing. All these small objects, the coffee cups, ashtrays, everything, were not good. He lost his nobility.' It is a poignant choice of words, and although Gréco is far too subtle a thinker to brand everything that Buffet did after 1958 as rubbish, she believes that this sort of painting tainted him forever, diminishing him in her eyes and those of an increasingly hostile artistic establishment. 'He was able to do things of genius but he did not remain pure. It became a business and that is what has bothered people, I think. But his genius remained his genius.'[11]

Yet an important component of that genius was to remain true to himself as he saw it, and of course there was a part of him that wanted to do what was likely to enrage and perplex the critical establishment. It was probably with something of both of these aims in mind that in 1970 he painted a picture of a dishwasher. It is a sophisticated work that reminds one just how much variety of tone and shade he was able to coax out of grey and black. Maybe it is reading too much into the medium – Isorel, or hardboard, a resolutely twentieth-century type of surface – but one could make a case of a match of subject and artist's materials. And in elevating such a quotidian object to the level of art, he was doing what artists do best: inviting us to look at the world around us, the world we take for granted because we are overfamiliar with it, and actually see it. In seeing it as if for the first time, we assess it differently, appreciating it and perhaps allowing it to kindle a sense of wonder within us that human civilisation has arrived at a point at which an entire industrial culture and economic activity can be constructed around the concept of getting the dirt off cutlery. It is perhaps what Buffet meant when some years later he was asked to explain why he painted the dishwasher and gave one of his typically laconic answers. 'Because it is beautiful looking. As beautiful as a Rolls.'[12]

But then, as he would have delighted in reminding us, it is also just a picture of a household appliance.

Chapter 30

Breton Spring

In the same year as he painted his dishwasher, Buffet also painted his studio. Six metres long and over two metres high, the canvas is conceived on the sort of heroic scale of which he was fond. But it is neither the size nor the Mondrian-like grid formed by the interplay of ladders and easels that impresses, but the sheer number of empty bottles. There are simply so many. There are bottles on tabletops, bottles on upturned boxes, bottles on shelves, bottles balancing on the treads of ladders . . . and not a milk bottle among them. It is hard to count exactly how many there are, as sometimes they are so densely forested as to be difficult to pick individuals out, but there are comfortably more than fifty. It is like a museum full of Morandis all on one canvas.

Buffet's drinking, always on the weighty side of heavy, was getting out of control. For her part, his wife was not so much an enabler of his habit, but a competitor in terms of quantity. 'Basically we drank as one sleeps or as one works, without thinking about it.'[1]

He was gaining weight, and his face had a cadaverous look to it, yet even though he was well into middle age, he was in some respects still a child. As one astute friend said, 'Although he has finally surpassed the age of 40, he knows more than anybody else that he is still just an incomplete youth, and acts accordingly. But he is not ashamed of that fact.'[2]

The same could be said of his wife; in fact she said it of herself.

Poor Maurice. When he looked at a picture of Bernard for the first time, did he know what he was getting himself into? He has undoubtedly dedicated his life to the work of Bernard. He takes care of it to perfection, but that's not my point. He is not content to be a great merchant, a collector, and even a patron. He has taken charge of our lives; he is forced to be the grown-up, wise, watchful, sometimes severe,

striving to spare us worries, whatever they may be. Spoiled children, we got in the habit of abusing this. From serious things down to daily minutiae, I hand everything over to him . . . plumber, invoices, mail, in short, whatever annoys me, or wastes my time, or that I do not know how to handle on my own. He never complains. His greatest and only problem is Bernard. He hates to annoy him; the simple idea of bothering or angering him completely turns him upside down. Amazing Maurice, whose cold, almost haughty, body language intimidates many people . . . and who in spite of appearances shows immeasurable tenderness towards us.[3]

Even by the early 1960s it had been noted that Buffet 'has no sense of money, he spends without bothering counting. He does not say "How much?" He says "I like that." And he has to have it at once, whether it is a new Rolls, the interior decorated with pear wood, or a neckerchief.'[4] He and Annabel were as unaware of the value of money as children, with every bill sent for Maurice to deal with. Just how financially naïve and incapable they were became clear after the painter's death, when Annabel called Maurice for some financial advice: she wanted to make a withdrawal from a cash machine, but was utterly ignorant as to how to go about this simple task.[5]

In removing the shackles of quotidian concerns, Maurice Garnier had inadvertently placed Buffet in another prison, where every wish could be gratified and there were few consequences to be feared, which given the personality of both the artist and his wife was not entirely healthy. She puts it bluntly enough when she says, 'We were thirty when we met. We were both alcoholics.'[6]

Alcoholism is pernicious. In the rooms of Alcoholics Anonymous it is talked of as a cunning, baffling and powerful disease. This is not the place to go deeply into the psychological effects of addiction, but that Buffet had an addictive personality is beyond doubt. He was constitutionally incapable of moderation; his life was one of extremes. Typical was his observation that he either worked intensely or partied until dawn, but found it impossible to balance work and leisure together. Hourdin had used the memorable simile of Buffet painting in the way that an addict injects morphine.

Photographs almost invariably show him with a cigarette in his hand; it is there so often that one begins to wonder whether it has been grafted on. When painting, the slender finger of tobacco was

replaced by a brush and moved to the other hand, placed between his lips or laid in an ashtray within easy reach. Close companion of the cigarettes was the alcohol. Among pictures showing Buffet enjoying the invigorating and consoling properties of a cigarette and a drink is one that sees him in his studio, intently lighting up. In front of him are two bottles – one of dark spirits, the other of what looks like wine – three fresh packs of Gitanes and a variety of tumblers, one of which is filled near to the brim with something refreshing and inviting. The studio is flooded with light, and it is tempting to imagine that he is beginning his working day and has laid in the supplies he needs: the unopened packs of cigarettes, the wine, the spirits . . . things as essential to his work as paints, brushes, turpentine and canvas.

No matter what his consumption, Buffet seldom appeared drunk.[7] By contrast Annabel knew when she'd gone to bed in an alcoholic blackout because she would awake to find her clothes neatly folded rather than strewn around the room.

Together their lives demonstrate the classic symptoms of an alcoholic checklist. There is a sense of low self-esteem left over from fractured childhoods that is inseparable from a sense of grandiosity. Although still insecure children (albeit in adult bodies), at the same time the Buffets were above normal existence and its daily chores; theirs was a life of creativity, castles, Rolls-Royces and yachts. Buffet became increasingly impulsive and extravagant; he let Maurice take care of the everyday stuff.

Then there was the restless dissatisfaction. The couple were forever doing a geographical, moving house every six or seven years, sometimes more frequently. Already in November 1962 Buffet had shown signs of wishing he were somewhere other than Château l'Arc, when he published the series of engravings depicting the Breton coast that had been dedicated to his mother in memory of their holidays, and in 1964, he decided to move there. He was to spend the second half of the sixties living one of his childhood dreams, at La Vallée, a house in Saint-Cast that he had admired as a child. Once again there was a wish to retreat to those happy beach holidays with his mother, only this time he was a millionaire rather than a wan little boy from Les Batignolles.

He was not the only person to whom this fairy tale appealed. 'Bernard Buffet has given himself the chateau of his childhood dreams'

ran the headline of an article that announced the family's arrival in the seaside community.

> Once upon a time there was a little boy called Bernard. He spent his holiday at Saint-Cast on the Côtes-du-Nord. Every day he played with two little boys who lived in the nearby chateau. From his window, little Bernard could see the castle. He found it beautiful. His parents did not have much money. But he made a promise to himself: one day, when he was 'grown up', he would make lots of money and would buy the Château de la Vallée.[8]

The 'chateau' in which the Buffets had taken up residence was actually a large, handsome, solidly built house with stout walls of rusticated dressed stone, steeply pitched, hipped roofs of dark slate, and one turret with an almost ecclesiastical roofline and far-reaching views out to sea. The work of architect Eugène Olichon, who special-ised in affluent seaside villas in the area, it was a particularly notable example for having been commissioned by a local entrepreneur, builder and mayor, Mathurin Macé. Although it was built in 1925, the archi-tectural style is that of a generation earlier. Conservative, substantial and traditional in manner, it would already have looked decidedly old-fashioned when Buffet first set eyes on it a decade after it was completed. What today would be called its 'retro' style would have no doubt enhanced its appeal for the painter, who was seeing it with both the nostalgic eye of childhood and that of the artist whose tastes were increasingly not those of the era in which he found himself living. La Vallée made, among other things, a perfect showcase for his burgeoning collection of lamps, vases and glassware by the art nouveau master Émile Gallé. And even though he would famously paint a dishwasher, his kitchen was a rustic affair, with a large wooden table and walls covered with copper pots.

There is the sense that the Buffets wanted to make a new start here. Annabel told reporters how Bernard just loved to cook and how he was really rather good, specialising in fish. She added that he would often 'go fishing himself with an old sailor who knew the waters'.[9] And when Bernard did not feel like setting sail with the salty old sea dog to net the catch of the day, the couple would head off to market in their little Renault 4. Apparently in the mornings they could be found in boots and oilskins walking for miles on end, greedily gulping

down invigorating lungfuls of the iodine-fragranced air. Indeed, the sea air got everywhere, and much as he liked the rambling villa close to the beach, Bernard found it so damp that he had to have special apparatus installed to dry his paintings.

At best, the atmosphere was bracing rather than balmy. 'Bernard and Annabel love Brittany and know how to live there: they do not look at the sky each morning in the hope of seeing a ray of sunshine. They do not go out onto the sands expecting to get a tan. They love nothing more than Brittany in winter.'[10] And while Bernard wallowed in the warm bath of his idealised childhood memories, it is easy to imagine how Annabel, that creature of Saint-Tropez-des-Prés, more accustomed to nude sunbathing and *nuits blanches*, regarded life in their Breton idyll.

It would be hard to envisage a life more different from that in the South of France, with its lazy heat, its chirruping crickets, its blinding sun and its cloudless sky. But they made a decision to put all that behind them, hoping, maybe even confidently believing, that with the change of scene and a fresh start, whatever problems had been assailing them and demons tormenting them would have been left at their old address.

Instead, of course, they travelled with them in the removals lorry along with the antiques and curios. That was another thing. Bernard loved stuff and seemed to think that assembling enough of it would in some way protect him. It is a trite observation but not necessarily untrue that he looked to possessions to fix him, seeking solace in the latest distraction (whether house, car, yacht, or collection of antique whistles), hoping that the most recent object to fascinate him was indeed the last piece of an emotional jigsaw puzzle that would leave him feeling full, complete, entire – not entirely dissimilar to comfort eating or binge drinking.

The trouble with Annabel was that she was not just addicted to the effects of alcohol – 'Until the month of January 1982, I had never once envisaged life without this magic potion,'[11] she says of a drinking career that had begun as a child four decades earlier – she was also addicted to the drama that alcohol brought into her life. She feared bourgeois stability and regarded the absence of upheaval as the presence of failure, evidence that something had gone wrong rather than right. Having drunk since childhood and been in a relationship with the alcoholic and drug-dependent Sagan before marrying Buffet, it

was perhaps unsurprising that she found the idea of sobriety not just unusual, but terrifying.

It is no coincidence that, with the exception of an apartment that was more of a bolthole in Saint-Tropez, the longest period in which the Buffets lived at one address was between 1986 and 1999 at La Baume in Tourtour, when both had finally achieved sobriety.

But of course stopping drinking is the very final resort, the ultimate desperate measure that an alcoholic will take after the changes in location, relationship, work, environment and so on have failed. In Alcoholics Anonymous, the term 'rock bottom' is frequently heard; often it refers to a level of material destitution or degradation of living standards, or a drastic change of circumstances such as imprisonment or homelessness that forces the alcoholic to confront his or her addiction. Part of the reason that Bernard and Annabel kept drinking so heavily for so long was that superficially, everything seemed to be going brilliantly. They were arguably the most famous couple in France, they lived like the millionaires they were, and it must be remembered that half a century ago, attitudes towards alcohol and addiction were very different. The cliché of the alcoholic was of an unwashed, malodorous vagrant drinking methylated spirits, a cliché that was about as far as possible from the apparently charmed life of the Buffets, and so they looked elsewhere for solutions to their depression and anxiety.

Children were an obvious fix that needed to be tried, but as much as they clearly made full use of each other's bodies, the couple were unable to conceive, and so they adopted Virginie, born in 1962, but neither she nor her sister Danielle, who was born a year later, brought them contentment.

This is not to say that they did not love their children. Far from it: in 1971, Buffet painted some meltingly tender portraits of the two girls. Danielle, blue-eyed, with slightly prominent front teeth, has straw-coloured hair that cascades down her back in almost Rapunzel-like quantities, while Virginie, with the sort of gamine haircut that her mother favoured, looks a little more like a tomboy. The portraits capture the little girls' innocence in a way that is almost painful; they recall the painting of Bernard's niece Blanche, and to some degree, the pictures of Annabel. Some of the latter had a cloying feel to them, more schmaltz than sentiment, but there is a discernible similarity between them and the pictures of Buffet's daughters and niece; we

see the full kindness of the man and the refusal to view these subjects, those whom he loves, as anything other than perfect.

Much later in his life, in the mid 1990s, there is a similarly idealised portrait of the family group, in front of which Buffet and his wife were photographed. Annabel, by now well into her sixties, inclined to stoutness but is depicted at her gorgeous lithe best, poised and casual in jeans, but the biggest contrast is between Bernard Buffet in person and on canvas. The bearded but rangy figure in the painting is almost unrecognisable as the wheezy deflated blancmange of a human being seated in front of it. This is clearly how Buffet wanted his family to appear. There was the feeling throughout much of his life that he was trying to travel back to a time that never was, in search of a perfect happy family life such as he never experienced as a child, nor, really, as an adult. Throughout his life, whether in his work or geographically with his move to Saint-Cast with its mental slide show of childhood happiness, he periodically attempted to create an emotional idyll that like Tantalus he was never quite able to grasp.

Also in that mid-1990s family group is a young man with collar-length hair in a suit and cravat; this is Nicolas, their son, who joined the family at the beginning of the 1970s. Now a musician, he has the saturnine good looks and artfully tousled hair of a rock star, with wraparound sunglasses and a tattoo of one of his father's emblematic drawings of a sunflower on his left forearm. Although his upbringing was unconventional, it must be remembered that he knew no different; he also knew, most importantly, that he was loved with an affection that neither of his parents had experienced.

I never heard about anybody of his family, and even of my mother's family. So it wasn't normal, because I never heard about his brother [the two had fallen out shortly after Bernard's marriage], never heard about anybody, so it was quite special. What he built with his wife, the fact that he adopted my two sisters and me and they built a family, was really important to him. But he said, and it was something he thought really seriously, that you can have children and when they grow up you can be friends with them, but you can also not be friends with them. For my part I was lucky because when I grew up, we got on. With my sisters it was a little more complicated. But for him it was really important that once he did what he had to do as a father, and made life easier for his children, for him it was okay, it was enough.

After, if the magic works and if there was an intellectual or a spiritual exchange, he was really excited by that, but if it wasn't the case it wasn't that important, because once again the most important thing for him was his painting. That was what was going on first, and even my mother came after. She knew that.[12]

Nicolas's delicate euphemism, of things being 'a little more complicated' for his sisters, refers to the emotional and physical tumult into which Buffet was hurtling as the 1960s came to a close. He was to suffer a profound personal crisis that would give birth to a series of paintings that over forty years later have lost none of their power to disturb. The reason things were slightly easier for their son was because he was in effect the bandage that the Buffets applied to their severely injured marriage, an injury that can be traced back to a chance meeting at Castel, the chic Left Bank nightclub.

Chapter 31

Alcohol, Tobacco and Pandora's Box

Annabel Buffet and Pierre Bergé could hardly have been more different, but there was one thing that the fun-loving chanteuse-novelist and the intellectual Svengali-businessman shared. Looking back on her first ten years of married life, Annabel observed, 'I had never left my husband for more than one hour.'[1] She was experiencing exactly the same intense, almost claustrophobic relationship that Bergé would later remark upon as the most singular aspect of his years with Buffet. Like her predecessor, she found that one should not underestimate the fixity of opinion of timid people.

He had just finished the paintings for his February exhibition. It was most likely the beginning of 1968 (she states 1968, but then erroneously says that Bernard was working hard, 'locked up for weeks in the solitude of his studio',[2] preparing his corrida paintings that were the subject of his 1967 show; truly spectacular canvases, huge, densely worked, vivid pieces that for all their colour have an almost religious solemnity to them). However, the paintings shown in 1968 were *Les Plages*.

After the Herculean efforts, the intense absorption and concentration, she felt he 'needed some distraction and we decided to throw ourselves into a giant party'.[3] And so – presumably leaving their daughters in the care of their live-in nanny, although Annabel omits the finer details of the childcare arrangements – the Buffets took themselves off to Paris and went on a massive bender. Bending it like Buffet was a serious business, and she thinks, but cannot be quite sure, that it was at Castel where they ran into Guy Béart.

Béart, father of *Manon des Sources* actress Emmanuelle, a singer and highly successful composer, had known the Buffets for years and had worked with Bernard in 1959, writing the music for Marcel Aymé's *Patron*, a musical for which Buffet had designed the sets.[4] He was an accomplished songwriter, many of whose *chansons* had been interpreted by Juliette Gréco. However, times had moved on since young

people had held hands and gazed into each other's eyes to the accompaniment of his gentle and soulful songs. Music was no longer the whimsical, charming stuff it had been: Woodstock was around the corner, and the Paris riots of May '68 were even closer. This was the age of Hendrix, the Stones, the Doors, the Grateful Dead, Creedence Clearwater Revival and Country Joe and the Fish: popular music polemicised and politicised as a medium of protest. Perhaps realising that his acoustic guitar, warbling voice and sensitive lyrics were a little *démodé*, Béart had reinvented himself in the late sixties as a television personality, hosting a light programme of musical variety that spoke to people of his generation; he was a couple of years younger than the Buffets. 'At that time he was producing a television programme: *Bienvenue*, which we thought very well done. He wanted to devote one to Bernard, who, influenced by the atmosphere of gay abandon, accepted.'[5]

The abandon must have been pretty gay and the drink flowing freely; shy, taciturn Bernard did more than acquiesce to appear on television. He and Béart decided that in addition, Annabel would sing. During their decade of married life, Annabel had never sung. When they had met in Saint-Tropez, she was embarking on her career as a novelist, and when Buffet had invited her to join him forever, he had asked her to come with just the clothes she stood up in, as he wanted her without the baggage of her previous existence. Now he was asking her to return to a chapter of her life that she regarded as finished. That night in the smoke-filled rooms at Castel, in a buoyant mood, enjoying the drink-fuelled cathartic release after a sustained period of creativity, Buffet had lifted the lid and peeked into a Pandora's box.

Bienvenue was a new kind of television programme that has since become familiar. The atmosphere was intimate and relaxed, almost as if taking place in one of the Saint-Germain nightclubs that Annabel more or less lived in before she married Bernard. A small studio audience of young people was ranged around the room; however, as the programme was made by state broadcaster ORTF, they were not riskily young. The men's hair may have been longer than perhaps Charles de Gaulle would have liked, but the collars it skimmed were those of suits and sports jackets worn with ties. The women, while clearly selected for their figures and looks, demonstrated some cognisance of fashion but remained demurely attractive. They were not

the sort of student radicals who would tear up the centre of Paris in a modern-day revisitation of the Paris Commune. The occasional cigarette was smoked, but on the whole these were nice young people to have in your sitting room on a Saturday night when you turned on the television. Complete with a soufflé of vividly black bouffant hair and smart suit and tie, the softly spoken Béart, with his gentle, slightly feminine voice, rendered the whole thing soothing rather than seditious. Had the audience started swaying gently from side to side and broken into a spontaneous rendition of 'Kumbaya', it would not have seemed out of place. It was in this environment that Béart show-cased a mixture of pop music and café society culture.

The show had that French gift of adding cultural polish and an intellectual dimension to popular art forms, France is not a nation where singers sing songs; they interpret them. Britain has Dame Shirley Bassey, France has Juliette Gréco. Béart was the perfect presenter for such a show. His winning charm and sweet smile aside, his songs were more like poems set to music rather than three and a half minutes of commercial catchiness. Thus, one of his early guests was Buffet's Dallas travelling companion Louise de Vilmorin, who appeared on the show in November 1966 to declaim a few poems.

Today it is hard to understand that *Bienvenue* was something of a revolution in television. The real architect of its success was not so much Béart as Guy Job, who used the latest technology of video cameras to create a new type of programme. Thanks to these advanced cameras, Job was able to watch what was being filmed as it happened. Sitting at his control panel, his bespectacled eyes flitting between a quartet of monitors, he could issue brisk instructions through his headset to the cameramen. Thus, without stopping and starting for retakes and to review footage, he kept the cameras turning and created an atmosphere so relaxed that guests and audience quickly became almost unconscious of being filmed and 'did not hold back . . . so that the interview resembled a general conversation'. It would appear that the seductive atmosphere worked its magic on the shy painter, who was uncharacteristically open.

Bernard, won over by the warm atmosphere, came out of his usual reserve. This mute decided to speak. This is probably what caused the impact of the show when it aired. We discovered a very different man from the worldly and snobbish image of him that people had. The

fact remains that we could no longer make a step without someone complimenting him for his performance. The fascination of the small screen is no secret. To appear on it is supposed to be some sort of consecration. Someone else would have been delighted by this success. Him, not at all: he was furious. How could you congratulate him on what had been a game? Worse yet, to attach more importance to his appearance and his ramblings than to his work? These are his own words. He was wrong . . . The alleged ramblings were intelligent, full of good sense and courageous in the way they dealt with serious issues such as conscientious objection. But he is not one to change his mind. All that he had to say was in his painting and since then he has refused to do any television except a few brief laconic appearances on the news when he had an exhibition.[6]

Knowing her husband as she did, Annabel must have been half expecting such a reaction. For her, however, the experience of appearing on prime-time national television was electrifying. Thanks to a recording of that show, Béart's soothing, kindly voice purrs just as seductively as it did almost half a century ago when he voices the words 'Annabel, you have not sung for ten years. Have you kindly decided to sing for us this evening?' She is clearly nervous. Standing up, she smooths her figure-hugging crew-neck top and adjusts the broad belt that rests on her slender hips. Her hair is cropped mannishly short but with a spirit-level-straight fringe ending a little above those large, expressive eyes that Buffet had painted so often over the years. Then, hooking her thumbs into her belt, she begins to sing – sorry, interpret – a song that Béart himself had written in 1960, 'Il N'y a Plus d'Après'.

It is worth quoting the refrain:

Il n'y a plus d'après
À *Saint-Germain-des-Prés*,
Plus d'après-demain, plus d'après-midi,
Il n'y a qu'aujourd'hui.
Quand je te reverrai
À *Saint-Germain-des-Prés*,
Ce ne sera plus toi,
Ce ne sera plus moi:
Il n'y a plus d'autrefois.

It is a song about the change that time works on two lovers, and elegiacally celebrates the *carpe diem* spirit of a Saint-Germain-des-Prés that is itself changed and in which even the coffee no longer tastes as it once did.

Même les cafés crème
N'ont plus le goût que tu aimes.

The words had an almost eerie aptness for Annabel, and as she sang them for the studio audience and the millions of viewers of *Bienvenue*, she must have realised their relevance to her situation. She was celebrating her fortieth birthday, and found herself living a cloistered – she uses the word 'monastic' – existence governed rigidly by her husband's working schedule, just as the preordained timetable of prayers and services dictates the day of a religious order. Moreover, singing of Saint-Germain-des-Prés, it would have been impossible for her not to recall the delicious discovery of a way of life that for the last ten years had ceased to be hers.

Did Béart know what he was doing? Who chose the song?

It is fascinating to watch Annabel change as she begins to sing. Still fabulous-looking and svelte at forty, she appears half a generation younger than the husband beside whom she has just been sitting. His receding hair and impeccably cut dark suit enable him to give a particularly accurate impression of a notary. She, however, in her low-slung belt and tight clothes, is all sensual sixties sex kitten. Her interpretation of the song is throaty, melancholic, seductive and irresistibly French. It is a performance that lasts all of two minutes and twenty-two seconds, but it is, to use an accurate cliché, spellbinding. At the beginning, the audience look politely bored; ninety seconds later, they are singing along to the refrain, even if not all of them are familiar with the words. Annabel's features are illuminated as if from within. The camera stays with her as throughout the brief performance she casts smiles and affectionate glances to the right, where Buffet is sitting. But are they directed at Buffet? At the end of the song she rushes over in a tumult of relief and excitement and throws her arms around Béart's neck, while Buffet permits himself a smile and a bit of restrained applause.

A little while later, she is coaxed up on her feet again, this time to sing 'La Mauvaise Réputation':

Au village, sans prétention,
J'ai mauvaise réputation

Once again the choice of song is almost clairvoyant: Annabel lives
in a small village and she is, to put it elegantly, a woman with a past.
This time at the end of the song Buffet does not even bother to
applaud; he seems far more interested in the cigarette he is smoking
and generally gives the impression that once he has completed the
attention-absorbing activity of inhaling its smoke, he will turn his
hand over and inspect his fingernails.

The trouble with Pandora's boxes, as with genies in bottles, is that
once the contents are allowed out, they are difficult to put back.

It is hardly fanciful to suggest that the root of Buffet's violent aver-
sion to this television broadcast was not so much its portrayal of him,
although his dislike of having given too much of himself away was
characteristic; it is rather that he saw what had happened to his wife,
and the effect of the adulation on her. And sensitive as he was, every
congratulation from a well-meaning friend, acquaintance or stranger
would remind him of that evening and torment him invisibly like pins
in a voodoo doll.

> For me, the consequences of *Bienvenue* were very different. I had my
> share of success at his side and Bernard liked my way of singing. Eddie
> Barclay offered me a contract and was very insistent. I should have
> been more modest and particularly more far-sighted. Eddie loves
> publicity so much that he would readily offer a recording contract to
> a cow, if she won first prize in an agricultural competition! I asked for
> a couple of days to think about it. I knew what the job required; my
> girls were only five and six years old; I had never left my husband more
> than an hour. I was wary of the impact that this return to singing
> could have on my private life.[7]

Of course she signed the contract.

This was a busy time for Annabel, into which the events of May 1968,
when the country teetered on the brink of anarchy, did not overly
intrude. As well as preparing to return to a career as a singer, she was
writing the screenplay for a television adaptation of her most recent
book, directed by video camera king Guy Job.

She started to become restless in Saint-Cast: 'Without being outright unpleasant, I was in a bad mood, I drank in silence.'[8] Bernard took the hint and said that it was time they had a little holiday in the capital, and Annabel called Pierre Lazareff to say that they were coming to town and would be passing by Louveciennes. He suggested that they come for lunch – not one of the grand Sunday lunches, but just the four of them. It was while they were having their aperitifs that Bernard told Pierre that he had been suffering from severe migraines. Pierre erupted angrily.

> This is ridiculous! A migraine, a headache could be the beginning of flu or anything. Amazing! People are incredible! They service their cars regularly, but don't look after their bodies. If you were in my place, you would know the price of health. I know a great chap. Come into my office, we are going to ask for an appointment.[9]

Bernard meekly followed the pugnacious little media baron into his office and emerged calmly a few moments later saying that he had an appointment the following afternoon. Thinking nothing more of it, they had lunch and the Buffets went on their way to Paris and dinner with friends, followed by one of their long whisky-soaked nights. Waking with terrible hangovers and irritated that they had not cancelled the appointment, the couple went to the doctor and Bernard underwent a long and detailed examination.

He was seriously ill.

It was vital that he stop drinking and smoking, and it was only on this condition that the doctor would treat him. Buffet was of course at liberty to decline and seek a second opinion. The doctor asked him to think about it and said that he would see him again at the same time the following afternoon, when, if he acquiesced to the condition, he could be admitted to hospital. Agreeing to the doctor's stipulation, he was admitted to the American Hospital of Paris in Neuilly-sur-Seine. Apparently his intake of alcohol and cigarettes was endangering his vision. Tobacco's effects on the eyes is just as pernicious as on other parts of the body; the risk of cataracts is increased by 200–300 per cent, and chances of macular degeneration, which destroys the central vision, eventually making reading, driving and even the recognition of facial features impossible, are doubled. In 2015, an anti-smoking advertisement aired in Great Britain showed a heavy smoker from her

teens receiving a monthly injection into the eye. Buffet too had been a teenage smoker and had continued to consume tobacco on an epic scale, and now, after almost a quarter of a century of chain-smoking, his vision was under threat. His optic nerve had suffered damage linked to his drinking and smoking. Without eyesight he could not paint. Without painting he could not live. And if it were a choice of the bottle, the cigarette or the paintbrush, the decision was clear.

The first thing he did was to put a bottle of Johnnie Walker and a carton of Gitanes on his bedside table. They were not there to be drunk and smoked; they were there precisely not to be consumed. It was a matter of showing who was in control, the cigarettes and Scotch or the painter. They remained untouched throughout his stay.

If anything, it was Annabel who suffered.

> That evening I asked permission to sleep there. I was refused. It would have been egotistical if I had really insisted on not leaving him. I was not worried for him, but well and truly worried about myself. We had never been separated. I had forgotten what an empty bed was like, too big . . . I was cold, I was alone and I did not have the courage to be on my own. I finally slept a troubled sleep, plagued by my childhood fears.[10]

By the next morning, Bernard had arranged for her to stay at the hospital, but even though they were physically close, the emotional gap between them widened with every successive day of Bernard's sobriety.

When he left hospital, he was a completely different man: the absence of alcohol and its concomitant disruption emphasised what his wife called 'the mysticism that was at the base of his character'.[11] Gone were the sudden flashes of anger and the need to go on binges; not only did Annabel find herself married to a new man, she keenly felt the absence of a playmate. From her description it seemed she felt she was living with some transcendental being, a figure of Buddhist serenity who existed on a different plane. 'He surrounded himself with silence, he seemed to float above us . . . All that existed was his work; everything else washed over him without any effect.'[12]

Frustrated, she sought solace in the bottle and the recording studio.

But while Buffet may have become a figure of Yoda-like equanimity, his painting, at least at first, appeared to suffer.

Initially the move to Brittany had stimulated his creativity. Buffet always preferred to paint rather than to think. The mechanical activity of filling a canvas was both a challenge and a reassurance. He tended to paint what was to hand, or rather what he saw, either around him, or in his mind's eye. Like a painting machine he sought to process or make sense of life by putting it on canvas. One of the reasons he cited for moving house was that after five years he got bored of looking at the same view out of his window.[13] He abhorred painting *en plein air*, and every time he saw an artist setting up his easel beside a river, he had to resist the powerful urge to rush over and push him into the water. He even preferred artificial light to the real thing.

Later in his life Buffet would provocatively say that he did not believe in inspiration, but earlier in his career he did talk of it. In 1966, for instance, he said that 'it was evident that inspiration did exist and that one had to wait for it, wait for it all the time',[14] (careful to make clear that while waiting for it), he was working; just putting in ten hours in front of a canvas would not necessarily guarantee good paintings. Gradually over the years his opinion would harden. In 1983, for instance, he said, 'You cannot just wait for inspiration. If you wait for inspiration, you risk waiting a long time.'[15] As time passed, his curmudgeonliness got the better of him. 'I don't believe in inspiration, I just keep working,'[16] he said, a great soundbite that fitted the image he cultivated of the unpretentious, thick-skinned craftsman and which was often trotted out in posthumous articles about him.

The truth is of course a mixture of all the above and more. Inspiration is a nebulous term, and given the amount of time that he spent in his houses, either working in the studio or resting after hours of painting, the idea of a change of scene must have seemed appealing, even if he was only swapping one large, messy, floodlit studio for another large, messy, floodlit studio. His inspiration would come from experiences; his series of 1965 paintings of flowers and spring in Saint-Cast seem to explode off the canvas. He could not have painted those in Provence.

The corrida paintings of the following year, which after the clowns and the flowers remain his most popular works, and for which he often used his wife as a model, are utterly brilliant works. It is not a Breton theme, of course, unlike *Les Plages*, the series of paintings he exhibited in 1968, and completion of which he was celebrating in

Castel the night Guy Béart invited him to appear on *Bienvenue*. It has to be remembered that the works he showed at Maurice Garnier's gallery every February represented just a fraction of his annual output of around 150 or so paintings; not counting drawings, aquarelles, book illustrations, engravings, posters, advertisements . . . Nevertheless, those monumental canvases had to have been born out of some experience; they had to have been inspired by something, even something as banal as looking out of the turret at La Vallée and seeing tourists on the beach. The beach paintings have the air of a Jacques Tati film committed to canvas, and in the 1967 series, his focus on the female figure manages to be voyeuristic without being erotic.

The paintings shown in 1969, after his fortieth birthday, the intimation of his own mortality and Annabel's drift back to her singing career, are very different. Sombre to the point of dreariness, they are morose pictures of churches all over France. Some grand, like the cathedrals of Nantes and Chartres, some squat and ugly, they are all more or less equally dispiriting to look at. Each is identifiable as a real site of Christian worship, though they are occasionally interpreted with a bit of artistic licence. Buffet said that when painting them, he was thinking of the men who had built them and the monumental stone they had used, and indeed they weigh like heavy masonry on the spirits. There is little uplifting about them. Hanging in the Galerie Maurice Garnier, these thirty brown canvases must have made a doleful spectacle; if he set out to convey a sense of the monumental, the result is merely ponderous. 'I painted my thirty churches in three months,' he said proudly. Many were painted in Paris, where he had decided to spend time, not feeling strong enough to return to Saint-Cast and face the solitude of life in the country, let alone traipse around France visiting sites of religious observance. 'I have known them for a long time, that is to say that I have cardboard boxes not of sketches but of *dessins poussés* of almost all of them.'[17]

He might also have added that he had cardboard boxes full of postcards, which were put to use for his next show, *Les Châteaux de la Loire*. There was a convenience about not having to actually go to the Loire, and after all, he had used postcards effectively before.

He seemed preoccupied, almost on autopilot. At the same time as he was convalescing, Annabel was reigniting her career in music, and she would return home to their Parisian apartment, where Bernard would listen to her distractedly. Often she would come in to find him

playing with his daughters, and having happened across this touching, if unremarkable, domestic scene would experience the disagreeable sensation that she was interrupting them. Her observation, typical of the self-absorption of the addict, was that he had replaced her with the children.[18]

The *Châteaux de la Loire* are not bad pictures at all, but they are decorative and well crafted rather than truly inspired. Familiar views of familiar subjects, they lacked the impact of his eerily empty Parisian scenes or his linear depictions of New York of the preceding decade. More embarrassing was the fact that this series of paintings landed him in court.

It was not the only time that he had had to fight a legal battle over his work. The first court case had concerned a kitchen appliance that would become the subject of a no less than 'seminal' article, 'The Refrigerator of Bernard Buffet',[19] by a Stanford law professor called John Henry Merryman.

While this 'seminal' essay may have a touch of bathetic comedy in its title, Buffet was serious. He and a number of other artists had been asked to each decorate a fridge, which had then been sold at a charity auction at the Galerie Charpentier in December 1958, the year of Buffet's apotheosis. A few months later, Buffet came across his fridge, or at least part of it, in an auction catalogue; the Swedish owner had dismantled it and was selling the six panels separately as 'paintings on metal by Bernard Buffet'.[20]

Buffet sought and got an injunction against the sale, which was halted; the owner appealed, and after six years a Paris court found for the painter, judging that 'the refrigerator in question, having been acquired as such, constituted a single unit, both in the subjects that were chosen and in the way in which they had been treated. By stripping the panels from the refrigerator, the owner had mutilated a work of art.'[21]

This case has been cited periodically ever since, and according to the journal *Copyright: Monthly Review of the United International Bureaux for the Protection of Intellectual Property*, 'The author's moral right in an artistic work gives him the right to take care that his work is not distorted or mutilated after being disclosed to the public, when the work in question, having been acquired as such, forms a unit in respect to the subjects chosen and the manner in which they have been treated.'[22]

At the end of six years of legal action, a moral victory was more or less all that Buffet could claim; he was awarded costs and symbolic damages of a single franc. He had wanted to have the panels returned but he had to settle for the court prohibiting the fridge's break-up and distribution even privately.

Now he found himself on the other end of a legal action from the owner of one of the chateaux he had painted, who had forbidden all unauthorised reproductions of his castle. Apparently visitors to Château de Moulin-Lassay would have been acquainted with this fact as it was printed on their entrance tickets; however, working at long distance in Paris by a sort of artistic remote control, from postcards rather than the original, Buffet was ignorant of this interdiction. Put another way, he had been caught out; as art historian and author of *Bernard Buffet: Le Peintre Crucifié* Stéphane Laurent puts it, 'The use of postcards had played a nasty trick on the painter.'[23] The humiliation dragged on until 1972, when Buffet lost the case and had to pay damages: again a symbolic single franc, and 3,000 francs towards the castle owner's costs.

Rifling through cardboard boxes of postcards to – how should one say – jog his memory, shutting up the studio early so that he could come home and play with his children . . . it sounded like Buffet was coasting, treading water, going through the motions, reheating artistic leftovers. And then, apparently out of nowhere, in 1971 he showed a series of paintings that was arguably more powerful and disturbing and certainly more splenetically personal than even *Horreur de la Guerre*.

Chapter 32

Portrait of a Marriage in Crisis

Photographs of Buffet at work on *Les Châteaux de la Loire* have an almost meditative quality about them. There is one of him sitting motionless amidst what looks like an alluvial deposit of detritus left by a flood that has crashed through his studio and receded to leave him among the debris. The paintings are scattered around here and there, some flat, some stacked upside down against each other in much the way that old Dutilleul had kept his paintings, and in their midst sits a slightly slumped Buffet. His left hand resting on his knee holds four paintbrushes, his eyes gaze almost unseeing at the table piled with bottles in front of him. To return to the analogy of the flood, he gives the impression of a householder numbed by the extent of the devastation.

Other photographs show him painting the minute architectural details of the castles, painstakingly picking out each crenellation, machicolation, glazing bar, spire, weathervane and window shutter. This is almost painting as a therapeutic exercise. Like some of his London canvases, these require the steady hand and gimlet eye of a Canaletto. If slightly repetitive, they are also serene.

Not so *Les Folles*.

There is one particularly telling photograph of Buffet at work on this sustained, gaudily voyeuristic, misogynist masterpiece. He is in the foreground, his hand moving so fast that it is blurred; behind him the giant canvas, six metres long and over two metres high, is nailed to the wall. The nails hammered in every couple of inches impale the defenceless canvas as Buffet works at it with a taut fury and ferocity. There is an immediacy that the passage of the years is powerless to diminish.

This giant canvas is *La Mariée*, the culminating piece in the series. The figures are picked out in the harsh, confident black lines of Buffet the master draughtsman. There is for instance a dog. Outlined with

the maximum economy, sketched on to the canvas with a few sure strokes from the painter's hand, the canine figure is brought to quivering, intelligent life. The depiction of man's best friend is actually better at this stage in the evolution of the painting than in the finished work. But it is not the dog that commands the attention; it is the women. The dog is not man's best friend; in this hideous world of female depravity it is his *only* friend, a small beacon of hope amidst a cavalcade of dissipated women.

In her memoir of her battle against alcohol, *D'Amour et d'Eau Fraîche*, Annabel does not actually admit to having physical affairs during this period, but the sections relating to close friendships with men are strongly suggestive of it. *Les Folles* is Buffet's response. It marks the end, for him, of pure love. Having made the mistake of idealising her at the beginning of their relationship – as well as the portraits, Maurice Garnier explained that *The Birds* was also an extended love letter to his wife – he now had to deal with the toppling of his idol. He reacted with all the fury of both wronged husband and deceived, disillusioned child, pouring his pain and confused emotion into these paintings. Interestingly, work on the pictures began when Annabel was away singing; when she returned, he painted other works, resuming *Les Folles* when she went away again.

'There are things in *Les Folles* that could make you think of Dix,' says Fabrice Hergott, director of the Musée d'Art Moderne de la Ville de Paris. 'Think of a prostitute by Otto Dix.'[1] Certainly Maurice Garnier believed this to be one of the summits of Buffet's career, and it cannot be denied that he had rediscovered the anger, pain and cynicism that had assailed him in earlier years. It seemed that Buffet was right about inspiration: it could come from surprising places. 'The theme is inspired by Annabel, when Annabel cuckolded Bernard Buffet. She went with other men. Bernard knew, and at that time he painted *Les Folles*,'[2] explains Garnier.

In this series, Buffet vomits up metre after square metre of pure bile. The paintings are in a way the antipodal extreme of those for the chapel of his Provençal chateau. Although an older man, there is the same look of frenzied absorption as he goes about the work that is reminiscent of Fournol's pictures and Negulesco's description of him engaged on the religious series.

La Mariée is, of course, everything a bride should not be. She may have a great body, but the bridal veil crowned with flowers sits atop

a head that is a grinning skull, its tongue stuck out in mockery. This figure is the death of marriage. Around her are other women, all with more or less the same figures that conform to the accepted norms of sexual desirability, all wearing mauve stockings held up by suspenders and knickers or basques. The faces are similar to those of Buffet's clowns, exaggerated, but this time cruel. Beneath the central figure a jewellery casket lies open, the dark pearls strewn on the floor. They are not the only Annabel reference: the broad-brimmed summer hats in which he painted her at Cannes are worn by three of the women, who are busy flaunting their bodies, pawing each other, kissing or otherwise engaged in some grim parody of coquetry.

Femmes au Salon is as luridly sexual as its title is decorous. Here the women are wearing even less, and their bodies are so entwined that it is difficult to distinguish which parts belong to which woman. It brings to mind the scenes that Martin Summers described at the Château l'Arc. The two canvases *Le Repas I* and *Le Repas II* form a parody of the Last Supper; among the glasses, the sauce boat, the lobster and sole are skulls and a severed human foot.

Just as Annabel knew that she was in a marriage with three partners – herself, her husband and her husband's art – so Bernard was beginning to discover what it was like to be in an even more polyhedral union, with himself, his art, his wife, her singing and her lovers.

There is no *catalogue raisonné* of the works of Bernard Buffet; it would be immense. There is, however, a three-volume monograph commissioned by Maurice Garnier with text written by Yann Le Pichon. Le Pichon is often minded to take the reader down some highly ornamental garden path with plenty of floral language and distracting allusions to philosophers, poets, playwrights and of course other artists. But when it comes to *Les Folles*, he is untypically direct.

After kicking off with a bit of Dante and the rhetorical question 'What hell did he go to in the galley of a Charon who took him to the shores of damnation?' Le Pichon then explains that the ferryman for the dead had docked at the shore of damnation otherwise known as 28 Boulevard des Capucines, the address of a handsome late-nineteenth-century music hall called L'Olympia, where the greats of French music, among them Jacques Brel and Édith Piaf, had performed. 'It was in 1970, when Annabel undertook a series of concerts at L'Olympia. A few sleepless nights, haunted by his distressing chimeras, saw Bernard Buffet fill these immense canvases – the largest measuring

six metres in length by two high – which are today among his most original works.'[3] But then Annabel and Bernard were, to say the very least, an original couple.

It is always hard, if not impossible, to dissect a relationship, let alone one between a world-famous bisexual alcoholic artistic prodigy and a beautiful bisexual alcoholic chanteuse-novelist, both of whom lost their mothers at unfortunately early ages. It was an emotional knot at once Gordian, Faustian and Freudian.

When it came to sex, Bernard clearly found his wife attractive, and periodically throughout the 1960s he created nudes and even paintings of couples having sex that leave nothing to the imagination. *Les Folles* are frightening, repellent, but they are sexy too, a nightmarish vision of Robert Palmer's 1986 video 'Addicted to Love'. Aficionados of Palmer's famous video would probably enjoy Buffet's series of drawings *Jeux de Dames*. Like almost any Buffet drawings they are highly skilled, and the fact that reproductions of them remain popular demonstrates that there is no underestimating the commercial appeal of a couple of women pictured wearing nothing other than stockings and high-heeled shoes.

He liked painting women in a state of undress, or indeed without any clothes at all. *'J'adore le striptease,'* he admitted to an interviewer in the mid 1960s. 'There is no sight finer than the human body. I would find it very normal to meet a woman that you find interesting and ask her: "Excuse me . . . would you mind showing me how you look naked?" It need not be sleazy. You do not always have to associate nudity with vice.'[4]

Thus, as well as his almost Impressionist pictures of Saint-Cast in spring that had been inspired by his arrival in Brittany, 1965 saw him paint a series of women in their underwear. Talking of Saint-Cast, Annabel said, 'This is where Bernard painted women so different from the ones he normally painted. Tall, beautiful, Nordic-blond and surprising. I don't know what inspired him.'[5]

According to Céline Lévy, granddaughter of Garnier's wife by an earlier marriage, who began working for Garnier during the 1990s, it is likely that the inspiration was right under Annabel's eyes: her half-sister Isabelle, who had come back into Annabel's life when Bernard expressed curiosity about meeting the Jewish *grande bourgeoisie*. A dinner at the Ritz was organised with her father, stepmother and Isabelle. After that, they started seeing each other regularly. Time had

not improved the stepmother, who declared one evening that it was 'regrettable that Bernard had not married Isabelle'.

'What a strange period of our life!' recalled Annabel.

> If the complete incompatibility of my stepmother and me had been revealed, I was able to disguise it with a smiling politeness without too much trouble. Things were completely different with young Isabelle whom I had liked from the first time I saw her. The feeling was mutual. She was ravishing, delicate, distinguished, as blonde as I was brunette . . . She also wanted to be a painter. To say she admired Bernard is an understatement. Very quickly, we became inseparable. In Paris she was great fun. When we left for Provence, she came to join us for long stays. She had the appearance of the perfect girl of good family, *bon chic, bon genre*, and not at all clever, which amused me a lot. I did not ignore the fact that she had tried to slip into my husband's bed, but he did not let himself be taken in by her charms, which made me smile. She chose her lovers amongst our friends and our life was harmonious.[6]

She regarded her stepsister as a charming toy. And it would appear that as far as Bernard was concerned, Isabelle looked good enough in bra, panties and suspenders to inspire his February show in 1966.

Where the Nordic blondes in their underwear had been calm and docile, *Les Folles* were anything but. However, the series shows that Buffet also found the female form appealing in general. Wounded by Annabel's behaviour he might have been, but he cannot revert to the folded flesh of the sagging, mannish women he painted in his bourgeois *maison close* period of the 1950s. And in this it might be possible to see an underlying love, a foundation of affection of which physical attraction was a considerable part. Although he was sad, hurt and angry, there was none of the coldly matter-of-fact manner in which he had told Pierre Bergé that if he left Château l'Arc to attend the Dior fashion show he would not find him at home when he returned.

Thus although *Les Folles* marks the end of a sort of extended honeymoon of a decade, it does not mark the end of the marriage. After Buffet's health scare and his sobriety, and Annabel's attempt to reconnect with her youth in Saint-Germain-des-Prés, they were both very different people, and their relationship entered a new phase.

Nicolas Buffet, who was adopted after the huge upheaval of the late 1960s and early 1970s, certainly believes that

> the love that was between them was stronger than anything. Once again I was too little to see what was going on at that time, but now, if I think about it, I have my opinion and my opinion is that their love was stronger than everything and so at some point my mother said, 'Okay, I have some needs, you have some needs, so let's have our needs met from outside.' My father stayed at home a lot working and my mother just went and had her friends and her parties and everything, but I think it wasn't at all a problem for my father. He was sure that she would always be back, and be back with arms open wide. So he was really quite above that.

According to Nicolas, *Les Folles* is also a wider commentary on 'a certain kind of people in society. I think it's more something like that. If you look at the painting it's quite brilliant, but it's unaesthetic, it's not nice, it's just saying something really, really violent . . . it's like a punch . . . it's like a big punch in the face.'[7]

Whether wider social comment, portrait of a marriage in crisis, or a combination of both, the violence of *Les Folles* and its assault on the viewer is undeniable, which makes the work that followed even harder to understand.

Chapter 33

Pulling Up the Drawbridge

With so much going on, and going wrong, in Buffet's life, there was of course only one solution. It was time to move house.

New decade, new chateau; this time the Château de Villiers-le-Mahieu, about sixty kilometres west of Paris, beyond Versailles. It is perhaps the most impressive house that Buffet inhabited – by comparison Château l'Arc was just a starter castle – and shows that, whatever else had happened to him, he had certainly not lost his taste for grandeur.

Built in the Middle Ages – one account tells that the first buildings dated from the time of Charlemagne[1] – Château de Villiers-le-Mahieu was extensively remodelled during the seventeenth century. The house is on such a vast scale that only aerial photography can convey an accurate sense of it – the windows, for instance, held 3,580 panes of glass. But its impressive extent apart, what appeared to appeal to Buffet was the fact that it was 'buried in dense forests'.[2]

The chateau had a moat with a bridge, and for much of the 1970s it was as if Buffet had pulled up a metaphorical drawbridge, shutting off connection between himself and the wider world. Although his routine varied, the pace never slackened, and by the end of 1977 he slept just four hours, from 4 p.m. until 8 p.m. and painted all night, breaking only to toss bread from the window of his studio to the carp that teemed in the moat below. He did not watch television. He did not listen to the radio. He did not read newspapers. Cocteau had revelled in the medieval luxury of the Château l'Arc. Annabel had once described her life with Bernard as being lived in the nineteenth century, albeit with central heating and a refrigerator.[3] Now, in his moated castle, with the exception of the pinball machine that he had installed in the great hall, it was as if twentieth-century life going on in the world across the bridge had somehow not succeeded in breaching the chateau's three-metre-thick walls.

And as he retreated from the 1970s, so did his painting. His break with the conventions of the time was total. He painted his children. He painted castles, derided by one critic as 'fake little chateaux, in fake landscapes, with a fake sky and an even more fake sea, for real morons with real bank accounts and a real veneration for that which is at their sad level'.[4] He painted the great harbours of France filled with sailing vessels and steamships, creating insanely detailed and painstakingly worked canvases; his library in the chateau was easily able to accommodate large-scale models of yachts and ships from the great days of sailpower, with masts that towered over his head. He later commented that he 'had never been happier than when painting the *Boat* series'.[5]

By 1973–4 he had regressed, or rewound, to an almost Barbizon style of landscapes that could have been painted by Corot. The parallel with the Barbizon school, by no means exact, does bear further exam-ination. Buffet's knowledge of art history was impressive, and when it came to the nineteenth century, it was encyclopedic. He once surprised Emmanuel David by rattling off the CV of a relatively recondite mid-nineteenth-century French painter and illustrator Émile Bayard, one of whose works he happened to spot at his art dealer's mother's house; impressive given that he was then only just in his twenties.

Courbet was a sort of god for Buffet; he had painted his own version of *Le Sommeil* in 1955. His love of the monumental history paintings of the preceding century was what had first inspired him to work in huge formats. For him, the nineteenth century was a miraculous age, a '*siècle extraordinaire*'[6] for painting, so he would have been steeped in the pictorial culture of the age and intimately familiar with the painters and movements of the period. Although to the south-east of Paris, Barbizon was within more or less the same radius of the French capital as Villiers-le-Mahieu. Of course Buffet was not one to go and plant his easel in the great outdoors and start painting *en plain air*, but part of his daily routine was to have breakfast with his family and then go for a walk in the eleven hectares of woodland that surrounded the property, immersing himself in the natural world.

Even the signature had changed. Once it used to dominate the canvases and drawings, its angularity as familiar to the consumers of Les Trente Glorieuses as the chevrons that meant Citroën or the interlocking letters YSL that signified the fashions and fragrances

created by his ex-boyfriend's increasingly drug-dependent lover. Now, as the seventies progressed, it shrank until it hovered politely, almost self-effacingly, in the top right- or left-hand corner of the canvas, and although still recognisable, it was rounder and softer, like the works themselves and the man who painted them.

Look hard at these paintings and one can discern traces of the Buffet of the past: similarities between the manner of painting foliage and trees in his 1970s pictures of rivers and his pictures of Saint-Cast; the familiar linearity in the fenestration of cottages and village houses; the absence of human beings that characterised his cityscapes. However, one needs to be fairly forensic to detect these similarities when in the foreground there is a horse that might have been painted by Stubbs, as in the 1974 pictures called *Cheval Anglais*.

But while not as readily identifiable as much of the rest of his work, it would be incorrect to call these paintings atypical, in that for a period of five years they characterised his output. Moreover, given that Buffet seemed throughout his life to be chasing his childhood, it is interesting to note that there are marked similarities with the landscape paintings he had done around Quesnoy as a teenager thirty years earlier, a location that appears once again in the paintings he was doing in the second half of his forties. He delights in depicting a France that was vanishing, and the paintings made over the course of the autumn and winter of 1975–6 stay in the mind. Like Monet, he seems to enjoy handling the effect of light on snow and the accent that it puts on the boughs of skeletal trees, the platforms of deserted railway stations, the eaves of quiet cottages and the boundary walls of *maisons de maître*. It may sound strange, but there is something almost lyrical in his depiction of tyre marks in the snow following the curve in a road.

Not all the work from this period is good. There is a series of paintings from 1973–4 that is remarkable for the almost indiscriminate use of an autumnal saffron and a gold so garish it recalls iron pyrite; normally so adept as a painter of light, it is strange to see Buffet so heavy-handed.

But to write off this part of his career as an embarrassment, as a period characterised by a loss of nerve and doubt in the style of painting that had made him famous, is too simplistic. They are without doubt the least understood and appreciated of his paintings. It is a view held by his son.

There is a period that I really love, it's not the greatest period of his height but it's the period during '72 to '75. For me it's the peaceful period. It's the only period of his life where he's just in peace. And then he tried . . . he did not try, he successfully used different techniques because maybe he was sick of hearing 'Yes, Buffet, it's always the same thing, it's always black' and "He is not a good draughtsman', which was not the case; he was one of the best draughtsmen of his time.

So he decided to do something else, and during two or three years, when he was living at Villiers-le-Mahieu, that was what he did. And for me there are some absolute masterpieces in that period. Some of them are almost Impressionist. I really love this period, and it's the most unknown period of his art. But it deserves to be known because it's incredible, you just want to get in the painting and have a walk in that countryside. It's beautiful and peaceful. If you see the rest of his art it's beautiful but really, really violent, really tortured.[7]

It is perhaps this utter difference between the rest of his oeuvre and this period that has led to these being perceived as Buffet's wilderness years.

The 1970s was a time very different from our own, and with the passage of years it can be seen that it was an era of even more profound social change than the decade preceding. History does not adhere to the calibration of decades and centuries that mankind tries to tame it with. It has the untidy habit of following its own timetable, and during the 1970s much of the social change that had begun in the late 1960s started to be felt in a society forced to question the fundamental values on which it had rebuilt itself following the Second World War.

The unrest of May 1968 in France had brought the country to the brink of revolution. Some feared open civil war as students and workers united to defy the political system with mass strikes, violent demonstrations and the occupation of public buildings. Although dramatic, the events in Paris were not unique: there were increasingly violent demonstrations in America and in Britain against the war in Vietnam, all part of the wider context of the youthquake of the late 1960s. The spectre of terrorism rose over Europe: separatist organisations such as ETA and the IRA carried out ever more audacious and violent acts, and the era saw the rise of militant left-wing terror groups such as the Baader-Meinhof gang in Germany and Italy's Red Brigade, which

targeted business leaders and politicians. The struggle in the Middle East spilled over into Europe with such tragedies as the Munich Olympics hostage debacle.

Had he turned on his television in the early 1970s, Buffet would have seen grainy footage of aircraft hijackings, and almost inter-changeable photofit pictures of the perpetrators of bombings and kidnappings. The fabric of the society that had created such material abundance was being torn apart by the generation to whom the post-war years had given peace, prosperity and plenty. Nor was terrorism the only thing to lose sleep over. Climate change became a new topic of public debate, even if at the time the majority of predictions were of a new ice age, with *Time* magazine running a front page with the headline 'How to Survive the Coming Ice Age'. After the oil shock of 1973 and the economic crash that followed, a brooding cloud of apocalyptic doom settled over the developed world. The period of explosive post-war growth came to an end. Les Trente Glorieuses sputtered and died.

It is no surprise that, faced with the prospect of being blown up, kidnapped, hijacked, or eaten by one of the polar bears that would soon be romping down the Champs-Élysées, Buffet retreated behind his thick castle walls and buried himself in pictures of rural villages, soothing landscapes, fanciful castles, sailing ships and Stubbs-style steeds.

Because of the controversy that had attended his early works, it had perhaps been tempting to see Buffet as the rebellious voice of a generation, with something to say about the era in which he lived. But given his enigmatic *oui, non, peut-être* approach to explaining his art, any commentary on the times was in the eyes and minds of those who saw it, wrote about it, bought it and projected their own meaning on to it. For Girardin and Dutilleul he had been in the bloodline of Picasso, Utrillo and Modigliani. For young critics such as Descargues and Cabanne he was an artist who was their contemporary, who had shared their experiences and who dared to challenge accepted notions of what could be viewed as art. For ageing celebrities such as Cocteau he presented a chance to convince himself and others that he was still in touch with the young. For those among the cultural and political elite of France in the Fifth Republic, to have one's portrait by him was a sort of consecration and to have him at one's dinner table was to be chic.

But for Buffet, a painter was a painter, not necessarily a righter of wrongs who needed to be offering a commentary on current affairs. By the early 1970s the abstract versus figurative debate had diminished in importance. As abstraction became increasingly dominant, and the majority of 'serious' painting was no longer directly representational, the need to intellectualise, interpret and explain art increased. Ever the contrapuntist, Buffet proved stubbornly deficient in answers.

It is hard not to feel sorry for André Parinaud, who was interviewing him in 1966 for *Arts et Loisirs* and who tried to broaden the conversation to embrace the issues of the day.

Beyond painting, does the epoch in which you live interest you?
No, I suffer it.
Are you not buoyed up by enthusiasm at the idea that we will go to the Moon?
That does not interest me at all.
Or that there will be atomic energy galore?
It is pointless, because we die.
Or that people have at least the minimum wage?
This does not interest me. Where is the 'progress'? What will remain of the furniture of 1965? All eras – the Directoire, which lasted a few years, the Empire, for example, which lasted fifteen years, Charles X, Louis-Philippe – all epochs have had a style of furniture. Today, can you define a 1965 style! Let us agree on the criteria and the style of the progress.
Before the style, there are perhaps needs to be met?
Needs! Yes . . . when you leave Paris to go to Le Bourget, you see these enormous 'blocks', home to the people, people who are, moreover, unhappy to live there.[8]

The upheaval of the late 1960s and 1970s is almost completely absent from Buffet's work. There is, however, one small (50 x 65cm), charming watercolour of a young man with a flower hanging out of his mouth. The word 'PAIX' is written in capital letters above his head. And as a non-smoking, teetotal, nocturnal country gentleman who lived in his castle and had severed contact with the outside world, Bernard Buffet seemed to have found his own type of peace.

Chapter 34

The Canute of Contemporary Art

When giving his opinion about the miserable boxes in which the unhappy people of *les banlieues* lived, which given the subsequent events did not prove to be inaccurate, Buffet uses urban architecture as a metaphor to explain his painting. While no manifesto, it gives a graphic idea where he sees himself in relation to the artistic current of the time.

> All of a sudden, you will see a small suburban villa, with a red roof, a kind of mockery in the middle of these monsters of modern architecture. *Eh bien!* me, I'm the small detached house in the suburbs with the small garden with a greenhouse . . . the little detached suburban villa in the middle of modern painting.[1]

And what he had seen in the ten years since he had given that interview in 1966 had done nothing to change his opinion. He had stopped bothering to even pretend to engage with the art world of his day. For instance, the preface to his 1973 exhibition of harbours and ships, the one that he was so happy painting, was written by neither an art critic nor an intellectual but by a retired admiral, Admiral Georges Cabanier, former head of the French navy.

A highly decorated war hero and hard-line supporter of de Gaulle, Cabanier was a wiry little man with jug ears, baggy eyes and amusingly high, circumflex-like eyebrows that gave the impression of being perpetually raised in mild surprise. A submarine commander at the outbreak of the Second World War, he had been the first naval officer to join de Gaulle's Free French. After the war, he was the last French naval commander in south Indochina, and when de Gaulle returned to save the nation again in 1958 (the summer when Buffet had been playing hide-and-seek along the Riviera with his ex-boyfriend and the

French media), he called upon his old friend to serve as Chief of Defence Staff in his first cabinet. From 1960 until the beginning of 1968, Cabanier had been head of the French navy; now in his late sixties, he was Grand Chancellor of the Légion d'Honneur. In his obituary, his interests are listed as 'hunting, fishing and golf'.[2]

Handy with a rod, rifle, shotgun and golf club, Cabanier was a tough, loyal pillar of the social order that the young intellectuals in their dirty denim and shoulder-length hair seemed determined to overthrow. Had Buffet been looking for a character more calculated to offend the liberal intelligentsia, he would have had trouble finding one.

The old sailor rose to the task splendidly. His was not the vocabulary of the art critic. He knew about fighting and about the sea, so that was what he wrote about. The vast, bewildering jumble of the artist's studio is described in stirring martial language: it is a battlefield in which the discarded, sometimes broken brushes are 'abandoned as lances splintered after a battle', the painter's stock of new brushes and colours are 'weapons and ammunition laid in reserve waiting for a new confrontation'. Given that he is a frank, no-nonsense character, he does not want to pass himself off as a connoisseur: 'I will not risk talking about the painting of Bernard Buffet, even less to dissect it: futile exercises. I love it, I admire it, and this is enough for me.' The veteran submariner may not have known much about art, but he knew what he liked, and it was Bernard Buffet.

He was, however, on safer ground – or perhaps it would be more appropriate to say he found himself in less choppy waters – when it came to maritime history. He treats the crowd that turned up to the exhibition at the Galerie Maurice Garnier in February 1973 to a potted history of seafaring vessels, from those of antiquity, 'with their primitive sails, which moved through still waters with hefty oar strokes', to 'atomic age vessels, the strange shapes of which already overshadow our harbours'.[3] Even though he had once been described as the Orestes or Pylades of the atomic age, these days of course Buffet was not having anything to do with the nuclear era; instead his pictures dealt with the moment when sailpower was giving way to steam. However, it had not escaped the Admiral's notice that the bridges and superstructures of Buffet's vessels, like his landscapes and city scenes, were empty of human beings, eerie *Mary Celestes* moored in similarly deserted ports.

Among his supporters, an important part of the Buffet myth is that he has been systematically excluded from French cultural life, the victim of a carefully orchestrated, unwritten but officially sanctioned, protracted and vindictive campaign of persecution. In 2014, Maurice Garnier went to his grave utterly convinced of the fact.

However, to say that Buffet was completely ostracised from official life in France at the time he retired to his moated castle is, quite simply, untrue. Much as he may have been seen, at least by himself, as a lone and heroic champion of traditional values, it is incorrect to say that he went unrecognised by all except his bank manager.

In 1971, he had been made a Chevalier of the Légion d'Honneur. The ceremony of the investiture of the Légion d'Honneur can be tailored to the personality of the recipient, who can nominate to receive it from the hands of a prominent friend in a location of his choosing. Thus the ceremony on this occasion took place on 31 January 1971 in the Louveciennes home of the Lazareffs. It was a discreet, private event. Ranged around the book-lined room in which the ceremony took place were Annabel, looking sexy in a trouser suit, Olivier Guichard, variously minister of education, public works, and justice from 1969 to 1977, the watchful Maurice Garnier and of course the Lazareffs themselves.

He was presented with the insignia by his old friend and supporter the novelist Maurice Druon, one of the giants of French cultural life in the third quarter of the last century. A distinguished man of letters, Druon had won the Prix Goncourt in 1948, the year of his thirtieth birthday (and of course of Buffet's Prix de la Critique). As youthful prodigies around town, he and Buffet had become firm friends. Buffet painted a portrait of him in 1964 when the writer was in his late forties; the slender fingers with which the artist often endowed his portraits lend an air of sensitivity to the delicately handsome features. Although forty-six when he sat for this portrait, his face is virtually unlined. The painter has placed a trio of light brushstrokes along the brow beneath the lustrous head of chestnut hair, not so much to suggest age, but more, one feels, to impart a sense of intellectual activity, of great thoughts being thought in a head that was still young. And indeed, Druon's reputational trajectory was not dissimilar to Buffet's. While not as conspicuously and sensationally youthful as Françoise Sagan, his credentials were the right ones for success in the France of the 1950s and 1960s. A young man when war broke out, he

had joined the Free French. Cultivated and refined, he was one of the drawing room darlings of post-war Paris, and had continued his career as a professional youthful prodigy with election to the Académie Française at the age of just forty-eight. He was a young man in an old, increasingly creaky value system, and as such there was a natural kinship with Buffet.

In 1971, when he pinned the insignia of the Légion d'Honneur on Buffet's lapel (the artist was still recognisable as his young, slim self), Druon now well into his fifties, was still enjoying a miraculous career as one of the perennially youthful prodigies that France had a requirement for in the years following the war. He had found commercial success with a sequence of historical novels about the kings of France during the thirteenth and fourteenth centuries; their popular appeal can perhaps be likened to that of the novels of Hilary Mantel or Philippa Gregory in the UK in the twenty-first century. As the seventies dawned, he could look back on a career unblemished by failure and forward to even greater international fame, first because his medieval novels were being adapted for television, and second because he would soon be named France's Minister of Culture.

The appointment of a close friend and collaborator – Buffet had illustrated some of Druon's work, and Druon was the author of a lavish hagiographical monograph on the artist – to run the government department of most direct relevance to Buffet's career hardly suggests official ostracism. Moreover, the man Druon would replace, Jacques Duhamel, was also an old friend of Buffet, who had painted both his portrait and that of his wife Colette back in 1951. After the decade-long rule of Malraux, who was antipathetic towards the sort of work that Buffet represented, it seemed that things were changing. Indeed, 1974 saw the artist receive one of the greatest honours that France can bestow on its citizens: election to the Institut de France.

The Institut de France is comprised of five learned societies or *académies*, the most famous of which is the Académie Française, whose role is the protection of the French language. The Académie was instituted by Cardinal Richelieu and recognised by Louis XIII in 1635, and numbers forty members (*les immortels*), who are elected for life. New members can only be admitted to occupy one of its chairs, or *fauteuils*, when the incumbent dies. But the point of the Académie is

not so much its lexicographical function, nor the distribution of literary prizes, but the prestige that it confers on its members. In its various forms, l'Institut de France has witnessed almost four centuries of French history, with just a slight hiatus during the darkest days of the French Revolution.

The branch of the Institut concerning the arts, the Académie des Beaux-Arts, traces its antecedents back to the academy of painting and sculpture that was founded in 1648, a direct link to the era of that most absolute of absolute monarchs, Louis XIV. The weight of history rests quite literally on the shoulders of those who enter this institution, in the form of *l'habit vert*, a tailcoat adorned with rich embroidery, which covers the lapels, edges and trouser seams like a particularly virulent form of gilded lichen. The defining accessory is the academician's épée worn by each member, designed in a manner that reflects their personality and interests. Cocteau's sword by Cartier is amongst the most flamboyant and well known.

Buffet's by comparison was a relatively simple weapon, the guard of which was shaped in an uncharacteristically curvilinear 'B'. The sense of history, pageantry and grandeur in which the Académie is steeped all appealed to him enormously; he saw his election to this august body as placing him in the bloodline of the sort of French painting in front of which he had sat during those long Sunday afternoons four decades earlier.

> It is a major event for me, for two reasons. The first: I entered the École des Beaux-Arts at the age of 15. At the time, the Prix de Rome, the Institute, were goals that were very difficult to reach: a supreme, almost unattainable reward. So, entering the Institute aged 46 is a great joy for me. The second reason makes this even more moving. How can you not be proud to sit in a place which hosted Ingres, Gros, Delacroix and others? I hate the worship of the damned, I despise the refusal of honours, which seems pretentious. As for false modesty, it is stupid.[4]

In his election at the conspicuously youthful age of forty-six, to occupy Fauteuil VII, vacated by the death of the ninety-five-year-old animal painter Paul Jouve, it is perhaps possible to discern the hand of his friend Druon, who in 1985 would be named perpetual secretary of the Académie Française.

It seemed that there was also more good news for Buffet vis-à-vis officialdom when Georges Pompidou, prime minister of France during much of the de Gaulle era, was elected president.

Pompidou, Duhamel, Druon et al. were, along with Buffet, all part of the Louveciennes lunch set; Pompidou and his glamorous wife Claude would arrive at the wheel of a contrapuntally chic 2CV. Indeed, he and Lazareff were so close they would dine once a fortnight at the Élysée when Pompidou became president after a campaign that had been largely planned at La Grille Royale.

These men shared friendships that reached back as far the 1950s. Pompidou's diaries show that even though as prime minister his agenda was full, he still carved out time to attend Buffet's exhibitions. For instance, Tuesday 11 February 1964 was a day of back-to-back meetings with his military chief of staff, the secretary general of the Gaullist party, and a string of ministers, followed by dinner with the Soviet ambassador; and yet he still found an hour and a quarter between 2.30 and 3.45 p.m. to view the artist's paintings.[5]

Chain-smoking Pompidou was one of the most fascinating men of post-war France. A former schoolteacher, he had then gone to work for Guy de Rothschild. He had a remarkable mind and a prodigious memory. Although he had been born in the Auvergne and had enjoyed a far from privileged upbringing, he adapted to the life of being a banker with surprising ease, also learning to swim and ski at the relatively late age of forty.

He had joined de Gaulle's staff in 1944, and when the General left public life in the mid 1940s, Pompidou was picked to help run a family charity for children with Down's syndrome, from which de Gaulle's daughter suffered. De Gaulle found him invaluable, and from 1962 he was installed at the Hôtel Matignon, the official residence of the prime minister of France, although he and his young wife Claude, who disliked official life, decided that they would continue to live in their Paris apartment.

The Pompidous moved to the Quai de Bethune, on the elegant, medieval Île St Louis, opposite Notre Dame Cathedral, and filled their four-room apartment with antique furniture and modern paintings. He and his wife spent their summers in garish St Tropez. In Paris they led a brilliant social life, frequenting the theater, fashionable bistros, art galleries and well-known couturiers. They mixed with pretty, titled

women, such writers as Françoise Sagan, such painters as Bernard
Buffet, stars of the press and television – a small, fashionable world
known as Claude Pompidou's 'clique'.[6]

And it was to this clique, where talk of politics was prohibited, that
he would retreat after a day spent playing Marshal Berthier to de
Gaulle's Napoleon.

Pompidou was generally held to have behaved with dispatch and
good sense during the crisis of May 1968, when even de Gaulle seemed
momentarily unequal to the situation, establishing him in the public's
eyes as the General's natural successor. Something of course that de
Gaulle did not especially like.

De Gaulle was a towering figure who summed up post-war France
in the way that Churchill had been emblematic of Great Britain. He
had not so much hogged the limelight as blotted everyone else out,
so when Pompidou – who after 1968 had been invited by de Gaulle
to take a rest – emerged as the General's heir, the international media
scrambled to give their readers a picture of the man who smoked
three packs of Winston cigarettes a day and held 10,000 lines of French
poetry in his head. The *New York Times* offered its readers a particularly
telling vignette.

> One of Pompidou's first gestures on his arrival at the Palais Matignon
> was to take down the portraits of Richelieu, Colbert, Sully and Mazarin.
> 'In any case they were bad paintings,' he said, smiling. 'And further-
> more, historical men inhibit me.' De Gaulle was enough for him, no
> doubt. On the golden Louis XV wood panels he hung a large modern
> canvas by Soulages, a small still life by Braque, a Nicolas de Staël, a
> Buffet. On his desk stood a photo of de Gaulle dated 1954 and bearing
> the dedication: 'To Georges Pompidou, my collaborator for the last 10
> years, my companion and friend forever.'[7]

Thus although Buffet may not have had an easy time under Malraux,
ostensibly the seventies looked bright for him. The job of culture minister
passed from one of his portrait sitters to another even more visible and
vocal supporter, while the Élysée Palace was now occupied by a man
widely regarded as a sophisticated moderniser and an intellectual who
preferred to surround himself with blue-chip modern and contemporary
art, including Buffet's, rather than the portraits of Louis XIV's apparatchiks.

And yet, with all the auguries looking so propitious and suggesting a place for Buffet in national cultural life after the unfavourable cultural climate of the Malraux years, the decade failed to see even a partial rehabilitation, and for this Buffet himself must bear some of the responsibility.

The effects of the events of May 1968 in France did not disappear once the unrest had been put down with a brutality that would not have seemed out of place in a despotic Latin American tyranny. The power of the people had made itself felt, and in the febrile climate of revolutionary politics it became fashionable for art to carry a strong and disruptive anti-establishment payload. Instead of looking to the Galerie Maurice Garnier for a history lesson on the development of marine transport delivered by a retired admiral, attention was more focused on such movements as Italy's Arte Povera, which with its explicit challenge to government authority and industrial power was in tune with the zeitgeist. Conceptual art was increasingly mainstream, bringing with it the idea that just ideas could be art. Gender politics, another important aspect of the period, were making themselves felt with the rise of feminist art.

The sort of work that proved fashionable in avant-garde circles at that time was from the likes of Marina Abramović: while Buffet was painting his romantic landscapes, she was cutting herself with knives and allowing an audience to strip her and inflict pain on her as part of her now celebrated *Rhythm* series of performance pieces. Buffet's response can be imagined. Similarly he would have scoffed at Carl Andre's *Equivalent VIII*, which was acquired by the Tate Gallery in 1972 and became a cause célèbre when the *Sunday Times* chose to question the validity of a national institution acquiring what the popular press delighted in calling 'The Bricks'. Moreover, it was not just the art but the way in which it was collected and appreciated that was changing. Whereas art collecting had once been about being a scholar, it was becoming about being a discoverer and a pioneer; a violent apostle of the new rather than a priestly guardian of historical values.

Viewed from the second decade of the twenty-first century, Buffet's Canute-like stand against a tide of sometimes meretricious junk has a certain nobility to it, although whether he was taking anything as calculated and conscious as a stand is questionable. His dealer did not see his role as that of impresario and manager, but simply to sell pictures to enable the artist to paint what he wanted.

Buffet's immense commercial success had freed him from the financial need to follow trends, but then he often said that whether he made money or not he would have painted the same way, and knowing his tenacity and strength of character, this is probably true. However, individuals of such fixity of purpose as Maurice Garnier and Bernard Buffet are rare. Most people are influenced by fashion, and museum directors and curators have careers to think about. With so many superficially attractive, exciting, controversial, and, above all, new ideas to be distracted by, it is easy to understand how Buffet came to be neglected.

One of the unarguable benefits of the young is that they know everything, and an important part of that omniscience is that what has gone before tends to be inferior. There are of course exceptions to this gross generalisation, but one of the duties of the young is to replace the old, and as the 1970s progressed, those people who had bought Buffet when he was the effulgently bright rising star of the Paris art scene, the saviour of the future of the French painting, the new Picasso, and all the rest of it, were either dead or of an age when their opinion counted for less. For Buffet, the chief problem was that although he was firmly identified with the cultural leaders of the regime, the regime was no longer deemed to be in touch with culture.

'Poor old Maurice Druon,' wrote the *New York Times* of France's new Minister of Culture in May 1973.

Darling of the Paris salons, youngest 'immortal' of the French Academy, winner of the prestigious Prix Goncourt for his second novel, a success at everything. And now? The French intelligentsia's public enemy No. 1.

The new Minister of Culture has succeeded in unifying the biggest pack of loners, carpers and infighters of French society and done it in record time.

Early in May, within a month of taking office in Premier Pierre Messmer's Cabinet, he served notice that in doling out the taxpayers' money he was not about to give priority to cultural elements he deemed subversive.

'People who come to the door of this Ministry with a begging bowl in one hand and a Molotov cocktail in the other will have to choose,' he announced. The universal inference drawn was that the 'Molotov cocktail' referred to leftist political activism.

Mr Droun, who is 55 years old, has denounced the 'intellectual terrorism' of those who 'confuse liberty with opposition'. He looks with disfavor on 'apologies for the degradation of the human person' – in short pornography. This week he asked in Parliament: 'Should we subsidise films that are mediocre in content and base in their expression?'

In response, scores of persons in the intellectual and creative world have sprung to their typewriters, calling him an 'intellectual dictator' determined to wipe out dissent.

On May 13, thousands of actors, poets, sculptors, painters, television directors, playwrights, singers, film stars and leftist political leaders, some wearing gags and chains, others in mourning garb, staged a 'funeral march' in central Paris behind horse-drawn hearses.

The hearses contained 'the mortal remains of free expressions' that the protesters said had been killed by Mr Druon.

The new Minister, author of 15 books and two plays, wrote, with a team of literary collaborators, a popular historical novel called *The Accursed Kings*. He is now being called the 'cursed minister'. He has been compared by some of his detractors with the Nazi Joseph Goebbels.

Jean-Louis Barrault, the actor and impresario, warned that Mr Druon was 'sounding the trumpet of cultural repression; the tune he has chosen is one of contempt and menace'.

Others who have joined the pack are the film director Claude Chabrol, the composer André Jolivet, the actor Pierre Fresnay and the surrealistic playwright Eugene Ionesco, also one of the 40 members of the French Academy.

Mr Druon said, in the only interview accorded since he took his government post, that 'anti-culture gives me the shivers'.

Says Mr Ionesco: 'Can Maurice Druon consider himself the reliable judge of that which is artistic and that which is not? All new forms of art seem at first to be anti-artistic.'

But Mr Ionesco also castigated the tight little intellectual cliques that 'exclude, don't discuss and refuse to take into consideration anybody who doesn't agree with them'.

Roger Planchon, the actor, playwright and director of the Théâtre National Populaire, deplored the 'scorn and impudence' of Mr Druon in allegedly equating artists who receive financial aid with beggars, and a cabinet minister with a dispenser of charity. 'Pernicious,' he said.

The 1973 budget of the Ministry of Cultural Affairs is $239 million – one half of 1 per cent of the national budget – but it has gone up steadily since André Malraux was named as its first and most famous head a dozen years ago.

Before that, the post was a minor one, relegated to a Secretary of State for Fine Arts charged with preserving the nation's past glory through its historical monuments, museums and national theaters.

Mr Malraux looked to the future as well. His vision was not only the cleaning of the great buildings of Paris, which he began, but a spreading of culture and state aid to all the plastic and performing arts throughout France, including films and first plays.

There is genuine alarm in intellectual circles here that Mr Druon is returning to a pre-Malraux outlook. He told Parliament this week that he saw his mission as, first, preservation of France's artistic heritage; second, teaching; and 'finally, the stimulation of literary and artistic creation'.[8]

And while this carnival-like demonstration of a unified and defiant front was being put on by the art world, Buffet was painting his boats, his villages and his landscapes. Druon's tenure as culture minister was as short-lived as it was unpopular with the intelligentsia. He did not last a year in the job and was replaced in March 1974. The following month, Georges Pompidou died unexpectedly.

At the time of his death, the Centre Beaubourg, a contemporary arts museum, was under construction on the site of the old Les Halles, where those early Buffet collectors Jean and Dusty Negulesco had ended a magical night in the French capital just after the war. This arts centre was renamed the Centre Georges Pompidou, and yet the irony is that four decades after its eponym's death, it has yet to mount a serious exhibition of one of his favourite painters.

Speaking about his relationship with the Pompidous towards the end of his own life, Buffet revealed himself as resentful.

'I've never expected the least recognition from the French government,' he told author Jean-Claude Lamy testily.

'But weren't you friendly with the Pompidous?'

'With President Pompidou, not with his wife Claude. His ideas were very different from hers. After his death, all kinds of ideas he never had were ascribed to him. He liked my painting and bought some for the Matignon residence when he was prime minister.'

'What about the Pompidou Centre?'

'I've never set foot in the place.'[9]

It seemed that all the memories of times spent together bronzing under the Saint-Tropez sun, lunching at Louveciennes or talking long into the night as part of Claude Pompidou's clique on the Quai de Béthune had soured with the passage of the years until they were nothing more than the bitter dregs of an old man's rancorous disappointment.

Chapter 35

The Howard Hughes of the Art World

Buffet's response to the frightening and confusing world of the 1970s was to withdraw from it. He was happy so long as he was painting sailing ships and an idealised French countryside. His public appearances in the beau monde of which he had once been such a beautiful ornament became fewer and fewer.

However, there were brighter days, among them 25 November 1973, which dawned crisp, clear and cloudless over a snow-capped Mount Fuji. In the midst of the gently undulating forested countryside, at the mountain's foot, a hillside had been cleared. For some time the townsfolk of nearby Mishima had been watching a large, gleaming triangular structure rising from the cleared ground. Fearlessly contemporary in style, it was very different from the traditional buildings in this sleepy rural part of Japan, looking not unlike a futuristic reworking of a medieval citadel; the inner triangular tower girdled by a lower circular gallery. One face of the building carried dark European letters some metres high that traced the familiar signature of Bernard Buffet. Writing about the museum in 1976, the art review *L'Oeil* had nothing but praise 'for the simplicity of the plan, the elegance of proportions, the nobility of the materials and an almost ascetic sobriety'.[1]

On that brisk late autumn day, the sun shone on this the first museum dedicated to a living artist under the age of fifty, as a large, respectful crowd began to gather. Such was the number of visitors that the terraced seating in the open-air theatre was soon full; those who arrived later filled the hillside between the recently planted saplings, stood on the walls and crowded the various pathways and low steps that meandered through the as yet barren grounds. There was the sense of an oversold rock festival, albeit with fans in formal dark suits and ties for the men, and for the women demure suits – or in the case of Kiichiro Okano's young and conspicuously glamorous second wife, a full-length belted trenchcoat made of lynx.

All in all some 1,300 guests filled the tiered semicircles of the theatre and stood on the slopes and pathways, politely craning their necks for a view of the dignitaries on what was almost a state occasion. Officiating with due gravity, and instantly recognisable thanks to the almost complete absence of a chin, was Emperor Hirohito's younger brother Nobuhito, Prince Takamatsu, a noted patron of the arts. The French ambassador was naturally present, as were, among many others, the governor of Shizuoka province, giants of Japanese letters Kojiro Serizawa and Yasushi Inoue, and of course the museum's founder and his fur-coated wife, who was eclipsed in chic only by a willowy Annabel in a full-sleeved hippy-de-luxe blouse and hair dyed a striking blonde.

There were musical performances of pieces commissioned specially for the occasion, most notably 'Maître Bernard Buffet',[2] written by the distinguished Tadashi Hattori, who had composed the music for a number of Akira Kurosawa's films, after which the Numazu choir gave a stirring rendition of 'Suruga, Oh My Homeland!' And as the last of the applause echoed across the hills, the museum was declared open. Over the next three months, 9,000 visitors would make the pilgrimage out to this isolated spot to venerate the work of the great artist.

The chinless imperial prince and the bisexual chanteuse and novelist cutting a tricolour ribbon; the governor; the ambassador; the poets and authors; the 1,300 guests representing 'the diverse spheres of Japanese society';[3] the Numazu choir in full throat; the premier of the new composition, all under a cloudless cerulean sky . . . Okano could reflect on a perfect day. Well, an almost perfect day. There had been one absence from the list of invited guests: Bernard Buffet had declined the invitation to attend the inauguration of his eponymous museum.

He did, however, have the courtesy to drop his host a line apologising for his absence.

Dear Friend,

I am deeply touched by your gesture and that of your country.

I want to thank you for the museum you have dedicated to me.

I will not be with you to celebrate the inauguration. Do not take my absence as a sign of indifference – I am a solitary person – I have asked my wife to pass on my friendship and she will tell you of the joy that I have of knowing that my pictures are in Japan.

Amicalement.

Bernard Buffet[4]

Not even the opening of a museum in his honour could tempt the reclusive artist from the safety of his chateau. According to his son Nicolas:

> He sent my mother to go to the inauguration, and after that he spent the rest of his life regretting that. It was a really big regret. I think he was afraid, not of the plane flight, but of the fact that there was a guy who had made a museum with his painting. He was 44 or 45, so for him it was impossible to imagine. I think that to some degree he thought, 'I'm not dead, I don't need a museum.' He was uncomfortable with that. He did not think it was normal to have such a big museum when you are still alive.[5]

Buffet's character was a curious mixture of insecurity and arrogance. He presented an opaque personality to the world, sheltering behind various personae, whether the taciturn unwashed youth, the *mondaine* man of the world, the professional curmudgeonly reactionary, or his latest incarnation as a recluse; but all the time he inwardly craved approval. Annabel would later remark that he remained, in part, a sensitive child all his life, mistrustful of the 'grown-up' world. Moreover, the infantilising nature of his relationship with Maurice Garnier was not just restricted to the inability to operate a cash dispenser or pay a household bill. Every year when he sent his works to Paris for the annual exhibition, rolled up in giant aluminium tubes, just as he had dispatched his first canvases from Provence half a lifetime earlier, he would remain agitated, pacing the room and unable to settle to anything until he had heard a favourable opinion from Garnier. Viewed in this light, his reaction to the opening of a museum in his honour would have been informed by a highly uncomfortable cocktail of emotions.

He had always been shy, and even at the height of his fame in the late 1950s, Pierre Bergé had said that the mere 'idea of shaking unknown hands'[6] paralysed him. By the 1970s, this fear had become crippling; if he became almost unbearably agitated and afflicted by a sort of stage fright at the thought of his annual exhibition in Paris, just an hour or so from his moated castle, then the prospect of a museum entirely devoted to his work on the other side of the world filled him with both pride and utter dread. In modern bustling Japan, Mr Okano may have revered him as a great artist, but Bernard Buffet

the seldom seen millionaire in the forest near Versailles remained in some ways the emotionally fragile child of the 1930s and 1940s.

And on the score of his Japanese museum, his anguish was heightened, because he tortured himself with guilt. 'I know – and this is really important,' stresses Nicolas, 'that he felt that the fact that he didn't come the first time was some kind of treachery towards Mr Okano. He regretted that till the end, till his last breath. Mr Okano did not think in the same way, but I think it just stayed in his mind and it was a really, really big problem.'[7]

As Buffet's retreat from the world became more exaggerated, the idea of going to Japan assumed an insurmountable terror for him. It became easier for him to deal with life by leaving the house less and less frequently. Eventually, during the mid seventies, forays out of his charmed demesne and into the twentieth century stopped altogether.

He did not even accompany his wife and children on their summer holiday; in 1975 they went to Saint-Tropez without him.[8] By the beginning of 1976, his reclusiveness had reached a Howard Hughes level of intensity. He seemed paralysed by a fear of life, and afraid to move out of what today would be called his comfort zone. He did not even attend the traditional pre-exhibition lunch at the beginning of the year. 'For more than a year he has not set foot outside the estate,' explained Annabel, adding that he had received very few visitors 'except of course Maurice Garnier his dealer, his photographer Luc Fournol, and he has seen Maurice Druon twice'. She continued, 'You would not recognise him, he has a beard and he has put on a bit of weight.'[9]

More than a bit. His frame had ballooned. His weight was now around 120 kilos. He adopted the wild looks of a figure out of the Old Testament: a prophet, hermit, or some anchorite of ancient times. He grew a beard of Tolstoyan dimensions that straggled down his chest. Gone was the precise surgeon's smock he had worn when painting at Manines; instead his overalls were held together with safety pins. Approaching his fifties, he was utterly unrecognisable as the man with the film-star looks and elegant wardrobe of just four or five years before. His changed appearance would have distressed him, especially as a man who enjoyed his clothes; he was a customer of Charvet and is still remembered fondly by the famous Parisian shirtmaker. One of his last public appearances had been for his formal admission to the Institut de France in January 1975, when, with his biblical beard,

corpulent frame and extravagantly braided *habit vert*, he looked like Brian Blessed in fancy dress. At least alone in his studio with his work, his paint-stiffened overalls pinned together, it did not matter what he looked like. In a way it must have been a return to a youth spent encased in the filthy Canadienne, when he only felt safe painting in his bedroom.

For eight years he had neither drunk nor smoked, and had embraced what his wife called an 'exemplary sobriety without complaining'.[10] The sage equanimity that had at first surprised her had become the norm. Even his views on the contemporary art scene became less trenchant. In a rare interview to mark his election to the Institut, *Le Figaro* had asked him where he saw himself in relation to his contemporaries and immediate predecessors. Talking 'without enthusiasm, but with a tranquil assurance', Buffet said that this was a subject about which he did 'not like to speak'.

'I am unfamiliar with my "so-called" great contemporaries. I am free to prefer Rosa Bonheur to Picasso. I will not judge the art of today,' he said, almost as if the fight had gone out of him. More remarkable still was the note of balanced optimism. 'You seem to believe that art is in crisis, this is not my opinion. It is certain that people seem to express a certain weariness for lyrical abstraction and other fancy varieties.' As he saw it, the cult of cubism was being forgotten in 'rediscovery of Bonnat, Bouguereau, Harpignies, Paul Jouve. Young people you see in the street seem to come out of pre-Raphaelite paintings. Anyway, you do not make cultured individuals by force, it is for them to choose what they need!'[11] Could it really be? Bernard Buffet, the small suburban villa of tradition in the midst of the concrete towers of contemporary art, the lone figurative voice raised against the tumult of abstraction, uttering diplomatic platitudes about art . . . live and let live . . . each to his own?

'He showed excessive wisdom, spoke like a wise old man, or laughed out loud with his children. He was no longer consumed by sudden passions, nor by rages. I found him changed,' observed Annabel. 'I thought him happy, I thought no more about it.' But from time to time she caught him unawares and 'discovered what I had not suspected. Several times I saw his face when he thought he was alone', and what she saw distressed her.

'He had an unbearably melancholy expression,' she observed, and she became 'increasingly concerned by his detachment. He was drifting

away. I understood that what I had taken for serenity was indifference.'
After turning it over in her mind, she confronted him.

> I confessed my suspicions and not for a moment did he try to deny
> that he was unhappy, that he felt alienated, almost an outcast. On my
> advice, he relaxed the strictness of his regime.
>
> He allowed himself some champagne or wine, and then he began
> smoking again. He lost weight. He was rejuvenated. I found that once
> again he sparkled with life. He went regularly to the ophthalmologist
> and his eyes were perfectly all right under this light return to drink.[12]

It would appear that Buffet resumed drinking at around the end
of 1975. Speaking at the beginning of 1976, when asked if her husband
was still neither drinking nor smoking, Annabel answered that he had
started drinking 'just a little red wine when he ate and at times, a
little champagne for a special occasion. Christmas Day for example is
the only day of the year on which he does not work.'[13]

Annabel confesses that she was 'ashamed to be happy on my own',[14]
an admission from which it is not unreasonable to infer that she was
ashamed to drink on her own. The wedge that had come between
them when Bernard had received the doctor's stark ultimatum was
hammered deeper into their relationship with every day that he was
sober. Without their dependence on alcohol and tobacco to bind them,
they had indeed drifted apart, with Buffet now keeping completely
different hours to his wife.

In her memoir of her own battle with alcohol, she says she was
ignorant of the medical facts surrounding alcoholism, and above all
the near impossibility of an alcoholic being able to resume drinking
in moderation. Of course much more is understood about the nature
of addiction today than was the case in the mid 1970s; even so, she
must have been aware of the insidious nature of alcohol and how,
incrementally, almost imperceptibly, it reasserts its hold over the addict.
Once it has been permitted to return to the alcoholic's life, it takes
on a persuasive and tempting character. At first it seems docile and
amenable. Gradually, self-imposed rules are relaxed: that single glass
of wine with dinner gets bigger, then one glass becomes two, and
next a bottle . . .

Sure enough, 'little by little the disorder due to the abuse [of alcohol]
showed itself, we were not even surprised. We had returned to a

climate that was ours.' She welcomed the upheaval and disruption. She was even prepared to put up with being scared of her husband if it meant that she could drink with him again.

> At times Bernard made me afraid, but I did not really suffer. Thanks to the Scotch I was like an ostrich blithely sticking my head in the ground. I found these mood swings natural; I had always known them, except for a few years when Bernard had not seemed himself, and I preferred this difficult and eventful existence to that excessive calm that had given me the impression of a crack between us. We were in our element, our lives bathed with an urgent intensity.[15]

As the long, hot, arid summer of 1976 began, 'Bernard was again the man I had followed, subjugated, without a look at what I left behind. I lived to the rhythm of his rages and laughter.' A few months back on the drink and the alcohol quickly undid the work of eight years of sobriety. 'His mood swings, as fascinating as they were incomprehensible, continued to seduce me. I do not pretend that it was easy to live with. But I do not have the taste for easiness and I am always happy to be protected from monotony.'[16]

'I was not the only beneficiary of this renaissance,' she says almost jubilantly, exulting in the fact that after half a decade of technically perfect but anodyne landscapes, Bernard had gratifyingly conformed to the melodramatic stereotype of the alcoholic artist inspired to ever greater heights of lyrical creativity by the very substance that is poisoning him. Nevertheless, clichés tend to be rooted in fact, and during that summer, when so little rain fell in northern France that crops began to fail, he embarked in the frenzied way of old on a piece of work that he would come to regard as the defining point of his career.

Chapter 36

Descent Into Hell

In the midway of this our mortal life,
I found me in a gloomy wood, astray
Gone from the path direct: and e'en to tell
It were no easy task, how savage wild
That forest, how robust and rough its growth.
Which to remember only, my dismay
Renews, in bitterness not far from death.
Yet to discourse of what there good befell,
All else will I relate discover'd there.
How first I enter'd it I scarce can say,
Such sleepy dullness in that instant weigh'd
My senses down, when the true path I left,
But when a mountain's foot I reach'd, where clos'd
The valley, that had pierc'd my heart with dread,
I look'd aloft, and saw his shoulders broad
Already vested with that planet's beam,
Who leads all wanderers safe through every way.
Then was a little respite to the fear.
That in my heart's recesses deep had lain,
All of that night, so pitifully pass'd:
And as a man, with difficult short breath,
Forespent with toiling, 'scap'd from sea to shore,
Turns to the perilous wide waste, and stands
At gaze; e'en so my spirit, that yet fail'd
Struggling with terror, turn'd to view the straits,
That none hath pass'd and liv'd.

Reading the opening lines of Dante's *Commedia*, it must have been hard for Buffet not to see himself staring back out of the fourteenth-century poet's words.

The *Commedia* was written while Dante was exiled from his beloved Florence and roaming the country as a peripatetic guest at the various courts of late-medieval Italy. To describe it as complex is to say nothing; the levels upon which the poem communicates with the reader are manifold and bewildering.

There is the ostensible narrative of the poet's fantastical journey through the afterlife; there is the allegory of the soul's journey towards God; there is the detailed and involved commentary on the religious, social, artistic and political issues of Dante's own time; and then there is a cast list that would have made Cecil B. DeMille's *Ten Commandments* seem as sparsely populated as *Waiting for Godot*. Dante marshals an ensemble cast that ranges from the beasts of mythology and the philosophers of antiquity to Christian saints and crusaders. Along the way he uses the poem to settle scores with those who have crossed him, eulogises those he favours, and examines the current affairs and power struggles in the many scintilla states that would eventually become the nation of Italy, a process that can be argued to have commenced with his own use of vernacular Italian. To read the *Commedia* in a sense other than moving one's eyes along the poem's 14,000 or so lines and hoping for some of its magic to take root in one's mind, one needs at least – and among many, many other things – a rudimentary knowledge of classical literature, medieval Italian, medieval cosmology, numerology, the Guelph–Ghibelline struggle, the state of the papacy in the early fourteenth century, the early history of the monastic orders of SS Dominic and Francis, and Dante's own relationships with everyone from the Pope to obscure Florentine homosexuals of the late thirteenth century.

It is, in a word, daunting. The *Commedia* may well be seen as one of the defining triumphs of European literature, but while its place in the cultural canon is accepted, it remains for all but the most scholarly of modern readers an opaque, unread text. As A. N. Wilson, a man more scholarly than most, makes clear in *Dante in Love*, appreciating it is simply beyond the reach of most people who live in the modern world. But by the mid 1970s, Buffet was no longer living in the modern world. And away from the currents of everyday life, his imagination was captured by the *Commedia*. For centuries it had fascinated the greatest writers and artists of Europe, among whom Buffet clearly saw himself – although he would not have admitted so in public (not that

he was out and about among the public these days). Far removed from the times in which he lived, the world of Dante would have seemed far more real to him than that of punk rock and conceptual art.

As, after his marathon painting sessions, he picked up this epic poem and immersed himself in the world, the life and the imagination of this remarkable individual who had died five and a half centuries before, he would have been struck by the parallels between Dante's experience and his own.

Like Dante, Buffet was more or less 'in the midway of this our natural life'. Like Dante, he had been connected with the leading poets of his age, and had moved among the social, cultural and political elite. He too was tasting the bitterness of banishment: he was in effect expelled from an artistic world in which he had once been a significant figure. He lived in the middle of dense forests. He was physically tired, carrying too much weight; he was breathless and his health was again suffering – his new problem was cholesterol. He too had confronted his own mortality. From his bed at the American Hospital of Paris, with a bottle of Scotch and a carton of cigarettes on the nightstand, he had viewed 'the straits, That none hath pass'd and liv'd'. Like Dante in the poem, looking back on his eventful life thus far, he must have wondered how he had arrived at this point. Just as Dante was experiencing the most famous mid-life existential crisis in European literature, so Buffet was forced, through setbacks in his health, the new stage into which his marriage was moving, and the direction in which the art world was heading, to examine his own life. Moreover, as a believer, the question of arriving at a closer relationship with God explored by the *Commedia* would have been of profound relevance and interest to him.

But the *Commedia* is as disturbing as it is moving; the ingenious cruelty that Dante inflicts on the damned resonates down the centuries. And just as Buffet had, at the urging of his wife, surrendered his sobriety, so he had sacrificed his equanimity. Reading Dante, his sleep was destroyed by terrible nightmares as he feared that he, like those about whom he was reading, would be damned in hell. 'Did you think that you had sinned seriously enough for your God to send you among the damned imprisoned in the eternal ice?'[1] asked his wife.

And if his nights were filled with hellish visions of the exquisite cruelties visited upon those beyond redemption, so were his waking hours, as Annabel would later recall.

Bernard was gripped by extraordinary creative fever. In the Middle Ages, those who seemed to be different, and on the margins of society, were said to be 'possessed'. The devil was accused of the possession. If, in relation to Bernard, Lucifer is not responsible for anything, I can't find other words to explain what happens to him when he is 'inhabited' by painting. Of course this possession does not happen every day, but when it seizes him, it often indicates the need for a large subject. I see him change without him even being aware of it. Nothing else exists, neither time, nor hunger, nor sleep . . . When he decides to come out of his lair, he strives to behave naturally. The children do not notice that he is absent. Me, I know he is. He does not see us. He does not even know what we say. He is too far away for me to reach him . . .[2]

And as the heat of that long summer beat on the stout-walled moated idyll to which he had retreated from a frightening and inimical world, he immersed himself fully in the terrors of the next world as envisioned by Dante. 'I knew he was obsessed by a big idea and I knew the theme he had chosen to paint to express it. I just had to wait for him to invite me to see the first picture.'[3]

The calming landscapes had been replaced by a barren world of perpetual winter and unending horror. Although Delacroix painted Dante's crossing of the Styx, upon seeing Buffet's version it is to Géricault's *Raft of the Medusa* that the mind turns. Dante cowers in fear while Virgil stands erect as a piece of sculpture, and a wild-haired, crazy-eyed Charon guides his boat through a tangled tumult of human bodies.

This canvas of 2.5 x 5.8 metres is simply astonishing. Reproductions are not adequate preparation for the sight of the original work dominating one wall of a vast, echoing triangular hall in the Bernard Buffet museum in Japan. Where the golden glow had been too heavily applied to his early 1970s landscapes, in this painting it hovers over the horizon, a menacing portent as in *Horreur de la Guerre*, rather than a pleasing effect of sunlight. Sea and sky meet and merge little over halfway up the canvas in a manner that would not have displeased Rothko, but this is no exercise in pared-down abstraction; in the foreground, the writhing bodies are portrayed in their agony, each face set in a rictus of fear and misery, and just as Dante peopled his inferno with those whom he had known in life, so Buffet appropriates those known to him. The bearded Maurice Garnier's face bobs up out of the waves, a hand at the end of a long, emaciated arm clawing at the breast of a woman

whose face is a tortured reworking of that of his dignified wife Ida. Meanwhile, on the other side of the boat, gazing over her shoulder, is Annabel according to Koko Okano. Later, in the canvas called simply *Decapitated Man*; a headless body thrusts a severed, bearded head very like Buffet's towards Dante and Virgil, while in the foreground a man with Buffet's head on his shoulders waves handless arms and a third man tries to reinstall his entrails, which have spilled out of a gash in his belly. Lucifer is a giant multi-faced being that consumes and regurgitates human forms. The damned locked in the ice seem like cannibalistic zombies on loan from a twenty-first-century apocalyptic horror film.

It is as if he had reconnected with the angry young man who had painted *Horreur de la Guerre*, but he also informed this work with the technical experience that comes only from maturity. Along with the seven major canvases for the walls of Maurice Garnier's gallery, he also spent that summer engaged on the exhausting task of dragging a sharp spike across a blank copper surface to create drypoints to accompany the monumental oil paintings. His talents as a draughtsman and his stark graphism lend themselves to the subject admirably. The twisting muscles of a neck; a bared row of teeth; a head arched back in agony until it is an almost abstract depiction of sternocleidomastoid tension: all these manifestations of mental and physical agony are perfect for the harsh, unforgiving technique of Buffet the engraver, with his mastery of light and shade.

And of course the gaunt, care-furrowed features of Dante make the long-dead poet the ideal subject for the artist. The prototypical image is bequeathed to us by Botticelli, who painted Dante a century after his death. Topped with its laurel crown, the hook-nosed profile created a silhouette and facial geometry that imprinted itself on European consciousness, recognisable to even those with just a casual knowledge of his epic poem. Yeats put it better than anyone when he wrote:

> The chief imagination of Christendom
> Dante Alighieri, so utterly found himself
> That he has made that hollow face of his
> More plain to the mind's eye than any face
> But that of Christ.

Buffet's genius is to take that well-known template, reinforced by countless interpretations over the generations, and to make it

recognisably both Dante and his own. The most fleeting glimpse is sufficient to know the identity of both subject and artist; even when Dante is depicted as a tiny figure like those in the works of Caspar David Friedrich, Buffet renders him unmistakable.

The impact of the work at the time was heightened by the contrast with the years of gentleness that had preceded it; even though she knew what he was working on, the result nevertheless astounded Annabel.

> I waited for the innocuous little phrase that signals the return of calm at the same time as the permission to see what was born of the storm . . . Nineteen years of this rite had not prepared me for the shock that I received on this day.
>
> 'You can go in if it amuses you. I left it lit.'
>
> In the studio, I was intellectually and physically upset . . . I was as unable to speak, as to analyse the hurricane of emotion that grabbed me . . . I stayed a long time in front of Dante's barge afloat on the river Styx . . . Yes, it is that day that I realised that my quest since childhood was fulfilled. The thirst for absolute love was not utopian. The man I loved was my raison d'être. Finally, I knew why I had been born, and what I was striving for. I had an identity, a sense of belonging. I forgot my fear of suffering and only thought of his.[4]

Perhaps she felt particularly close to this set of paintings because she believed that in releasing Buffet from his sobriety she had freed him to undertake this work. However, simultaneously she had unchained the inner demons that he had kept in check with abstinence. Her mixed feelings of pride and sadness are easy to understand, if hard to define, and her attachment to the series of paintings depicting Dante's vision of hell remained with her for the rest of her life, as she explained almost 25 years later.

> As far as I'm concerned, the paintings based on Dante's 'Inferno' represent a highpoint of contemporary art. I don't mean on a technical level – it's the job of critics and historians to decide that. But there's no need for education or explanation in order to approach, to appreciate, and to love paintings. You just need to look – and everyone will find what they're looking for, depending on their sensibility, curiosity, imagination. For me, these damned souls project a tragic solitude, a distress, a painful lucidity that strangely resembles the sterile confusion

of life today. They reflect the same dread as *L'Horreur de la Guerre*, though more powerful, more clairvoyant: a vision of the icy world inevitably produced by egotism, greed, and cowardice.[5]

If Buffet had a favourite set of works, this was it. Interviewed during the 1990s, he was asked, 'Is there one of them that is a favourite of yours?' To which he responds, 'There isn't one in particular,' but then thinks better of it and adds in complete contradiction, '*L'Enfer de Dante* is a favourite.' In the very last interview he gave, to the French television station TV5, the interviewer commences: 'Your work is marked by very tough pictures like *Les Écorchés*, the victims of war [*sic*], *Les Folles*, *Les Exclus*, *L'Enfer de Dante*—' but before he can complete his question, Buffet interjects, 'Dante's *Inferno* is a marvellous poem, an extraordinary book. It is the image of life.'[6]

Nor were the artist and his wife the only ones to be enraptured by the work. The correspondent of the *Journal de l'Amateur d'Art*, which had faithfully, if of late dutifully, recorded the opening of Buffet's February exhibitions, certainly noticed a difference.

'Each year, on the first Friday of February, the Parisian public has its rendezvous with Bernard Buffet. One remembers a number of exhibitions, in particular the earliest: the Passion, the nudes, the horrors of the war, the circus, Paris, etc., a little later the birds, *les écorchés*, the corrida.' But compared to these past glories, 'there was sometimes the impression that the painter was running out of steam', observed the critic, who had often heard it said that Buffet did nothing new; that 'he had passed on to academicism before he was elected to the Académie des Beaux-Arts' and that he had descended into the failure of painting sentimental works.

Without being a hard-core Bernard Buffet enthusiast, I am one of those who appreciated his attempts to use colour that was so far removed from his usual graphic style. The landscapes of 1974 and 1975 were interesting and especially in retrospect when, with the snowscapes of 1976, one could enjoy a fairly successful synthesis or rather a true equilibrium of colour and graphics.

With Dante's *Inferno* we have Buffet in his deepest, most consistent, vein which is also the most dramatic: it is again the cry, painful and desperate, like the Passion of 25 years ago, but with very different resonances of bitterness and perhaps resignation.

In all there are only seven pictures (crossing the Styx, the Minotaur, the Harpies, the transformation, the beheaded man, the damned caught in the ice and Lucifer) but at the highest level of painting. *Du grand Buffet.*[7]

Le Figaro also detected a return to form. It dismissed the landscape exhibitions of the early 1970s, confidently pronouncing that they had merely 'marked a break between two dramatic periods'. For *Le Figaro*, this period had been a lull of 'small houses carefully placed against a background of spinach tempered with egg yolk. Poplars along canals.' Using a term that was familiar to readers of Buffet's friend Simenon's novels, '*il ne se passe rien*'. Nothing was happening. 'But today, there is plenty going on his paintings: people being stoned, strangled, disembowelled, decapitated. This is the hell of Dante in seven huge pictures,' in which 'Buffet takes up some of the themes of his debut: hunger, martyrdom, the massacres, loneliness'.

For *Le Figaro*, it was a near perfect pairing of subject and artist. 'Buffet is faithful to the Dantesque spirit because he treated each episode as a cameo: the characters emerge, suddenly enlightened, fixed for eternity in their critical attitude. *Inferno* is his most powerful work. Some of the choices of the painter have in the past seemed arbitrary; and not apparently suited to his style.' However, 'This time, he is dealing with the human body and is supported by the tragedy of the book. In a corner of each picture, Dante and Virgil contemplate, petrified, the damned. We identify with the two travellers. We have the same passport to hell.' There was even something menacing about the way the pictures hung in the exhibition, closing in around visitors to Garnier's gallery 'like a crater'.[8]

In the midst of this artistic volcano, *Le Figaro*'s critic was able to trace links to artists as diverse as Vasari and Caspar-David Friedrich. 'There are so many connections that testify to the richness of this new work.'[9]

The impact of these paintings is undeniable, and the following year Buffet tested himself again with a topic that was another risky artistic high-wire act: the French Revolution.

Perhaps it is because the events depicted have a familiarity, or maybe it is because they lack the intensely personal connection with the artist that is in evidence in the Dante paintings, but although impressive, the canvases fail to scale quite the same peaks of emotion as the *Inferno*. Here the artist's graphism leads him down the path of the cartoon, as he transforms the drama of the last decade of the eighteenth century

into a comic strip. There is something rather too adaptable-about the depiction of events and characters; it is almost as though they have been reduced to a series of graphic devices or logos, something that was borne out a few years later, when, to celebrate the bicentennial of the Revolution, he painted a revolutionary figure, shirt open to red-sashed waist, brandishing a tricolour. It was used to decorate the spinnaker of the vessel *Revolution France*, which participated in the round-the-world race of 1989.

Robespierre has the characteristic sloping forehead of the famous anonymous portrait and the smile of a man altogether too pleased with himself. He gives the impression of being a late-eighteenth-century stand-up comedian about to deliver a line of which he is inordinately proud, rather than one of the chief architects of the Terror. Marat looks like he is terminally ill and seems almost relieved to be knifed by a rather manly woman in an attractive colourful gypsy skirt of the type worn by bourgeois bohemians in 1970s Saint-Tropez.

Buffet is rather better on the set pieces of the Revolution: the guil-lotine looming in front of a classically inspired facade borrows from the sinister starkness of his still-life paintings of domestic utensils. And he presents a novel twist on the perennial theme of Marianne, the allegorical figure of Liberty leading the people so beloved of the French state. In the large-format canvas depicting the taking of the Tuileries, he paints not one but two Mariannes, not so much *sans culottes* as *sans soutien-gorge*; these women with their toned physiques present them-selves stripped to the waist like glamour models, their faces and flowing tresses owing much to Buffet's friend Françoise Hardy, with whom he was frequently photographed during his years of heavy socialising and whose portrait he painted in an unusually flattering manner.

Exhibited in 1978, these were accomplished illustrations rather than great paintings, an opinion that would appear to have been shared by the French postal service, which commissioned the design of a three-franc postage stamp from him that year. It showed a Paris scene familiar to recipients of picture postcards of the French capital: the Pont des Arts, with the dome of the Institut de France in the back-ground. To mark the occasion, an exhibition of his paintings was mounted at the Postal Museum.

Though perhaps not a major retrospective at an internationally regarded cultural institution, nevertheless, this exhibition demonstrated Buffet's undimmed popular appeal. The catalogue carried an essay by

Maurice Druon that covered familiar territory and rehearsed his customary arguments in support of the painter: how that in a celebrity-obsessed age, it was not unreasonable to find a well-known artist earning as much as a film star, and so on. However, the official text prepared by the PTT, then the administration of France's postal, telegraph and telephone services, is perhaps more interesting in that it begins with what amounts to official state recognition of his 'exile'. 'Bernard Buffet is a phenomenon in the history of modern painting; shunned by the critics and by the avant-garde, he has seen, before his fiftieth birthday, a museum devoted to his work by a Japanese patron of the arts and enjoys a fame with the general public that is almost equal to that of Picasso.'[10]

As well as being able to buy a Buffet for the price of a postage stamp, reproductions of his work in the form of prints and lithographs appeared on the walls of ordinary homes and offices the length of the country. 'Whoever has never seen Bernard Buffet's Sad Clown has never set foot inside a dentist,' sneered one particularly caustic critic. 'Bernard Buffet will remain the redneck Titian, the Raphael of the waiting room and the Rembrandt of dabblers on the stock exchange.'[11] Of course Buffet himself saw nothing to be ashamed of in the proliferation of his work, and in 1981 he launched a range of porcelain for Bernardaud. Later there would be a Bernard Buffet Nike training shoe, the Nike Dunk Low Pro SB Paris. Introduced in 1985, the Dunk is to Nike what the 911 is to Porsche, and many of the subsequent iterations are regarded as highly collectible by those whose field of scholarship is athletics footwear. In 2014, eBay provided a ranking of the most important Dunks ever made, and in second place, after the original model, was Bernard Buffet's trainer.[12]

For him, the line between applied, decorative and fine art was there to be blurred; this was to be seen in the nature of the objects he amassed. For instance, his collection of Gallé that had been shown to such great effect at La Vallée in Saint-Cast testifies to his belief that artists were perfectly entitled to express themselves using the medium of everyday objects: if Gallé made lights, why shouldn't Buffet decorate a dinner service? 'Why should a painter be satisfied that his works are just hung on walls?' he asked. 'If I've decorated plates, it is so that people find pleasure in eating. I have decorated many other objects that are part of our everyday life. Lighters. And even braces, although I never wear them. It is an old tradition of artists which was a little lost after the Renaissance.'[13]

Chapter 37

Discreet Charm of the Bourgeoisie

But while Buffet was positioning himself as a versatile Renaissance man capable of turning his creative energies to braces, cigarette lighters and crockery as well as massive canvases interpreting the deathless verse of Italy's greatest poet, his dealer on the Avenue Matignon was becoming ever more specialised.

In 1968, Buffet and Emmanuel David had parted. A decade later, when David was asked about the break and whether it had brought his relations with the artist to an end, he was diplomatic. 'In one way, yes, but for all that, it does not stop me from retaining my unconditional friendship and admiration'[1] was his gnomic answer.

Without David, Garnier found himself spending ever more time on Buffet. So in 1977, he took the decision to focus exclusively on the artist, binding their fortunes together. Garnier, an extraordinary man by any standards, was no ordinary art dealer; he was Buffet's gatekeeper, handled all his financial affairs and approached his responsibilities towards the man he regarded as one of the greatest artists of the century with sacerdotal seriousness As far back as the 1950s he had been identified as having entered into the work and the world of Bernard Buffet as one might enter a religion, and now he had decided, to continue the religious analogy, to be doggedly monotheistic. If Buffet were to become a religion, then Garnier would be its Pope. As a far-sighted man, and someone unshakeable in his belief in the painter, Garnier was placing Buffet's career on a road map of his own devising. And once settled on a decision, he was not a man to be distracted.

> I worked with other artists but with Bernard Buffet more and more. And from 1977 I decided to work only with Bernard Buffet. Then and there I gave up other artists. I had 10 other artists under contract; good artists but not great artists. There are many good artists in all countries

of the world, there are good artists but not many great artists. And in our time, unfortunately, it is just the great artists who are shown, all the time. Others are not shown. There are other artists who could be shown and who are good artists. You can call them *petits maîtres*. Now only the grand masters of international quality are wanted. There is Renoir, the Impressionists, Matisse, Picasso, there is Fernand Léger, Amadeo Modigliani, and that's about it. There are no others. Take for instance Raoul Dufy. Dufy was an excellent painter but if one can say so, he made the mistake of being too French and works less well internationally.

Of course Garnier believed that Buffet had global appeal and relevance. 'One of the qualities of his work is that it is universal in its subjects and its techniques. He changes technique according to his subjects and it is highly approachable, it is universal in the home. The whole world understands Bernard Buffet.'[2]

But although priestly in his demeanour, Garnier was not celibate. His wife, Ida, was a strikingly attractive woman ten years younger than himself; if Koko Okano is to be believed, she appeared as one of the damned in the painting of the crossing of the Styx. The second decade of the twenty-first century sees her alas widowed from the man with whom she spent almost forty years of her life, but she retains the poise, elegance, style and taste in couture and *haute maroquinerie* that made her so attractive to Garnier.

She recalls how she first encountered Garnier in the gallery on the Avenue Matignon.

> It was in 1971. I came to the gallery to buy a picture. Maurice was absolutely adorable with me. Of course he is a charming man to a woman. He helped me choose the picture. And then he asked me if I wanted some advice as to where to hang it and came himself the next day to show me where I had to hang the picture, with what I already had. Everything went well and then I came back afterwards to buy other paintings and it was in 1973 that Maurice invited me to lunch and our story began.[3]

She found him impossible to refuse and their intimacy deepened, until she left her husband and married the gallerist. 'Maurice was so knowledgeable and so cultured. I have never met anyone as cultured.

He is the love of my life. I divorced for him.'⁴ But before they became man and wife, there was one further hurdle to be cleared: Ida had to be approved by Bernard and Annabel. She recalls with a smile the initial lunch at the artist's usual table, a booth to the left of the entrance in his favourite Chinese restaurant, a Paris institution called Tong Yen, near the gallery.

Garnier was not just taking a wife; he was recruiting a high priestess for the cult. He was only half joking when he said that the reason he married was because he had looked into the statistics and found that married men outlived their unmarried counterparts, and he intended to live as long as he could in order to usefully serve the interests of the painter who by the end of the 1970s was his sole concern. Although in good health, he certainly looked after himself better than Buffet did, and remained trim and recognisable as the man Buffet had painted back in the 1950s. Garnier celebrated his sixtieth birthday in 1980, and as a supremely pragmatic man who believed in planning and organisation, he had already formed a very clear picture in his mind of the goal towards which he was working.

The museum in Japan was all very well, but Garnier reasoned that a museum in Buffet's homeland was axiomatic to ensuring the reputation the painter would bequeath to posterity. He had already physically built his gallery around Buffet's annual February exhibition of large-format works, a rhythm that had resumed in the second half of the seventies with Dante's *Inferno* and the French Revolution. And he had further consecrated the space to Buffet by ending his contracts with other painters; from now on, only works bearing the famous arachnoid signature would hang on its taupe-curtained walls. With Ida given the benediction of Buffet's approval, Garnier had at his side a life partner with whom he could devote the years ahead to securing Buffet's place in history. And as the symbolic date of the end of the century became visible on the horizon, he began to give thought to how best to ensure that a museum dedicated to the artist was raised on French soil, so that the incredible legacy of this remarkable union between dealer and painter could continue posthumously.

Towards the end of the 1970s, however, there were more immediate problems to face. Having been involved with the artist from the very earliest days of his commercial representation, Garnier had kept meticulous records of his prolific output: photographic negatives, colour slides, details of dimensions, medium and subject – all were

recorded in the records of the Galerie Maurice Garnier. Even small China ink drawings would find themselves catalogued and referenced.

This archive would prove crucial to maintaining Buffet's reputation. Counterfeiting of his paintings had come to light as early as the summer of 1960, when someone with a Buffet he wished to sell left it with the concierge of the Galerie David et Garnier during the August holidays. Once the gallery reopened in the autumn, concerns about the painting's authenticity were confirmed by Buffet himself. Via a Swiss hotelier, a Berne gallery and a Swiss artist already convicted of forgery, the trail led back to Paris, where in the basement of La Petite Galerie on the Rue Drouot, further fakes were discovered, the work of a Greek painter who claimed an ancestry reaching back to the princes of Byzantium.[5] By the end of the seventies, the number of fakes being sold had become significant enough to disturb the market for his work, and for Garnier to initiate a police investigation that led to the arrest, conviction and imprisonment in July 1979 of a particularly industrious forger.[6] Of course the task of cleaning the market of fakes would remain an Augean one, impossible to complete, a task complicated by the painter's own prodigious output, the true extent of which may never be known but which, at the most conservative estimate, is at least 8,000 canvases.

Garnier's characteristically thorough system of authenticating those works listed in his archives and issuing certificates signed by himself, then by himself and his wife – and later in his life by Ida Garnier and long-time gallery employee Jacques Gasbarian, who have continued to sign the certificates after Garnier's death – has done much to maintain the stability of the market for the artist's work. Among collectors, dealers and auction houses, such is the value of certification by Garnier that many dealing in works in the twenty-first century declare that a Buffet is more or less unsaleable unless accompanied by this document.

But during the late 1970s, counterfeiting was not the only problem afflicting the Buffet market. Critical opinion veering from bored indifference to outright hostility had eroded the seriousness with which the artist was being taken. The oft-repeated slur that he was only repeating himself had become accepted wisdom among a generation who had been too young to experience the hysterical Buffet-mania of the post-war years. Of course his early collectors were long gone and his high-profile champions were dead or dying. Pompidou and Pierre Lazareff had both died in the early 1970s. Cocteau had expired in his

chateau in 1963, succumbing to a heart attack triggered, so it is said, by hearing of the death of Édith Piaf. Mauriac too was gone, perishing in 1970, the same year in which Jean Giono had died of a heart attack. Aragon had just passed his eightieth birthday and would die aged eighty-five in 1982. Even jug-eared, circumflex-eyebrowed Admiral Cabanier was no longer around to regale Buffet connoisseurs with his tales of life on the high seas, having died from a suspected stroke in 1976.

Buffet's works remained popular and saleable, but they were no longer the hot artistic property they had once been, a fact reflected in the calibre of the galleries that now represented him. Once his works had been exhibited by Beyeler in Basel, Knoedler in New York, and Tooth and Reid & Lefevre in London. These galleries placed him, by association, alongside the greats of what was then considered modern art. The Beyeler gallery would eventually become a world-renowned foundation and museum with a permanent collection of some of the masterpieces of the twentieth century, including priceless works by Giacometti and Mondrian. Noted American collectors such as Edward G. Robinson had bought their Impressionists from Knoedler. Tooth had been a leading London dealer since being founded in the nineteenth century, while Reid & Lefevre had been one of the first galleries to show Van Gogh's work, and through him had become associated with many of the leading Impressionists. But by the 1970s, this blue-chip international representation was crumbling. Alexander Corcoran, who now runs Lefevre, having inherited the business, tells how his grandfather was furious when his son, Alexander's father Desmond, decided to drop Buffet. But given that Desmond Corcoran is widely regarded as one of the shrewdest art dealers of the late twentieth century, his decision is amply expressive of how the critical backlash against Buffet had tainted his reputation.

Instead, the painter found himself doing strong business in such affluent ghettos as Palm Beach, where retired American millionaires in their Mizner mansions played their games of social one-upmanship by displaying power pictures sold to them by the local branch of the Wally Findlay gallery. Findlay's had been founded in the late nineteenth century in that well-known cradle of the arts, Kansas City, Missouri. In 1961 it had opened in the Florida enclave, where it had 'made many millions off French Impressionists as well as Bernard Buffet'.[7] Those millions had been made selling not to the likes of Dutilleul and

Girardin, but to socialites, the sort of people Tom Wolfe would christen social X-rays, who were as bulimic about their art as they were about their food. 'Lord, how they buy,' commented a rival Palm Beach gallerist. 'They buy and buy till they don't have wall space for any more. Then they give their old paintings to the hospital so they can buy some more.'[8] For such people, a Buffet was like a Rolls-Royce, a symbol of wealth that needed to be updated regularly. By the early 1980s, his work was being shown in Palm Desert and Johannesburg.

Very rarely can a painter be a star at every stage of his career. Even Picasso produced many bad paintings, and although his later work now commands high prices, until relatively recently the childlike bright, colourful and crude musketeers that he churned out towards the end of his life were not taken particularly seriously. Likewise Monet, once accused of overproduction of mediocre works, took the drastic step of destroying a batch of paintings, a PR move on the part of his canny dealer Paul Durand-Ruel to reassure the market that quality control was in place. It can only be imagined what the value of even these substandard works would be today.

Garnier had absolute faith that Buffet would one day come to be regarded as one of the giants of twentieth-century painting, and on the last occasion the author of this book met him, his final words of farewell were accompanied by hand gestures to the effect that while Buffet's reputation was currently languishing – for emphasis he flattened his palm and lowered his arm, as if patting the head of an invisible dwarf – one day his greatness would be recognised and his reputation would rise – here he lifted his arm as high as he could reach.

However, at the beginning of the 1980s, the artist's reputation with the critics was at its nadir. Garnier needed to deal with the problem and keep the business running. He had taken a significant risk in betting everything on Buffet, especially as, at the time he did so, the accusations of repetition and unoriginality had been made so frequently that, irrespective of their validity, they had become accepted as axioms. And then there was the spending. Buffet was used to money just being there when he needed a new house, or when he saw a particularly attractive piece of Gallé at an antique shop, or set eyes on a car that he would enjoy not driving.

Buffet was an impulse buyer. For instance, during the 1960s, he got it into his head that he needed a yacht. Even though he was no longer

living there, he still owned Château l'Arc, and when the owner of a yacht called *Le Briséis* expressed an interest in taking it off his hands, Buffet agreed to swap the castle for the boat and some cash. By twenty-first-century giga-yacht standards, *Le Briséis* is nothing to get too excited about, but to judge it alongside the playthings of modern-day tech billionaires and oligarchs does not give a true idea of its impact. More useful is comparison with his contemporaries among the world's super-rich of the time, European industrialists, Greek shipowners and the occassional film star. *Le Briséis* bears comparison with the *Kalizma*, Richard Burton and Elizabeth Taylor's converted Edwardian motor yacht, acquired by the couple in 1967, was just over 50 metres (165 feet) in length, while the *Creole*, which was the most famous sailing yacht of the day and belonged to Greek shipowner Stavros Niarchos, was a little over 65 metres in length.

'It was absolutely spectacular. It was ocean-worthy. It had one of those singular smoke stocks,' recalls one who spent a day on the boat shortly after Buffet had sold it during the Seventies. 'This ship, it was a ship, not a boat – was absolutely enormous. It was appointed with beautiful polished mahogany throughout, a very stately ship.'⁹ *Le Briséis*, was just the most impressive amongst a fleet of vessels owned at one time or another by Buffet, from the more or less dinghy-sized boat that he had owned during his time with Pierre Bergé, to a sailing yacht he acquired after disposing of *Le Briséis* which his son Nicolas remembers was called *L' Elan* (the name on the back of a yacht he painted in the harbour of St Tropez in 1979). However, *Le Briséis* was the most spectacular: it was even big enough for Buffet to install a studio below decks to enable him to keep working while on holiday, because if there was one thing that he enjoyed more than taking his yacht on a cruise, it was painting, which, given the scale on which he lived, was just as well.

The money to maintain this scale of living, not least in terms of wages paid to staff and crew, and maintenance of yacht and chateaux, had to be found somewhere, and so Garnier turned to places that were not as sophisticated in their artistic tastes: the French provinces, where the petite bourgeoisie who had grown up with Buffet during the Trente Glorieuses had achieved a significant improvement in their standard of living when compared to the preceding generation. They had begun buying engravings and reproductions of his work, and now, as they reached the summit of their working lives as doctors, dentists,

lawyers, or the owners of small businesses, they regarded a Buffet as the hallmark and seal on their success.

To return to the religious analogy, if Garnier was the papal figure at the head of the Church of Buffet, he set about finding bishops to carry the word out into the countryside. In the major cities outside the capital there were prosperous people whose thinking was more in line with that of Maurice Druon, whose works they had read and watched on television and whose views on art were akin to their own. They were men like Admiral Cabanier: respectable, patriotic, maybe even regular churchgoers, with conservative tastes. For them landscapes, identifiably French subjects such as castles, still lives, paintings of flowers and so forth were decorative, reassuring examples of artistic skill rather than dated reactionary junk. And so a Buffet became a fixture in comfortable *maisons de maître* of the sort that the artist had depicted in his landscape paintings of the early 1970s, and bourgeois town houses in cities such as Lyons and Bordeaux. Today, as the owners of these houses pass on and their belongings are sent to auction, it is a rare month in which a Buffet oil or aquarelle depicting flowers or landscapes or boats is not to be found in the catalogue of a provincial saleroom – along with, perhaps, a mediocre Vlaminck, maybe a Derain, and an Yves Brayer or two.

Seldom are they exceptional works, but there is an honesty about them that testifies to a period in the painter's life and the cycle of his reputation; they were not bought by collectors, but by people who had worked hard and achieved a level of standing in their communities that was reflected through their possessions. Of course the fashionable avant-garde sneered at such people. 'Buffet has a certain class of bourgeois for admirers,' explained one particularly vitriolic critic, who said that he had visited the gallery on at least five occasions, and each time had encountered 'the same faces sweating a gangrenous politeness, fear in their bellies, holding their breath, their souls in their socks: these people are typical of a bloodless breed of bourgeois cowards for whom it is not admissible that a child is made by the introduction of a phallus into a vagina, and who pray all morning for the next atomic bomb to be full of rose petals'.[9]

It is an unnecessarily harsh, violently expressed judgement, but it must be borne in mind that the class struggle was much more of an issue when that critic was writing in the mid 1970s. Another view is that they were ordinary men and women who were proud of their

Buffets and enjoyed them. It is agreeable to imagine those respectable and slightly dull country dinner parties during the 1970s and 1980s, the uncorking of a good Cru Bourgeois, the exchanging of local gossip, the flirtation with someone else's spouse; in short, a scene that, but for the Citroëns and Renaults parked outside, the television aerial on the roof and of course the Buffet on the wall, would have been familiar to the reader of Balzac.

The painter produced thousands of such works and, industrious and devoted though Maurice Garnier may have been, even he could not personally sell each one, so over time, a retail network grew across France and overseas that did much to maintain the Buffet market during difficult years. Some of these galleries continue to sell the works of Bernard Buffet today.

One such is Christian Dazy. Today Dazy is a prosperous art dealer in his sixties, with a gallery in the French ski resort of Megève and another in a superb sixteenth-century *hôtel particulier* in the centre of Dijon. He opened his gallery in 1989, and specialises in twentieth-century French paintings, mostly of the École de Paris. His career with the works of Bernard Buffet began in 1968, when, at the age of eighteen, he went to work for an engraver in Montmartre.

His role was not dissimilar to that in which Pierre Bergé had begun his working life at the bookshop opposite Maurice Garnier's gallery. He was a 'courtier', or broker, picking up what he could in the way of engravings and then making the rounds to his clients to see if he could sell them. But for the most part he was a factotum, helping out, running errands and laboriously working the hand-turned press that pushed the thick snowy paper against the inked copper plate. He particularly loved being able to spend time in the workshops with the artists as they engraved their plates or came to inspect the impressions that had been made.

'I was a broker initially, a young broker, a broker in engravings and lithographs. I was at Lacourière-Frélaut, an engravers' workshop which is in the Butte in Montmartre. You could say that I was the workshop's odd job man. I was doing all sorts of work around the studio. It was I who was working the etching press, etc. And there I met first of all Dunoyer de Segonzac, and then a few days later Yves Brayer.' Brayer had supported Buffet's election to the Institut. 'Bernard Buffet was introduced to me by Yves Brayer. Buffet was already a famous painter.' And while Dazy recalls Buffet being accorded the respect of the other painters

who frequented the atelier, he was also aware that his wider reputation was suffering. 'The problem of Bernard Buffet at the time was that he was someone very well known, but who was already very criticised.

'As a broker I specialised in works on paper to start with. And I was going to the doctors, lawyers, notaries to sell.' Dazy recalls Garnier being very protective of his relationship with Buffet. 'There was always this slight barrier between us and Garnier and Bernard Buffet because we did not have the right to deal directly with him. Even so Lacourière or Robert Frélaut allowed me to have a few prints directly from the workshop which normally would have been returned to the publishers. And there were still a few artists' proofs or rejects that I could sell directly from the workshop. So I did this for years and years and then I specialised in exhibitions.' Gradually those exhibitions became more substantial. 'I added paintings, and started to sell original works of art, not just by Buffet, but including artists such as Priking, Brayer, and Lorjou.'

The people to whom Dazy was selling were very different from the far-sighted collectors who had bought Buffet in the early years. They weren't speculators, they were certainly not of the beau monde, nor were they Louveciennes-level power-brokers and influence-peddlers. 'They were people of my age who had been affected by the work of Buffet, people who had arrived socially speaking and professionally in life.' They were clients that in some cases he had cultivated for years,

going to see them, inviting them to exhibitions, and they told me, 'You know, Christian, one day if I can afford it, I will buy a Bernard Buffet.' It was a longing to own a painting, it was not speculation. There were even people to whom I sold engravings at the beginning, because they had limited means and in those days I had no paintings. And afterwards, when I started to have Bernard Buffet oils, watercolours or things like that, I took back the prints I had sold them and I sold them an original. These were the buyers that I brought on little by little, and it was this customer base which was very, very important. Above all what I wanted was the contact, and to see the evolution of the customer from that time until today.

I did not become a great friend of Buffet, but there was always a very friendly relationship. Whenever and wherever we met we only talked about paintings. What he wanted to know and what I was able to tell him was what people thought of his painting. Because I could

claim to have personally sold lots of Buffet pictures, including some very beautiful ones. He wanted to know what people thought of his painting. He wanted to know how the end client felt. He already knew what institutions thought and what some of the other painters thought.

This hunger for knowledge of what the final customers thought of his work only increased as he grew older. 'He had been criticised so much and the worse it got and the older he got the more he needed to reassure himself as to what people thought of his painting. How people found it. What the profile was of the people who bought his paintings.' Dazy believes that he was able to give Buffet a perspective on the reception of his work that was different from both the scorn and excoriation of the public institutions and the empty compliments that would have been spoken to his face at the opening of his annual exhibition.

I told him that it was mostly people who had just followed his work since the beginning and who, now that they had succeeded professionally, purchased a work because they loved him. And of course it was understood they had money; he was no fool, he knew that his paintings were valuable. The professions who bought Buffet were initially doctors, at the beginning, and then all sorts of other professions: notaries, lawyers, pharmacists, etc. They were mostly people in the professions. And he said, 'That's good, because they are people who are cultured and educated.' It was people who have really had a successful career. There was a time when it was necessary to have a Bernard Buffet at home, even in spite of the institutions, Malraux and everything. People told me, 'We grew up wanting a Bernard Buffet.' On some level it was a reward for success.

And later I told him that there were fewer doctors because they could no longer afford his work; it was rather the surgeons, the specialists, and especially those who were in industry. I sold many, many pictures to industrialists and to people who had succeeded in finance. And when I told him this he would say, 'That's good, that's good.' But he was never a great talker.

Not of course that Dazy got much of a chance to chat to Buffet. Even though he sold Buffet's work over a thirty-year period, he never became close to the painter and was at all times conscious of Buffet's unique relationship with Garnier.

Garnier was a man who refused that one saw Buffet anywhere else than with him. He was very protective of Bernard Buffet, which is logical, and I respected that.

I bought, I sold, with the support of Mr Garnier. Maurice Garnier did an extraordinary job, putting on exhibitions, taking risks, and in general did a lot of things. But Buffet knew, he knew that behind him and his dealer I, and others like me, was doing this work. They were very happy . . . While remaining in the shadow, I had done a job. Garnier was very clever in taking brokers. He was the boss and then there were lieutenants. There were several galleries in France and some abroad who did good work which has supported Buffet. Garnier was an extraordinary leader but it should not be forgotten that there were plenty of people a little bit like me, who did much for the work of Buffet.[10]

Over time, the exhibitions and events that these 'lieutenants' mounted became increasingly ambitious. Dazy's largest-selling show was of fifty paintings, the majority of which had been entrusted to him by Maurice Garnier; it was held at his seventeenth-century mansion in the centre of Dijon. Short of taking over a public institution, such a show would have been impossible in Paris, and at the time it was one of the largest exhibitions of Buffet works seen in France since the long-gone days of the Charpentier show.

'When Mr Garnier came to see the building and to hang the exhibition he was blown away. He said, "It's fantastic, it's fantastic",' recalls Dazy proudly. 'There were fifty paintings: New York, clowns of course, there were still lifes; it was a complete variety. We had works from our side, but also works that were on consignment from Mr Garnier. Very beautiful works.'[11]

However, this exhibition in Dijon was not to take place until 1997, and would mark the culmination of nearly three decades of Dazy's working life.

Meanwhile, back at the beginning of the 1980s, as Garnier's lieutenants scattered across the various départements of France groomed their clientele of country doctors, dentists, surgeons, provincial lawyers and local businessmen, there still remained one market in which Buffet was white hot, and it was neither the sun-drenched retirement resorts of rich Americans nor the picturesque towns and villages of rural France.

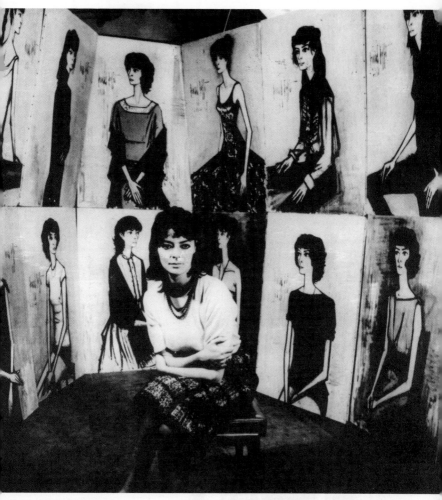

Annabel Schwob de Lure was one of the more remarkable women to emerge from the subterranean nightclubs and pavement cafés of post-war Saint-Germain-des-Prés. If she can be said to have had any profession, it would be that of a bohemian. After studying to be an artist, she had worked as a mannequin, she sang in nightclubs, and when she met Buffet in 1958 she was writing her first novel. Her chief talent was her beauty, which bewitched Buffet who devoted his 1962 show to portraits of his new wife.

Moscow in 1965: Bernard and Annabel Buffet in Red Square with the beau monde amongst the throng: Baron de Rédé, the Carita sisters, Gunter Sachs, Jean-Noël and Florence Grinda, Paul Louis Weiller, Cristiana Brandolini, Guy Laroche, Jacqueline Delubac, the Comte and Comtesse de Ribes, Pierre Cardin, Georges Cravenne, Marc Bohan, Jacques Chazot.

Bernard and Annabel, Saint-Tropez, May 1964. Les Buffet were one of the most in-demand of fashionable couples at the height of the *Les Trente Glorieuses*, friends with everyone from fashion designers to a future president of France.

Along with Johnny Hallyday
and Brigitte Bardot inter alia
Les Buffet became pillars of
Paris Match society.

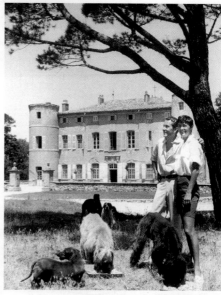

Château l'Arc, the Buffets' home in the
South of France. Chateau l'Arc was typical
of the grand houses that Buffet would occupy
from the second half of the 1950s until his
death. Buffet seemed to have no problem with
enjoying the rewards his work brought him,
whether a castle, a yacht, a luxury car or, as
this picture (*left*) suggests, a ride in a helicopter.

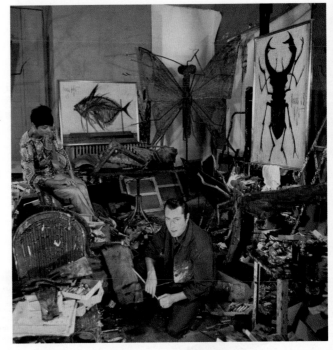

Buffet where he was most comfortable, in the studio surrounded by the comforting chaos of creativity.

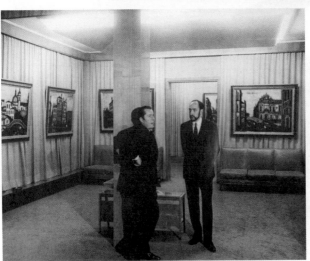

Bernard Buffet with Maurice Garnier, eponym of the gallery that would represent the painter up to and beyond his death. The unique relationship between the artist and dealer was to last a lifetime. Even today the gallery is little changed since its opening in the 1950s.

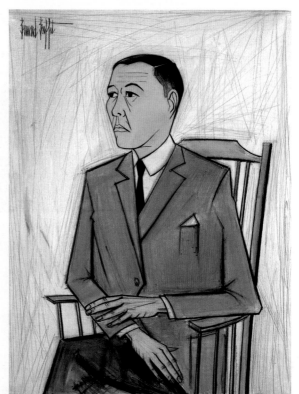

Portrait of Kiichiro Okano,
1973, oil on canvas,
130x90 cm.
'He thought he owed
Mr Okano his life,' says
Nicolas Buffet of his
father's relationship with
banker Kiichiro Okano,
who opened the Bernard
Buffet Museum in 1973
and played a fundamentally
important role in
establishing the painter's
rock star status in Japan.

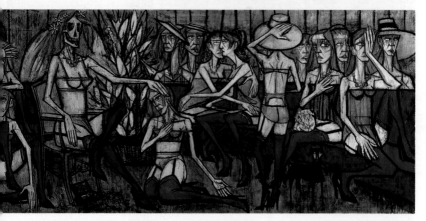

Les Folles – La Mariée, 1970, oil on canvas, 210x600 cm. Portrait of a marriage in crisis.
Some of Buffet's most powerful work was born out of the personal turmoil of the late 1960s,
when he stopped drinking and smoking and his wife resumed her singing career.

Saint-Malo, voiliers, et paquebots dans le bassin, 1972, oil on canvas, 89x130 cm. For a period in the 1970s Buffet turned to the soothing and absorbing creation of highly detailed villages and landscapes around an idealized France. He is said to have been his happiest while painting his series of old boats in harbours.

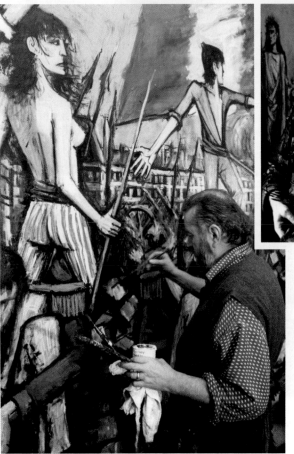

For much of the 1970s Buffet was a virtual recluse, seldom venturing out of his moated castle. Even if he had been seen out and about, his soaring weight and beard of Old Testament dimensions would have made him unrecognisable as the man with the film star looks of just a few years before.

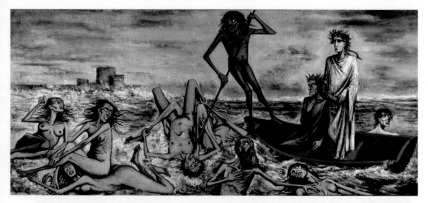

L'Enfer de Dante – La Traversée du Styx, 1976, oil on canvas, 250x580 cm. Eve to his Adam, Annabel tempted Buffet back onto the booze and cigarettes, and the result was the arresting series of paintings based on Dante's *Inferno* that he worked on during 1976.
(*Bottom left*) The melodramatic still life depicting roulette wheel, weapons and intoxicants provides an intriguing commentary on his resumption of alcohol.

Buffet and the series of disturbing self-portraits that hinted at the impending physical collapse that occurred in the early 1980s.

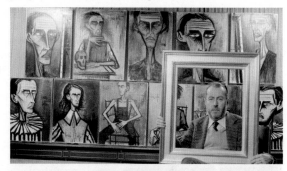

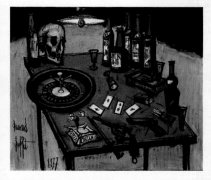

Le Grand Jeu II, 1977, oil on canvas, 130x162 cm. During the final two decades of his life Buffet returned to some favourite themes, among them the story of Don Quixote. At this time he also painted Captain Nemo – as a man who felt he had been excluded from the official cultural life of his beloved homeland, he identified strongly with these literary mavericks.

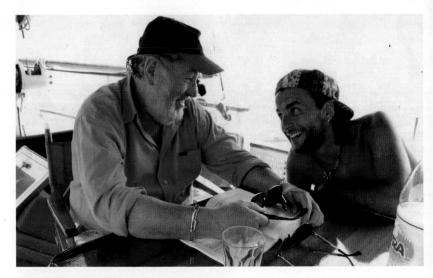

'He was really withdrawn. He was not a big talker. So that's why it felt so important when you were in connection with him; it was really important for him because he wasn't connected with so many people.'
Nicolas Buffet and his father.

La Mort 10, 1999, oil on canvas, 195x114 cm. Buffet ended his life with that of the century and a valedictory series of paintings. *La Mort* can be read as a summation of his career and as a suicide note in colour on canvas.

Chapter 38

Big in Japan

By 1980, the fun had rather gone out of flying. No longer was it the exciting adventure it had been when Buffet had been sent off from Orly with a champagne reception, on his mission to bring culture, braces and perfume to the citizens of Dallas. Now he, Annabel, Danielle and Nicolas settled into the seats they would occupy for the next few hours with little more than a sense of impending tedium.

'In short we could have been anywhere. Had it been New York or Moscow, nothing would have been different,' said Annabel, who deplored the bland modernity, the mechanised conformity and the general ennui. She was probably looking forward to getting stuck into the miniatures of Scotch when 'all of a sudden, the journey really began. In mid-air, amidst the plastic plates, the pre-cooked meals and all the paraphernalia of a robotic world, nothing could have prepared us for this fairy tale. The hostesses in traditional costumes, spring kimonos, sashayed out silkily, proud and smiling, sliding amongst us, magic butterflies, transforming our jet plane into a flying dragon of childhood dreams.'[1]

The childlike side of Bernard's character was enraptured. It was at that moment, 'in the middle of the flight that I experienced what would make me love this country on the other side of the world'.[2] Charm, colour, exoticism, tradition . . . Bernard Buffet had made up his mind to like Japan as much as Japan adored him.

Now in his fifties, slimmer of figure and trimmer of beard, seven years after the opening of the museum dedicated to his work, Bernard Buffet had at last accepted the invitation of his patron Kiichiro Okano, and he could not have chosen a more propitious time. In common with many European countries, Japan had benefited from a prolonged post-war boom, but in contrast to Europe, where economies were now languishing, the boom had not just continued during the 1970s but had accelerated. In 1979, the year before the Buffets boarded their

flight to Tokyo, Japan's GDP topped a trillion dollars, around five times what it had been in 1970. Of the Western economies, only the USA boasted better figures. Japan was hailed as an economic dynamo; its methods were studied fearfully in the West, where it was confidently predicted that this nation on which the United States had dropped not one but two nuclear bombs thirty-five years earlier would take over the world.

Time magazine threw itself into the coverage of this new threat to the accepted world order with much the same relish and enthusiasm that it demonstrated when warning of the impending ice age in 1973. 'How Japan Does It, The World's Toughest Competitor' was its cover line in March 1981, with a drawing of a samurai wearing a digital watch and wielding a calculator, a set of car keys, a tie and a bag of golf clubs. The message was clear: the Japanese were coming and they were going to buy everything in sight. By the end of the decade, the inevitability of Japanese global domination would have become so accepted that Hollywood would make such Nippon-phobic big-budget thrillers as *Die Hard*, *Black Rain* and *Rising Sun*.

Three decades later, exactly the same predictions would be made about China, but as Buffet touched down in Tokyo that spring, the future belonged to Japan. And when they weren't busy learning to play golf, demolishing the American car industry or selling the world pocket calculators, computer games and tape decks, the Japanese were buying art.

They had acquired European paintings before. There had been Japanese collectors among the clients of legendary Impressionist dealer Paul Durand-Ruel. 'But the wave of Japanese buying French Impressionist paintings that broke over the art world in the 1980s was unlike anything that had gone before,' Philip Hook of Sotheby's would later recall.

The original interest in Impressionism was given huge new momentum by the gathering strength of the Japanese economy. In 1985 the yen was revalued and by 1987 it had risen nearly 100 per cent against the dollar. A year later, 53 per cent of all auction sales of Impressionist and modern paintings were being made to Japan. The Japanese are great consumers of brands, and 'Monet' or 'Renoir' were brand names that had a particular financial and cultural resonance.[3]

The decade proved to be a bonanza for Western art in Japan. Okano was not the only successful individual to build a museum. It was a characteristic of his generation of business leaders, as his grand-daughter explains. 'After the war, many museums began to open, and during the seventies many private museums opened. It was a natural thing for somebody who collected art to want to open a museum. Maybe at first it was his personal interest,' she says, but the more immersed he became in Buffet's art, the more convinced he grew that he was engaged on a highly significant cultural mission, carrying an important message. There was something almost Victorian in his belief in the improving power of art. 'He said there's a message: because he loved French culture very much, he wanted this culture to flourish in this region.'⁴ In part he saw it as an inherited duty: his family had founded a bank in the Meiji period, which was intended to benefit the wider community. 'It is from a desire to rescue the economically weak region that the founders undertook their work and it is in this spirit that the bank continues to exist.'⁵

This was not an isolated instance of a site of cultural interest being located in a country setting; there was a generation of philanthropi-cally minded collectors who clearly believed that the tranquillity of the lakes, forests and hills of rural Japan's national parks favoured the contemplation of works of art. A few years after the Bernard Buffet Museum opened, industrialist Eiichi Ikeda chose Shizuoka, fifty miles or so from Mount Fuji, as the location for a similarly modern-looking home for his collection of twentieth-century masterpieces spanning Bonnard to Dalí. In 1969, media giant Fujisankei, which by the early 1990s would be the world's fourth largest company, had inaugurated a sculpture park, exhibiting hundreds of works by Picasso, Rodin, Moore and Hepworth, inter alia, also not far from Mount Fuji, in an idyllic bucolic setting of landscaped gardens and wooded hills framed with views of the Hakone mountains. This was Japan's first open-air museum; it proved so popular that a sister site was opened in the Nagano prefecture in 1981. Even religious sects were getting in on the museum-building boom. The Soka Gakkai branch of Buddhism built an impressive museum next to the famous Taisek-ji temple in the foothills of Mount Fuji that united Japanese painting, Chinese ceramics and a collection of European works, the star of which was a master-piece by Claude Monet.

By the 1980s, a company museum was a visible emblem of corporate health, and as the Japanese economy thrived and those companies grew ever more prosperous, overpaying for trophy paintings became a national pastime. In March 1987, Yasuda, an insurance company, paid £24,750,000 for an admittedly very good Van Gogh sunflower painting, over four times the high estimate of £6,000,000. The painting was carted off to Tokyo and put on display on the forty-second floor of the corporate HQ, where tens of thousands of paying visitors came to cast their eyes over it. Philip Hook observed, 'The massive media publicity that was generated for Yasuda, which in turn led to the sale of a lot more insurance, meant that the Van Gogh to all intents and purposes paid for itself.'[6]

And within a couple of years, it seemed as if the directors of Yasuda could congratulate themselves on having bagged something of a bargain. May 1990 saw two important works come up for sale in New York. *Au Moulin de la Galette* by Renoir was offered by Sotheby's, while Christie's fielded a Van Gogh portrait of the early Impressionist collector Dr Gachet. The Renoir went for $78,100,000; the Van Gogh fetched $82,500,000. The staggering sum of $160,600,000 had been spent on just two works of art, and incredibly they had been bought by the same man: Ryoei Saito, owner of a paper manufacturing company, 'a modern industrial baron – the shogun of Shizuoka prefecture'.[7]

'I was able to purchase two great paintings, and I feel like riding to heaven,' he told Reuters. 'I was very lucky because it is a very rare thing that the paintings by Van Gogh and Renoir would be out in the market.'[8] He had started buying Western art only in 1967, his first acquisition being a Bonnard. By the 1980s he was on a protracted shopping binge, borrowing heavily against his business, which was the second largest paper company in Japan, and dressing up his big spending in patriotic rhetoric, as he told a Japanese newspaper, 'It's a wonderful thing that those celebrated paintings are coming to Japan.'

Reporting on this astonishing news, the *New York Times* said, 'The purchases are considered likely to deepen already serious concern over the manner in which Japanese businessmen are amassing and displaying collections of Western art.'[9] But far from being concerned, Buffet was delighted.

If Renoir, Monet and Van Gogh were considered brand names, then Bernard Buffet, with his identifiable style and famous signature, seemed to have been invented with the Japanese market of the 1980s

in mind. The inflated prices being paid for indifferent and even poor Impressionist art presented a marvellous opportunity for Japanese art dealer Kiyoshi Tamenaga.

His marketing strategy was straightforward. He believed that Japan had come to Impressionism too late to be able to acquire the best pieces in any quantity. Tamenaga had spent his early years in Europe.

Starting in Paris, I visited art museums and galleries. The impressions European art made on me helped me to decide to be an art dealer. When I returned to Japan I found Western-style Japanese works to be weak and substandard. Unable to appreciate this art, I devoted myself to introducing French art to Japan.

Japan was a backward country in terms of modern art. Good Impressionist works were in museums and private collections throughout the world, and American museums had especially excellent pieces. But I realised that the pieces in Japan were only second class or lower. The Ohara Art Museum, which began the first collection of modern European works in Japan, had been acquiring and exhibiting French art works since the 1930s. But I sensed there was something different about the works. They were somehow not the same as those I had seen. They had no sense of familiarity for me.

Comprehensive collections of modern art had been established at such institutions as the Metropolitan Museum of Art in New York City and the Art Institute of Chicago at the beginning of the twentieth century. Their collections grew in tandem with America's burgeoning financial supremacy. It irritated me to see the Japanese praise the inferior Impressionist works they had access to in their museums. Because Japan had been late entering the world of modern art collecting, it had had to seek the best it could find among what work remained. There were no good examples of Fauvism or cubism left.[10]

While in Paris, he had become friends with Tsuguharu Foujita, who although Japanese had taken French citizenship and the first name Leonard. Through Foujita, Tamenaga had become acquainted with the work of an entirely different circle of painters. 'I realised that what I could introduce to Japan were the École de Paris artists, Modigliani, Kees van Dongen, Moise Kisling, and Maurice Utrillo',[11] and of course Buffet. 'I became friendly with a number of younger artists. I knew Bernard Buffet as a young painter with a keen appreciation for the work

of the post-war era.'[12] Quite how accurate Tamenaga was in his assessment that Buffet had a keen appreciation for the work of the post-war era is debatable . . . unless he meant the post-Napoleonic War era.

Nevertheless, Tamenaga had spotted not so much a gap as a chasm in the market, and it was a chasm that he was to fill with Buffets, in their thousands. Nobody knows quite how many Bernard Buffet paintings were shipped to Japan, but after that first still life was brought in as part of Furukaki's wife's hand luggage, and as the country prospered, they poured in. Garnier used to say that there were at least 3,000 paintings in Japan, more than enough to create an entirely self-sufficient market. But when aquarelles, drawings and prints are considered, the number must be considerably higher. The Bernard Buffet Museum alone has around 2,000 works, of which approximately 600 are oil paintings. For every shogun of industry who spent a seven- or eight-figure sum on an Impressionist painting, there were hundreds of Japanese who chose to demonstrate their sophistication, their awareness of European culture and of course their enhanced economic status by buying a Buffet.

'We find it's very European, in the sense we admire the culture, the European culture, and in the painting of Bernard Buffet we see them. On the other hand,' observes art dealer Kiyotsugu Tamenaga, who now runs the business that his father established, 'there's some kind of similarity with our tradition, using these black lines.' In particular it was 'his famous black vertical lines' that were 'always easily received by Japanese. I think he is by far the biggest name, if I could say, or that we consider him as the biggest artist probably in the world.'[13]

Certainly Okano shared this opinion, and was in no doubt that Buffet was worth collecting. He did have other artists in his personal collection, but their works, and indeed most of the rest of the canon of Western art, were but pale flickering candles next to the flood lamp of Buffet's talent.

His unique genius may be called 'the originality of despair', a sensitivity absent in art from Ancient Greece, Rome or the Renaissance. The originality of despair is where Buffet's very life is found, where Buffet receives his highest praise, and where he achieves the greatest harmony with our times.

It is also instructive to note that Buffet infused his thoughts into the lines with which he composed his paintings. Matisse's

decorativeness and Chagall's reveries are void of any consideration of the contemporary times. They are expressions of their technical eminence, but lack any philosophical reflection that bears witness to their times.

I love Buffet's paintings for a singular line or a dark monotone space; they pulsate vibrantly with the generations, society and trends that form a backdrop to his environment. For even in a single iris he has painted, I see the fearful image of a 'reed swaying in the wind': of man living in this nuclear age.[14]

Given that Buffet is on record as having no interest in the atomic age, or for that matter anything much to do with the late twentieth century, just how much of mankind's nuclear age angst he was channelling is open to question.

Hyperbolic it might have been. Nevertheless, in describing his work as, in some way at least, of a higher order than the entire artistic output of the two great civilisations of antiquity, and for good measure the Renaissance, as well as surpassing the likes of Chagall and Matisse, Okano demonstrates just how seriously Buffet was taken in Japan during the late 1970s and 1980s.

Of course as befitted a towering genius, he was given the sort of welcome that he had not seen since his trip to Dallas. He might have been seven years late for the opening of his museum, but Okano liked to do things in style and on an impressive scale. Buffet was treated as if he were a visiting head of state.

The visit made an indelible impression on the young mind of Nicolas Buffet.

For me it was a great, great trip. The Okano family is an amazing family and they did things that you can barely imagine. At the hotel they reserved an entire floor for us. They made special towels for the bathroom with 'Bernard Buffet' written on them. It was completely crazy – completely crazy. I was nine, so for me I thought it was usual that when you go into an hotel you have your father's name on the towel![15]

For Buffet it must have been a truly remarkable experience. The wariness and insecurity of the 1970s melted away in the warmth of his reception. Not since the days of the Charpentier show in the 1950s had he been so publicly feted. The joy of reacquainting himself with

the agreeable aspects of the uncritical celebrity status that he had last experienced in his twenties must have been all the more powerful, in that it contrasted so markedly with the years of hermit-like withdrawal and the wearying and dispiriting knowledge that his work was either ignored or attacked by a hostile and inimical art world.

To his surprise and then delight, Buffet discovered that he was not just big in Japan; he was a major celebrity. Accordingly Tamenaga ramped up the frequency of exhibitions, often staging more than one a year. In 1979, Buffet's canvases depicting the French Revolution made a tour of Okayama, Osaka and Hiroshima, while the series of flower pictures painted in 1978 to mark his twentieth wedding anniversary were exhibited in both Tokyo and Osaka. And 1982 was a splendid vintage, with three shows: one that appeared in both Tokyo and Sapporo; an exhibition of self-portraits that did the rounds of Tokyo and Osaka; and a third called *Whole Aspect* in Fukuoka. As Kiyotsugu Tamenaga recalls, the 1970s and 1980s were great years to be in the art business in Japan, when his father was one of a small number of dealers. 'Not so many of them were handling European contemporary art back then, representing living artists in the Japanese market. There was not much competition. So whatever he brought into Japan did work quite well.'[16]

However, Tamanega was not a man given to complacency, and he came up with ideas about how to reach those neophyte collectors who might be daunted by the prospect of pushing open the door to one or other of his galleries – by the late eighties he had five in Tokyo and Osaka, as well as one a few doors down from Maurice Garnier in Paris, with another planned for New York. Had one been a guest at the Hotel New Otani in either Sapporo or Tokyo at the beginning of 1982, one would have been able to catch a Buffet show.

Buffet-mania continued to mount throughout the decade, and on 7 December 1988 there was a landmark sale of a Japanese collection of his works from 1945–55 at the Okura Hotel in Tokyo conducted by Jean-Louis Picard, representing the 'Compagnie des Commissaires-Priseurs Parisiens'. It was a flamboyant affair, not merely because the appetite for the artist's work was at its peak, but because of the added theatre of the fact that the Okura was linked to the Drouot in Paris, and the sale was conducted simultaneously in the two locations. The use of this new technology lent a frisson of further excitement and tapped into the zeitgeist of an era obsessed with the idea of global

financial markets that no longer slept, linked by exciting technology such as cumbersome mobile phones, fax machines that spewed out rolls of paper, and giant electronic boards that flashed the prices of stocks – or for that matter Buffet paintings – simultaneously in Deutschmarks, dollars, francs, sterling and, most importantly of all, yen.

But perhaps even more remarkable than the readiness of Buffet collectors to part with vast sums were the huge shows that would take place in department stores – Mitsukoshi was a particular favourite – as Tamenaga's son explains.

> They had a strong role. It was different from the art dealers, it's a particular system in Japan; and my father had a big role in that. He was a very close friend of some of the department store presidents, and he suggested they should bring culture into the department store. And they made their own art section in the department store. Then they allocated an entire floor and called it their museum floor. It started to work and they started selling art pieces at the department stores. They put a lot of money into the publicity; they worked with journalists and they put huge advertisements in the newspapers and so on.[17]

And the customers poured in; according to Tamenaga, such events might draw 'a hundred thousand of them'.[18]

Of course not every shopper was a Buffet buyer, but as brand-building exercises the shows were remarkable. Ida Garnier, who together with Maurice accompanied the artist on these tours, remembers how women from remote provinces would travel by train to the city to catch a glimpse of Buffet as if he were a famous actor. Photographed for one magazine cover in Cuban-heeled cowboy boots that he bought from Western House in Paris, he looks like a rock star. It was Hourdin and his *vedette* system all over again, just a quarter of a century later and on the other side of the world.

Back on the booze and back in the news, Buffet was visibly a different man. The Old Testament beard had been replaced by a neatly trimmed Vandyke. He looked his elegant old self in a three-piece suit.

But more than the adulation and the sales of his work, Buffet discovered that he loved Japan. Any apprehension he might have felt vis-à-vis Okano and his decision not to attend the opening of the

museum seven years earlier evaporated when he met his patron in person. 'When he realised the depth of Mr Okano's love for his painting, when he saw how important it was for him, things started to change in his mind,' says Nicolas Buffet.

There was a mutual admiration between them. Mr Okano was a very enigmatic man, very powerful and charismatic, and he was like a shogun, like a big lord. He didn't speak French at all. I remember he could read it but he couldn't speak it, so they could not have a real exchange, because my father didn't speak English at all. So instead they had some kind of very special connection. I remember that every time I was in a room with the two of them, you could feel that there was something just happening between them, something really strong, really, really powerful. It wasn't language, it was something else. I think that Mr Okano took a very, very important place in my father's heart and mind.

He did not give his affection to a lot of people. My mother was the contrary, she was a woman who was full of affection for everyone. But he was really withdrawn. He was not a big talker. So that's why it felt so important when you were in connection with him; it was really important for him because he wasn't connected with so many people.[19]

But as well as connecting with Okano, Buffet also felt in touch with the country. Japan engrossed him. It must be remembered that almost forty years ago, beyond the cliché of its extraordinary economic success, Japan was little understood in the West, and given that Buffet spoke no English, let alone Japanese, and had spent the 1970s more or less holed up in his castle, immersing himself in French culture, with the occasional break to bring the demons of Dante's *Inferno* onto the Avenue Matignon, the overwhelming strangeness of the country in which he found himself feted as a superior being struck him forcefully. The country 'spoke' to him on an almost mystical level, as his wife noted when they saw their first Japanese rock garden, with its pristine pond of raked gravel surrounding islands of rock. Annabel found the concept perplexing and slightly alarming, but 'Bernard, more sensitive than me to all forms of mysticism, seemed to instinctively understand the secret.'[20] If William Blake had been able to see a world in a grain of sand, then the Japanese were able to 'construct

an entire spiritual universe based on just a single stone',[21] and it was a concept that Buffet, with his strong, if somewhat unorthodox, sense of religious belief found extremely attractive. Perhaps on seeing the stony palette of the rock garden he experienced a spiritual connection that reminded him of those minimalist early canvases bleached of all colour and pared to their essentials. Perhaps in the geometrically precise little furrows left by the rake in the gravel he could see his younger self, scratching frantically at the thin paint to create those hundreds of little cicatrices on the works that had propelled him to the front rank of European art while still little more than a boy.

And just as the calm of the Zen garden attracted him, so did the tension, energy and violence of sumo. It is strange to think that a man so identified with the rectilinear should be so enchanted by the spectacle of two enormous and extremely well-rounded human beings wearing nappies colliding in a mass of quivering flesh and grappling with each other. Perhaps as he took his seat and witnessed his first sumo, he was transported back thirty years to the boxing match he attended with Pierre Bergé in the days before they first became lovers. Perhaps he liked seeing vast, nearly naked men. Perhaps it was the highly ritualised and ceremonial nature of the thing, the delicate, almost balletic way in which the combatants squatted in front of each other, arms extended, surveyed by the fan-bearing referee in his bright robes and solemn biretta-like headgear that gave his stern features the impression of a judge about to pronounce the death penalty. 'As well as the sport, I was fascinated by the ritual, almost religious side to it.'[22]

It was a similarly religious level of ceremony, tradition, flamboyant colour and sombre gravity that had attracted him to the corrida, and inspired him to produce his remarkable series of paintings, and to return again and again during the 1960s to the subject of the *torero*. Perhaps the solemn preparation for what was after all a form of entertainment reminded him in some way of the painstaking application of face paint that transforms a human face into the grinning mask of the clown. Perhaps he was touched on all these levels and many more besides. Over the years, he would become an aficionado of sumo, and in 1987 he would produce a sequence of works dedicated to the sport and to the equally ritualised and even more mysterious kabuki. 'I think he was purely interested in Japanese culture. Otherwise he wouldn't paint sumo wrestlers,' observes Koko Okano. 'He went to sumo every time he came to Japan, and he was watching sumo in

Paris, when it was on TV. So he was just interested in Japanese culture.'[23]

The only aspect of Japanese life that he did not care for was the geishas, whom he found terrifying: 'They are chirruping doll-hostesses,' he said, 'who drink from your glass and give you mouthfuls of food as if you were a baby, and they touch you ceaselessly.'[24]

But this was a decidedly minor cavil. After all, how could he not feel a kinship with a country that had such profound respect and reverence for art? As well as his childlike delight in seeing something new and different, a large part of the country's appeal was its enigmatic opacity. Some years later he was asked what accounted for the popularity of his work in Japan. 'Nobody knows the answer to that. Japanese like art. Even if they don't have the money to buy. At lunchtime in Tokyo galleries are full of people; they go for pleasure – not to buy, just to look.'[25] He is frequently quoted saying that one should feel painting rather than analyse or discuss it, and he liked the fact that a sophisticated culture could respond positively to his work without anyone being able to explain what it was they found so appealing. Japan was much more than a place to sell his pictures; it would fascinate him for the rest of his life. In the mid 1990s, halfway through what Japan would call its lost decade, when the bubble had burst and the overinflated art market had crashed, he was still captivated. 'The more I go to that country, the more I learn about it.'[26]

Like those European artists of the late nineteenth century, such as Whistler, Monet and Van Gogh, whose incorporation of oriental motifs into their work had given rise to the term *Japonisme*, Buffet had succumbed to the sorcery of this exotic far-flung land that Annabel delighted in calling 'the country at the end of the world'.[27] Over the three weeks he was there, he filled his sketchbooks and left vowing to return; he would make eight visits to Japan in all, a significant number for a man who did not particularly care for long-distance travel.

He landed back in Paris brimming with enthusiasm about his trip, saying how he had been able to feel the 'overwhelming energy, the dynamism', and how he had so liked 'the temples, the streets, the way the houses were arranged precisely and compactly one next to the other'.[28] And in common with many Western observers, he marvelled at the industry of the Japanese people.

It is hard to overestimate the importance that this three-week visit in the spring of 1980 held for him.

Today, after more or less a generation of economic stagnation, Japan remains one of the largest economies in the world, but it trails miserably behind the USA and China. The days when Hollywood made films about the 'Japanese peril' and when *Time* magazine ran cover stories about its unstoppable economic rise have long passed into history, as have the tales of the twentieth-century shogunate of art-buying businessmen. And the popularity of Buffet in the Japanese market has come to be regarded as a collective moment of national eccentricity, a time when, in Philip Hook's slightly patronising words, as 'great consumers of brands', the Japanese could be duped into buying anything. However, the past is just the present with the benefit of hindsight; there were plenty at the time who believed that the Japanese were only going to get more powerful, or who were too busy selling them things to question how this boom was funded and whether there was a bubble waiting to burst.

Today the art world may look back on this time in wonder and perhaps slight embarrassment; nevertheless, the fact remains that during the 1980s, the entire art market let itself become dominated by the tastes of this island nation on the other side of the world from Europe, which, along with Impressionists, bought the works of Bernard Buffet. Happily, human memory is short, and although the names of the artists and the nations are different, the same thing happened during the early years of the twenty-first century, when Brazil, Russia, India and China became the focus of the attention of a new genera-tion of Europeans keen to sell their patrimony, whether it happened to be in the form of handbags, vineyards or works of art.

Once back in France, Buffet busied himself with a number of works recording his experiences. There was a set of lithographs; a lavish book in which his illustrations were accompanied by a text written by Annabel and transcribed in his distinctive hand; a series of land-scapes that captured both the tradition and the progress of Japan; some monumentally scaled paintings of storks, huge and colourful; and a striking bust-length portrait of a naked, skinny man with Mount Fuji in the background.

Although it does not look like Buffet as he was in his early fifties, it is hard not to see him as he had been in his twenties: ribs visible through the pale skin, thick black hair swept back off his forehead.

He stands with his arms outstretched, looking at an easel on which rests one of his own flower paintings. It is a strange picture, but also a happy one, in that although he looks serious in the portrait, he also looks young. The flowers, too, were always a good sign.

Flowers were a subject to which he would return over and over again throughout the course of his life. Some would be characterised by heavy impasto and the use of Van Gogh-bright colours, in huge formats. Others would have the air of Dutch Old Masters, just a few inches square, on panels, with a sort of luminous quality that belied their small size. Flowers were enormously significant for him; it was with an exhibition of flower paintings that he demonstrated to Annabel that, however much their marriage might have changed in the two decades since they had leapt fully clothed into the pool of Château l'Arc on the morning after his thirtieth birthday, his affection for her was still very strong. 'Flowers,' he once said, 'are woven into our lives with every twist and turn of emotional events. Scarcely born, before we're even aware of it, we inhale the subtle scents of bouquets offered to the woman who brought us into the world.'[29] Their appearance here is clearly significant. It is almost as if Buffet is inviting us to decode this large canvas of 4.2 x 2.4 metres.

He tended only to put his own paintings into his pictures when he was depicting places that were personally relevant to him. He had done so when painting Maurice Garnier's Galerie Visconti in 1954; they can be seen in the paintings of the studio and the interior of Manines, and in 1987 they would feature in a series dedicated to La Baume, the house where he would end his days in such dramatic fashion. Otherwise, for a painter who was so prolific and whose identifiable motifs recur with frequency throughout his oeuvre, there are remarkably few instances of this sort of *jeu d'esprit*. Is it too fanciful to read this picture of a man, naked as at his birth, with the flower painting in Japan, as an allegory of the rebirth and renewal that Buffet experienced upon visiting the country for the first time?

'I don't know why, but he thought he owed Mr Okano his life,'[30] says his son. In a very real sense, Okano had indeed given him a new life. Buffet had passed 'the midway of this our mortal life'; he had been, quite literally, through hell with Dante and Virgil, and had emerged from self-imposed house arrest in his thick-walled castle in the middle of a tangled wood to bask in the warmth of the affection from the Land of the Rising Sun.

That slightly surreal painting of the scrawny naked man against the grey-brown snow-capped pyramid of Mount Fuji rising from the towers of modern urban Japan, with the vivid splash of colour of the flowers on the easel, may not have been an accurate representation of how Buffet looked physically at the beginning of the 1980s, but it was a perfect snapshot of his emotions. It showed how he felt: young, free and, for the time being at least, happy and fulfilled. Ignored or scorned in the country of his birth, he had travelled to the ends of the earth, where he had found another homeland in which he was revered and respected.

No wonder he felt he owed Okano his life.

Chapter 39

Another Decade, Another Chateau, Another Brush With Death

Back in France, Buffet engaged once more with life.

A familiar pattern had rapidly reasserted itself. By 1978, the chateau in the forest was abandoned. Boredom? The need for a change of landscape to paint? The desire to put the associations of the 1970s behind him? Or just too much drink? In all likelihood it was a mixture of all these and more. As Annabel put it, 'We fell back into the cycle of moving home, fleeing the anguish, passing from a mad mirth to the depressing certainty of chronic anxiety.'[1] And during the end of the seventies and the beginning of the eighties, the Buffets made up for the years of his cloistered sobriety with a bewildering and rapidly changing slideshow of houses and apartments.

In 1978, the family bought a spacious house in Saint-Tropez, in addition to their apartment in the town. But there was barely time for the children to get into the pool and Annabel into her hotpants and knee-high suede boots before they had moved out the following year.

Between 1979 and 1981, the Buffets lived in a sprawling duplex of 1,000 square metres[2] on the Boulevard de Courcelles bordering the Parc Monceau, where his mother had taken him as a child because she considered that it offered a better class of playmate for her pale young son.

Hung, as usual in his houses, only with his paintings, the decorative scheme was less formal and museum-like than the grand apartment on the Boulevard de la Tour Maubourg near Les Invalides, with its soaring ceilings, gilded woodwork and carefully placed antiques, that had been the couple's Parisian pied-à-terre between 1965 and 1973. Nevertheless, its scale allowed for the display of some of his more impressive canvases, including a spectacular painting of Venice that at 2 x 3.5 metres still managed to look a little small on the wall of the dining room. Lounging on one of a suite of a dozen leather sofas

that in their high 1970s way manage to capture something of the beanbag, the futon and the hotel sunlounger, it is easy at first glance to miss Bernard and Annabel; they seem lost in the giant room amidst the profusion of clutter: a pair of coromandel screens, and numerous tables and chests covered with a profusion of bibelots and bric-a-brac, with further camouflage supplied by a carpet as busy as the Métro during rush hour. Besides, the eye is drawn ineluctably to the pair of giant elephant tusks that arch high over the fireplace.

By 1981, those tusks had moved a few minutes' walk away to Avenue de Wagram, where the Buffets kept an apartment until 1986 and where any pretence at a planned interior design was submerged under a tsunami of objects and more flea-market trouvailles.

Meanwhile, in November 1980 Buffet had bought the Manoir de Saint-Crespin, in Normandy, a former episcopal residence that conformed admirably to the image of seigneurial grandeur he sought in a country house. While not perhaps as impressive as the castle he had left behind (it lacked the moat and turrets) it was nonetheless of a sufficient size to be described as a chateau in some of the magazine reports – he had started doing interviews again after a hiatus during some of the 1970s. It was a large, handsome red-brick house from the time of Louis XIII, with a row of mansard windows projecting from a steep tiled roof; it was in this cavernous attic that Bernard located his studio and finished the paintings of Japan for his exhibition of February 1981. There was also a chapel and a wing, like an orangery, to the side of the main house. Possessed of the sort of drive that estate agents would probably call sweeping, the park in which the house was set was more than large enough for the children to go riding, Bernard following on his bicycle, while Annabel walked with their increasing number of dogs, some the size of small ponies.

And so life settled into a routine, governed of course by Bernard's working hours. The house was large enough to keep the outside world at a distance, but he was no longer the recluse he had been for most of the 1970s, and they now spent four days of the week in Normandy and three in Paris.[3]

Their marriage had evolved since *Les Folles*; the claustrophobia that had characterised the relationship had given way to a contented co-existence underpinned by genuine affection. She spent more time in Saint-Tropez and would write him long letters and phone, quite happy to come and go as she pleased . . . until a few days before the end of October 1981.

Bernard had been working on a series of self-portraits. They are a strange collection of pictures, some of them making use of fancy dress: Buffet as the nineteenth-century soldier, Buffet in seventeenth-century garb, Buffet in pleated ruff – a painterly device that recalls de Chirico's self-portraits. But these are not light-hearted spoofs of ancestral portraiture to accompany his taste for grand houses. Whether in period or contemporary clothes, it is always the same emaciated face, hollow cheeks, sunken eyes and etiolated neck picked out in harsh black strokes so as to be little more than windpipe and taut, stringy muscle. In a pair of dungarees worn over a bare torso of parchment-like skin pulled tight over clavicles and ribcage, he looks like he has strayed from one of Walker Evans's photographs of American farmers during the Great Depression.

They are the artistic negative of the series of paintings of Annabel of twenty-one years earlier. Where those had been idealised images of an already beautiful woman made to look younger and more beautiful, these expressed if not self-disgust then certainly an unsparing self-criticism. One picture is particularly disturbing. Set against a background of dirty saffron, the head fills the top of the canvas while the bottom is blocked by the shoulders, giving the impression of two halves of an hourglass linked by that fragile tube of a neck. The eyes are slit-like, the lips pulled back in a snarl. The effect is not far from that of one of the *écorchés*. It is not the image of a happy or well man.

'I knew that for some time Bernard was not all right. He painted his self-portraits, howls of pain poured out of those pictures of him,' Annabel would later recall. 'I should have sensed that he was ill, and not let myself be fooled by his air of calmness.'[4]

And then, one 'endless night' just before Halloween, she thought he would die. 'Finally, the morning came. I called the ambulance. I can still hear his monotonous voice: "Too late . . . I won't make it . . . too late . . ."'[5]

We talk about death. We write about death. We live in its shadow . . . But the night when she came into my house with the intention of taking him . . . when I saw that he found her beautiful and when I thought he was going to follow her, I was invaded by a terror that only hatred of this rival allowed me to overcome.

I fought until dawn to snatch her prey from her. Through the windows of the ambulance, I saw her fluttering around the vehicle.[6]

It would be five days before she knew that her husband would survive. As he convalesced in the American Hospital, he was told that if he resumed drinking and smoking after this, he would die, or worse than that, be unable to paint. This time he gave up for good. According to his son:

He had different periods when he stopped. I remember that there was a long period when he drank a lot, a lot, a lot. It was amazing, but I never saw him drunk, never, never. He was just full of alcohol all the time but never drunk, never. It was normal for him. The last time that he stopped it was because the doctor said to him, 'You're going to be blind if you continue to drink.' So he stopped, and never started again.

As far as Nicolas Buffet recalls, the cessation of drinking did not seem to cost his father much effort, at least none that he cared to show. But by now he was an expert at masking his emotions, one reason perhaps why he liked painting clowns.

He had a very strong mind, few people have as strong a mind as him, so he dealt with that thing, that problem, with a lot of strength. For me, again I was really a little boy at the time, so I had the eyes of a little boy. When my father stopped drinking, my mother just continued for something like four years, and she was a very serious alcoholic, but he never drank again. The point is that for my father, it wasn't at all a problem for him that his wife just continued and he stopped. He said, 'Okay, do whatever you want, it's not a problem for me if you want to smoke, if you want to drink, I don't care. It's not harder for me if I see you drink.'

I don't know how he did it, he did that, because you can imagine, if you are just strongly addicted to something and then the person whom you're living with is in the same situation and continues, then you stop, how can you deal with that? But he did, without any problem.[7]

In 1985, Annabel finally admitted that she was powerless over alcohol and began the painful process of rehabilitation. The torment of the last four years of solitary drinking can be imagined: the fear of losing her husband to his addiction (or for that matter his sobriety); the eventual realisation that as she approached her sixtieth birthday her drinking was destroying her health (although for a woman in her late

fifties who took little care of herself, she looked fabulous); the anger that she would have to be separated from the only substance that deadened the pain of life; the understanding that she would be forced to face life without being able to hide in a bottle of Scotch – all were troubling thoughts.

'She stopped because she was getting sick, and when I grew up, I realised it was really much more difficult for my mother.'[8] Just how difficult became clear when in 1986 she published a memoir of her sobriety called *D'Amour et d'Eau Fraîche*. It is more substantial and revealing than Sagan's *Toxique*, but alas does not benefit from her husband's illustrations.

And so, at last, amidst much drama, Bernard and Annabel finally conquered their dependence on alcohol.

However, the addict has to be very careful and vigilant. If an addiction is kicked out of the front door, it will come in through the back, and if the back door is locked, it will try and get in through the windows or down the chimney. It must be remembered that the only reason Buffet had to give up drinking was because it threatened his primary addiction to painting. Hourdin's simile of the drug addict shooting morphine comes to mind, as does his own admission that if he did not paint, he became irritable and unsettled. Besides, even though he had put down the VAT 69, he had discovered the compensatory pleasures of prescription medication, as Nicolas recalls.

At this time he started to take some medication and that was worse for me. He had to take pills to wake up, he had to take pills to get hungry, he had to take pills for sleeping, he had to take pills for everything.

It was in his nature to be too much. Everything was too much with him. So when he started to take some pills, he did too many pills, like he always did everything. He was like that. Too much, everything was too much. I think that a normal guy would already have been dead years and years before.[9]

However, Buffet was not yet ready to die. Sustained by an ever-increasing dosage of prescription medication, he was to work, flat out, for very nearly two decades after he had his final drink in the autumn of 1981.

Chapter 40

The Milestones that Mark the Road

To say that Buffet's painting never varied is patently untrue.

To suggest, as did his former lover Pierre Bergé, in his volume of pen portraits of the famous people he had known, that Buffet's dealer kept him from the artistic movements and the life of his time and that he remained a figurative painter because 'figurative art reassured him' and 'he believed as El Greco that it was enough to change perspective'¹ is slightly disingenuous.

Yes, he was a figure out of the mainstream of art; yes, figurative art reassured him. But another argument is that he is all the more interesting because he did not embrace each passing artistic trend like some tragic middle-aged man who dyes his hair and affects younger clothes in order to appear *au courant*, but succeeds only in sacrificing his identity and dignity. Figurative art reassured him because he believed in it, as passionately as he believed abstract art to be little more than an elaborate confidence trick.

Instead he chose to push figurative art as far as he could, not just in terms of the subjects he treated but in the manner in which he executed them: sometimes forensically academic, sometimes in a deliberately crude graffiti style of the sort that characterised street art that would come out of New York during the 1980s. His starker *torero* paintings and the harsh, bold and vigorous still lifes of roulette wheels, skulls and ashtrays of 1977 with which he marked his return to the bottle and his break with the academic style of his landscapes could easily hang alongside the work of Basquiat, as could an overlooked series of 1997 paintings of booted and balaclava-masked gunmen, bullets, guns, knives and knuckledusters.

Elsewhere the roads, level crossings, hotels, cafés, churches, telephone wires and so forth in his village scenes from the 1980s and 1990s are not just touristic toytown vignettes, but exercises in Mondrian-like geometric construction; little more than shapes that are vehicles for

colour and graphic effect. And he considered some of his paintings so close to abstraction that he feared showing them in his lifetime, as his son explains. 'At the beginning of the sixties there were three or four paintings which were the sea and the sky. And he didn't want to show them to the public because he didn't want people to think that it was abstract art.' They remained hidden for almost forty years and were only seen 'after he passed away'.[2]

The irony of Bergé's remark, presumably intended to be disparaging, that like El Greco, Buffet believed that a mere change of perspective was sufficient variety, is that Maurice Garnier, even when he could barely see, would ask for his staff to hand him a book of El Greco paintings, which he would leaf through, explaining as he did so that Buffet was not the only painter to use the alteration of perspective to produce a different work of art. As was the case with the accusation of Garnier being Buffet's nursemaid, it was another of the rare instances when he and Bergé were of the same mind, albeit with completely different motivations.

Moreover, Annabel was at pains to point out that there was plenty of difference between repetition and recognisability.

> I frequently read or hear that Bernard always paints the same thing, a received and absurd idea that his oeuvre formally contradicts. If however you take the trouble to look at it objectively, certainly the graphic quality remains the same even though the drawing has gained in strength won by force. This characteristic handwriting allows him, through a spontaneous recognition of his inner identity, to continue a dialogue with the public, uninterrupted over 47 years.[3]

Even so, the accusation of repetition so often levelled at Buffet is not without foundation. The work he produced in the late 1980s is amongst his most accomplished. His watercolours of Venice in 1986 show a city familiar to tourists and to those who attended his early sixties show of oil paintings of the sinking city in the lagoon. In 1988–9, Paris is painted, again, and without people it looks much the same as it did when he painted it in 1956. In 1989, his deserted New York looks a lot like it did when he was painting it in a garage in Saint-Tropez in 1958. Granted, there are differences: in the size of the works; in the change of perspective. Then there are the details. The gondoliers of 1986 are black stick figures, while in the 1962 works they are splashes

of white. He chooses different landmarks in Paris. By 1989, the New York skyline is dominated by the two towers of the World Trade Center. To the close observer there are plenty of differences between the way he paints his Breton villages at the beginning of the 1990s and the way he paints them at the beginning of the 1970s; but overall it is easy to see how he fulfilled what was expected of him by his supporters and his detractors alike.

And it is here that Buffet is to some extent the victim of his Stakhanovite output. He is not the only artist to revisit themes: after all, Monet painted water lilies more than once during the last thirty years of his life; and Degas clearly enjoyed the races, although not as much as the ballet, a subject that apparently accounts for about half of his entire oeuvre.

But the sheer quantity of work that Buffet produced emphasises any repetition. Bernard Dorival, a former director of the Museum of Modern Art and a noted critic and art historian, was brutal, saying that Buffet's only merit was that 'of having rivalled Renault for the record of French productivity and raised the painting to the dignified level of an object of mass production of an industrial level'.[4]

And inevitably, as he spent so much time in his studio painting rather than out experiencing the life of his times, as it would appear that Bergé wishes he had, some motifs reappeared. Just as Degas found that dancers sold well, or Monet, old and with failing eyesight, did not want to stray too far from his garden pond, there were certain subjects favoured by Buffet that were readily saleable: clowns and flowers come to mind.

The passage of time is experienced subjectively, but the years seem to flit by more rapidly with age: those accumulated make the diminishing number to come appear to pass ever more fleetingly. A summer that stretches into infinity for a child passes with an indecent haste for the child's grandparents. Thus the relentless, largely self-imposed deadline of the February show seemed to come round more quickly every year.

And although not the complete recluse that he had been during the mid seventies, he was nothing like as social as he had been in his twenties and thirties.

After he and Annabel moved to La Baume, his final house in Provence, in 1986, the couple mixed with society far less than had been their wont. He did not maroon himself as completely in the Var

as he had done in the forests to the west of Paris, and whereas his earlier isolation had been characterised by what could be perceived as a fear of the modern world, here he appears to have found a place that he genuinely loved and where he wanted to spend time. And while he was slightly more aware of the world in which he lived, he maintained his distance from it; for instance he refused to answer the telephone, regarding it as an uninvited intrusion.

He continued to visit Paris but again restricted himself to places with which he was familiar 'We never go out in society. There was a time when it used to amuse us,' he said, but by the beginning of the 1990s, the high point of a sojourn in Paris was a visit to the flea markets and antique shops. 'They are the ruin of me,' he admitted cheerfully. 'We don't go to the theatre unless it is a spectacle put on by Robert Hossein.' Born in the 1920s, Hossein – like Buffet – had been so savaged by the critics that he had abandoned cinema and instead devoted himself to staging popular entertainments on a large scale, finding success in 1980 with the first production of the musical Les Misérables. 'Occasionally we go out to eat at "Tong Yen". I am not familiar with others. I never go the cinema because as soon as I have sat down I want to have a pee.'[5]

Fond of middle-brow musical theatre, eating in just one restaurant, pottering around antique shops, unable to sit through a film because of his weak bladder: his world was becoming smaller with age. He had even done with moving house. 'Now that is finished. We are getting old.'[6]

Instead he just liked being at home. 'Bernard attaches extreme importance to the place where we live for the good and simple reason that he hardly ever leaves it. Work and pleasure are concentrated in this place. Only there is he truly himself,' observed Annabel. 'Extremely sensitive, Bernard seems to have found a refuge in this exceptional place where, away from a world that confronts him with violence, he can reconnect with his passion for painting, with his taste for the quiet life, especially in his search for serenity.'[7]

And the less he went out, the fewer his external stimuli.

Much of the 1980s and 1990s lacked the originality and spontaneity that created say, L'Enfer de Dante, Les Folles, Les Écorchés, the pietà of 1961, Les Oiseaux and so on. Had sobriety removed a component of his creativity? 'I should not really say so, but I find alcohol is a very good thing in the artistic and creative context. Naturally it is a

double-edged sword,' he observed after having been sober a few years. But when asked if he thought that stopping drinking had changed the way he painted, he replied, 'No, I don't think so. At first you are a little disoriented and afterwards you get back into it.'[8]

The suggestion that sober he could not paint as well is trite; however, it is undeniable that the sensation of powerful emotions and the injection of drama into his daily life that often led to his most powerful work was absent. As a newly sober man, with three decades of marriage behind him and a comfortable, tranquil Provençal old age ahead of him, it is perhaps natural not to expect displays of painterly pyrotechnics.

Another way of looking at it is that the best of his later works are sequels to, or continuations of, themes that he had tackled before. While this was not perhaps best suited to an art market that was increasingly geared towards a ready supply of novelty, it is perhaps easy to understand that if the subject had once appealed to him, it would do so again.

British artist Marc Quinn believes that Buffet suffered from an inability to stop painting and pause to rest, reflect and think. Of course for Buffet the job of a painter was to paint, and had it not been for the vital discovery of Japan by the artist, and vice versa, his painting during his later years would have become even more repetitive.

However, there are times when Buffet might have heeded Quinn's warning. During the 1980s and early 1990s, there was a period when he seemed to have painted whatever crossed his desk. The most flagrant example of this was the series of car paintings. The indefatigable Buffet supporter may view them as Pop Art; alternatively they may just be bad paintings. If the latter, then the inspiration was nothing if not banal. 'It is very simple,' he said. 'The idea for this exhibition came to me following a commission from Renault's management. They wanted an aquarelle for the launch of the R25. I got hooked. I continued. Actually the mechanics do not interest me. It is the bodywork that I find inspiring.'[9] If these paintings are of value, it is for their biographical interest, for Buffet retained fond memories of the 4CV, a cheap car that filled the roads of France during the late 1940s and 1950s. And Garnier recalls this exhibition as being the only time that he remembered Pierre Bergé crossing the threshold of the gallery on the Avenue Matignon, because among the vehicles hanging

on the wall was the Rolls-Royce that Buffet had painted when the two men were living together.

The Seven Deadly Sins, painted in 1994, was another forgettable series of works, produced largely, one suspects, so that he could hang seven large-format works on the walls of the gallery, and because with the self-imposed February deadline approaching he needed to have some work ready. The bitter, frightened energy with which a younger Buffet might have attacked the subject was no longer there.

Even Annabel, who by now wrote almost all of his catalogues, had difficulty keeping a sense of weary predictability out of her prefatory texts. Introducing *The Seven Deadly Sins*, she wrote:

> The years pass and February returns inexorably. For Bernard Buffet, this month is like the milestones that mark the road he is taking. No one forces him to challenge himself on a fixed date and if he issues himself a challenge that is hard to overcome it is, I think, so that he does not get caught up in the trap of facility. Indeed, success can send creativity to sleep.[10]

In 1998, Buffet painted La Baume, their home in Provence, clearly a house he loved, as he had already painted a series of works depicting it for an exhibition in New York a decade earlier. However, Annabel's cycle of repetition was if anything even shorter.

> The years follow each other inexorably, the rhythm of their flight set by the *vernissage* for the first Thursday of February. For forty years already I have been at the birth of these canvases, fascinated by the energy which gives life to such creation and impressed by the desire that Bernard shows to challenge himself. He could just as well rest on his laurels . . . The word 'rest', in relation to him, makes me smile so much as it suits him so badly!

Just three years separate this from the more or less identical introduction to *The Seven Deadly Sins*. 'In my humble opinion, the word "End" will only appear at the bottom of Bernard's work when he has passed through the mirror that separates us from the unknown.'[11]

Maybe Annabel felt confident that there would be a good few more years, marked of course by the annual milestone of the first Thursday in February, and that Bernard would continue to test himself for some

years to come before walking through that metaphorical mirror. As she put down her pen in October 1997 after composing this introduction, the biggest problem facing her must have been how to say the same thing in different words for next year's catalogue, and the year after that and the year after that . . .

As it happens, she need not have worried. Within two years her husband would be dead.

Chapter 41

'The last big artist in Paris'

If not as impactful as those early crucifixions and the startlingly original canvases that he showed he was capable of producing up until the disturbing self-portraits of the 1980s, the works of Buffet's later life have a strong biographical interest and the themes that interest him are not hard to identify. His series of kabuki and sumo paintings of 1987 deserve to be seen in canvas; the colours and the scale of the works are simply not captured in reproductions. They were painted after his fourth visit to Japan; Annabel recalls how, having got home, slept for a few hours and snatched a quick breakfast, he had begun painting, seeming not to be affected by jet lag or tiredness.

Literature had always been a fecund ground for inspiration, and at the end of the 1980s, he turned to painting misunderstood mavericks who set themselves apart from the rest of humanity. The parallels with his own view of himself are not hard to detect. His 1989 show was devoted to Don Quixote, followed a year later by another literary loner, Captain Nemo in *Twenty Thousand Leagues Under the Sea*.

In both these series, the sense of the narrative conveyed in the manner of a comic strip recalls something of his Joan of Arc, but is here delivered in a more light-hearted way. As has been seen, Buffet was as omnivorous in his literary tastes as he was voracious: his interests were encyclopedic rather than eclectic and ranged from Dante to comic books as the mood took him. Moreover, it is likely that in his infatuation with Japanese culture, he absorbed something of the popularity of Manga, which was becoming an increasingly important aspect of the Japanese publishing industry during the 1980s, and would in time become accepted as a mainstream art form.

Whereas the Joan of Arc paintings had something of the sculptural, posed quality of a *tableau vivant* that recalled in its formality the history painting of the nineteenth century, these later works have a more animated – in all senses – quality about them. Quixote's skeletal mount

rears in front of the windmill, and the intrepid submariners in prim-
itive diving suits fight with a shark and plunge a dagger into its belly;
both of these scenes could easily be frames frozen from an animated
film or panels in a cartoon instead of canvases five metres long and
two and a half high.

These pictures once again demonstrate Buffet's incredible range.
His work varied enormously, and not just in theme: viewing the
academic landscapes of the mid seventies alongside the 'Manga' inter-
pretations of literary classics, it is hard to believe that they were painted
by the same artist. Signature aside, the only thing uniting these works
is the fact that looking at them, even a child could say what was being
depicted. Figurative art will always contain an element of familiarity;
after all, it is the familiarity of recognition of a form that tricks the
eye into believing it has seen the image before, which it has (in that
it recognises the object being portrayed), and which it hasn't (the artist
has arranged the composition and depicted the events in a distinctive
style). Instead of accusing Buffet of never varying, his detractors would
be more accurate if they castigated him for remaining faithful to
figurative painting; something of which he was proud.

It is hard not to see these two series as extended self-portraits. The
final canvas that depicts Cervantes' unfortunate knight locked in a
cage being tormented is almost the articulation in painting of the
proclamation Buffet first made in the sixties: 'I have the faith of
madmen and I am proud of it.'[1] After years of sustained critical attack,
the persona of the lone paladin of painting, misunderstood by the
world, had become deeply ingrained. 'We all have a part of Don
Quixote inside us,' he said. 'We all have our windmills. Me as well.'[2]
When it came to discussing his choice of Verne's aquatic adventure
story, he was even more blunt. 'I would like to live at the bottom of
the sea like Captain Nemo.'[3]

Entering his sixties, he accepted the fact that he was scorned by
the intellectual establishment. Thirty years earlier, he had tried to
change the minds of a dismissive intelligentsia: leaping through hoops
of his own devising, presenting a creative high-wire act and carrying
off feats of artistic acrobatics that rivalled anything done by the
performers in his circus pictures.

Now, in the late 1980s and early 1990s, he tried to wear his decades
of ostracism with defiant pride. The final years of his life saw him
become increasingly outspoken about his critical rejection, though in

the course of conveying his doubtless authentically held belief that he had always been an outsider loathed by the intelligentsia, the museums and so forth, he was apt to forget that at one time he had been lauded by critics, had been chosen to represent his country at art's Olympic Games, the Venice Biennale, and had received state commissions in the form of postage stamps. Thus the early 1990s saw him broadcasting his frustration with what he saw as the ostracism of the French cultural establishment and protesting rather too much that he would far rather be appreciated by a broad public than admired by a small coterie of intellectuals.

> The state once bought a picture of mine. That was in 1950! But I don't care. All the museums in France are closed to me. The intelligentsia does not appreciate me. The public really likes me.[4]

> The museums in France have never bought one of my pictures. The state has never commissioned me, be that as it may, but I don't give a damn about their racism. The abstract crap that they buy is with money from taxpayers, and that is disgusting.[5]

> I have my public, and I am not expecting anything from the Ministry of Culture.[6]

> It is of no importance that the state despises me.[7]

> French people like me and I am really pleased that they like me . . . already at the beginning 'officials' did not like me. They despised me. Their successors did the same thing. But to be ignored by a couple of cretins is all the same to me.[8]

But beneath the bravado, which he kept up even at home, affecting not to be worried by critical opinion, the absence of any meaningful recognition in the form of a retrospective in a major museum, a significant acquisition by the state, or a public commission hurt him deeply. Annabel was certainly not taken in by his dissembling. 'You told a huge lie when you pretended that the official "non-recognition" of your oeuvre was water off a duck's back, when it struck you in your heart.'[9] She was convinced that there was a high-level conspiracy against her husband. 'How you suffered from this ostracism that was bordering on

criminal. You pretended to be indifferent to this malice. You lied. Nobody likes to be punished, pushed aside, nothing can justify this contempt from a minority, powerful for sure, but a minority all the same!'[10]

And there was no doubt in Buffet's mind as to who was to blame for the artistic climate that he found so inhospitable. 'When Malraux went to a private view he did not even glance at the works. Only at the people who were there.'[11]

'It is Malraux who brought disaster into the world of painting. He is a great writer, but when it comes to painting, he only talked bullshit.' It was over twenty years since Malraux had stepped down as Minister of Culture, and thirteen years since his death, yet at the end of the 1980s, Buffet's animosity was still as fierce as ever. 'Did you ever see Malraux at an exhibition? Those who saw him would tell you the same thing as me: he spoke of painting without looking at the pictures! It's extraordinary. It is not serious of course, but it is annoying.'[12]

Of course for Buffet it *was* serious. He always remained robustly anti-intellectual, maintaining that when it came to painting, 'one does not talk about it, one does not analyse it, one feels it'.[13]

Nevertheless, it would be incorrect to say that the closing years of his life were just a cycle of artistic repetition and bitter rants. For those who followed him – and his following remained sufficiently significant for Le Figaro magazine to write in 1986, 'with the general public his name is as well known as Picasso's'[14] – the annual spectacle of his February show was an event to look forward to.

Moreover, during this period, Garnier was busy securing Buffet's reputation. The gallerist was happy to admit that he acted as everything from banker to nursemaid, but as has been seen, he did not seek to guide Buffet in the direction of fashion, allowing him instead to follow his own course, even if it took him out of the artistic current of the time. In the course of an association lasting over half a century, Garnier only ever suggested one theme to the artist,[15] and that was the penultimate exhibition, the last that Buffet would live to see, Mes Singes (My Monkeys). Perhaps had he been less diffident and reticent about suggesting topics for his artist to tackle, the later work would not have laid Buffet open to such criticism of repetition. However, while he may have been shy of daring to suggest the artistic direction that the master might wish to pursue, Garnier was utterly fearless when it came to promoting his work, and confident in his ambitions for the painter's reputation.

In 1985, Garnier published, at his own expense, two lavish books of reproductions together with accompanying texts by Yann Le Pichon. Housed in a stout, handsome slipcase, the quality of printing, paper and binding is impeccable. In 2007, they would be joined by a third companion volume.

Le Pichon eschews a biographical approach in favour of an ornamental style of writing that transcends what is usually understood by art criticism and instead takes the reader on various high-flown excursions aboard a magic carpet of quasi-poetic belles-lettres larded with learned allusions galore, including pretty much every deity and legend of antiquity. It is a rare paragraph that does not invoke the name of a great poet, novelist, artist or philosopher; often they are strung together in consecutive sentences, decorating the prose in the way that the strings of black pearls adorned Annabel. A typical paragraph may begin with a sentence quoting Shakespeare, which is succeeded by one that refers to Proust, with Hemingway casting his macho shadow over the third sentence, and so on.

But if this was not a standard biography, nor was it a *catalogue raisonné*: that would be a publishing task of Herculean dimensions. The estimated lifetime total of 8,000 canvases is the figure that is most widely accepted. Speaking in the early 1990s, Buffet said that since 1946, he had completed 'a painting more or less every other day', and by that he meant oils. 'Of course that is without counting the drawings, watercolours, lithos and illustrations of books.'[16] Had he thought about it, he might also have added film posters, magazine covers, crockery, nightclub decors, postage stamps, ballet set designs . . . No, the purpose of these books was more to buttress the artist's reputation and, so it was hoped, force a change of thinking on the part of this shadowy cabal of critics and museum directors who, so Garnier believed, were denying Buffet his deserved place in the national cultural pantheon.

Garnier was frustrated by what he saw as the irresponsibility of critics in simply not bothering to look at the work, and this frustration would remain with him until he died. 'They did not come to see exhibitions. Every year, for almost fifty years, we put on an exhibition, but they never came to see exhibitions. So they do not know. If people don't come to see exhibitions, they do not know.'[17]

If the critics no longer came to the annual exhibitions, then Garnier was going to send the exhibitions to them, and more besides: almost

1,200 pages in two beautifully bound volumes, plus slipcase, weighing in at a respectable eight and a half kilos.

'People who think that Bernard Buffet doesn't change are people who don't see his painting. There are always people who will voice their prejudices in ignorance', and predictably there were those who demonstrated as little interest in the books as they did in the exhibitions. 'For instance when we published a book about Bernard Buffet our press attaché sent it to all the art critics, including the art editor of *Le Monde*, who said that she didn't have five minutes to waste looking at the book,'[18] recalled Garnier some years after publication.

However, there were some who were not quite so pressed for time, among them Otto Hahn, one-time art critic of *L'Express*, a magazine he had joined in 1963. Hahn was typical of the critics who had found their voice in the 1960s and for whom Buffet had seemed irretrievably passé. 'For twenty years I wasn't really aware of Bernard Buffet, I didn't go to see his annual exhibitions,' he admitted. 'Because one is influenced by the context, because he exhibits on the Avenue Matignon, not in Saint-Germain-des-Prés or Beaubourg, and Avenue Matignon is associated with the world of money.'

It was not just the ritzy location of the gallery that had kept him away. 'There's a moral pressure, moral terrorism, and sometimes that is what interests me,' he said, adding conspiratorially, 'For example you are not allowed to like both abstract and figurative paintings. The art world exerts a moral pressure that amounts to saying, "So you write about absolutely anything. You defended me, but if you write about any old thing, don't bother writing about me." It's intellectual terrorism. It never goes very far, but it exists. It's a small world.'[19] Quite whether a received opinion or, to put it more forcefully, widely held prejudice amounts to intellectual and moral terrorism is debatable; nevertheless, Hahn's remarks do illuminate the body of opinion and the anti-Buffet sentiment that prevailed in the French art world during the late 1980s.

With the books, as with all things to which he set his mind, Garnier was thorough and exacting. They may have been self-published, but in terms of overall quality they eclipsed the output of many established art book publishers, winning the 1986 Élie Faure Prize, an award named in honour of an art historian to recognise the outstanding art book of the year. The success of the book earned Le Pichon and his classical learning an appearance on *Apostrophes*, a prime-time book

programme hosted by an avuncular donnish figure called Bernard Pivot, whose accessible erudition, floppy hair and half-moon spectacles that had a habit of sliding down the bridge of his nose endeared him to his five or six million regular viewers. Attracting such literary heavyweights as Nabokov, Solzhenitsyn, Kundera and Eco, judiciously seasoned with celebrity intellectuals like Claude Lévi-Strauss, world leaders including Mitterand and the Dalai Lama, and auteurs of the calibre of Truffaut, Godard and Polanski, the show can be seen as a televised version of the lunches at Louveciennes.

At around this time it is possible to detect a subtle change in the way that Buffet is treated in the media. He is not so much seen in the adversarial context of the abstract versus figurative debate – painting in general was making way for new forms of art – but is instead presented as a paradox. 'Why,' asked *Connaissance des Arts*, the magazine that had announced him as the leading post-war artist over thirty years before, 'is an artist as well known to the public abandoned by the critics?'[20] His reputation was beginning to become as much of a subject of interest as his work.

Among those who pondered the puzzle presented by Buffet was Andy Warhol. In the middle of the 1980s, the American artist was interviewed by rising art historian and academic Benjamin Buchloh. Today Buchloh is a professor at Harvard. When it comes to intellectualising art theory, he takes no prisoners. He is certainly not a man who can be accused of easy populism; instead he takes his place in the vanguard of critical theory: take for instance his snappily entitled essay of 1985 'From Gadget Video to Agit Video: Some Notes on Four Recent Video Works'. Equally seductive is his 1981 treatise 'Figures of Authority, Ciphers of Regression: Notes on the Return of Representation in European Painting'. If Yann Le Pichon reads like a nineteenth-century scholar who has imbibed the entire canon of classical learning, then Buchloh's work bristles with modern intellectual jargon, giving the impression of a man steeped in the orthodoxy of the avant-garde. In sentences of Proustian length he develops his themes with the sort of rhetoric that would not look out of place in a comedy of campus manners. Here he is on the return of representation.

> If the perceptual conventions of mimetic representation – the visual and spatial ordering systems that had defined pictorial production since the Renaissance and had in turn been systematically broken down since

the middle of the nineteenth century – were reestablished, if the cred-
ibility of iconic referentiality was reaffirmed, and if the hierarchy of
figure-ground relationships on the picture plane was again presented
as an 'ontological' condition, what other ordering systems outside of
aesthetic discourse had to have already been put in place in order to
imbue the new visual configurations with historical authenticity?[21]

As a rhetorical question, it is crying out more for the use of the subjunc-
tive than for an answer. Given his views on intellectualising painting,
it is a pity that Buffet and Buchloh never sat down with each other.

However, in 1985 Buchloh sat down with Andy Warhol, and
towards the end of their interview Warhol shares his enthusiasm
for the emerging street artists of the time. 'I'm just really excited
about all the kids coming up, like Keith Haring and Jean-Michel
[Basquiat] and Kenny Scharf. The Italians and Germans are pretty
good but the French aren't as good,' observes the Factory boss, and
then corrects himself. 'But the French do really have one good
painter, I mean, my favorite artist would be the last big artist in
Paris. What's his name?'

Buchloh: A painter?
Warhol: Yes, the last famous painter. Buffet.
Buchloh: Many of the new painters seem to imitate him anyway.
Warhol: Yes, the last famous painter. Buffet . . . I don't see any differ-
ence between that and Giacometti. Somewhere along the line, people
decided that it was commercial or whatever it was. But he's still painting,
and I still see the things; the prices are still $20,000 to $30,000. He could
still be there. His work is good; his technique is really good; he's as
good as the other French guy who just died a couple of days ago,
Dubuffet. What do you think has happened? Do you think it is not
that good?[22]

It seems that at that point Buchloh realises that Warhol actually does
mean Bernard Buffet rather than Dubuffet. He says that he certainly
does not believe that Buffet is any good, and with that he terminates
the interview.

In his preface to a volume of interviews with Warhol in which this
encounter is reproduced, its editor, distinguished poet and academic
Kenneth Goldsmith, explains that it was coming across the interview

in a second-hand bookshop that gave him the idea to bring out an anthology of Warhol's meetings with the media. His analysis of the Buchloh piece is highly percipient.

> It seemed that the more pointed Buchloh's questions became, the more elusive Andy's answers were. Buchloh would hit harder and Warhol would get slipperier, repeating things he'd said many times before as if Buchloh's questions were irrelevant. In the end, I realised that by saying so little, Warhol was inverting the traditional form of the interview; I ended up knowing much more about Buchloh than I did about Warhol.[33]

In short, Warhol was mocking Buchloh, and by mentioning a painter so anathematic to the avant-garde, he was showing his contempt for Buchloh's tenets. It is also vintage Warhol, a throwaway remark that has nevertheless become one of the central pieces of evidence adduced in Buffet's defence, ranking alongside the anecdote about how Picasso became upset when his children asked for Buffet's autograph. It is indeed powerful stuff, Buffet named the last big artist in Paris by the king of the New York art scene, which by the 1980s had obliterated Paris as the capital city of contemporary art. It seems almost churlish to suggest that, had the homonymous Dubuffet not died on 12 May (the interview took place on the 28th), Warhol might not have been reminded, via association, of the similar-sounding and still living Bernard Buffet.

However, it appears that Buchloh was not the only art historian to whom he vouchsafed his opinion of Buffet, as Henry Périer attests. A critic and curator who would become a tireless champion of Buffet during the twenty-first century, Périer was a young man at the beginning of the 1980s, taking full advantage of the nocturnal amusements of the city that, in those days at least, never slept.

His memories of one night in particular have stayed with him for thirty-five years. It was, he says, 'a scene that would be worthy of a movie'. Just as the painters in Paris a century earlier had gone to the Moulin de la Galette and the Lapin Agile, so in New York artists carried on the tradition of creative carousing in places such as Danceteria and Xenon, and it was to the latter, one night in 1982, that Périer and an artist friend called Alain Soucasse were invited for a party.

Later in the evening, the club started to empty and the air became more pleasant to breathe. Alain, at that time a young artist with a pop style, was on the dance floor with a dream girl dressed like a cowboy, with pistols on her hips.

In a theatrical manner, the girl pulled out her gun and gave the impression of shooting at her cavalier, who went along with the game, pulled back, stumbled over and fell on a group of people sitting at a table. A man grabbed him by the shoulders and helped him to get back on his feet. 'Nice to meet you.' It's none other than Andy Warhol in person!

They joined Warhol's party. 'The American star talked little and had an ability to withdraw into a state of inner peace by lowering a curtain of silence', a characteristic shared with Bernard Buffet. 'But this mattered little to me; with the privilege that youth gives you, I started talking with him and asked him who his favourite French artist was. He mumbled: "Bernard Buffet." Words which to me are worth gold . . .'[24]

Warhol would of course say the same to Buchloh, but its mention to Périer three years earlier without any associative prompting from the death of Dubuffet indicates that this was an authentic personal opinion formed out of a genuine appreciation for the work of the then unfashionable French artist. 'I am absolutely convinced,' says Périer, 'that Buchloh and I are not the only ones to have heard this judgement about the French artistic scene.'[25]

As the end of the 1980s neared, Buffet supporters had reason to feel optimistic that if not actually turning, then at least the tide of opinion against the painter was weakening. In 1987, Yann Le Pichon was able to write in a lengthy article that 'Without doubt the time has now come to evaluate his work with a detailed eye that would, finally, result in a major restrospective of his oeuvre at the Grand Palais. This is the wish that I have in my heart, to answer so much jealousy and frivolity. I am ready to bet that it will be packed: his creativity is timeless.'[26]

Alas, the glimmer of the rosy fingers of dawn, to use an Homeric turn of phrase that might please Le Pichon, proved to be false, a cruel mirage that was exposed the following summer.

On 30 June 1988, an important exhibition opened at the Centre Georges Pompidou. Called simply *Années 50*, it claimed to offer a new

approach and a major assessment of the art of the fifties. The exhibition began with a black-and-white room featuring works by 'those figures of post-war reference' Matisse and Picasso, followed by a room of Hartung, de Kooning, Kline and Mathieu that would expand upon a 'new mode of abstraction which, under the names of lyrical abstraction, *tachisme* or informal art, will be one of the most spectacular aspects of the post-war period'.[27] Next, some American artists (Rothko, Morris Louis, Sam Francis) focused emphasis on colour, highlighting both the physical quality and its power to transmute it into light.

Opposing this approach painters such as Bram Van Velde, Estève, Poliakoff, and painters of the École de Paris (Bazaine, Manessier, Vieira da Silva, etc.) use structures from post-cubism and colours marked by the influence of Matisse and Bonnard. This exhibition is an opportunity for a re-evaluation of their contribution.

A set of the last works of Matisse and Léger faced with a Calder mobile will show how the question of the colored form in space then arises, a problem that will also be addressed by the abstract-geometric painters (Magnelli, Herbin, Sonia Delaunay, Ellsworth Kelly, Vasarely, Morellet, etc.) who, in the face of informal art, represent the other great movement of abstraction in the 1950s. It is these which will gradually introduce the idea of the movement [*sic*], first in film (with Pillet, Robert Breer, or Raymond Hains), and then with works marking the beginning of the kinetic painting (Pol Bury, Soto, Agam, Tinguely, etc.).[28]

The list of artists and movements goes on and on and on: Fautrier, Lam, Matta, Hélion, Morandi, Giacometti, Fernandez, César, Germaine Richier, Dubuffet (of course), Bacon, de Kooning, Alberto Burri, Rauschenberg, Nevelson, Tàpies, Jorn, Alechinsky, Michaux, Jackson Pollock, Saura, Vedova, Martin Barré, Twombly . . . leading 'to the idea of monochrome work (Fontana, Yves Klein, Manzoni, etc.) to which the last room of the exhibition will be devoted'.[29]

It seems that the Pompidou had gone out of its way to omit one artist from this otherwise wide-ranging roll call of leading figures of post-war art. It is incredible that Bernard Buffet was not represented in this show. *De gustibus non est disputandum* aside, even the most cursory survey of the art scene of the 1950s shows his significance: a room at the Venice Biennale, a major restrospective before his

thirtieth birthday, works in leading European and American collections inter alia.

His critical reputation might have suffered subsequently, but even his most vehement critics could not deny that Buffet had without doubt been a towering figure in the artistic life of the period that this show pretended to survey. To omit him altogether (while including his Biennale colleague Giacometti and the one-trick bottle-painter Morandi) is a compelling piece of evidence for a conspiracy, pogrom or campaign of intellectual terrorism . . . Viewed in the context of this blatant and painfully public snub, Buffet's vitriol and asperity on the subject of the museum that bore the name of his old friend can perhaps be better understood.

Chapter 42

Back in the USSR

The exclusion from a major exhibition treating the era he bestrode like a colossus in a Canadienne seemed to mark the closing of a period in Buffet's life. The sexagenarian *enfant terrible* of a time long past, he was not even history; he had been written out of art history. France had turned its back on him.

By 1990, the once booming Japanese economy had begun a precipitous fall, and with it went his major export market. This was compounded by Saddam Hussein's invasion of Kuwait, a territorial grab that would set in train events that would destabilise the world for a generation to come. But long-term geopolitical problems aside, the immediate effects on the art market were dramatic.

> No one was buying any more. Famine had succeeded feast almost overnight. The loss of confidence spread to all areas of the art market. As an art dealer, I noticed the change immediately after the summer holidays. No matter how many telephone calls you made, how many pictures you offered to your clients at suicidally reduced prices, there was simply no business to be done any more.[1]

Hopes that the Japanese market might recover were soon dispelled. 'Gradually revelations emerged about the corruption that underlay the recent Japanese enthusiasm,' and it became evident that

> A lot of the buying had been motivated not by love of the art but by the need for a vehicle in which to move money around, often illicitly. For instance, in an effort to cool an over-heating property market the Japanese authorities had capped the price of real estate. You got round that as a purchaser by throwing a bunch of Monets into the deal, selling them to the vendor for 10 million and then buying them back a month later for 20 million. The technical term here was *zaiteku*,

which translates euphemistically as 'financial engineering'. French Impressionist pictures, in what was already a dramatically rising market, were perfect for the purpose, because they had no fixed and provable value. They were worth what you wanted them to be worth.

The buying of trophy art, once a source of national pride, had become synonymous with crime. 'Once what had been going on became clear, the Japanese authorities cracked down heavily on anyone who had been buying art, which meant that the innocent as well as the guilty fell under suspicion.'[2] Even the famous art-loving paper magnate Ryoei Saito was convicted of tax offences in 1995, the same year in which Buffet's loyal collector and friend Kiichiro Okano died, a blow from which Nicolas Buffet says his father never really recovered.

Mr Okano took a very, very important place in my father's heart and mind and I remember that when Mr Okano died, it was horrible for my father, because from this time he started to think that he made a very big mistake when he decided not to go to Japan for the opening of the museum. I'm pretty sure that Mr Okano completely pardoned him. It wasn't a problem. He understood that. But for my father it wasn't good, he did not do the right thing at the right time. And once Mr Okano passed away he lived the rest of his life with that black shadow in his mind. And it stayed, like a big dark cloud over him, until the end.[3]

France's museums were closed to him, he was no longer represented by the prestigious international galleries that had once courted him, and his major growth market had disappeared almost overnight. The 1990s should have begun bleakly for Buffet, but the indefatigable Garnier was not about to let a few little things like war in the Middle East, global economic uncertainty and the evaporation of a once dynamic market unsettle him. The late 1980s and early 1990s had not just brought bad news; they had also presented opportunities.

On the evening of 9 November 1989, remarkable scenes appeared on television screens around the world as thousands of East Germans swarmed through the checkpoints along the Berlin Wall and with primitive tools, or just their bare hands, began spontaneously to demolish the most concrete symbol, figuratively and physically, of the Cold War. Thereafter the pace of events quickened. It took barely

eighteen months for the once mighty Soviet Union to fragment into a patchwork of unfamiliar states. In the summer of 1991, Leningrad voted to rename itself St Petersburg, but more people were worried about how to feed themselves. Rationing, last seen during the dark days of the 1940s, was reintroduced. Appeals were made for humanitarian aid. The nation was humbled. Hard currency was desperately needed. There were deals to be done.

'It was my husband who paid for it,'[4] says Ida Garnier of one of the most remarkable episodes of Bernard Buffet's long and varied career. 'I have nothing to do with the exhibition in Moscow,' said Buffet in late 1990, after it was announced that during the spring of 1991 the Pushkin in Moscow, followed by the Hermitage in what was still Leningrad, would mount major exhibitions of his work.

> The Russians and Maurice Garnier have everything arranged. Me, I do nothing other than paint. It's like my museum in Japan: it's flattering, it's true, even more so because it is not my country that did it. But I had nothing to do with it! As for the prices that my paintings currently fetch in sales, it is perhaps a kind of recognition, but it is also the current market conditions. Art, fortunately, has escaped those who have made it their mission to talk about it. In France, I am hated in intellectual circles because I believe that I do painting that speaks to people. Those who are in charge of painting in France try to make the weather in the field of taste, and create fashions. This is stupid! You simply cannot prevent people from having emotions. You can say what you want: if they like something, they like it. That demonstrates the utter pointlessness of critics, who are absolutely useless . . .[5]

Maybe Buffet genuinely believed that the exhibitions in Moscow and Leningrad were spontaneous demonstrations of the Russian people's love of his work. Certainly money alone is not enough to buy wall space in a museum like the Hermitage. The truth, however, was rather more nuanced, and in a circuitous way, it linked him to his former lover Pierre Bergé.

By the 1980s, Bergé had risen further than he could ever have imagined when he was a young man earning a living as a buyer and seller of second-hand books, and then as the lover of an internationally famous artist. As Buffet had discovered to his cost, the world had changed during the thirty years since they had split; the difference

was that Bergé had changed with it. The need to work for a living and to manage his mercurial, unstable, fashion designer boyfriend and business partner Yves Saint Laurent had been the making of him. His talent for making influential friends and his emergence as a successful businessman had made him one of the most powerful men in France. As such, he attracted the attentions of ambitious younger men, much in the way that he himself had been drawn to older powerful and famous figures in his youth.

One of the members of the court with which he found himself surrounded in the 1980s was Hugues-Alexandre Tartaut. Efforts to contact him have proved frustrating. Internet searches reveal a man with diverse interests: as well as founding the 'Association pour la Sauvegarde et le Rayonnement de l'Oeuvre de Bernard Buffet', he is listed as co-author of a book on Russian ballet from 1738–1840, and is most picturesquely described, inter alia, as 'founder & chairman of the Buddhist children orphans' foundation, the Himalayas, India'.

However, by the second half of the 1980s, he was riding high as Yves Saint Laurent's 'adviser for foreign relations',[6] and in December 1986 he hit the news as the organiser of an exhibition of YSL clothing 'at the exposition hall of Dom Khudozhnikov, the home of the Soviet Artists' Union'. When the exhibition closed in January 1987, it moved to the Hermitage in Leningrad, where it would run until mid March. He was even quoted as a spokesman on the future direction the company might take, with one report observing that 'Tartaut discounted the possibility of opening a Saint Laurent business venture in the Soviet Union soon, although he did not rule out future developments. "It is entirely up to the Soviet side," he said.'[7]

The acceptance of fashion as appropriate for exhibition in major cultural institutions was still a relatively recent phenomenon; Cecil Beaton's landmark show *Fashion: An Anthology* had been staged at the V&A only fifteen years earlier, in 1971, a couple of years before Diana Vreeland had joined the Met in New York as a consultant to the Costume Institute. And indeed Vreeland was involved with bringing the YSL show to the Met, after which it was shipped off to Beijing.

Tartaut had experience in the Far East; according to Nicolas Buffet, he helped Pierre Cardin take the Maxim's brand to the Orient. In 1981,

the fashion designer had purchased the Paris restaurant where Buffet had been such a frequent diner in his beau monde years, and part of the international brand expansion included the opening of a branch in Beijing complete with a boulangerie in 1984.[8] Having worked for two of the biggest names in French fashion, he now set about applying his knowledge and contacts in Russia and Asia to the oeuvre of Bernard Buffet.

According to Nicolas Buffet, Tartaut was introduced to his parents by a friend, who said, '"You have to meet this guy." And he was really charming, very pleasant, very cultivated . . . very, very charming. And there is something which is quite funny – at this time he looked physically really, really close to Saint Laurent.'[9] Tartaut was in his mid to late thirties, but according to Nicolas Buffet he looked much younger. The sudden appearance of this charming man who resembled the timid young fashion designer Buffet had drawn at the beginning of the eventful year of 1958, and for whom his lover had left him, must have awoken some long-dormant memories and complicated emotions for the old man. But in addition to his professional skill, Tartaut knew how to make himself agreeable, and soon he had become indispensable to the ageing couple.

He essentially provided a photocopy of the YSL roadshow for Buffet, beginning in Moscow with the opening on 15 January 1991 of a retrospective at the Pushkin, to which, as a gesture of goodwill, Maurice Garnier donated a Buffet painting of Notre-Dame de Paris. The trip also enabled Buffet to relive his memories of his jet-set trip with Jacqueline de Ribes and le Tout-Paris, only this time the picture was of an older couple, their faces lined by time and the extreme cold of the Russian winter.

It was, however, the visit to Leningrad that left the more enduring impression on Buffet, although it was not without its last-minute dramas. 'There wasn't enough empty wall space to hang all the works, and the Russian curators were adamant about not taking down their Matisses and Gauguins,' observed Tartaut. 'They agreed only after we threatened to cancel.'[10]

Yet in spite of the overcautious Soviet curators, the show proved to be a remarkable popular success. It would appear that it had come at just the right time for a country that was on the threshold of immense change. Traffic through the turnstiles was excellent, and while the number of visitors is hard to pin down – one estimate putting it at half a million,[11] another at 300,000 – it was an immense PR coup too. Tartaut had learned a thing or two about promotion

from Pierre Cardin and Bergé. A camera crew from the French state television channel Antenne 2 joined the caravanserai in Leningrad and was on hand to record the artist wandering around the vast halls of the former winter palace of the tsars. Old, stout and bearded, Buffet walks as if in a trance. It is almost as though he cannot believe that he, the boy from Les Batignolles, has caused the Matisses and Gauguins to be removed from the walls of one of the world's most famous museums so that his pictures can be shown.

It is possible to see the gratification and pride illuminating his features from within as he smiles in recognition of the works on display and his achievement both in bringing so many paintings into being and then seeing them exhibited in such beautiful and prestigious surroundings.

Annabel studied her husband's reactions intently.

The day following the festivities and speeches that marked the opening of the retrospective of his work, Bernard asked to return to the Hermitage before it opened its doors to the public. Remaining on the threshold of the gigantic hall that was devoted to his work, I watched the man as he walked around alone as he always wished. This tête-à-tête with forty-five years of daily painting continued in tranquillity and silence . . . Then Bernard returned to me, looking serious, and concerned by the stern expression stirred by his incurable perfectionism, I asked him if everything was all right. I saw his face light up with a smile. He answered with three innocuous words: 'I am pleased.' Pleased, finally![12]

Her husband's contentment notwithstanding, Annabel still believed that the spectre of French cultural exclusion haunted even the echoing halls of the Hermitage, as she later wrote. 'When the Hermitage museum in St Petersburg, at the time still Leningrad, decided to hold a retrospective of your work, some members of the French ministry of culture intervened in order to get this project cancelled. The Russians did not let themselves be influenced by their opinion, tinged as it was with blackmail concerning a future collaboration.'[13]

The trip had made a deep impression upon him, and it wasn't just the gratification of a successful show at the Hermitage. 'I rediscovered the beauty of this city with its palaces that had been rebuilt around St Petersburg after having been destroyed by the Germans during the

Second World War. Only the furniture was saved. The Russians have completely restored them. It is fabulous. It is magical.'[14] He was so much taken with the palaces that he made them the subject of an exhibition, returning to the city two years later to show them at the Hermitage during the White Nights of June 1993.

Throughout the first half of the 1990s, Tartaut's fingerprints are to be found all over Buffet's career. A master promoter, he applied the lessons he had learned from the fashion and licensing business, and if he failed to find good opportunities for the artist at home – 'Should Buffet be burned?' was a headline in Le Figaro that seemed to summarise his standing in the French art world – then he would simply promote him in the emerging markets of Asia.

The Japanese market still had some life in it. Okano was planning a third wing of his museum devoted to Buffet's works on paper, and the Buffet Museum would serve as a useful beachhead in Tartaut's oriental assault. Thus in April 1995, after attending a retrospective at the Odakyu Museum in Tokyo, and a selling exhibition at the Printemps department store in Ginza, he took the Buffets to Shanghai and then on to Beijing, where they stayed in a state residence. The following year they were back in Japan for the opening of the new wing of the museum, after which Tartaut took them to Taiwan for the inauguration of a retrospective there.

But in addition to the shows around the Far East, including one at the Hyundai Museum in Seoul, there were many more exhibitions closer to home, in numerous small provincial museums in France as well as in, among other places, Beirut, Paiania (a suburb of Athens), Tiblisi, Yerevan and Innsbruck. These may not have been places immediately known for their contemporary art scene, but there was one exception: Kassel.

It may be cynical to say so, but in the choice of this town buried in the heart of Germany, halfway between Düsseldorf and Leipzig, there is the suggestion of what in the world of brands, with which Tartaut was familiar, is known as product placement. Every five years, Kassel stages documenta, a recurring art event that rivals the Biennale of Venice for its importance to the world of contemporary art. While Buffet was not invited to show at the actual event, the then recently inaugurated documenta-Halle was the venue for a 1994 retrospective. The documenta-Halle is a huge space, big enough to show Buffet's largest works, which according to the exhibition's organiser, Otto Letz,

was crucial. 'People who were not familiar with Bernard Buffet's complete oeuvre were very much against it. They didn't want to taint their reputations with Bernard Buffet. But showing his complete oeuvre made the critics change their minds. If we look at the press reaction in Germany, there are favourable reviews, and hostile reactions. The criticism is balanced I think.'[15]

At that time, Professor Dr Tilman Osterwold, a distinguished art historian and author specialising in Pop Art, was working at Kassel's Fridericianum Museum, and was approached to write the catalogue for the exhibition. He was intrigued by the project. 'The reputation was of a schickimicki artist, but you found something else. You discovered something a bit different.' He recalls the reaction of his colleagues in the art world: '"What, Tilman, you write on Bernard Buffet? Are you crazy?" Yes, it was shaming to tell somebody that I was writing a text on Bernard Buffet.'

However, Osterwold persevered. 'The exhibition was fantastic,' he says. 'Bernard was very fascinated. He was there at the opening, so I did the speech and we met. He was not healthy, I think. He was *sympa*, very shy and not so overloaded with self-importance.'[16]

If Kassel is the Lourdes of contemporary art, showing there even out of the documenta would, at the very least, draw attention to an artist. After all, Jeff Koons, then recently married to pornographic actress Ilona Staller, had not been invited to prepare work for documenta 9 in 1992 but was able to benefit from the halo of credibility-enhancing controversy that attended the installation of a 43-foot-high topiary puppy in nearby Bad Arolsen during documenta. For Koons, this was a watershed work that propelled him to the very top of the contemporary art world: the puppy subsequently found its way on to the terrace of the Guggenheim in Bilbao, now its permanent home. The Kassel connection seems to have worked for Bernard Buffet too, or at least it might have been a lucky talisman, as from 1994 onwards, a new kind of interest was taken in his work.

Alexander Roob is what one expects a proper German contemporary artist to look like: serious, shaven-headed, a touch earnest and gratifyingly contrapuntal in his views. As well as being a talented and recognised artist, he is a highly intelligent, articulate and sensitive man.

Buffet became relevant for me during my studies of painting in the early eighties at the Hochschule der Künste in West Berlin. Of course

I had a fuzzy after-image of Buffet-mania, which was present when I was a child. At the time of my studies he was only known as a shadowy existence, who stood at the art-historical pillory because of having trespassed certain limits of taste, condemned by the high priests of canonical modernism to lifelong contempt. I was really excited about those examples of his work which I discovered in an article of the German art magazine *Art*, 'Das feine Elend des Bernard Buffet' ('The refined misery of Bernard Buffet'), in April 1983. Behind his challenging artistic approach I discovered a rich tradition. His references were not limited to fine arts, but came also from various fields of popular culture. Both his terse and powerful linear grasp as well as the panoramic conception of his oeuvre became exemplary for my own work.[17]

Unafraid to attract controversy and flout accepted intellectual convention: thus it was, in his best taboo-busting manner, that Roob crossed the threshold of the Maurice Garnier gallery and fell in love with everything he saw. 'I first visited his gallery space in 1994. It looked antediluvian, completely fallen out of time. Buffet's painting cycle *L'Odyssée* was on display.' Buffet loved Greek mythology, and in his later years he preferred the tranquillity of cruising in the Aegean to the *tohu bohu* of Saint-Tropez. 'I had been interested in the case "Buffet" for some time, but I never would have expected such a strange situation, such an inspiring and lively mixture of a hot painting cycle, an antique outfit, which wasn't really wrong, and a professional gallery business in the background consisting of quite a number of persons. Monsieur Garnier wasn't there, but I left a message.'

Five years later, Roob returned, bringing with him a contemporary gallerist from Düsseldorf, Ursula Walbröl, who was, he says, to play 'a crucial active part in the rehabilitation of Buffet'. On this visit, the two Germans met Garnier, who appeared to Roob 'unconventional like his gallery, a very present and autonomous figure completely fallen out of time. Although he had the manners of a *grand seigneur*, he was unpretentious in a radical way.'[18] Garnier and Walbröl also established a strong rapport. Roob describes them as

somehow correlating characters in the sense that both harmonised in being artists' gallerists, not driven by any personal benefits, but in complete devotion to the cause. Garnier saw that he could totally trust her and she became an important adviser. You can say that the things

she prevented were as important as the things she engineered. Garnier would phone her if he got a new museum offer, and there were similar offers around like the show in Kassel, which would have further undermined Buffet's reputation. She stopped this direction and instead started to show him at art fairs in a context with unknown but promising artists.

She presented his work at both the 2002 edition of Art Frankfurt and a year later at Art Brussels. 'Without her enthusiasm and her reputation as a gallery operating beyond the speculative market, the enterprise would have failed. In 2001 she managed to arouse Fabrice Hergott. He then was the director of the Strasbourg Museum, with an interest in her young programme, and he admired her courage to show Buffet.'[19]

As well as Garnier, Roob and Walbröl had the opportunity to meet Buffet himself, who was in the final months of his life.

Maurice Garnier had arranged that Buffet was present at our meeting. It took place in the back room of his gallery shortly before his death, around 1999. Rarely a word was spoken. Buffet was suggestive of being a kind of Buddha, in complete harmony with himself. The few words he uttered were hard to understand. Garnier was also very taciturn. After the audience he apologised for the speechlessness due to the master's declining health. Later he confessed that they never ever had spoken much. One couldn't question him on anything concerning Bernard Buffet's ideas, because they simply never had talked about such an ephemeral subject like artistic concepts during their extraordinary long business relationship.[20]

Although the wheezing, disease-racked blancmange Buddha that was all that was left of Buffet probably did not realise it, he had just witnessed the first sparks of interest from a generation of intellectually sophisticated connoisseurs who were too young, too curious and too independently minded to be overly affected by the oppressive weight of the decades of critical denigration and neglect that the artist had suffered.

Chapter 43

The Gates of Hell Ajar

It is significant that when Buffet and Garnier met the earnest intellectual artist and the avant-garde Düsseldorf gallerist in the private room next to Garnier's office, it was without the wunderkind Tartaut.

As has been seen, Tartaut spent the 1990s working tirelessly on Buffet's legacy and gaining his confidence. Soon he was an intimate in a way that Garnier, who had known the painter for half a century, since before Tartaut was born, had never achieved. This is not to say that the gallerist would have wanted to cultivate the sort of intimacy that Tartaut was enjoying. He once admitted to the author of this book that although he had enjoyed plenty of friendly relations with people, he had no friends to show for his ninety-three-year sojourn on the planet. This extraordinary admission was not made with the slightest scintilla of self-pity, nor with any overtones of misanthropy, just as a plain statement of observed fact. Garnier was a singular man, possessed of a quality that is best described as a sort of moral incorruptibility.

According to Stéphane Laurent's study of the artist, *Le Peintre Crucifié*, the two men were on a collision course, and it was, ironically, the prospect of a retrospective in Paris, a long-nurtured ambition of both the painter and his dealer, that brought the underlying current of tension swirling to the surface.

Tartaut had accumulated a pile of correspondence with various officials, hoping to persuade them to mount a Parisian retrospective. Suave, cultured, charming and a skilled networker, he had, it seemed, been able to bring about a change of heart at the very top of the culture ministry. Space was offered at La Grande Arche de la Défense, in the financial district. When Garnier went to see the proposed venue, he described it as a 'banal seminar room'.[1] Stubbornly he argued that

it was either Le Grand Palais, the Musée d'Art Moderne de la Ville de Paris, the Pompidou or nothing. When the younger man continued to push for the show, Garnier had simply had enough. Instead of choosing between La Grande Arche or nothing, Buffet had to choose between Garnier and Tartaut.

Maurice Garnier may have been a strong, and at times dominating, character, and over the course of a relationship lasting half a century it is inconceivable that there were not occasional differences of opinion. But he set himself and others high standards and had been a champion of the artist's work since the 1940s.

Although it must have been a highly uncomfortable situation for the artist, who had hidden behind the *oui, non, peut-être* formula of apparent timidity throughout his whole life, with the benefit of hindsight it seems like an obvious decision. Tartaut may have been an adept promoter of brand Buffet, and he had secured him the gratifying shows at the Pushkin, the Hermitage, and the museums in the Far East, as well as the exhibition in Kassel. But he had not even been born when Garnier and Buffet had been regulars at those smoky evenings of table tennis in *la piscine* during the hungry but exciting years after the war, or when Garnier had introduced the painter to Pierre Bergé.

'He was somebody with a very great strength of character and somebody who could be very persuasive,' recalls Nicolas Buffet of Tartaut.

> I saw that my parents really loved and appreciated him, I let him be and said okay. And the fact is that he did something for my parents. He was really involved in the exhibition in Moscow, in St Petersburg, and also in Taipei – those are the three main events that he worked on.
>
> After my mother passed away, Tartaut just disappears. No news, no response to calls, no response to mail. Disappears.[2]

Tartaut was, says Nicolas, supposed to be an executor of Annabel's will and in charge of managing the inheritance.

Annabel died in the summer of 2005. To make matters more complicated for the Buffet family, and for Galerie Maurice Garnier, Tartaut presented himself as the holder of the moral rights of Bernard Buffet, and on 10 January 2014 the Court of Appeal in Paris

found against him. He had taken legal action against a Buffet enthu-
siast who had set up an internet site devoted to the painter. In his
defence, he adduced the wills of both Bernard and Annabel. However,
the court was reported to have questioned the validity of Bernard's
will. While observing that the text of the will was written in a
different hand to the one which made the signature, the court held
that it disregarded the usual formality. Moreover, the court ruled
that the moral rights belonged to the painter's descendants, the
couple's adopted children. The court took a dim view of the manner
of the action Tartaut had taken against the website's owner, and the
'disproportionate sums' he had sought, especially as the site was
established purely out of enthusiasm for the painter's oeuvre. Tartaut
was ordered to pay 8,000 euros in damages and the same sum towards
court costs.

To be fair to Tartaut the state of Buffet's handwriting at the time
of his death was very badly affected, as well as Parkinson's, the fall
that he had sustained was bad enough to stop him from painting.

Tartaut did not give up and contested the Court of Appeal's deci-
sion in the Court de Cassation. On 28 May 2015, the court did not find
in his favour.[3]

Buffet was tired, and very little seen in public beyond the occasional
restaurant visit and appointments such as the meeting with Alexander
Roob. Once in a while he made an effort, for special occasions such
as the gathering for the fiftieth anniversary of *Paris Match*, of which
he had been one of the chief and longest-standing ornaments.
However, the photographs taken of that event show a man whose
ageing body may be present but whose vacant gaze betrays a mind
that is elsewhere, bearing out his wife's observation that he had already
'embarked upon the journey of no return'.[4]

By the beginning of 1999, he was incorporating his infirmity into
his art. His hands are clearly unsteady. Paint is applied crudely,
more crudely than ever before; incapable of the soothing, detailed
brushwork that had characterised various periods of his output, he
abandoned rigorous draughtsmanship for loosely painted effect.
Occasionally there are days of remission when the clarity of the old
Buffet returns; there is one particular clown painting from 1999,
depicting a figure of genuine pathos playing a mandolin. But in the
main, it is only through increasing doses of medication that he is
able to manage the shaking in his hands, and the works become ever

more frenzied and urgent as he realises that the time remaining is short; very, very short.

Annabel's memoir of grief and widowhood, *Post Scriptum*, is a moving work that essentially flits back and forth between three periods: their courtship and marriage, the final years of his life, and her widowed existence. Its contrast of age, physical decline and loneliness with youth, vigour, beauty and love is extremely poignant. In it she addresses Buffet personally as if he were still alive. Whatever the nature of her physical infidelities, the strong emotional attachment that she felt for him is clear enough.

Although critical of some aspects of Annabel's conduct during their marriage, and of the influence she exerted over Buffet – encouraging him to drink is one of the most obvious – Garnier was full of praise for the way in which she looked after her husband in his declining years, when age, illness, medication and fear made him by turns emotionally needy and vexedly dictatorial.

'You were possessive in the extreme,' writes Annabel in *Post Scriptum*.

During those last three years, you let me go to Paris, to Saint-Tropez and even to Marrakesh, but no argument could make you decide to accompany me. Before my departure you seemed charming; you insisted that I needed some distraction; you said that only your work prevented you from coming with me. The first few times I believed you. Well . . . almost.

On the phone, your good mood seemed artificial. Very quickly you stopped this play-acting; you complained of being abandoned. I did not give in to what I took to be a form of blackmail. I was even angry with you. I felt it was unforgivable that you did not deign to bother yourself to see your children, your friends, or even to have fun with me as we always did. At home, you lived your life without taking account of mine. You demanded that I be available; you called me to the workshop for a yes or a no; you established inflexible schedules; in short, you were tyrannical. As long as this authority served your work, I agreed as I always did.

But you really spoiled things when you tried to extend your sacrosanct will to our hours of relaxation. No one could compel me to watch videocassettes for hours on end; when you were not in front of the television, you were reading.

What exasperated me was the choice of your films and your reading matter. You wanted only to see police thrillers and action films, in short, violence in all its forms. Of course, I felt that something in you was wrong.

And yet, intolerable though they found each other at times, they clung to each other ever more tenaciously in their isolated idyll, with its honey-coloured, sun-gilded walls; the gardens dappled and striped with the lance-like shadows cast by cypresses that dotted the domain like jets of dark green flame; the crash of the waterfall as it forced its way out of the rock and bounded down the cliff-like face into the cool, clear dark pool below; the still rooms with their vitrines and shelves and cabinets of ostrich eggs, porcelain, glassware, bibelots and and bric-a-brac gathered over nearly five decades of antique-hunting; the rambling kitchen, its walls glinting dully with copper pots, its ceiling hung with baskets and garlands of dried peppers; and of course in every room, from tiny paintings of flowers just a few inches across to giant canvases, the paintings of Bernard Buffet. La Baume, once their retreat from an inimical world, had become during his final months a prison for them both.

> I do not know why I clung to your carnal envelope. I needed this presence to have the illusion that we were still a couple. I refused to imagine life without you. I was made desperate by your suffering but even more by the prospect of losing you. During these endless nights when you shouted your anguish, hanging on to me like a drowning sailor to a piece of wood, you told me of your demons, you told me of your horrors, you also begged me to never leave you. You begged for my love, like a lost child; you said: 'I want to die', and as I cried, you pulled me against you. You murmured: 'I promise you I would not do it. So hush, go to sleep. I'll take my medication and it will get better.' You fell asleep, and lying close to you, eyes wide open in the dark, I struggled to find a scrap of hope.[5]

However, during those last years of decline, following his diagnosis with Parkinson's in 1997, there were brighter times. There was still one palliative that worked when the consolations of money, medication and love had failed. 'When you started the large canvases on Death, I really thought we had won the battle against the disease.

There was such power, such mastery of your art and such humour in these pictures that I abandoned myself to the happiness of finding you once more equal to yourself.'[6]

La Mort is an extraordinary series of works. Painted between 1998 and 1999, it shows skeletons, some of them hermaphrodites, equipped with genitalia and in some canvases even a foetus, going about their business: smoking, praying, urinating, feeding birds and so forth. Just as Buffet once said that the hatred with which he was surrounded was the greatest gift that he could have been made, so it can be argued that he made his physical decline into one last marvellous going-away present.

'In this work there is the best of you. You reveal yourself as strong, vulnerable and also untouchable, with a touch of childish mockery towards this death that does not frighten you.'[7]

These paintings are unlike anything he had done before; their subject matter and the almost primitive style of their execution meant that they could hang alongside the most challenging of contemporary works. But as well as maintaining the power to surprise those who thought they knew his oeuvre well, there are elements of his earlier work to be seen throughout this series and in other paintings from this final period of his life. There are miniature representations of birds that recall *Les Oiseaux*. There are two grinning transvestite skeletons, one waving a wand-like cigarette holder, the other in a large hat, who could have strolled into this canvas from *Les Folles*. A skeleton scarecrow is depicted against a background with all the familiar touchstones of a Buffet landscape: a church with its steeple, a little house, telegraph poles. Christian ritual, a strong theme throughout his life, provides the scene for the skeleton kneeling at the altar of a simple chapel of the sort that he himself decorated with his own works in the various grand houses he lived in. Period props – ruffs, wimples, cloaks, feathered hats and swords – reference his lifelong attraction to the past, and bring to mind his 1981 self-portraits and his startling 1968 homage to Rembrandt's *Anatomy Lesson* among others.

In *La Boucherie*, a maniacal figure more *écorché* than skeleton stands in front of a *tête de veau* with a butcher's cleaver embedded between its eyes, mimicking the famous picture that Buffet was filmed painting during the 1950s. The butcher's shop could have been one that he painted in the 1940s, a memory that is forcibly evoked by another

1999 canvas showing a side of beef hanging from a hook. Fifty years, half a century, separate it from the earlier works on this subject, executed by the same hand but a different man, one little more than a boy painting the life he saw in 1940s Paris, the other a dying man looking across the decades to his younger self. Buffet was saying goodbye.

'All the time it took you to complete these canvases and to refine them you seemed well. They remained in the atelier for two weeks before you shipped them to Maurice. Once the truck was loaded under your vigilant eyes, you decided to rest a few days. I never saw you paint again.'[8]

The countdown to death had commenced.

'The day after, you were in the garden to fetch some flowers to bring them to the Virgin of La Baume.' Annabel insisted on accompanying him to gather this floral tribute to the guardian spirit of their estate. 'You were tired and once again your legs seemed very weak. You had your cane but it was of no help. You fell. You could have fractured your thigh like everyone else! But no, it was a double fracture of your right wrist. You panicked.'[9]

They went to Nice, a two-hour cross-country drive that must have been agonisingly painful. Once at the airport, Annabel chartered a private plane to take them to Paris and the American Hospital, where he was operated on. The surgeon offered the usual medical platitudes: 'Patience, seven weeks of plaster, a bit of physiotherapy and the broken arm would be a distant memory.' Annabel saw it differently. 'I knew immediately that the gates of hell were ajar.'[10]

Now, as well as the cruel, creeping debilitation of the Parkinson's, his painting arm was imprisoned in plaster from the shoulder to the fingers. The frustration at being unable to paint for the first time in his life was compounded by the humiliating need to be helped by his wife to dress, to undress, to use the lavatory and to eat.

Once the plaster came off, he started having physiotherapy, submitting himself with docility to the regime of physical rehabilitation, but it was obvious to Annabel 'that your hand made no progress and that you would never be able to paint'.[11]

He started to have dizzy spells, and would stumble over the smallest obstacle as he dragged himself around the house, covering himself with bruises. On the rare occasions that they received visitors, he would put on a brave show. That summer, his daughter Danielle came

to stay with her husband and son. Buffet rallied, buoyed by the sight of his grandson. Nicolas also visited.

And yet for all the smiles, the love and the sunshine of that summer in Provence, six weeks later Buffet would place a polythene bag over his head and tape it tightly around his neck.

'I remember one day he said to me and to my mother, "How am I going to write the year 2000?"' recalls Nicolas of that last summer with his father. Thinking about this strange question today, he believes that Buffet was afraid, but not necessarily of death. 'He felt that he belonged to the old century.'[12] Besides, he could simply no longer trust his hands. Shortly before he died, he laboriously wrote, or rather scrawled, a few sentences on a page torn from a desk diary. It is a document comprising just forty words, including a signature so shaky that it no longer resembles his famous trademark, but rather the hesitant, childlike hand that had tentatively signed those first canvases. The effort these words cost him is clear: smudged, smeared and at times almost illegible, it is tragic in both execution and content. Headed 'Testament', and dated simply 1999, it says that he wishes to be cremated, and for his ashes to be taken to the museum in Japan that had been built for him by his patron Okano. Rather poignantly, he has attempted to draw a heart pierced by an arrow, but the fletching is just an indistinct mark, and there is no arrow head.

So it was, with the determination of the timid that Pierre Bergé had identified five decades earlier, that Buffet made sure he would never need to date his paintings with anything other than the century he had recorded with such fecundity.

Chapter 44

I Still Love Him

With the approach of the year 2000 he decided to stop. It has been said that he was sick, that he committed suicide because he could no longer work. And were it not that, then any pretext? If he understood that he could no longer paint? Not only physically, but because the genius which one day had touched him had deserted him a long time before.[1]

'*Les jours s'en vont je demeure*' ('The days disappear, but I remain'); this mournful line from Apollinaire's poem 'Le Pont Mirabeau' takes on an almost triumphant tone in Pierre Bergé's hands as he adopts it as the title of a series of pen portraits of his famous friends throughout the years. And it is with this cruel judgement that he concludes his chapter on his former lover. If nothing else, it has handed Buffet's supporters 'evidence' that Bergé is in some way behind or involved with the systematic exclusion of the artist from French cultural life, and that he still seeks to control the lover he left, implying that while they were a couple, he was a great painter, and that when Bergé left, so did Buffet's genius. In an interview for his book about the painter, French author Jean-Claude Lamy cites a friend of Sagan's as having said that Bergé, after spending the summer of 1958 looking for Buffet, vowed to revenge himself upon his former lover.

Whether this amounts to evidence of a carefully orchestrated campaign to destroy the reputation of the painter in his homeland is uncertain – one might argue that in the years after Buffet, Bergé had enough to deal with trying to manage the highly strung Yves Saint Laurent, as well as making his fortune and his way up French society. Nevertheless, it is undeniable that there remains strength of feeling in Bergé where his lover of almost seventy years ago is concerned.

Buffet partisans and conspiracy theorists have tended to see Bergé as some sort of malicious mastermind, a sinister puppet master manipulating museum directors, curators and officials so that his quondam

lover remains not just forgotten but derided, his reputation not just suppressed but destroyed. 'He was upset that Bernard Buffet went off with a woman after he had left him'[2] is the theory advanced by Maurice Garnier to explain Bergé's opinion that the work Buffet painted in the last four decades of his life is inferior to that which preceded it. 'He knows that it is wrong, he says it anyway. He continues and continues. I thought that after the death of Bernard, his hatred would stop,' said Garnier in the year before his own death. 'But no, he continues. Then I said to myself, after the death of Annabel, he will stop. No, he continues. He continues to try to prevent Bernard Buffet from taking off.'[3]

'Bergé certainly played a very important role for his success in the fifties,' says Fabrice Hergott, director of Paris's Museum of Modern Art. 'And when he writes about Buffet, he says Buffet was a very good painter, but that after the fifties his work has no more interest.'[4]

'That's why one day it would be my dream to organise an exhibition of Bernard Buffet of these first ten years,' says Bergé. 'I would do 1946–57. If one did that, I am sure everyone would be astonished.' However, he still stands by his observation that Buffet's talent left him a long time before his death, though he downplays any suggestion that this was exactly coincidental with his departure. 'I'll be very honest with you, I should not say that it was the day when I left him. It must be clear, it was before. I do not know how it happened. Maybe I should have been vigilant, attentive. I was not. But for me, Bernard Buffet is an exceptional painter until 1955.' He does concede, though, that 'afterwards there are sometimes very good things'.[5]

He becomes upset when it is suggested that he has been behind a six-decade vendetta against his former lover.

> No, not at all. That is absolutely false. Buffet is someone for whom I have great respect . . . for whom I had a great passion, a great love, and I have no animosity against him. If someone says that, it is absolutely wrong. I had great respect for him, great admiration – it is not my fault if I like his later work less, that is true. But I always say it is not because he left me. I want to be clear. I don't want there to be false interpretations.[6]

Bergé's remarks could be interpreted in another way entirely. Instead of being evidence of a conspiracy, could they not indicate what Ida Garnier has long suspected: that Buffet was the love of Bergé's life

and he only realised as much when he had definitively lost him? Maybe on that morning in the summer of 1958 in their castle in the South of France, he should have heeded his own warning as to the determination of timid people.

'I really loved Bernard Buffet, I still love him. It is necessary that you understand this,' says Bergé today, and as if to make the point especially clear, he switches from French into English to repeat himself. 'I do love him, after so many years.' The tragedy is that this realisation did not come until it was too late. 'And when he died, I didn't think it would give me such a shock. It was a terrible shock. In 1999, I learned of his death in my car. It was a terrible shock.' His features are creased and folded with the years. His eyes are rheumy; perhaps with age, perhaps with the memories of those years in Provence when he and Buffet were young, energetic and beautiful. There is something incredibly moving about seeing this very old, very rich and very powerful man remembering his great love and recalling a time when their lives, seemingly indissolubly linked, stretched ahead of them into a glorious future as the Orestes and Pylades of the atomic age.

Still speaking in English, he says, 'When you fall in love, it is more important than anything else.'[7]

But even though the artist was now dead, back on the Avenue Matignon, Maurice Garnier was going to make sure that there was still one place where the memory would be kept alive.

Garnier was never a man to be diverted from what he set his mind to, and he certainly did not permit Buffet's death to disrupt the annual cycle of exhibitions. The February ritual would continue.

In 2001, with no new work to show, Garnier had decided to present the first instalment of a retrospective exhibition. Called simply *Tableaux pour un Musée*, it treated the painter's oeuvre in chronologically sequential segments, and would run for years to come. By 2002, it seemed that Annabel, at least, believed that she would live to see the inauguration of an actual physical museum dedicated to her late husband in his homeland; in the preface to the catalogue, she described the works from 1950–4 as the 'second exhibition of canvases destined for the Bernard Buffet Museum in Colmar',[8] and signed off her introduction by saying that to discover the next instalment, it would be 'necessary to wait until next year or even better the inauguration of the museum'.[9]

However, by 2005, the museum remained uninaugurated, and in her preface to the catalogue covering the years 1965–9, Annabel talked instead of Garnier's 'unwavering desire with which he overcomes the difficulties encountered in creating a museum'.[10]

The following year, Annabel was no longer around to write the preface, her ashes having been scattered in the bay of Saint-Tropez in the summer of 2005. Happily, the apparently immortal Maurice Druon carried the torch and penned a splendidly stirring page saying how he had known Buffet in his days in Haute-Provence; how he had known Annabel when she had been one of the *égéries* of Saint-Germain-des-Prés; and how she had been Beatrice to Buffet's Dante.

In 2007, the paintings from 1977–84 were to be found on the walls of Garnier's gallery. In February 2008, in addition to *Tableaux pour un Musée*, there was another exhibition . . . and it was not on the Avenue Matignon.

On 18 April, 600 kilometres or so east of the Galerie Maurice Garnier, an exhibition opened in Frankfurt; it was called *Bernard Buffet: Maler, Painter, Peintre*. In what was described as 'the first major museum exhibition in Germany for many year[s], the MMK Museum für Moderne Kunst is showcasing 60 works by Bernard Buffet (1928–1999), stretching across six decades of artistic endeavor. The exhibition is thus dedicated to an artist who was once feted as being one of France's most important painters and the legitimate successor of Picasso.' It aimed to be provocative. 'The MMK exhibition will present a broad spectrum of this polarising oeuvre and put it up for renewed discussion.'[11]

It was to mark a turning point in the reputation of the painter. This was not provincial France or the former Soviet Union, but a twenty-four-carat, blue-chip, copper-bottomed cultural institution in Western Europe. The MMK had been part of a museum-building binge undertaken by Frankfurt during the booming 1980s perhaps to efface or at least adumbrate the city's reputation as just a powerful financial hub. This orgy of statement architecture saw five new museums rise on the south bank of the River Main, designed by such leading names as Richard Meier and Oswald Matthias Ungers.

The MMK was the work of avant-garde Austrian architect Hans Hollein, and what the burghers of 'Bankfurt' got for their seventy million Deutschmarks was a reassuringly contemporary-looking

wedge that became immediately known locally as the 'Tortenstück', or slice of cake. Building aside, its credentials as a contemporarily correct cultural institution are impeccable. Its permanent collection includes works from the mid twentieth century to the present, including pieces by Roy Lichtenstein, Carl Andre, John Chamberlain, Andy Warhol, Claes Oldenburg, Jasper Johns, Dan Flavin, Yves Klein and Donald Judd among many, many others. For good measure the museum's director curated the German pavilion at the Venice Biennale twice in a row, in 2011 and 2013, and it was another German pavilion curator, from 2001, Udo Kittelmann, who curated the 2008 Buffet show. Kittelmann is a regular presence on *Art Review*'s Power 100, and the same year as staging the Buffet show, he was appointed director of the National Gallery in Berlin.

The hang was uncluttered and uncompromisingly early twenty-first century. A vast wall of Pepto-Bismol pink was adorned with one tiny painting of an owl, hung high, like a small window. The colourful car paintings, inspired by the commercial commission for Renault, popped brightly against a featureless white wall. The anguished homoeroticism of the grey and taupe works of the late 1940s contrasted effectively with soothing mauve walls. While the Jules Verne series was given ample space in a huge viridian-walled hall, acidic orange of the sort more commonly worn by construction workers was the backdrop for the more violent pieces, such as *Le Grand Jeu* of 1977, which marked Buffet's return to alcohol and tobacco with a combination of cigar box, bottles, glasses, Cinzano ashtray (with smouldering cigarette), matches, human skull, roulette wheel, playing cards, dice, dagger and a pair of handguns cluttering a green baize table.

Contextualising material was minimal: visitors were neither instructed nor guided, but rather encouraged to experience an emotional reaction to the works, just how Buffet always said a painting should be appreciated. However, there was no doubt as to how the artist's work was being positioned: near to one of the 1958 New York landscapes, painted in the Saint-Tropez garage in between bouts of frenzied lovemaking with his gorgeous wife-to-be, was an arrangement of Andy Warhol Brillo boxes.

Alexander Roob, who had wandered into Maurice Garnier's gallery fourteen years earlier and been enchanted by the period feel, wrote a lengthy essay to accompany the show. In language that could give Buchloh something to worry about in terms of high-brow opacity, he

locates Buffet unequivocally in the crucible of mid-century creativity. Here he is on the artist's fondness for cartoons:

In her discussion of French post-war art, Sarah Wilson identifies an 'epistemological rupture' in the mid 1950s, prompted by a nascent coincidence of 'high' and 'low'. In fact, the first influential blending of the two occurred many years earlier in the oeuvre of the young Buffet, embedded like a futuristic succubus in the body of existentialist art.

His spider-web-like linear style of the early post-war years first appeared in 1946 at the same time as the emergence of the so-called 'ligne claire' in the Belgian school of comics, as championed by Hergé and André Franquin. That same year saw the publication of Saul Steinberg's All in Line, which was pioneering for 1950s cartooning that relied on geometrical shapes. The development of Buffet's eclectic graffito style occurred simultaneously, with him absorbing stimuli from printed illustrations and in turn influencing these.

The strength of Buffet's concept of the line is that it is not genuinely a matter of drawing but arises from work with the material construct of the image. An element of tension and injury plays a role here. The hypnotic effect that his art exerted at the time, above all on youthful viewers, no doubt resulted not least from its potential cathartic function – like a vent for excess steam – and like bebop and rock 'n' roll it could thus become an integral part of a youth movement. Buffet was an ecstatic proponent of the line. In his lines, the calligraphic orientalism of French modernism (which at that time had reached a climax in the abstract action graffiti of a Georges Mathieu) is combined with the hieratic expressionism of a Rouault or Manessier and the 'ligne claire' of contemporary printed illustrations.[12]

He concludes his essay with a call to action, or at least to reconsideration of the body of work.

Whether the risky pictorial world of the nullified and vilified Bernard Buffet could even have been seized with the tools of painting criticism in the 1980s can be doubted. Yet there is a vital disquiet exuded by the abysmal paradoxes of the oeuvre of an artist who Picasso considered the zero and Warhol the No. 1 of French painting. His coolly hot temperature is as far removed from the archaising heat of the painter as it is from the self-confident coolness of the rhetoric of

representation in Pop culture. And the supposition that an ambiguous
post-modern pictorial strategy was at work must be unsustainable in
the face of the truly drastic and laconic quality of an art that forged
a tangible image by combining the most extreme violability with self-
assertion, and that unleashes an incredible presence.[13]

To the non-academic reader, this splendidly abstruse style is perhaps
not immediately accessible, and therein lies its brilliance and impor-
tance. At last, Buffet was once again being talked of and written about
in the language of clever people. Interest in the artist was no longer
an intellectual taboo. Or perhaps more accurately it was *because* he
was a taboo that he was of interest to a new generation of intellectuals
who, just as the critics and collectors of 1940s and 1950s Paris had once
done, wanted to discover meaning in the work, in the face of the
artist's stubborn and persistent refusal to provide any. It does not
matter if one disagrees with Roob. It does not even matter if one fails
to understand him. What matters is that thanks to the confluence of
rigorous, intelligent and informed critical study, prestigious institu-
tional venue, and contemporary *mise en scène*, it was no longer neces-
sary to fall back on the weary argument that whatever the critics
might say, the painter and his work enjoyed a high level of recognition
and popularity with the public.

The Frankfurt show was the most visible and high-profile sign that
a Buffet revival was under way, early signs of which could be detected
shortly after the painter's death. One of the most evangelical prophets
of his return was of course Alexander Roob, who had come away
from his meeting with Garnier and the dying Buffet determined to
share his enthusiasm with a wider public, in the course of which his
own passion for the painter deepened. 'Subsequent to the two exhibi-
tions of his work, which I curated in 2001 for the Gallery Ursula
Walbröl in Düsseldorf, I had the opportunity to live for some months
with his paintings, as they were partly stored in my studio and in my
apartment. Gradually I became aware of the immense painterly quality
of his works, which still have a kind of negative reputation as being
results of a mass production.' His physical proximity to the work
evoked such powerful emotions that 'at the end it was hard for me
to part with them'.[14]

Even in France, the accepted Buffet-phobic tenet of cultural life
was being questioned. The summer of 2002 had seen the opening of

an exhibition called *Cher Peintre* at Buffet's detested Pompidou Centre. The concept of the exhibition, however, was identical to the line that he had been faithfully repeating throughout his career, namely that figurative painting was actually less restrictive than abstraction, and that there were as many different styles of figurative painting as there were figurative painters. The list of artists represented included rising contemporary stars Luc Tuymans and Peter Doig, accepted masters Francis Picabia and Sigmar Polke – and a selection of works by Bernard Buffet.

Henry Périer, who during the 1980s had heard from Andy Warhol's lips the same benediction for Buffet that had been shared with Buchloh, had, like Roob, been fascinated by the Buffet oeuvre since his student days during the 1970s, when he was studying medicine in Sweden. In 2003, he persuaded the Paul Valéry Museum in Sète, a resort town twinned with Hartlepool in the UK, and known a trifle ambitiously as the Venice of Languedoc, to hold a show of Bernard Buffet's works. It remains, says Périer, the best-attended show in the museum's history. Périer has gone on to become one of the leading Buffet apostles in twenty-first-century France, publishing a study of the artist's lifelong fascination with Provence, making television appearances to talk about the painter and also curating a highly successful Buffet show in the northern French resort of Le Touquet during the winter of 2014–15. Held at the Musée du Touquet-Paris-Plage, it was, says Cěline Lévy, Ida Garnier's grand-daughter, 'their best-attended show, with 15,000 visitors. More than their Dubuffet show, for instance.'[15]

Chapter 45

The Mozart of Modern Art

The changing character of the interest in Buffet's work is best explained in the preface written by Kittelmann to the Frankfurt show:

> The intention is not only to jog the memories of the generation that grew up with Bernard Buffet's images. A different and younger audience, hitherto untouched by the reception of an oeuvre that was once so influential, needs first to be familiarised with it, since it seems virtually to have vanished from both public collections and the curricula of modern art history. Yet anyone today, in the 21st century, wanting to find out how Europe felt in the 1940s, 1950s and 1960s, and what visual idioms were symptomatic of the day, must turn to Bernard Buffet. Hardly any other work in the realm of visual arts seems to offer a better evocation of those decades.[1]

Bernard Buffet was history, in the sense that he could now be viewed without being obscured by the cultural baggage that had accompanied him throughout his life. As such he was being not so much rediscovered as discovered by a generation only hazily aware of his work. Typical of those whose minds were opened to the artist by the Frankfurt show of 2008 is Sébastien Janssen, scion of a Belgian pharmaceutical dynasty and a dealer in contemporary art. He was in his early forties when he attended the Frankfurt show.

> My grandfather was a collector of Impressionists and Post-Impressionists. My father is also a big collector; he still is. We were all very involved in art and surrounded by art since forever. My father was a gallerist in the 1960s and 1970s in Brussels mainly selling the COBRA group [an avant-garde group of Marxist Expressionist artists]. He was very upset when I mixed up Buffet and Dubuffet. For this generation of people like my father, Buffet was considered *ringard*, as we say in French. It

was so tacky to have a Buffet poster; it was for the concierge, the housekeeper, people like that.

At that time, abstraction was really for intellectuals. Now of course when you speak to people who don't know anything about art they all love abstraction because of the nice colours, but in the 1970s figurative art was the most natural art. People could relate to this art: nice landscapes, nice views of animals . . . they became like touristic images and Buffet was a bit like a tourist souvenir from France like Utrillo was before.

In common with many Buffet converts of his generation, it was the strength of feeling against Buffet that initially attracted him to investigate the painter further. 'It was so polemic and that interested me first,' he says. 'The big change in my mind was the show in 2008 in Frankfurt. Visiting that show I understood that there were fantastic paintings from the 1950s to the end. Every period had its very good masterpieces. That changed my mind.'

He decided to show a Buffet on his stand at the FIAC, the Paris contemporary art fair. Encouraged by the positive response, he contacted Maurice Garnier and began to sell works. He decided that whenever he participated in an art fair he would show a Bernard Buffet. At the 2012 Art Basel show, the annual highpoint of the international art circuit, he decided to turn his entire booth over to an exhibition of Buffet's final series of paintings, *La Mort*. 'The apotheosis was this show of the last paintings of death. I was selected [by the fair's jury] on this project and that was a big change, for a big fair, an important fair like Basel, to do this. I sell Bernard Buffet painting to collectors of contemporary art and younger collectors aged between thirty and fifty-five, so there is a completely new audience who accepts Buffet as an important artist.'[2]

'My art focus and collecting has been centred around the European post-war period and artists,' says Stephan Wrobel, a financier in his early forties, who lives between London, Paris and Megève. He has spent the last decade assembling not just a collection of Buffet's works, but also an extensive library of literature and collateral material on an artist he believes to be among the greatest of the second half of the twentieth century.

This was a time of a strong divide between abstraction and figuration but also between lyrical and geometrical abstraction. Overall there was a strong rejection of the human figure, which characterised this period.

At that time few artists remained capable or willing to paint the human figure, and even fewer painted it meaningfully. It took strength, courage and certainly some creativity to keep with that theme. Buffet, like Giacometti, Bacon or Freud, was one of them.

His paintings stand out, and as I looked at his work, it emerged that he brings a personal vision, a new grammar and a distinctive way of painting – composition, colours, line, backgrounds. He is going to the essential, composition is phenomenal, drawing is unique and he does not make a lot of mistakes.

Among the new generation of Buffet collectors, Wrobel is arguably the best informed. Having examined each period minutely, he believes that 'there is amazing variety in his work, and I struggle to see how he can be qualified as repetitive if you have studied closely a large enough body of his work. I feel closer to the simplicity, humility of a Buffet painting than the opulence of many other painters who appealed to so many of the baby boom generation.'

Indeed, as Wrobel sees it, Buffet's work is a commentary on the values of the baby boomers.

His work is in the tradition of Ecce Homo, describing the pain that comes with being a man. He also reveals the spiritual emptiness of the second part of the twentieth century. The perception and the expression of the feeling of his time is uncannily accurate and fascinating for anybody interested in that period.

A new eye, a new generation and a global market will reposition Bernard Buffet where he should be. He is the continuation of art history in painting. There are so many references or dialogues with the masters in his work: the primitives, Dürer, Rembrandt, El Greco, Goya, Courbet, Gros, Delacroix, Turner, Cézanne, Van Gogh, Braque, Picasso, Utrillo, Derain, Soutine, de Chirico, Morandi, Matisse, Vlaminck. He reconstructed a world of painting that Picasso and the cubists broke. But more importantly, he is as close to a primitive painter, to a nineteenth-century Gros or Delacroix, a Morandi still life or a de Chirico empty city street scene as he is to a pop artist like Warhol or even to a street-art artist.[3]

Janssen too believes that the best of Buffet can hold its own with the work of those who have come after. Of the circles in which he moves,

he says that collectors 'mix his work with the most contemporary artists, and that is a very interesting thing as it is really something you mix with very young artists, very conceptual artists'.⁴ Which is exactly what one of Janssen's collectors did for a show in his New York gallery.

Adam Lindemann resists categorisation; he is a collector who has a gallery on Madison Avenue and who also writes and blogs about art. He could be called a smaller, American Saatchi, although he would probably prefer to be known as a larger-than-life Adam Lindemann. Even his gallery is a riddle; the look is downtown Meatpacking District, but the location is uptown Madison Avenue, opposite the Carlyle, where Buffet stayed in 1957. 'I'm in the mood to go against the trend right now in my collecting, in my gallery, in my writing, because there's so much trend today,' says Lindemann. 'You look at all the kind of mediocre painting out there that people pay fortunes for, and then you look at Bernard Buffet, the greatest artist in France in the fifties.' He has bought a number of Buffets, including one from *La Mort* and one of the museum-sized beach paintings, and opposite his desk is a spectacular Buffet painting of a cockerel, the paint thickly impastoed, the pigments bright, the feel not contemporary but time-less. Lindemann has an eye.

As well as enjoying being contrapuntal, Lindemann finds the life story of the artist utterly compelling. 'Why Picasso?' he asks rhetori-cally. 'Why not Buffet? Well, you'd have to ask, why did history go that way?' For him the Buffet story can be read as a parable. 'I think it's one of the most interesting stories in art history of the twentieth century, because you can touch all the different questions about why this one and why not that one. Why is this in a museum and that's not in a museum? Why is this a good painting and why is that not a good painting? And all of these social parameters and contexts, which are at the end of the day not about the art.'⁵

Like his friend Janssen, Lindemann grew up surrounded by conven-tionally collected art that fell within the canon of educated taste – Impressionism rather than miserabilism – so for him the illicit, forbidden nature of Buffet has appeal. It is almost as if he sees Buffet as a sort of cultural hand grenade, to be thrown into the middle of what he decries as the 'convergence' of modern collecting. 'Art collecting today has almost been overwhelmed by this idea of impressing others with how smart you are and how early you bought it and how much it's worth.'⁶

As Lindemann indicates, much of the excitement about the art market in the second decade of the twenty-first century resides in the act of discovery. Once collectors would pride themselves on their scholarship; today, in the information age, scholarship is cheap, and in a fast-moving world there is a thrill and a premium attached to successfully identifying the latest and newest 'next big thing'. Of course, once upon a time, a very long time ago, it was Buffet who was the newest next big thing.

Now the rapid elevation and coronation of mega-artists is what characterises an important segment of today's art world; youth is not seen as an indicator of inexperience, but is instead prized as evidence of freshness. The London art market of the New Labour, Cool Britannia years was built, primarily, on youth and shock value: just as Buffet was propelled to fame as the gaunt, unkempt, chain-smoking winner of the Prix de la Critique for a painting of two men, one naked legs splayed, the other naked except for a beret and a pair of shorts around his knees, so the defining moment of the Young British Art phenomenon that survives in the collective memory is the *Sensation* exhibition of 1997 at the Royal Academy. And just as Buffet would forever be the young man who became rich painting misery and hardship, so the Young British Artists of the 1990s have remained young and avant-garde even though they are now in their fifties. Like Buffet, they have enriched themselves, some to a far greater extent than the serial chateau owner ever managed.

The reason that today's world no longer has a problem with artists being brands is in part because Buffet, in embracing the jet-set joy of consumerism and showing that accumulating possessions could be fun, presented a new template of artistic success. Picasso was doubtless richer, but he hid his wealth – the image posterity retains of Picasso is not of a dandified princeling stepping from a Rolls-Royce, but rather of a paint-stained, baggy-trousered creator in a latitudinally striped T-shirt (which by the way can be bought at the Picasso Museum in Malaga).

The scale of their fortunes aside, the other great difference between today's artists and Buffet is that commercial success has long since ceased to be perceived as a vulgar stain on the reputation: the multi-millionaire status of today's artists is sufficiently commonplace for it to be unremarkable, or, if it is remarked upon, to be seen as some sort of clever postmodern artistic statement.

The sums of money paid for the most sought-after contemporary art of the twenty-first century dwarf those that Buffet achieved during his lifetime: his record price came in 1990, at the height of the late 1980s art boom and just before the Japanese market collapsed, when his 1955 *Le Cirque, Clowns Musiciens* sold for 5.5 million French francs (around a million dollars). Thereafter his pictures continued to sell, but the prices reflected the sharp downturn in the art market: throughout the 1990s, a million French francs would remain typically the upper end (a New York landscape fetched that sum in 1993). Two years before his death, his prices began to rise with the market and one of his Crucifixion paintings sold for three million French francs, but this was an exceptional price for an exceptional work.

When Janssen started getting interested in Buffet during the first decade of the current century, prices had not moved much, with oil paintings starting at 30,000 euros and exceptional works fetching at most 200,000 euros.[7] A decade on, 'it starts at 50,000 and goes up to 500,000'.[8] But the prices for outstanding works from leading dealers are higher still. During the summer of 2015, a gallery in Cannes declined an offer of 900,000 euros for a large 1988 painting of the Eiffel Tower, viewed from a window with a brightly coloured vase of flowers in the foreground. At the same time, Tamenaga on the Avenue Matignon was offering one of Buffet's monumental canvases from *Les Oiseaux* – the series that had given rise to controversy and queues down the Avenue Matignon – for two million euros.[9] As prices for good works become ever higher, says Janssen, 'I don't know who is really buying.'[10]

Perhaps a clue can be found on London's Bond Street, where amidst the luxury brands, the London branch of Opera Gallery is found.

What makes Buffet so interesting in the twenty-first century is that in an age where the brand is king, his instantly recognisable praying mantis signature is no longer a barrier so looming that the viewer is unable to look at the picture it signs; rather it is a powerful tool of attraction, as Gilles Dyan has discovered.

Dyan is the proprietor of the Opera Gallery. A polarising operation, Opera is a global network of galleries, with branches in locations as diverse as Aspen and Hong Kong, which is changing the way big-name art is bought and sold. The established art world tends to be dismissive of its methods and its prices and yet envious of its success. Whatever its detractors may say, Opera appears to be flourishing. In a landscape in which auction houses are now entering the primary market and

opening gallery spaces to show new work by living artists, and as mid-size galleries close, retail power is increasingly concentrated in international gallery chains that are to be found wherever there is an appetite for art and the money to spend on it. This is not an entirely new phenomenon: that arch-promoter of the Impressionists Paul Durand-Ruel had branches in various world cities, but today the names are different. Larry Gagosian, and his eponymous galleries, is the best-known example, and although their aspirations and marketing strategies are different, there are nonetheless parallels with the Opera Gallery.

Like Gagosian, who started as a poster salesman, Dyan did not begin at the blue-chip end of the business.

Before opening Opera Gallery, twenty years ago, I was selling lithographs and paintings that were painted in series in Hong Kong: one person would paint the sky, the next flowers and so on. I opened the first Opera Gallery in Singapore twenty years ago, because we did an art fair there. At the time, business in France was very, very bad and at that fair I sold twenty-five or thirty paintings. So I decided to open a gallery in Singapore. There was almost nothing in Singapore, only two or three local galleries. I chose the name Opera, because I had it in mind to open in other countries, and I wanted to have a name that can be understood all over the world.

The concept we have is a special concept for an art gallery. First we have the best locations in all the cities where we are established: locations close to the luxury groups. And what we are proposing is a collection, with a huge range. It means we have contemporary artists from all over the world, premier artists, and confirmed artists, mixed with masterpieces covering all the movements of the twentieth century. In a classical gallery normally they do only very contemporary or conceptual or modern. This is more generalist, and to have the location in the places where you have the luxury brands, we can reach both the normal collectors and also people who may never have thought to enter a conventional gallery.[11]

Whereas the Gagosian model is predicated on presenting big-brand contemporary artists in an atmosphere that combines cool with a touch of scholarship and a sense of the exclusivity that comes from being one of the happy few, Opera is an altogether more accessible and inclusive operation: provided you have the money.

Dyan is of the generation of Frenchmen who grew up with Buffet.

I knew him since I was four years old, five years old. For me Buffet was someone unbelievable, a genius. For my bar mitzvah, when I was thirteen years old, I got some money from my family and I bought a print of a clown and I had it in my bedroom since I was thirteen, so therefore for me it was something fantastic, you know, and I always loved his work even though I didn't have money to buy paintings, because my parents were schoolteachers. And so I started to work with Buffet. I met Maurice Garnier when he came into the gallery we have on the Rue Saint-Honoré. We had a nice chat, he saw that we had a painting in the window by Buffet that I bought in auction, and after that we started a relationship with him.[12]

Dyan has an engaging, relaxed manner that appeals to the modern buyer, and through Opera and its network of well-located galleries, Buffet's work has been introduced to a new generation of collectors, including soul artist Lionel Richie. Richie tells how some years ago he visited Opera in Los Angeles, and Dyan asked him which of the pictures he was attracted to. His eye was immediately drawn to two Buffets, a particularly fine clown and a late painting of flowers from 1999.

Opera Gallery has been an important driver of the twenty-first-century Buffet revival, attracting younger collectors from fast-growing economies and targeting the brand-literate leisure shopper for whom the snobberies of the European art world are irrelevant and for whom Buffet offers the chance to acquire a known artist with an unmistakable style.

'I think people like it because it is very easy to recognise a Buffet painting,' explains Jean-David Malat, a handsome, athletic-looking young man with hair cropped close to his scalp. In his slim-lapelled suit, white shirt and narrow tie, a few millimetres of crisp white handkerchief protruding from his breast pocket with geometric precision, he could have strayed from the runway of a fashion presentation in Milan or Paris. And indeed, before he entered the art business, Malat worked for French fashion designer Jean-Claude Jitrois, heading up his London operation. Although he lacked any formal training in art or art history, he was headhunted by Gilles Dyan in 2005 to run the London branch of the Opera Gallery. 'A work by Buffet has a real style,' he continues. 'It is strong and sometimes it's difficult to say

why people love his work. But they do. I think most of the people buy a Buffet because they like it, but now that the market is picking up a lot, people are grabbing them also for investment.'[13]

Interviewed by London's *Times* in the summer of 2014 under the headline 'Why Celebrity Art-lovers Adore Jean-David Malat',[14] he highlighted the investment potential offered by Buffet. 'If I had £100,000, I'd invest in a painting by French expressionist painter Bernard Buffet,' he told the newspaper, adding, 'I can tell you, his paintings will go up fivefold. It's very good investment.'[15] His prediction would seem to be accurate: since that article appeared, the market has moved on and there are fewer good-quality works at the £100,000 level. Quite how beneficial Opera's endorsement will be for the long-term critical rehabilitation of Buffet's oeuvre remains to be seen.

But the art world is a curious place, where passion and emotion meet money and prestige; thus one of the more exotic results of Opera's involvement with Buffet was a museum show on the shores of the Caspian Sea of works loaned by the Fonds de Dotation Bernard Buffet, set up by Maurice Garnier. The exhibition was brought to the capital of Azerbaijan under the patronage of Leyla Aliyeva, the daughter of the president. Aliyeva is a slight young woman with soulful eyes and delicate features, who looks like an unlikely candidate for Buffet's work; nevertheless, her response was personal, emotional and immediate. 'I discovered Buffet and his work a few years ago and straight away fell in love with his paintings. For me, his work is full of emotion and expresses so many of his deepest feelings. Even his darkest drawings convey a positive energy and allow us to look inside what is clearly a very sensitive and special soul. The energy that comes through in his work is extremely powerful.'[16]

And so September 2014 saw a show of works by Buffet open at the gleaming new Heydar Aliyev Centre. It may be intended as a showcase for the cultural and artistic life of this new nation, but the building is also a powerful work of creativity in its own right, the huge folds of concrete rippling out of the ground and then looping into the darkening Caspian sky on the evening of the *vernissage* like some luminous hypermodernist roller coaster. Designed by that darling of the international intelligentsia Zaha Hadid, the building speaks just as eloquently of its era as the Soviet-period structures around the city do of theirs, and was recognised with the Design Museum award of 2014.

For Aliyeva, the arrival of Buffet's paintings in the nation's capital was clearly as much of a cultural coup as getting Hadid to design the building in which they were shown. 'I am delighted that this unique retrospective of Bernard Buffet's work has come to Baku and is being showcased in the Heydar Aliyev Centre so beautifully created by one of the world's most talented architects, Zaha Hadid'[17] was the way she put it in her words of welcome.

Over the past year, we have been lucky enough to have some of the world's greatest artists on show here, from Andy Warhol to Tony Cragg. However, this particular project holds a special excitement for me, as Buffet is one of my favourite artists. It is said that Warhol was a fan too (and who can doubt his judgement!), so it feels appropriate that we are able to bring the works of both these two amazing artists to Baku in under a year since the Centre launched.[18]

Their arrival caught in the ragged stroboscope of photographers' flashbulbs, the audience on the opening evening was an appreciative one. But as well as the attendance of what in the West would probably be described as local oligarchs and the predictably respectful attention of the local and regional media, there were also international artists including Joana Vasconcelos, Jean-Michel Othoniel, Idris Khan and Annie Morris dotted among the throng, along with star curator Hervé Mikaeloff, an informal cultural adviser to the Heydar Aliyev Centre.

Aliyeva concluded her welcoming words in a way that was part plea and part call to action.

Although a prodigious painter, who produced over 12,000 pieces of work, in many ways today [Buffet's] work has been forgotten. I am hopeful that by showcasing his drawings and paintings at this retrospective in Baku, more people will, like me, discover him and more galleries and museums will fall in love with his paintings, as I have done, and put them on display around the world.[19]

However, it was not the museums and galleries around the world that were proving hard to convince, but rather the ones in the painter's homeland. As has been seen, France's smaller regional museums had no problem exhibiting the work of Bernard Buffet and enjoying the

high visitor numbers that resulted. Périer's Le Touquet show, for instance, was particularly high profile, even warranting coverage on national television.

It is a great sadness that, rather like Moses condemned to lead his people to the Promised Land but not to live in it himself, Garnier died in January 2014 without knowing whether a mooted show of Buffet's works at the Musée d'Art Moderne de la Ville de Paris was going to take place or not. Instead he went to his grave convinced that Buffet was still a cultural pariah. As it was, his last experience dealing with a French museum had been particularly frustrating. In 2012, his gallery had been approached to mount an exhibition of Buffet's works at the Espace Fernet Branca in Saint-Louis, a small town near France's border with Germany and Switzerland. He had visited the space and created the catalogue, but with only a few months to go, the show had been cancelled. It was only some time later that he heard that one possible reason for this abrupt cancellation was that funding might have been withdrawn had the exhibition been held.

'They wanted it to be a foundation so they had to be linked to receive money from the FRAC [the Fonds Régional d'Art Contemporain]. The FRAC asked what the next exhibition was and they said Bernard Buffet and they cancelled,' explains Céline Lévy who now runs his gallery following Garnier's death. 'But we were not told the reason, the real reason, until Sébastien [Janssen] heard it at the Basel fair.'[20]

However, even as this regional museum was finding it difficult to put on its Buffet show, minds at the top of French cultural life were becoming more open to the possibility of the artist's work. In 2013, the tireless Périer assisted Beijing-based art dealer Fabien Fryns in bringing a show of Zeng Fanzhi's work to Paris's prestigious museum of modern art.

In those days Fanzhi was white hot, the most expensive living Asian artist at auction. He is, like Buffet before him, a figurative artist. Like Buffet too he is unafraid to tackle monumental canvases; the difference is that while Buffet had to clamber up and down ladders, Fanzhi makes use of an automated cherry-picker platform of the sort used by engineers to mend street lamps and overhead cables. Fanzhi too experienced a shift from poverty to extreme riches, and like Buffet he is unafraid to enjoy the better things that life has to offer: one of his paintings is of a pair of red shoes made by John Lobb. He shops at Hermès, he smokes rare and expensive vintage Cuban Davidoff cigars,

and instead of a Rolls he has a Ferrari. His paintings hang in some of the most prestigious collections in the world, and the desirability of his work and the parallels with Buffet have not escaped the auction houses. One catalogue of 2015 presenting a clown painting by Buffet for sale in its Chinese saleroom likened Buffet's clowns to Fanzhi's highly collectable series of mask paintings.

During the course of preparing the Fanzhi exhibition, Périer and museum director Fabrice Hergott would discuss Buffet. Hergott is a softly spoken, sensitive, scholarly man. Like many others, he was intrigued by the swift, diametric revision that the artist's reputation underwent.

Of course, he was affected and maybe hurt by the fact that no museums, serious European museums, were interested in his work. I think for him it was very hurtful and this maybe pushed him to make paintings that are not so novel. For an artist, having no success is a problem, having too much success is a problem too. In his life he had the challenges of the two. He was very successful when he was young and totally hated by official people when he was older. But he still continued to paint.[21]

As Hergott studied Buffet's remarkable output, various art-historical parallels began to present themselves to him. First of course was Buffet's debt to Francis Gruber, the original painter of *misérabilisme*. Then what struck him was Buffet's mastery of light. 'What is very important is the way of representing the light. I think that he is a great artist of light. It is very impressive how he succeeds in putting a sensation of light into his art.' In this respect Hergott likens him to Toulouse-Lautrec or 'Derain in the twenties and thirties; and sometimes Fautrier'. The more he looked into Buffet's work, the more he found. 'Perhaps you have things in *Les Folles* which make you think of Otto Dix's prostitutes.' In *Horreur de la Guerre* he found 'a subject which is very close to *Guernica*'.[22]

And then the realisation dawned on Hergott that he was looking at the work of a genius. 'In his way of working he is something like Mozart. He is full of talent. He can do everything. The only thing is that he did a lot, too much, and there are a lot of very commercial paintings that he made without thinking of what he was doing, just repeating himself,' he says. 'But you have to look at his work more closely and you see that there is not so much repetition.'

He determined to mount an exhibition of the entire oeuvre of the painter, though there would be one major problem. 'It's very difficult to make the selection, because I think there are a lot of good paintings. It will be very hard to make a good selection, to still have a good show, [as] I think people are not able to see more than 100 to 140 paintings, so we have to be very selective. This will be the main problem with the show.'[23]

As to Buffet's place in the history of twentieth-century art, Hergott positions him exactly where the critics in the middle of the century saw him. 'I think that one can probably say that Buffet is the link between Picasso and Andy Warhol.' In support of this argument he cites Warhol's high regard for Buffet. As to the question of Buffet's standing vis-à-vis Picasso: 'It is hard to say,' he observes sagely, 'but I believe they are both major artists. It is true that Picasso is perhaps more creative, more inventive in technique, there is variety. *Chez* Buffet there is something very spectacular and very striking, which is very personal. I believe that Picasso is perhaps a greater artist, but that is to be seen.'[24]

It may be that the most interesting chapters in the extraordinary story of Bernard Buffet have yet to be written.

Acknowledgements

This book simply would not have happened had it not been for the help, support and belief of many people. In such cases the author can claim merely to be a conductor of an orchestra interpreting a piece of music. Most significant is of course my publisher Trevor Dolby, who somehow managed to convince his colleagues at Random House of the wisdom of publishing a book about someone who, at least at the time I embarked upon this book, was a neglected French painter; without his encouragement I would have been lost. His colleague Lizzy Gaisford has likewise been a great support. As ever I must thank my agent Luigi Bonomi, who has accompanied me throughout what in my more self-important moments I call my career as an author.

The Galerie Maurice Garnier deserves not just my thanks but those of the art world for its extraordinary work preserving the Buffet oeuvre for posterity. I do not think it too far-fetched to say that had it not been for the iron will of the late Maurice Garnier and his belief in the painter, Bernard Buffet would be fading into memory. Although he is not around to read this I would nevertheless like to thank Maurice Garnier for his kindness, his time and for making me feel so welcome in the world of Bernard Buffet; he was a remarkable individual. I would like to thank Maurice's widow Ida, who now owns the gallery and whose recollections of life in Buffet's inner circle have proved highly illuminating. Céline Lévy, who manages the gallery, has been indispensable; she has helped with so many aspects of the book that to enumerate them here would lengthen this book by quite a few pages. Céline's colleagues Jacques Gasbarian, Bernard Meheust and Jean-Luc Margotteau have also been kind enough to assist in many ways. They have given me the access to many archives and to the works belonging to the *Fonds de Dotation Bernard Buffet* and shared with me their unequalled knowledge of Bernard Buffet and his work. I am

extremely grateful to Nicolas Buffet for his time and memories and for his patience spending hours being asked tedious questions by the author. Likewise Koko Okano of the Musee Bernard Buffet in Japan has been crucial in putting together the pieces of this extraordinary life and I am so grateful for the time she spent with me during my visit to Japan and for her help throughout the project. I must also thank Leyla Aliyeva for a fascinating visit to Baku on the occasion of the Buffet exhibition at the Heydar Aliyev Centre.

I am also extraordinarily grateful to the people who were able to share their memories of Buffet and his times. I was privileged to be able to meet Pierre Bergé, one of the giants of modern France, and I thank him for his candour and his time. Jacqueline de Ribes, the most elegant woman in France, was, as ever, wonderful to spend time with and imparted her recollections of being with the Buffets in Moscow and Leningrad on an extraordinary trip taken by Le Tout Paris to the USSR at the height of the Cold War. Juliette Greco meanwhile shed valuable light on life in St Germain des Pres after the war and helped me better understand the mores and the people of that time. I was also extremely fortunate in being able to take some of Sir John Richardson's valuable time and to learn more about life at the court of Picasso. Martin Summers also deserves my thanks for his remarkable revelations about Buffet's birthday party. Indeed all my interviewees were extremely helpful: Doris Brynner, Christian Dazy, Marc Donnadieu, Gilles Dyan, Fabrice Hergott, Sebastien Janssen, Adam Lindemann, Jean David Malat, Tilman Osterwold, Henry Perier, Alexander Roob and Kiyotsugo Tamenaga among them. Out of Buffet's collectors Stephan Wrobel has been a true collaborator on, and supporter of, the project; he must be one of the best-informed Buffet scholars, and getting to know him as a connoisseur of cigars as well as art has been one of the great pleasures of writing this book.

But as well as pleasure there has been a lot of organisation, so I am lucky to have had the support of my assistant Venetia Stanley, whose hard work has been essential. I also had the good fortune to have been assisted in the research by Fabian Midby, and by Bridget Arsenault in the task of compiling the bibliography, which would have been even more of a nightmare had she not been able to spend her weekends making sense of my unintelligible notes and incomplete citations.

Among the many others who helped me are: Bernard Arnault, Charles Saumarez-Smith, Evelyne Genta, Caroline Scheufele, Lionel Richie, Jean Paul Claverie, Michael Burke, Isabella Capece Galeota, Francoise Dumas, James McBride, John Rolfs, Philippe Leboeuf, Nicolas Nebout, Edward Sahakian, Stansislas de Quercize, Andrea Riva, Karen Markham, Annie

Holcroft, Karen Hibbert, Charlotte Owen, Annabel Davidson, Rosalia Pagliarani, Anne Boulay, Pietro Beccari, Jean Pierre Martel for his expertise on the corrida, Lucy Fryns, and of course her husband Fabien, the man who made me decide that a book about Buffet needed to be written in English.

Picture Credits

All images © ADAGP-2015 except:

Section one

p.5 bottom: supplied by Stephan Wrobel
p.6 bottom: Maurice Jarnoux/Getty
p.7 bottom: Maurice Jarnoux/Getty
p.8 top section, top right image: Luc Fournol/Diomedia; top section, bottom left: Keystone-France/Getty; top section, bottom right: Dean Loomis/Getty; bottom section, top left: Philippe Le Tellier/Getty; bottom section, top right: Bertrand Rindoff Petroff/French select/Getty; bottom section, bottom left: Der Spiegel

Section two

p.2 top: private collection; bottom: Luc Fournol/Diomedia
p.3 top: RDA/Hutton archive/Getty; bottom left: Luc Fournol/Diomedia; bottom right: Dean Loomis/Getty
p.4 top: Francois Pages/Paris Match Archive/Getty
p.5 top: Musée Bernard Buffet, Japan/ photo by Tadasu Yamamoto
p.7 middle and bottom right: Benjamin Auger/Getty
p.8 top: Nicolas Buffet

Notes

Introduction

1 Cocteau, *Le Passé Défini V*, p.444 (14 February 1957)

Chapter 1

1 Annabel Buffet, *Post Scriptum*, p.8
2 'Bernard Buffet, l'Artiste d'une Époque'
3 McNay, 'Bernard Buffet'
4 Smith, 'Bernard Buffet, French Painter'
5 Oliver, 'Bernard Buffet: Prolific French Painter'

Chapter 2

1 Maxwell, 'Whatever Happened to Bernard Buffet?'
2 *Bernard Buffet, From Here to Eternity*
3 Lamy, *Bernard Buffet: Le Samourai*, pp.20–1
4 Laurent, *Bernard Buffet: Le Peintre Crucifié*, p.11
5 Lamy, *Bernard Buffet: Le Samourai*, p.22
6 Flanner, 'Le Gamin'
7 Laurent, *Bernard Buffet: Le Peintre Crucifié*, p.18
8 Flanner, 'Le Gamin'
9 *Bernard Buffet, From Here to Eternity*
10 Bernard Buffet, 'La Leçon de J. A. Gros'
11 Annabel Buffet, *Post Scriptum*, p.16
12 Ibid., p.17
13 Flanner, 'Le Gamin'
14 Hourdin, *L'Enfer et le Ciel*, p.118

Chapter 3

1 Perrault, *Paris Under the Occupation*
2 Ibid.
3 Flanner, 'Le Gamin'
4 Ibid.
5 Descargues, *Bernard Buffet*, p.19
6 Greffe, 'Chez Bernard Buffet'
7 Descargues, *Bernard Buffet*, p.20
8 Hourdin, *L'Enfer et le Ciel*, p.119
9 Perrault, *Paris Under the Occupation*, p.18
10 Ibid.
11 Ibid., pp.13–14
12 Descargues, *Bernard Buffet*, p.21
13 Flanner, 'Le Gamin'
14 *Bernard Buffet, From Here to Eternity*
15 Flanner, 'Le Gamin'
16 Descargues, *Bernard Buffet*, p.21
17 Nanquette, 'C'était Bernard Buffet'
18 Flanner, 'Le Gamin'
19 Perrault, *Paris Under the Occupation*, pp.13–14
20 Annabel Buffet, *Post Scriptum*, p.157
21 Lamy, *Bernard Buffet: Le Samourai*, p.26
22 Ibid., p.27

Chapter 4

1 Descargues, *Bernard Buffet*, p.14
2 Guth, 'Il Ne Faut Pas'
3 Bauer, *Bernard Buffet*
4 Maxwell, 'Whatever Happened to Bernard Buffet?'
5 Descargues, *L'Art est Vivant*, p.321
6 Sartre, *Existentialism and Humanism*, p.25
7 Descargues, *Bernard Buffet*, p.22
8 Nanquette, 'C'était Bernard Buffet'
9 Descargues, *L'Art est Vivant*, p.323
10 Gauthier, 'Dans l'Atelier'
11 Guth, 'Il Ne Faut Pas'
12 Bauer, *Bernard Buffet*
13 Bergé, *Bernard Buffet*, p.11
14 Ibid.

15 Descargues, *L'Art est Vivant*, pp.323–4

16 Descargues, Bernard Buffet first exhibition catalogue

17 Descargues, *Bernard Buffet*, p.30

Chapter 5

1 Flanner, 'Le Gamin'

2 Nanquette, 'Bernard m'écrit'

3 Ibid.

4 Flanner, 'Le Gamin'

5 Ibid.

6 Stievenard, p.21

7 Nanquette, 'Bernard M'écrit'

8 Quoted in Sotheby's catalogue, Paris, 4 December 2013

9 Letter to Maurice Jardot, August 1947, quoted by Jean-Michel Stievenard, *L'Art Modern à Villeneuve d'Asq*, p.24

10 Modigliani, *Portrait de Roger Dutilleul*

11 Flanner, 'Le Gamin'

12 David, *Le Métier de Marchand de Tableaux*, p.214

13 Ibid.

14 Flanner, 'Le Gamin'

15 David, *Le Métier de Marchand de Tableaux*, p.215

16 Ibid.

17 Correspondence, Saturday 21 August 1948, LAM archives

Chapter 6

1 David, *Le Métier de Marchand de Tableaux*, p.39

2 Maurice Garnier, interview with the author, September 2013

3 Ibid.

4 David, *Le Métier de Marchand de Tableaux*, p.39

5 Ibid., pp.39–40

6 Ibid., p.213

7 Ibid., p.216

8 Ibid., pp.219–20

9 Beevor and Cooper, *Paris After the Liberation*, p.419

10 Negulesco, *Things I Did*, p.255

11 David, *Le Métier de Marchand de Tableaux*, p.95

12 Negulesco, *Things I Did*, pp.257–9

13 Ibid., p.169

14 *How to Marry a Millionaire*, original cinema trailer

15 Negulesco, *Things I Did*, p.260

16 Tyrnauer, 'To Have and Have Not'

17 Negulesco, *Things I Did*, pp.235–6

18 Stone, 'Paintings by Bernard Buffet'

19 David, *Le Métier de Marchand de Tableaux*, p.93

20 Negulesco, *Things I Did*, p.259

21 Manceaux, 'La Réussite'

Chapter 7

1 Barry, 'To Them Picasso Is Old Hat'

2 Flanner, 'Le Gamin'

3 Nanquette, 'Devant la Porte de Mon Hôtel'

4 Ibid.

5 Barry, 'To Them Picasso Is Old Hat'

6 Ibid.

7 Ibid.

8 Hourdin, *L'Enfer et le Ciel*, p.30

9 Flanner, 'Le Gamin'

10 Hourdin, *L'Enfer et le Ciel*, p.30

11 Ibid.

12 David, *Le Métier de Marchand de Tableaux*, p.220

13 Flanner, 'Le Gamin'

Chapter 8

1 Nanquette, 'C'était Bernard Buffet'

2 Nanquette, 'Devant la Porte de Mon Hôtel'

3 'Bernard Buffet: Métamorphosé par l'Amour'

4 Nanquette, 'Devant la Porte de Mon Hôtel'

5 Ibid.

6 Ibid.

7 Nanquette, 'Le Mariage le Moins Cher Possible'

8 Nanquette, 'Devant la Porte de Mon Hôtel'

9 Nanquette, 'Le Mariage le Moins Cher Possible'

10 Ibid.

11 Ibid.

12 Ibid.

13 Ibid.

14 Ibid.

15 Nanquette, 'Le 28 Novembre 1948'

16 Nanquette, 'Le Premier Soir Fut Atroce'

17 Ibid.

18 Cabanne, *Bernard Buffet: Peintres d'Aujourd'hui*

19 Nanquette, 'Agnès, Me Lanca Bernard'

20 Ibid.

21 Ibid.

22 Ibid.

Chapter 9

1 Maurice Garnier, interview with the author, September 2013

2 Ibid.

3 Ibid.

4 Ibid.

5 Maurice Garnier, interview with the author, 24 May 2013

6 Maurice Garnier, interview with the author, September 2013

7 Simenon and Bouret, *Buffet, Bernard*

8 Video made by Sotheby's to accompany sale of Amedeo Modigliani's portrait of Dutilleul, 4 December 2013

9 Buffet and Lamy, *Bernard Buffet: The Secret Studio*, p.37

10 *Bernard Buffet, From Here to Eternity*

11 Hourdin, *L'Enfer et le Ciel*

12 Bergé, *Bernard Buffet*, p.16

13 Kramer, 'The Impressario's Last Act'

14 Peyrani, *Pierre Bergé*, p.61

15 Maurice Garnier, interview with the author, 24 May 2013

16 Pierre Bergé, interview with the author, 17 December 2013

17 Ibid.

18 Ibid.

19 Pierre Bergé, interview with the author, May 2013

20 Ibid.

21 Pierre Bergé, interview with the author, 17 December 2013

22 Ibid.

23 Pierre Bergé, interview with the author, May 2013

24 Ibid.

25 Ibid.

26 Pierre Bergé, interview with the author, 17 December 2013

27 Descargues, *Bernard Buffet*, p.32

28 Pierre Bergé, interview with the author, 17 December 2013

Chapter 10

1 Descargues, *Bernard Buffet*, p.54

2 Ibid.

3 Ibid., p.56

4 Manceaux, 'Entretien: Bernard Buffet'

5 Greffe, 'Chez Bernard Buffet'

6 Laurent, *Bernard Buffet: Le Peintre Crucifié*, p.123

7 Pierre Bergé, interview with the author, 17 December 2013

8 Durand, *La Divine Comédie de Bernard Buffet*

9 Ibid.

10 Descargues, *Bernard Buffet*, p.63

11 Watt, 'Paris Commentary'

12 Ibid.

13 Browder, *Andre Breton: Arbiter of Surrealism*, p.9

Chapter 11

1 Pierre Bergé, interview with the author, 17 December 2013

2 Jarnaux, 'Bernard Buffet: Vous Fait Visiter Sa Ferme'

3 Bergé, *Les Jours S'en Vont Je Demeure*, p.67

4 Ibid., p.66

5 Simenon and Bouret, *Buffet, Bernard*

6 Ibid.

7 Ibid.

8 Pierre Bergé, interview with the author, 17 December 2013

9 Galerie Maurice Garnier, email to the author, July 2015

10 10 March 1956. 'Revue Giono', p.105

11 Ibid.

12 Ibid.

13 Pierre Bergé, interview with the author, 17 December 2013

14 Bergé, 'Eight Drawings'

15 Kramer, 'The Impresario's Last Act'

16 Bergé, *Bernard Buffet*, p.29

17 Ibid., p.28

18 Aragon, 'Le Paysage Français'

19 Ibid.

20 Hussey, *Paris: The Secret History*, p.392

Chapter 12

1 Bergé, 'Eight Drawings'
2 Descargues, *Bernard Buffet*, p.76
3 Ibid.
4 Ibid., pp.78–9
5 Guth, 'Il Ne Faut Pas'
6 Manceaux, 'Entretien: Bernard Buffet'
7 Unidentified press clipping, 1954/5
8 Guth, 'Il Ne Faut Pas'
9 Descargues, *Bernard Buffet*, p.76
10 Pierre Bergé, interview with the author, 17 December 2013
11 Anonymous press clipping, 1954/5
12 *La Presse*, 24 January 1956
13 'Is the Buffet Bubble About to Burst?'
14 Nationwide Building Society website, 2015
15 ONS House Price Index, 13 January 2015
16 Descargues, *Bernard Buffet*, p.76
17 Sir John Richardson, interview with the author, November 2014
18 Ibid.
19 Laurent, Stéphane, Le Peintre Crucifié, p.148

Chapter 13

1 Fabrice Hergott, interview with the author, 24 May 2013
2 Descargues, *Bernard Buffet*, p.76
3 Barry, 'To Them Picasso Is Old Hat'
4 de Vlaminck, *Dangerous Corner*, p.77
5 Barry, 'To Them Picasso Is Old Hat'
6 Maurice Garnier, interview with the author, 24 May 2013
7 Sir John Richardson, interview with the author, November 2014
8 Unidentified press clipping, 1954/5
9 Cartier, 'Le Cirque Vu par Bernard Buffet'
10 Ibid.
11 Bergé, 'Bernard Buffet Vu par Pierre Bergé'
12 Bergé, *Bernard Buffet*, p.9
13 Druon, *Bernard Buffet*,
14 Guth, 'Il Ne Faut Pas'
15 Manceaux, 'Entretien: Bernard Buffet'
16 Sir John Richardson, interview with the author, November 2014
17 Ibid.

Chapter 14

1 'Buffet: Elend in Oel'
2 Ibid.
3 Barbero, *Venice: The Art Scene*, p.62
4 Ibid., pp.66–7
5 David, *Le Métier de Marchand de Tableaux*, p.231
6 Maurice Garnier, interview with the author, 24 May 2013
7 Ottoni and Jarnoux, 'Bernard Buffet'
8 Ibid.
9 Descargues, *Bernard Buffet*, p.11
10 Maxwell, 'Whatever Happened to Bernard Buffet?'
11 Bernard Buffet, 'On Me Reproche de Gagner Trop d'Argent'
12 Cocteau, *Le Passé Défini V*, p.83
13 Ibid.
14 'Buffet: Elend in Oel'
15 Ibid.
16 *Spectator*, 20 September 1956
17 Barry, 'To Them Picasso Is Old Hat'
18 *The Times*, 14 April 1951
19 Pierre Bergé, interview with the author, 17 December 2013
20 *Spectator*, 20 September 1956
21 *Bernard Buffet, From Here to Eternity*, archive film clip
22 Maurice Garnier, interview with the author, 24 May 2013
23 *New Yorker*, 1959
24 Ibid.
25 Hook, 'Monet, Manet, Money'
26 Ibid.
27 *Life* magazine, 25 November 1957
28 Special Correspondent, 'Seven Paintings'
29 Love, '7 Paintings Sold'
30 Pierre Bergé, interview with the author, May 2013

Chapter 15

1 Bernard Buffet, 'On Me Reproche de Gagner Trop d'Argent'
2 Wagener, *Je Suis Née Inconsolable*, p.344
3 Ibid., p.343
4 Ibid.
5 Unidentified press clipping, Dallas Morning News Archives

6 Ibid.

7 Wagener, *Je Suis Née Inconsolable*, p.345

8 Pierre Bergé, interview with the author, 17 December 2013

9 Maxwell, 'Whatever Happened to Bernard Buffet?'

10 Pierre Bergé, interview with the author, 17 December 2013

11 Rawsthorn, *Yves Saint Laurent*, p.30

12 Ibid., p.31

Chapter 16

1 Schneider, 'France's Fabulous Young Five'

2 Ibid.

3 *New York Times*, 27 October 1957

4 'An Artist Must Eat'

5 Devay, 'Ce Jeune Homme Pale'

6 'An Artist Must Eat'

7 Williams, 'The Story of the Creation of Françoise Sagan's Le Rendez-Vous Manqué'

8 *The Times*, 19 February 1958

9 Schneider, 'France's Fabulous Young Five'

10 'Paris Gets a New Play'

11 Ibid.

12 Pierre Bergé, interview with the author, 17 December 2013

13 *New Yorker*, 21 November 1959

14 Ibid.

15 Exhibition catalogue, Galerie Charpentier

16 Fels, 'Le Roman de l'Art Vivant', p.246

17 Mauriac, 'Le Bloc-Notes de François Mauriac'

18 'Bernard Buffet a Signé des . . . Tickets de Métro'

19 *New Yorker*, 1 February 1958

20 'Atmosphère de Grand Match de Boxe'

21 'The Eye of the Artist'

22 Ibid.

23 'Le Peintre Bernard Buffet a du Sortir'

24 'Atmosphère de Grand Match de Boxe'

25 *New Yorker*, 1 February 1958

26 *Arts*, 19–25 February 1958

27 'Une Exposition "A Sensation" à la Galerie Charpentier'

28 Mauriac, 'Le Bloc-Notes de François Mauriac'

29 *New Yorker*, 1 February 1958

30 'Témoinages Contradictoire'
31 Association Georges Hourdin
32 Hourdin, *L'Enfer et le Ciel*, pp.11–12
33 Ibid., p.30
34 Ibid., p.23
35 Ibid., p.36
36 Ibid., pp.16–17
37 Ibid., p.19
38 Ibid.
39 Ibid., p.64
40 Ibid., p.65
41 Ibid., p.104
42 'Atmosphère de Grand Match de Boxe'
43 'Bernard Buffet a Signé des . . . Tickets de Métro'
44 Descargues, *Bernard Buffet*, pp.92–3
45 Ibid., p.92
46 *New Yorker*, 21 November 1959

Chapter 17

1 Cocteau, *Le Passé Défini V*, p.444 (14 February 1957)
2 Devay, 'Ce Jeune Homme Pale'
3 Fels, 'Le Roman de l'Art Vivant', p.253
4 Descargues, 'Jeanne d'Arc en 7 Tableaux'
5 Cohen-Solal, *Leo and His Circle*, p.235
6 David, *Le Métier de Marchand de Tableaux*, p.232
7 Maurice Garnier, interview with the author, autumn 2013
8 Ibid.
9 Ibid.
10 Druon, *Bernard Buffet*

Chapter 18

1 Druon, *Bernard Buffet*
2 Sischy, 'Jeff Koons is Back'
3 *Daily Mail*,
4 Cornell, 'The Buffet Enigma'
5 Druon, *Bernard Buffet*
6 Gaillard, 'La Nouvelle Maison d'An'

7 Druon, *Bernard Buffet*

8 Cocteau, *Le Passé Défini V* (13 July 1958)

9 Descargues, *L'Art est Vivant*, p.327

10 Druon, *Bernard Buffet*

11 Ibid.

12 *New Yorker*, 21 November 1959

13 Annabel Buffet, in Druon, *Bernard Buffet*

14 *New Yorker*, 21 November 1959

15 Bergé, *Les Jours S'en Vont Je Demeure*, p.71

16 Maxwell, 'Whatever Happened to Bernard Buffet?'

17 Pierre Bergé, interview with the author, 17 December 2013

18 Bergé, *Les Jours S'en Vont Je Demeure*, pp.69–70

19 Ibid., p.71

20 Maxwell, 'Whatever Happened to Bernard Buffet?'

21 'An Artist Must Eat'

22 Cocteau, *Le Passé Défini V* (7 June 1957)

Chapter 19

1 *New York Times*, 31 January 1958

2 Rawsthorn, *Yves Saint Laurent*, p.36

3 Ibid.

4 Pierre Bergé, interview with the author, May 2013

5 Loren, 'Actress Sophia Loren's Favorite Things'

6 Pierre Bergé, interview with the author, 17 December 2013

7 Ibid.

8 Private collection of Martin Summers

9 Martin Summers, interview with the author, July 2014

Chapter 20

1 Juliette Gréco, interview with the author, 15 July 2014

2 Ibid.

3 Maurice Garnier, interview with the author, autumn 2013

4 Juliette Gréco, interview with the author, 15 July 2014

5 Buffet and Sagan, *Toxique*, p.22

6 Nicolas Buffet, interview with the author, February 2015

7 Buffet and Sagan, *Toxique*, p.35

8 Brigneau, 'Les Maries de Provence'

9 Buffet and Lamy, *Bernard Buffet: The Secret Studio*

10 *Arts*, 19–25 February 1958

11 Maurice Garnier, interview with the author, October 2013

12 Ida Garnier, interview with the author, 23 January 2015

13 Juliette Gréco, interview with the author, 15 July 2014

14 Annabel Buffet, *D'Amour et d'Eau Fraîche*, p.18

15 Ibid., p.90

16 Ibid., p.132

17 Ibid., p.133

18 Ibid., p.137

19 Ibid., p.148

20 Annabel Buffet, *Post Scriptum*, p.57

21 Ibid., p.58

22 Ibid., p.57

23 Ibid., p.58

24 Ibid.

25 Ibid., p.59

26 Ibid.

27 Juliette Gréco, interview with the author, 15 July 2014

28 Annabel Buffet, *Post Scriptum*, p.59

29 Ibid., pp.59–60

Chapter 21

1 'Bernard Buffet: Métamorphosé par l'Amour'

2 Annabel Buffet, *Post Scriptum*, pp 61–2

3 Ibid., p.63

4 Ibid.

5 Dariel, 'Le Peintre Bernard Buffet a Disparu'

6 Annabel Buffet, *Post Scriptum*, p.59

7 *Paris Match*, 23 August 1958

8 Annabel Buffet, *D'Amour et d'Eau Fraîche*, p.250

9 'Bernard Buffet: Métamorphosé par l'Amour'

10 Ibid.

11 Ibid.

12 Annabel Buffet, *D'Amour et d'Eau Fraîche*, pp.292–6

13 Cocteau, *Le Passé Défini* VI, p.401

14 Annabel Buffet, *D'Amour et d'Eau Fraîche*, p.110

15 Ibid., p.157

16 Pierre Bergé, interview with the author, May 2013

17 Annabel Buffet, *D'Amour et d'Eau Fraîche*, p.292

Chapter 22

1 Hussey, *Paris: The Secret History*, p.397

2 *Guardian*, obituary of General Jacques Massu, 28 October 2002

3 Annabel Buffet, *Post Scriptum*, p.59

4 'Bernard Buffet: Métamorphosé par l'Amour'

5 Simenon, Monsieur Georges, et Madame Bernard Buffet

6 Restany, 'Bernard Buffet'

7 Bouret, *Les Lettres Françaises*

8 Ibid.

9 Roe, *In Montmartre*, p.270

10 Druon, *Bernard Buffet*

11 Lamouche, La Theorie Harmonique, p.48

12 Maurice Garnier, interview with the author, 24 May 2013

13 Buffet and Lamy, *Bernard Buffet: The Secret Studio*, p.34

14 Laurent, *Bernard Buffet: Le Peintre Crucifié*, p.213

15 Ibid.

16 Lamy, *Bernard Buffet: Le Samourai*, p.246

Chapter 23

1 Zana, 'Bernard Buffet, Le Paria'

2 *New York Times*, 10 May 1959

3 Canaday, 'Jean Dubuffet'

4 Ibid.

5 *Buffalo Courier Express*, 17 March 1960

6 Druon, *Bernard Buffet*

7 Beaton, *The Unexpurgated Beaton*, p.246

8 Zana, 'Bernard Buffet, Le Paria'

9 'Annabel Buffet Vue par Bernard Buffet'

10 'Bernard et Annabel Buffet: Un Château de Bohême'

11 'Annabel Buffet Vue par Bernard Buffet'

12 Annabel Buffet, *D'Amour et d'Eau Fraîche*

13 Annabel Buffet, 'Ou Sont les Bretelles de Bernard?'

14 Greffe, 'Chez Bernard Buffet'

15 Cocteau, *Le Passé Défini V*, p.83

16 'Annabel Buffet Vue par Bernard Buffet'

17 Annabel Buffet, *D'Amour et d'Eau Fraîche*, p.254

18 Ibid., pp. 251–2

19 Greffe, 'Chez Bernard Buffet'

20 Ibid.

Chapter 24

1 'The Phenomenal Mr Buffet'
2 Ibid.
3 Descargues, 'Bernard Buffet le Peintre le Plus Discuté de Notre Époque'
4 Ibid.
5 Descargues, *L'Art est Vivant*, pp.326–7
6 D'Assailly, 'À La Découverte de Bernard Buffet'
7 Annabel Buffet, *D'Amour et d'Eau Fraîche*, p.272
8 Ibid., pp.118–19

Chapter 25

1 Ajamé, '12 Questions à Bernard Buffet'
2 Descargues, *L'Art est Vivant*, pp.326–7
3 Bergé, *Les Jours S'en Vont Je Demeure*
4 Pierre Bergé, interview with the author, 17 December 2013
5 Maurice Garnier, interview with the author, September 2013
6 Ibid.
7 Pierre Bergé, interview with the author, 17 December 2013
8 Maurice Garnier, interview with the author, September 2013
9 Ibid.
10 Pierre Bergé, interview with the author, May 2013
11 Maurice Garnier, interview with the author, September 2013

Chapter 26

1 Yamamoto, *Bernard Buffet 1945–1999*
2 *Bernard Buffet, From Here to Eternity*, newsreel footage
3 Descargues, *Bernard Buffet*, p.27
4 Clark, *Civilisation*, p.34
5 Ochsé, 'Bernard Buffet, Peintre de la Passion'
6 Ibid.
7 Negulesco, *Things I Did*, pp.261–2
8 Ochsé, 'Bernard Buffet, Peintre de la Passion'
9 *Bernard Buffet, From Here to Eternity*
10 Galerie Maurice Garnier, email to the author, July 2015
11 Rosalia Pagliarani (on behalf of Dr Micol Forti), email to the author, 29 December 2014

12 Druon, *Bernard Buffet*
13 Ibid.
14 Ibid.

Chapter 27

1 Ajamé, '12 Questions à Bernard Buffet'
2 Ibid.
3 Manceaux, 'Entretien: Bernard Buffet'
4 Ibid.
5 Druon, *Bernard Buffet*
6 Cabanne, *Bernard Buffet: Peintres d'Aujourd'hui*
7 Ibid.
8 Furukaki, *Mon Buffet*
9 Cabanne, 'Buffet Retrouvé'
10 Ibid.
11 Ibid.

Chapter 28

1 Kiichiro Okano, 'Buffet and I'
2 Akasegawa et al., *Bernard Buffet: 1945-1999*
3 Koko Okano, interview with the author, 11 December 2014
4 Ibid.
5 Ibid.
6 Ibid.
7 Furukaki, *Mon Buffet*
8 Ibid.
9 Kiyotsugu Tamenaga, interview with the author, October 2014
10 Furukaki, *Mon Buffet*
11 Ibid.
12 Kiyotsugu Tamenaga, interview with the author, October 2014

Chapter 29

1 Delassein, *Les Dimanches de Louveciennes*, Introduction
2 *Der Spiegel*, No.15, 1965
3 Comtesse de Ribes, interview with the author, 10 January 2015
4 Ajamé, '12 Questions à Bernard Buffet'
5 *Bernard Buffet, From Here to Eternity*

6 Wilson, 'It Happened Last Night'

7 Doris Brynner, interview with the author, December 2014

8 Sheppard, 'There's a New "In" Spot in Paris'

9 Negulesco, *Things I Did*, pp.261–2

10 Maurice Garnier, interview with the author, 24 May 2013

11 Juliette Gréco, interview with the author, 15 July 2014

12 Maxwell, 'Whatever Happened to Bernard Buffet?'

Chapter 30

1 Annabel Buffet, *D'Amour et d'Eau Fraîche*, p.163

2 Furukaki, *Mon Buffet*

3 Annabel Buffet, *D'Amour et d'Eau Fraîche*, pp.69–70

4 'Bernard et Annabel Buffet: Un Château de Bohême'

5 Maurice Garnier, interview with the author, 24 May 2013

6 Annabel Buffet, *D'Amour et d'Eau Fraîche*, pp.87–8

7 Nicolas Buffet, interview with the author, February 2015

8 Bolloré, 'Bernard Buffet: S'est Offert le Chateau des Rêves d'Enfant'

9 Ibid.

10 Ibid.

11 Annabel Buffet, *D'Amour et d'Eau Fraîche*, p. 157

12 Nicolas Buffet, interview with the author, February 2015

Chapter 31

1 Annabel Buffet, *D'Amour et d'Eau Fraîche*, p.157

2 Ibid., p.156

3 Ibid.

4 Fiette et al., *Zizi Jeanmaire*, p.202

5 Annabel Buffet, *D'Amour et d'Eau Fraîche*, p.156.

6 Ibid., p.157

7 Ibid.

8 Ibid., p.158

9 Ibid., p.160

10 Ibid., p.162

11 Ibid., p.171

12 Ibid.

13 *Paris Match*, February 1984; Godard, 'Pour Survivre Nous Sommes Nomades'

14 Radio interview, RTL, 5 September 1966

15 Video interview, 1983

16 Buffet and Lamy, *Bernard Buffet: The Secret Studio*, p.37

17 Parinaud, 'Je Suis Toujours Heureux de Peindre'

18 Annabel Buffet, *D'Amour et d'Eau Fraîche*, p.173

19 Heath and Kamperman, *Landmark Intellectual Property Cases and Their Legacy*

20 'Paris Court Thwarts an Icebox Multiplier'

21 Ibid.

22 *Copyright: Monthly Review*

23 Laurent, *Bernard Buffet: Le Peintre Crucifié*, p.258

Chapter 32

1 Fabrice Hergott, interview with the author, 24 May 2013

2 Maurice Garnier, interview with the author, 24 May 2013

3 Le Pichon, *Bernard Buffet*, p.265

4 Giannoli, video interview

5 Buffet and Lamy, *Bernard Buffet: The Secret Studio*

6 Annabel Buffet, *D'Amour et d'Eau Fraîche*, p.243

7 Nicolas Buffet, interview with the author, February 2015

Chapter 33

1 De Beauvais, 'Buffet Peint la Révolution dans Son Château'

2 Ibid.

3 Annabel Buffet, *3 Petits Tours et 40 Ans*, p.25

4 Bosquet, 'L'Irrésistible Déchéance de Bernard Buffet'

5 Yamamoto, *Bernard Buffet 1945–1999*

6 Manceaux, 'Entretien: Bernard Buffet'

7 Nicolas Buffet, interview with the author, February 2015

8 Parinaud, 'Je Suis le Pavillon de Banlieue de la Peinture Moderne'

9 Mark Forgy, interview with the author, September 2015

Chapter 34

1 Parinaud, 'Je Suis le Pavillon de Banlieue de la Peinture Moderne'

2 'Georges Cabanier, French Admiral, Dies'

3 Buffet and Cabanier, *Les Bateaux*

4 Tasset, 'Bernard Buffet l'Enfant Chéri de la Gloire'

5 Institut Georges Pompidou

6 Turenne, 'Now a Pretender to the Gaullist Throne'
7 Ibid.
8 Robertson, 'French Left Attacks Minister of Culture'
9 Buffet and Lamy, *Bernard Buffet: The Secret Studio*

Chapter 35

1 Daulte, 'L'Oeil'
2 Musée Bernard Buffet, archive article on the opening of 25 November 1973
3 Ibid.
4 Musée Bernard Buffet, private publication
5 Nicolas Buffet, interview with the author, February 2015
6 Bergé, *Bernard Buffet*, p.9
7 Nicolas Buffet, interview with the author, February 2015
8 *Jours de France*, 29 January 1976
9 Ibid.
10 Annabel Buffet, *D'Amour et d'Eau Fraîche*, p.275
11 Tasset, 'Bernard Buffet l'Enfant Cheri de la Gloire'
12 Annabel Buffet, *D'Amour et d'Eau Fraîche*, pp.275–6
13 *Jours de France*, 29 January 1976
14 Annabel Buffet, *D'Amour et d'Eau Fraîche*, p.276
15 Ibid.
16 Ibid.

Chapter 36

1 Annabel Buffet, *Post Scriptum*, p.97
2 Annabel Buffet, *D'Amour et d'Eau Fraîche*, p.191
3 Ibid.
4 Ibid., p.192
5 Buffet and Lamy, *Bernard Buffet: The Secret Studio*
6 'Bernard Buffet, l'Artiste d'une Époque'
7 *Journal de l'Amateur d'Art*, No.601
8 Mazars, 'La Saison en Enfer de Bernard Buffet'
9 Ibid.
10 Exhibition catalogue, Musée Postale, 4–26 February 1978
11 Bosquet, 'L'Irrésistible Déchéance de Bernard Buffet'
12 eBay, 'Top 6 Nike Dunks of All Time'
13 *Jours de France*, 11 January 1981

Chapter 37

1 David, *Le Métier de Marchand de Tableaux*, p.233
2 Maurice Garnier, interview with the author, September 2013
3 Ida Garnier, interview with the author, 17–18 October 2013
4 Ibid.
5 Le Garrec, 'Bernard Buffet: "Je Ne Suis Pas l'Auteur"'
6 Laurent, *Bernard Buffet: Le Peintre Crucifié*, p.289
7 *New York Times*, 14 March 1971
8 Ibid.
9 Bosquet, 'L'Irrésistible Déchéance de Bernard Buffet'
10 Christian Dazy, interview with the author, July 2014
11 Ibid.

Chapter 38

1 Annabel Buffet, *Le Voyage au Japon*
2 Ibid.
3 Hook, *The Ultimate Trophy*
4 Koko Okano, interview with the author, 11 December 2014
5 Okano, 'Letter'
6 Hook, *The Ultimate Trophy*, p.188
7 *Wall Street Journal*, 28 May 1991
8 *New York Times*, 19 May 1990
9 Ibid.
10 Galerie Tamenaga, private publication, circa 1989
11 Ibid.
12 Ibid.
13 Kiyotsugu Tamenaga, interviewed in *Bernard Buffet, From Here to Eternity*
14 Okano, 'Buffet and I'
15 Nicolas Buffet, interview with the author, February 2015
16 Kiyotsugu Tamenaga, interview with the author, October 2014
17 Ibid.
18 Ibid.
19 Nicolas Buffet, interview with the author, February 2015
20 Annabel Buffet, *Le Voyage au Japon*, p.84
21 Ibid., p.92
22 Bernard Buffet, interview with Chieko Hasegawa, 1980
23 Koko Okano, interview with the author, 11 December 2014

24 *Paris Match*, February 1981
25 Maxwell, 'Whatever Happened to Bernard Buffet?'
26 Ibid.
27 Annabel Buffet, *Le Voyage au Japon*, p.84
28 Bernard Buffet, interview with Chieko Hasegawa, 1980
29 Buffet and Lamy, *Bernard Buffet: The Secret Studio*
30 Nicolas Buffet, interview with the author, February 2015

Chapter 39

1 Annabel Buffet, *D'Amour et d'Eau Fraîche*, p.276
2 *Paris Match*, February 1979
3 *Paris Match*, February 1981
4 Annabel Buffet, *D'Amour et d'Eau Fraîche*, p.219
5 Ibid.
6 Ibid., p.218
7 Nicolas Buffet, interview with the author, February 2015
8 Ibid.
9 Ibid.

Chapter 40

1 Bergé, *Les Jours S'en Vont Je Demeure*, p.68
2 Nicolas Buffet, interview with the author, February 2015
3 Exhibition catalogue, *Les Sept Péchés Capitaux*, 1995
4 *Le Figaro* magazine, 25 October 1986
5 Galante, 'J'Aimerais Vivre au Fond de la Mer Comme le Capitaine Nemo'
6 Ibid.
7 Exhibition catalogue, *La Maison*, 1998
8 Portrait of Annabel and Bernard Buffet, broadcast 5 December 1987, FR3
9 De Liedekerke, 'Buffet: Je Sais les Peindre, Mais Pas les Conduire'
10 Exhibition catalogue, *Les Sept Péchés Capitaux*, 1995
11 Exhibition catalogue, *La Maison*, 1998

Chapter 41

1 Druon, *Bernard Buffet*
2 Galante, 'Bernard Buffet: Tous les Musées de France'

3 Galante, 'J'Aimerais Vivre au Fond de la Mer Comme le Capitaine Nemo'

4 Galante, 'Bernard Buffet: Tous les Musées de France'

5 Prat, 'Bernard Buffet: Cette Fois-çi, Il Illustre Jules Verne'

6 Darmon, 'Buffet sur le Gril'

7 Zana, 'Bernard Buffet, Le Paria'

8 *Paris Match*, 11 February 1993

9 Annabel Buffet, *Post Scriptum*, p.148

10 Ibid.

11 Cruysmans, 'Bernard Buffet Don Quichotte'

12 Chelbi, 'Nous Sommes Tous des Don Quichotte'

13 Druon, *Bernard Buffet*

14 'Bernard Buffet: Histoire d'un Forcené de la Peinture'

15 Roob, *Maurice Garnier: The Last Artist's Gallerist*

16 Prat and Saint Vincent, 'Bernard Buffet: Le Mal Aimé Qui Peignait à la Chaîne'

17 Maurice Garnier, interview with the author, 24 May 2013

18 *Bernard Buffet, From Here to Eternity*

19 Ibid.

20 Le Pinhon, 'Bernard Buffet: A-t-il Fait Son Temps?'

21 Buchloh, 'Figures of Authority'

22 Goldsmith, *I'll Be Your Mirror*, pp.331–2

23 Ibid.

24 Henry Périer, interview with the author, October 2013

25 Ibid.

26 Le Pinhon, 'Bernard Buffet: A-t-il Fait Son Temps?'

27 *Années 50*, Centre Pompidou website

28 Ibid.

29 Ibid.

Chapter 42

1 Hook, *The Ultimate Trophy*, p.191

2 Ibid., pp.191–2

3 Nicolas Buffet, interview with the author, February 2015

4 I da Garnier, interview with the author, 23 January 2015

5 Grenier, 'Un Comble Moscou le Reconnaît avant la France'

6 Inquirer Wire Service, 'Capitalist Chic Comes to Communist Bloc'

7 Ibid.

8 Hesse, *Maxim's Mirror of Parisian Life*, p.133

9 Nicolas Buffet, interview with the author, February 2015

10 'French Artist Gets No Respect'

11 Ibid.

12 St Petersburg, exhibition catalogue preface, 1992

13 Annabel Buffet, *Post Scriptum*, p.133

14 Prat and Saint Vincent, 'Bernard Buffet: Le Mal Aimé Qui Peignaità la Chaîne'

15 Otto Letz, interviewed in *Bernard Buffet, From Here to Eternity*

16 Tilman Osterwold, interview with the author, 22 July 2015

17 Alexander Roob, email to the author, summer 2013

18 Roob, *Maurice Garnier: The Last Artist's Gallerist*

19 Alexander Roob, email to the author, 2 July 2015

20 Roob, *Maurice Garnier: The Last Artist's Gallerist*

Chapter 43

1 Laurent, *Bernard Buffet: Le Peintre Crucifié*, p.334

2 Nicolas Buffet, interview with the author, February 2015

3 Cour de Cassation, Civile, Chambre Commerciale, 12/10/2010, case 09-70.337, Bulletin 2010, IV, no. 153

4 Annabel Buffet, *Post Scriptum*, p.116

5 Ibid., pp.114–16

6 Ibid., p.117

7 Ibid.

8 Ibid.

9 Ibid., pp.117–18

10 Ibid., p.118

11 Ibid., p.121

12 Nicolas Buffet, interview with the author, February 2015

Chapter 44

1 Bergé, *Les Jours S'en Vont Je Demeure*, p.72

2 Maurice Garnier, interview with the author, 24 May 2013

3 Ibid.

4 Fabrice Hergott, interview with the author, 24 May 2013

5 Pierre Bergé, interview with the author, 17 December 2013

6 Pierre Bergé, interview with the author, May 2013

7 Pierre Bergé, interview with the author, 17 December 2013

8 Annabel Buffet, *Tableaux pour un Musée 1950–1954*

9 Ibid.

10 Annabel Buffet, *Tableaux pour un Musée 1965–1969*

11 Exhibition press release, MMK, http://www.artnews.org/mmkfrankfu
 rt/?exi=11078&Museum_f_r_Moderne_Kunst&Bernard_Buffet.

12 Kittelmann et al., *Bernard Buffet: Maler, Painter, Peintre*

13 Ibid.

14 Alexander Roob, email to the author, summer 2013

Chapter 45

1 Kittelmann et al., *Bernard Buffet: Maler, Painter, Peintre*

2 Sébastien Janssen, interview with the author, 24 May 2013

3 Stephan Wrobel, interview with the author, June 2015

4 Sébastien Janssen, interview with the author, 24 May 2013

5 Adam Lindemann, interview with the author, October 2013

6 Ibid.

7 Galerie Maurice Garnier

8 Sébastien Janssen, interview with the author, 24 May 2013

9 Stephan Wrobel, interview with the author, June 2015

10 Sébastien Janssen, interview with the author, 24 May 2013

11 Gilles Dyan, interview with the author, September 2014

12 Ibid.

13 Jean-David Malat, interview with the author, September 2014

14 Cavendish, 'Why Celebrity Art-Lovers Adore Jean-David Malat'

15 Ibid.

16 'Bernard Buffet', Heydar Aliyev Centre

17 Ibid.

18 Ibid.

19 Ibid.

20 Céline Lévy, interview with the author, June 2015

21 Fabrice Hergott, interview with the author, 24 May 2013

22 Ibid.

23 Ibid.

24 Ibid.

Select Bibliography

Exhibition and auction catalogues

Akasegawa, Genpei, Hiroshi Sugito, Shuichi Kato and Toshiyuki Horie, *Bernard Buffet: 1945–1999*. Japan: Nohara and Musée Bernard Buffet, 2014.

Asada, Hiroshi, *Bernard Buffet and Jean Fusaro*. Galerie Tamenaga catalogue, 1989.

Barbero, Lucas Massimo (curator), *Venice: The Art Scene 1948–1986: Photographs from the Archivio Arte Fondazione*. Fondazione Cassa Di Risparmio, Modena, Italy, 2006

Bernard Buffet: Een Omstreden Oeuvre, 1 July–10 September 2006. Gemeente Museum Den Haag, 2006.

Bernard Buffet, Heydar Aliyev Center, exhibition catalogue, 26 September 2014–15 January 2015.

Bernard Buffet: La Chapelle de Chateau l'Arc. Galerie David & Garnier, 1962.

Bernard Buffet, *The MMK Museum für Moderne Kunst: April 18–August 3, 2008*. Exhibition press release, art news.

Bouret, Jean, 'Manifeste de l'Homme Témoin', 1 June–21 July 1948. Galerie du Bac, 1948.

Buffet, Annabel (pref.), *Bernard Buffet: La Maison*, February 1998. Galerie Maurice Garnier, 1997.

Buffet, Annabel, *Bernard Buffet: La Mort*. Galerie Maurice Garnier, 2000.

Buffet, Annabel (pref.), *Bernard Buffet: Les Sept Péchés Capitaux*. Galerie Maurice Garnier, 1995.

Buffet, Annabel (pref.), *Bernard Buffet: Vingt Mille Lieues Sous les Mers*. Galerie Maurice Garnier, 1990.

Buffet, Annabel (pref.), *La Baume*. Galerie Maurice Garnier, 29 October 1993.

Buffet, Annabel, *Pékin 1996*, February–March 1996. Galerie Maurice Garner, 1996.

Buffet, Annabel (pref.), *Tableaux pour un Musée 1950–1954*. Galerie Maurice Garnier, 2001.

Buffet, Annabel (pref.), *Tableaux pour un Musée 1965–1969*. Galerie Maurice Garnier, 2004.

Bernard Buffet: L'Empire ou les Plaisirs de la Guerre, February–March 1993. Galerie Maurice Garnier, 1993.

Bernard Buffet: L'Odyssée. Galerie Maurice Garner, 1994.

Bernard Buffet: Promenade Provençale, October–November 1993. Galerie Maurice Garnier, 1993.

Bernard Buffet: Saint-Pétersbourg, 24 September–28 November 1992. Galerie Maurice Garnier, 1992.

Bernard Buffet: Sumo et Kabuki, 4 February–28 March 1988. Galerie Maurice Garnier, 1988.

Bernard Buffet: Souvenirs d'Italie: October–November 1991. Galerie Maurice Garnier, 1991.

Bernard Buffet: Vues de New York. Galerie Maurice Garnier, 1991.

Buffet, Bernard, and L'Amiral Georges Cabanier (pref.), *Les Bateaux*. Galerie Maurice Garnier, 1973.

Buffet, Bernard, *Paintings of London: 9th–30th March*. The Lefevre Gallery, 1961.

Buffet, Bernard, *Recent Watercolours*. The Lefevre Gallery, 1963.

Buffet, Bernard, *Bernard Buffet: Don Quichotte de Cervantes*. Galerie Maurice Garnier, 1989.

Descargues, Pierre (pref.), Bernard Buffet first exhibition, December 1947

Dion, Mark, *Oceanomania: Souvenirs of Mysterious Seas from the Expedition to the Aquarium*. France: Mack Books, September 2011.

Druon, Maurice, 'Maison de la Poste et de la Philatelle', *Musée Postal*, 4–26 February 1978.

Druon, Maurice, *Tableaux pour un Musée 1970–1976*, February–March 2006. Galerie Maurice Garnier, 2006.

Durand, Georges, 'Catalogue de l'Exposition "La Chapelle de Chateau l'Arc"'. Galerie David et Garnier, 1962.

Fabre, Dominique, 'Catalogue de la Retrospective Bernard Buffet'. Knokke-le-Zoute, 1959.

Giono, Jean, 'Préface du Catalogue de la Rétrospective "Cent Tableaux de 1944 à 1958 par Bernard Buffet". Galerie Charpentier, 1958.

Giono, Jean, 'Préface du Catalogue du l'Exposition "Bernard Buffet"'. Galerie Lucien Blanc, 1955.

Kittelmann, Udo, Dorothee Brill, Alexander Roob and Bernard Buffet, *Bernard Buffet: Maler, Painter, Peintre*. MMK, Frankfurt. Munich: Walther König, Mul edition, 2009.

Le Pichon, Yann, *Bernard Buffet, Vol. 1, 1943–1968*. France: La Bibliothèque des Arts, 1986.

Le Pichon, Yann, *Bernard Buffet, Vol. 2, 1962–1989*. France: La Bibliothèque des Arts, 1986.

Le Pichon, Yann, *Bernard Buffet, Vol. 3, 1982–1999*. France: Maurice Garnier, 2007.

Modigliani, Amedeo, *Portrait de Roger Dutilleul, 1919*. Paris: Sotheby's, 2013.

Musée Bernard Buffet, archive article on the opening of 25 November 1973.

Musée Bernard Buffet, private publication, anonymous press clipping.

Nacenta, Raymond, *Cent Tableaux de 1944 à 1958 par Bernard Buffet*. Galerie Charpentier, exhibition catalogue, 1958.

National Museum of Modern Art, Georges Pompidou Centre, Paris, France. Musée Bernard Buffet, anonymous press clipping.

Okano, Kiichiro, 'Buffet and I'. Musée Bernard Buffet, April 1978.

Okano, Koko, 'Letter'. Musée Bernard Buffet archives.

Okano, Mitsuyoshi, 'On the 40th Anniversary of the Museum'. Musée Bernard Buffet, 2013.

Périer, Henry, *Bernard Buffet Post 1958: Une Symphonie de couleur*. Le Musée du Touquet-Paris-Plage, 29 November 2014–31 May 2015.

Périer, Henry, 'Préface du Catalogue de l'Exposition "Bernard Buffet"'. Musée Paul Valéry, 2003.

Poirot-Delpech, Bertrand, 'Preface du Catalogue de l'Exposition "Bernard Buffet Tableaux pour un Musée 1977–1984"'. Galerie Maurice Garnier, 2007.

Poirot-Delpech, Bertrand, *Tableaux pour un Musée 1977–1984: L'Ineffable Dévoilé*, February–March 1997. Galerie Maurice Garnier, 1997.

Roegiers, Antoine, *Les Sept Péchés Capitaux*, Praz-Delavallade Gallery. Exhibition catalogue: 12 January–16 February 2013.

Roob, Alexander, *Bernard Buffet: Terrain Vague*, ed. Udo Kittelmann. MMK. Dorothee Brill, Frankfurt-Köln, 2008.

St Petersburg, exhibition catalogue preface, 1992.

Sillevis, John, *Bernard Buffet: A Controversial Oeuvre*, exhibition catalogue, Gemeentemuseum Den Haag, 1 July–10 September 2006.

Stone, Irving, *Paintings by Bernard Buffet*, exhibition, Los Angeles County Museum, 10 December 1954–16 January 1955.

Tableaux pour un Musée 1950–1954. Galerie Maurice Garnier.

Tableaux pour un Musée 1965–1969. Galerie Maurice Garnier.

Yamamoto, Makoto, *Bernard Buffet 1945–1999*. Musée Bernard Buffet and Nohara, 2014.

Books

Bacall, Lauren, *By Myself and Then Some*. London: Headline, 2006.

Bauer, Gérard, *Bernard Buffet: Paris*. New York: Tudor Publishing, 1961.

Bauer, Gérard, *Paris*. France: F. Hazan, 1961.

Beaton, Cecil, *The Unexpurgated Beaton: The Cecil Beaton Diaries As He Wrote Them, 1970–1980*. London: Knopf Publishing Group, 2003.

Beevor, Antony, and Artemis Cooper, *Paris After the Liberation: 1944–1949*. London: Penguin, 1994.

Bergé, Pierre, *Bernard Buffet*. Geneva: Pierre Gailler, 1958.

Bergé, Pierre, *Bernard Buffet Vu par Pierre Bergé et par Bernard Buffet*. France: Art et Style, 1958.

Bergé, Pierre, *Horreur de la Guerre*. France: Éditions Parenthèse, February 1955.

Bergé, Pierre, *Les Jours S'en Vont Je Demeure*. France: Folio, 2004.

Bouret, Jean, *Le Cirque par Bernard Buffet*. France: Art et Style, 1956.

Browder, Clifford, *Andre Breton: Arbiter of Surrealism*. Switzerland: Librarie Droz Geneva, 1967.

Buffet, Annabel, *3 Petits Tours et 40 Ans*. France: Éditions Julliard, 1973.

Buffet, Annabel, *D'Amour et d'Eau Fraîche*. France: Messinger, 1986.

Buffet, Annabel, *Le Voyage au Japon*. Paris: A. C. Mazo, 1981.

Buffet, Annabel, *Post Scriptum*. France: Plon, 2011.

Buffet, Annabel, and Jean-Claude Lamy, *Bernard Buffet: The Secret Studio*. France: Flammarion, 2004.

Buffet, Bernard, *Naples*. Paris: Compagnie de Saint-Gobain, 1959.

Buffet, Bernard, and Françoise Sagan, *Toxique*. France: E. P. Dutton & Co., 1964.

Cabanne, Pierre, *Bernard Buffet*. Paris: Fernand Hazan, 1966.

Charbonnier, Georges, *Le Monologue de Peintre*. France: Éditions Julliard, 1959.

Clark, Kenneth, *Civilisation: A Personal View*. London: John Murray, 2005.

Cocteau, Jean, 'Poésie Critique'. Bernard Buffet archives, 1959.

Cocteau, Jean, *La Voix Humaine*. France: Éditions Parenthèses, 1957.

Cocteau, Jean, *Le Passé Défini IV, 1955*. France: Gallimard, 2005.

Cocteau, Jean, *Le Passé Défini V, 1956–1957*. France: Gallimard, 2006.

Cocteau, Jean, *Le Passé Défini VI, 1958–1959*. France: Gallimard, 2011.

Cohen-Solal, Annie. *Leo and His Circle: The Life of Leo Castelli*. New York: Knopf Publishing Group, 2010.

David, Emmanuel, *Le Métier de Marchand de Tableaux: Entretiens avec Hervé le Boterf Broché*. France: France Empire, 1978.

De Bergerac, Savinien de Cyrano, *Voyages Fantastiques aux États et Empires de la Lune et du Soleil: Pages Choisies, Illustrées de Pointes-sèches par Bernard Buffet Reliure Inconnue*. France: Joseph Foret, 1958.

Delassein, Sophie, *Les Dimanches de Louveciennes: Chez Hélène et Pierre Lazareff*. France, Grasset & Fasquelle, 2009.

Descargues, Pierre, *Bernard Buffet*. Paris: Éditions Universitaires, 1959.

Descargues, Pierre, *Collection Artistes de Ce Temps*. France: PLF, 1949.

Descargues, Pierre, *L'Art est Vivant*. France: L'Archipel, 2001.

de Vlaminck, Maurice, *Dangerous Corner*. California: Elek Books, 1961.

Druon, Maurice, *Bernard Buffet. Bernard Buffet. Text, Maurice Druon. Captions, Annabel Buffet. Design, Jean Widner. With portraits and reproductions*. London: Methuen & Co, 1965.

Durand, Georges, *La Divine Comédie de Bernard Buffet*. France: Desclée de Brouwer, 1986.

Furukaki, Tetsuro, *Bernard Buffet: Paris de Mon Coeur*. France: Joseph Foret, 1961.

Furukaki, Tetsuro, *Mon Buffet* October 10, 1973 'My Bernard Buffet' July, 1963 Reprinted from 'Paris-Tokyo' (Kajima Institute Publishing Co., Ltd.) Bernard Buffet Reprinted from 'The Annoyingly Superior People' (Asahi Shimbun Publications Inc.) First Edition November 25, 1973 Issued by Bernard Buffet Museum Publisher Kiichiro Okano Binding Kazumasa Nagai Printing Seibu Printing Co., Ltd

Giono, Jean, *Bernard Buffet*. France: F. Hazan, 1956.

Goldsmith, Kenneth, *I'll Be Your Mirror: The Selected Andy Warhol Interviews*. New York: Da Capo Press, 2004.

Gréco, Juliette, *Je Suis Faite Comme Ça*. France: Flammarion, 2012.

Gréco, Juliette, *Jujube*. France: Stock, 1982.

Harambourg, Lydia, *Bernard Buffet et la Bretagne*. France: Editions Palantines, 2012.

Hasegawa, Chieko, *Les Grand Maîtres de l'Art et Chieko Hasegawa Rencontres*. Paris: Chêne, 2013.

Heath, Christopher, and Anselm Kamperman Sander (ed.), *Landmark Intellectual Property Cases and Their Legacy*. The Netherlands: The Kluwer Law International, 2010.

Hellal, Salina, *Jacqueline Delubac, Le Choix de la Modernité: Rodin, Lam, Picasso, Bacon Broché*. France: Beaux Livres, 1994.

Hesse, Jean-Pascal, *Maxim's Mirror of Parisian Life*. France: Assouline, 2011.

Hook, Philip, *The Ultimate Trophy: How the Impressionist Painting Conquered the World*. New York: Prestel, 2009.

Hourdin, Georges, *L'Enfer et le Ciel de Bernard Buffet*. France: Les Éditions du Cerf, 1958.

Hussey, Andrew, *Paris: The Secret History*. London: Penguin Viking, 2006.

Job, Richard Ivans, *Riding the New Wave: Youth and the Rejuvenation of France After the Second World War*. California: Stanford University Press, 2007.

Lamy, Jean-Claude, *Bernard Buffet: Le Samourai*. France: Albin Michel, 2008.

Lamy, Jean-Claude, *Et Dieu Créa les Femmes: Brigitte, Françoise, Annabel et les Autres*. France: Albin Michel, 2011.

Laurent, Stéphane, *Bernard Buffet: Le Peintre Crucifié*. France: Éditions Michalon, 2000.

Lautréamont, Comte de, *Les Chants de Maldoror: Two Volumes*. France: Les Dix Editeurs, 1952.

Lelievre, Marie-Dominique, *Sagan à Toute Allure*. France: Éditions Denoël, 2008.

Lelievre, Marie-Dominique, *Saint Laurent, Mauvais Garçon*. France: Flammarion, 2010.

Mason, Raymond, *At Work in Paris: Raymond Mason on Art and Artists*. London: Thames and Hudson, 2003.

Michel, Georges-Michel, *De Renoir à Picasso – Les Peintres Que J'ai Connus*. France: Éditions Arthème Fayard, 1954.

Mourlot, Fernand, *Graves dans Ma Memoire*. France: Robert Laffont, 1979.

Negulesco, Jean, *Things I Did and Things I Think I Did*. New York: Simon and Schuster, 1984.

Périer, Henry, *Bernard Buffet et la Provence*. France: Éditions Palantines, 2007.

Perrault, Gilles, *Paris Under the Occupation*. Vendome Press and André Deutsch, 1989.

Peyrani, Béatrice, *Pierre Bergé, Le Faiseur d'Étoiles Broche*. France: Pygmalion, 2011.

Rawsthorn, Alice, *Yves Saint Laurent: A Biography*. London: HarperCollins, 1997.

Rheims, Maurice, *Bernard Buffet Graveur 1948–1980*. Éditions d'Art de Francony and Éditions Maurice Garnier

Roe, Sue, *In Montmartre: Picasso, Matisse and Modernism in Paris, 1900–1910*. London: Fig Tree, 2014.

Sartre, Jean-Paul, *Existentialism and Humanism*. France: Methuen, 2007.

Sillevis, John, *Bernard Buffet: 1928–1999*. France: Éditions Palantines, 2008.

Sillevis, John, *Bernard Buffet: Een Omstreden Oeuvre*. Germany: Waanders, 2006.

Simenon, Georges, and Jean Bouret, *Bernard Buffet: Les Cahiers de Peinture*. Paris: Presses Artistiques, 1958.

Stievenard, Jean-Michel, *L'Art Moderne à Villeneuve d'Ascq*. Éditions Ravet-Anceau, 2010.

Wagener, Françoise, *Je Suis Née Inconsolable: Louise de Vilmorin, 1902–1969*. France: Albin Michel, 2008.

Wilson, A. N., *Dante in Love*. London: Atlantic Books, 2012.

Newspapers, journals and magazines

'7,000 Personnes Assiègent l'Exposition Bernard Buffet: 100 Tableaux, 14 Ans de Peinture'. *L'Aurore*.

Ajamé, Pierre, '12 Questions à Bernard Buffet'. *Les Nouvelles Littéraires*, 13 February 1964.

'An Artist Must Eat'. *Time*, 27 February 1956.

'Annabel Buffet Vue par Bernard Buffet'. *Paris Match*, 31 December 1960.

'Annabel et Bernard Buffet à Saint-Tropez'. Galerie Maurice Garnier archives.

'Annabel: Fair Son Examen de Conscience'. *Nous Deux*.

Aragon, Louis, 'Le Paysage Français à Quatre Siècles et Bernard Buffet 24 Ans'. *Les Lettres Françaises*, 19 and 26 February 1953.

Askew, Rual, 'Art and Artists: Bernard Buffet Sees City in Verticals Under Violet'. *Dallas Morning News* archives, 1957–8.

Askew, Rual, 'Art and Artists: Faces of Spring'. *Dallas Morning News*.

Askew, Rual, 'Art and Artists: M. Buffet Liveliest French Touch of All'. *Dallas Morning News* archives, 1957–8.

'A Stark Success: Buffet Adds His Grimness to Reality'. *Life*, international edition, 18 April 1955.

'Atmosphère de Grand Match de Boxe: Au Vernissage Bernard Buffet'. *Le Figaro*, 20 January 1958. Musée Bernard Buffet archives, anonymous press clipping.

'À Trente Ans, Bernard Buffet Peint l'Épopée de Jeanne d'Arc et Prend le Chemin du Retour à la Tradition'. *La Galerie des Peintres Contemporaire*, February 1958.

Auger, Benjamin, 'Bernard Buffet, 1987'. *Paris Match*, 27 October 1987.

Auger, Benjamin, 'Bernard Buffet, 1989'. *Paris Match*, January 1989.

Auger, Benjamin, 'Bernard Buffet dans L'Atelier de Son Château de Saint-Crespin, 1987'. *Paris Match*, 1987.

'Auto-Portrait', Galerie Charpentier. Galerie Maurice Garnier archives, unidentified press clipping.

Avila, Alin Alex, 'Bernard Buffet'. *Nouvelles Éditions Françaises Casterman*, 1989.

Barnes, Jeanne, 'The Woman's Angle: Painting Collection Fits into Marcus Home'. *Buffalo News*.

Barry, A. Joseph, 'To Them Picasso Is Old Hat: The New Look in Paris Art'. *New York Times* magazine, 8 January 1950.

Becker, Beril, 'The Millionaire Painter of Misery'. Musée Bernard Buffet archives, anonymous press clipping.

Benhamou-Huet, Judith, 'Pierre Bergé: A Collector Sells All'. *Interview*, December 2013.

Bergé, Pierre, 'Bernard Buffet Vu par Pierre Bergé et par Bernard Buffet'. *Art et Style*, No. 4, 1958.

Bergé, Pierre, 'Eight Drawings: Bernard Buffet'. *Paris Review*, No. 2, Summer 1953.

Bergé, Pierre, 'L'État Trouverait Normal Que Ce Calder, dans Mon Bureau, Soit dans un Musée'. *Magazine de la Gazette*, 10 October 2002.

Buffet, Annabel, 'Ou Sont les Bretelles de Bernard?' Galerie Maurice Garnier archives.

'Bernard Buffet'. *Vogue*, 1957. Musée Bernard Buffet archives, anonymous press clipping.

'Bernard Buffet à la Galerie Charpentier'. Musée Bernard Buffet archives, anonymous press clipping.

'Bernard Buffet a Signé des . . . Tickets de Métro'. Galerie Maurice Garnier archives, unidentified press clipping.

'Bernard Buffet Découvre. St-Tropez'. Musée Bernard Buffet archives, unidentified press clipping.

Bernard Buffet: *Espagnole Nue*'. Galerie Maurice Garnier archives, unidentified press clipping, 1955.

'Bernard Buffet: Histoire d'un Forcené de la Peinture'. *Le Figaro* magazine, 25 October 1988.

'Bernard Buffet, l'Artiste d'une Epoque'. *Le Figaro* magazine, 9 October 1999.

'Bernard Buffet, Le Plus Cher des Peintures Vivants, a Appris le Dessin aux Cours du Soir'. Musée Bernard Buffet archives, unidentified press clipping, January 1956.

'Bernard Buffet: Métamorphosé par l'Amour'. *Jours de France*, 27 December 1958.

'Bernard Buffet: Retour en Provence'. *Jours de France*, 6 September 1986.

'Bernard et Annabel Buffet: Un Château de Bohême'. *Adam*, No. 277, December 1962–January 1963.

Bernard Buffet's Studio in Montmartre. Musée Bernard Buffet archives, unidentified press clipping.

Bernier, Georges, and Rosamond Bernier, 'L'Oeil: L'Art Sous Toutes Ses Formes'. *Revue d'Art*, Paris. Lausanne: Sedo Lausanne SA, March 1976.

Berruer, Pierre-Francois, 'La Bretagne de Mon Enfance et de Mes Rêves'. *Ouest-France*, 13 October 1990.

Berteaux, Christopher, 'Maurice Garnier et Bernard Buffet, Portraits Croisés'. *11, rue Royale*, 26 November 2000.

Berthier, Francis, *Collection Roger Dutilleul: Thèse*. Paris, 1977 (http://www.worldcat.org/title/recherche-sur-la-collection-roger-dutilleul/oclc/490028853).

Berthier, Francis, 'La Merveilleuse et Grande Aventure de Roger Dutilleul'. *Galerie des Arts*, No. 220, December 1983–January 1984: 46–71.

Bolloré, Annie F., 'Bernard Buffet: S'est Offert le Chateau des Rêves d'Enfant'. *L'Aurore*, 12 August 1965.

Bosquet, Alain, 'L'Irrésistible Déchéance de Bernard Buffet'. *Galerie Jardin des Arts*, April 1975.

Botsford, Keith, 'A "New European Man" Runs France'. *New York Times*, 29 August 1971.

Bouret, Jean. *Les Lettres Françaises*, 12 February 1959.

Brigneau, François, 'Les Maries de Provence'. *Jour de France*, September 1958.

Brincourt, André, 'Bernard Buffet: Une Mise à Vif'. *Le Figaro*, 5 December 1986.

Buchloh, Benjamin H. D., 'Figures of Authority, Ciphers of Regression: Notes on the Return of Representation in European Painting'. *Art World Follies*, Spring 1981.

Buffalo Courier Express, 17 March 1960. *Dallas Morning News* archives.

'Buffet'. *Jours de France*, February 1984.

'Buffet'. *Table Ronde*, 1955. Musée Bernard Buffet archives, anonymous press clipping.

'Buffet, Bernard: Je Reclame Justice'. *Les Lettres Françaises*, 30 July 1959.

'Buffet: Elend in Oel'. *Der Spiegel*, 11 July 1956: 34.

'Buffet Expose Son "Cas". Arts Beaux Arts à la Galerie Charpentier, 1947 to 1958'. Galerie Maurice Garnier archives, unidentified press clipping.

'Buffet: Je Suis Toujours Heureux de Peindre'. *La Galerie des Arts*, 15 February 1969.

'Buffet: Sous un Ciel Vide'. *Les Nouvelles Littéraires*, 20 February 1969.

Buffet, Annabel, 'J'Étais Sure Qu'avec Lui, Il Ne Pouvait Rien M'arriver'. *Arts Actualités*.

Buffet, Annabel, *Plage*. 1968.

Buffet, Annabel, 'Plaquette pour la Rétrospective de l'Oeuvre du Peintre Bernard Buffet de 1947 à 1990'. *Moscou et Leningrad*, 1991.

Buffet, Bernard, 'La Gazette de l'Hôtel Druot'. *L'Automne*, No. 1, 3 January 1997.

Buffet, Bernard, 'La Leçon de J. A. Gros'. *Les Lettres Françaises*, 14 January 1954.

Buffet, Bernard, 'On Me Reproche de Gagner Trop d'Argent'. *Les Lettres Françaises*, 9 February 1956.

Buffet, Bernard, 'Paris Désert, Impassible et Mélancolique'. Musée Bernard Buffet archives, anonymous press clipping.

Cabanne, Pierre, *Bernard Buffet: Peintres d'Aujourd'hui*. Paris: Fernand Hazan, 1966.

Cabanne, Pierre, 'Buffet Retrouvé'. *Arts*, 10–16 February 1965.

Cabanne, Pierre, 'Le Phénomène Buffet'. *Lectures pour Tous*, February 1969.

Calonne, Alain, 'Bernard Buffet'. *Valeurs de L'Art*, October 1993.

Canaday, John, 'Jean Dubuffet: France's Leading Post-War Artist in an Impressive Survey Exhibition L'Art Brut: Klee and Dubuffet'. *New York Times*, 25 February 1962.

Cartier, Jean-Albert, '100 Témoignages sur "le Cas Buffet"'. Galerie Charpentier, 27 January 1961.

Cartier, Jean-Albert, 'Le Cirque Vu par Bernard Buffet'. *Le Jardin des Arts*, Revue Mensuelle, March 1956.

Catinchi, Philippe-Jean, '"Pierre Bergé. Le Faiseur d'Étoiles", de Béatrice Peyrani: Pierre Bergé, Ou le Roman d'une Vie'. *Le Monde*, 26 October 2011.

Cavendish, Lucy, 'Why Celebrity Art-lovers Adore Jean-David Malat'. *The Times*, 23 June 2014.

Chaigneau, Jean-François, 'Depuis Plus d'un Demi-Siècle, Chaque Année, Il Nous Presente Sa Vision de la Comédie Humaine'. *Paris Match*, 11 March 1999.

Chaigneau, Jean-François, 'Je Ne Veux Plus Me Laisser Encombrer par les Gens. Je Veux la Paix des Cigales'. *Paris Match*, 6 August 1998.

Chaigneau, Jean-François, 'Je Suis une Sorte de Cancre Qui a Réussi, un Mauvais Exemple pour les Bons Élèves'. *Décoration Résidences*, May/June 1995.

'Champigneulle, Une Double Exposition'. *France Illustration*, 21 February 1953.

Charmet, Raymond, 'Témoignages Contradictoires'. Galerie Maurice Garnier archives, unidentified press clipping.

Chelbi, Mustapha, 'Nous Sommes Tous des Don Quichotte'. *L'Affiche d'Art en Europe*, Éditions Van Wilder, 1989.

Cingria, Hélène, 'Bernard Buffet Termine Notre Enquête: Qu'est-ce Que l'Avant-Garde en 1958'. *Les Lettres Françaises*, 17 July 1958.

Clerc, Michel, 'Simenon: Des Milliards Sortent de Son Encrier'. *Paris Match*, 27 August 1960: 52–5.

'Collection of Artists' Originals Will Go on Sale at Sanger's'. *Dallas Morning News*.

Constans, Claire. *École du Louvre – Notices d'Histoire de l'Art*, 1983.

Copyright: Monthly Review of the United International Bureaux for the Protection of Intellectual Property (BIRPI), October 1965.

Corbaz, Aimé, 'Merci, Mon Amour . . .'. *Le Matin*, 18 August 2001.

Cornell, Kenneth, 'The Buffet Enigma'. *Yale French Studies*, 19/20: 94–7. Connecticut: Yale University Press, 1957.

Cour de Cassation, Civile, Chambre Commerciale, 12/10/2010, case 09/70.337, Bulletin 2010, IV, no. 153

Cruysmans, Philippe, 'Bernard Buffet Don Quichotte: Le Peinture Existe Toujours Il Monte sur Ses Grands Chevaux'. *Le Figaro*, 7 February 1989.

Dagen, Philippe. *Le Monde*, 3 March 2006.

D'Aler, Michel, 'Buffet, Bernard: La Passion du Christ'. *Arts*, December 1954.

Dana, E., *Bernard Buffet ou le Spectateur de l'Entracte*. France: Édition d'Art du Lion, 1960.

'Dans le Secret, Bernard Buffet a Décoré la Chapelle de Son Château Interdite au Public'. *Arts*, 20 September 1961.

'Dans le Secret des Jardins Clos'. *Jours de France* 14 July 1979.

Dariel, Jean-Loup, 'Le Peintre Bernard Buffet a Disparu, Depuis 6 Jours, avec Anabel [sic], la Chanteuse. Tout Saint-Tropez S'Interroge'. *France Soir*, 17 August 1958.

Darmon, Adrian, 'Buffet sur le Gril'. *Arts et Valeurs*, December 1990.

D'Assailly, Gisèle, 'À La Découverte de Bernard Buffet'. *Lectures pour Tous*. August 1962.

Daulte, Francois, 'L'Oeil'. *Revue d'Art Mensuelle*, No. 248. Musée Bernard Buffet, March 1976.

De Beauvais, Patricia, 'Buffet Peint la Révolution dans Son Château'. *Paris Match*, 9 December 1977.

'Decoration: Chez Bernard Buffet'. *Jours de France*, 5 March 1966.

'Delacroix et les Peintres d'Aujourd'hui'. *Les Nouvelles Littéraires*, 9 May 1963.

De Liedekerke, Arnould, 'Buffet: Je Sais les Peindre, Mais Pas les Conduire'. *Le Figaro* magazine, 2 February 1985.

Del Castillo, Michel, 'Buffet l'Oublié'. *Le Figaro*, 30 May 1998; *La Une*, July 1998.

Descargues, Pierre. 'Aquarelles et Peintures de Bernard Buffet' *Arts*, 2 February 1951.

Descargues, Pierre, 'Bernard Buffet'. *Editions Presses Littéraires de France*, 1949.

Descargues, Pierre, 'Bernard Buffet a Peint l'Horreur de la Guerre'. *Les Lettres Françaises*, 10 February 1955.

Descargues, Pierre, 'Bernard Buffet le Peintre le Plus Discuté de Notre Époque Est-il l'Anti-Picasso'. *Documents Scientifiques Guigoz*, 1961.

Descargues, Pierre, 'Jeanne d'Arc en 7 Tableaux'. *Les Lettres Françaises*, 13 February 1958.

Descateaux, Christine, 'Annabel Buffet: "Bernard Connait Tour Mes Beaux Mensonges"'. *Télé 7 Jours*, 1987.

Descateaux, Christine, 'Annabel Buffet: L'Amour Peut Tout Sauver'. *L'Oeil sur Eux*, 1986.

De Turckheim, Hélène, 'Bernard Buffet le Clown Blanc'. *Le Figaro Madame*, 25 January 1992.

Devay, J.-F., 'Ce Jeune Homme Pale, Solitaire, et Travailleur Qui S'appelle Bernard Buffet'. *Elle*, 13 May 1957.

de Vilmorin, Louise, 'La Place de la Bastille'. *Arts et Spectacles*, 12 February 1957.

'Diner Devant les Buffet'. *Le Figaro*, 20 January 1958.

Droit, Michel, 'Le Défi de Bernard Buffet'. *Plage*, 1968.

Fayard, Jean, 'En Attendant Bernard . . .'. *Le Figaro*, 11 June 1958.

Fels, Florent, 'Le Roman de l'Art Vivant: de Claude Monet à Bernard Buffet'. Librairie Arthème Fayard.

Fiette, Alexandre, Roland Petit, Zizi Jeanmaire and Isabelle Payot Wunderli, *Zizi Jeanmaire, Roland Petit, un Patrimoine pour la Danse*. France: Somogy Éditions d'Art, 2007.

Flanner, Janet, 'Le Gamin'. *New Yorker*, 21 November 1959: 57–112.

Foresti, Flora, 'Le Peintre Bernard Buffet Nous Ouvre les Portes de Sa Maison'. *La Dépêche du Midi Dimanche*, 15 February 1998.

'French Artist Gets No Respect'. *Victoria Advocate*, 3 November 1992.

Galante, Gisèle, 'Bernard Buffet: Tous les Musées de France Me Sont Fermés Mais Je N'en Ai Rien à Cirer'. *Paris Match*, 16 February 1989.

Galante, Gisèle, 'Il y a Toujours Quelque Chose à Decouvrir Chez la Femme Que l'on Aime'. *Paris Match*, 24 February 1984.

Galante, Gisèle, 'J'Aimerais Vivre au Fond de la Mer Comme le Capitaine Nemo'. *Paris Match*, 1 March 1990.

Gaillard, Annick, 'La Nouvelle Maison d'An'. *Madame Figaro*, 21 February 1981.

Gall, Michel, 'Buffet Devient Sculpteur Naturaliste'. *Paris Match*, 12 October 1963.

Garofalo, Jack, 'Bernard Buffet dans Sa Periode Bretonne, à Stagadon'. *Paris Match*, 18 June 1958.

Gauthier, Maximilien, 'Dans l'Atelier de Bernard Buffet'. *Les Nouvelles Littéraires*, 26 July 1956.

Gauthier, Maximillien, 'Le Flaneur des Deux Rives'. *Les Nouvelles Littéraires*, 11 February 1954.

Genevoix, Sylvie, 'Annabel Buffet: Dans son Dernier Livre Elle Avoue Sa Lutte Bouleversante Contre l'Alcool'. *Madame Figaro*, 1 February 1986.

'Georges Cabanier, French Admiral, Dies: Senior Naval Officer Fought Beside US in Pacific in World War II After Joining the Free French'. *New York Times*, 27 October 1976.

Giannoli, Paul, 'Face à Face avec Bernard Buffet'. *Candide*, 5 September 1966.

Giono, Jean, 'La Criée, Marseille: 1922–1923'. *Revue Mensuelle*, 2, Manosque, 1973.

Giono, Jean, *Recherche de la Pureté*. France: Creuzevault éditeur, 1953.

Godard, Agathe, 'Bernard Buffet Abandonne Son Chateau Pour S'installer dans un Garage'. *Paris Match*, 22 September 1978.

Godard, Agathe, 'Bernard Buffet: Pour la Première Fois Son Déménagement Annuel a Été Filmé par Sa Fille Daniele'. *Paris Match*, 20 February 1981.

Godard, Agathe, 'Pour Survivre Nous Sommes Nomades'. *Paris Match*, 15 February 1980.

Greffe, Noëlle, 'Chez Bernard Buffet: Les Peintres Dance Leur Cadre'. *Les Nouvelles Littéraires*, 17 August 1961.

Grenier, Alexandre, 'Un Comble Moscou le Reconnaît Avant la France'. *Le Figaro Mediterranée*, 3 November 1990.

Guidot, R., *Les Années 50. Centre Georges Pompidou*. Paris: 30 June–17 October 1988.

Guth, Paul, 'Il Ne Faut Pas Qu'un Peintre Ait des Idées: Me Dit Bernard Buffet, Moins-de-Trent Cinq Ans, Célèbre'. *Le Figaro Littéraire*, 24 April 1954.

Harambourg, Lydia. *La Gazette de l'Hôtel Drouot*, 11 February 2000.

Harambourg, Lydia. *La Gazette de l'Hôtel Drouot*, 20 February 2004.

'Has Success Spoiled Bernard Buffet?' *New York Herald Tribune*, 29 January 1958. Musée Bernard Buffet archives, anonymous press clipping.

Herubel, Michel, 'Pourquoi Peignez-Vous'. *Arts*, 23 January 1953.

Hook, Philip, 'Monet, Manet, Money'. *Financial Times*, 1 February 2009.

Huet-Benhamou, Judith, 'Bernard Buffet, Le Retour'. *Les Echos*, 30 September 2011.

'Il y a au Japon un Musée et une Rue Bernard Buffet (Qui Expose Vendredi à Paris)'. *France Soir*, 29 January 1976.

Inquirer Wire Service, 'Capitalist Chic Comes to Communist Bloc: Yves Saint Laurent Is in Moscow for a Show of His Work'. Philadelphia: 3 December 1986.

'Is the Buffet Bubble about to Burst?' *Evening Standard*. London: 16 February 1959.

Jacoby, William G., 'Public Attitudes Toward Government Spending'. *American Journal of Political Science* 38.2 (1994): 336–61.

Jarnaux, Maurice, 'Bernard Buffet: Vous Fait Visiter Sa Ferme Près de Manosque'. *Connaissance des Arts*, 15 July 1955.

Jones, Peggy-Louise, 'Art and Artists: Dallas Advertising Artists Gain National Recognition'. *Dallas Morning News* archives, 1957–8.

Jones, Peggy-Louise, 'Art and Artists: Two French Painters in New Exhibit'. *Dallas Morning News* archives, 1957–8.

Journal de l'Amateur d'Art, No. 601, 24 March 1977. Musée Bernard Buffet, anonymous press clipping.

Kramer, Jane, 'The Impresario's Last Act'. *New Yorker*, 21 November 1994: 80–100.

La Joconde, Cyril, 'Bernard Buffet Sombre Histoire'. *Daily Trok*.

'La Jeune Carrière de Bernard Buffet en Cent Tableaux'. *Le Figaro*, January 1958.

Lamy, Jean-Claude, 'J'ai Toujours Suscité la Polémique. Et Je M'en Fous'. *Le Figaro*, 3 February 1998.

'L'Artiste en Narcisse'. *France Soir*, 3 April 2004.

'L'Atelier de Bernard Buffet à Montmarte Est en Vente'. *Le Figaro*, January/February 2000.

'La Titularité du Droit Moral de Bernard Buffet'. *Le Journal des Arts*, 28 February 2014: 408.

'Le Cas Minaux'. *Urbanism*, No. 117–18. Musée Bernard Buffet archives, anonymous press clipping.

Leclerc, Franck, 'Bernard Buffet Star de l'Art'. *L'Ardennais*, 4 April 1999.

Lecoq, Bruno, 'Annabel Buffet: "Je Me Suis Sentie Abandonée"'. *Special Dernière*, 6 October 2001.

'Le Dernier "Scandale" de Buffet: vernir Sa Rétrospective à l'Âge où les Autres Débutent'. *Paris-Presse L'Intransigeant*, January 1958.

Legardinier, Claudine, 'À La Fois Adoré et Hai: Buffet est un Phénomène dans l'Art Contemporain'. *Muse Art*, July/August 1993.

Le Garrec, Evelyne, 'Bernard Buffet: "Je Ne Suis Pas l'Auteur de Cette Toile Signée de Mon Nom"'. *L'Aurore*, 17 February 1961.

'Le Peintre Bernard Buffet a du Sortir'. Musée Bernard Buffet archives.

Le Pinhon, Yann, 'Bernard Buffet: A-t-il Fait Son Temps?' *Connaissance des Arts*, 2 February 1986.

'Le Rideau Se Lève sur le Ballet de Sagan'. Musée Bernard Buffet archives, anonymous press clipping.

'Les Deux Recordmen de la Jeune Peinture'. *Paris-Presse L'Intransigeant*, 20 March 1957.

'Les Oiseaux par Bernard Buffet'. *Art et Style*, 1960

Le Tellier, Phillipe, 'Bernard Buffet, 1958'. *Paris Match*, 18 January 1958.

Le Tellier, Phillipe, 'Bernard Buffet, 1961'. *Paris Match*, 8 February 1961.

Leterreux, Michel, 'Buffet, Témoin de Son Temps'. *Var Matin*, 24 August 1993.

Loren, Sophia, 'Actress Sophia Loren's Favorite Things'. *Wall Street Journal*, 24 June 2014.

Love, Kennett, '7 Paintings Sold for $2,186,800; Top Price in London Auction Is Paid for Work by Cézanne High Prices Paid for Art in London'. *New York Times*, 16 October 1958.

Luce, Claire Boothe, 'Clare, in Love and War'. *Vanity Fair*, July 2014.

McNay, Michael, 'Bernard Buffet'. *Guardian*, 6 October 1999.

Malat, Jean-David, 'Day Five'. *How to Spend It*, 23 June 2014.

'Man with the Golden Arm'. Musée Bernard Buffet, anonymous press clipping.

Manceaux, Michèle, 'Entretien: Bernard Buffet'. *L'Express*, 13 February 1964.

Manceaux, Michèle, 'La Réussite Qu'est-ce Que C'est?' *Marie Claire*, February 1962.

Mariella Righini in conversation with Annabel Buffet, 'Mon Role auprès de Bernard? Le Rendre Heureux'. *Arts Actualités*.

Maubert, Franck, *L'Odeur du Sang Humain Ne Me Quitte Pas des Yeux: Conversations avec Francis Bacon*. Mille et une Nuits, 2009.

Mauriac, François, 'Le Bloc-Notes de François Mauriac'. *L'Express*, 23 January 1958.

Maxwell, Douglas, 'Whatever Happened to Bernard Buffet?' *Modern Painters* 7.2 (1994): 66.

Mazars, Pierre, 'La Saison en Enfer de Bernard Buffet'. *Le Figaro*, 5 February
 1977.

Michel, Jacques, 'Buffet aux Arènes: Dialogue'. *Le Monde*, 10 February 1967.

Monteaux, Jean, 'Annabel S'explique'. *Elle Vie Culturelle*, 17 November 1969.

Nanquette, Agnès, 'Agnès, Me Lanca Bernard, Méfie-Toi. Tu Vas Rater Ta
 Vie Parce Que Tu Es Dominée Pas Tes Sens'. *Paris Journal*, 15 December
 1958.

Nanquette, Agnès, 'Aujourd'hui Je N'ai Même Plus le Droit d'Être un
 Souvenir'. *Paris Journal*, 16 December 1958.

Nanquette, Agnès, 'Bernard M'écrit Qu'il M'aime. Le Même Jour Je Reçois
 une Lettre Que j'Attendais Depuis 2 Ans'. *Paris Journal*, 13 December 1958.

Nanquette, Agnès, 'Bernard Se Mettait En Colère. Nous Vivions une Vraie
 Vie de Chien'. *Paris Journal*, 12 December 1958.

Nanquette, Agnès, 'C'était Bernard Buffet'. *Paris Journal*, 5 December 1958.

Nanquette, Agnès, 'Devant la Porte de Mon Hôtel Bernard M'embrassa
 Timidement le Lendemain Nous Étions Fiancés'. *Paris Journal*, 8 December
 1958.

Nanquette, Agnès, 'Je Tombe Amoureuse d'un Autre Garçon et Bernard
 Commence à M'aimer'. *Paris Journal*, 6 December 1958.

Nanquette, Agnès, 'Le 28 Novembre 1948, Bernard, Fils de Leon-Feliz Buffet
 et de Blanche-Souveraine Colombe, Signe dur le Registre de Mariage Je
 Deviens Madame Bernard Buffet'. *Paris Journal*, 10 December 1958.

Nanquette, Agnès, 'Le Mariage le Moins Cher Possible Demanda Bernard'.
 Paris Journal, 9 December 1958.

Nanquette, Agnès, 'Le Premier Soir Fut Atroce. Le Len-Demain Nous Etions
 Deux Enfants Déçus Qui N'osions par Nous l'Avouer'. *Paris Journal*, 11
 December 1958.

Neville, John, 'Artists: Graphic Show at Contemporary'. *Buffalo News*.

'New Sanger-Harris Store to Show Master Art Works'. *Dallas Morning News*.

New Yorker, 1 February 1958. Musée Bernard Buffet archives, anonymous press
 clipping.

Ochsé, Madeleine, 'Bernard Buffet, la Solitude de la Morte'. *Jardin des Arts*,
 April 1973.

Ochsé, Madeleine, 'Bernard Buffet, Peintre de la Passion'. *Ecclesia*, No. 157,
 April 1962.

Oliver, Myrna, 'Bernard Buffet: Prolific French Painter'. *Los Angeles Times*, 8
 October 1999.

Ottoni, René-Jean, and Maurice Jarnoux, 'Bernard Buffet'. *Paris Match*, 4
 February 1956.

Pages, François, 'Bernard Buffet dans Son Château en Provence'. *Paris Match*,
 October 1963.

'Painters at Work – Bernard Buffet'. *Daily Mail*, 24 June 1950.

Parinaud, André, 'Bernard Buffet: La Profession de Foi de l'Artiste'. *Arts*, No. 658, 25 February 1958.

Parinaud, André, 'Je Suis le Pavillon de Banlieue de la Peinture Moderne'. *Arts et Loisirs*, 26 January 1966.

Parinaud, André, 'Je Suis Toujours Heureux de Peindre'. *Les Galeries des Arts*, 15 February 1969.

Parinaud, André, 'Les J3 à la Conquête de Paris, Bernard Buffet: Je Ne Suis Pas Prisonnier de Ma Chance'. *Arts*, 19 February 1958.

'Paris Court Thwarts an Icebox Multiplier'. *New York Times*, 8 July 1965.

'Paris Gets a New Play and a New Ballet'. *Times*, 23 January 1958.

Prat, Véronique, 'Bernard Buffet: Cette Fois-çi, Il Illustre Jules Verne'. *Le Figaro* magazine, 27 January 1990.

Prat, Véronique, and Bertrand de Saint Vincent, 'Bernard Buffet: Le Mal Aimé Qui Peignait à la Chaîne'. *Le Figaro* magazine, 29 September 1992.

'Quatorze Années de Peinture Étalées sur le Mur: La Moitié de la Vie de Ce Peintre de 28 Ans'. Musée Bernard Buffet archives, unidentified press clipping.

'Que Faut-il Penser de Bernard Buffet'. *Jardin des Arts*, No. 42, August 1958.

Restany, Pierre, 'Bernard Buffet'. *Archives Critique d'Art*, February 1959.

'Revue Giono'. *Association des Amis de Jean Giono*, No. 8, 2014–15.

Robertson, Nan, 'French Left Attacks Minister of Culture'. *New York Times*, 26 May 1973.

Roger-Marx, Claude, 'Buffet et Lorjou Demonstrant Ce Qu'est la Jeune Peinture'. *Le Figaro Littéraire*, 24 July 1948.

Roger-Marx, Claude, 'Le Combat Statique de Bernard Buffet'. *Le Figaro Littéraire*, 9 February 1967.

Roger-Marx, Claude, 'Les Solitudes de Bernard Buffet'. *Le Figaro Littéraire*, 13 February 1954.

Roob, Alexander, *Maurice Garnier: The Last Artist's Gallerist*. Düsseldorf: Melton Prior Institute, 11 January 2014.

Roux-Charles, Edmonde, 'Bernard Buffet au Désespoir'. Musée Bernard Buffet archives, unidentified press clipping.

Schneider, Edgar, 'Le Nouveau Paradis de Buffet'. *Jours de France*, 31 January 1981.

Schneider, P. E., 'France's Fabulous Young Five'. *New York Times*, 30 March 1958.

Sheppard, Eugenia, 'There's a New "In" Spot in Paris'. *Dallas Morning News* archives.

Simenon, Georges, 'Bernard Buffet'. *Les Cahiers de la Peinture*, No. 4, September 1958.

Simenon, Georges, 'La Chambre, Ballet'. *Paris Match*, 14 January 1956: 64–5.

Simenon, Monsieur Georges, et Madame Bernard Buffet. Galerie Maurice Garnier archives, unidentified press clipping, early 1959.

Sischy, Ingrid, 'Jeff Koons is Back'. *Vanity Fair*, July 2014.

Smith, Roberta, 'Bernard Buffet, French Painter, Dies at 71'. *New York Times*, 5 October 1999.

Special Correspondent, 'Seven Paintings Make £781,000 in 21 Mins: Records Broken at Sotheby's'. *The Times*, 16 October 1958.

'Sur la Scène de Monaco, Buffet Se Promene dans Sa Peinture'. Musée Bernard Buffet archives, unidentified press clipping.

Tasset, Jean-Marie, 'Bernard Buffet l'Enfant Cheri de la Gloire'. *Le Figaro*, 22 January 1975.

Tasset, Jean-Marie, 'Faut-Il Brûler Bernard Buffet'. *Le Figaro*, 22 September 1992.

'Témoinages Contradictoire'. Musée Bernard Buffet, anonymous press clipping.

Terray, Aude, *Claude Pompidou: L'incomprise*. France: Éditions du Toucan, 2010.

Tessier, Carmen, 'Le Peintre Bernard Buffet a du Sortir de Son Exposition à la Galerie Charpentier (où Plus de 8,000 Personnes Ont Défilé) Protégé par Deux Agents Comme une Vedette Internationale'. *Les Potins de la Commère*.

'The Art of Painting, France's Greatest Artist'. Musée Bernard Buffet archives, unidentified press clipping.

'The Phenomenal Mr Buffet'. *The Times*, 9 March 1961.

Trillat, Raymond, 'Buffet est un Être Secret Agressif, Tourné Vers Son Passé. Les Paysages de Paris de Bernard Buffet'. Musée Bernard Buffet, unidentified press clipping.

Turenne, Henri de, 'Now a Pretender to the Gaullist Throne'. *New York Times*, 23 February 1969.

Tyrnauer, Matt, 'To Have and Have Not'. *Vanity Fair*, March 2011.

'Une Exposition "a Sensation" à la Galerie Charpentier'. Musée Bernard Buffet archives.

Vallier, Dora, 'Le Crapouillot'. Musée Bernard Buffet archives, unidentified press clipping.

Vandel, Jacqueline, 'Buffet Grave à Montmartre'. *Le Figaro Littéraire*, 10 February 1962.

Vigier-Benoist, Geneviéve, 'Chez Annabel et Bernard Buffet'. *Jours de France*, 20 January 1978.

Wall Street Journal, 28 May 1991.

Warnod, George, 'L'Apocalypse de Bernard Buffet', *Le Peintre*, 15 February 1955.

Warnod, André, 'Le Cas Bernard Buffet'. *Le Figaro*, 9 February 1950.

Warnod, André. 'Le Gynéecée et le Bestiaire de Bernard Buffet'. *Le Figaro*, 8 February 1954.

Watt, Alexander, 'Paris Commentary'. *Studio London*, May 1952.

Wilde, Van (ed.), 'Bernard Buffet: Nous Sommes Tous des Don Quichotte'. *L'Affiche d'Art en Europe*, 1989.

Williams, Peter, 'The Story of the Creation of Françoise Sagan's *Le Rendez-vous Manqué* in Monte-Carlo'. *Dance and Dancers*, March 1958.

Wilson, Earl, 'It Happened Last Night'. *Desert Sun 73*, 3 January 1956.

Wrathwall, Claire, 'A Single Man'. *Baku*, Autumn 2014.

Zana, Jean-Claude, 'Bernard Buffet, Le Paria'. *Paris Match*, 21 March 1991.

Broadcasts and other

Bernard Buffet, From Here to Eternity. Dir. Valerie Exposito. Baseline, 1998.

Durieux, Jean, and Claude Deflandre, 'Annabel et Bernard Buffet'. Film TV, July 1987.

Dutilleul, Henri, 'Lettres de Dutilleul à Chapoval'. LAM Archives, 21 August 1948.

eBay, 'Top 6 Nike Dunks of All Time', 14 September 2014.

Esposito, Valerie, 'D'Ici a L'Éternité'. Film TV, July 1998.

Giannoli, Paul, video interview, 5 September 1966.

How to Marry a Millionaire. Dir. Jean Negulesco. Twentieth Century Fox, 1953.

http://m.ina.fr/audio/PHD88025756/bernard-buffet-audio.html

http://m.ina.fr/audio/PHD99201536/jean-giono-du-cote-de-manosque-8-audio.html

http://m.ina.fr/video/AFE85009471/bernard-buffet-15-ans-video.html

http://m.ina.fr/video/I04189963/la-biennale-des-jeunes-artistes-au-Musée-d-art-moderne-a-paris-video.html

http://www.britishpathe.com/video/bernard-buffet-at-work/query/Bernard+Buffet

http://www.britishpathe.com/video/the-eye-of-the-artist/query/Bernard+Buffet

http://www.dailymotion.com/video/xm4ahb_annabel-buffet-chante-il-n-y-a-plus-d-apres-guy-beart-1968_music

http://www.dailymotion.com/video/xm7yx2_annabel-buffet-la-mauvaise-reputation-georges-brassens-1968_music

http://www.ina.fr/video/CPF86615640/la-chambre-video.html

http://www.ina.fr/video/I10037091/montee-des-marches-du-11eme-festival-de-cannes-video.html

Jaujard, Jacques, and Jeanne Laurent, *Concours des Jeunes Compagnies*. France: Dictionnaire Encyclopédique du Théâtre, Corvin, 1948.

Magne, Michael, '*Le Rendez-Vous Manqué*: Ballet en 2 Actes de Françoise Sagan'. Pathé, 1958. Vinyl.

'The Eye of the Artist', Pathé News, 1958

Interviews with the author

Bergé, Pierre, May 2013

Bergé, Pierre, 17 December 2013

Brynner, Doris, December 2014

Buffet, Nicolas, February 2015

Dazy, Christian, July 2014

de Ribes, Comtesse (Jacqueline), 10 January 2015

Donnadieu, Marc, 31 May 2014

Dyan, Gilles, September 2014

Forgy, Mark, 3 September 2015

Garnier, Ida, 17–18 October 2013

Garnier, Ida, 23 January 2015

Garnier, Maurice, 24 May 2013

Garnier Maurice, 24 June 2013

Garnier, Maurice, September 2013

Garnier, Maurice, October 2013

Gréco, Juliette, 15 July 2014

Hergott, Fabrice, 24 May 2013

Jannsen, Sébastien, 24 May 2013

Lévy, Céline, June 2014

Lévy, Céline, July 2015

Lindemann, Adam, October 2013

Malat, Jean-David, September 2014

Okano, Koko, 11 December 2014

Osterwold, Tilman, 22 July 2015

Pagliarani, Rosalia, email on behalf of Dr Micol Forti, 29 December 2014

Périer, Henry, 18 October 2013

Richardson, Sir John, November 2014

Roob, Alexander, email, summer 2013

Roob, Alexander, email, 2 July 2015

Summers, Martin, July 2014

Tamenaga, Kiyotsugu, October 2014

Wrobel, Stephan, 10 June 2015

Archives

Bibliothéque nationale de France, (BNF)

Dallas Morning News

Galerie Maurice Garnier, Paris

Hermitage, St Petersburg

Institut national de l'audiovisuel, (INA)

Lille Métropole Museum of Modern, Contemporary and Outsider Art, (LAM)

Musée Bernard Buffet, Japan

S&S Wrobel

Index